W9-AGH-390

WILDERNESS EXPEDITIONS

by Heinz Sielmann

**Translated from the German
by Joachim Neugroschel**

FRANKLIN WATTS
NATURALIS

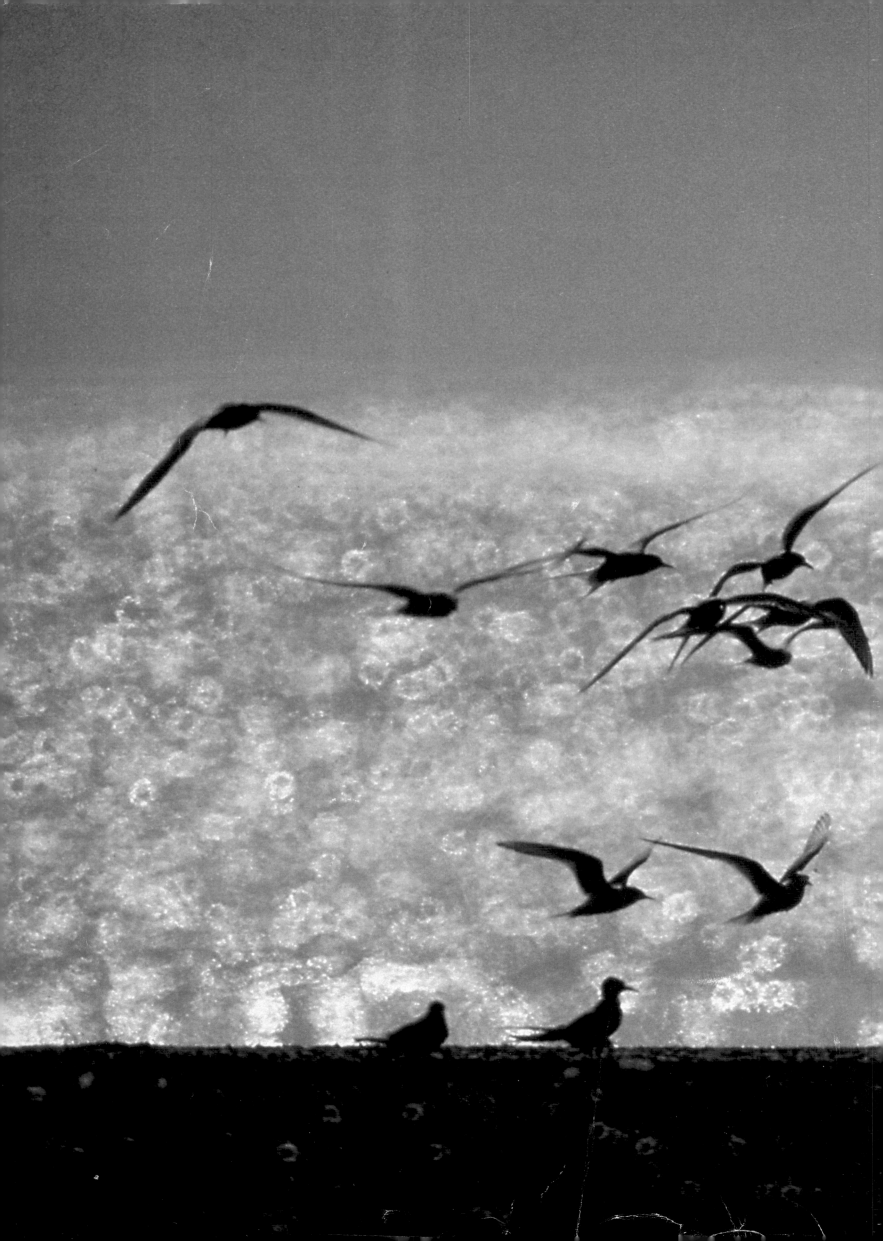

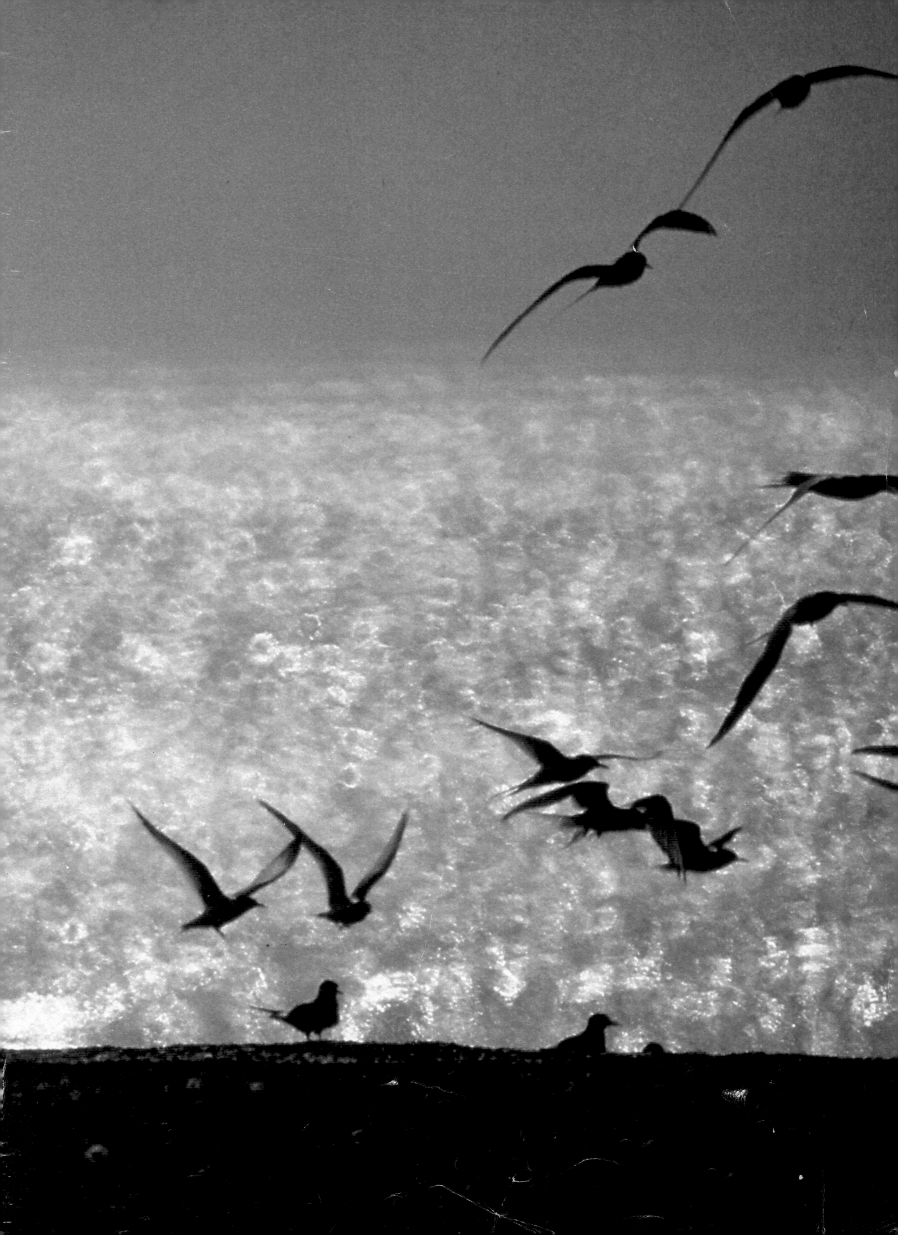

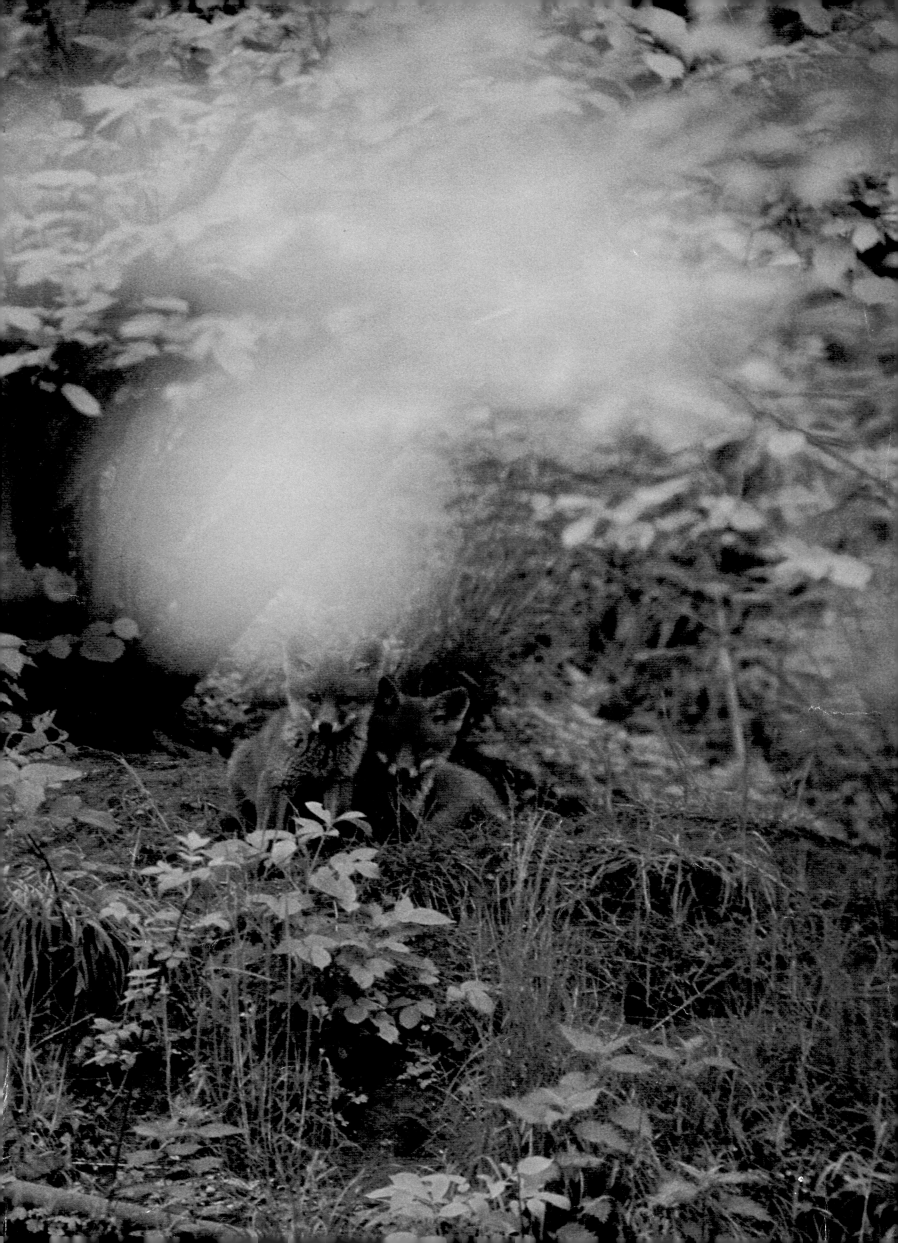

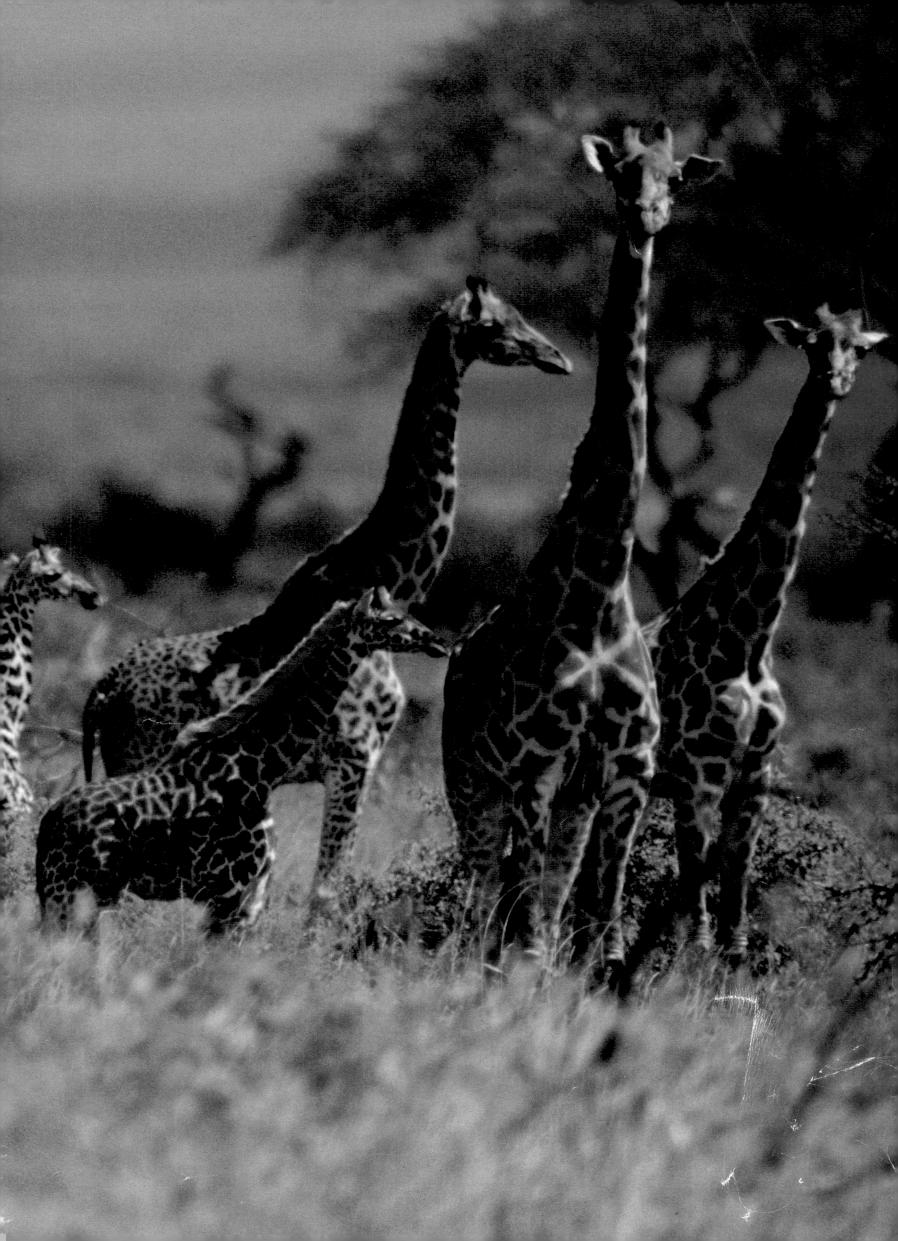

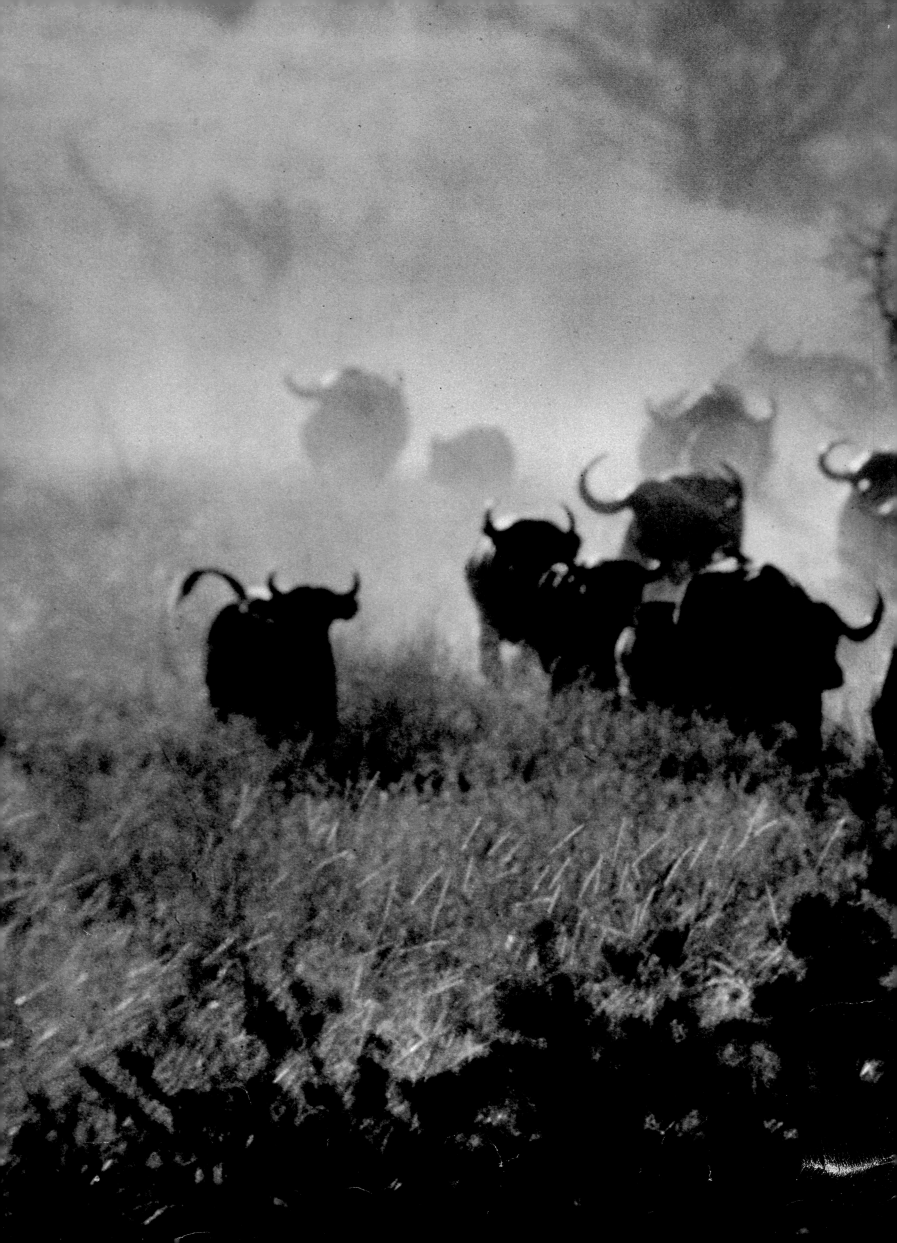

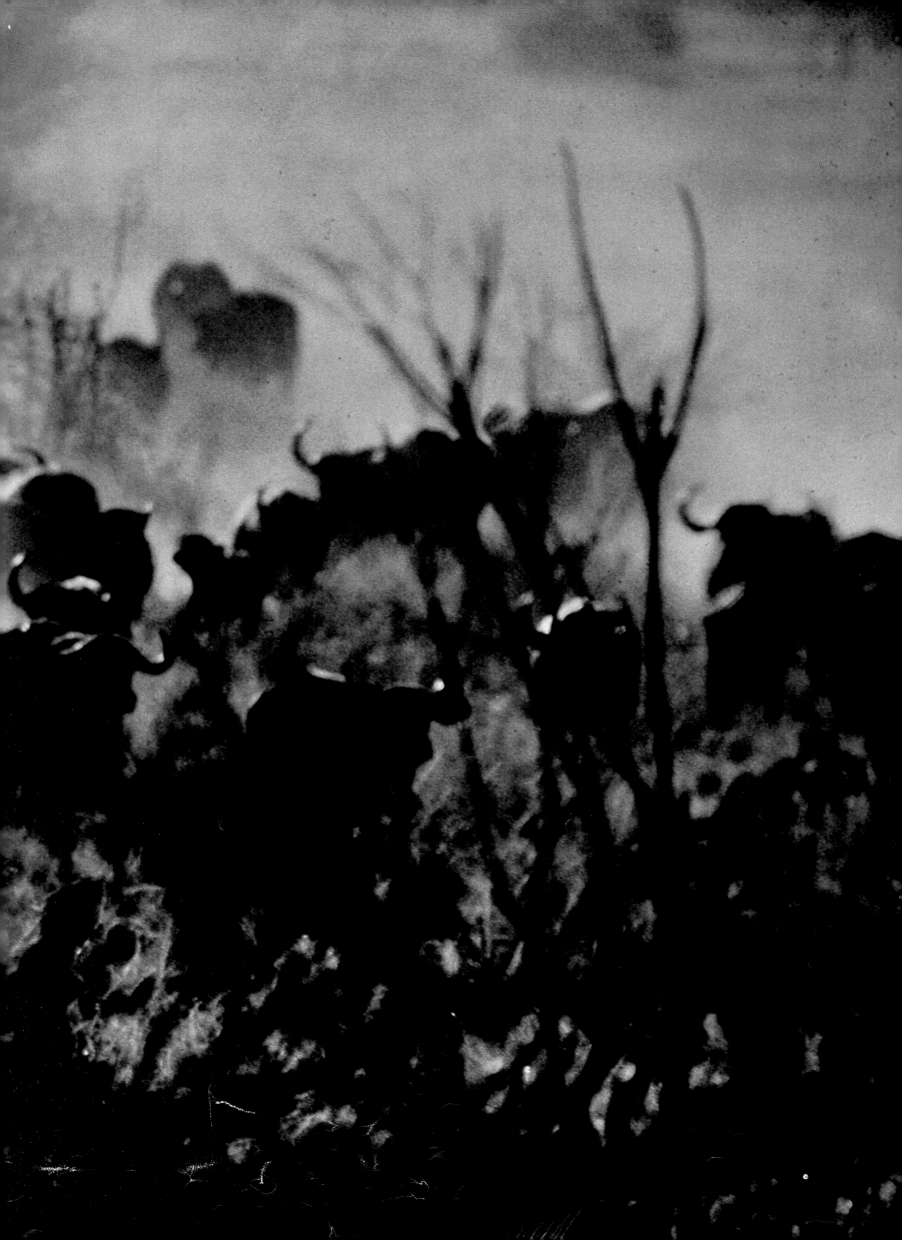

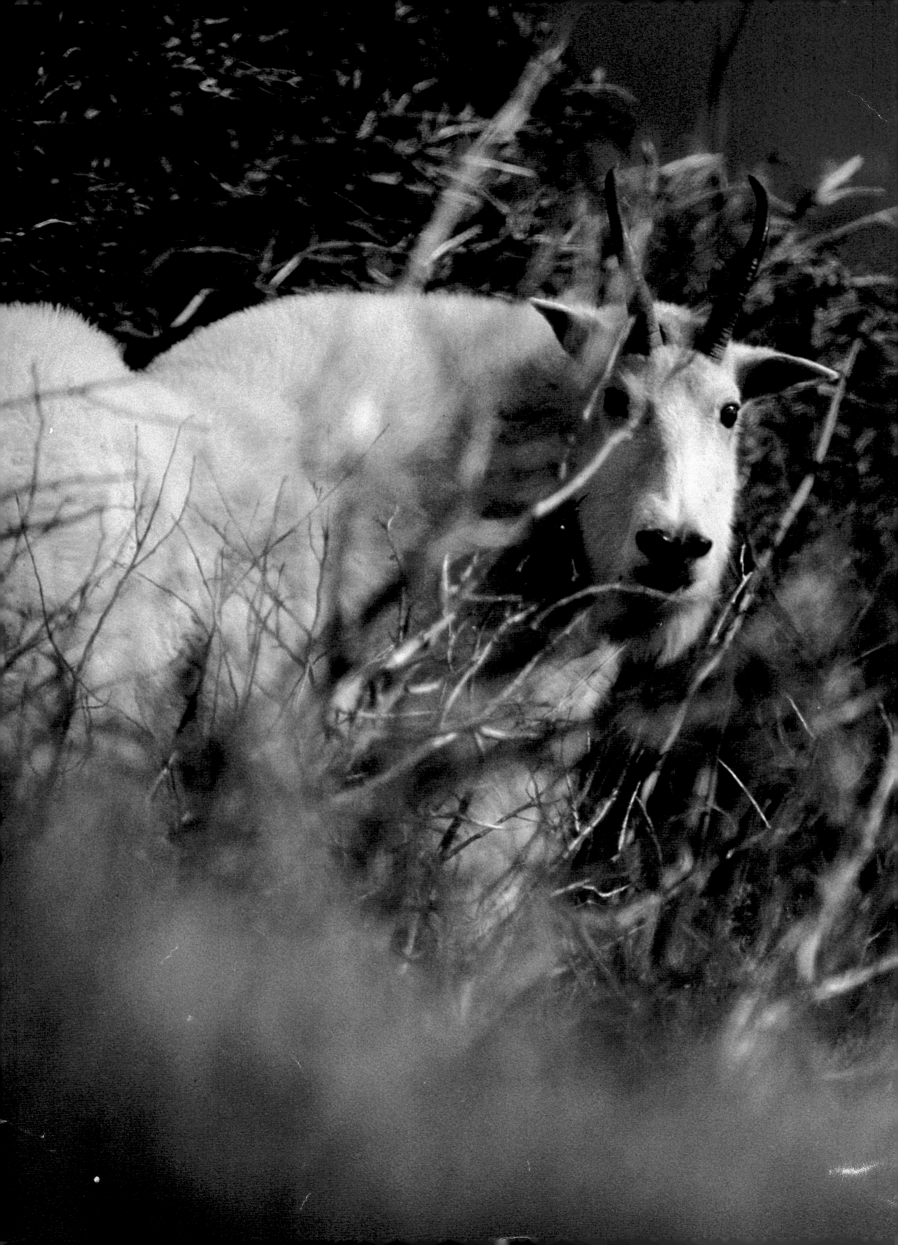

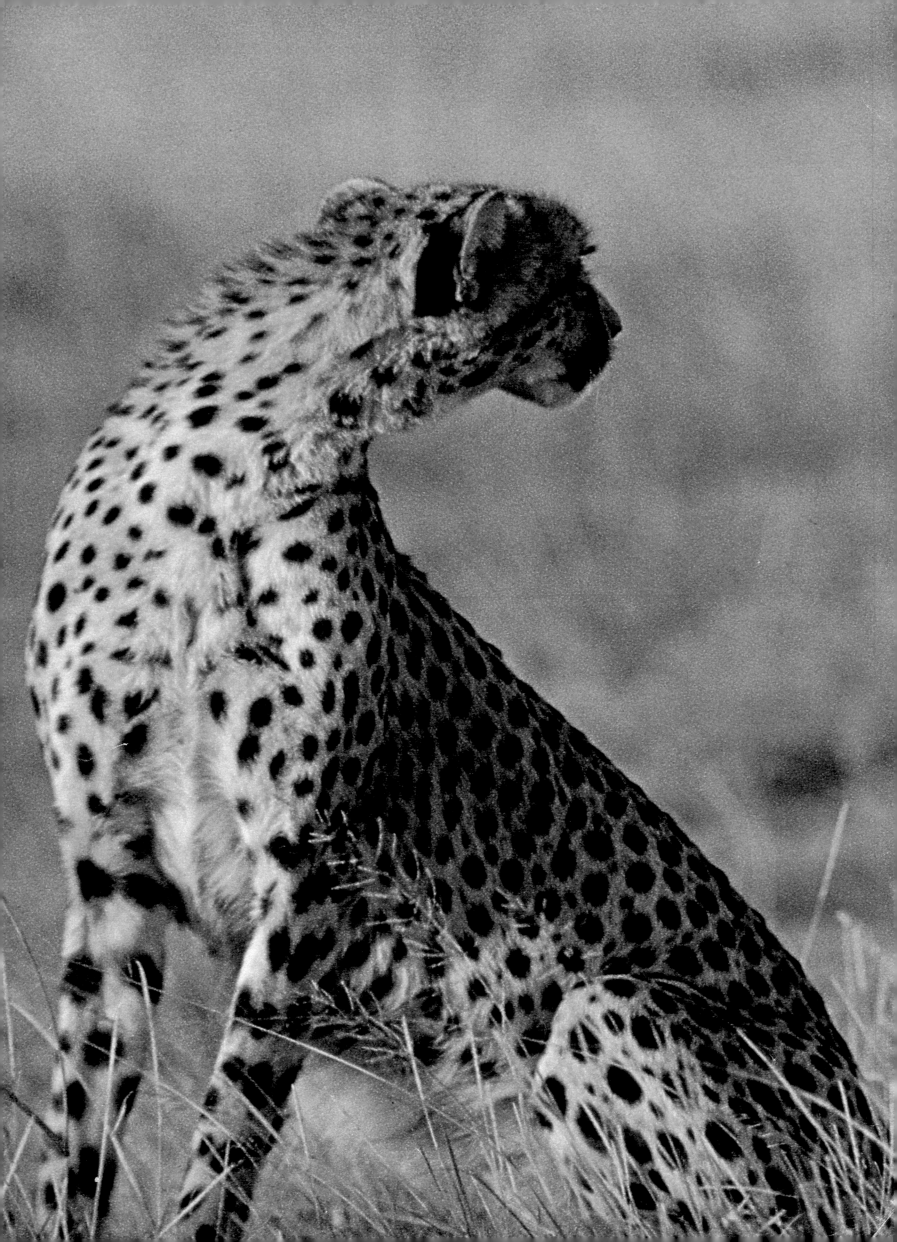

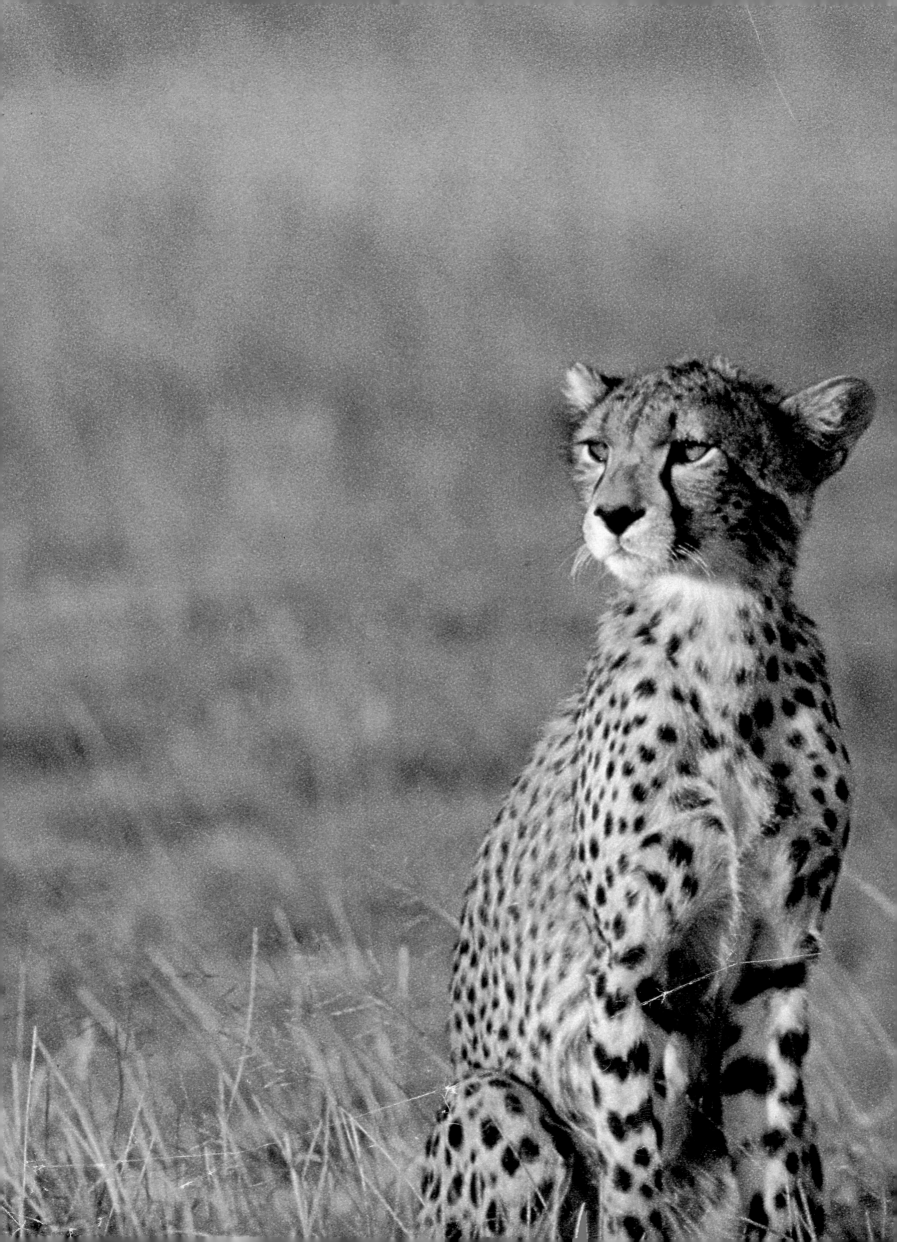

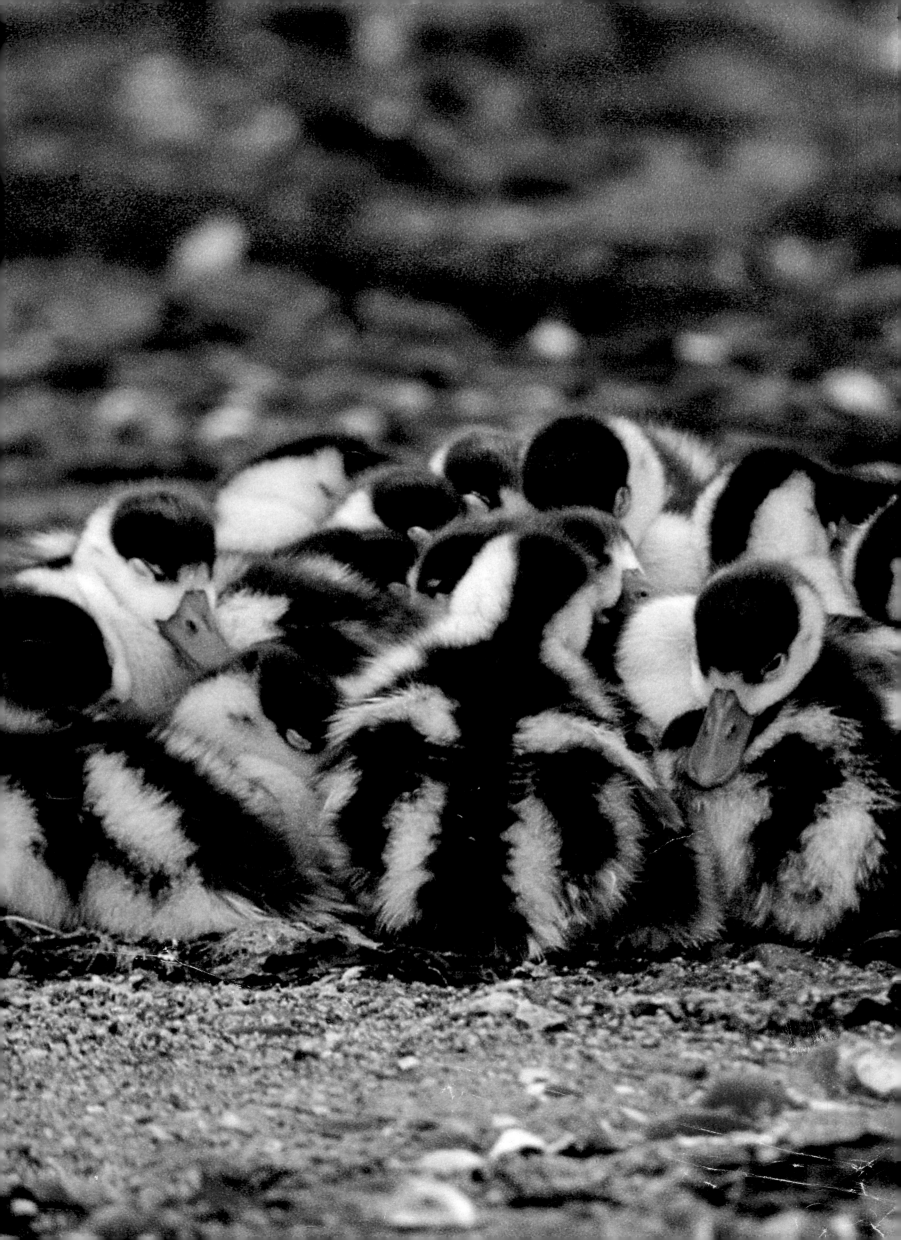

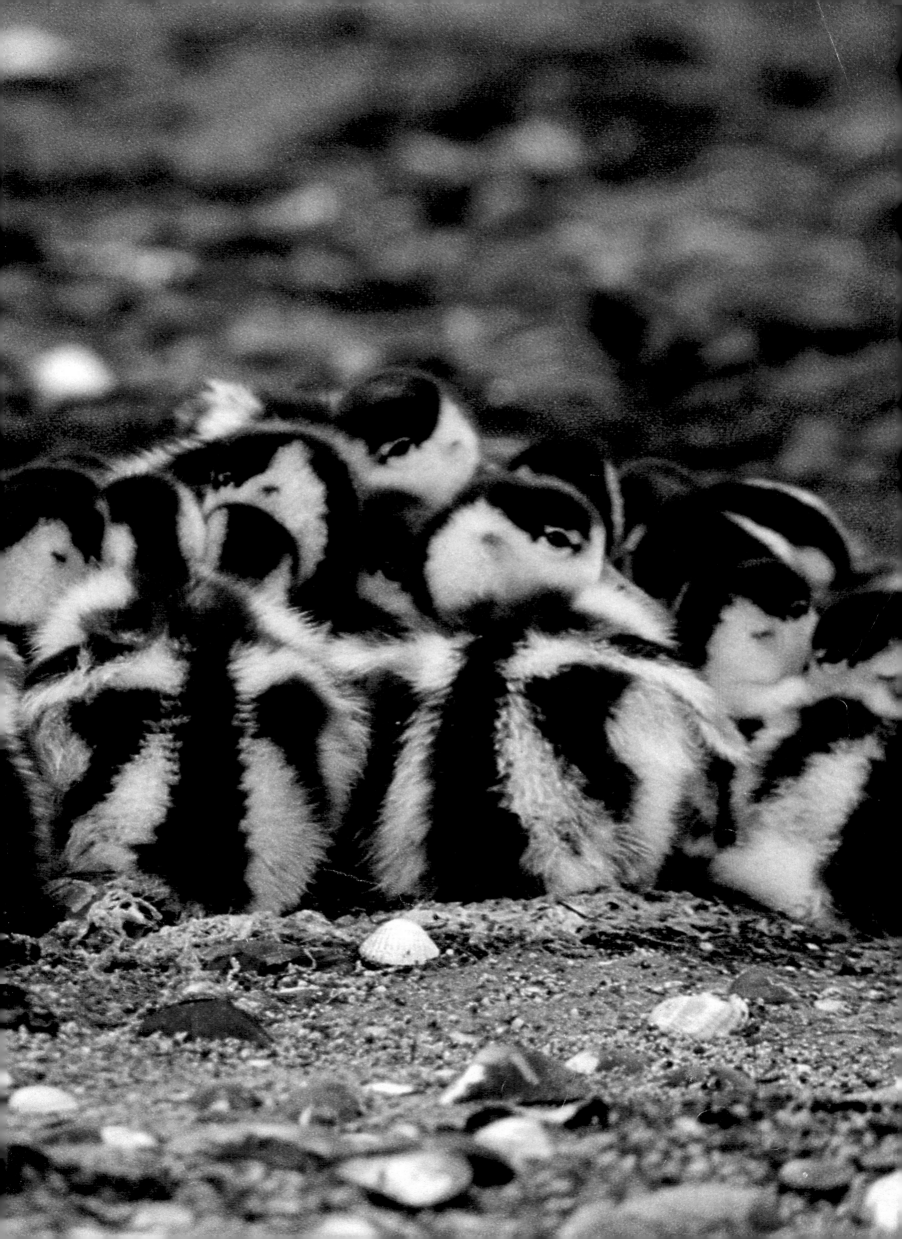

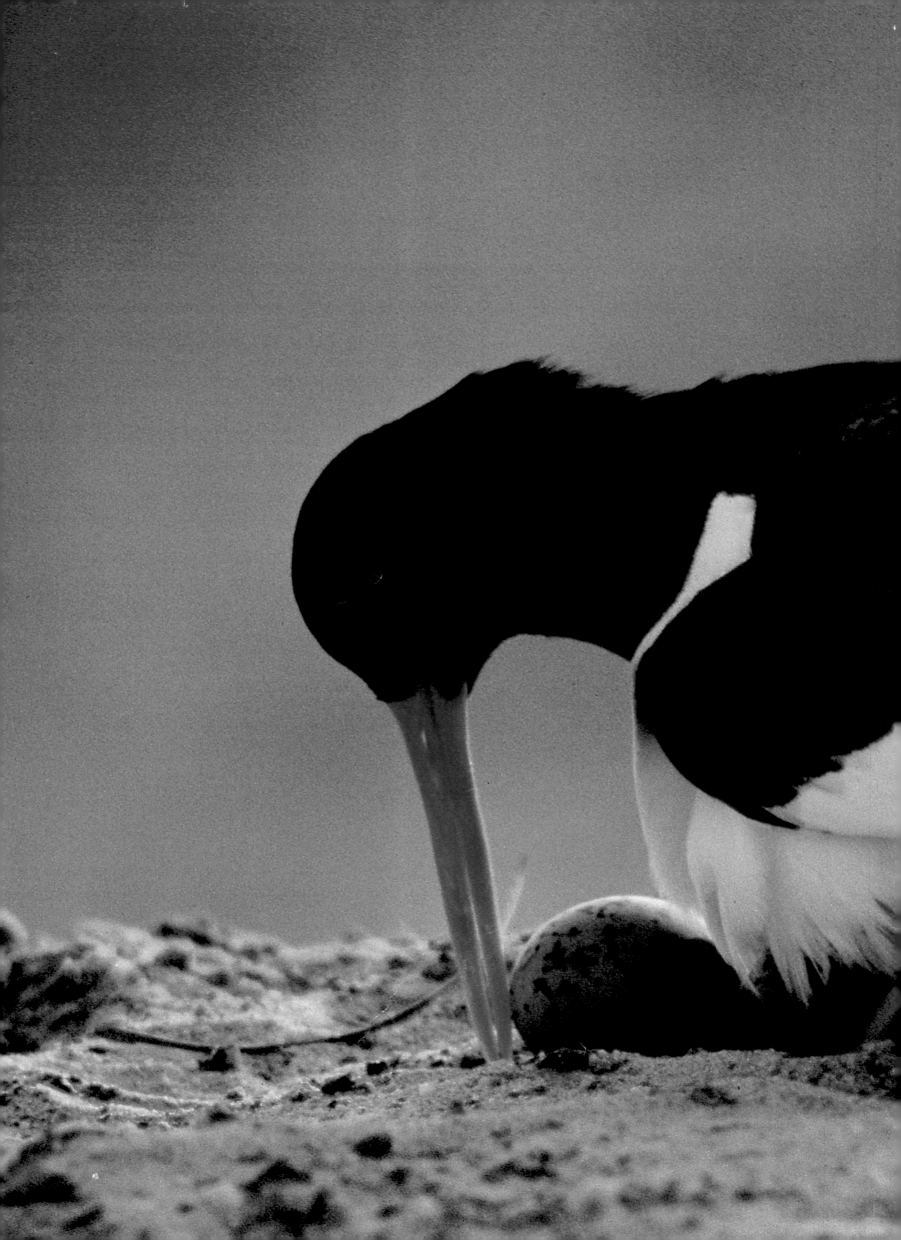

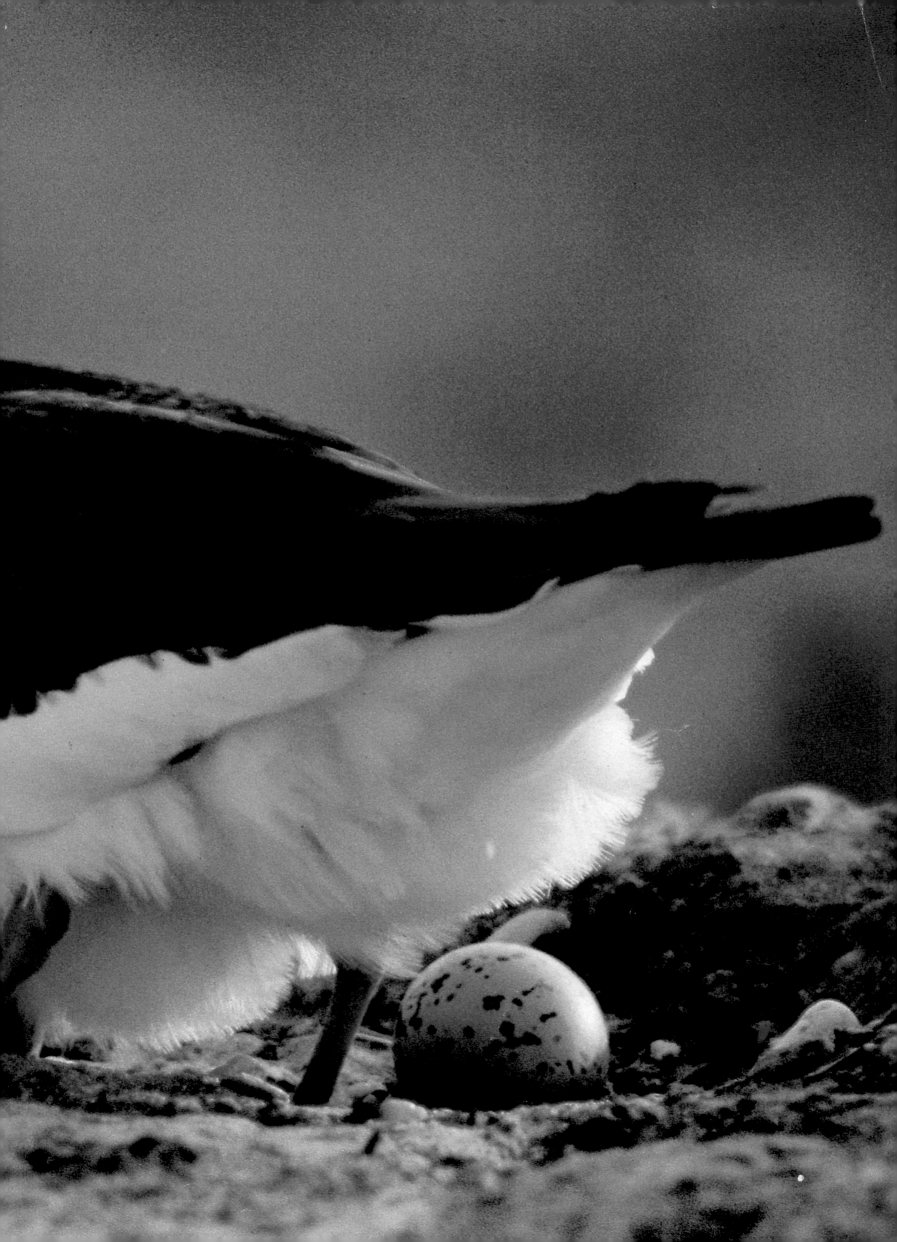

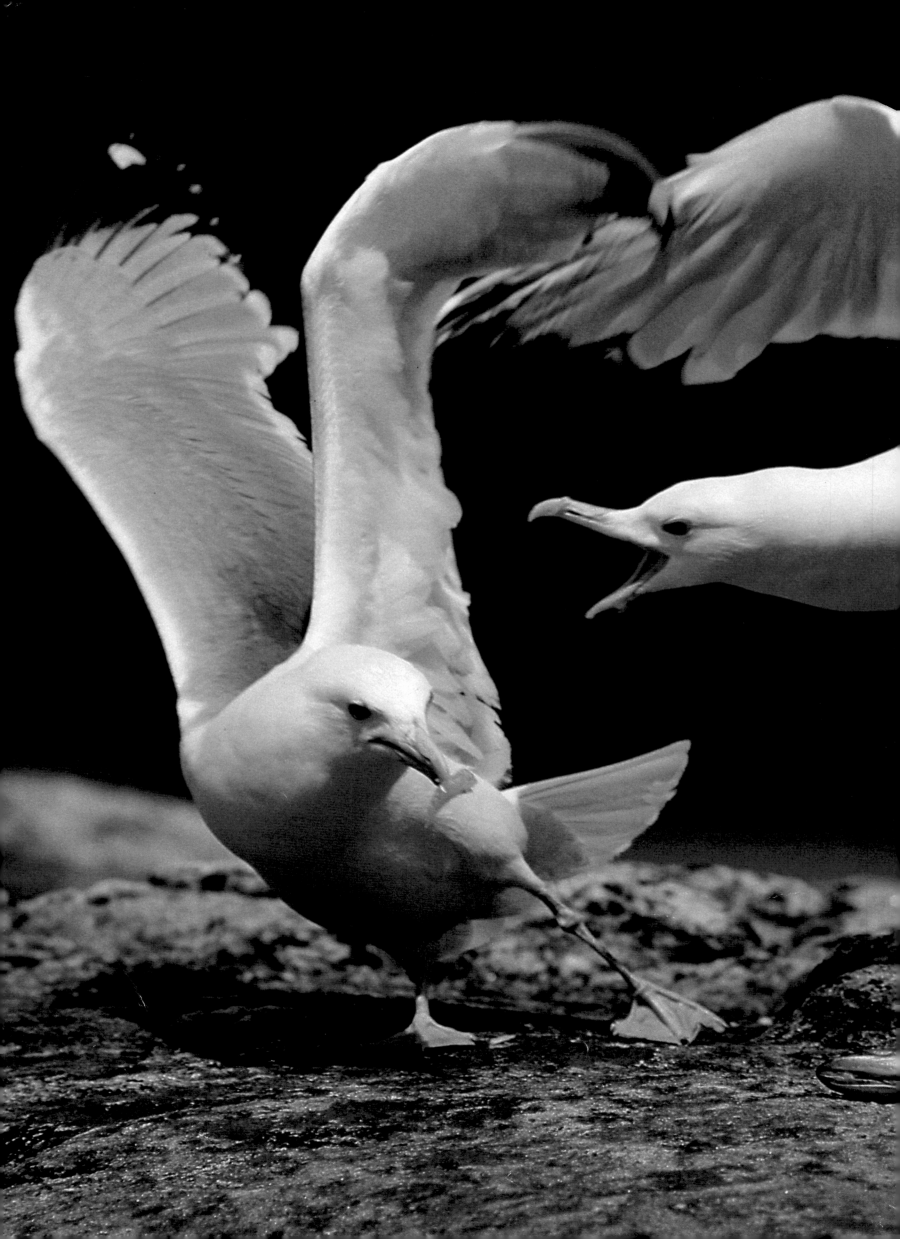

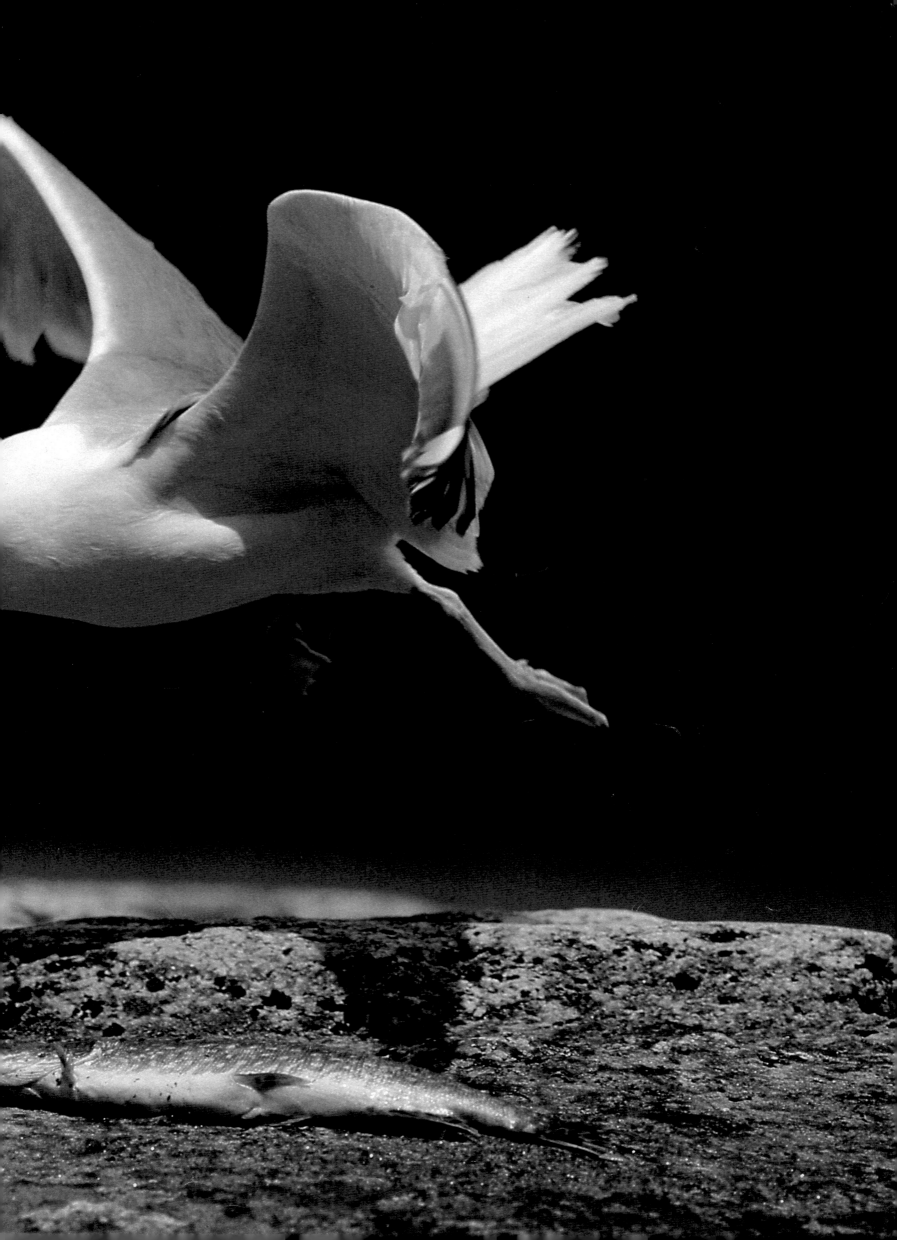

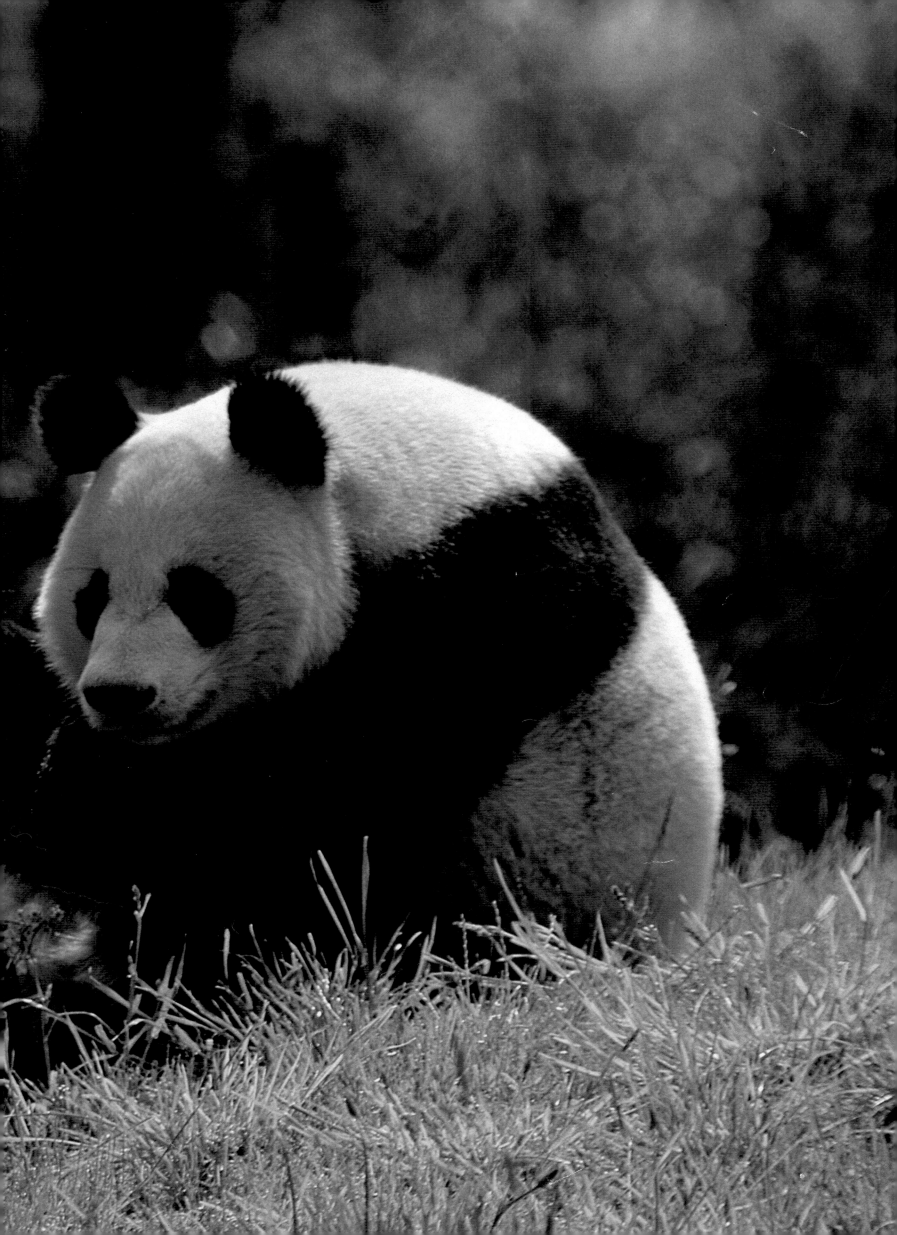

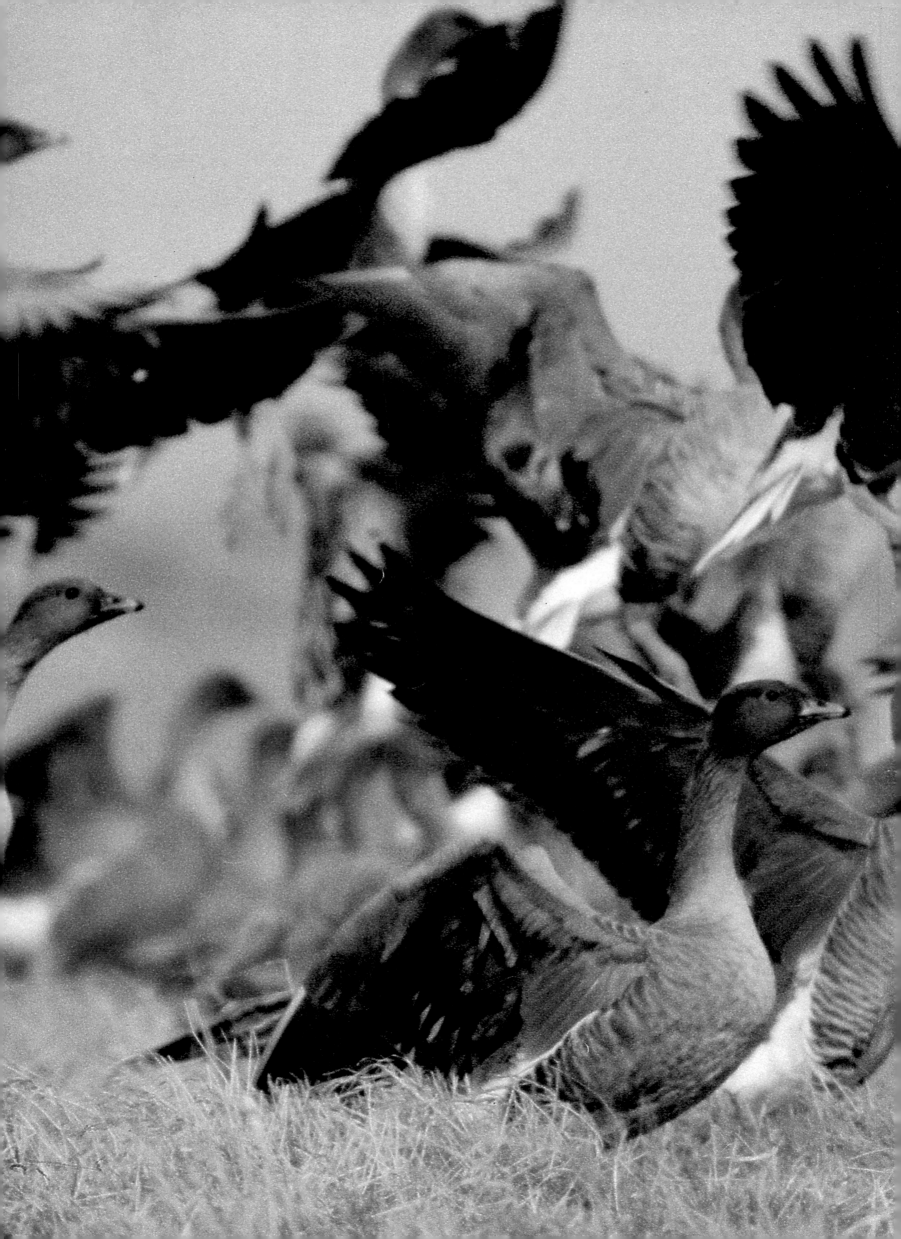

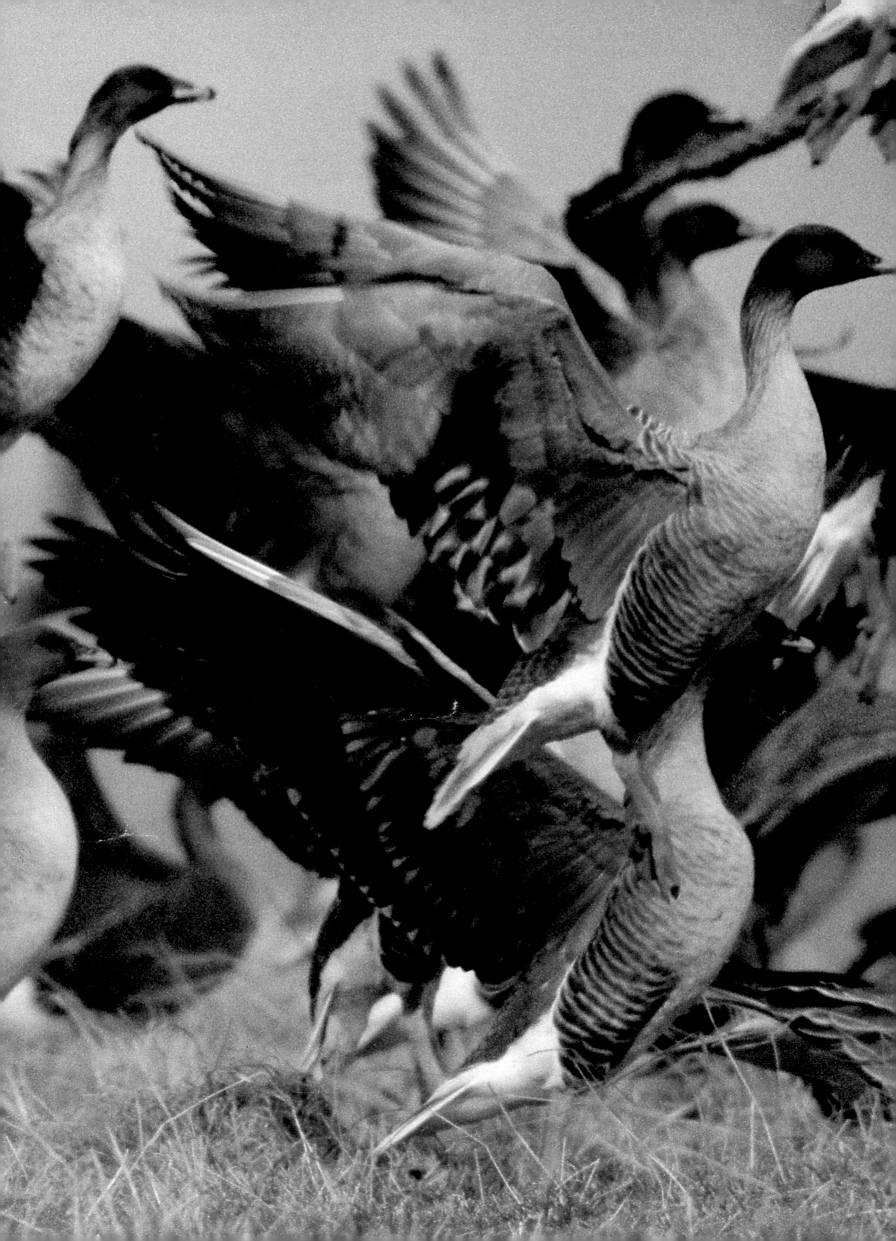

During the past few years, our attitude toward nature has become a lot more practical and down-to-earth. Today we inquire about the causes and effects, the purpose and the tasks, the meaning of life within the realm of nature. Romantic sentimentality about nature has been replaced by a keen interest in investigating the enigmas and unveiling the secrets of the animal kingdom. This curiosity characterizes our modern awareness of nature and the environment.

If this fundamental transformation is now perceptible, we owe it to men like Heinz Sielmann. He has spent the greater part of his life investigating and documenting nature's phenomena for science, schools, and the media.

Sielmann's pioneering work in animal films has earned him world renown during the past forty years. His first documentary film, *Song of the Wild,* was a tremendous success, and his feature-length nature film, *Ruler of the Jungle,* commissioned by the Royal House of Belgium, was produced in twenty-six languages. It won first prize at the Moscow Film Festival for its outstanding achievement.

Twenty-five years ago, Heinz Sielmann's animal studies became the first regular animal program on German television. "Expeditions into the Animal Kingdom" was a hit from the start and has always enjoyed high ratings, great popularity, and a loyal following.

In appreciation of this successful television series, Sielmann has received the German "Bambi" award, the "Golden Tube" Award, and countless West German film prizes, plus the coveted Cherry Kearton Medal of London's Royal Geographic Society. As further testament, Sielmann's movies have been used in biology classes throughout Germany and abroad.

The essence of Sielmann's experiences and observations are presented here in all their splendor. He has traveled the wildernesses of the world, a total of some 150,000 miles, to gather appropriate material for this book. His expeditions into the animal kingdom have led him into the icy mountain wilds of Alaska, the sultry tropical jungles of Borneo, the inhospitable volcanic region of the Galapagos Islands, as well as the endless reaches of the Australian continent. He has used planes, cross-country vehicles, reindeer-drawn sleighs, motorboats, canoes, helicopters, rafts, mules, inflatable dinghies, and dogsleds. He spent an uninterrupted ten months wandering through the eternal twilight of New Guinea's rain forest so that he might film animals known to the world only by name.

This book is more than just a catalog of Sielmann's travels and a compendium of fascinating details about life on earth, however. The best animal photographers in the world were employed to illustrate *Wilderness Expeditions,* and their unique photographs reveal that our remaining wilderness areas are very much alive and well, although, as the text explains, threatened. Highly developed reproduction processes guarantee absolutely flawless pictures of an almost unreal, legendary beauty.

Kurt Blüchel
Publisher

WILDE
EXPED

An unprecedented journey into

RNESS ITIONS

by Heinz Sielmann

the last wildernesses on earth

CONT

ENTS

EUR

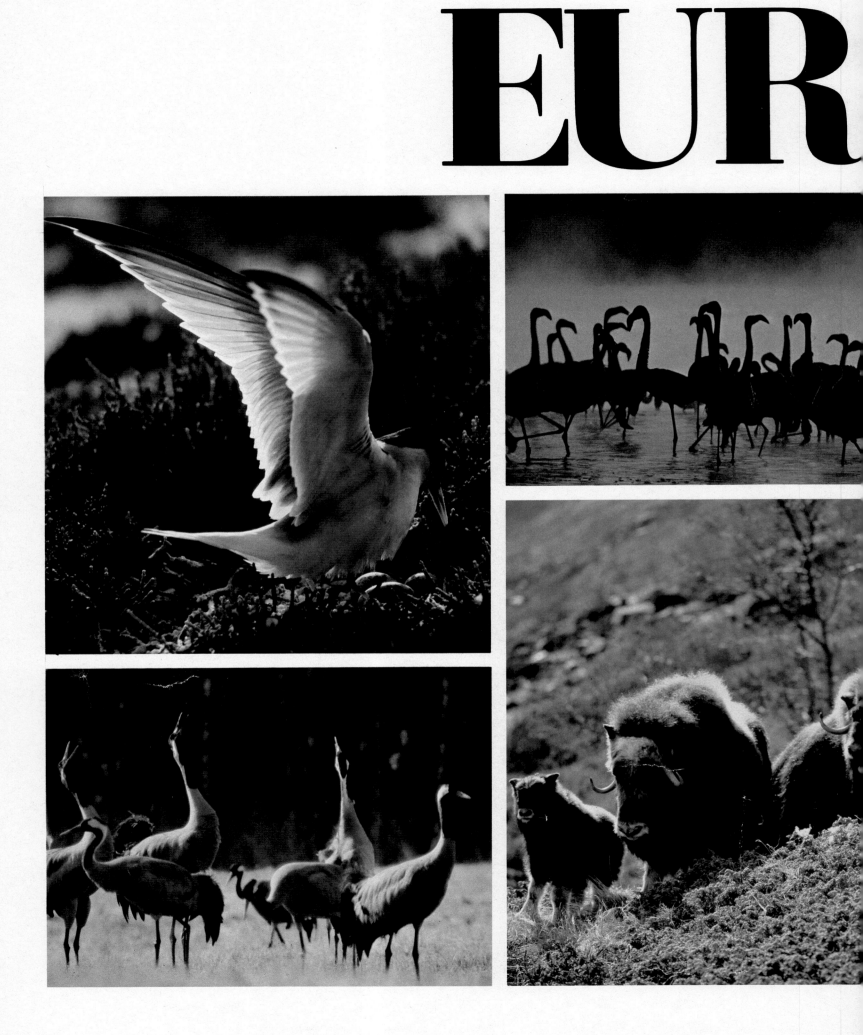

OPE

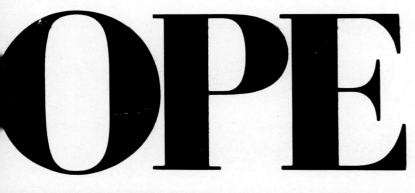

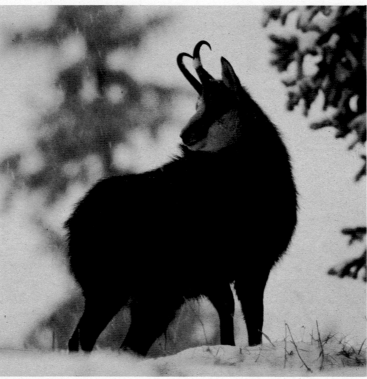

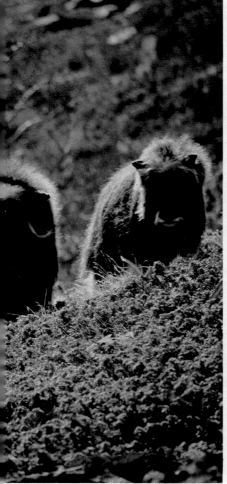

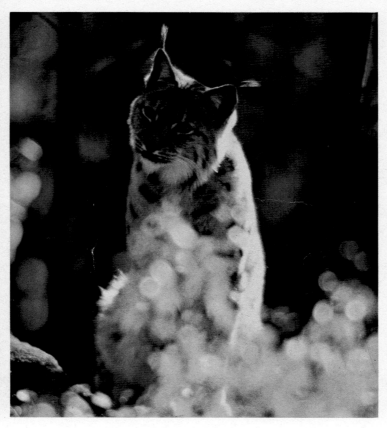

*The colors of the tundra are cold—whether in winter,
when the northern lights flicker,
or in summer, when the midnight sun shines.*

The Song of the Wild

in Lapland's Tundra

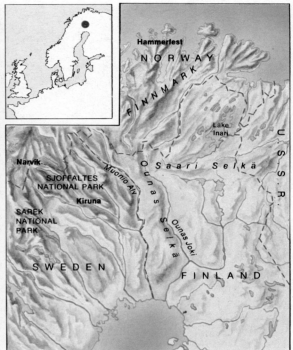

This lonesome land is the home of the Laps.

On bare mountain slopes and in the depths of conifer forests, the brown bear, the lynx, the glutton, and the wolf still hunt for their prey—even though the tundra usually seems monotonous and lifeless to a visitor. The only ubiquitous sound is the melancholy song of the golden plover. Its singing makes the silence audible.

A wilderness in Europe? Does it still exist? Big cities and congested areas crowd together and are spreading like a cancer across the land. Countless species of flora and fauna are on the verge of extinction because their habitats have been encroached upon and are steadily shrinking. So far, few regions have managed to escape the tentacles of civilization.

One area that has successfully resisted human encroachment lies in the far north of Europe. Lapland, the home of the golden plover, whose melancholy song echoes the loneliness of the tundra, stretches from the rugged fjords of Norway, across the Swedish fjelds (barren plateaus) and the Finnish highlands, into Russia's Kola Peninsula, encompassing an area of 100,000 square miles. Here, man plays an insignificant part.

It is a land of rocky massifs, dense forests, swamps, and highland tundra. Wherever man wants to create living space for himself, he must adjust to the demands of nature. The Lapps, today numbering some thirty thousand, have created a synthesis of harsh natural conditions and human needs. This synthesis has lasted for centuries.

The Lapps are the only nomads in Europe who still base their lives on the wanderings of their "domestic animals," the semiwild reindeer. Some 200,000 to 300,000 of these tundra reindeer populate the vast reaches of the Scandinavian north. Awkward and ungainly, the reindeer are not beautiful animals, but they do constitute the wealth of the Lapps and are the very basis of their existence. They provide milk and meat, supply a major portion of the clothing, and are the most important trade goods of this small nation.

Stillness rules the solitude for miles. Home of the bear, elk, lynx, and glutton, the tundra is their last remaining habitat in Europe.

Reindeer wander in herds numbering anywhere from a hundred to a thousand. With the change of seasons, they migrate either to their summer grazing areas along the coast or to winter quarters in the inland tundra where they scrape out their principal food, reindeer moss, from the thin layer of snow. Reindeer are the only species of deer of

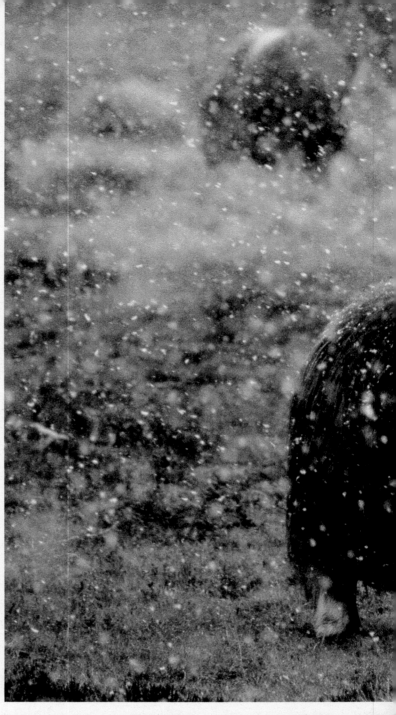

Musk oxen are leftovers from the Ice Age in the subarctic tundra.

In Norway's Dovre Fjell, these horned, short-legged creatures, whose matted winter coat hangs to the ground, are being renaturalized successfully. The musk ox, which looks prehistoric, is a distant kin of the American bison but is more closely related to goats and sheep than to the bovine species.

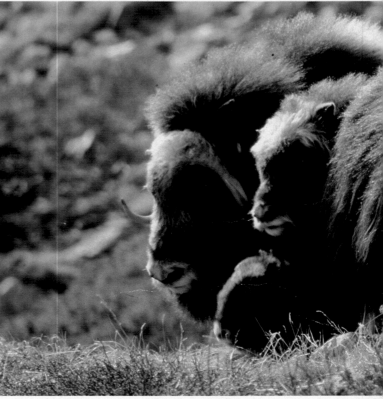

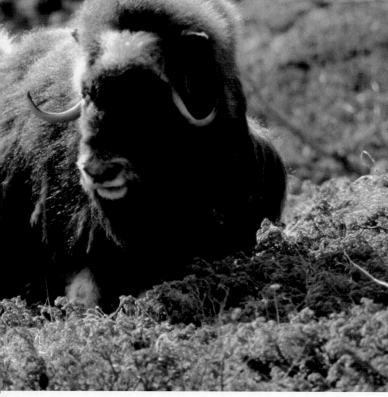

Pugnacious animals on the defensive

Although both cows and bulls have horns, only the bulls defend the small herd in an emergency. The bulls usually form a circle or a semicircle so that predators seldom have a chance.

which both male and female sport huge antlers, although these are but a summer adornment. The antlers grow in May, when the young are born, and are cast off in October, after the rutting season.

If not exactly a pet, the reindeer approaches that status in Lapland. As wild and willful as the land in which they live, reindeer cannot really be domesticated for they are unable to live in man's natural environment. Instead, man must follow these large wanderers year in and year out, at best only guiding their movement.

Between the North Sea and the Siberian taiga are found the last representatives of a European animal world which either is being resettled in other areas with great difficulty or can only be viewed in a zoo: the brown bear, the fox, the lynx, the glutton, and primeval giants like the

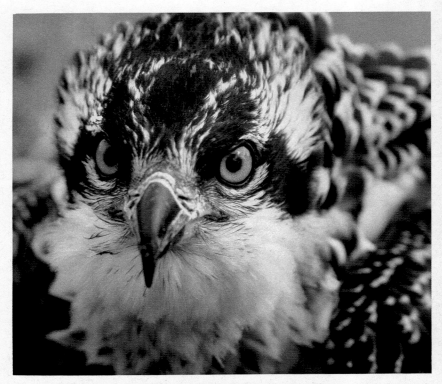

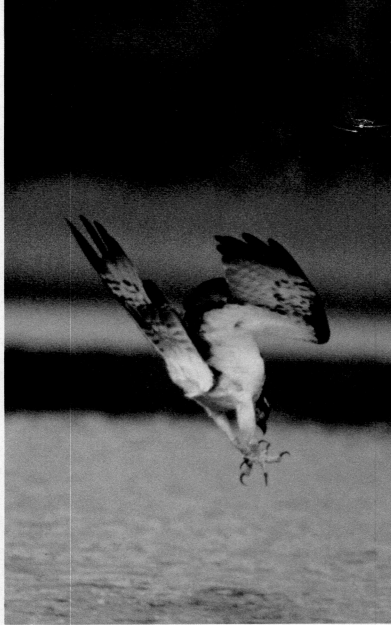

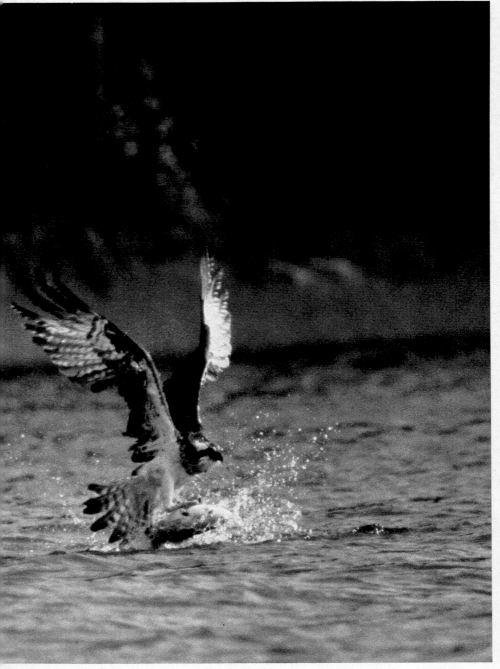

Ospreys go fishing— in search of a meal.

The osprey (or fish hawk), whose aerie is high in the trees, circles over quiet lakes at an altitude of sixty to ninety feet, often hovering like the kestrel. Once it spots its prey, it dives down into the water, sometimes catching fish that weigh more than it does. The size of a buzzard, this large bird of prey eats fish exclusively, so waterfowl seldom avoid it.

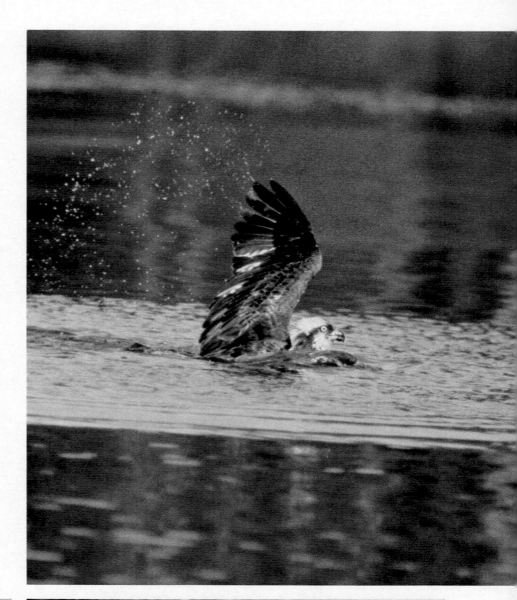

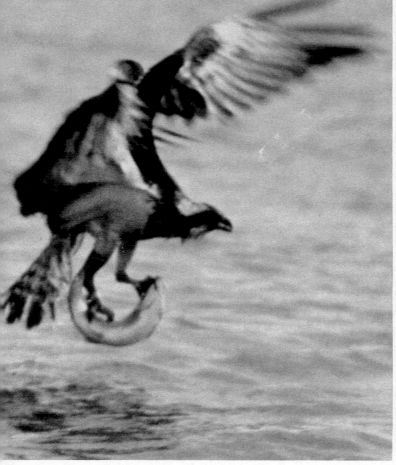

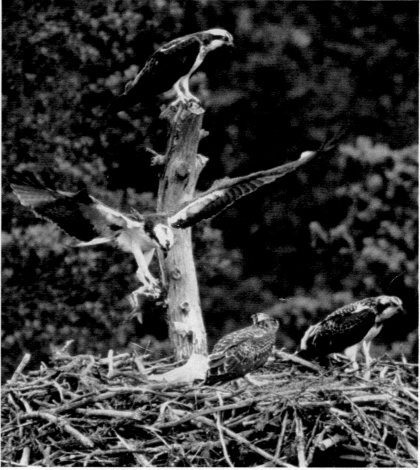

Typical inhabitants of the tundra

The mystery of lemming migrations is still not fully solved. Sometimes, as though at a command, they form a huge army and march off into the icy northern seas. In some years, these rodents (*below right*) appear in such great numbers that they destroy the food supply of reindeer (*right*) and the nesting opportunities of golden plovers (*below*).

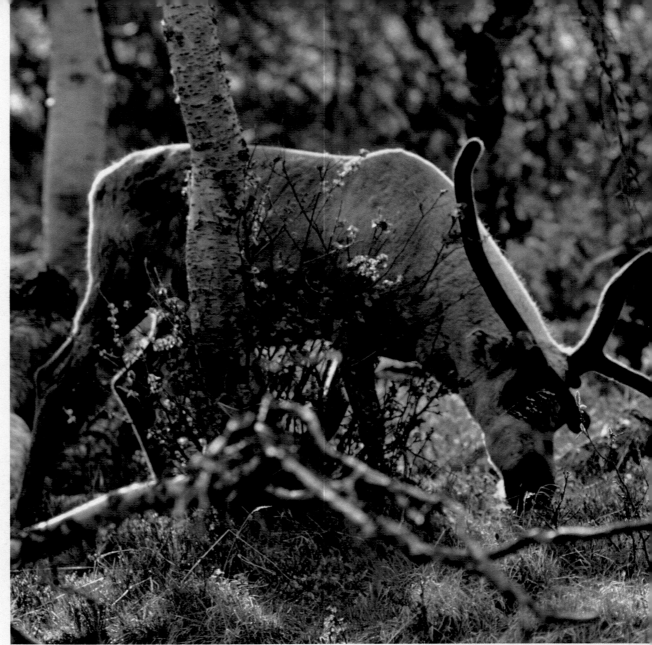

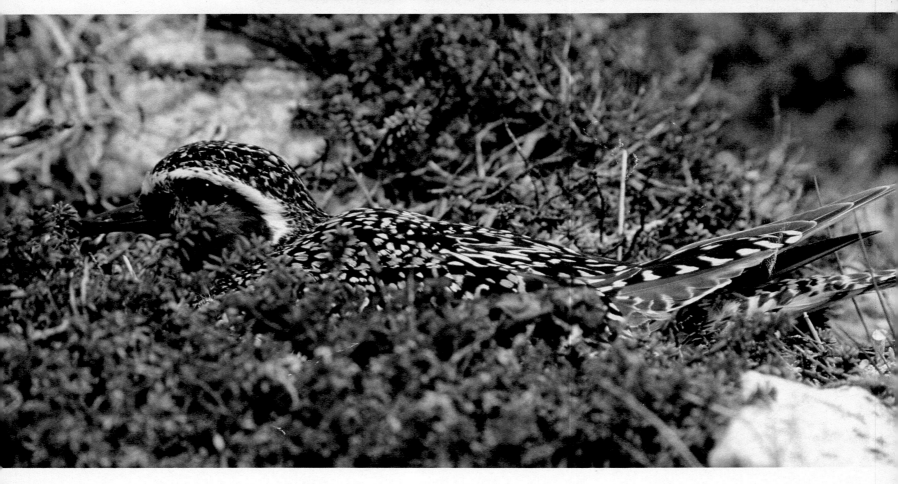

elk and the musk-ox. There is also an astonishing wealth of bird species that have migrated back from densely populated or tourist-mobbed areas: for instance, the ptarmigan, the willow grouse, the snowy owl, the red-necked phalarope, the golden plover, the whooper swan, the golden eagle, the merlin, and the gerfalcon.

While Lapland provides solitude and isolation for its plethora of rare animal species, it is not a true paradise. The flora and fauna must cope with the same difficulties that pose such problems for man: cold, wind, and barren land. However, there are mitigating factors. Lapland has a versatile landscape with a wide range of climatic zones. A maritime climate, strongly influenced by the Gulf Stream, brings the western region relatively mild winters and moderately warm summers. By contrast, the plateaus of the inland tundra are assaulted by a severely cold winter in October, and the brief summers here are marked by dry heat. Within reach of the mild ocean air, firs and pines thrive even in the far north, and mysterious forests grow where the tree line begins, according to the latitude. Long gray beards of lichen veil the trees, disguising them as giant forest demons. It is no wonder that Scandinavia is considered the home of elves and goblins!

In the inland tundra areas, the ghostly atmosphere intensifies. Here, in this world of total silence where only shrubs, mosses, and lichens claw their way into the rocky earth, a human being feels like an intruder. It is no place for man, the social animal.

The enchantment of the tundra plateau is not immediately apparent. But what miracles lie in the lichens that creep over the ground. A lichen is a symbiosis: a fungus spins a web around an alga, protecting it from cold and providing it with water so that it may produce food for both by means of photosynthesis. Lichens grow a maximum of one-fifth of an inch each year. Since they are able to live for centuries, however, they have all the time in the world. In winter, only a bit of snow protects these tiny plants, which buck the

As if to make up for the ruthless winter, a summer day is twice as long, due to the midnight sun. Then the tundra virtually explodes with life.

cold with leathery and somewhat hairy leaves. Lashed by fierce winter storms, the lichens look like so many dwarves huddled on the ground. Alas, while these primeval plants defy the harshest of climates, they are defenseless against air pollution; pollutants from as far as six hundred miles away can have a destructive impact on them.

The north of Europe is the land of the midnight sun. For two months in summer, there is not a night that is truly dark. (As if to make up for this, daylight is absent for two months in the winter.) By late April, the snow cover gradually begins to thaw from the bare surfaces of the plateau, the hibernating animals crawl out of their slumber caves, the reindeer head for their summer quarters, and the migrant birds return from their

▶

No sooner has the last snow melted than a white fur covers the swamps. Millions of downy snowballs—the flocci of the wool grass—dip the moors in glistening light.

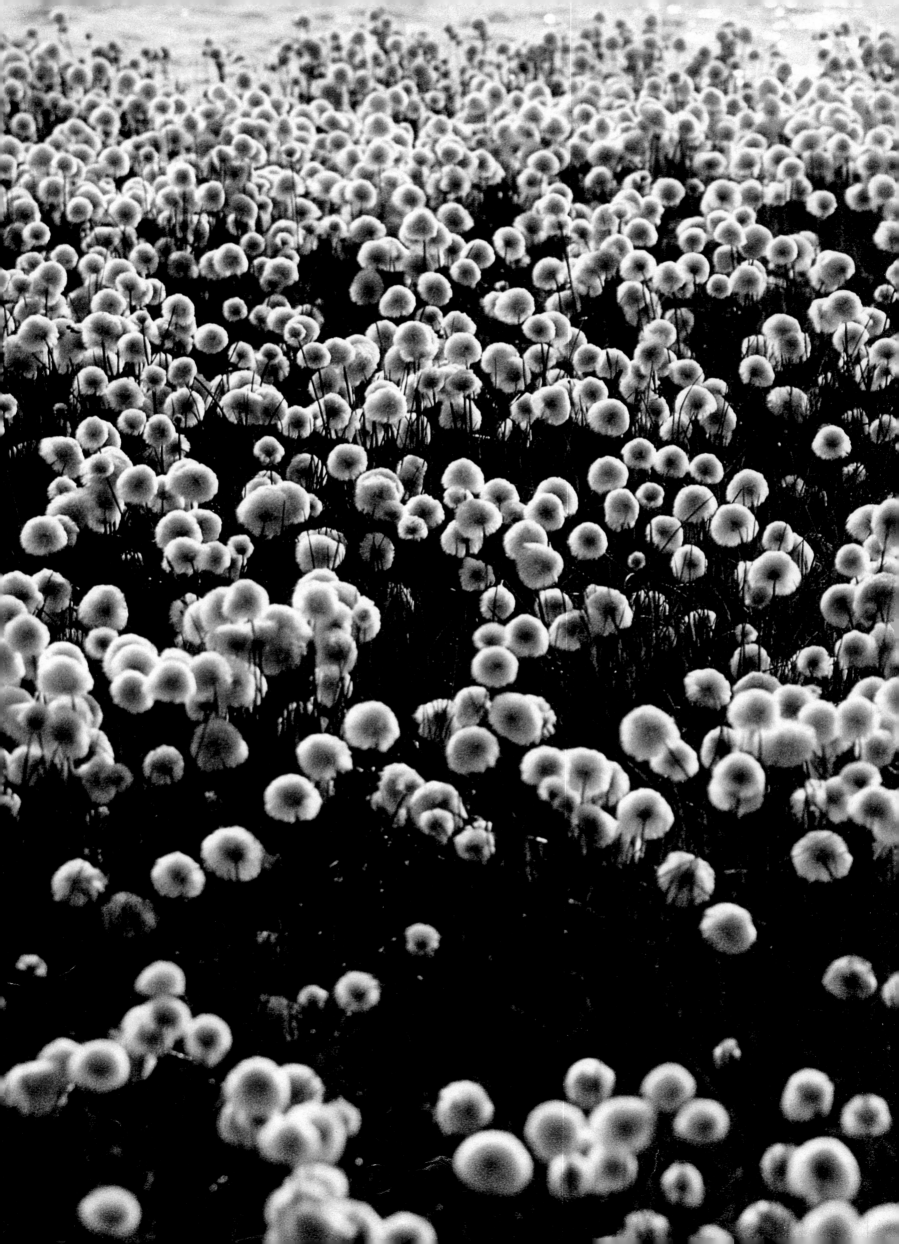

long southern voyage. Because of the short summer (spring, summer, and fall total only five months), both plants and animals must make the most of this time when night becomes day, and the sun spreads its radiance at midnight over the buds of the globeflower and goldenrod, the cloudberry and dwarf birch.

During the summer months, the hibernating creatures of the plateau—the white hare and the arctic fox, the ermine and the snow grouse—exchange their white winter garb for brownish fur or feathers.

The brief hatching season of the eider-duck, the whooping swan, and the whimbrel allows them to bring

Every few years the search for food drives the lemmings into the sea, a disaster that spares only the ones that bring up the rear of the large "army."

up their offspring before they are forced to begin the distant journey to the warmer south.

Now the calls and whistles of the golden plover echo across the fjelds. The sandpiper has found the very same nesting site that it abandoned last September when it set out for South Africa, and the "emancipated" female of the red-necked phalarope leaves the business of hatching to the male.

The snowy owl and the robber gull show up in the tundra wilderness if the previous winter was mild and the spring sun began to shine early. Both creatures rely on being able to find rich prey among the lemmings, whose increase is guaran-

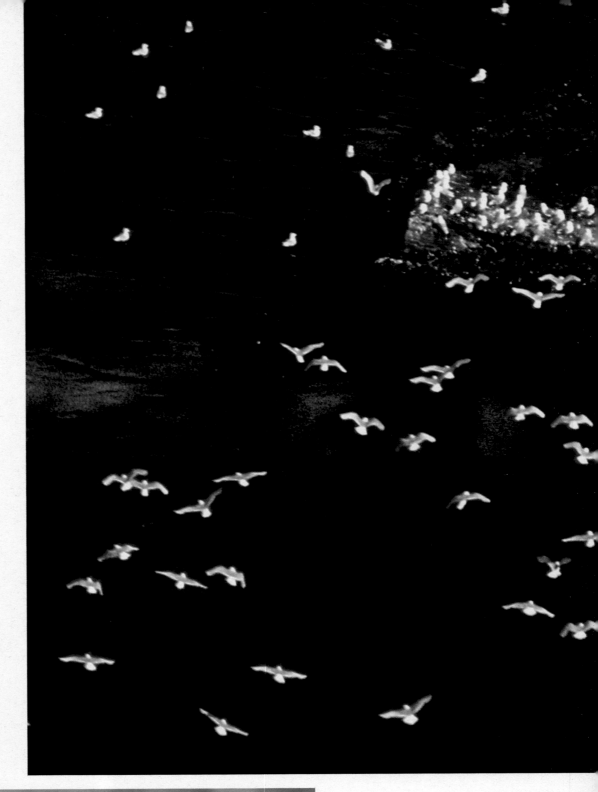

teed by mild weather conditions. This small rodent, the most important link in the food chain, is the staple nourishment for the predators in the tundra. When lemmings are in short supply, the number of ermines, gluttons, eagles, and falcons is reduced. Many zoologists believe that this little vegetarian, weighing only one and three-quarter ounces and at most measuring six inches long, must be a survivor of the Ice Age. In just twenty-four hours, the lemming, a voracious eater, can polish off twice its body weight in grass, leaves, and lichens!

Lemmings are strange creatures, and their behavior has given rise to countless legends. Every few years, lemmings experience a population

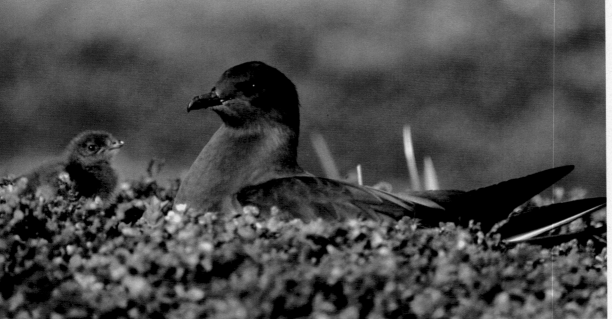

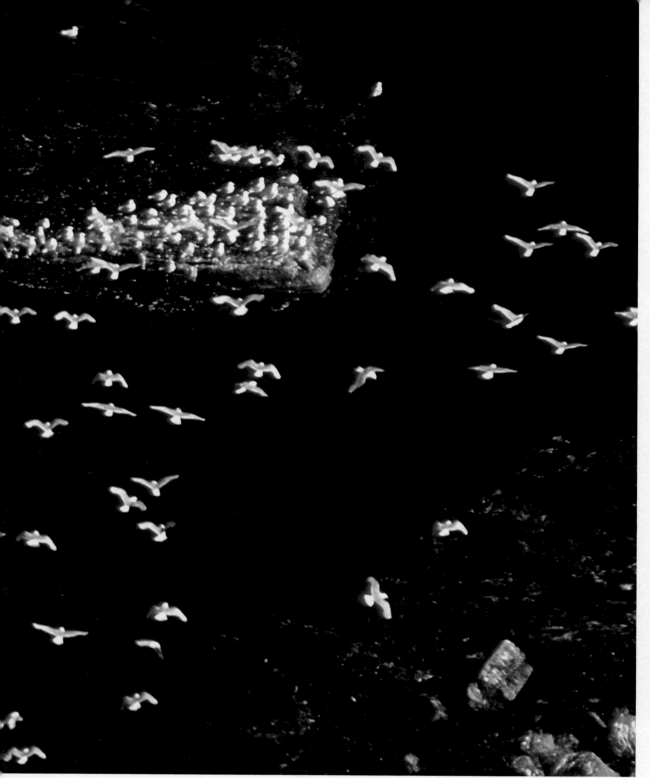

The coastal area is characterized by white-winged birds.

Kittiwakes drift like snowflakes around the rugged cliffs of Varangerfjord in Norwegian Lapland. Without moving their wings, they are carried on updrafts; when they lose momentum, they glide steeply down to the sea where they are caught by air currents. Kittiwakes (*below*) build solid nests to keep their eggs from dropping off the rocks. The parasitic jaeger (*bottom left*) lays its eggs in the middle of the tundra.

explosion, and their numbers can be decreased only if many of them move away from what is commonly known as their ancestral territories; hence their renowned exodus. This migration is actually a hunt for other feeding grounds and not, as myth would have it, an instinctive urge to go west in search of the sunken continent of Atlantis. The apparent mass suicide of lemmings, who plunge into the ocean by the score, also has a logical explanation. Lemmings, which cannot stand living in huge numbers, panic in their search for an escape route. If they come upon a hindrance to their journey, a fjord, for example, they fall into the sea, shoved by the ones behind them. They are not strong enough to

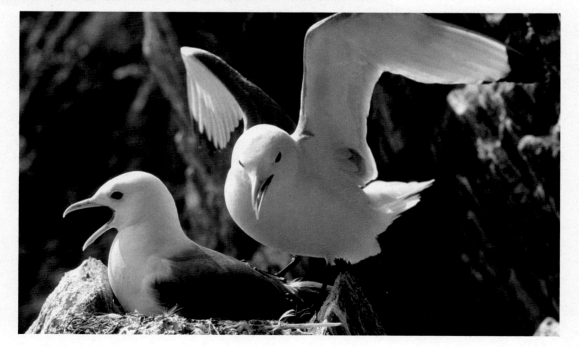

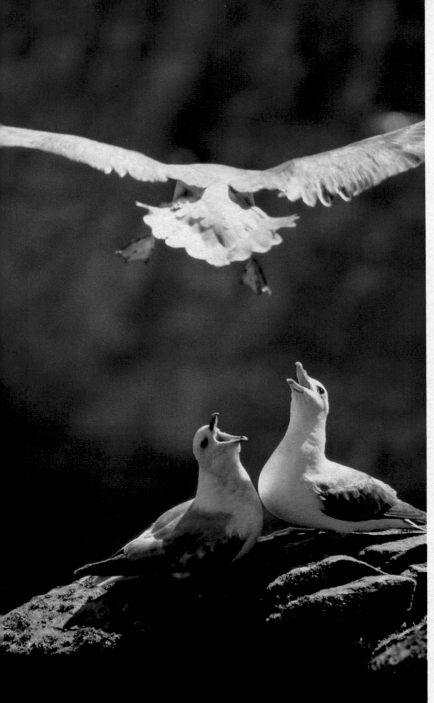

The border between the tundra and the Atlantic

The steep coast of northwestern Scandinavia is the breeding ground of countless ocean birds. Mallemucks (*left*) and puffins (*right*) appear to soar effortlessly into the sky from the narrow strips of rock. The hubbub of groans from shags (*below*) fills the air, which reeks of bird droppings. Hardly beating their wings at all, most of these birds are carried along on the wind, which strokes the sharp ridges of the cliffs.

reach the other side, so they drown. In this way, their population regains its normal size.

Lemmings defend their lovely fur with unbelievable courage. Although they are aggressive and readily charge anything, even bigger animals, they easily and frequently fall victim to the carnivores of the north.

Lapland is not one of the immediately threatened natural areas in the world. However, around the turn of the century, Scandinavians had the foresight to create legal protection for the primordial landscape; in 1901, the Swedish government established Sarek National Park in the Lapland massif in northwest Sweden. Seven hundred eighty square miles of virgin landscape of granite and gneiss, wild rivers, glaciers, lakes, and swamps form the largest wildlife sanctuary in northern Europe. Even today, this animal paradise has still not become a goal for amateur mountain climbers. Inaccessible valleys, gravel slopes, and rocky faces do not draw any Sunday visitors. However, the preserve is not unmenaced. Two highways now sandwich the park in, bringing more and more wanderers to the edge of Sarek.

The elk trots alone through the swampy countryside, its massive body surrounded by a cloud of mosquitoes in the summertime. The young shoots of trees in the mixed forest supply the elk with its favorite food. Looking for all the world like a phlegmatic giant whom nothing can disconcert, the elk becomes active and lively only during the mating season. Then, there is no road that is too long in his search for a willing female. However, once the elk's lust has dissipated, he retreats into his hermit existence.

The elk is an utterly phlegmatic creature which nothing can disconcert—except for a female elk. No road is too long if it leads to her!

The landscape of the delta, where the Rapaätno empties into Lake Laitaure, contains a highly diverse birdlife. Crested titmice and dotterels, pine grosbeaks and Lapland buntings live in the silence that surrounds the lake. This countryside is filled with a peace and quiet rather different from the depressing solitude of the mountains. Here, the merlin and the gerfalcon circle above, and, on warm spring morn-

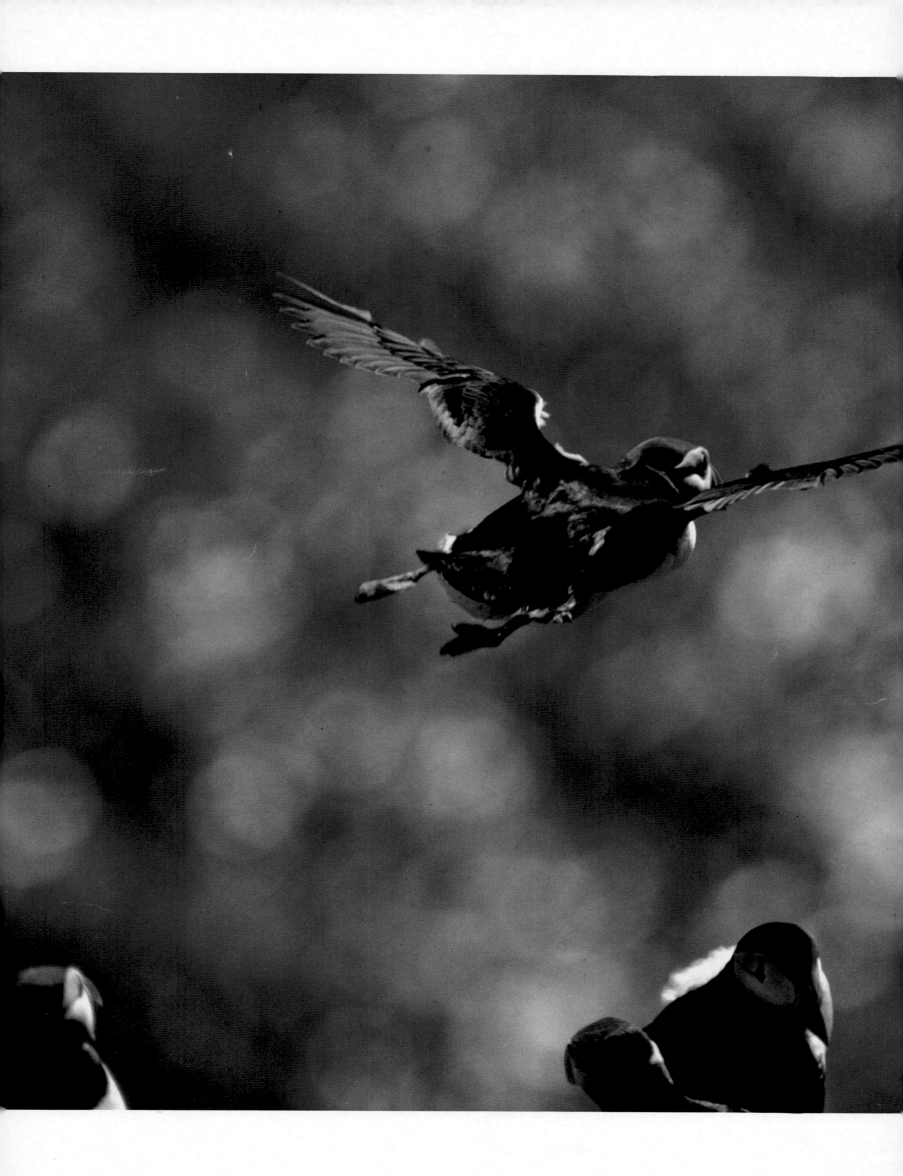

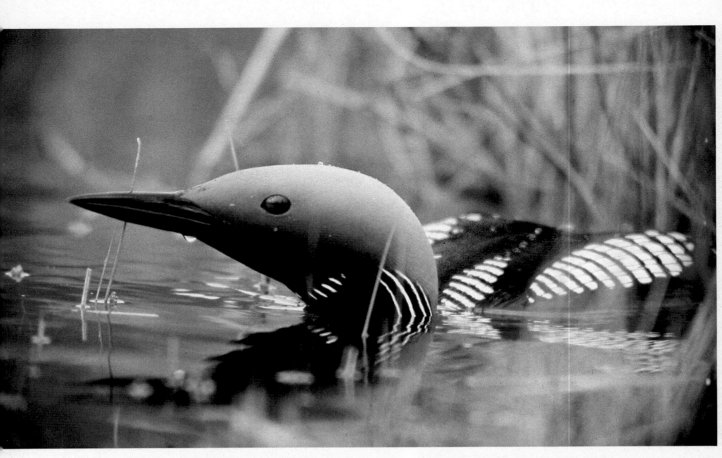

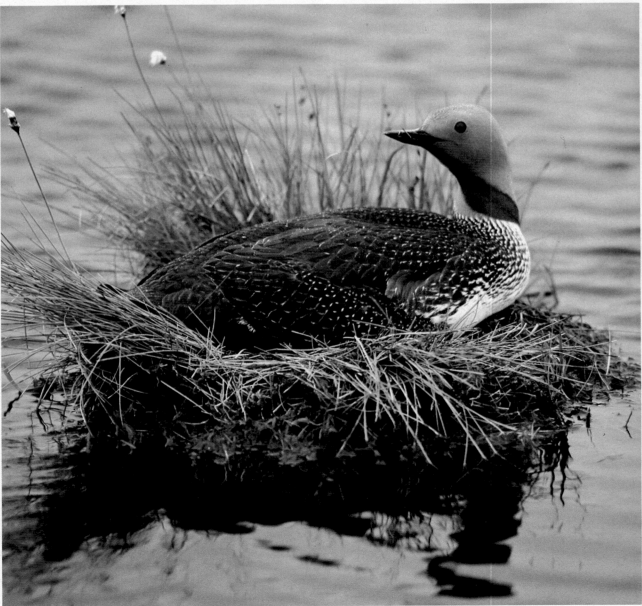

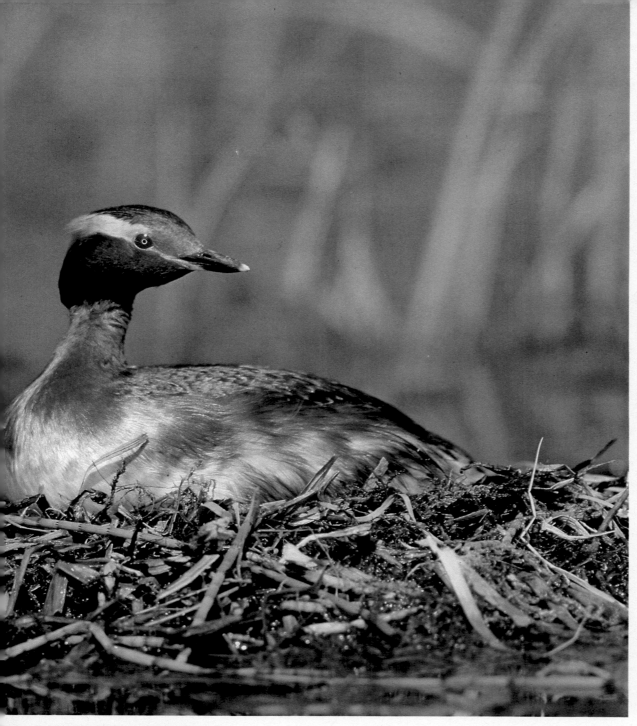

Gaudy grebes inhabit the still waters.

In May and June, when the ice melts on the lakes, the mating calls of the grebes resound across the shining waters. The steel-blue plumage of the black-throated diver (*top left*) and the marbled feather dress of the red-throated loon (*below left*) enliven the scenery, as do the rusty-red tones of the eared diver (*left*). The summer is very brief here, and sometimes the lakes and rivers are free of ice for only three months. Nevertheless, the birds have enough time to produce offspring. (*Below:* The eggs of the black-throated diver)

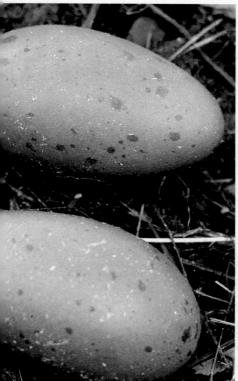

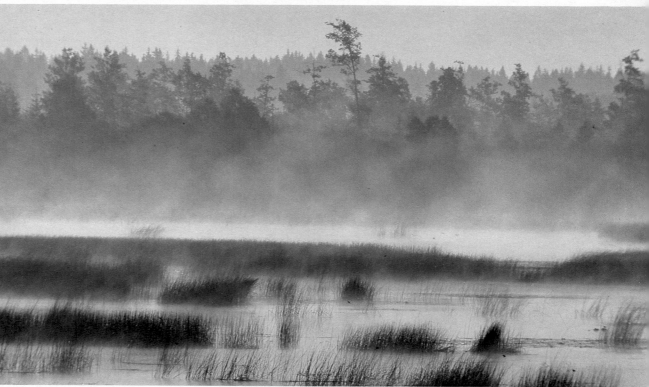

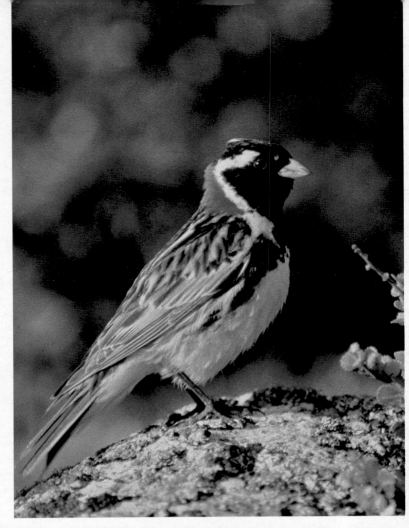

There are songbirds as far north as the Arctic Circle.

In the brightly lit nights of early summer, the Lapland bunting (*left*), the redspotted bluethroat (*bottom left*), the dotterel (*top center*), the redwing (*top right*), and the linnet (*bottom right*) come from southern fields.

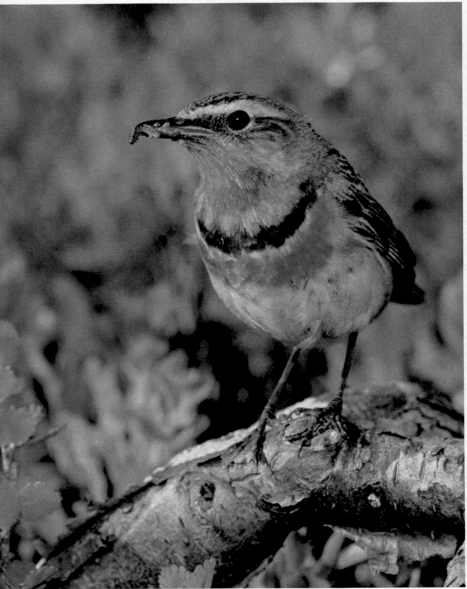

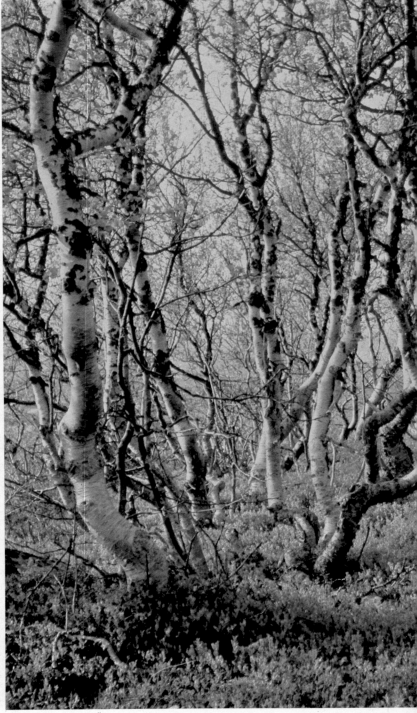

56

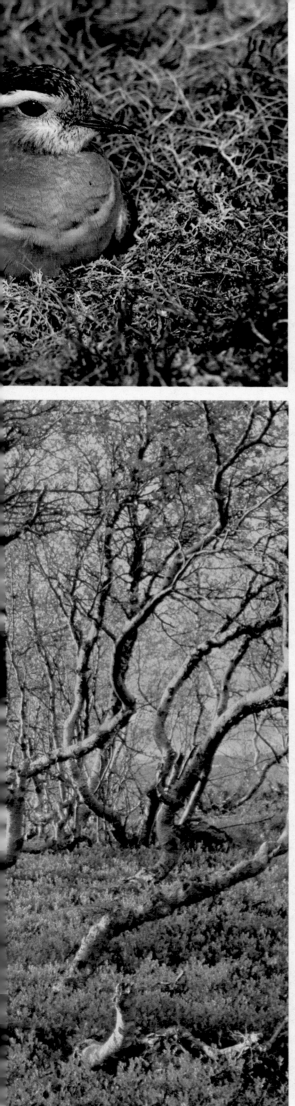

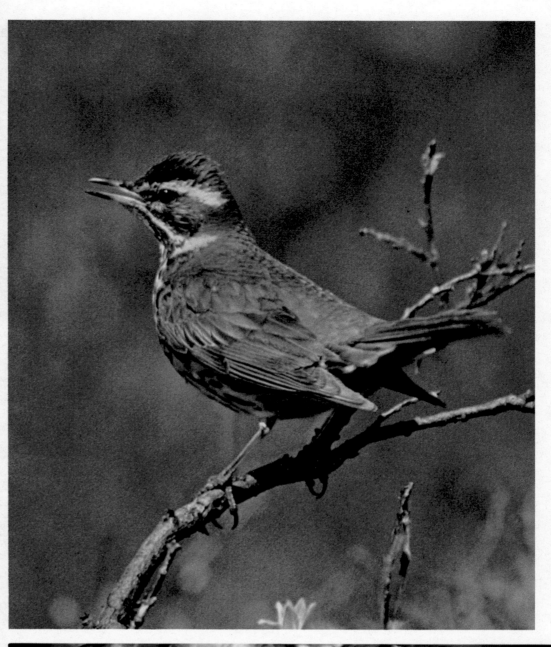

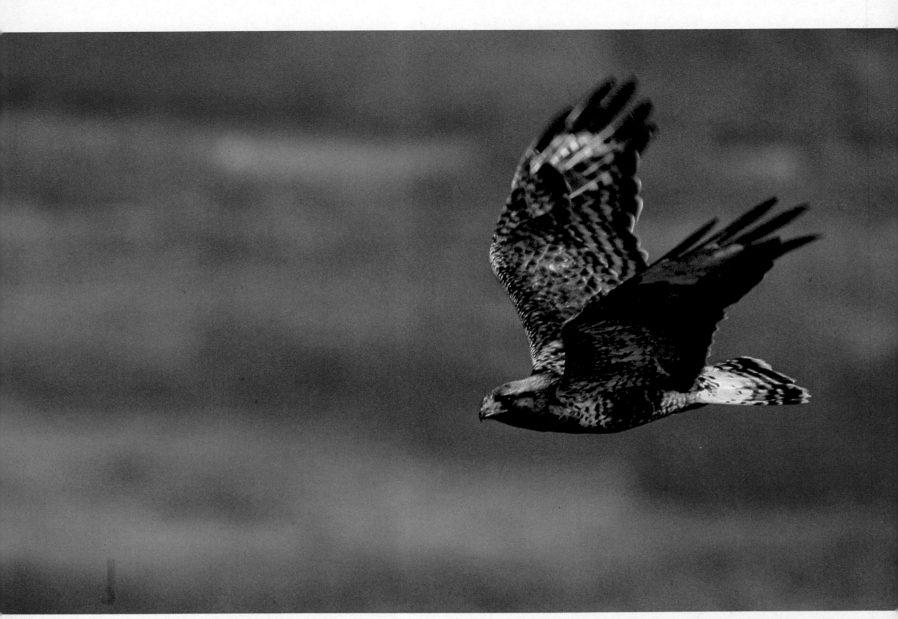

ings, the mating calls of countless willow grouse resound far and wide.

To the west lie the rugged fjords of the Norwegian coast, where water and ice have worked together to hollow out the rock.

This paradise will soon be destroyed. With oil comes death for the fish—which means bad times for cormorants and mallemucks.

A favorable alliance of cold and warm currents plus the northernmost influx of the Gulf Stream create a milder climate than one might expect in these latitudes. The result is an immense wealth of fish around the Norwegian islands; these fish in turn attract innumerable water fowl.

The sea eagle builds his aerie on the coastal cliffs, and there he and his mate, bound together for life, feed their young. Guillemots, kittiwakes, and arctic terns take possession of whole islands, filling the air with their cacophonous shrieks, screeches, and beating wings.

At mating time, the black-and-white puffin crams so many fish into its red-, yellow-, and black-striped bill that they cascade from it like a beard.

The cormorant, an elegant fisher, sails through the air like a flying cross, an impression derived from its craned neck, long tail, and broad wingspan. The mallemuck, a perfect flying machine, glides on the air currents.

Paradisal conditions for ocean birds, one might think, but here, too, human interests have had their destructive impact. The profuseness of fish has led to extensive fishing, and a rich oil supply has brought many tankers to these waters. The port of Narvik regularly dispatches the giant ore freighters, for example. Furthermore, colossal oil rigs excrete their refuse into the ocean. None of this promises a rosy future for creatures that depend on pure air and clean water.

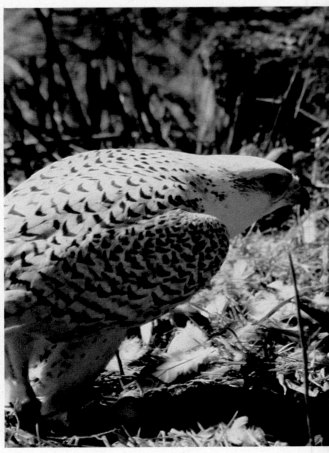

Swift hunters maintain the balance of nature.

When the population explosion of the lemmings threatens to inundate the tundra, the rough-legged buzzard (*left* and *right*) and the gerfalcon (*below*) have a great time. Since the tundra has no human inhabitants, the falcons have a balancing function in the natural economy.

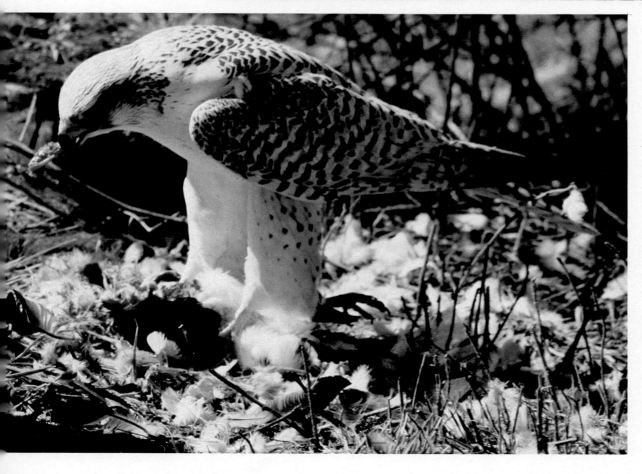

▶

The Canada goose, known for its loud trumpeting, has conquered large areas of Europe and has recently begun nesting in Sweden and Norway. In the tundra, it prefers to dwell in reed-covered lakes and swamps.

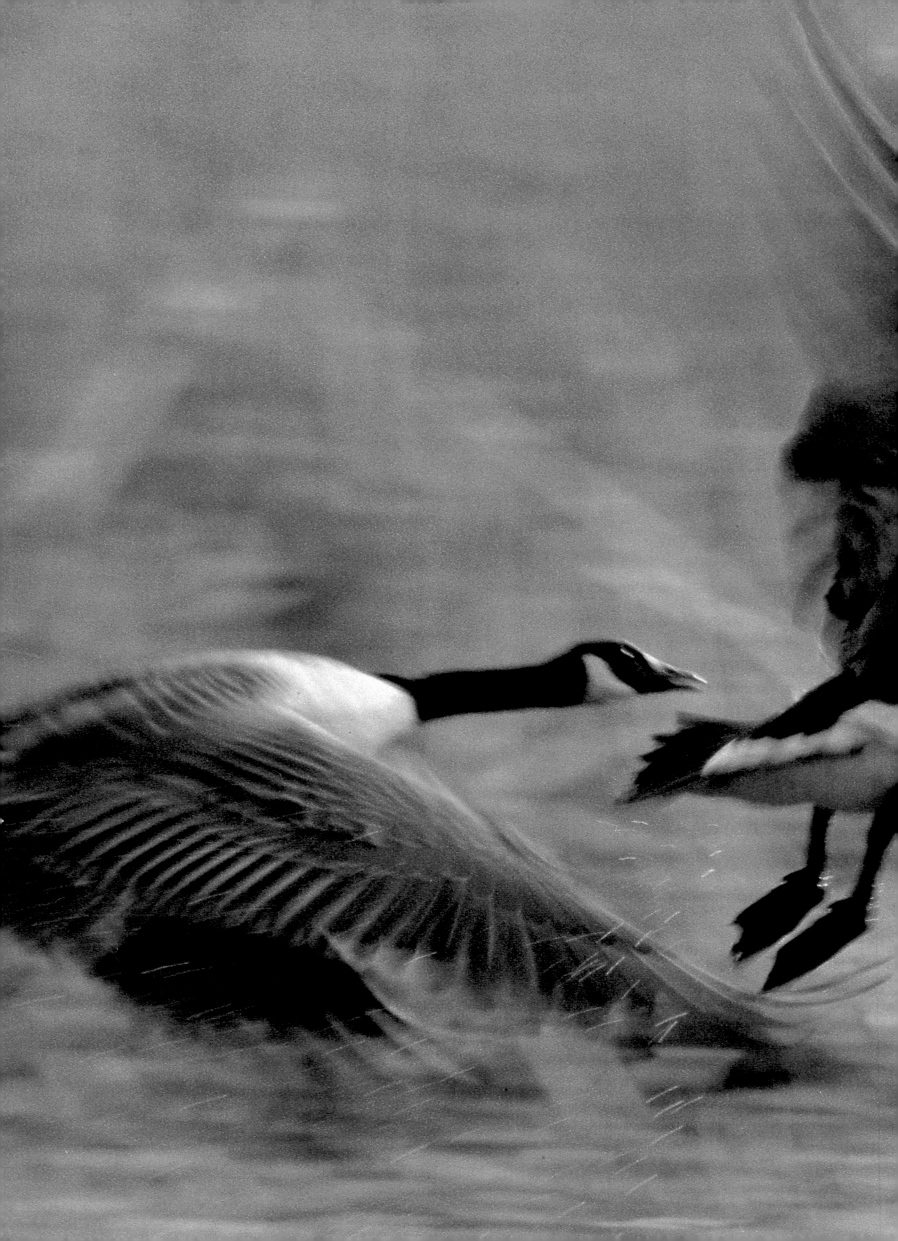

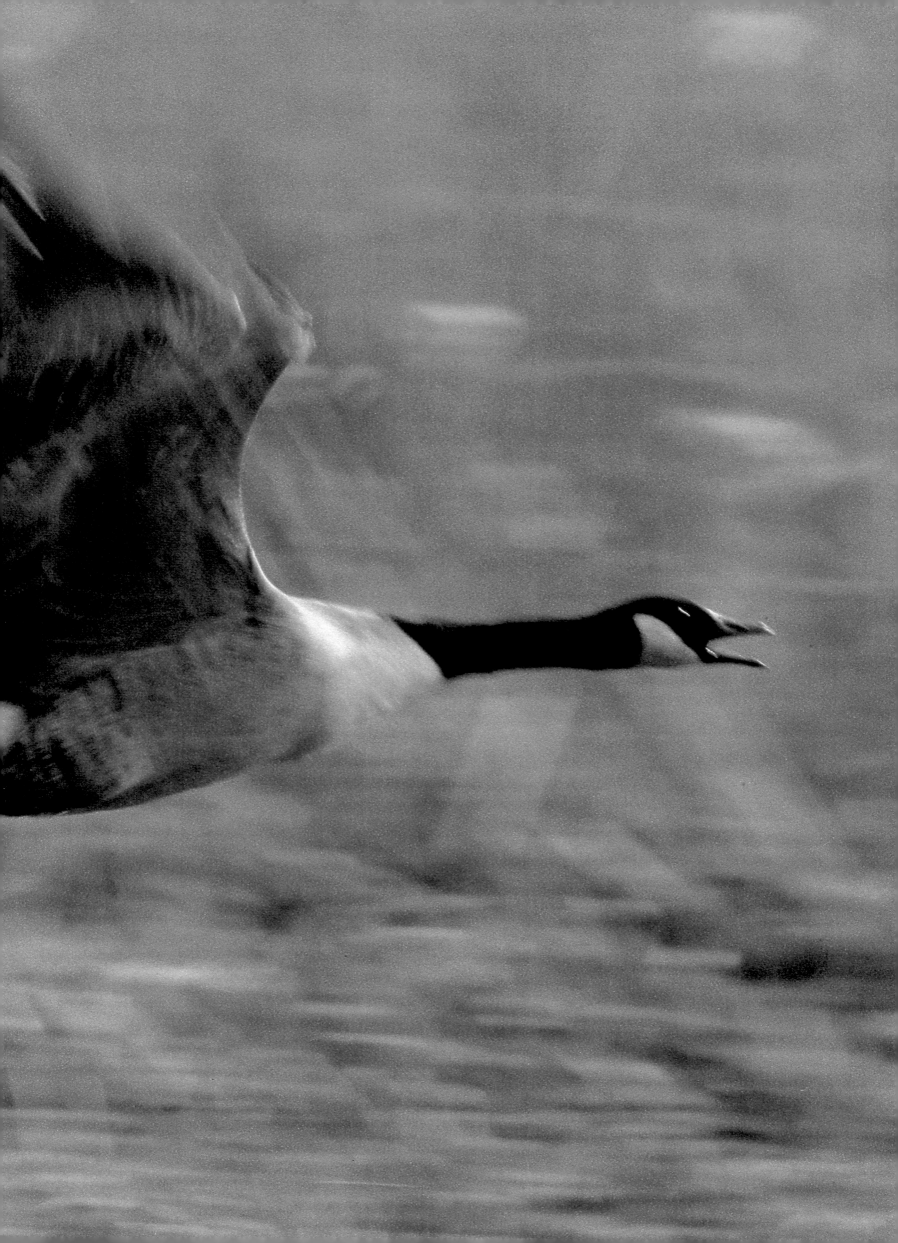

At ebb tide, human beings and birds can stroll on the bottom of the sea. High tide puts the sandy mud flats under three feet of water.

Between
Paradise in

Ebb and Flood: A Bird
the North Sea Tideland

The tideland is a never-never land for swarms of hungry birds.

The ocean sets a rich table for them. There are masses of mussels and crabs, starfish and sea anemones, jellyfish and worms, all garnished with green sea lettuce and packed in brown seaweed.

There is a long chain of islands off the North Sea coast of Holland, Germany, and Denmark, in front of which lies one of the natural wonders of central Europe: the tideland. This slippery tidal flat of mud between water and land is neither one nor the other but both—twice a day. Precisely every twelve hours and twenty-five minutes, the sea ebbs and flows, and this alternation of high and low tides creates an incredible hustle and bustle. Barely six hundred miles long and an average of three to six miles wide, this coastal strip is a hatchery for more than half a million coastal birds and a habitat for countless fish.

A square yard of the foul-smelling ooze teems with life: 35,000 tiny mud crabs frolic in an underground rich with food. The life arteries of the mud flats—the ramified tideways—carry tremendous quantities of food and organic material landwards and seawards. A thimbleful of tideland contains up to a million one-celled algae. These are paradisal conditions for snails, worms, mussels, polyps, sea urchins, crabs, and starfish. Here, flora and fauna (such as seals) do not have to worry about food. The tides deliver it to their front door in the form of a huge biomass.

Such an overabundance of nourishment lures an army of guests. The population of transient, hibernating, or aestivating birds is estimated at twenty to forty million. Despite this enormous assault, the natural balance of the North Sea mud flats has never been particularly disturbed by animals. The only danger that looms for this area comes from human beings—as tourists or as advocates of industry, which is already extending its menacing tentacles into the bird preserves. These preserves are the final bulwark of nature in the landscape of mud flats and ocean. While ecologists have bought up some of these refuges, saving them from being sacrificed to tourism and industrial use, there is an insidious death, invisibly mingled with sewage and garbage, which does not halt at the boundaries of the preserves. Together with the sumptuous

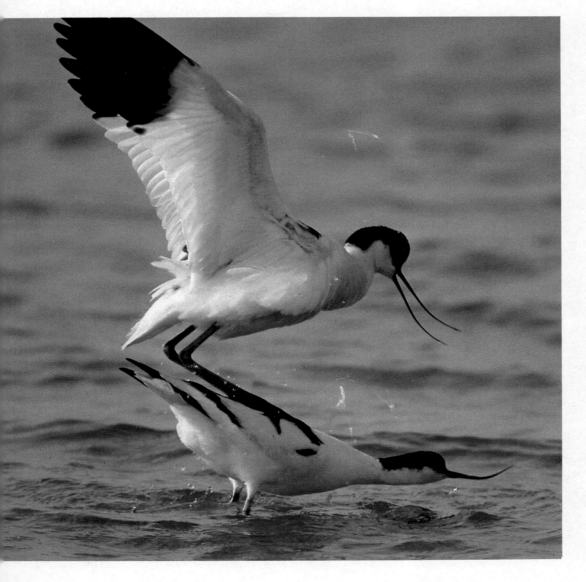

A graceful bird of the North Sea tideland: the pigeon-sized avocet

These birds with bills that curve like sabers and with dark caps on their heads and eyes, wade on long, bluish-green legs through the shallow coastal water. Avocets, copulating (*left*) and brooding (*right*), fly with wings pulled down, necks drawn in, and legs sticking way out in back.

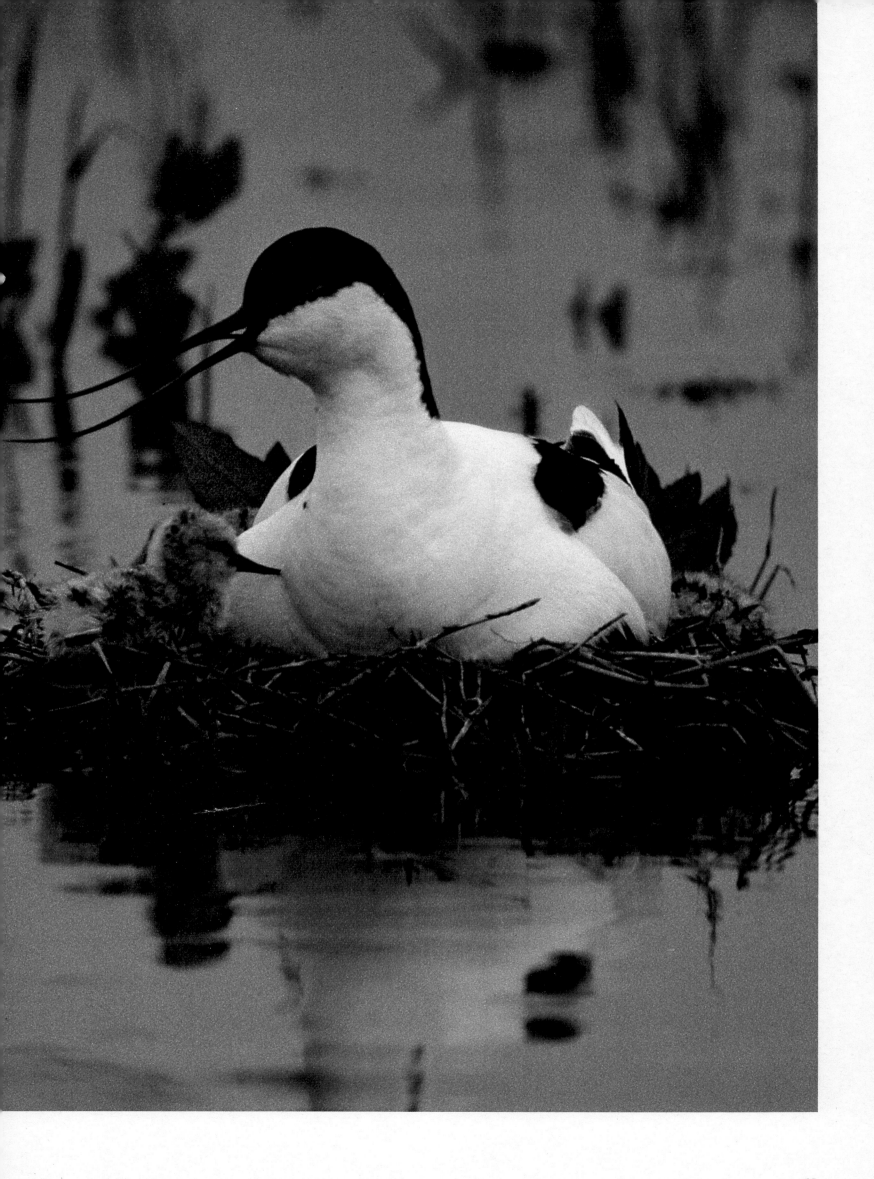

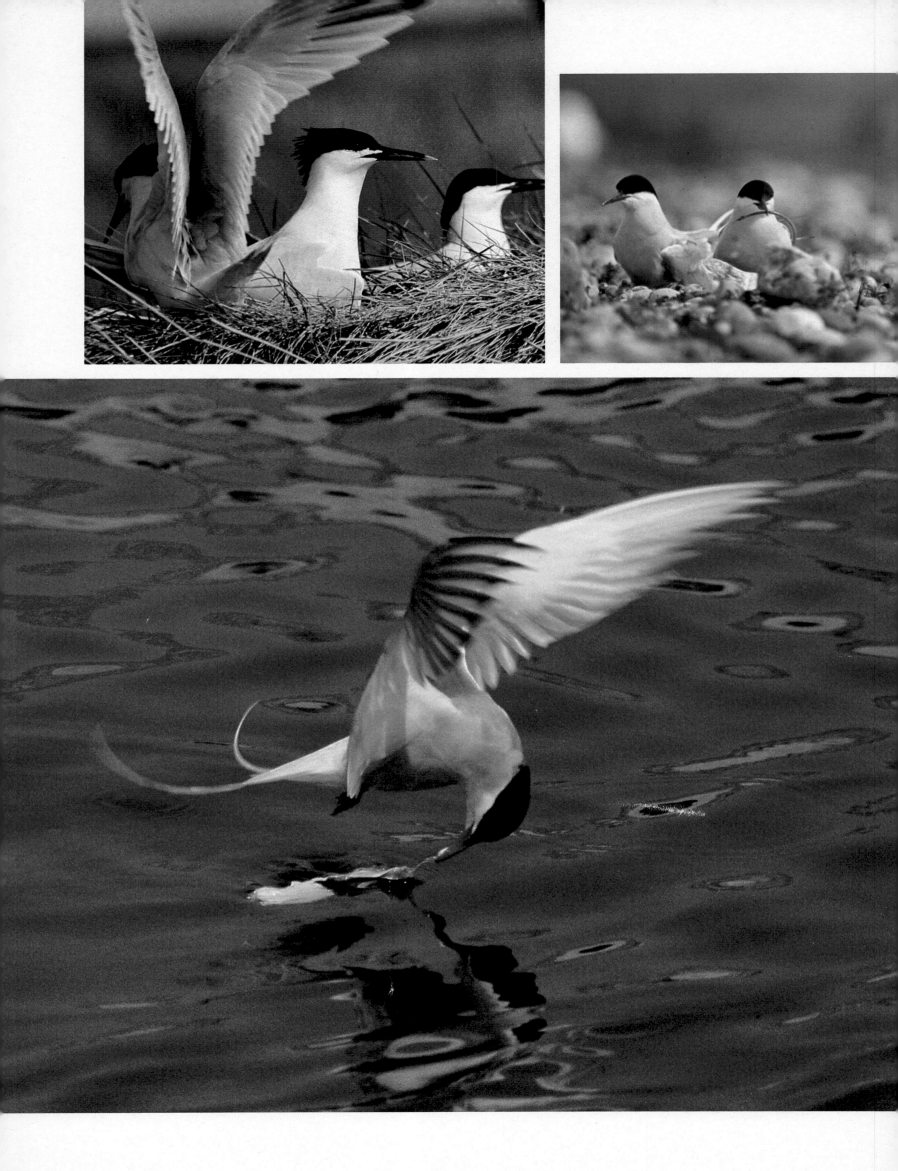

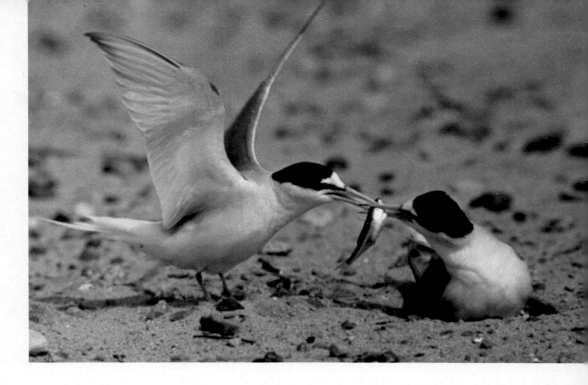

The most elegant fliers of all the seabirds: the terns.

Sandwich terns *(left top)* **brood only in colonies. Arctic terns** *(left)* **seek the proximity of common terns** *(below)***. Little terns** *(right)* **are skilled fliers.**

flood of nourishment, the water also brings poisons and refuse into the teeming islands. People may plunder the nests of gulls or terns or unwittingly prevent adult birds from brooding or feeding their young, but at least they can be educated against such carelessness; against poison, however, they are virtually powerless.

Without ornithological stations and preserves, these birds would have long since fallen victim to industry and to vacation resorts.

The poisons have taken their heaviest toll on the seals, whose bodies are veritable repositories of environmental toxins in amounts that far exceed the tolerance level for man or beast. In one experiment, seal livers from Holland yielded 2,-200 milligrams of mercury per kilogram. Between 1960 and 1974, the number of seals on the coast of Lower Saxony declined from 2,250 to 1,240.

Year after year, fewer and fewer seals come to the North Sea coast in March. Seals need rest, lots of herrings, and clean water, and the tideland coast is rarely able to provide a combination of the three. Instead, the noisy vacation areas continue to grow, the herrings continue to stay away in greater and greater numbers, and the water grows murkier each year. As a result, many young seals die, some abandoned by their parents on the beach as "wailing pups." A protective zone could certainly stabilize the stock of seals, but

the five North Sea countries have five different viewpoints on this subject. An international pact would make sense only if all the countries participated. Unfortunately, no agreement is yet in sight—primarily because the ever-diminishing number of seals remains fair game for Danish and English hunters.

Little Hallig Norderoog, a bird refuge since 1909, is a shining example of effective protection for wildlife. Often inundated in winter, this island is the only place along the tideland coast where the attractive Sandwich terns steadily hatch their young. In good years, there are as many as one thousand nests clustered here. Little Hallig is also a paradise for other species of terns; arctic terns, common terns, and even the rare little terns who nest here side by side with eider-ducks, snowy plovers, sand plovers (distinguishable by their red thighs), water skippers, and oyster catchers with their conspicuous black, white, and red coloring.

▶

The sea gull is a bit smaller than the silvery gull; otherwise, the two are almost indistinguishable from each other. Known as an egg thief, the gull has few friends among the seafowl.

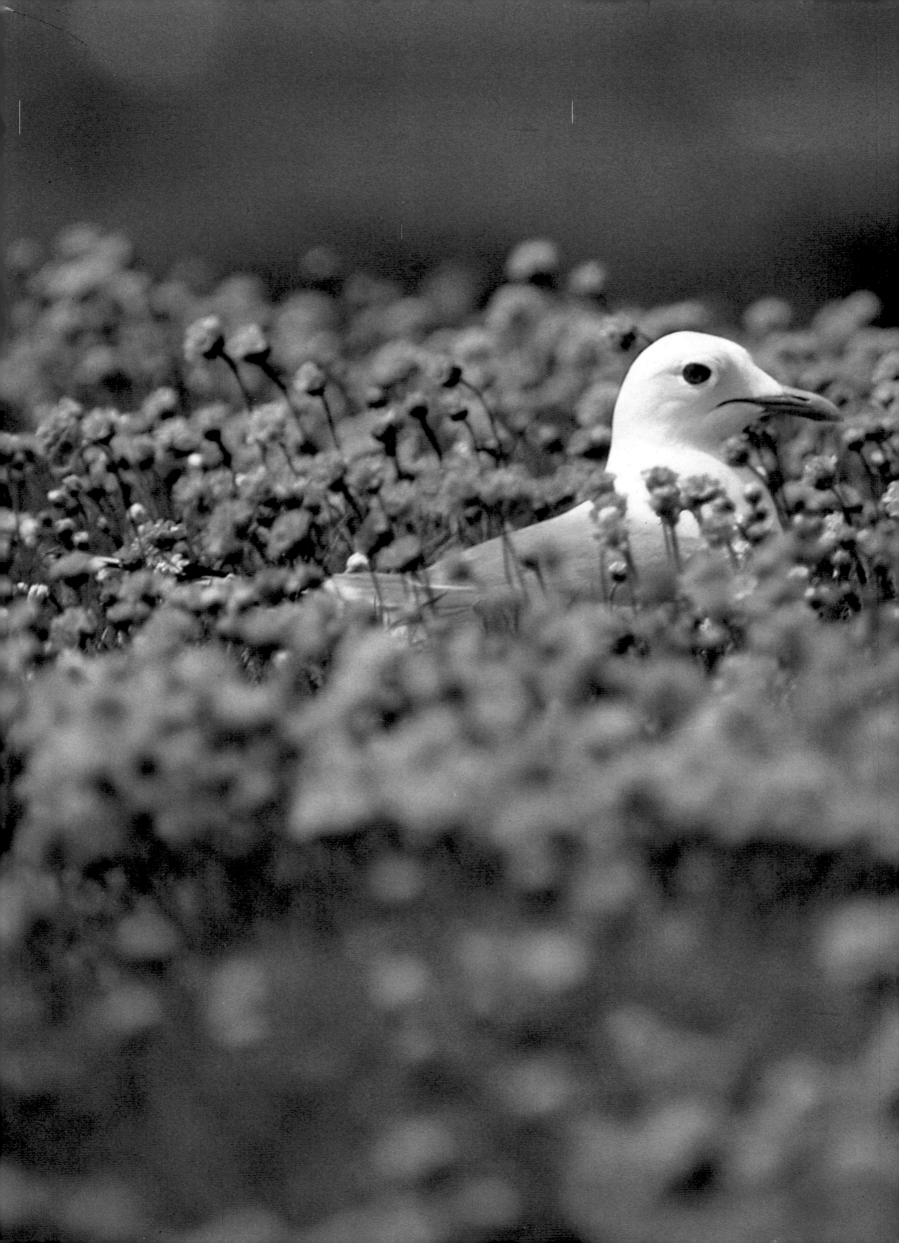

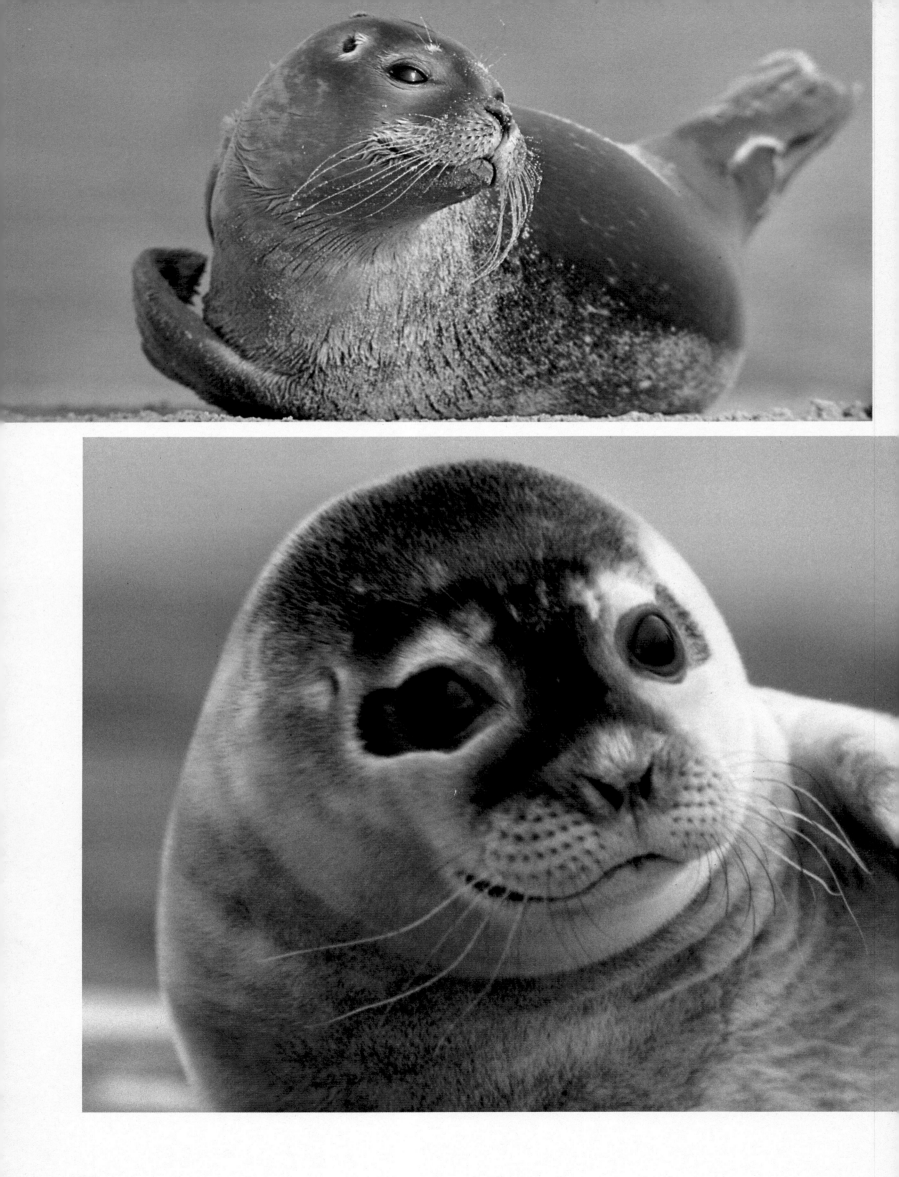

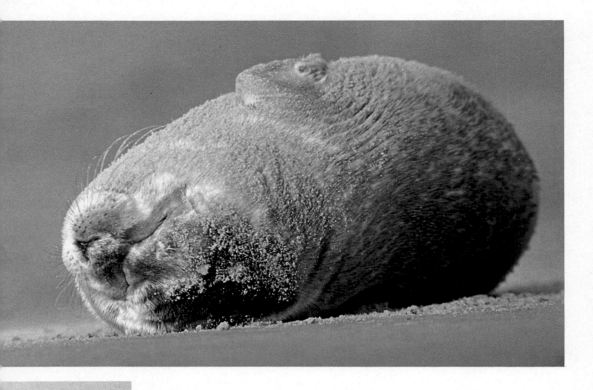

The seal is a champion swimmer and a sun worshipper.

With a bit of luck, you can spot the peculiar fellow (*left*, an almost full-grown young animal) with the round feline head, short snout, stately moustache, and loyal canine gaze. The best opportunity is during ebb tide on the sandbanks. If the seal is disturbed, it zips forward like a snake.

Impressive masses of snipes—red-backed sandpipers and knots—spend the summer in the tideland. They nest in the tundra but aestivate here. Ornithological stations in the North Frisian tideland sea estimate the number of birds at 400,000.

Oyster catchers are actually misnamed. Their diet is mainly worms, though it occasionally extends to mussels. However, once they develop a fondness for mussels, they insert their long red bills into the ooze or sand to hunt for mussel colonies. The birds then carry the flat mussels to a hard surface and smash the shells with a few strokes of their beaks, throwing their entire body weight into the task. In order to crack an unusually large mussel, the oyster catcher must insert its bill, which is narrowly compressed on the side with a chisel-like thickening at the tip—similar to a crowbar—in the siphon aperture of the mussel and open it with a leverlike thrust.

The turnstone has developed a different method for getting food. Although at home in the far north, it likes to spend the summer in the tideland. From a distance, the bird appears to run aimlessly up and down the beach; closer observation reveals that the turnstone is in fact very busy. The bird's beak turns over stones and seaweed, as well as driftwood and even washed-up cans and bottles with lightning swiftness, hoping to catch mollusks and insects hidden underneath.

The tideland is a world of highly complex ecological dynamics, where ground-nesting birds such as terns, avocets, and plovers suffer from the over-fertilized flora. This became very clear to me when I visited the colony of silvery gulls on the island of Langeoog. Intelligent and adaptable, this bird deals unusually well with civilization. All year round it takes advantage of the ample food supplies in refuse dumps and of the rich waste in fishing harbors. Some colonies of this elegant bird number as high as six thousand or more. Their droppings, as effective as guano, keep the ground of the island so well fertilized that the plants, which love nitrogen and phosphate, all run to leaf. These plants protect the young silvery gulls against enemies and heat, but they make it impossible for other ground-nesting birds to build homes and bring up their young.

Ornithological stations use a trick to correct this gaffe of nature: They remove the eggs from the nests of gulls and replace them with artificial eggs. Earlier attempts at restricting the silvery gull population with poison or egg piercing did not work; the former led to further pollution, and the latter caused the gulls to lay more eggs.

Ornamental plumage and a bit of showing off during a duel at dawn are important factors in the choice of a bridegroom.

Silvery gulls are not peaceful neighbors on the bird islands. They often destroy the clutches of other bird species, even other gull families. Similar ecological effects are observed on the foreshore of dikes. When the plants at the edge of the tideland grow high, and no sheep or cattle devour them, then oyster

▶

A flock of oyster catchers heads for the sea.

▶ ▶

Sandwich terns on the attack

▶ ▶ ▶

A swarm of spotted redshanks setting out

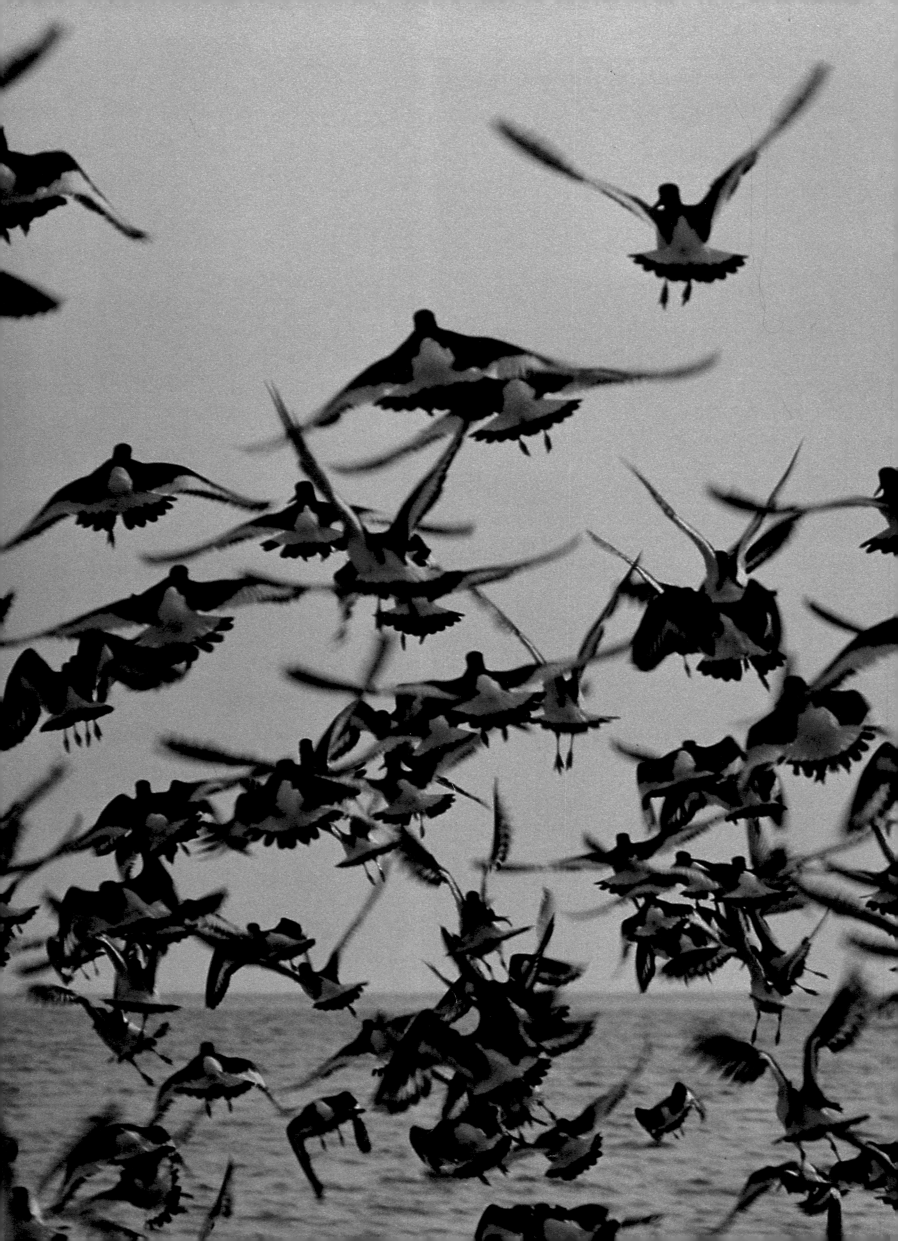

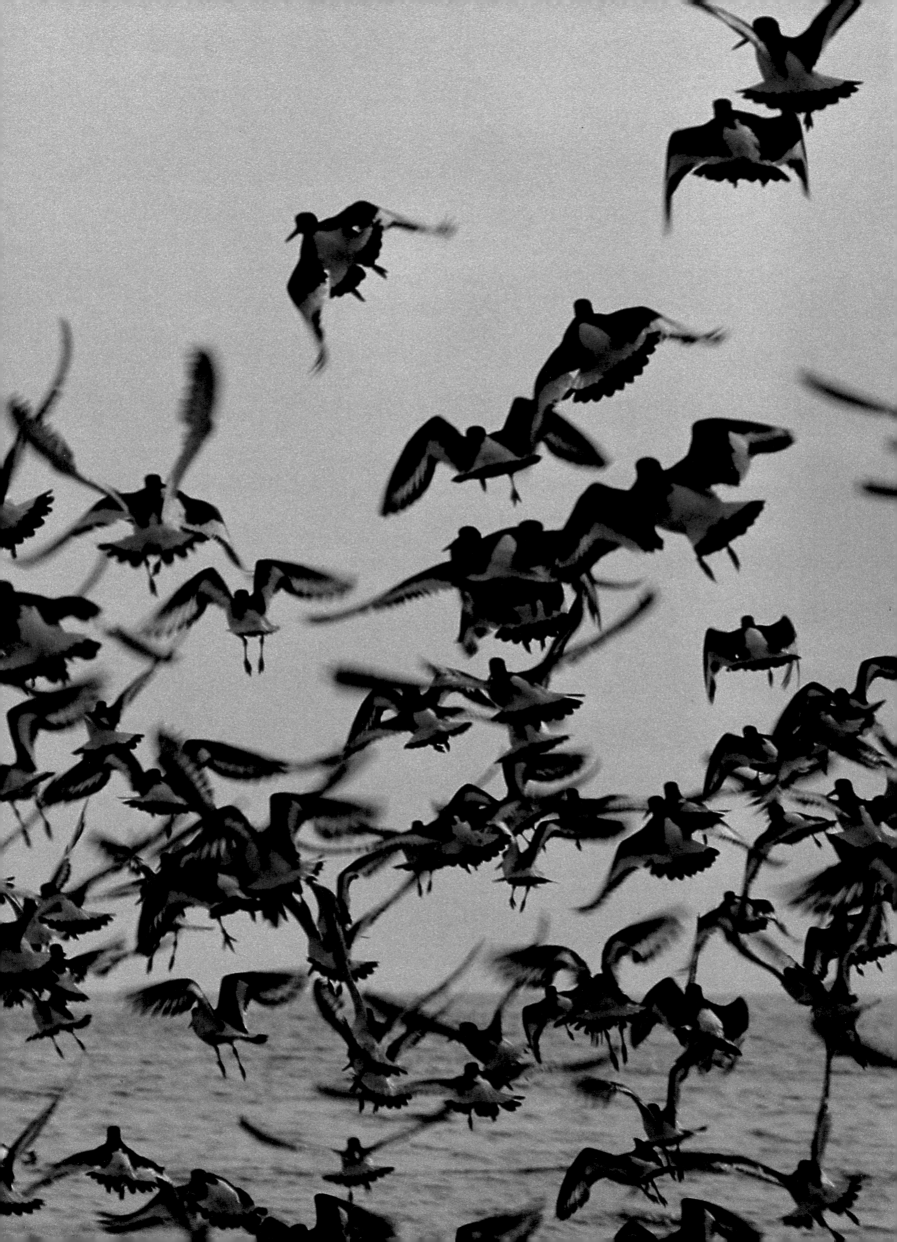

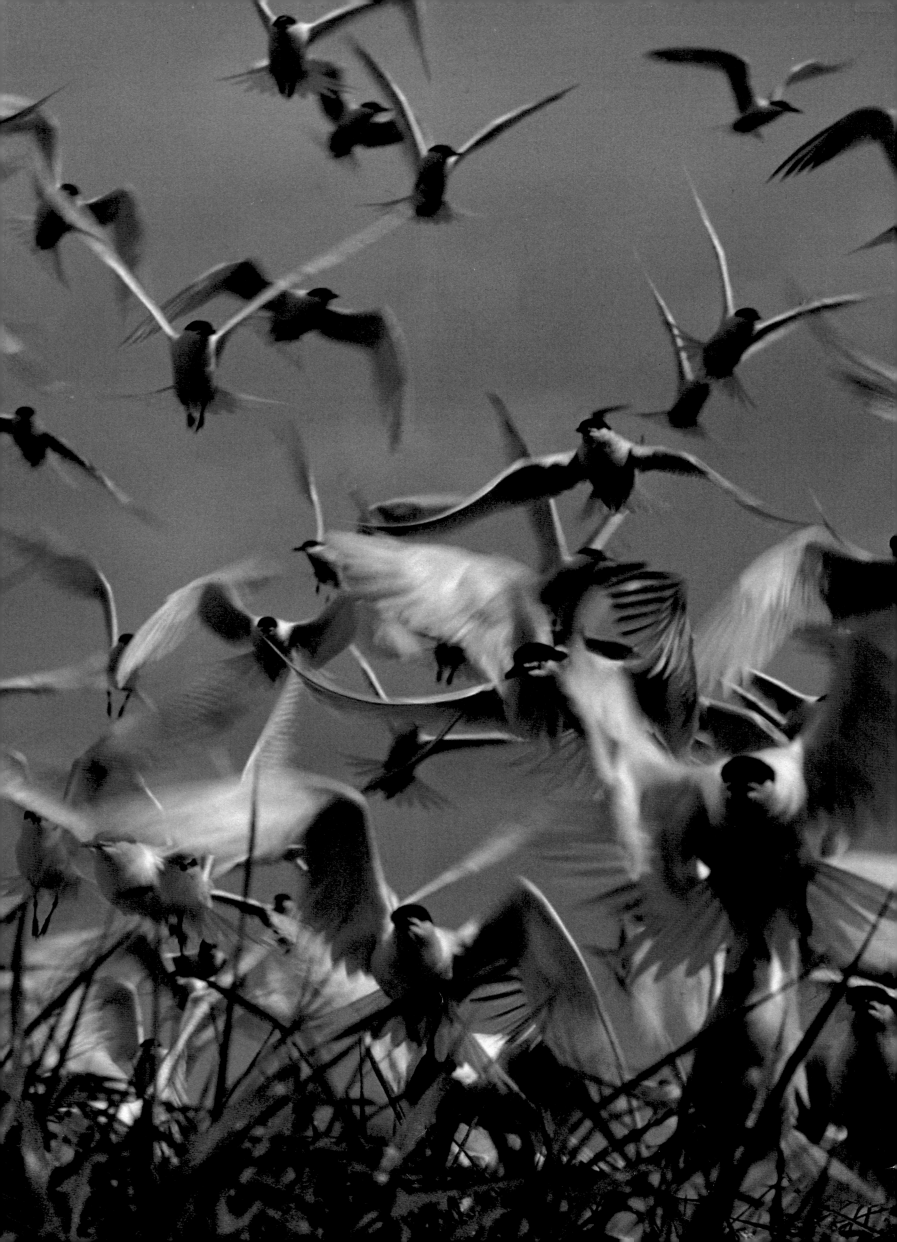

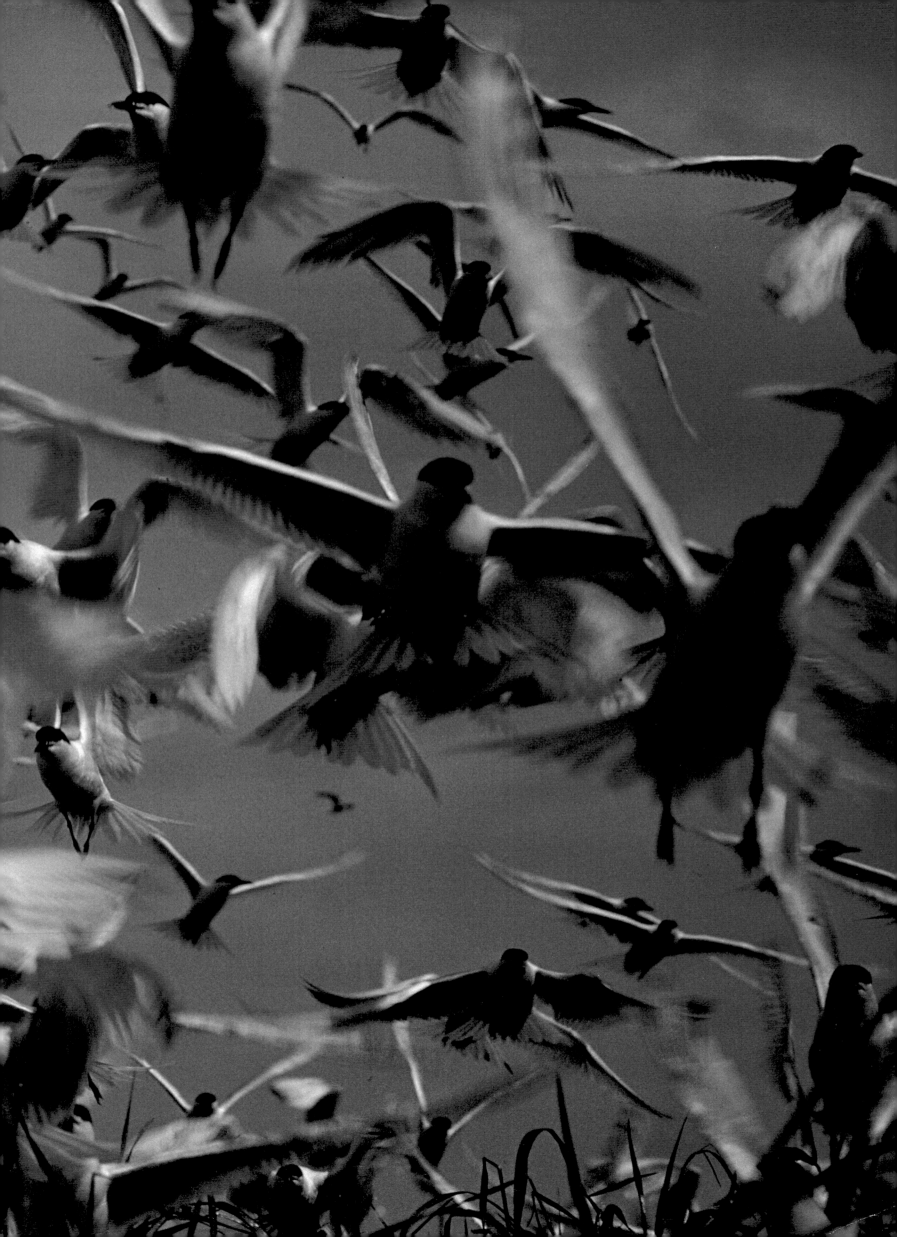

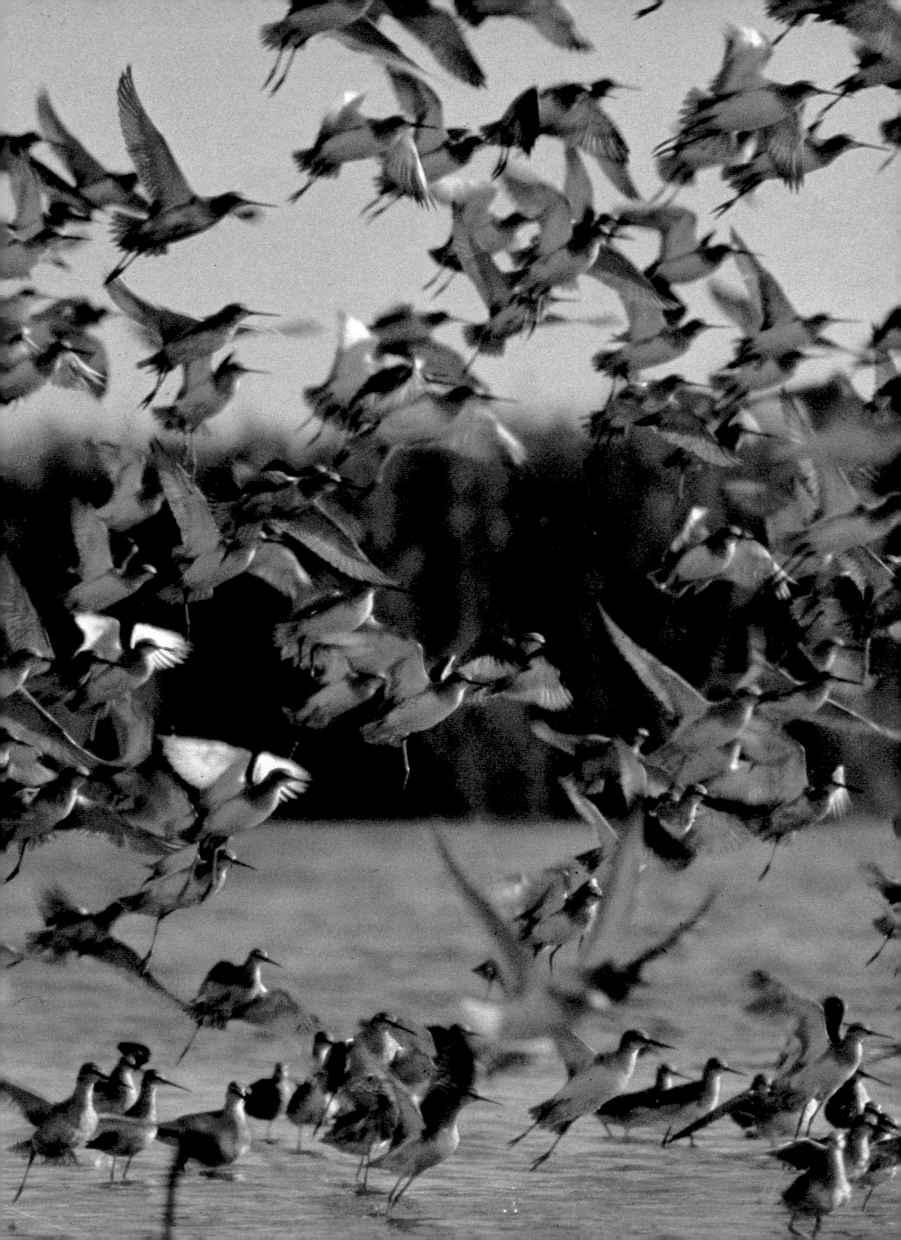

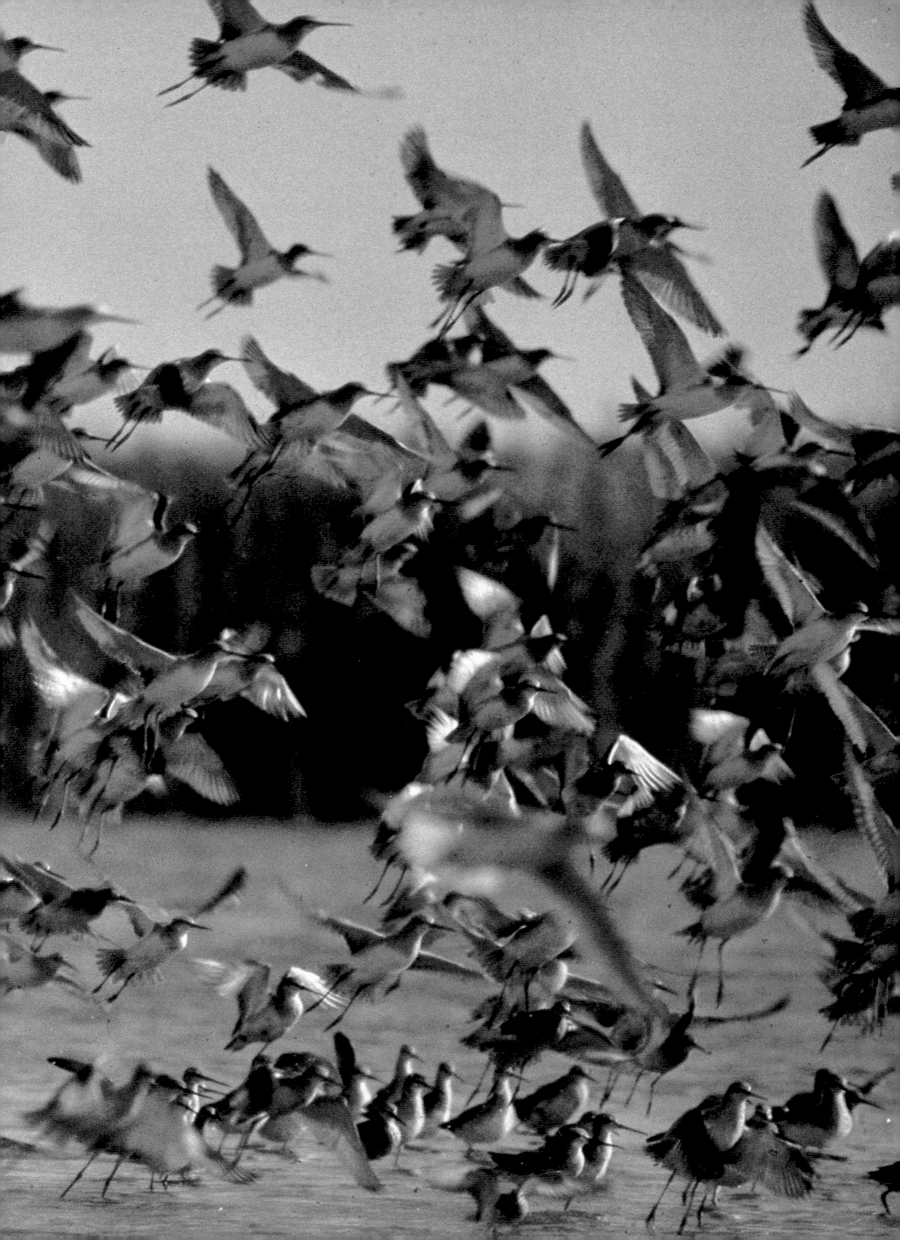

Special plants of the North Sea coast

Wherever the tideland comes close to the beach and gradually fills up with sediment, the glasswort (*right*) has done the necessary preliminary work, binding the slimy ooze and storing the sea salt in its thick stalks. The beach grass (*below*, with the snowy plover) sieves the sand out of the air. The splendidly colorful beach lilac (*left*) has special glands through which it excretes some of the salt water that it has removed from the ground.

The more excited males flutter over the ground in tempestuous duels.

I will never forget the spectacle of one such ruff tournament. Each contestant hurried to an ancestral site. The courtship arena was divided according to rank—chiefly age and strength. The "highest ranking" males claimed the central area, and the lower ranking males had to accept the edges. It was they who launched the attack into the middle, while the "higher" ranks had to defend their position. The coloring of the ruffs changed according to rank. The "satellites" wore a white ruff and played only a secondary part. The more a male had to offer, the darker his flaunting plumage. Such a noisy get-together is bound to attract the reeves. And when they show up, they are greeted according to a strict ceremony. The males beat their wings, puff out their ruffs, and stick

Color determines rank, and the shadow boxing is meant to dazzle. There are never any injuries.

up their ear tufts. They encircle their ancestral site (some twenty inches wide), vivaciously poke their beaks at their neighbors or shadowbox with a rival, never really wounding or getting wounded. As soon as one or more females enter the arena, the fluttering heroes get so excited that they sink to the ground all a-tremble, rise up again, and welcome their *adoratas* with lowered bills. The reeve has free choice among the suitors, but she never picks one from the lower rank.

In the summertime—July and August—the tidal flat on the huge Knecht sand between the estuary of the Elbe and the Weser becomes the

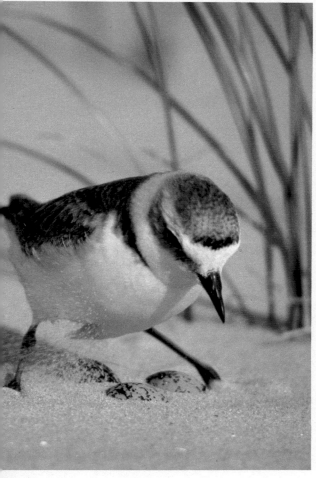

catchers, avocets, blacktailed godwits, redshanks, and ruffs move to a different hatching ground.

This great ruff is, with regard to shape and conduct, the most astonishing representative of the large family of snipes. In the winter, the ruff and the reeve look practically alike, but in the spring, when the male dons a colorful courtship plumage, a bizarre ruff of gaudy feathers adorns his neck. There is one amazing fact about this feathery ornament, which is coquettishly puffed up when a reeve comes into view: No two males have a ruff with the identical color combination.

In April, when these ruffs return from their African winter homes, the males, often ten to twenty strong, gather at certain places in the meadows to participate in unusual tournaments. Their upper bodies slightly bent, their ruffs and feathery ears puffed out, these birds wage spirited fights with their soft beaks.

▶

Barnacles on flotsam——a fascinating sight but also a welcome delicacy for the eider duck.

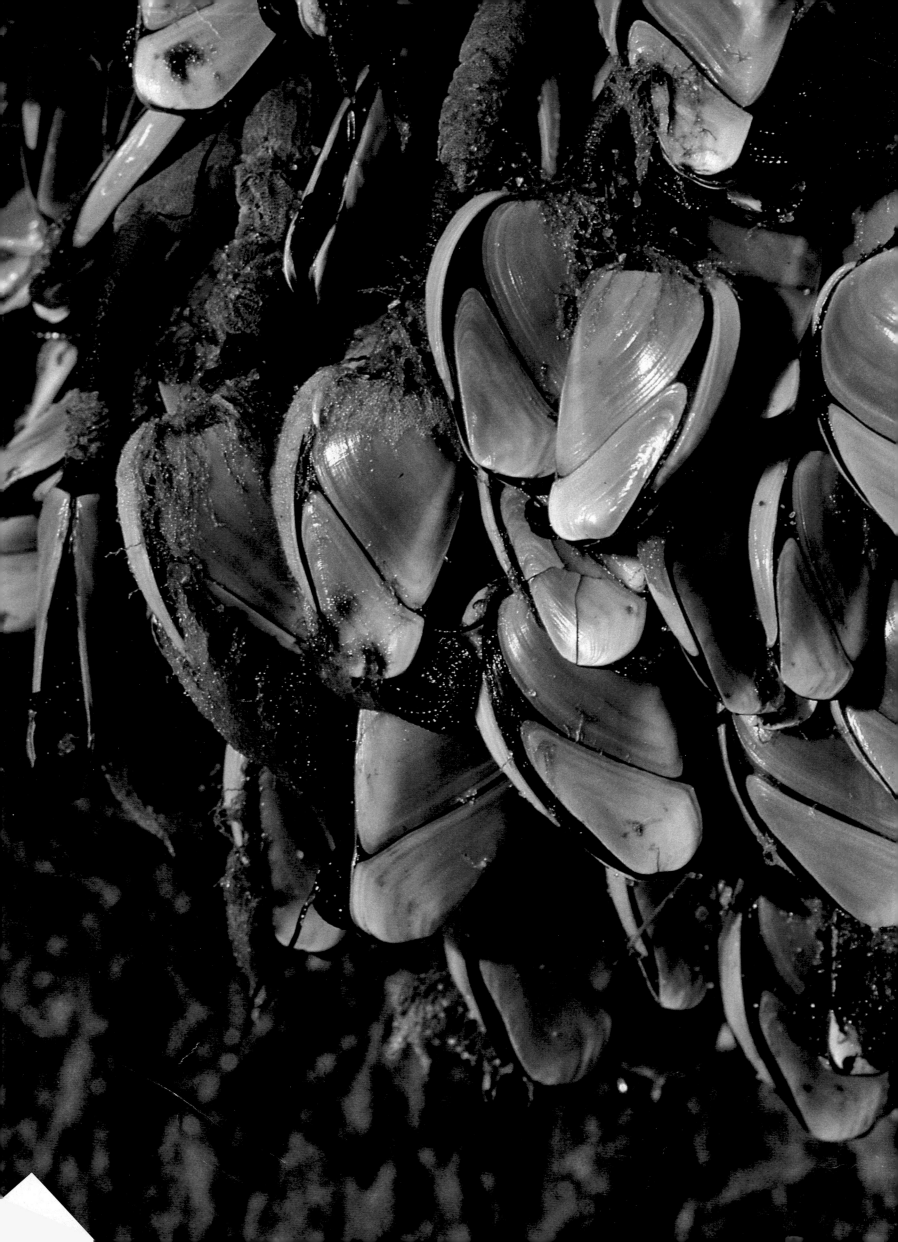

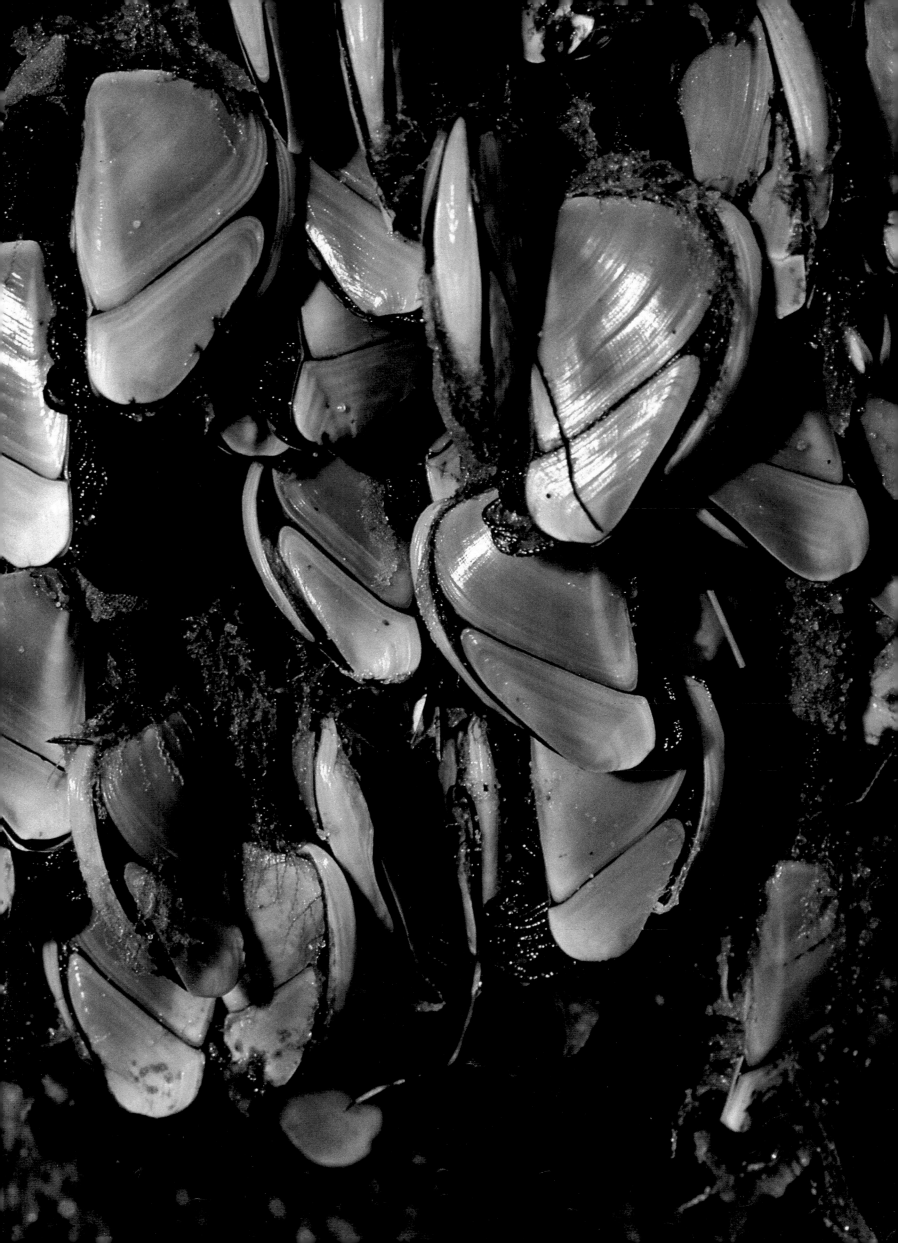

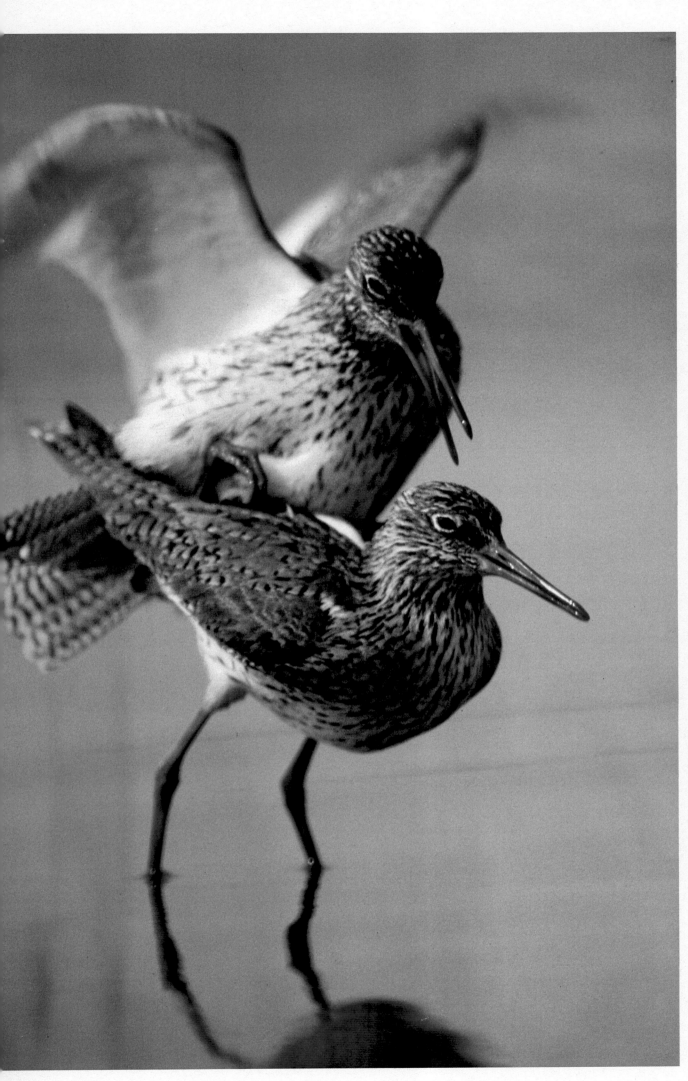

Bird nurseries lie between the dunes and the mud flats.

The redshank (*left*), the size of a thrush, has somewhat stiff legs. During mating, it keeps nodding its head, dropping its wings and performing pretty bows. It warbles and whistles pleasantly and shows the female several nest troughs. Later, it helps the female hatch the four spherical stone-gray eggs. With a wingspan of about three feet, the gull-billed tern (*top right*) is one of the largest terns on the North Sea coast. The Temminck's stint (*top right*) is a rarity here. The oyster catcher (*bottom right*) is one of the most conspicuous sights in the tideland area.

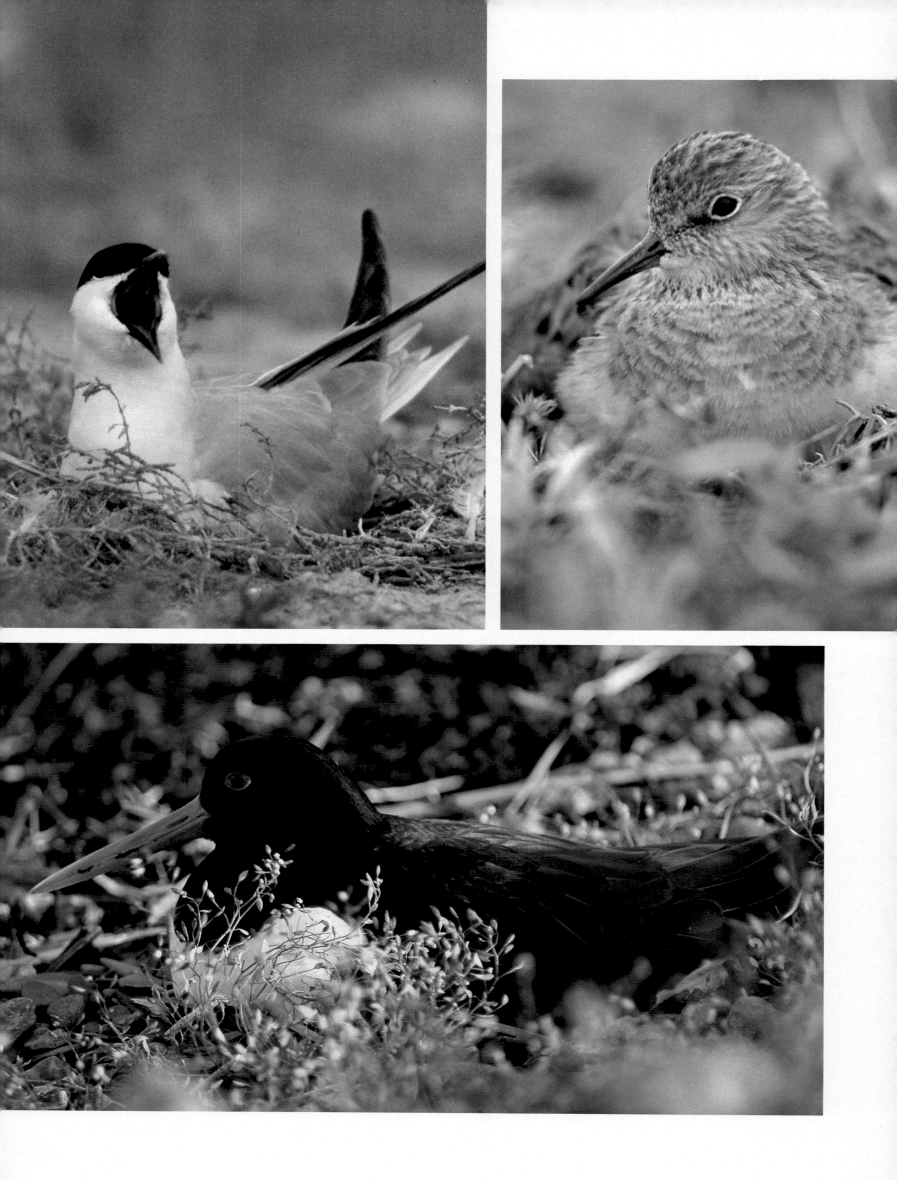

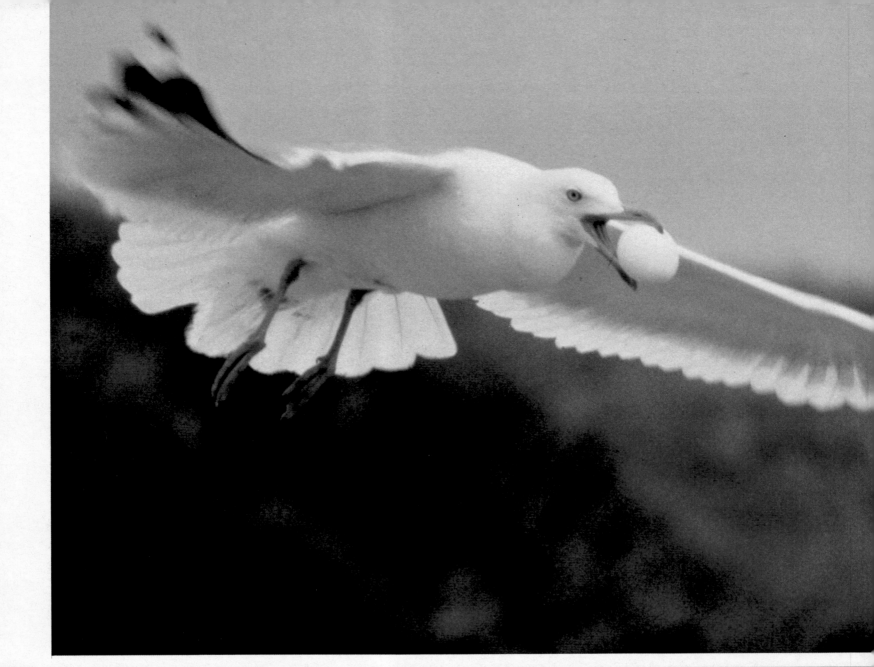

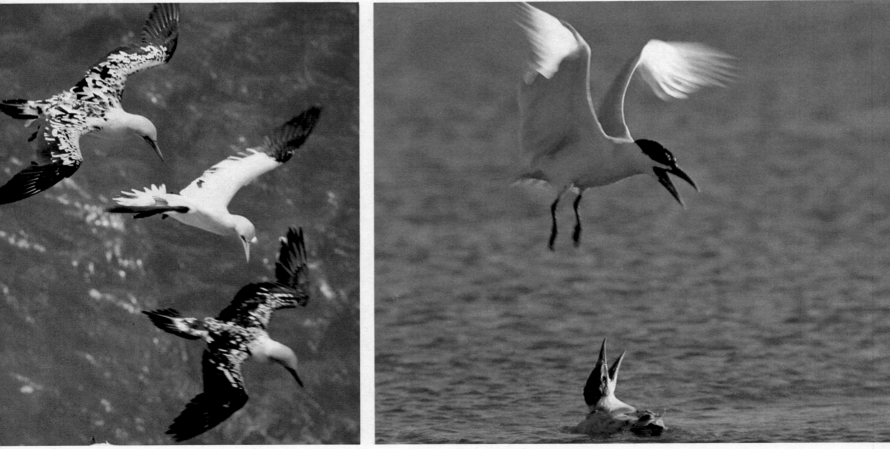

shedding grounds for one of the most interesting coastal birds in northern Europe. Year after year, some one hundred thousand sheldrakes come from the Helgoland Bay, England, Holland, Belgium, Ireland, Scandinavia, and the USSR to cast off their feathers and don a new, colorful dress. For four weeks, these creatures are unable to fly. The

No other area in Europe is as safe for the sheldrake and as rich in food as the Great Knecht Sand.

Knecht sand is the only place in Europe offering them so much security from enemies as well as sufficient food. The nesting behavior of the sheldrakes is the reason why they are so rare in the German island landscape today: They must have incubators, so they build their nests in the rabbit warrens of the dunes. Artificial incubators dug by conservationists in the dikes have succeeded in making the sheldrake reappear more frequently. One of

the sheldrake's fiercest enemies is the ubiquitous silvery gull. Normally, the gulls kill the cute sheldrake chicks during their very first outing to the sea.

While migratory birds fly south in winter, other water fowl come from the polar region to spend the winter on the North Sea: Bewick's swans from northern Russia and northern Siberia, barnacle geese from Greenland and Spitzbergen, and brent geese from the Arctic Sea. Any menace to the tideland coast would also threaten the wildlife of these regions.

The greater the conflict between vacationers and nature, and the further boats penetrate the tideland, the closer together the animals are forced to move. And the greater the conflict between industry and nature, the harder it becomes for animals to survive. Uncontrolled and unlimited use of the tideland by human beings will cut to the very quick of this marvelous area—and ultimately reduce its value. When the birds and seals are gone, the tideland will become a horrible-smelling ocean sewer, for the tremendous biomass will be without consumers.

Fliers over the tideland sea

The silvery gull (*left*) is a notorious egg thief. Young gannets flying in formation (*bottom far left*). Caspian terns fighting (*bottom center*). Arctic tern in front of the sun (*below*).

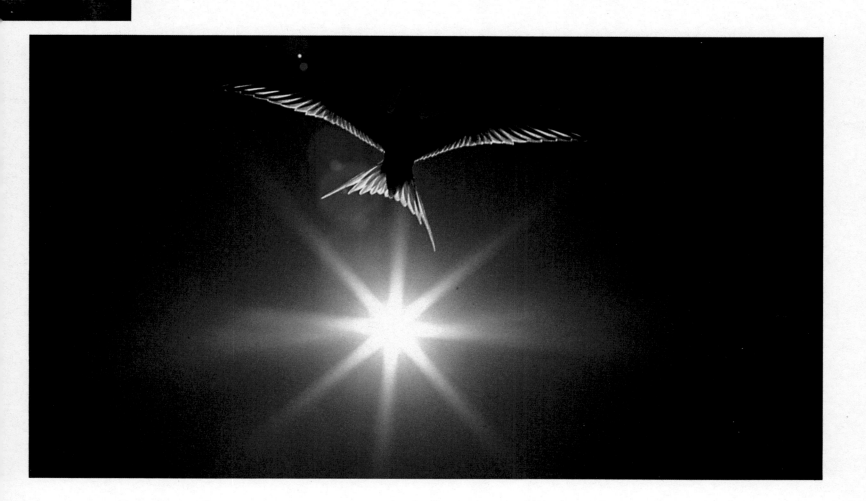

*Even for science
the forest remains full
of miracles and enigmas.*

On the

In Lonesome Woods: Trail of Secret Hunters

The most famous German fairy tales take place in the forest—with good reason.

Forests have always emanated something mysterious that arouses awe–if not more. The early Teutonic tribes even worshiped trees as deities.

In A.D. 100 the Roman historian Tacitus reported his impressions of the homeland of the Germanic tribes: "The countryside appears sinister because of its dark forests." Like the Harz and Spessart areas, the Black Forest and the Bavarian Forest were once feared and avoided. No wonder so many legends and fairy tales originated there. Long before the forest's effect on our environment was identified, it had an impact on the mind of man: In the Middle Ages, the poet Wolfram von Eschenbach celebrated the mysterious beauty of the forest, the fairy-tale land subsequently brought to life by the Brothers Grimm.

Until medieval times, the major portion of central Europe was forest, albeit an altogether different sort from the woods of today. In primeval times, the mixed oak forest with red beeches, maples, lindens, and elms predominated. The annihilation of these forests began in the Mediterranean countries, where lumber was needed to build ships for the growing fleets. The production of charcoal for blacksmiths inflicted further damage. Pasture farming and cattle raising had a devastating impact, too, because the peasants let the animals graze exclusively in those areas. (In present-day Turkey, some twelve million goats and another twelve million sheep graze in

The German forest–cleaned out by cattle and cleared out by charcoal burners–is now composed of fields of trees and rows of pines.

the few remaining forests.) Even stable feeding was particularly destructive; fallen leaves and needles were gathered from the forest floor and used as litter in stables.

The damaging effects of deforestation are distressingly obvious in the Mediterranean countries. The mountain chains, once covered with picturesque woods, are now karstic and present a bleak appearance.

The German forests would have suffered the same doom if the fuel value of coal had not been discovered. Between 1750 and 1850 the German forests were replanted, but the new version bore little resemblance to the primeval forests. The new forests were the results of an economic decision and therefore are

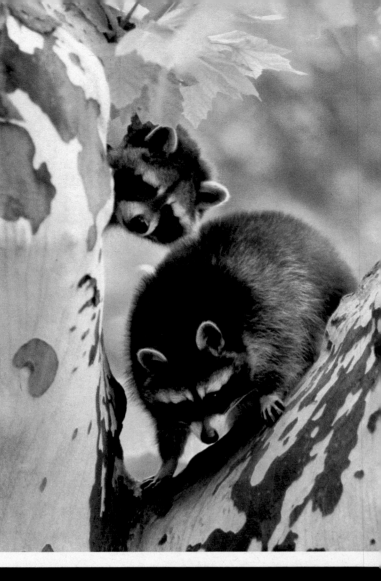

Mysterious wildlife in the shadowy kingdom of the forest

The silence of a forest is deceptive. The casual observer normally spots perhaps a dozen animals, mostly birds and insects. Actually, however, some four thousand different animal species live here—from the forest ant to the red deer. Raccoons (*right*) and Old World otters (*below*) are among the creatures one may happen to see. A few wildcats (*far right*) have survived in the most solitary and impassable regions of the mountain forests in Central Europe. For decades, this shy predator was so rare that it was placed under total protection. Only recently has the stock been restored, and now it is increasing.

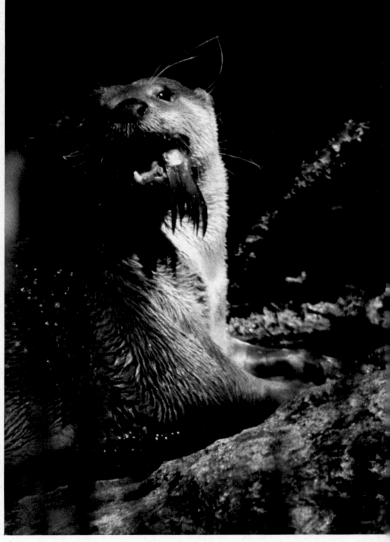

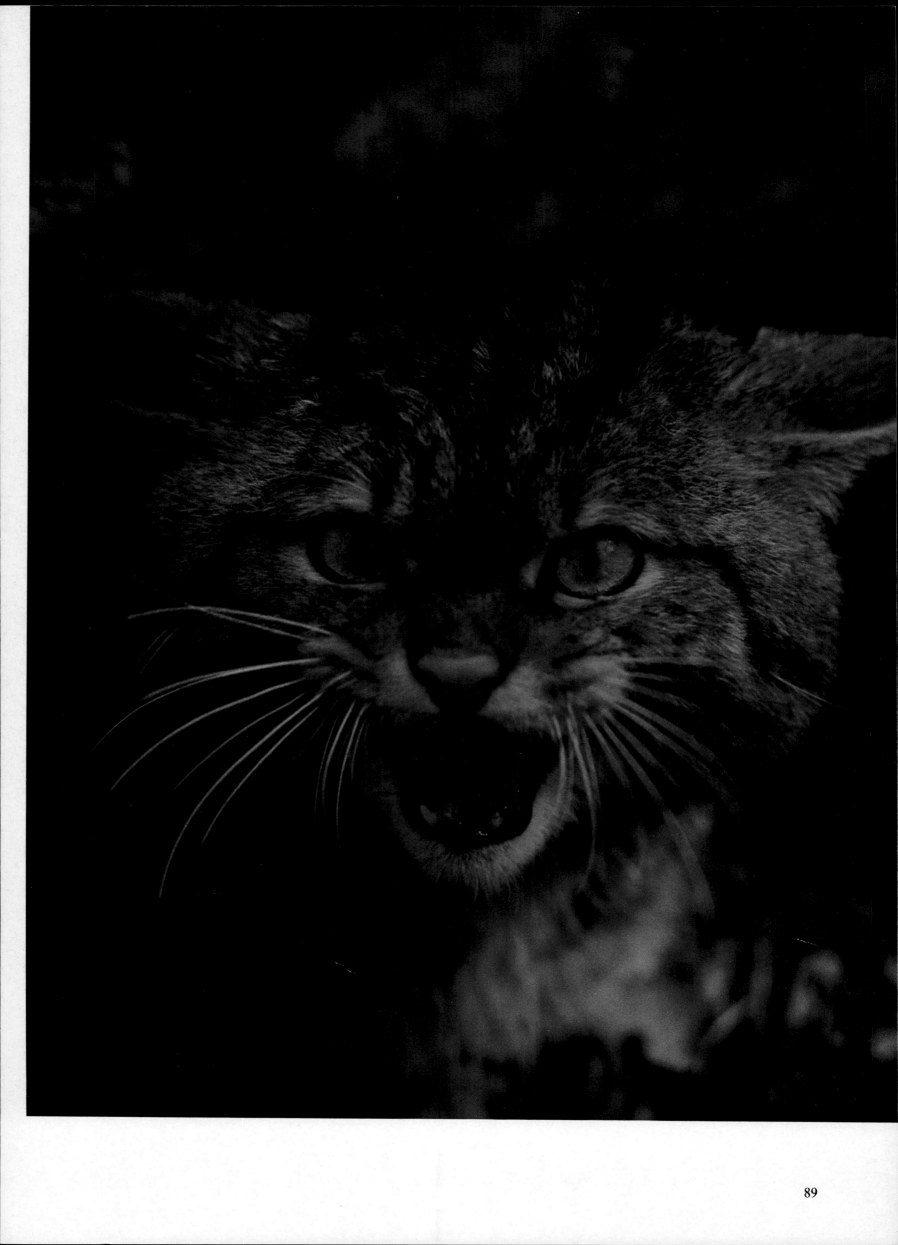

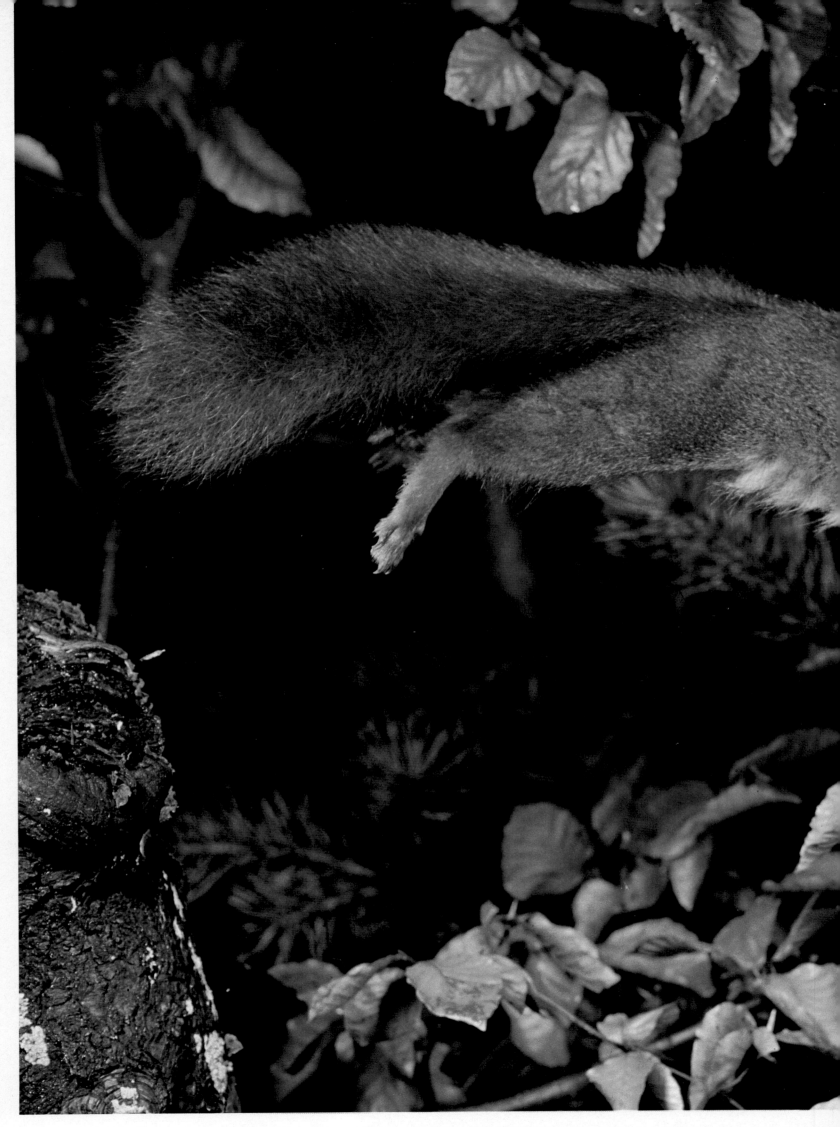

One of the most conspicuous animals in the Central European woods

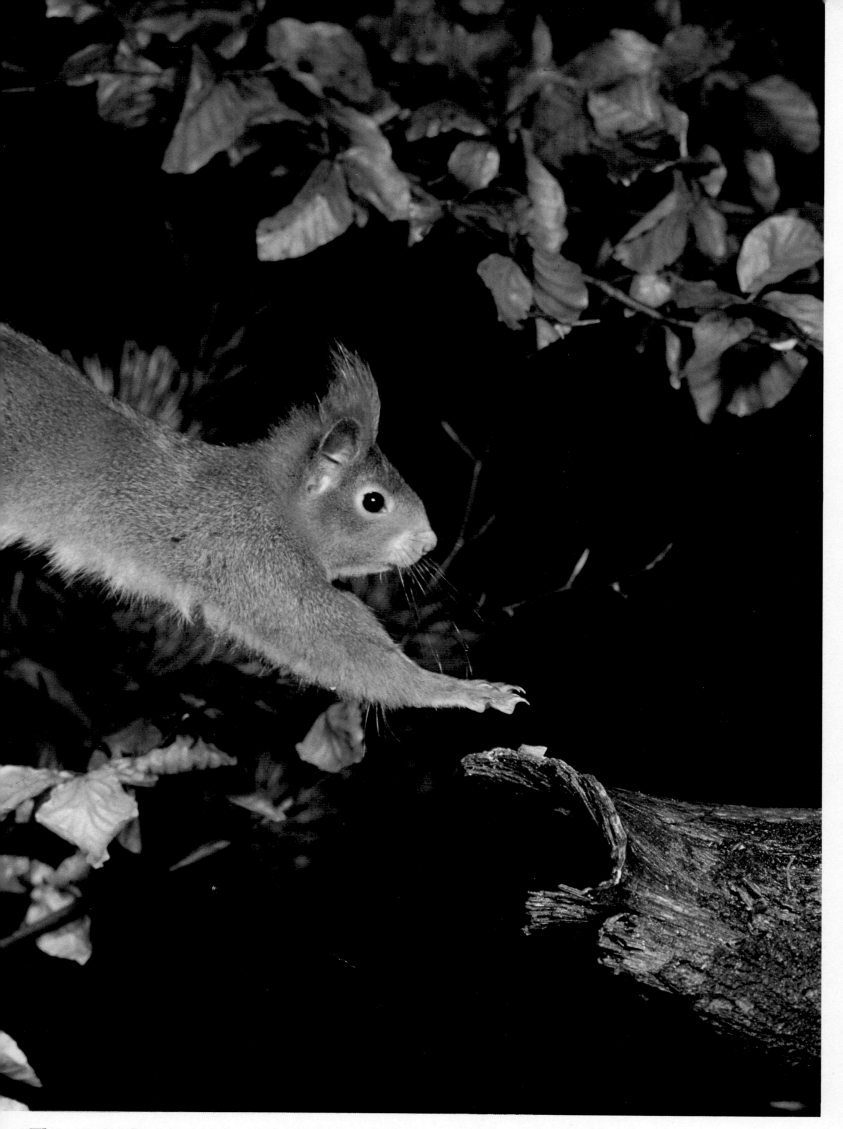

The squirrel spends more of its life in the trees than on the ground.

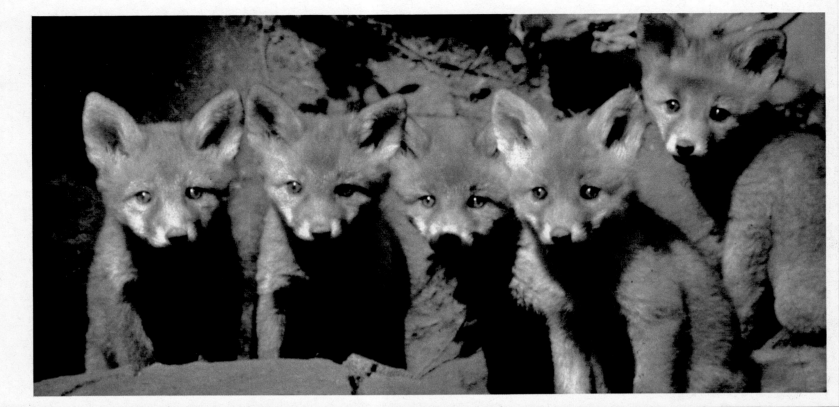

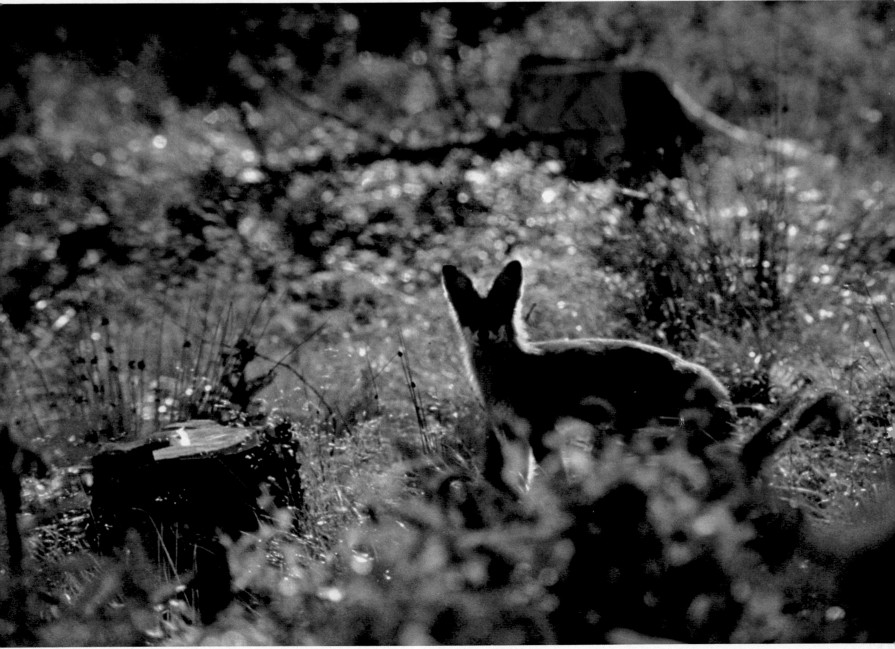

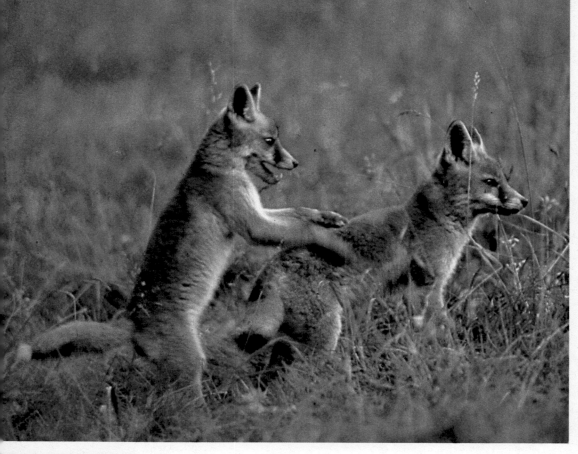

their numbers sufficiently. The red deer now lives predominantly in the densely forested areas of the low or Alpine mountain ranges, which are relatively meager habitats, the better ones having been made arable centuries ago for use as farmland. Hence, the deer, an animal that requires a very large food supply, must live off the poorest ground. It is therefore no wonder that deer are causing such considerable damage to the woods.

And it is no wonder that we are now confronted more and more

The lynx is no thief. On the contrary, in the Bavarian forest it helps the hunter by regulating the wildlife.

acutely with the question of whether and under what circumstances we should resettle predators like the lynx, the bear, and the wolf in mountain districts that are hard to hunt in. These predators help to regulate the stock of game and also aid the hunter. The lynx seems especially fit for this job. It is the only central European big cat which did not die out because of drastic changes in its habitat, though it has been ruthlessly hunted by man, who would not tolerate the lynx's rivalry for the same food.

The role of predators is no longer controversial. Thus, it was established in Eifel that even if the number of wildcats is too large, the stock of hazel grouse will not be harmed. The chief goal today in the care and protection of wildlife is the creation of preserves, for they alone ensure the healthy and original coexistence of a large number of species. The man who says, "A lynx does not belong in my preserve," forgets that other predators, like the fox, marten, polecat, ermine, or falconiformes, can wreak greater havoc than the beautiful big cat.

Along with the Bavarian Forest, the Alpine region, the Harz Mountains, and the Palatinate Forest are suitable habitats for the lynx. Now and then, of course, lynxes will catch domestic animals, but farmers should not be expected to suffer the damages. Instead, local or national governments should assume the cost. This has long been customary in Sweden, Yugoslavia, Italy, and Norway. Today, in the Bavarian Forest, lynxes exact a heavy toll of farm animals. These predators come mainly from the adjacent Czechoslovakian area of this largest contin-

The fox is no longer safe.

The fox, the badger, the marten, and the wildcat are important members of the forest community. They feed mainly on meat, usually mice and other rodents. If rodents multiply uncontrollably, they can cause great damage to the flora.

cultivated. The Germans realized that coniferous trees yield more wood than deciduous trees, and the effort to attain as much lumber as possible led to the creation of fast-growing softwood forests.

There are but few remnants of the original primeval forest in central Europe. The survivors are found in the Alpine region, in Czechoslovakia, in the Carpathians, and in the Bavarian Forest. Unfortunately, the primeval forests can never be recreated by man. After all, it took nature more than ten thousand years to develop this grandiose ecosystem.

What we *can* achieve, however, is the restoration of mixed woods. This project has been actively launched in private and government forests. Today we know that the bright mixed forest, with its far greater

Primeval forests cannot be recreated. However, we can plant mixed forests, which are beneficial for both people and animals.

wealth of flora and fauna species, has a greater appeal for human beings than the dark monocultures of pines. Furthermore, we have an increasing obligation not only to halt the alarming disappearance of wildlife species, but also to resettle animals that are mortally threatened or even driven away, and to increase

The forest (or red) ant is the forester's best helper.

In times of danger, the ant, a fierce fighter,
spurts a powerfully corrosive acid at the attacker.

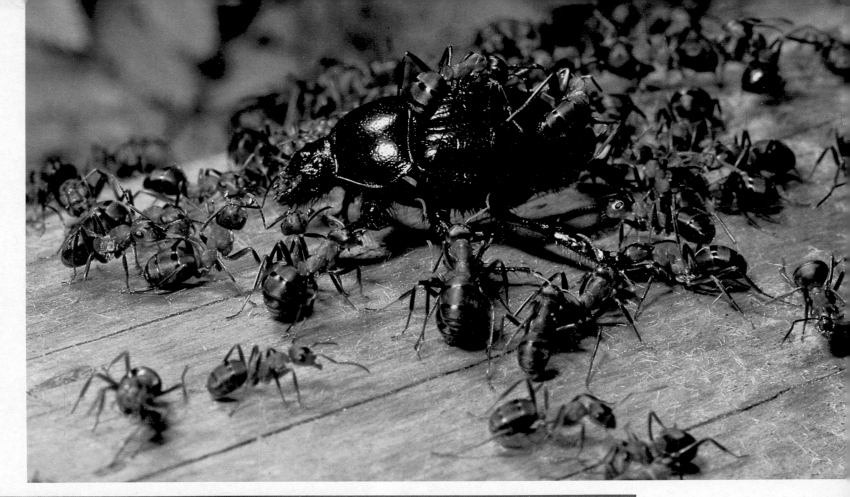

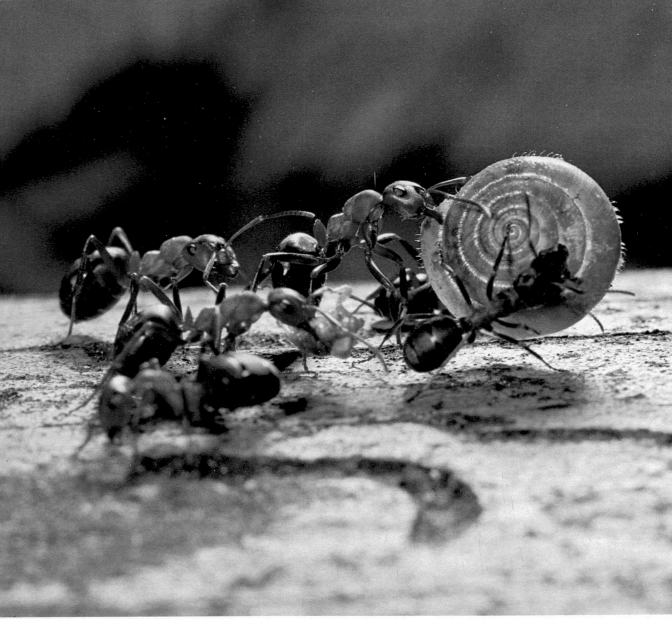

The red forest police provide order in the insect economy of the woods.

Forest ants occur in huge numbers. They tirelessly stalk harmful insects, thereby preventing any disturbance of the biological balance. Unfortunately, anthills are constantly being destroyed by ignorant hikers.

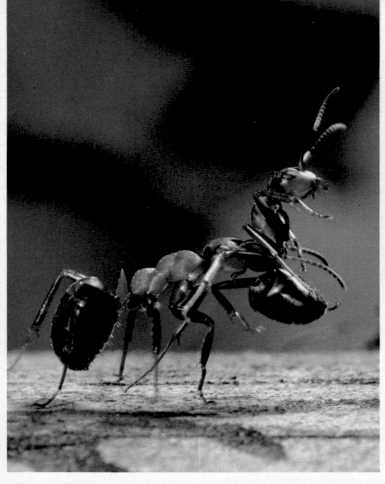

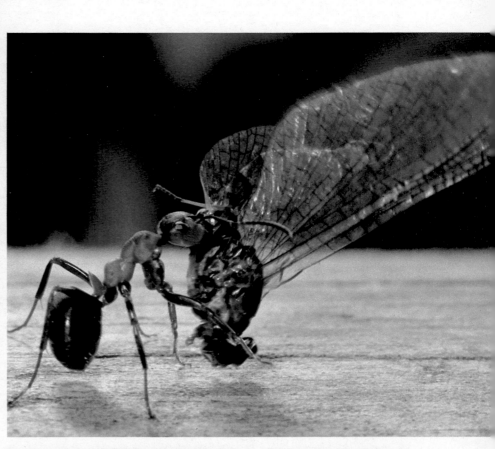

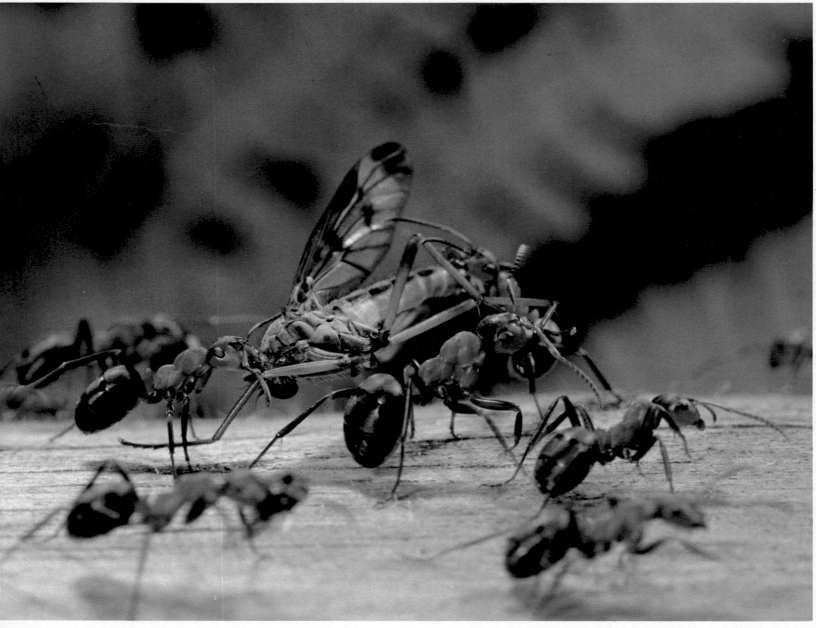

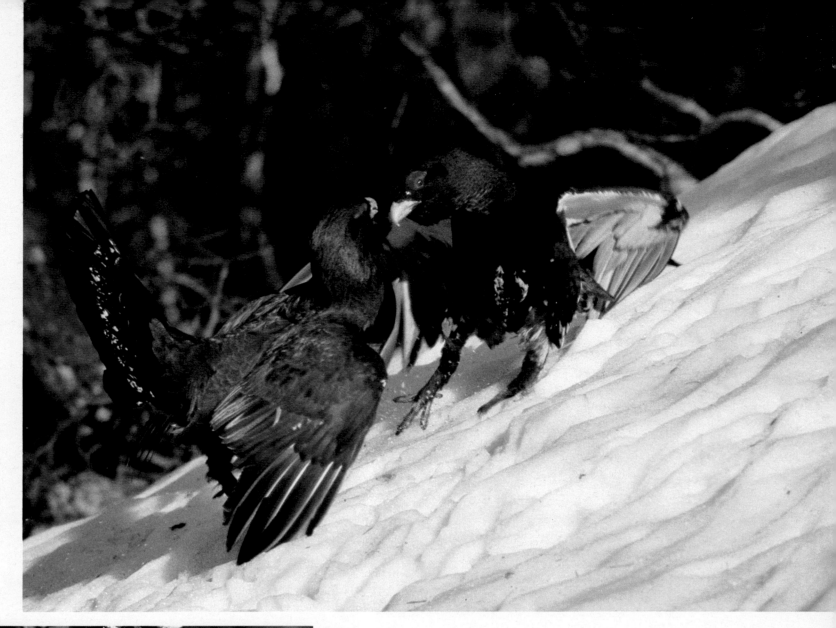

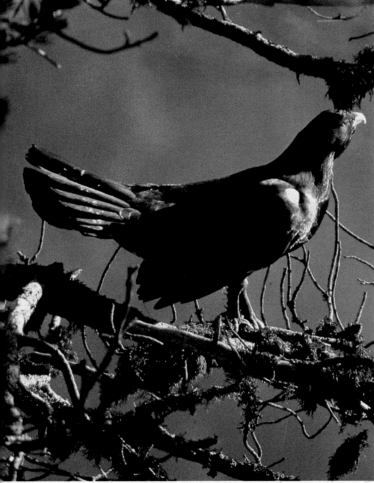

uous forest region in central Europe. It is hoped that the Czechoslovak government will set up an equally large wooded district as a national park, assuring the survival chances of the lynx and many other endangered species.

Until the sixteenth century, wolves, too, were the epitome of terror for peasants. In those days, what few cows there were remained on the farm. The most useful animal was the sheep, which supplied meat, milk, and wool; so sheep were raised everywhere. They grazed in the woods and meadows—resulting in a large increase of wolves that repeatedly carried off sheep. As a result, the peasants could not come up with their tithe, which posed a very serious problem: they couldn't purchase winter supplies. This situation changed with the introduction of hand firearms. The fight against wolves became a government task. Large bounties were paid for dead wolves.

Today, wolves are practically extinct in Europe. Some twenty wolves still live in Italy's Abruzzo National Park. With its 40,000 acres of surface area, this wildlife refuge is almost three times as large as the Bavarian Forest National park. Nearly seven thousand people live here—a tiny number considering the vastness of the region. There are some ten thousand sheep, roughly five hundred chamois, and forty-five deer, which were naturalized here only recently. Some of the wolves wear a transmitting device on their collars, allowing

Wolves and bears avoid human beings. They prey on domestic animals, which can be caught easily.

the researchers in the National Park administration to keep track of them. The researchers know their habitats and their hunting methods, and are able to find the leftovers of the wolves' prey, so that they can tell which and how many creatures have been killed and in what space of time. Since Abruzzo National Park

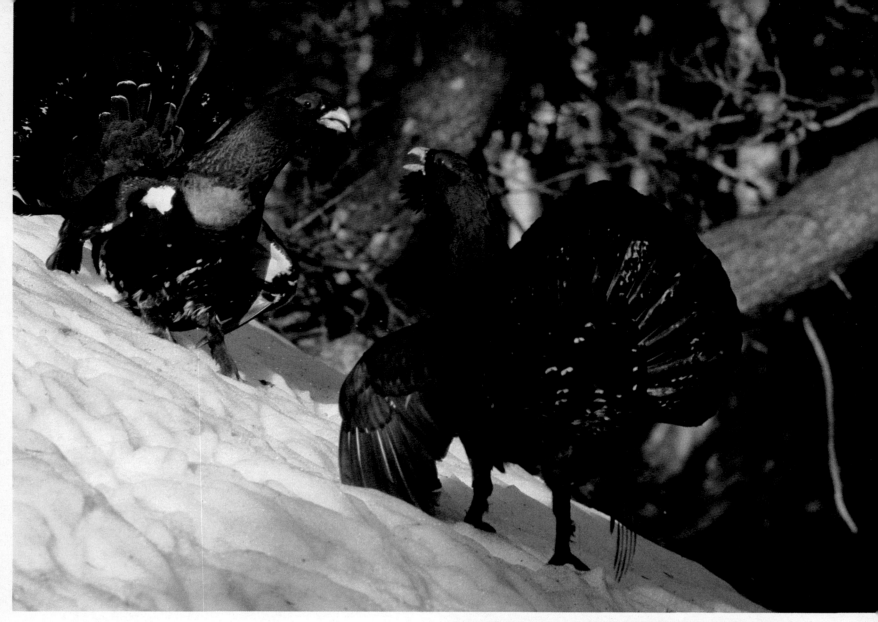

is very sparsely settled by human beings, and the government pays the farmers for any sheep killed by wolves, these fascinating wild animals will continue to track their way through the wild. In the German National Park, a renaturalization of wolves would be possible only if an equally large territory were established on the other side of the Czechoslovak border.

The same things can be said about the survival chances of the brown bear in Europe. There are still some thousand bears in the Rumanian and Hungarian Carpathians, some two hundred fifty in Czechoslovakia, some three hundred in the Polish section of the Carpathians. Even in Tyrol, in the Brenta Mountains, three or four bears are extant. During the past few years, ecologists have been trying to figure out how to renaturalize these splendid wild animals in suitable European woodlands, from which they vanished long ago. Bears living in the forest are not dangerous to human beings unless they are annoyed by them. If a bear is shot at or cornered, it can

The mountain cock lives in the most inaccessible mountain forests.

These birds are the size of geese, but their food demands are modest. The male (*bottom left*) is satisfied with bark, forest berries, and herbs. The female (*right*) also devours insects during the brooding period in spring. It is only during the mating season in spring that the love-crazed cocks get into fights (*top*).

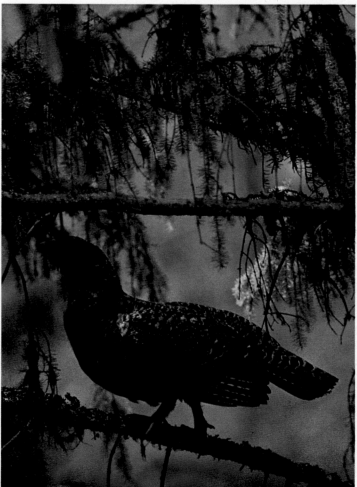

become a very dangerous opponent.

The food habits of bears make their resettlement difficult. Normally, bears are omnivorous and live on all kinds of plants and berries, insects, snails, and carrion. Naturally, they sometimes attack does or stags. But bears are lazy, so they usually hunt sick animals or ones feebled by age. Since they can easily catch domestic animals like sheep, goats, cattle, or horses, bears will hang around human settlements, causing a lot of damage. Needless to say, Germans have little possibility of observing a wolf or a bruin in the wild.

This is not true of the wildcat, which people used to regard as a cunning beast that mainly killed hares, fawns and young deer. Today, we know that the wildcat has an important job to do for the biological balance in the forest ecosystem. Examinations of leftover food have revealed that the wildcat lives mainly on small mammals like mice, moles, rats, white weasels, ermines, and

No animal species ever endangers the existence of another! Only man is capable of doing that.

squirrels, though it sometimes preys on birds, young hares, and fawns. However, since mice are a food staple for wildcats, the usefulness of wildcats in a preserve is obvious. Hunters realized this early on and placed them under protection in 1934. Thanks to their alertness, the European wildcat managed to survive in various wooded sections of West Germany like Hunsrück, the Harz Mountains, and Eifel. Unfortunately, wildcats crossbreed with domestic cats, which belong to the same species.

While the number of wildcats in West Germany is estimated at just a few hundred, there must be at least one hundred thousand stray domestic cats living as wild animals. From a distance, the two are not easy to tell apart. However, one sure hallmark of the wildcat is the strong tail which is rounded off at the end; the domestic cat's tail is thinner and comes to a point.

The Old World otter survives only in a very few isolated forest regions with unblocked rivers, brooks, lakes, and sloughs. We are seldom able to observe this otter in nature, although we can sometimes encounter its relatives: stone martens, tree martens, polecats, badgers, and wea-

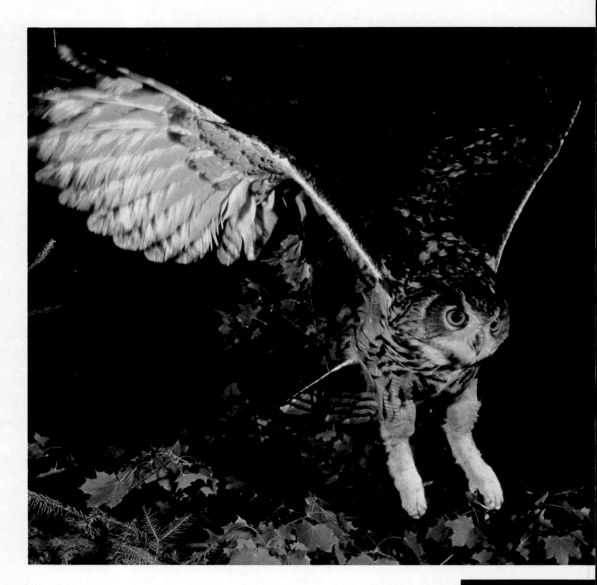

sels. The reason for the scarcity of the Old World otter is the radical transformation of its habitat. It has been ruthlessly hunted for centuries, either for its valuable thick fur or because of its reputation as a fish-eater. However, hunters have long since placed this endangered species under protection. The alarming reduction in the number of otters during the past fifty years is due not so much to hunters as to man's often short-sighted urge for change, which deprives the otter of its natural habitat and its basic nourishment. The fish stock in German rivers and lakes did not suffer because the Old World otter lived off them. Pollution of the waters and river regulations have caused the fish to die out. The pollution makes it harder for the otter to see its prey. Furthermore, dangerous amounts of pollutants collect in the fish themselves. Many fishermen wrongly believe that the otter lives exclusively on fish; in fact, the otter actually makes itself useful by wiping out water voles and muskrats. It likes to catch crabs, which, of course, have grown scarcer in the

The owl's hunt begins when darkness falls.

Flying soundlessly, bats, owls, and tawny owls look for prey. At no time is the forest livelier than in the early night. The eagle owl (*top left*), the little owlet (*top right*), and the barn owl (*right*) have developed remarkable techniques for their "night work." The pipistrelle (*top center*) and the long-eared bat (*bottom right*) take their offspring along when they go hunting.

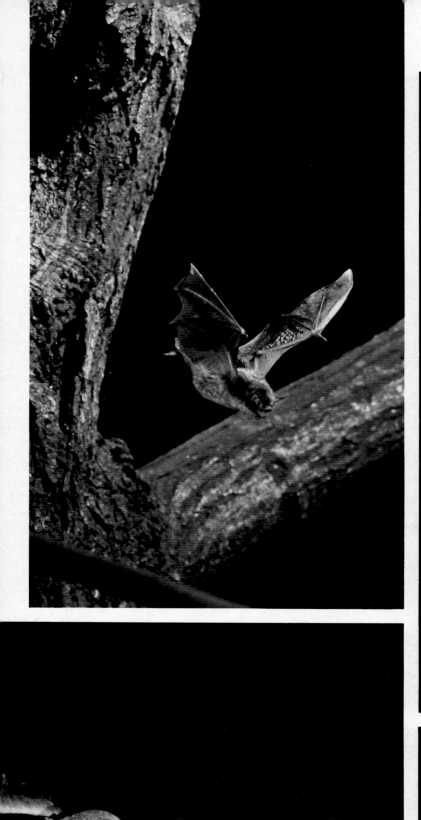

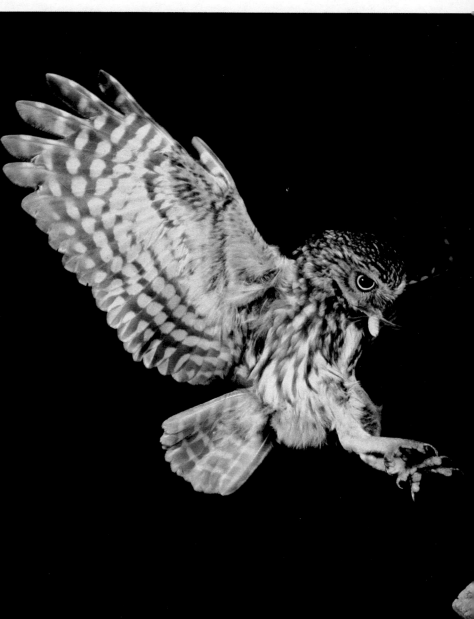

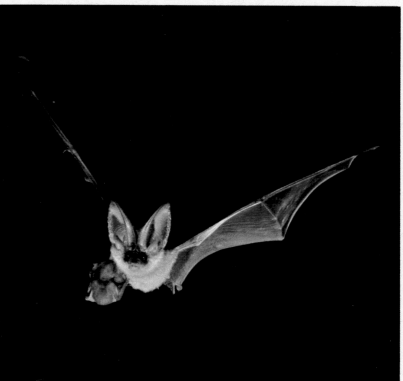

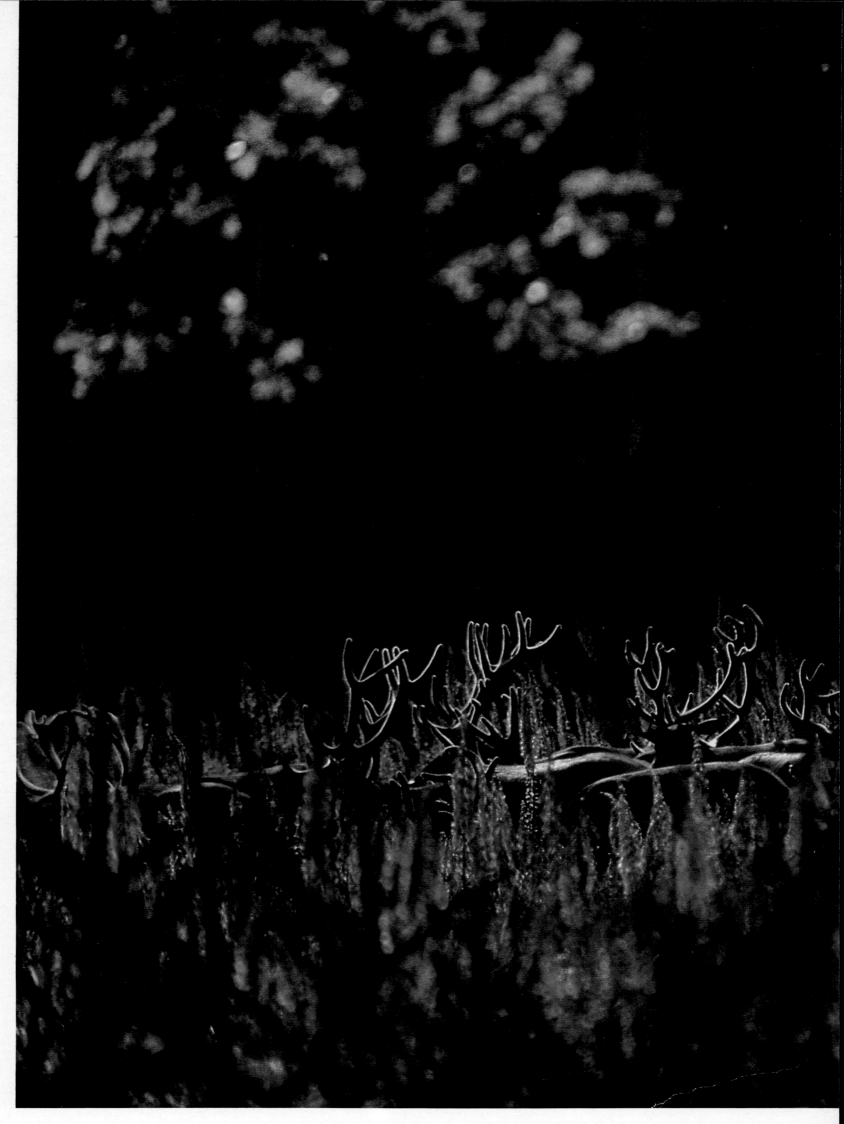

A herd of red deer grazes among the stalks of purple foxglove.

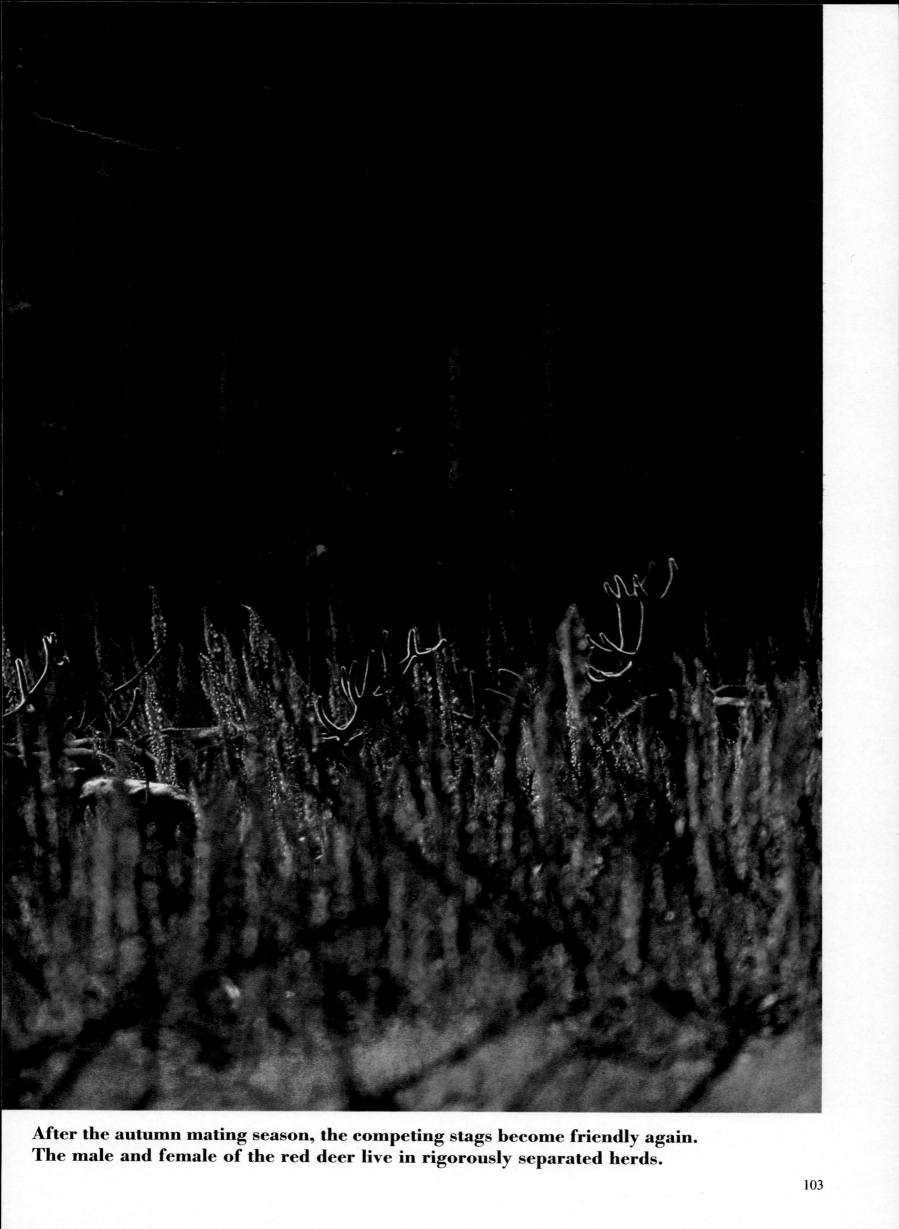

After the autumn mating season, the competing stags become friendly again.
The male and female of the red deer live in rigorously separated herds.

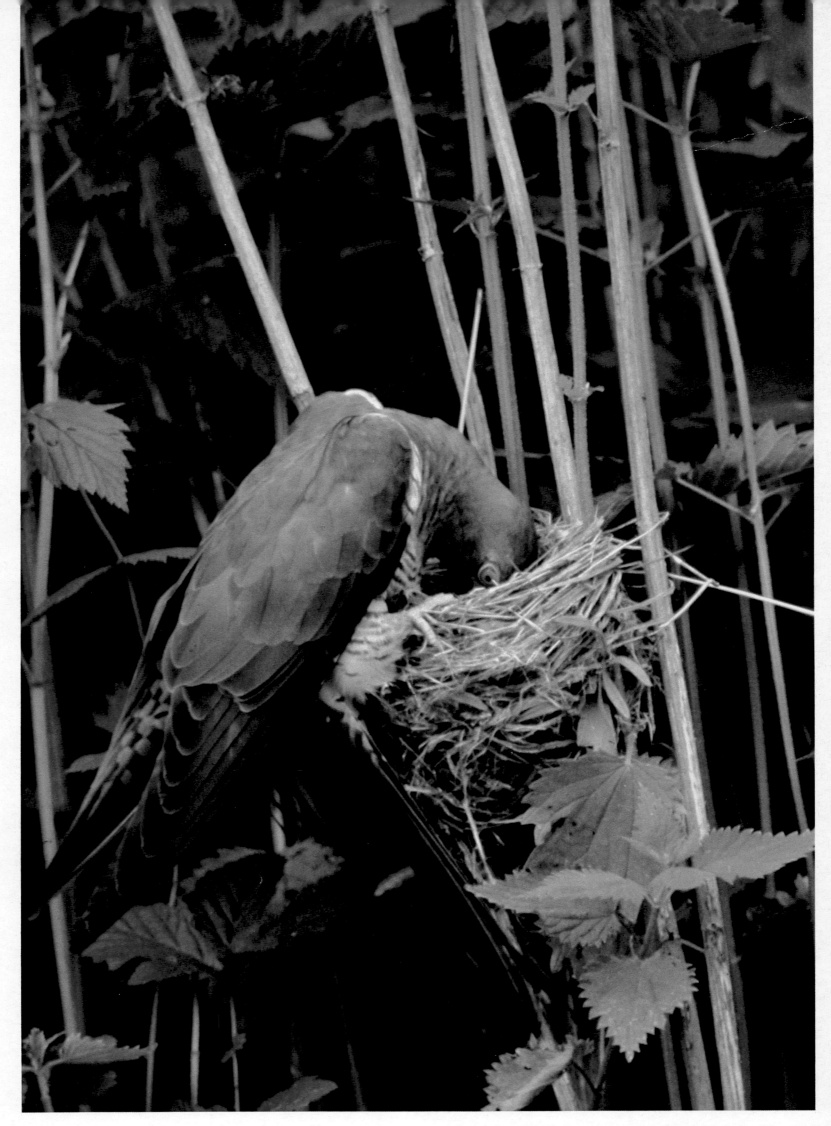

There are parasites in the bird kingdom, too.

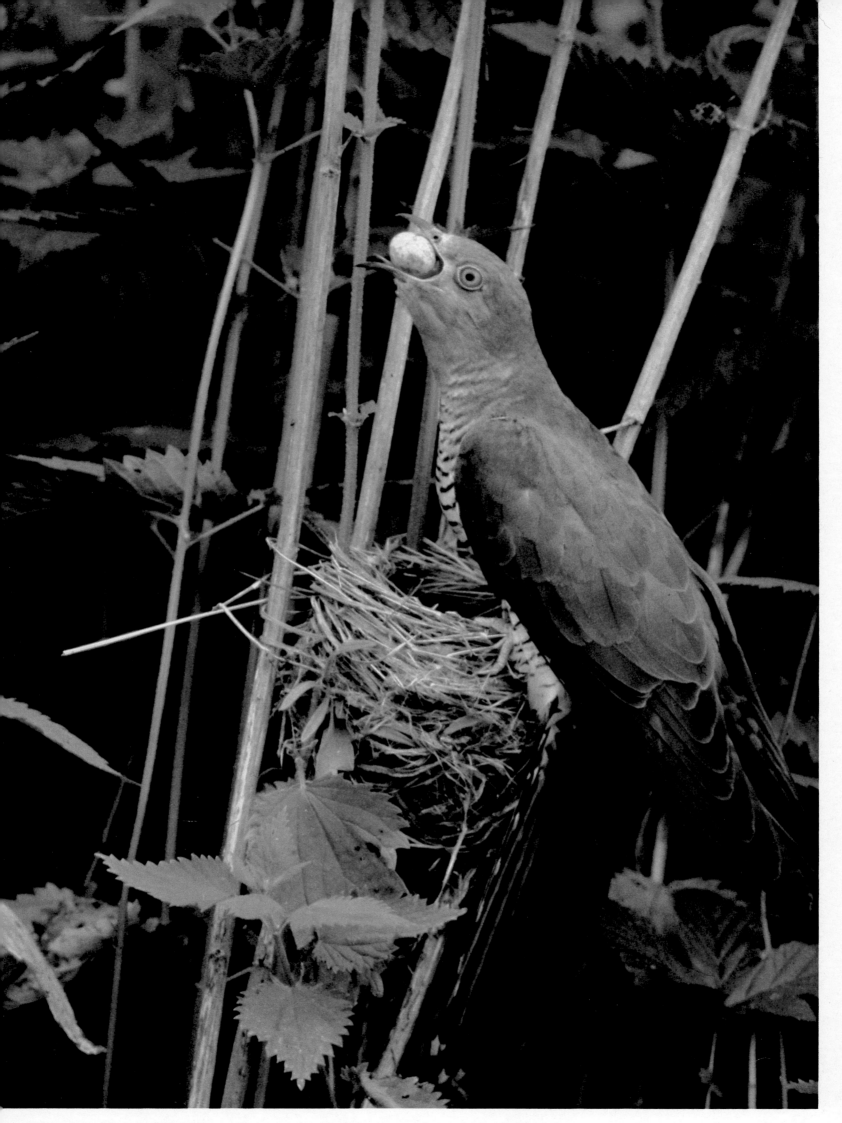

**The female cuckoo has discovered the nest of a reed thrush.
She eats the thrush's eggs and lays her own eggs in their place.**

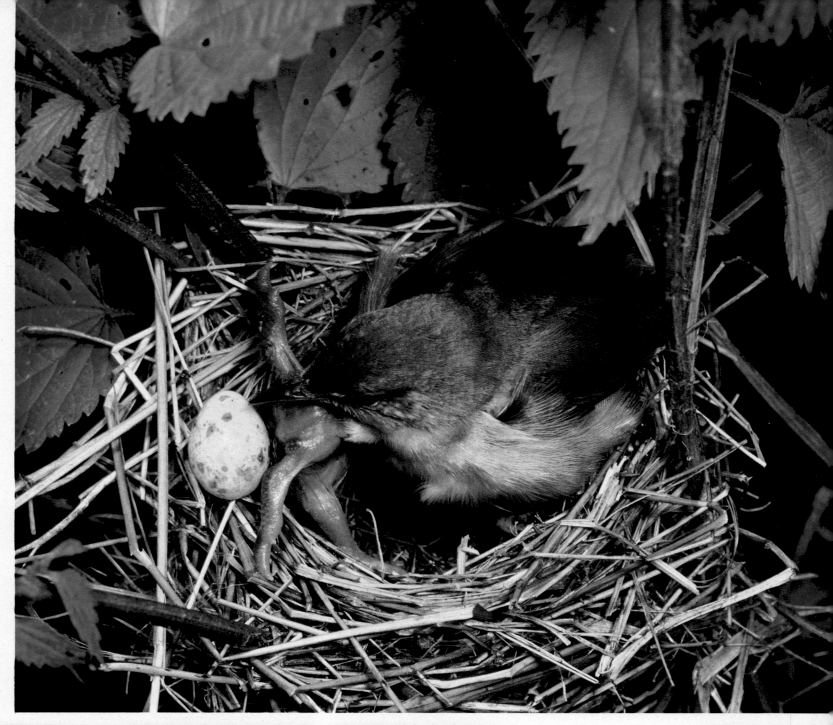

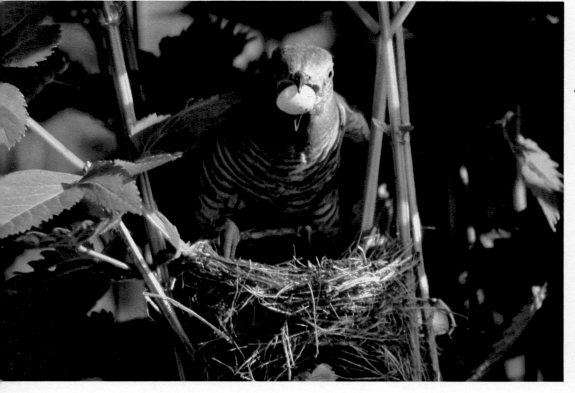

One of nature's secrets, photographed for the first time

A young cuckoo, before the eyes of a host bird (a reed thrush), maneuvers the victim's eggs out of the nest (*above* and *top right*). After the female cuckoo has laid her egg in the alien nest, the "deceived" reed thrush unsuspectingly adds her own eggs (*right*).

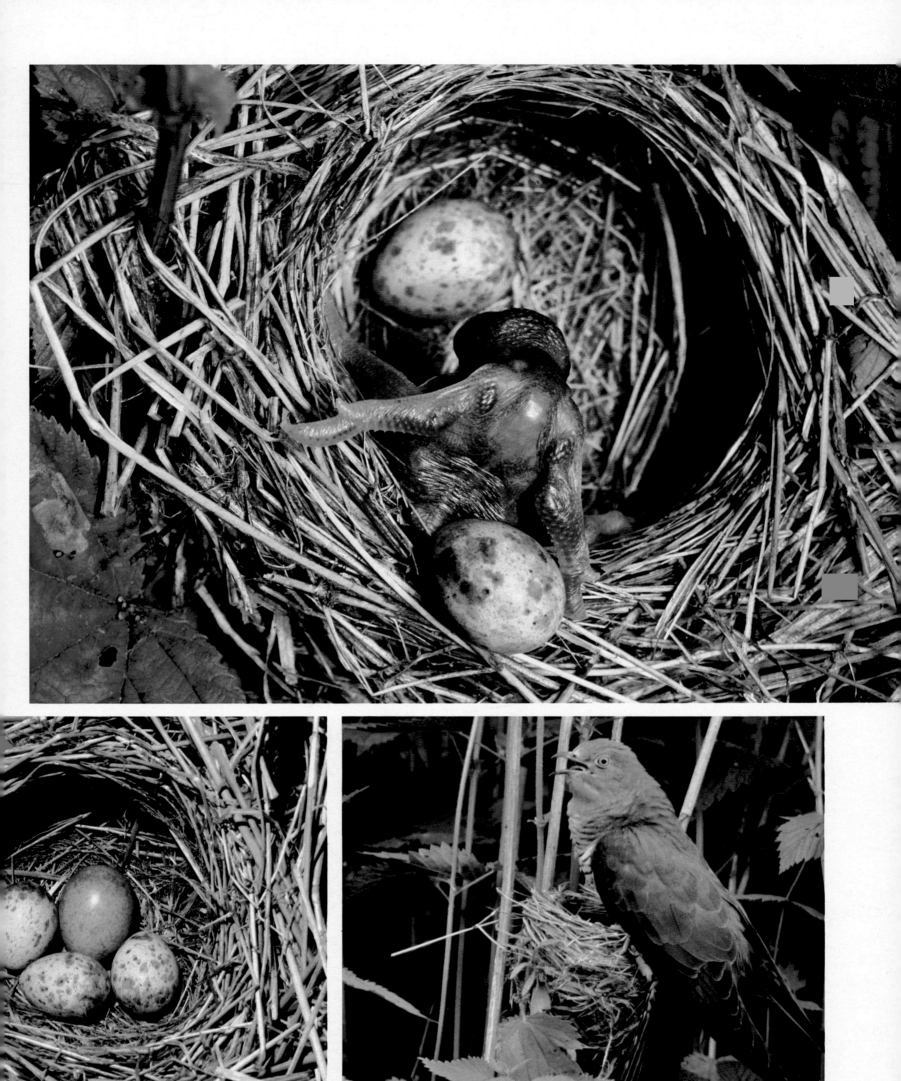

polluted waters. The otter also consumes coots and other water fowl as well as their eggs, plus frogs and water insects. Fish certainly make up a major part of the otter's nourishment, but a high percentage of these fish are sick, and so can be caught easily.

At this point, let us recall an insight of wildlife biologists: Never does one species of animal endanger the existence of another! The rapid decrease in so many feral creatures always indicates that man has negatively altered the habitats and the natural economy. Nature itself maintains the balance. Under human care, the Old World otter can become very trusting, as frequent experience shows. It is therefore tempting to breed these animals and then resettle them in the proper regions. Unfortunately, this is very difficult in practice. Many zoos keep Old World otters because these funny, playful creatures are great favorites with the public. However, they often do not survive very long in captivity. The only exception is a zoo which specializes in breeding endangered species, in particular, the Alp Zoo in Innsbruck. During the last few years, its director, Professor Hans Psenner, has had surprising and regular successes in breeding beavers. The first man to breed the Old World otter domestically is Phillipp Wayre. In his wildlife park at Norfolk, England, Wayre has concentrated exclusively on European mammals, especially

Old World otters exist almost exclusively in zoos. Prejudices and environmental poisons have nearly wiped them out.

Old World otters. He is deeply interested in renaturalizing the Old World otter in suitable landscapes, but a great deal of research must still be done before this becomes possible: The general public must recognize them as an endangered species; and, the ecological makeup of the possible territories must first be thoroughly examined. For the time being, the otters raised by Wayre and those at the Alp Zoo should be used for further breeding in the proper refuges. An ideal place would be one where otters live in the adjacent wild, such as the Bavarian Forest National Park's breeding refuge. Any offspring will therefore increase the ominously shrunken stocks of otters living in the wild, and biologists can see to it that the

animals are offered the best possible living conditions.

One of the most impressive and most endangered large birds in Germany is the eagle owl. It inspired the legend about itself as the wild hunter, an epithet that can be understood by anyone who has ever heard the dull "ooohooo" in the dark forest. In fact, the hooting gave the owl its name in German: *Uhu.* Twenty-five to thirty-two inches long, with a wingspan as wide as six feet, the eagle owl is the largest owl found in Germany. An unknowledgeable or superstitious hiker may

For a long time, the eagle owl, the king of the night, was an undesirable in German forests. Today, although it is almost too late, the Germans know better.

feel cold shivers running up and down his back when he hears the grisly hooting of this "King of the Night." Of course, only the patient observer can ever glimpse this soundless glider of a night bird, who remains concealed in the daytime.

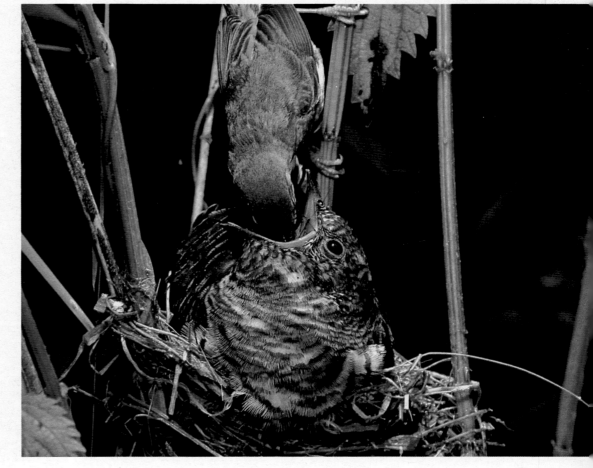

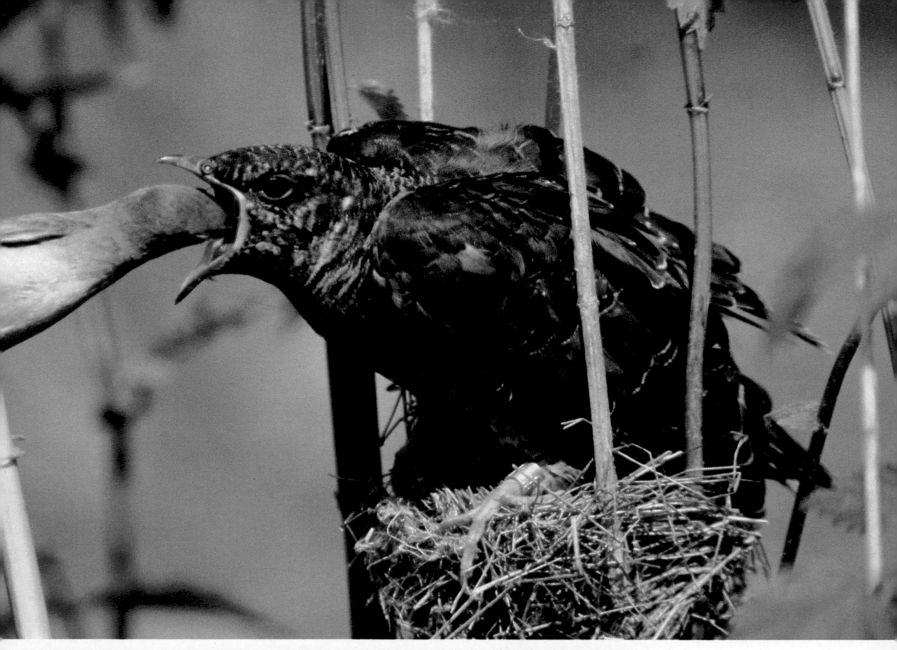

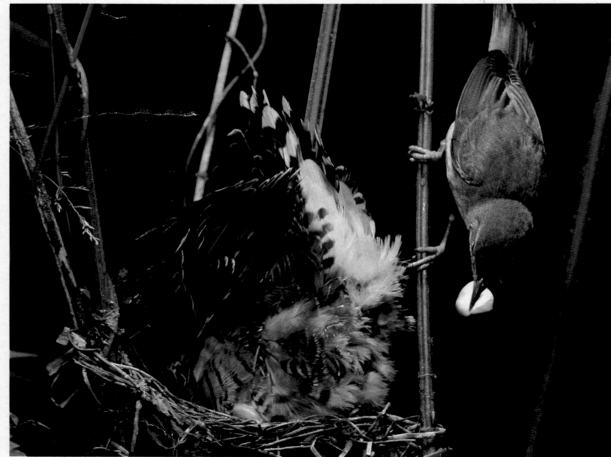

Sacrifice and devotion for the uninvited stepchild

The "murderer" of the reed thrush's offspring is fed and "diapered" by the senior reed thrushes as though it were their own. The needs of a growing cuckoo approximately equal those of four young reed thrushes.

The eagle owl used to be found in all German forest areas. Until the turn of the century, many of them dwelt in the extensive mountain woodlands. However, they were then hunted down in great numbers and ultimately exterminated in areas like Hesse, Rhineland-Palatine, North Rhine-Westphalia, and Schleswig-Holstein. This splendid bird was resented for catching rabbits, young hares, and gray partridges. Also, more and more Germans wished to decorate their parlors or hunting rooms with a stuffed owl. The most lethal stroke to the owls' existence was the removal of young birds from their nests, in order to raise them for hut-based fowlers. Since crows and falcons attack a tied-up owl, live owls were bound to a crutch pole; flying birds could then be picked off by the dozens from a well-camouflaged hiding place. This measure, for the "care and protection of birds and beasts of chase," had a fatal impact not only on the stock of owls, but also on falconiformes. As if all this were not enough, the eagle owls usually fly low and thus have been decimated by all the wires and lines suspended in the countryside.

Owls raised by humans must first learn how to hunt. While the instinct is innate, its perfection is not.

Between 1910 and 1937, the Germans placed eagle owls in suitable refuges in order to increase their numbers. Unfortunately, these efforts were unsuccessful. Today, we are having better experiences with renaturalizing vanished species and increasing the stock of endangered ones. Earlier attempts failed because the ecological requirements had not been sufficiently investigated. Renaturalization has prospects of success only if there are rocky forest areas with nearby waters. In the winter, coots and moorhens gather in these waters, and muskrats also appear. Areas are considered especially favorable if they include lots of wild rabbits.

However, the renaturalization territory must not be so isolated that the eagle owls cannot maintain contact with wild owls. It is therefore best to release the eagle owls at the edge of regions inhabited by wild owls.

There are two possibilities for increasing the stock of eagle owls in a suitable landscape. Young owls can

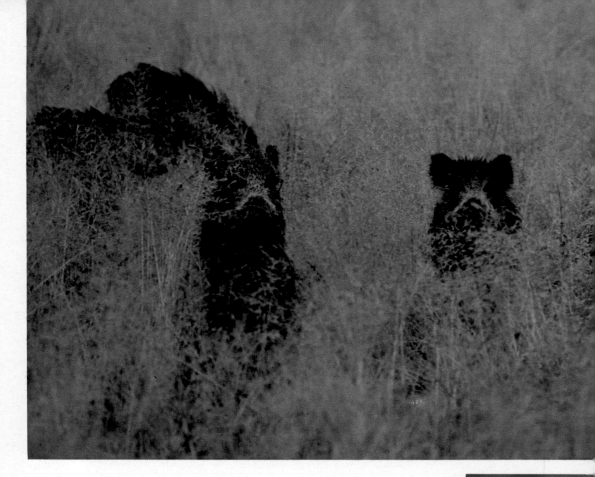

be added to nests that contain only one or two; if the young are no older than about three weeks, they are accepted by the adult birds with no further ado. Or, owls can be raised in volaries and set free at an opportune time. The very first prewar experiments in Germany are proof of the disastrous consequences of releasing adult owls without special preparation. The birds first *must* be trained to kill prey. Experiments have revealed that young owls (80 days old) can kill small live animals; at the age of one hundred ten to one hundred fifty days, they are capable of catching animals they have never even seen before.

I once visited Peter Mannes, an owl expert. As part of the project for increasing the number of eagle owls, carried out by the German Association for the Protection of Birds, he was in charge of breeding and releasing eagle owls in Lower Saxony. The volary, in which the birds were gradually accustomed to killing such live prey as mice or rats, was seventeen yards long, four yards wide and three yards high. It contained twelve owls. This large volary was created specifically to train young domestically-raised owls to kill prey on their own. I could readily see that the instinct to catch prey is innate in birds. But the perfect skill of overpowering quarry while in flight must be learned with a great deal of practice. Only after many attempts do the birds become good hunters who can

The largest animals in the forests of Central Europe

The most imposing representative of Central European game is the red deer (right). The stag's body grows more than six feet long, and the shoulders are almost five feet high. The antlers, impressive in old stags, are cast off in February but grow back by the mating season in the fall. The most pugnacious game in these climes is the wild boar (above). The strongest predator is the rare lynx (top right).

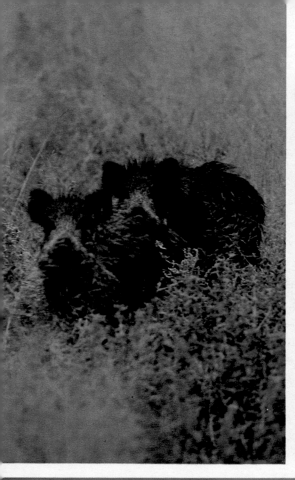

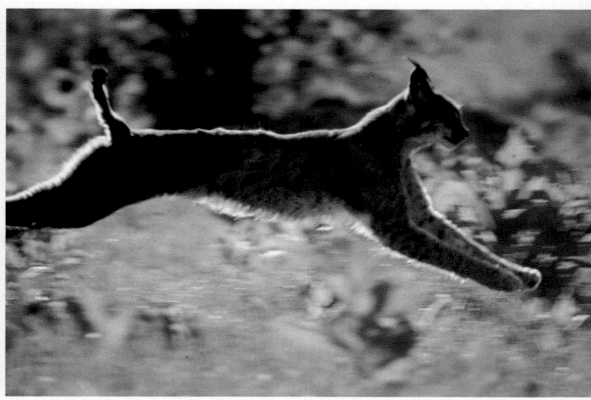

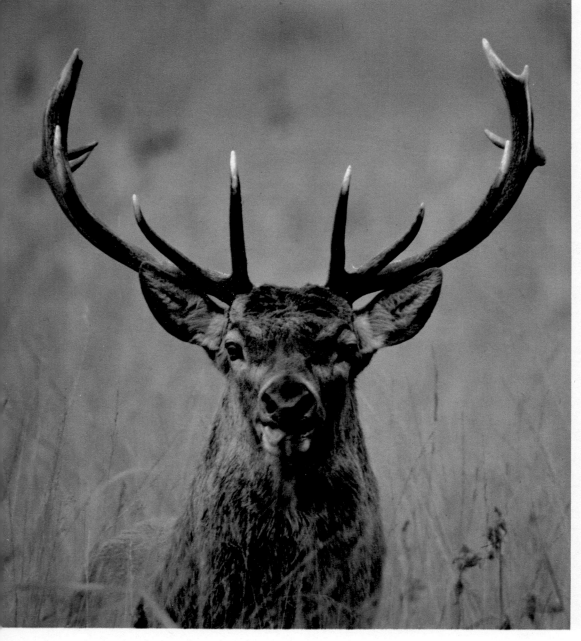

soar down and dig their claws firmly into their prey.

If eagle owls are to be released in areas where none are left, an adult couple ought to be kept in a volary for one or two weeks. Then, when the female is released into the forest preserve, she will remain in contact with the male in the volary. A feeding place is maintained next to the release volary; once this feeding place is visited regularly by the female, the male can be set free. Be-

The renaturalization of eagle owls is accomplished by setting them free in pairs, though the female is actually released first.

cause of his attachment to the female, the male will also continue to visit the feeding place. Previous experience has taught us that the birds will feed there for three or four weeks. After that, they obtain their food independently.

However, these possibilities are suitable only for filling in certain gaps. If large territories are to be re-settled, such projects cannot be financed by private or public environmental protection agencies. In northern Germany, especially in the Harz and Weser mountains, two

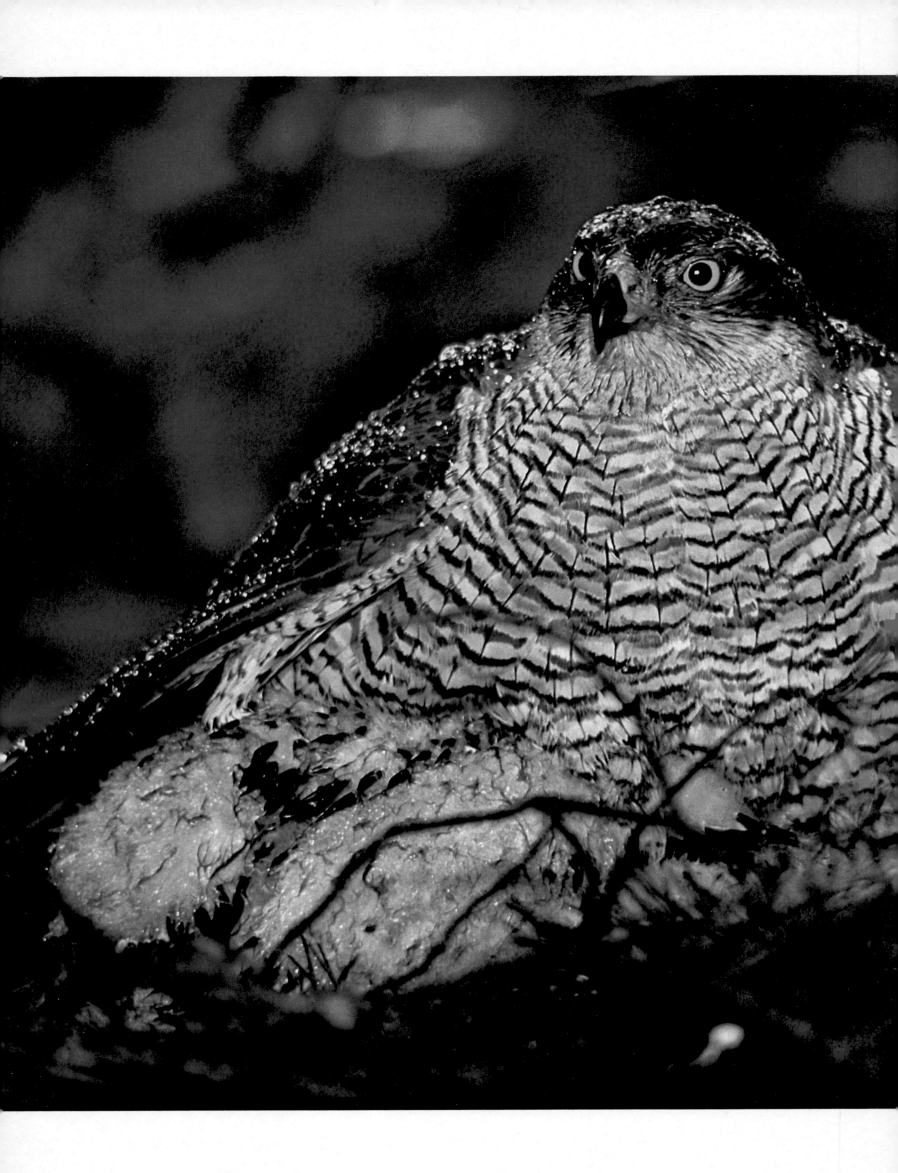

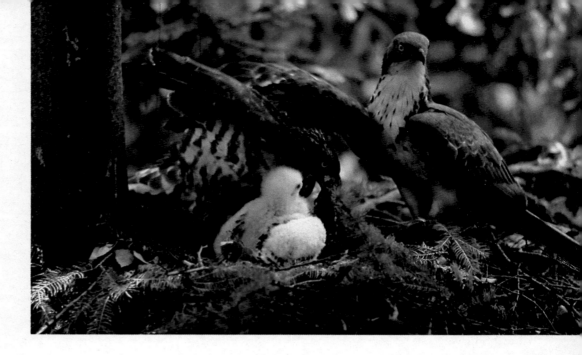

Falconiformes are crucial to a sound natural economy.

The goshawk—bold and reckless, cunning and distrustful, and more aggressive in its nest than any other eagle—here shields its brood against a rainstorm (*left*). The honey buzzard (*right*) is slower and lazier in its movements. A specialist at catching insects, it likes to eat the hives of wasps, bumblebees, and wild bees, which are filled with honey and mites.

agencies have developed the abovementioned, less expensive method. Young eagle owls are raised with proper care in zoos or privately and then placed in volaries and accustomed to skillful flying and to killing live prey. In September, by which time they have obviously learned their lessson, they are released on the outskirts of large forest areas.

Every year, as a portion of the countryside the size of Lake Constance is opened up, nature dies—albeit silently.

Since young owls instinctively wander within a radius of thirty to sixty miles, this method makes sense only if it is continued with a large number of birds over many years; only then can we be sure that an owl, settling in a preserve after a period of wandering, will actually be found by a mate.

Today, more cars zoom along our roads than there are stags and does tracking through the woods and fields. Traffic surfaces and populated

areas keep growing, even though stabilization was expected long ago. Every year, an area the size of Lake Constance is wrested from nature. The necessity of maintaining the extant natural landscapes with an irreplaceable flora and fauna has, fortunately, led to greater cooperation between hunters and ecologists—evidenced by joint efforts in recent years. One such German project focuses on resettling mountain cocks and black grouse with the help of birds raised in volaries. There has also been a great deal of cooperation on the part of hunters in the permanent supervision of our endangered sea eagles and peregrine falcons at their nesting places. Equally important is the cooperation of all associations who care about protecting the habitat and shielding the species with respect to area planning. Their efforts are crucial in fighting those forces that want to open up and encroach upon valuable refuges and idyllic landscapes.

More and more citizens are demanding that 10 percent of the various habitats must remain protected. After all, animals need open spaces, too.

Plants of many colors decorate deciduous and coniferous forests.

Golden yellow cowslips (*top left*) and violet-blue liverwort (*left*) are among the first harbingers of spring. They are followed by the bluebell (*top right*) and the willow herb (*bottom far right*). The cup lichen (*right*) can be seen all year long.

114

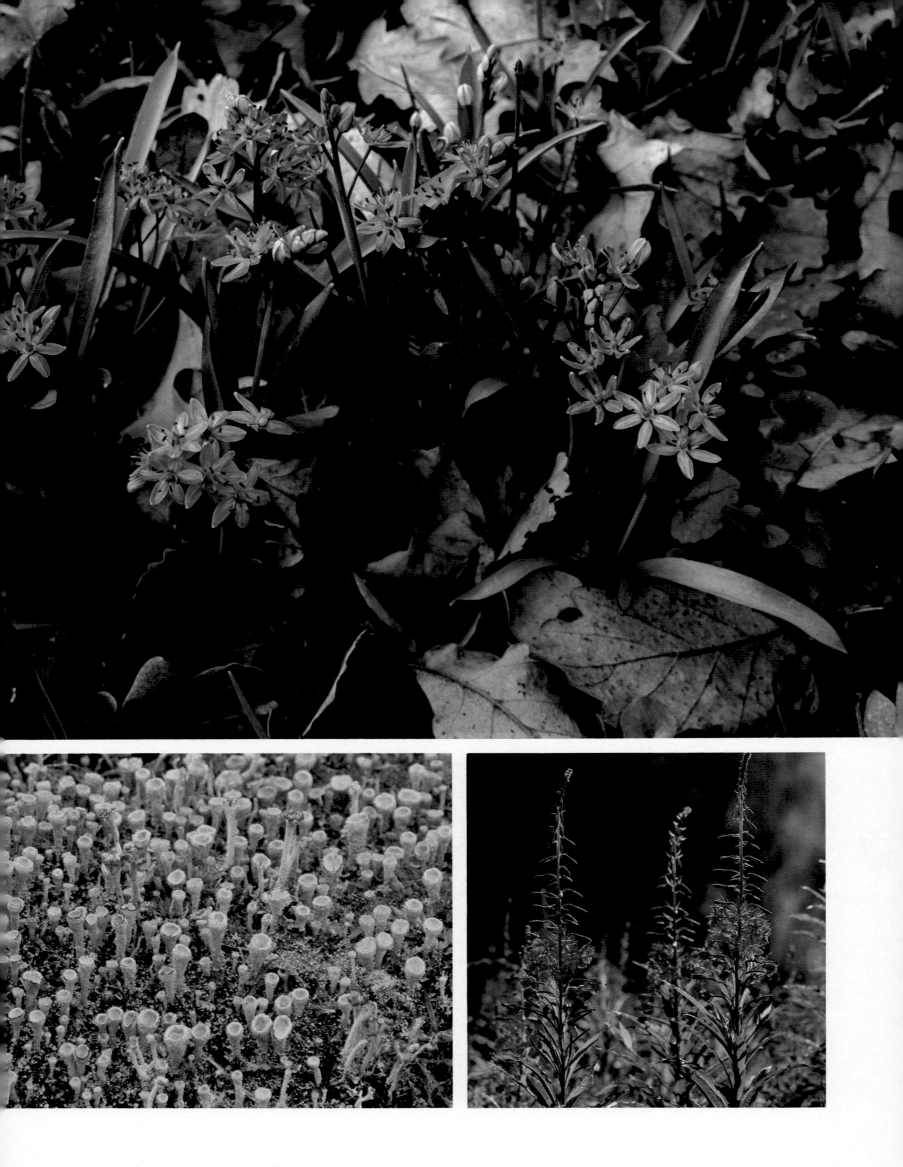

Moorland sheep and juniper are part of this landscape, which has been celebrated in countless North German poems and novels.

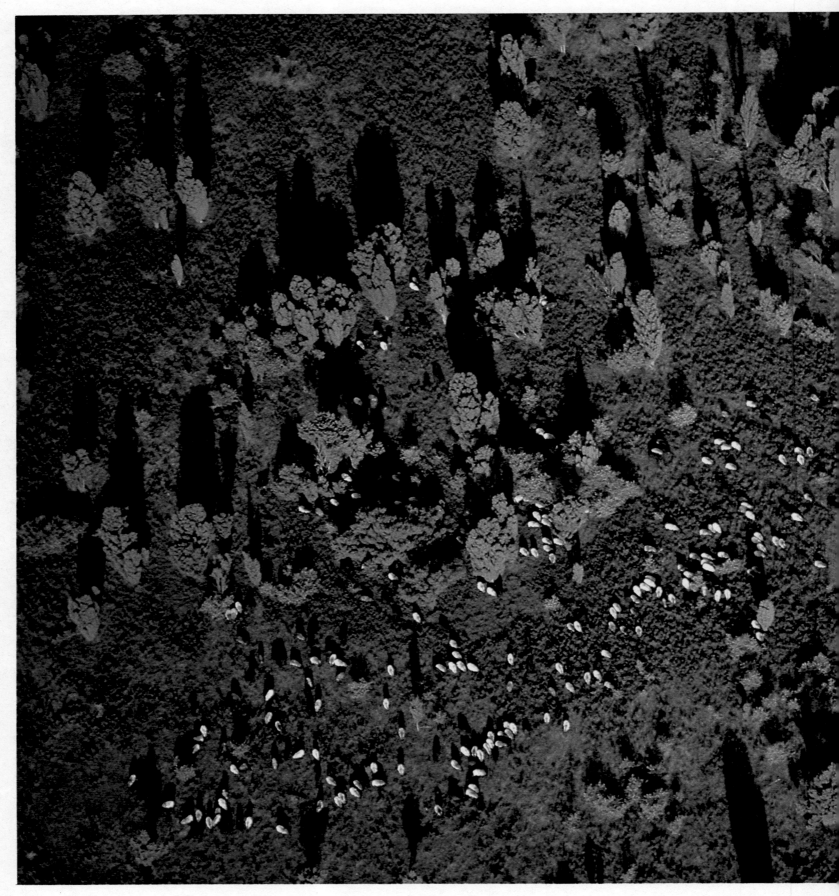

The Lüneburg Heath:
ade Wonders of Nature

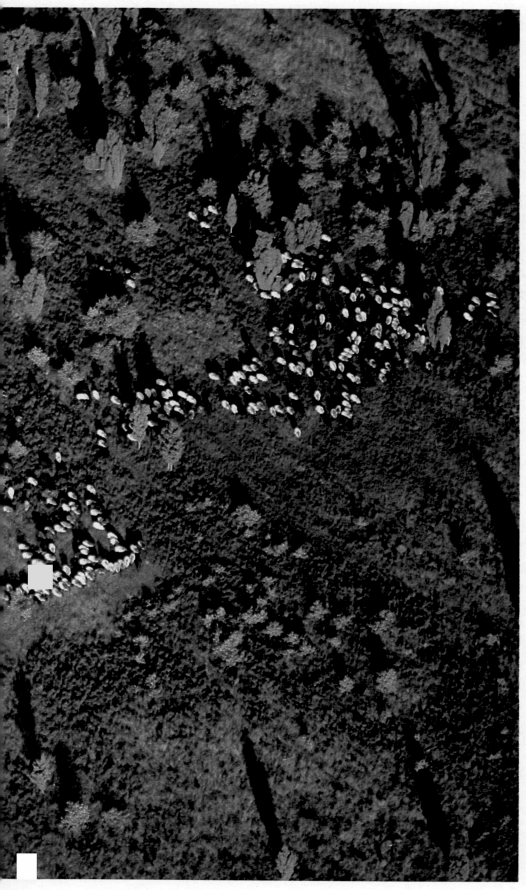

Moorland sheep keep the heath sur-face bare—sparing only the juniper.

Moorland sheep, which probably have mouflon blood, have been raised here for centuries. But as their numbers have decreased, the forest has returned. Today, the young trees are removed by men, for the few remaining herds of sheep no longer suffice to keep the pine forest away from this rose-red land that once stretched from Ham-burg to Hanover.

The heath landscapes in northern and southern Germany are unique in Europe. They are man-made—handcrafted nature, so to speak—in cleared forest territories, although the woods *are* reconquering the heath.

The word *heath* refers to uncultivated land. But this is inaccurate in regard to the German heath areas, which cover almost one tenth of the Federal Republic of Germany. Many centuries ago, there was no heath. Instead, these areas were filled with extensive oak forests. When the trees were chopped down for mining and ship-building, the surface of the land was soon covered with a rosy carpet of heather.

Precisely speaking, this heath plant is a lignified, winter-hardy dwarf shrub called the *Calluna* (beauty), also known as heath, ling, or besom. One of the more celebrated heathers is the bell heather. With its flesh-red umbels, it is far rarer and grows only on marshy soil on the outskirts of the heath.

The *Calluna*, which grows only in very barren soil that is almost useless for farming, can reach a height of three feet. In the southern German heathlands, the spring heather predominates. Its dark-red anthers adorn the flesh-red clusters of blossoms.

Other typical heath plants are: the crowberries with their many-colored blossoms and their supposedly intoxicating black fruits; the spicily aromatic cankerroot; and the andromeda, which, like the bell heather, loves dampness and which is also called wild rosemary.

Moorland sheep and human beings have to restrict the trees; otherwise the heath will become a forest.

The juniper bushes with their small, sharp needles and bluish green berries stand in the pink violet heath like ghosts in dark green loden cloaks. They grow extremely slowly, and many of the large shrub columns are hundreds of years old.

Juniper bushes are as intrinsic a part of the heathland scene as the silver (or white) birches, which, along with pines, are the typical tree species in heaths and moors. Vast areas are also covered by the aromatic gale, near to which one finds the moorberry. The fruit of the moorberry looks similar to the heath

The crane still nests in secret places in the heath and on the moor.

These birds, which are four feet tall, have a graceful, dignified walk. Often, they leap straight up and bow playfully. They also run around with outspread wings, whirl in circles as they fly, and blast their trumpet whoops across the moor. Even their fights are elegant and graceful.

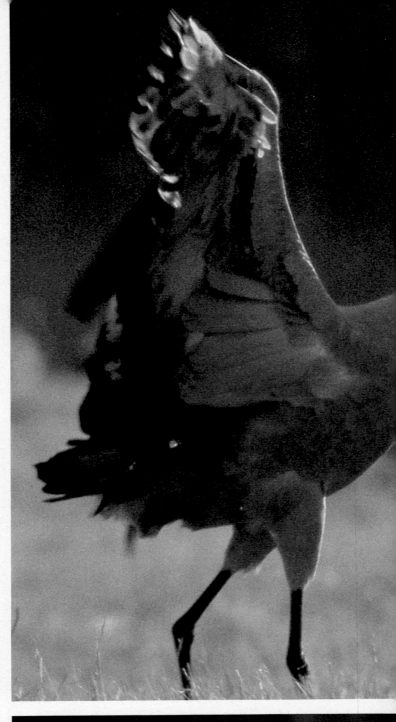

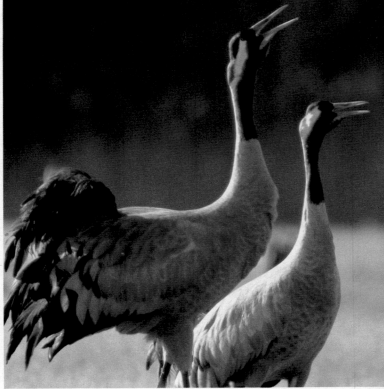

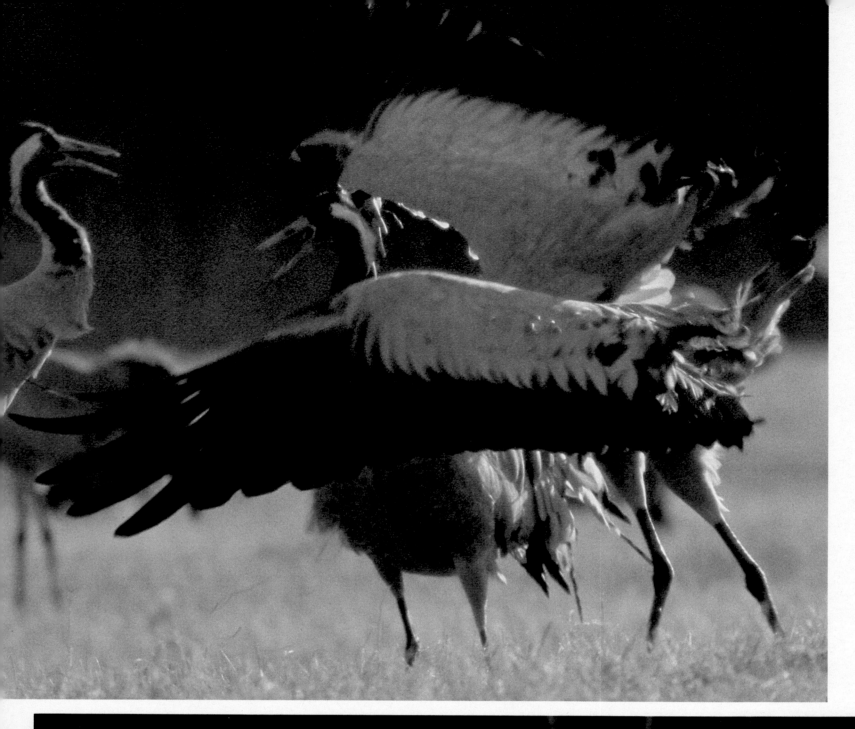

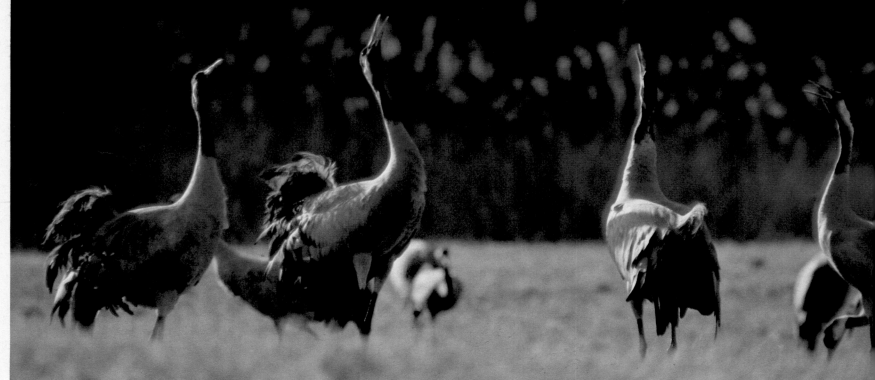

berry; on the inside, however, it is greeenish rather than purple. The fiery red cranberry and the burgundy red bogberry (on swampy peat bog grass) are other offerings of the heath.

The heath would become forest again were it not prevented from doing so. For instance, German farmers keep moorland sheep, for which the sprouts of the deciduous and coniferous woods are a delicacy. They eat the heath surfaces bare, leaving only the slow-growing juniper.

However, the stock of moorland sheep has been shrinking. In 1861, 770,000 of these sheep grazed in the heathland; today only 10,000 remain. The forest is creeping back, and human beings have to pitch in to keep the trees under control. Nevertheless, vast reaches of heath areas have become forests again. Once, the Lüneburg Heath stretched all the way from Hamburg to the gates of Hanover.

The situation is similar in the southern German steppe heaths, for instance in the Nature Park of Altmühltal. In the 1950s, when the pastureland on the Jura slopes receded, pines and beeches took over. Within fifty or a hundred years, on the slopes around Eichstätt and Solnhofen, a dense forest could be standing where today countless pasqueflowers with their lilac-colored blossoms render the countryside so enchanting in spring. The area is regularly "thinned out" to prevent the development of a forest. Together with methodical grazing—which depends on rainfall—this maintains the character of the heath.

A ghost in the heath—the nightjar. Whistling, whiplashing, humming, and cracking, it goes hunting for insects.

The wildlife in the heaths and moors is especially charming. Rabbits and foxes love the warm sandy soil. At the beginning of the century, the crane's mating dances and shattering trumpet calls enlivened the isolation of this countryside.

Once, the indigenous large glossy ibis raised its offspring on the largely untouched moors; today, the long-legged mascot of Lufthansa has vanished, but for meager remnants. The black grouse has also had a hard time of it. However, in April, if ber-

ries are available, one can hear the hissing and cooing of the blue black males with the bright red roses over their eyes, indicating that they are in full rut. By reforesting the heath areas, making them arable, and draining them, man has greatly reduced the stock of black grouse.

On some summer nights, the heathland may seem haunted to the inexperienced visitor. All at once, there will be shrill whistles and cracking whips, then bizarre sounds like the hum of a sewing machine. A simply endless "errrr—errrrrr" wafts across the heathland in the light of the full moon. While some people might regard this as a grisly ghost concert, it is actually part of the amorous game of the nightjar, which whirls through the air with clapping wings, then comes to a hovering halt, and finally, like a dry leaf, reels as it glides silently into the heather.

The nightjar, which is the size of a

Tiny creatures and aggressive creatures enliven the scenery of this vast domain.

Funny long-tailed titmice (*below*), aggressive pheasant hens (*far right*), and royal roebucks (*right*) can be sighted by the observant wanderer at every step of the way.

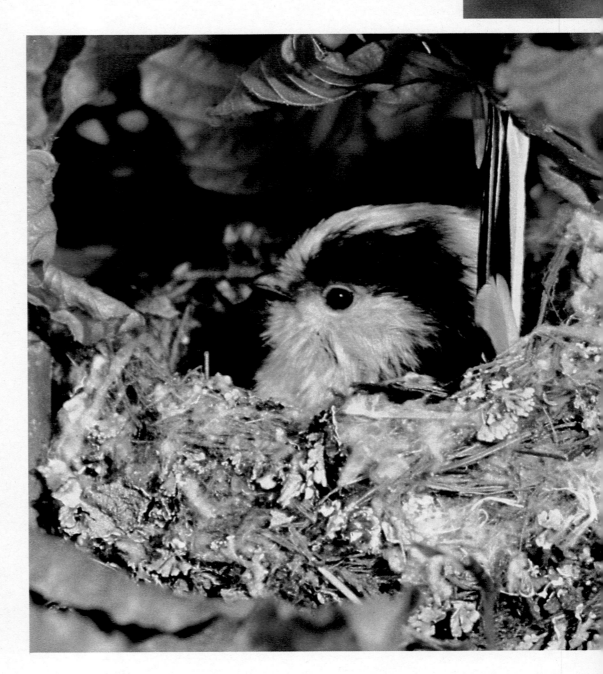

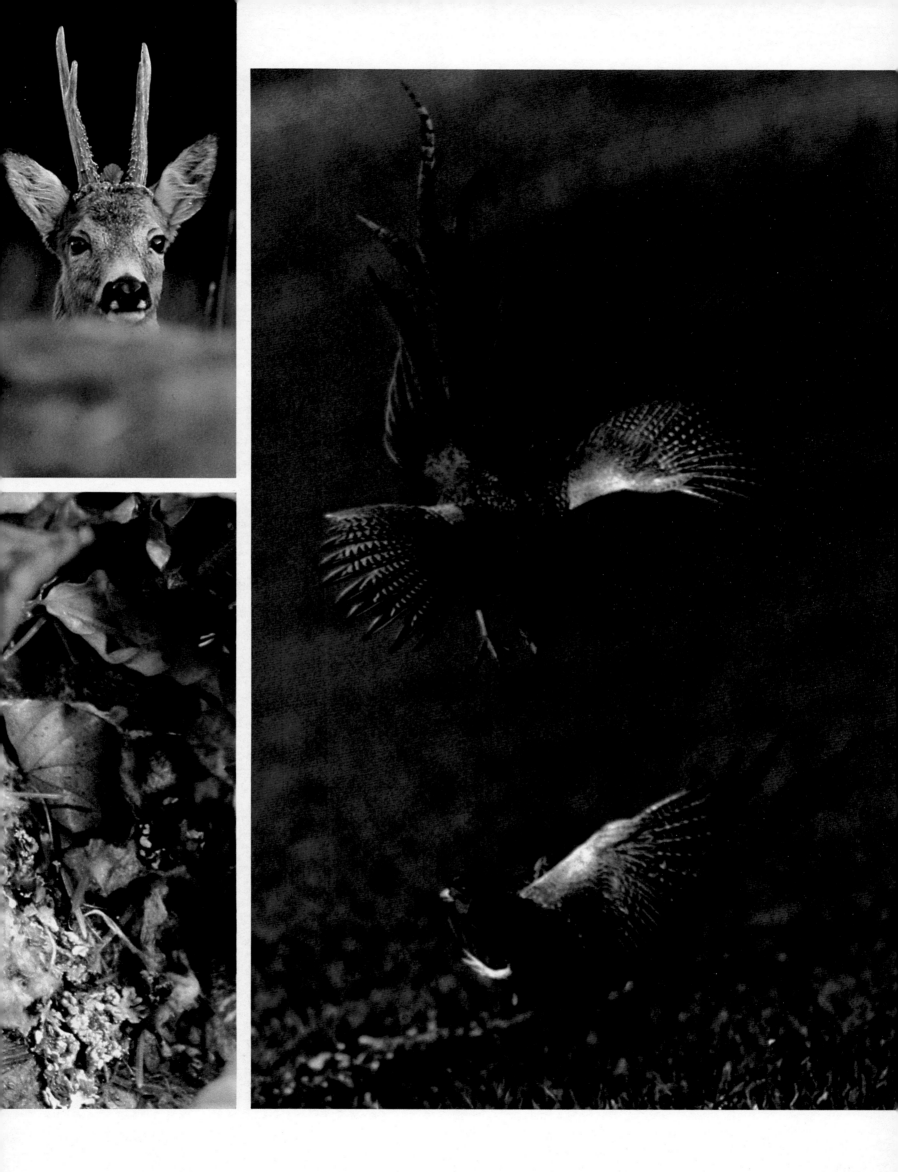

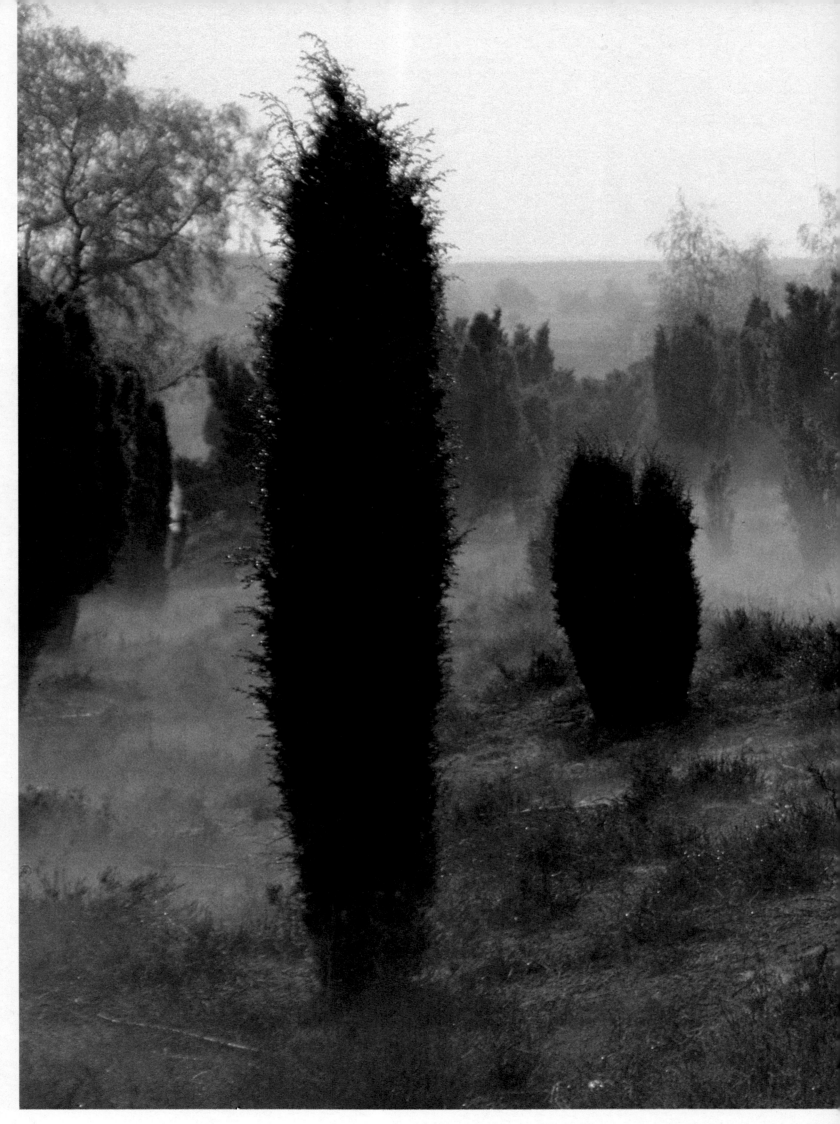

The heath—a natural wonder created by human beings

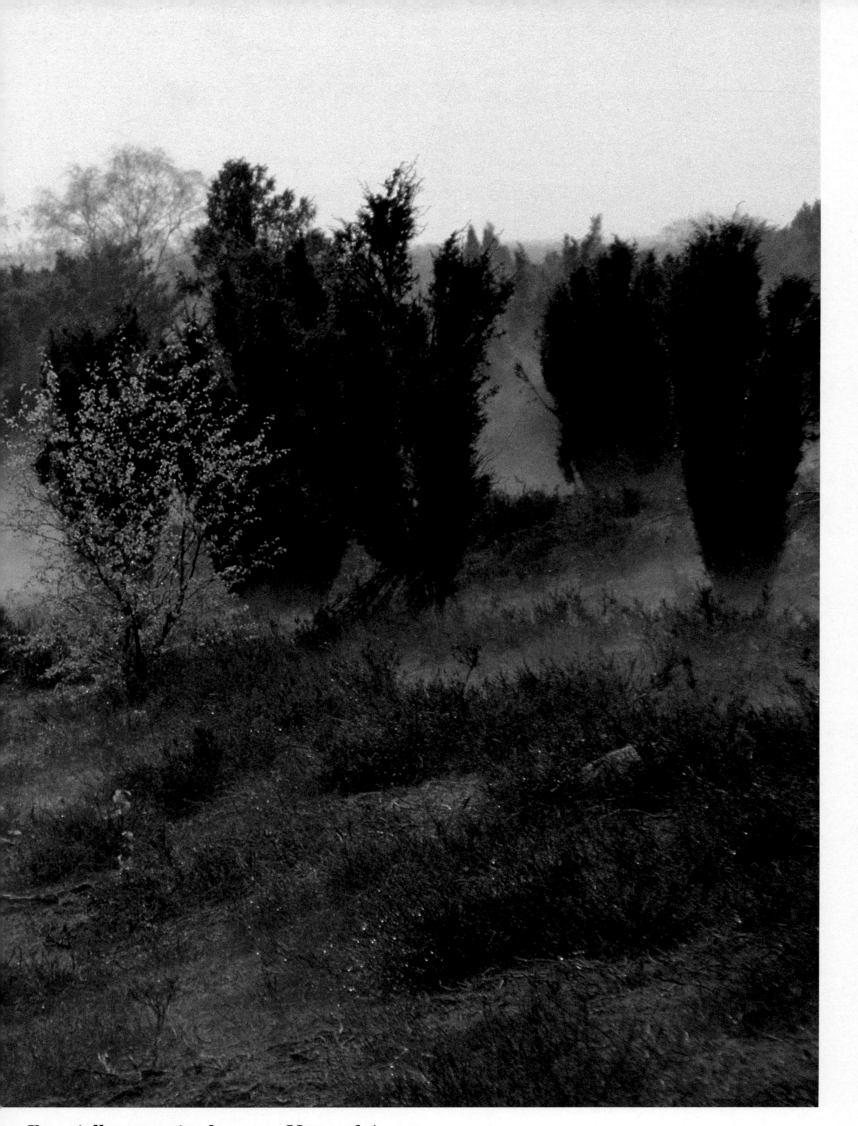

**Especially attractive between May and August,
the landscape of the heath is transformed into a sea of red blossoms.**

Plantlife of the heath and the moor

The horse willow (*left*) is said to have a healing property. Its gigantic forebears once grew in the hard-coal forests. The blue-black berries of the juniper (*right*) are highly appreciated as a spice. The greatly enlarged "tentacles" of the insect-eating sundew (*below right*) are deceptive signals for flies, small bugs, and other hexapods.

thrush, has soft, bark-colored plumage, like an owl. It is as harmless as any other bird; although it is also known as a goatsucker, in fact, it does not do this. It is likely that legend has ascribed this feat to it because it whirrs around grazing animals at night in order to catch insects in their vicinity.

If the weather is cool and rainy, so that only a few insects are flying about, the nightjar and its offspring fast. This might go on for several days and nights, and it is the reason why these birds fall into "a hunger sleep," something highly unusual in the animal kingdom. The nightjar is seized by a bizarre physical rigidity and awakens only when the weather conditions make it possible for the nightjar to resume its insect hunt.

Vast swamps and sloughs enclose the Lüneburg Heath. The landscape radiates peace and quiet, and a sort of melancholy. Only on lukewarm spring evenings does the solitude resound with a thousand-voiced bird choir. With coos and clucks, the

bleaters (becassines) soar over shiny white pubescent birches. Meadow pipits and larks "hang" in the sky and sing. A flock of wild ducks "jingles" past and plunges into a grove

Hunger forces sleep, which saves the nightjar's energy and allows it to wait for better times.

of reeds, where reed warblers are concertizing with a vengeance: moody swamp and water songs reminiscent of the sloughing and swishing of reed banks, the croaking of frogs, the grating of moorhens. With a loud "kiwit-kiwit," a couple of peewits reel over the wet meadows. As the deep groan of a bittern mixes with the gurgle of a short-eared owl, the trumpeting "grooh-grooh" of flying cranes comes from the distance. The hissing and rolling of mating black grouse, the sighing and

Colorful butterflies flitting across the springtime meadow

Orange tips are lured by the sweet nectar of the delicate meadow cress.

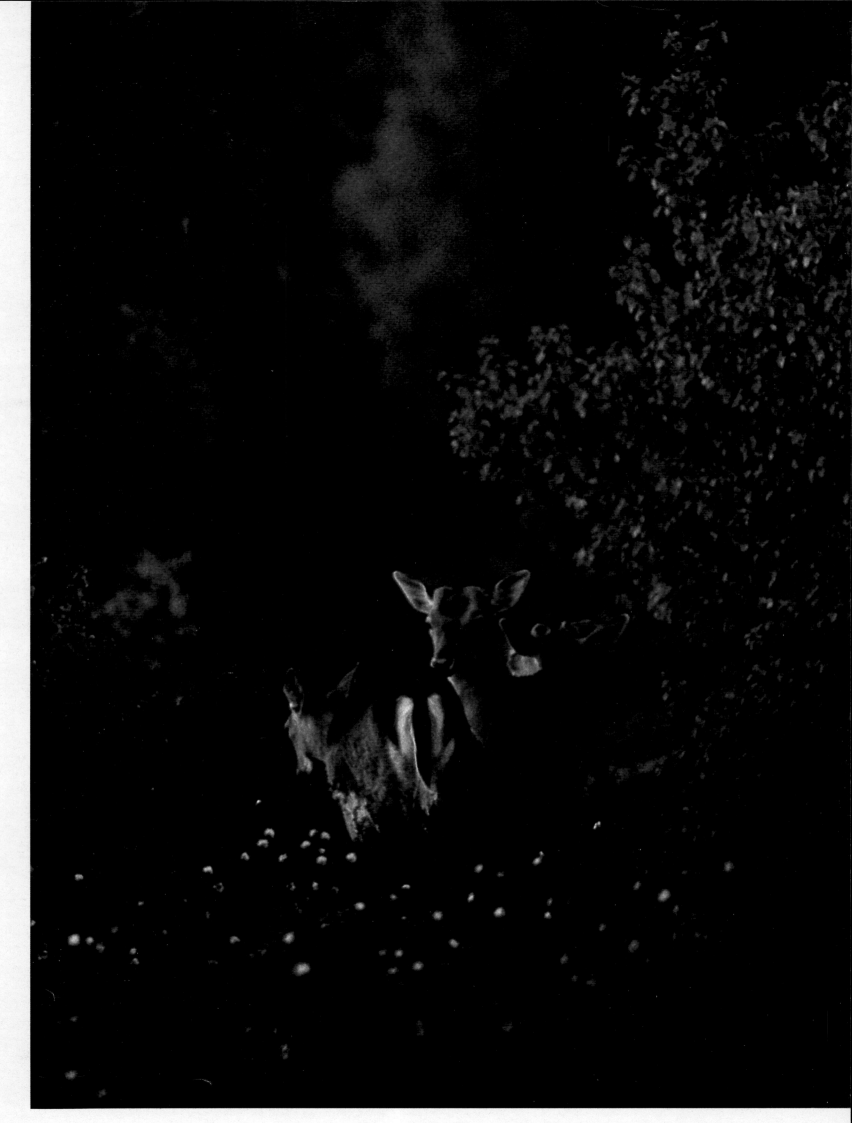

There is rich grazing for the game in the mixed forest.

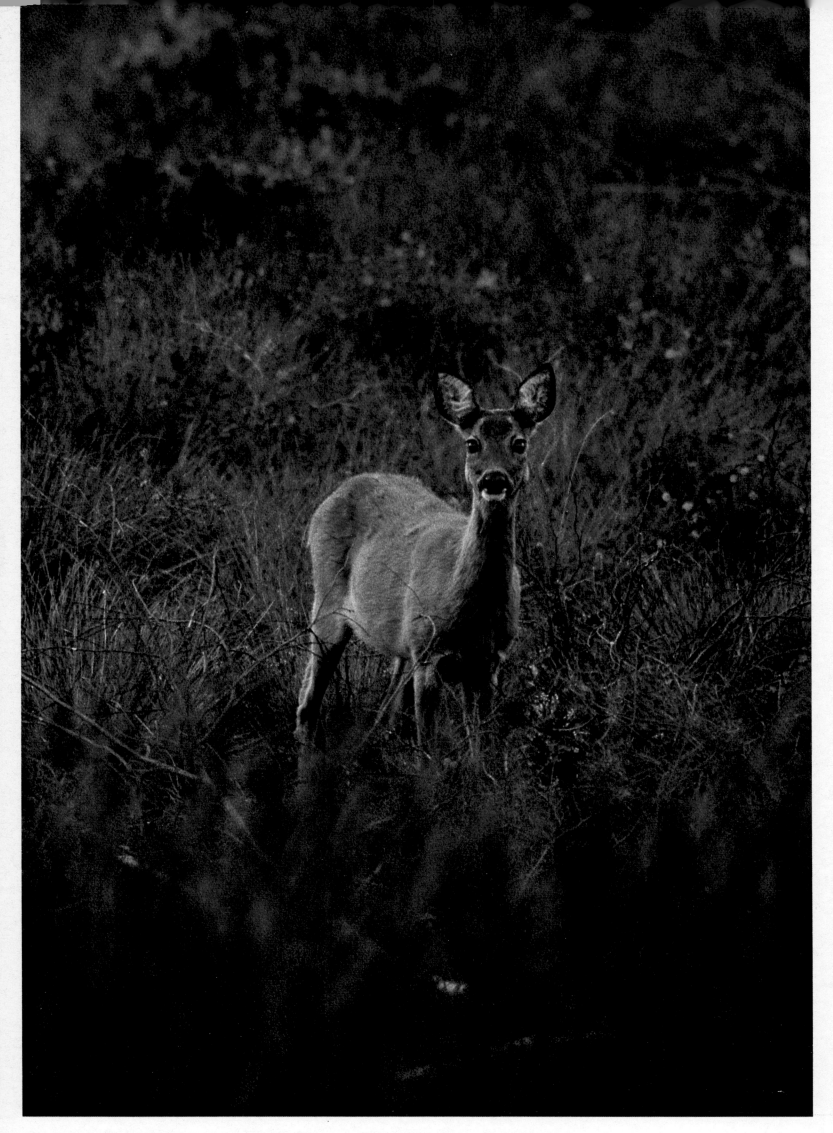

Roe deer and fallow deer (*left*) live well in this quiet landscape.

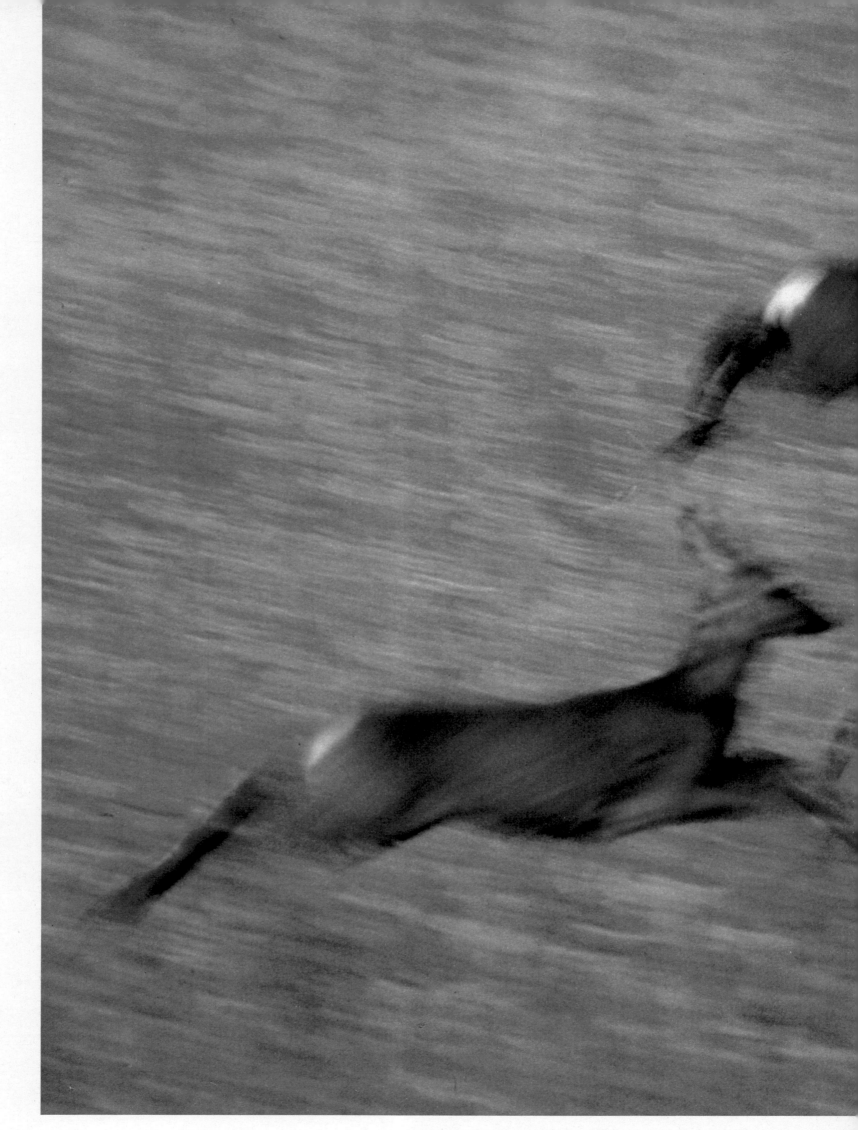

Not abstract painting but modern nature photography

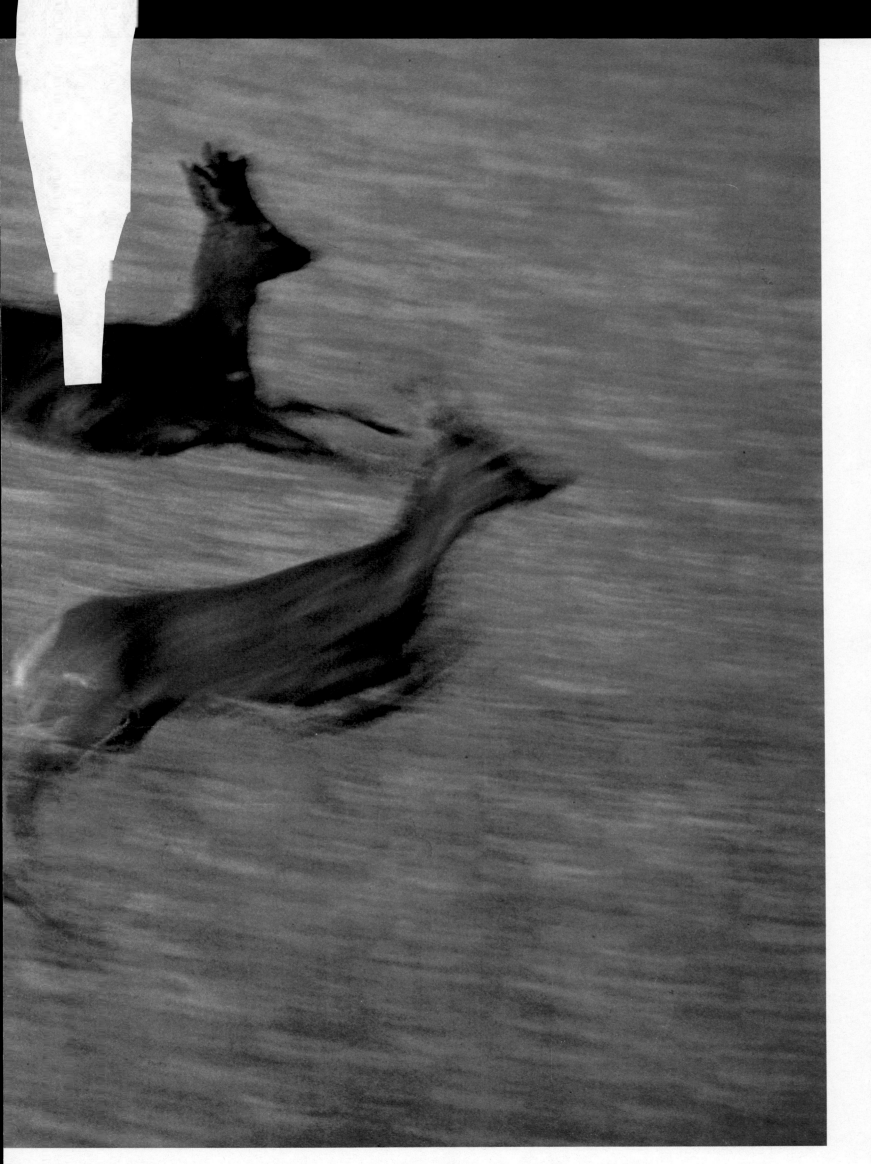

Fleeing deer can reach a speed of more than thirty-five miles an hour.

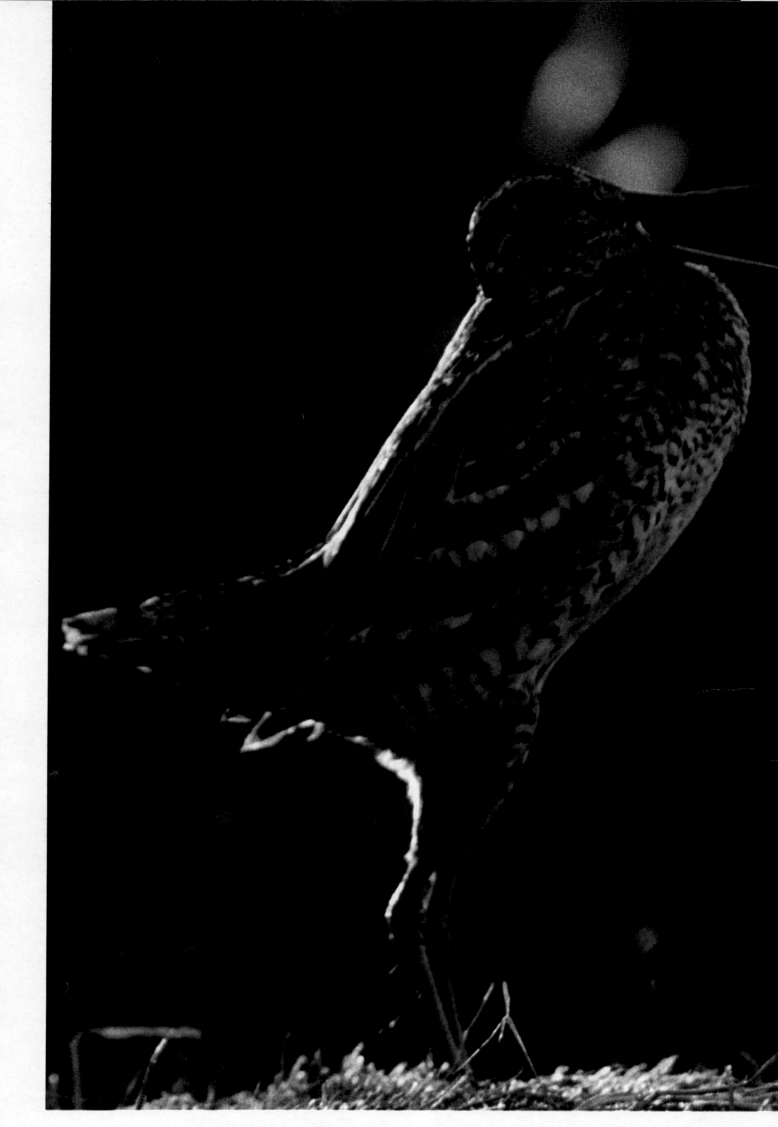

Tiny birds puff themselves up—spring mating in the moor and on the

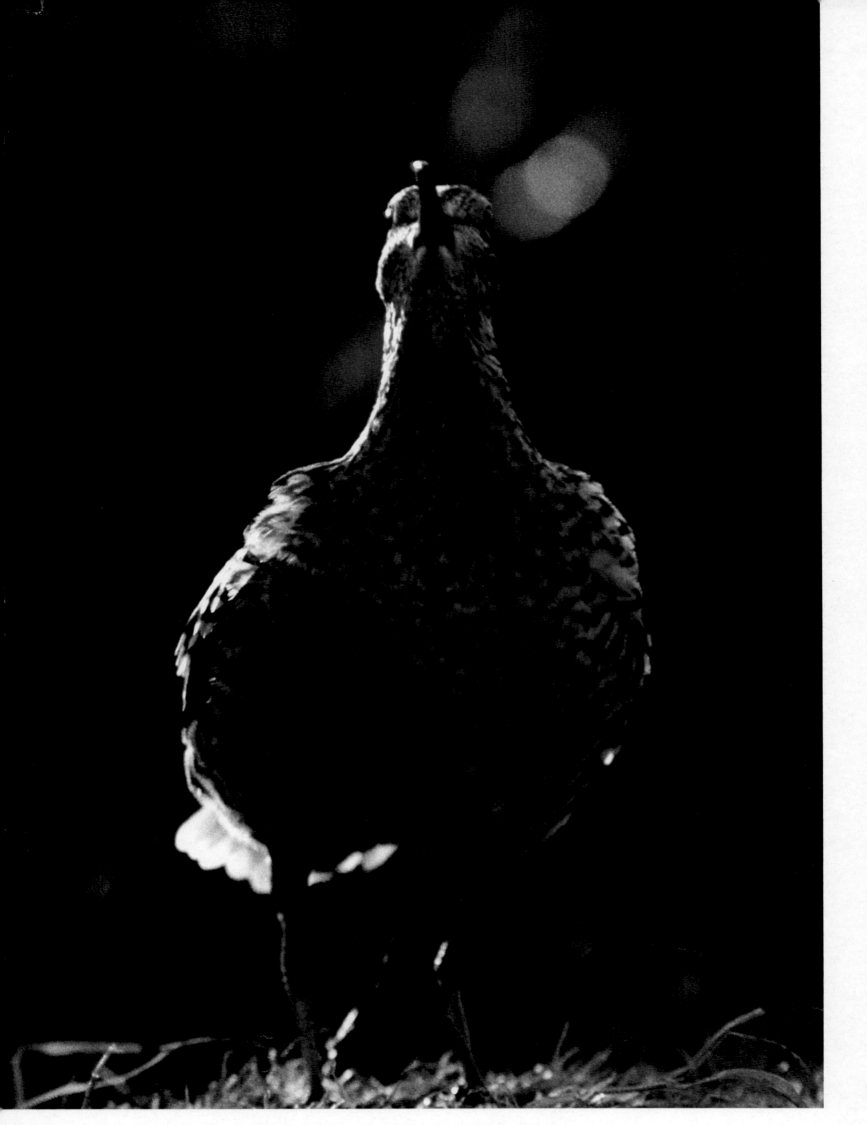

When the winter is past, the love games of the snipe begin.

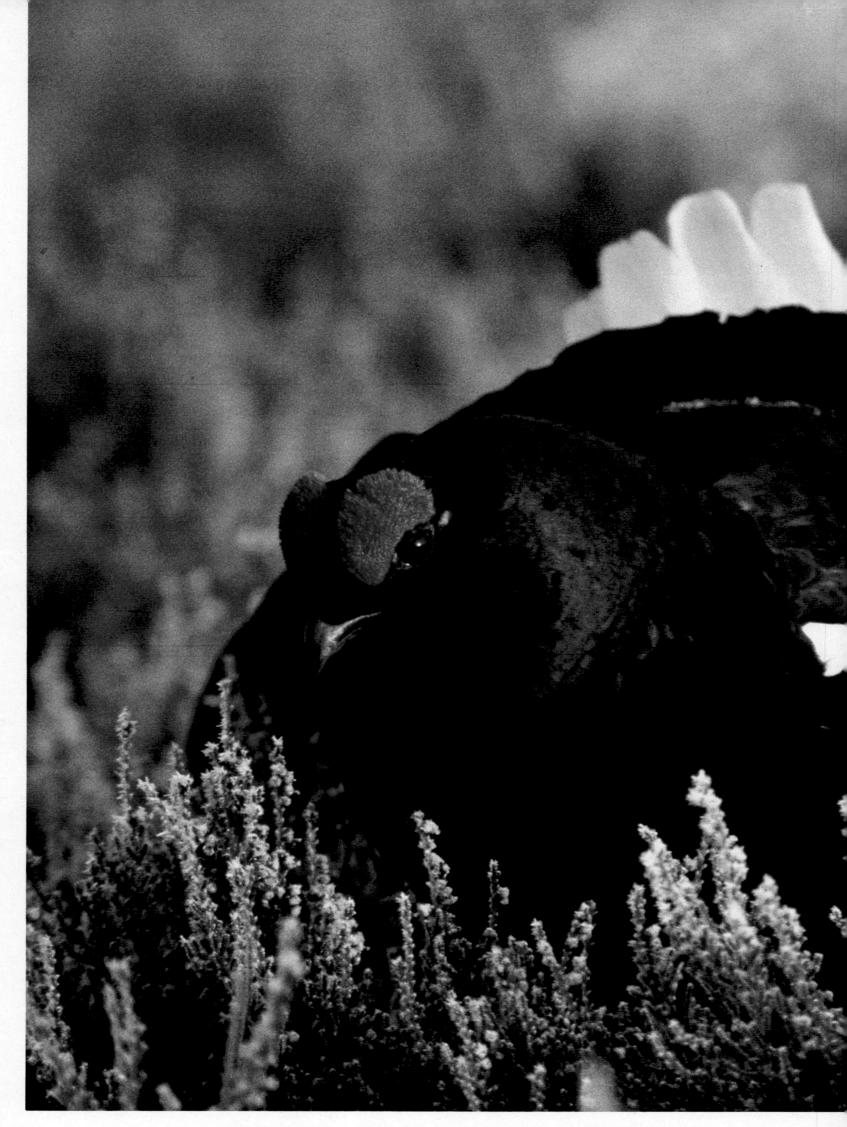

The spectacle of the black cock's mating game is getting rarer and rarer.

With stiffened feathers, drooping wings, and an upright tail, the black cock woos a female.

hooting of a tawny owl, the crowing of moorhens having a fight, and the even hum of a nightjar make a strange melody.

This acoustic spectacle of nature would be incomplete, however, without the ghostly trill of the curlew. Anyone who has heard the melancholy duet of the curlew and the

The moor is a concert hall; birds and frogs form an orchestra. A symphony is croaked, hummed, and blubbered.

golden plover blending with the song of the moor into a poignant symphony knows how impoverished this landscape would be if this unique bird were to vanish.

The steady shrinking of the moors and swamps is cause for concern. Of the some one hundred acres of nature that are taken over and developed every day in West Germany, the moist areas with their many species of birds form a considerable

Game reconnoitering early in the morning.

When dew soaks the plant wilderness, the deer leaves its hiding-place early (*left*). The rabbit also dries its fur in the first rays of the sun (*below*).

portion. The "useless" moor is drained, plowed, and farmed. It is no wonder, then, that practically all the heath inhabitants are in great jeopardy. The catastrophic forest fire in Lower Saxony during the summer of 1975 was the terrible result of draining and reforesting huge areas of the moor. The dessicated moor supplied so much fuel for the conflagration that human beings, with all their technological achievements, were barely able to prevent the worst.

However, if we want to preserve the moor fauna, then we should not just protect these last remaining habitats but also undertake renaturalization. The growth of bushes and woods must be reversed by extracting, careful burning, mowing, or by reintroducing pastureland. After that, the drainage ditches must be filled to prevent the rainwater from flowing away. Such measures have been carried out in the moors of Lower Saxony and have thus saved the stock of golden plover. Black grouse, redshanks, greenwings, garganeys, and black-tailed godwits have also increased in number.

We can scarcely reverse the process of destruction caused by draining and peat extraction in the northern German lowlands, where so much natural landscape has been wiped out in the name of farmland or fuel. Nevertheless, ecology organizations are leaving no stone unturned in order to restore the precious habitats. For example, they are now putting old peat cuttings under water. In many places, cotton grass is thriving again, and red cranberries

Drainage ditches are killing the moors. Only water can save the last habitats, and there is still time.

and blue-frosted bog bilberries are bearing fruit. Curlews and golden plovers have returned, and a few species of falconiformes are reappearing. The rare hen harrier and Montagu's harrier flit over meadows and heaths, and the short-eared owl, which likewise loves moors, marshes, and wet meadows, can be observed at its mating game in broad daylight.

Another remarkable plant of the moors is the indigenous "insect eater." Since swamp plants suffer when protein and nitrogen are in short supply, some of them procure animal protein. These plants be-

come meat-eaters, setting traps, catching all species of insects—from flies to dragonflies, from mosquito larvae to water fleas. Throughout the world, especially in the tropics, there are some four hundred fifty species of carnivorous plants. In Europe, their best-known representative is the round-leafed sundew. However, if you want to observe its seemingly cruel activities, you've got to kneel on the less than firm

The sundew: for flies, death comes as a glittering pearl. And the fly? Minerals and nitrogen for a hungry plant.

ground! Bedded deep in the peat moss, an approximately six-inch scape rises out of the wreath of leaves. The scape opens its tiny asters only in the blazing midday sun. But far more interesting than the unassuming blossoms are the cunning "murder tools." These are the extraordinary leaves of the plant, which have countless maroon gland-bearing hairs on their surfaces and edges. The tapering tips of these hairs have bright-red, flasklike bulges. Each bulge is surrounded by a drop of sticky, crystal-clear liquid, so that every leaf looks as if it were crowned with countless dewdrops sparkling in the sun. If an insect is inveigled by this sight and tries to sip this tantalizing glittery liquid, it will seldom manage to escape.

The victim on the sundew is treated somewhat like a fly on fly-paper. The more it moves, the more it sticks. The gland-bearing hairs bend toward the center of the leaf and draw the insect down to the bottom. The surrounding hairs support this entrapment until the prey has drowned in the droplets. Next, the edges of the leaf curve, taking on the shape of a hollow hand. The viscous liquid disintegrates the insect. Within a few days, it is completely digested, aside from minor remnants of chitin. Proteins from the victim's body are, so to speak, vitamins in the food economy of the sundew. A meat-eating plant can certainly exist without this additional nourishment, but experiments have shown that it grows quicker and has stronger blossoms if it is able to get its daily ration of meat.

A ghost in the summer night?

When twilight descends and the deer (*right*) head for their grazing sites, bizarre whistles and whip-cracks resound across the heath. Next some strange noises, like the hum of a sewing machine. It all sounds like a grisly ghost concert, but it is only part of the mating game of the nightjar (*left*).

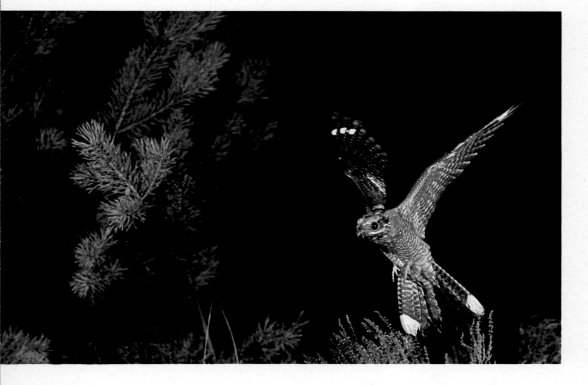

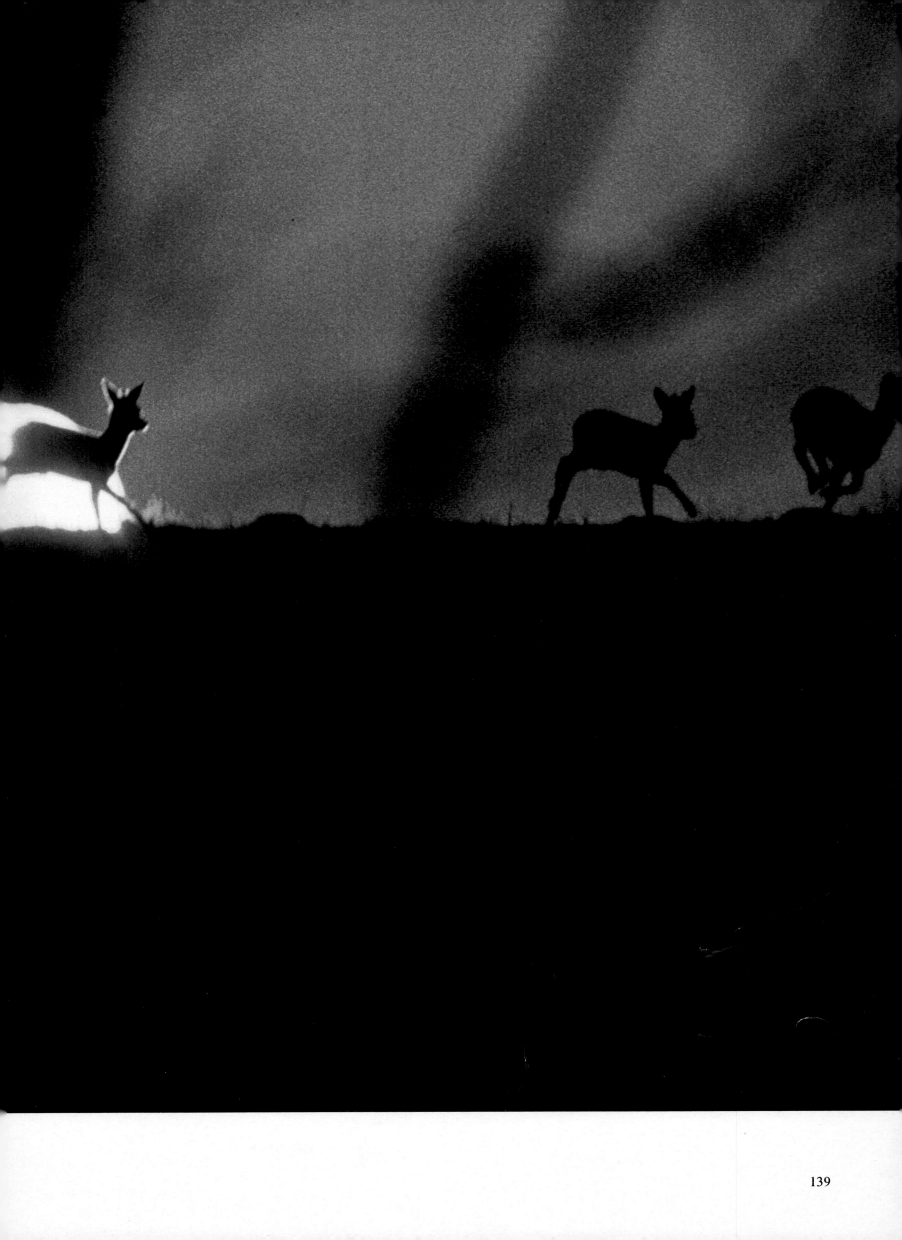

*In places where the bittern and the heron,
the ruff and the great crested grebe set the style,
nature becomes an adventure.*

Divers and Dancers in
and's Water Wilderness

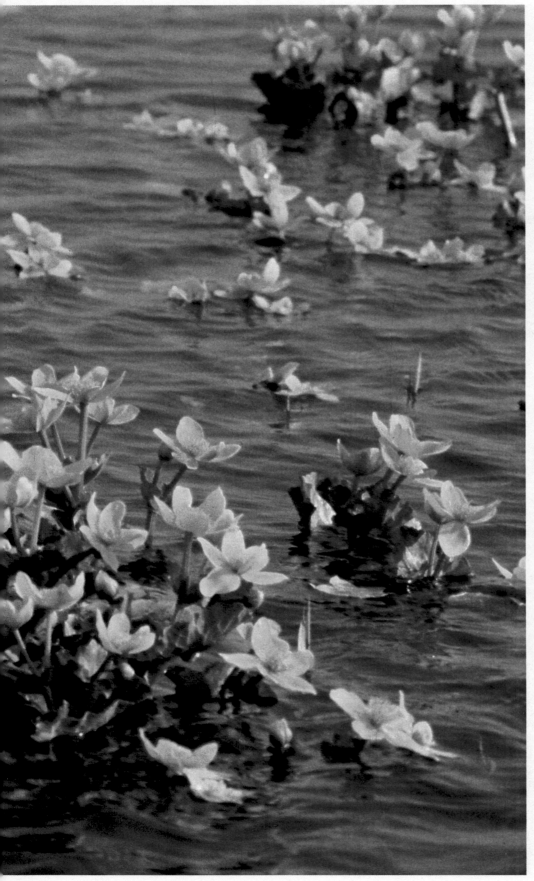

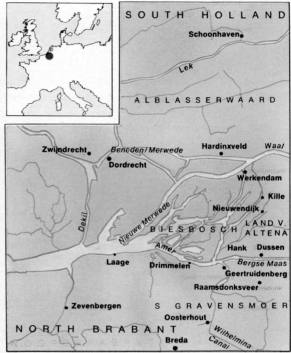

*Nature reveals her
beauty ideal even in
small things.*

**The magnificent
blossoms of the cow-
slip proliferate like
shiny gold buttons in
the sumptuous water
wilderness—an ideal
habitat for well-
known and lesser
known waterfowl.**

The Rhine is the largest river in Europe. In the north, where it surges toward the ocean, and hundreds of large and small branches ramify in all directions, the dim waters of the Rhine and the Meuse come together. Here lies the reed and swamp landscape of Biesbosch, Holland's important preserve for plants, water fowl, and reed creatures.

This sea of reeds has been taboo to human beings for a long time now. People can travel here only in boats. For most of the year, however, the Biesbosch is left to the birds, frogs, and fish. There were times when the countryside was afflicted by devastating floods from the nearby North Sea, but today, huge closure embankments along the coast shield the river landscape against high floods, and Holland is no longer in danger. The North Sea continues to ebb and flow.

However, without the effect of tides, the labyrinth of waterways is only a paradise in part. The alternation of wet and dry once brought a versatile range of life to the reeds. When the mud flats were dry, the tideland birds had rich nourishment. When the flood tide came, ducks, divers, and herons went hunting for food. Now, only the rivers provide sustenance. The Rhine and the Meuse leave all sorts of good and bad flotsam in the reeds. Cattails, bulrushes, reeds, and sedge, together with one-celled organisms, invertebrates, snails, and mussels, fish, reptiles, small mammals, and birds have to digest the nourishing and also poisonous flotsam. In spite of all this, life here is still wonderfully varied and generally healthy. Large numbers of great crested grebes, shovelers, common herons, and kingfishers can still be found. Each of these species performs a major function in the ecology of the river landscape.

Great crested grebes hunt, fight, and flee under water—and use diving games to choose mates.

Nearly all year long, the great crested grebe remains in the Biesbosch and in the many other bodies of water without which Holland would be inconceivable. The winter, however, covers the tributaries with a layer of ice; so this bird, an excellent swimmer and even better diver, migrates south. Otherwise, the grebe remains loyal to its area. And during the mating season, it remains faithful to its mate as well.

Great crested grebes are clumsy flyers and awkward runners. When they walk on land, they waddle laboriously; their element is the water. The great crested grebe hunts fish underwater. A highly skillful hunter

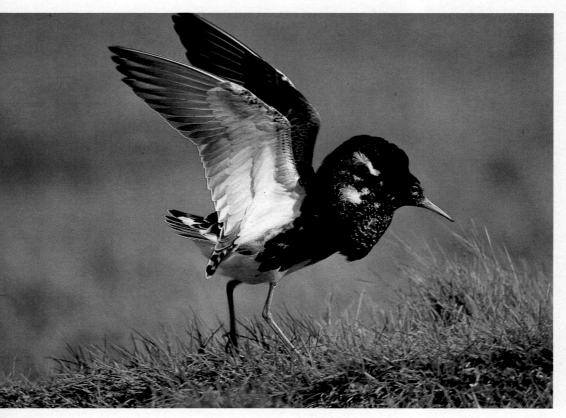

Birds that recall medieval knights.

In the spring, the ruffs play violent mating games, but never really injure one another. The females are a lot smaller and sport plain colors. They usually stand off to the side when the love-crazed males, adorned with colorful throat ruffs, fight their wild, lusty tournaments to see who is the strongest.

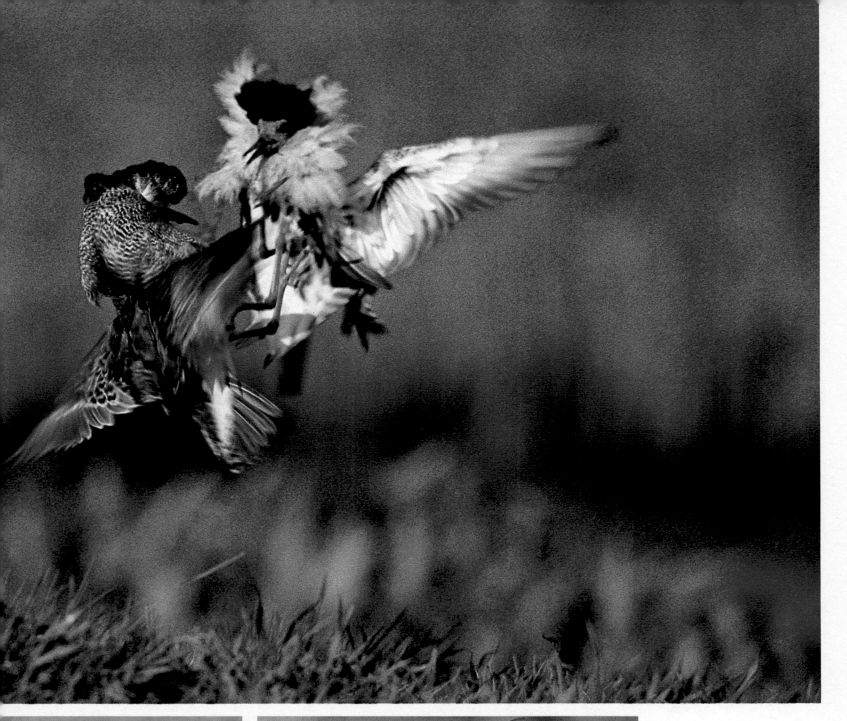

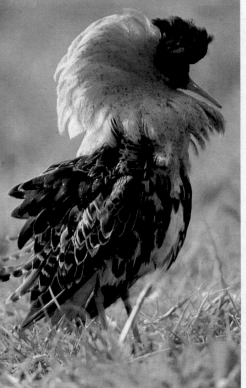

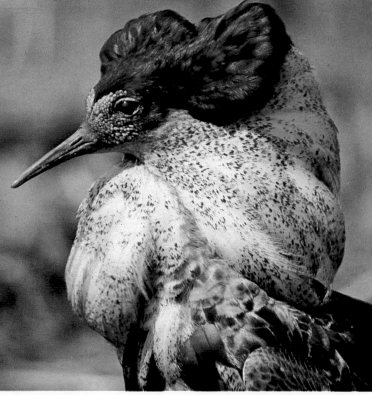

► The common heron struts on long legs through the shallow water like the bittern. It pecks quickly and sharply when it spots prey.

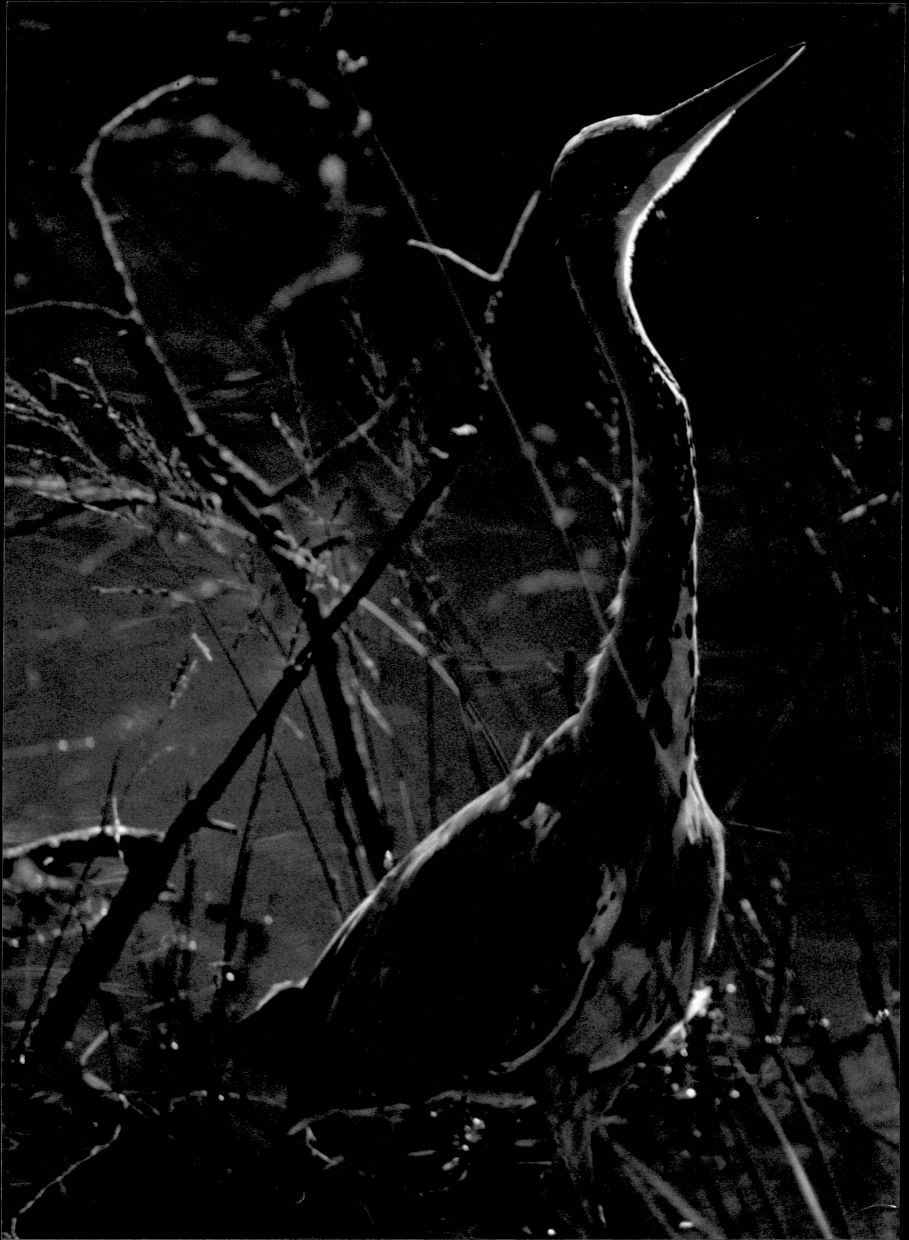

and amazingly quick, it can stay underwater for about thirty seconds. Then its head, adorned with its "orange bonnet" and ears, resurfaces so that the grebe can catch its breath and protect itself from enemies. When it dives, it can see marvelously well. Its main targets are the small fish that swim right under the surface of the water. But the grebe is also a specialist of the depths. It can comb the bottom for crabs as far down as one hundred thirty feet. It defends its territory even underwater, using its strong, sharp bill as a weapon. If the danger is too overwhelming, the grebe escapes by diving, swimming underwater, and keeping out of its pursuer's reach for minutes at a time. It also dives to find building materials for its floating nest. And finally, the grebe plays diving games to impress its mate.

The prewedding ceremony is synchronized like a minuet—albeit without music.

In the spring, the call of this swift diver resounds throughout Holland's water landscape. When these animals search for mates and woo each other, the male and the female look almost alike. Their greeting ceremony resembles the ominous shadowboxing of two male rivals. If a male encounters a female who is ready to mate, both shake their heads, vividly display their spread and erect head adornment to each other, and confront each other like aggressive fighting cocks. Standing in the water, they reveal their white bellies while turning their heads back and forth—as in an ancient dance. Then, they dive playfully into the water and resurface with engagement gifts, such as water plants. Each motion of one animal is paralleled synchronically by the other—as though the dancers were accompanied by a melody that only they could hear.

The wedding does not follow immediately, however. First a nest must be built of ooze, reeds, and water plants. And then a new ritual commences. This time, one mate shakes its head, flits across the water, and then drops into the water after a few yards. A further shake of the head means a temporary end to the scene. Next, one of the birds climbs into the nest, beckoning to the other with soft calls. But if the mate is not yet feeling very marital, it rears up in the water and bows in the di-

The nearly extinct diving bird: the cormorant

These birds, which are as large as geese, with their black-and-white faces touched with yellow and mane-like crests, usually brood in large colonies. Their raucous shrieks identify them from far away, especially at mating time.

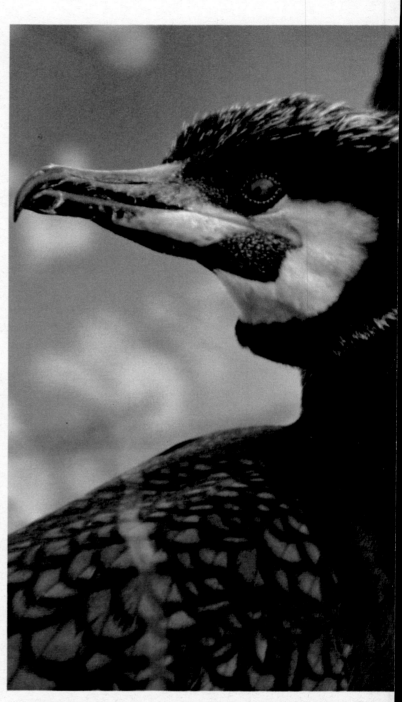

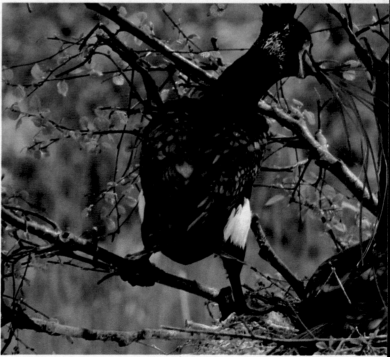

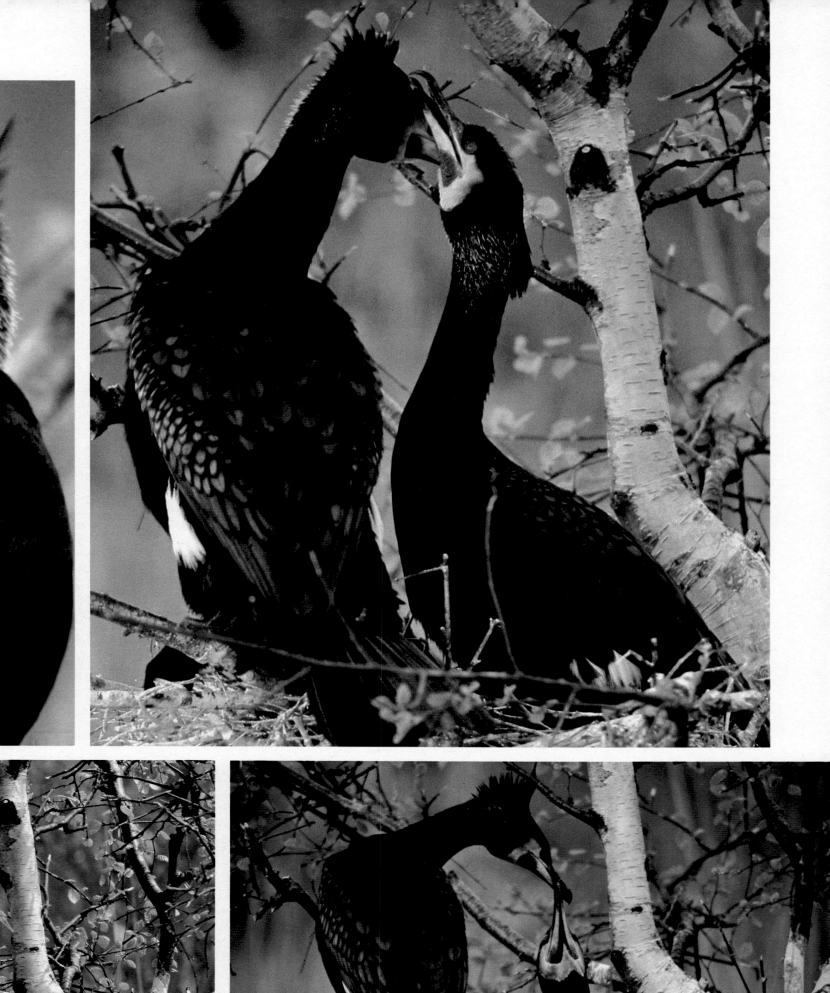

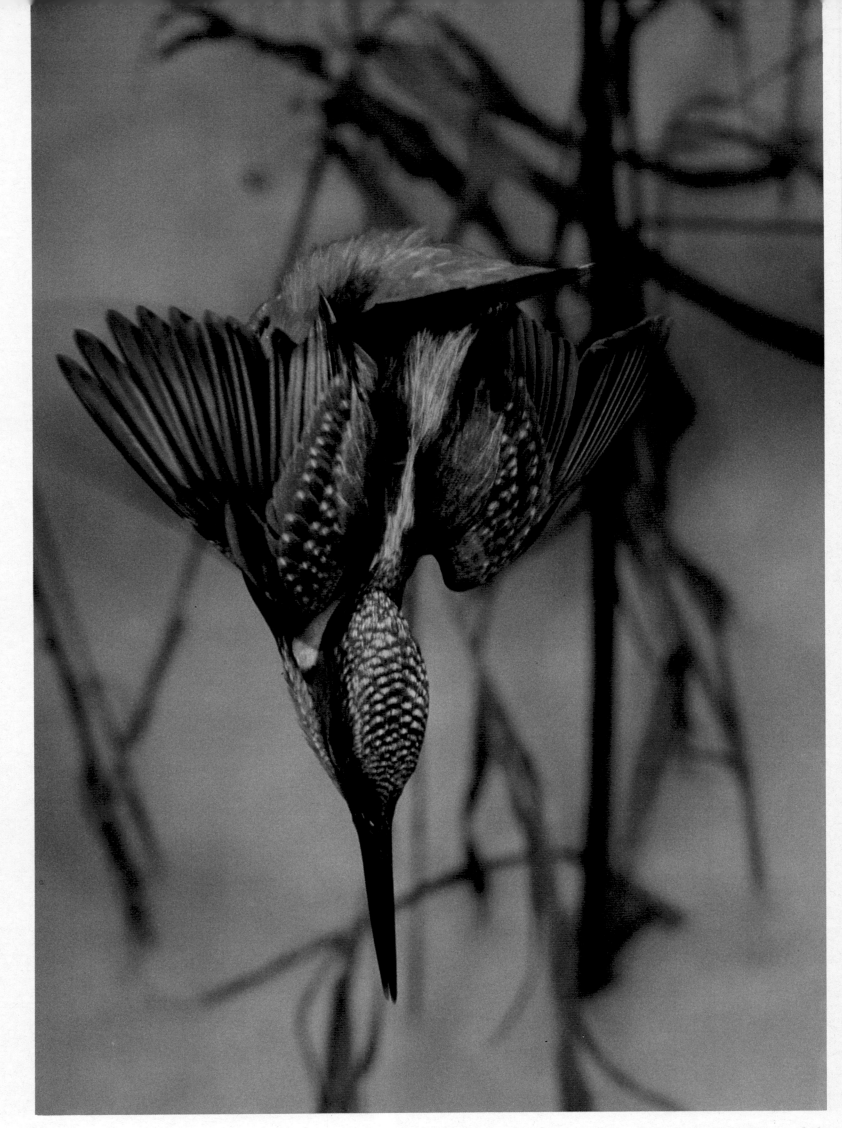

The "flying jewel" plunges straight down when it hunts fish.

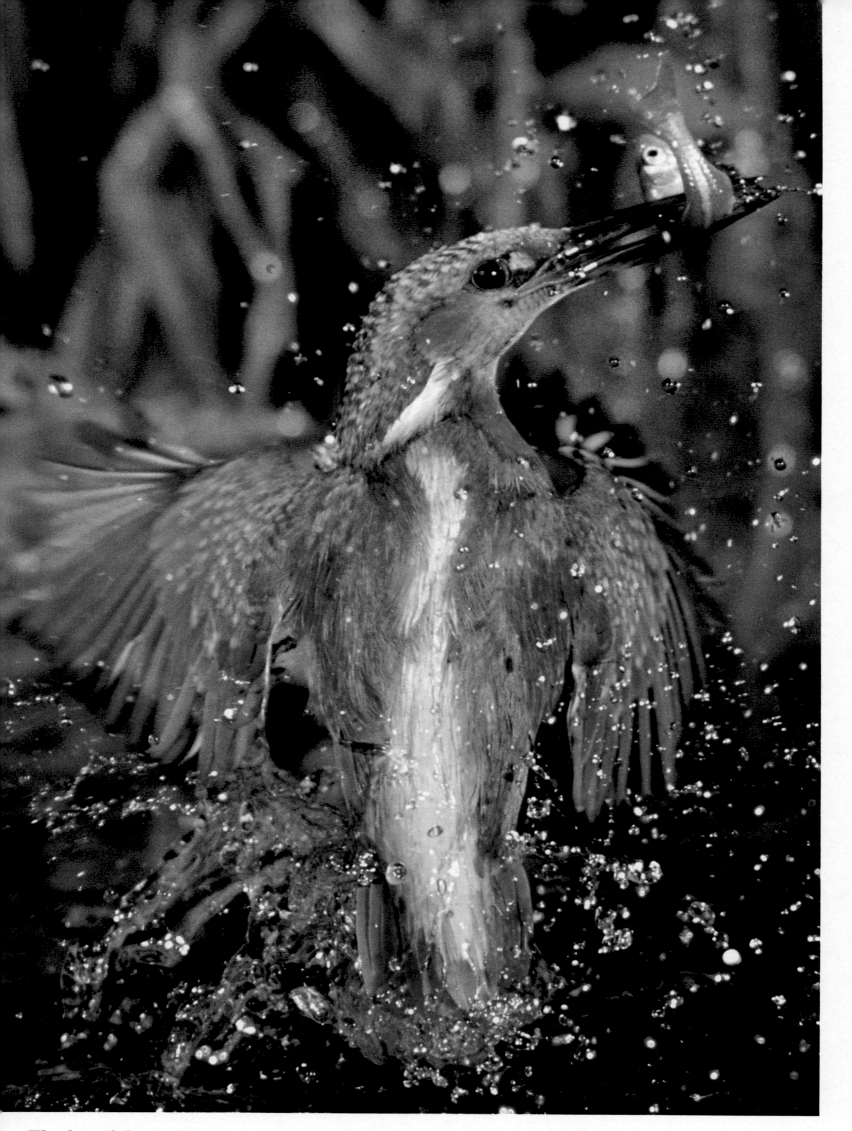

The kingfisher is known as an "ice bird" in German because of its plumage; the feathers look like shiny ice reflecting the sky.

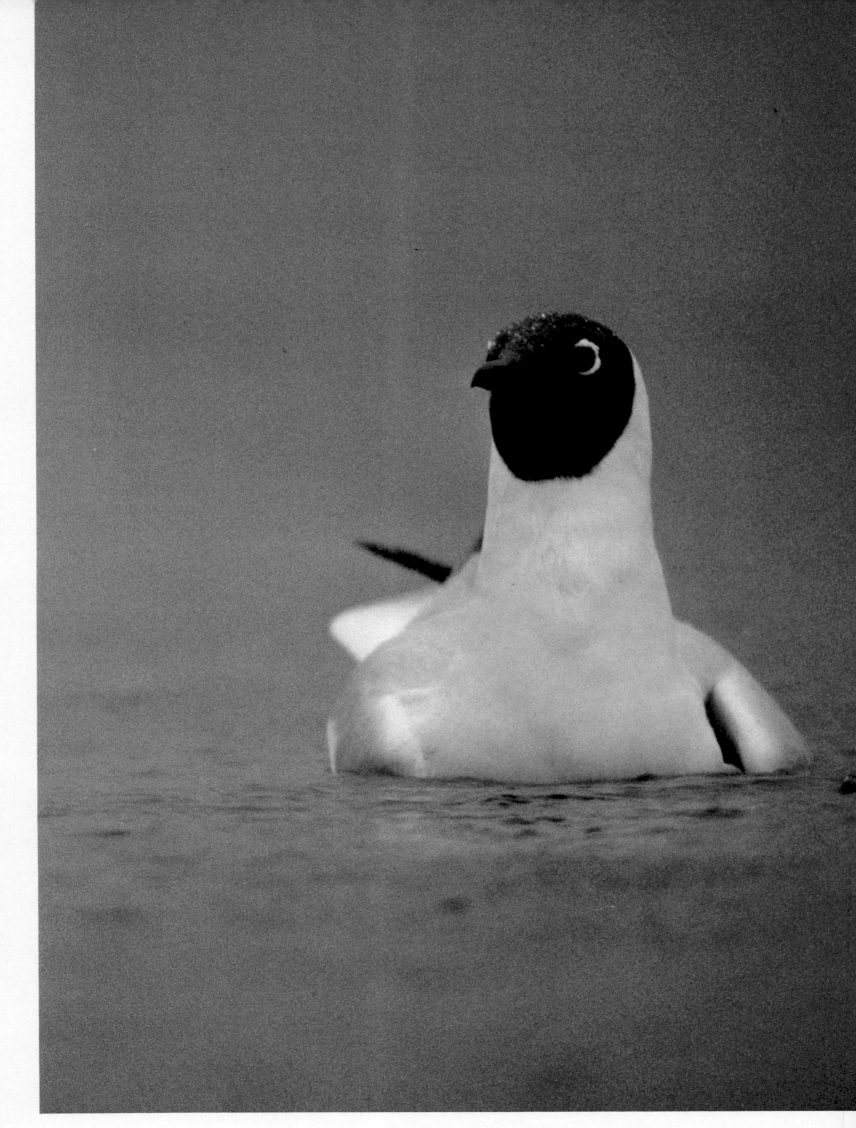

The breeding ritual of the masked bird is fixed genetically.

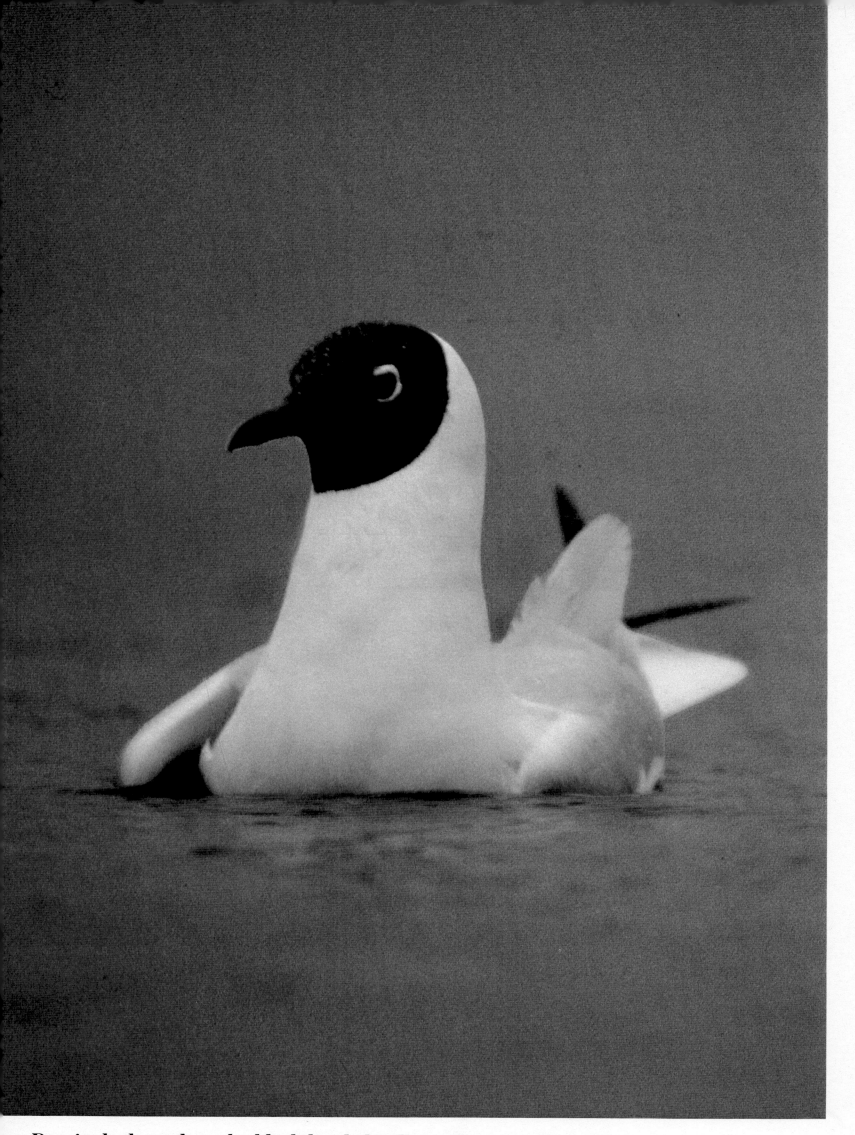

Despite bad weather, the black-headed gulls get into a mating mood and defend their territory with threatening gestures.

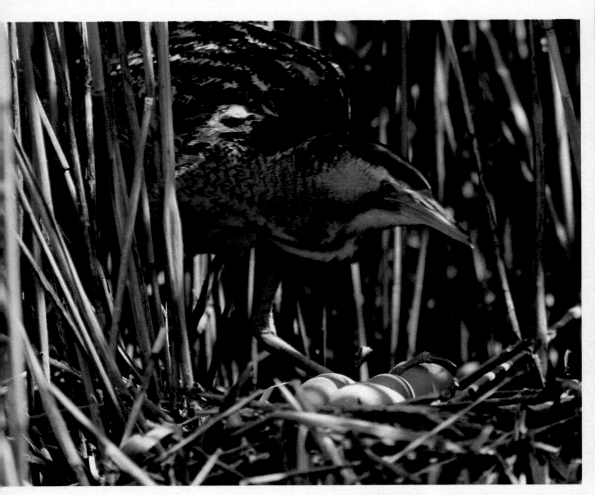

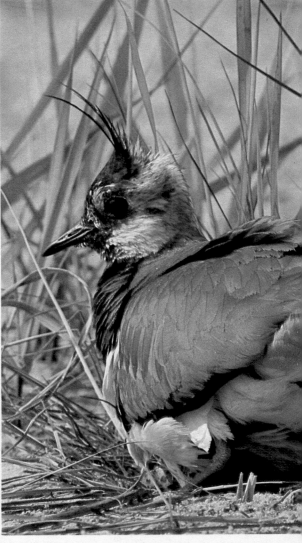

rection of the nest, indicating that the future spouse should wait. Once the bird is ready, it leaps from the water directly upon the bird sitting in the nest. After this surprise attack, the bird slips back into the water. A great crested grebe can repeat this ceremony up to forty times a day without mating. The actual mating takes place only when the ritual occurs less frequently. The brooding is shared by both the male and the female.

The frog is an amphibian jumping champion and a relic of prehistoric times.

Once the young are hatched, they leave the floating nest early to go riding on the back of either parent or to go diving. Often, however, the "submarine" loses its crew. Then the excited offspring have to wait until the parents reemerge, whereupon they climb on their parents' backs again.

Another excellent swimmer and diver lives more in the reeds than in the open water: the water frog. It lurks in the crackling, rustling reed banks, waiting to catch stragglers from the gigantic insect army that

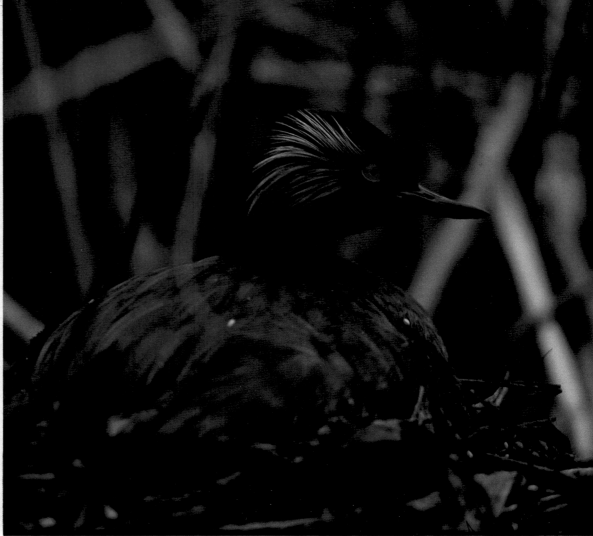

Hidden life in the stalk wilderness

Some people call the bittern a "moor ox" (*top left*) because when twilight sets in, the bittern stakes off its territory with a deep, almost lowing sound. The other birds emit squeals or groans—dull, shrill, but seldom harmonious. These birds also take care of their young in the reeds: the coot (*left*) the eared grebe (*top right*), and the peevit (*top center*).

swarms across the swamp landscape. Only the frog's huge gaping eyes loom above the water. If a fly or other insect approaches, the amphibian performs one of its artistic leaps into the air. Its sticky tongue shoots accurately out of its mouth during the leap. Before the frog even touches ground again, it has already swallowed its prey.

These frogs, also known as edible frogs, multiply at an inconceivable rate. During the spring, their spawn float in clumps through the shallow bays of the reeds. There is a good reason for the production of so many frog offspring. The eggs, shrouded in a gelatinous mass, are welcome prey for fish and birds. Furthermore, the tadpoles that hatch from these eggs have only one protection against pursuers: their incredible number. And indeed a few do manage to reach the end of their underwater phase. They grow four legs, their long tail shrinks, and they hop ashore, breathing through lungs. This phenomenal metamorphosis recalls the coming ashore of the saurians millions of years ago, when they left the sea and began settling the land.

If the matte green and brown of the reed silhouette is added to or replaced by dense bushes and trees, then a bird sporting unusually

153

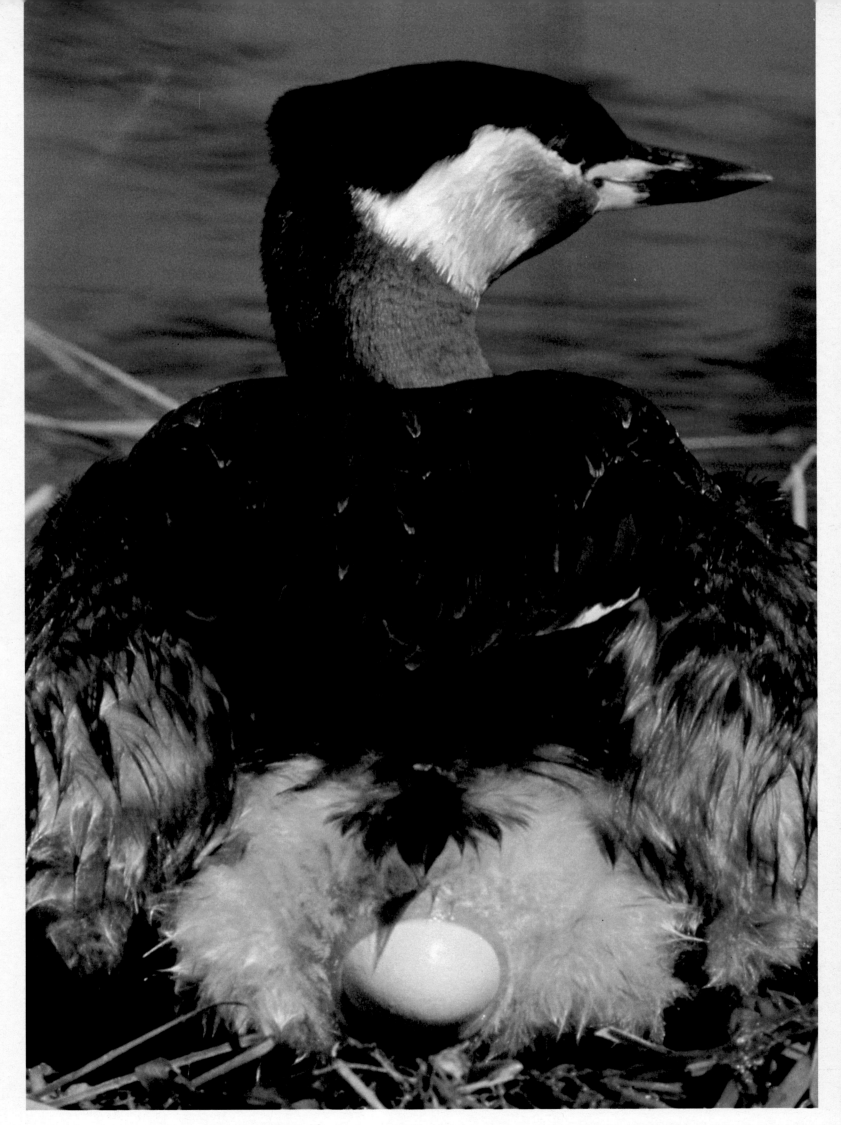

An event hardly ever observed by human eyes: the Holboell's grebe laying eggs.

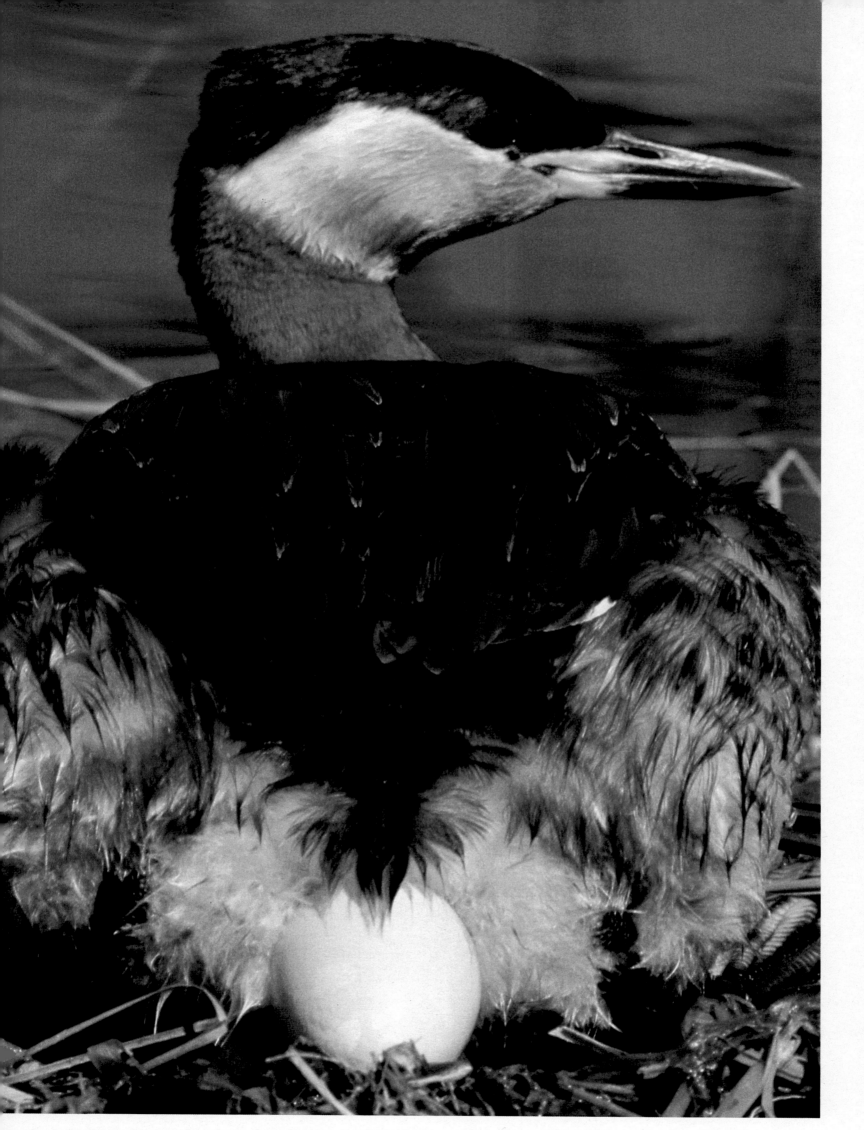

Its piercing cry echoes through the nocturnal reed forest like the squeal of a pig.

splendid colors will be conspicuous: the kingfisher. Once, the kingfisher lived throughout Europe, but now, it too has withdrawn to a few clean bodies of water.

The size of a starling, this bird is also known as a "flying jewel" in German and as a halcyon in English. Its shoulders and wing covers are sea green, its back is tur-

The kingfisher looks like a spear as it nosedives into the water.

quoise, its belly vermilion, its chin and throat are ivory, and it has aquamarine dots on its head and wings. Altogether, it looks more like a tropical gem than a familiar bird. But the blue kingfisher does belong in the European landscape. Its splendid colors are not a playful mistake of nature. A skillful hunter, its flying plunge into ice-cold water is necessary for catching small fish. The blue kingfisher must soar into the cold water an average of four times to bag a victim.

Watching the kingfisher hunting is an adventure. It flies across the water swift as an arrow (at over fifty miles an hour), hovers in the air like

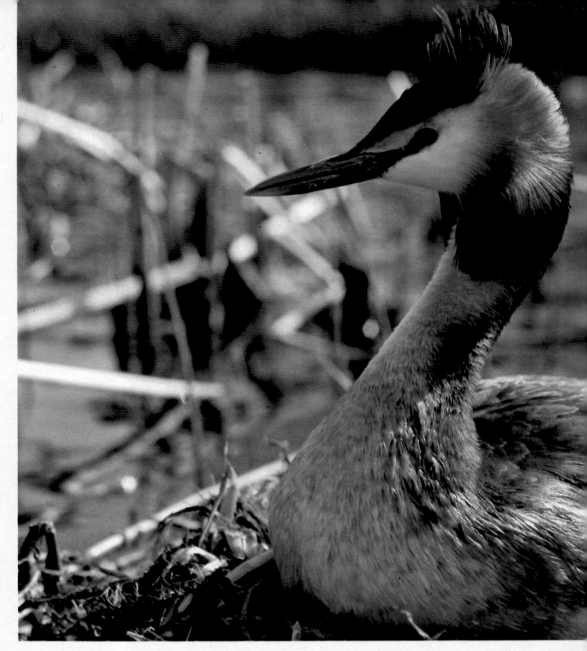

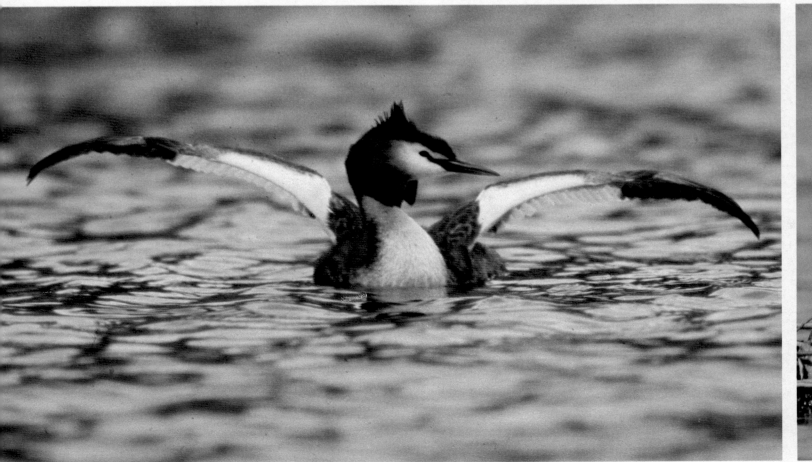

The great crested grebes live in strict monogamy.

For a long time they were hunted because they ate fish. Finally, men realized that, like the common heron, the great crested grebe acts like a sort of health squad for fish. During mating season, the spouses-to-be perform a breeding ritual. From the shaking of heads until the final confrontation, they demonstrate the countless ways of fixing the position for the floating nest site, attesting their willingness to mate.

a helicopter with whirring wings, and then, like a short, sharp spear, nosedives into the water. No sooner has the fountain of its splash dropped back to the surface than the kingfisher reemerges with its prey in its bayonettelike black beak. This bird is almost as swift when it carries the writhing fish to a branch and bangs it a couple of times against the hard wood. When the fish no longer stirs, it is either devoured or brought to the kingfisher's offspring in the hatching cavern, the halcyoneum, which is dug as deep as three feet into the side of the bank.

For a long time, men hunted the common heron because they thought it caught too many fish. Fishery and pond owners resented the large bird for its catches. Eventually, courts of law had to deal with the common heron, which makes no distinction between a man-made fish pond and a natural lake; fish is simply fish to the heron. In Holland, this gray glider is a familiar figure in the landscape of reeds and lakes.

Herons stand motionless in the morning fog like gray statues as they wait for passing fish. Anything venturing within reach of their dagger-like bill is skewered—fish, frogs, or snakes. In the wet meadows, the heron preys on mice, stealing after its victims as if in slow motion. When the victim is caught—the motion is lightning fast—a violent shaking of the head hurls it off the bill, and the bird has its meal.

Common herons nest in large colonies in high trees, far away from the waters. They feed their young the way many other water fowl do. The parent swallows a fish, mouse, or frog into his or her craw and then simply stuffs it into the wide-open beak of the young offspring.

Herons are very clean animals and spend many hours of the day taking care of their plumage. This is very important, for otherwise they could not maintain their body temperature of 104 degrees Fahrenheit.

▶

Among great crested grebes, both parents share the responsibility of raising the young. They give their offspring small fish, small green leaves, and delicate down.

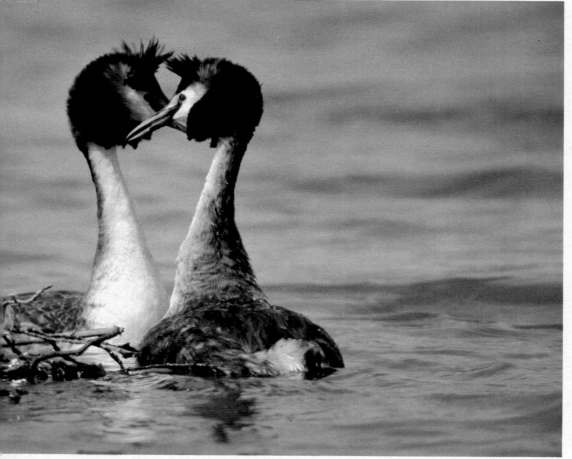

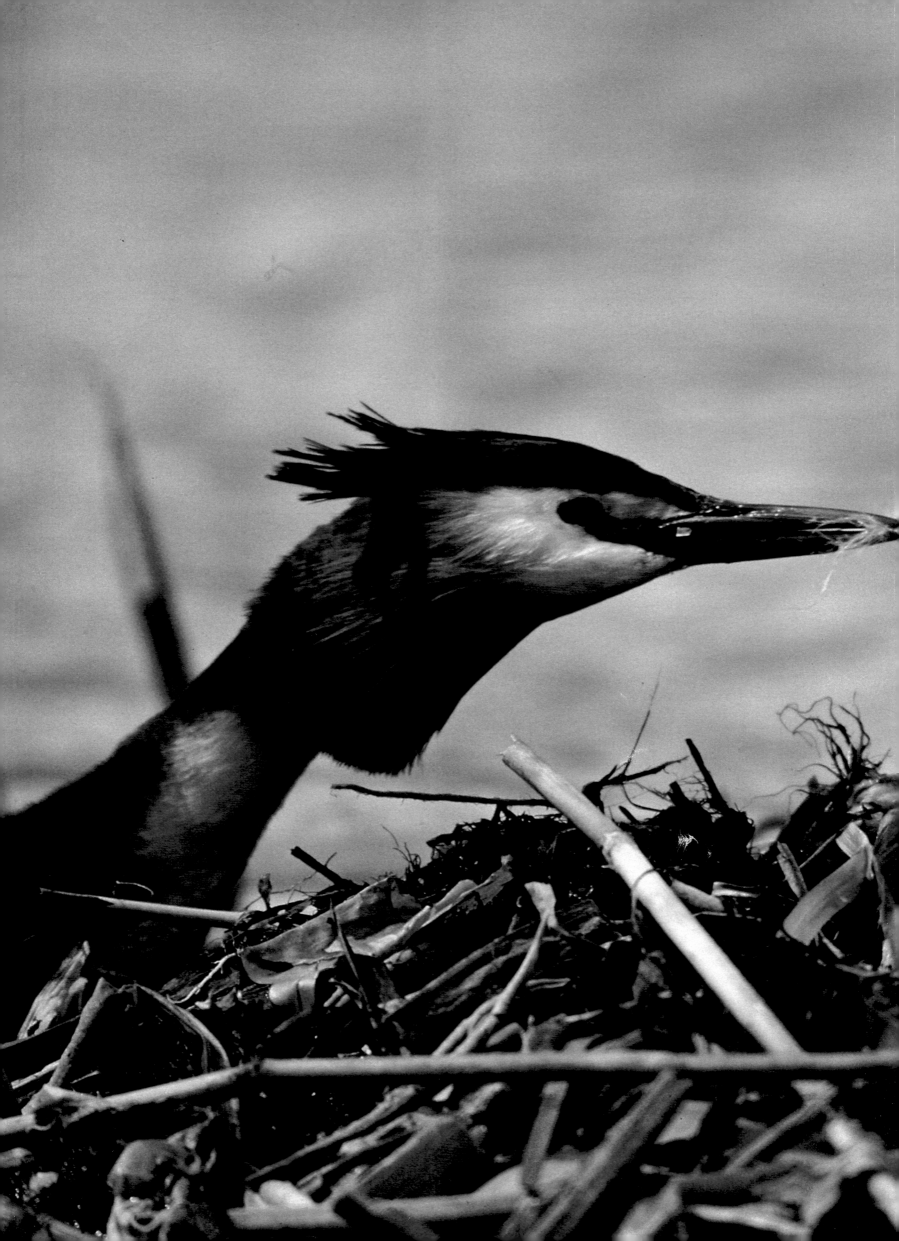

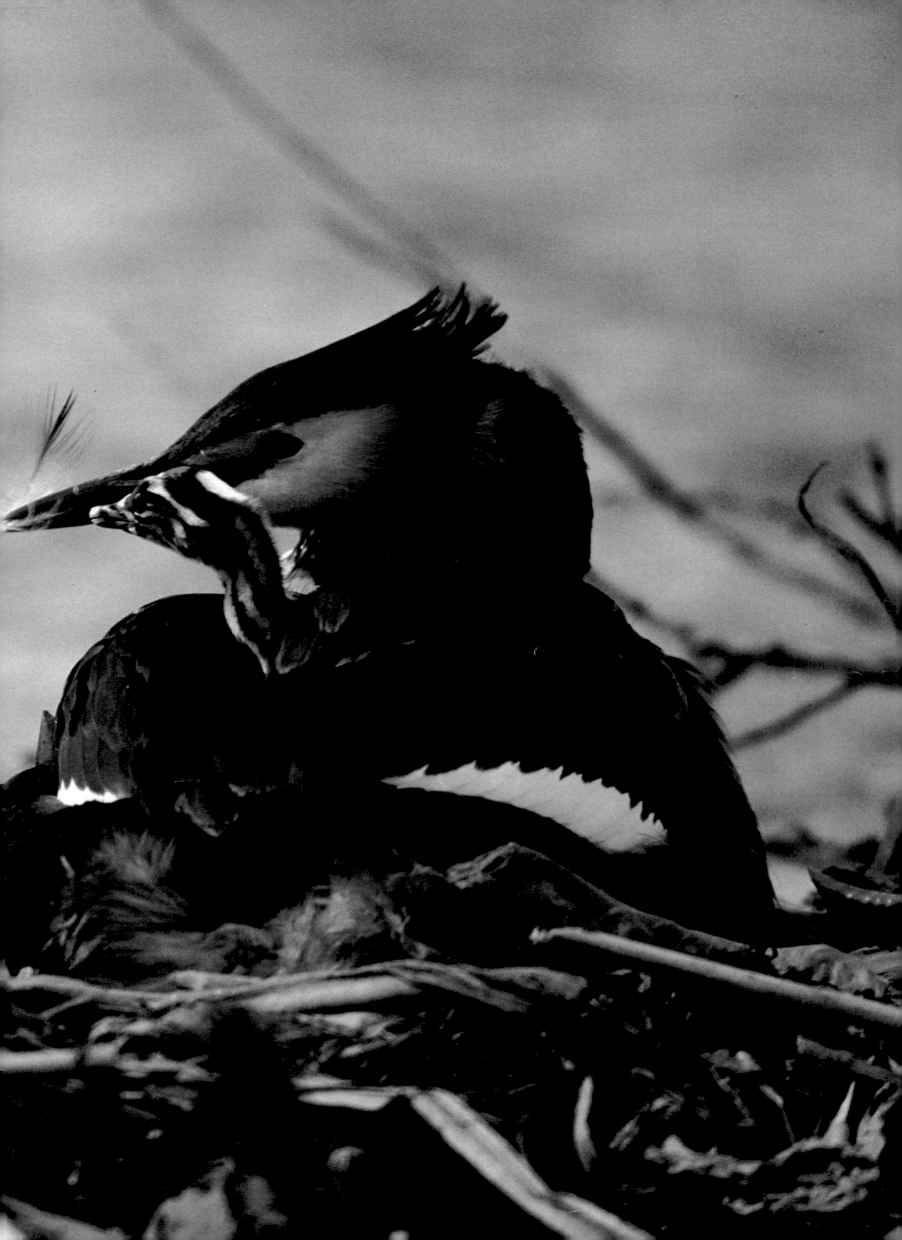

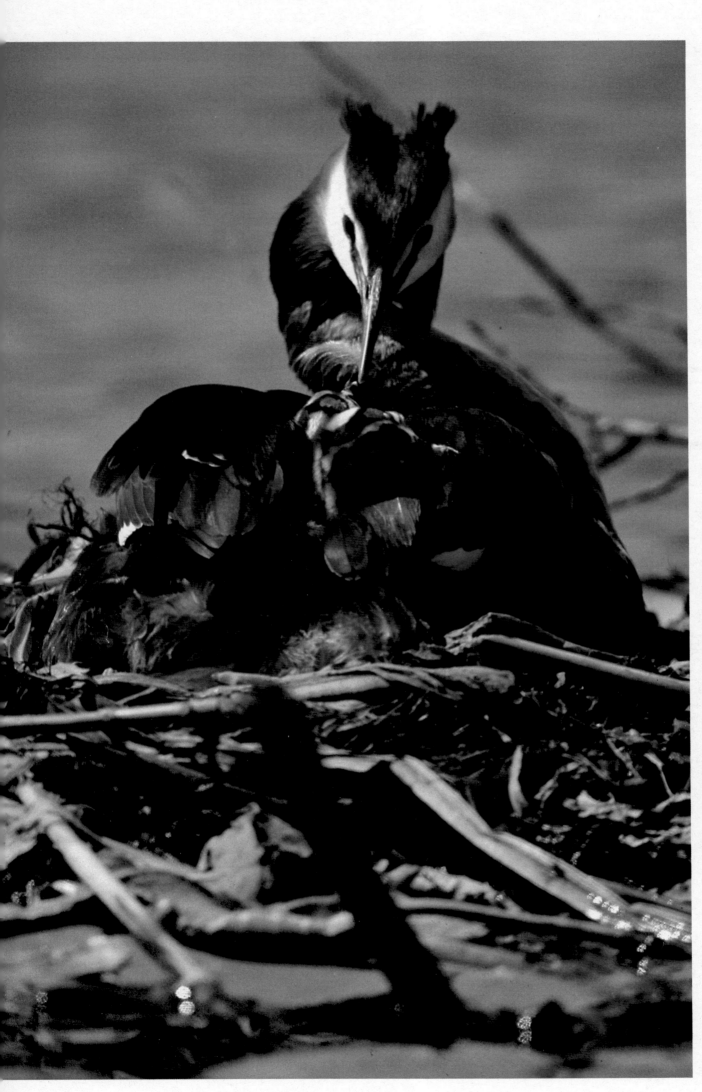

Resting, eating, and sunbathing on the "upper deck"

Great crested grebes conceal their young in special pouches on their flanks. These pouches are made of elongated feathers. Sometimes, the brightly colored offspring accompany their parents on the hunt—virtually riding piggyback, even under water. The young ride for a long time on their parents' broad backs—until they finally learn to fend for themselves.

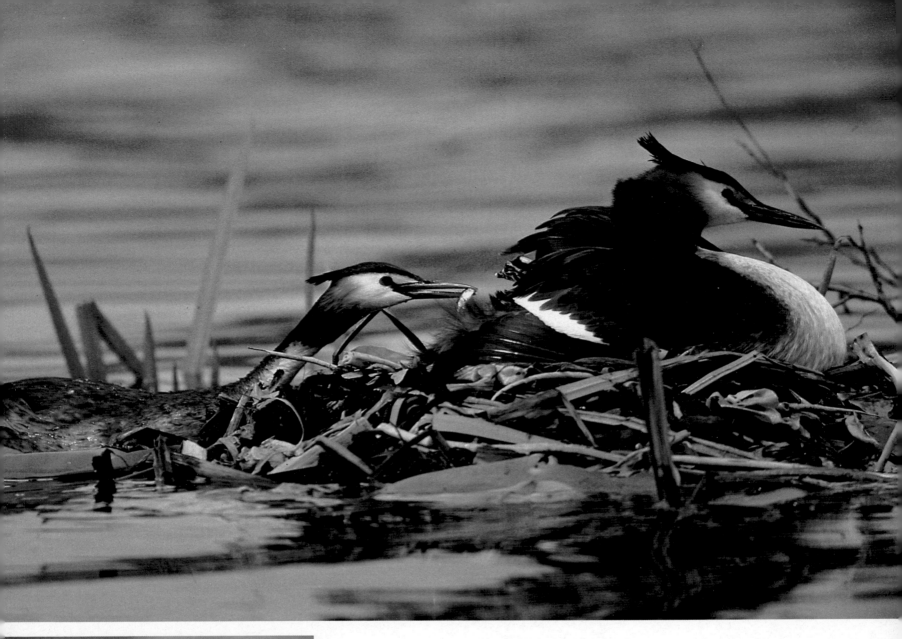

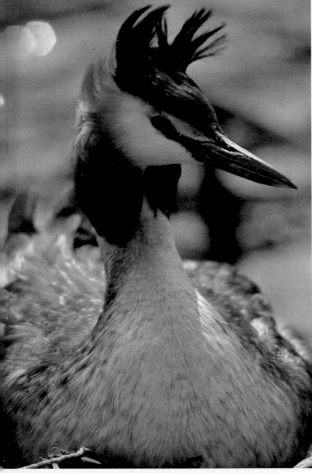

However, the heron's long bill can't get at the long feathers on its head. To clean them, it uses a natural comb: the claw of its middle toe is transformed into a dense row of comb-like teeth, with which it combs the head plumage. The heron does not rely only on the cleansing strength of water, it also uses a powder that it manufactures itself. So-called powder down, covered by the large feathers, grows in several places on the heron's body. These small feathers disintegrate into very tiny bits at their tips, producing a waxlike, water-resistant powder.

In the border area between water and land, the reeds stand like an endless wall. Without this wall, the shore zones of the rivers and lakes would not exist. Its flexibility is revealed only when the wind comes up. At such times, the individual stalks swing all the way down to the water surface, standing up again only when the force of the wind recedes. Not a single leaf on the stalk is broken and not a single crack can be seen. During storms and under the impact of waves, enormous weights burden the long fibers of the stalk, whose load-bearing capacity is exceeded only by that of bamboo. Cattails are also weight lifters. Not only do they carry dark brown cattails with hundreds of thousands of seed parachutes, but they also bend to and fro in the wind and spring back—only to be shoved in a different direction by the next gust a second later. Nature, a brilliant architect, has produced a true masterpiece of static engineering with these sentinels of the shore, a feat still unparalleled by man.

▶

The water frog croaks and whines in summer, sometimes all night long. His intelligence is far superior to that of most amphibians, and he is also a far better jumper.

Here amidst the warning cries of the marmots and the blossoms of brussels sprouts is the kingdom of the chamois and ibex.

Horned
The Verd

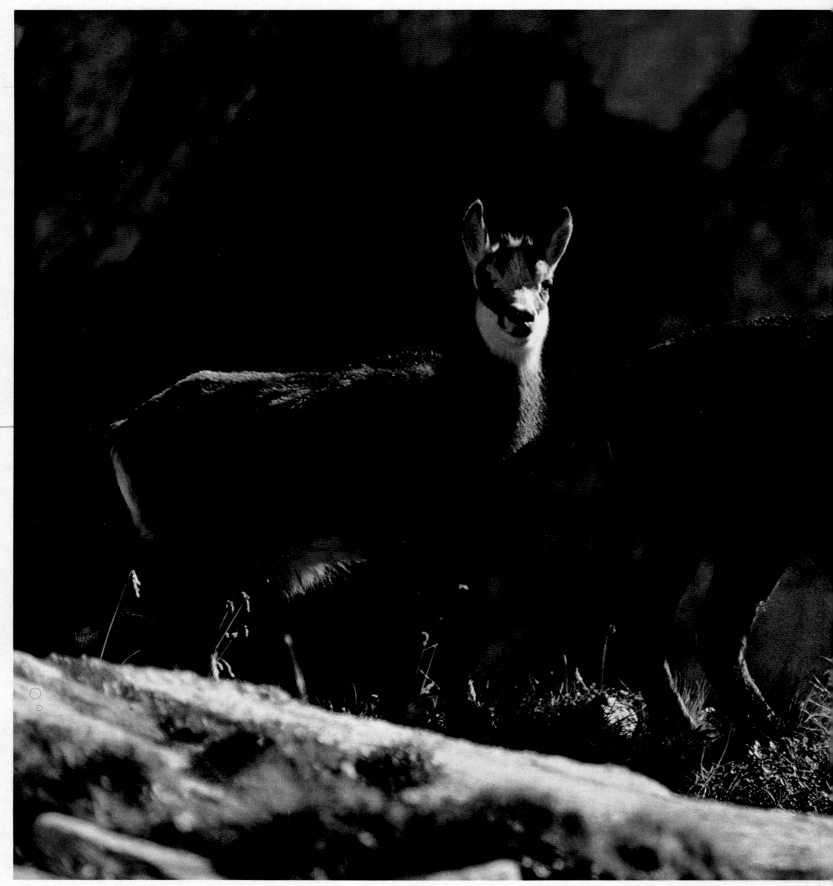

Stormers of the Peaks:
ant Garden of the Alps

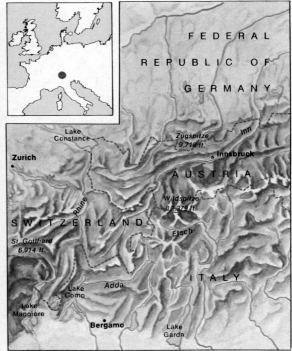

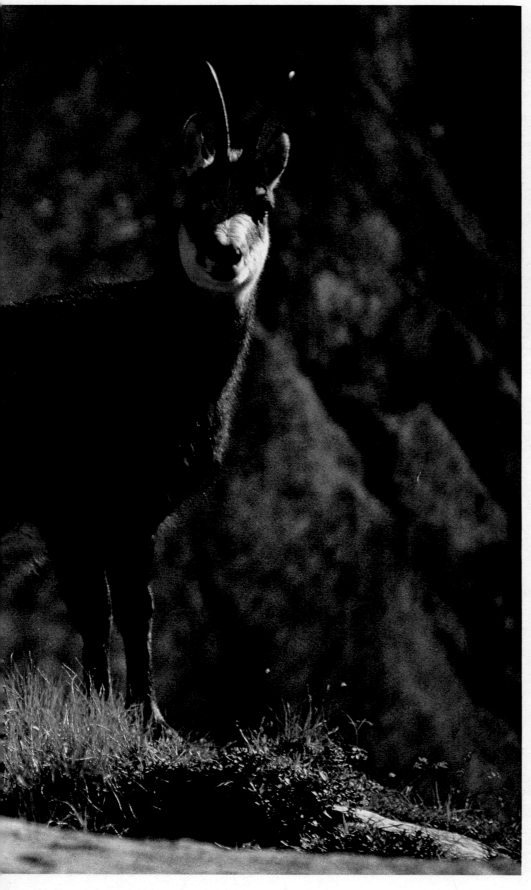

Climbing experts in their habitat

The chamois are at home in the almost inaccessible rocky region of the Alps. These animals spend most of their lives between the tree line and the snow line, and their tenacity is admirable. At dizzying heights, where any false step can mean death, they raise their young and escape their enemies—often at breakneck speed.

Europe has a thousand faces. Different climatic zones have produced a varied landscape. Broad-leaved forests, conifer forests, moors, heaths, treeless plains, and the tundra are as much a part of this continent as the eternal ice. If you want to visit this ice, you don't have to travel for days and days to the ice cap on the Arctic coast; a climbing tour through the Alpine garden of central Europe will suffice. The beech forest at the mountain level corresponds to the hardwood forest belt; pines, firs, and larches of the sub-Alpine softwood can be compared to the taiga belt; the Alpine pastures and meadows correspond to the treeless Arctic tundra; and the peak glaciers of the Alps have the same origin as the polar ice. The most diverse levels of climate and vegetation can be observed in fifty thousand square miles of mountain landscape. Like a bulwark of a largely primeval nature, the Alps are the most flower-laden stone garden on earth. Peaks ranging from six to twelve thousand feet loom from the rock ocean of the (geologically) younger mountains.

The high mountains are a world of extreme conditions, posing harsh challenges for flora and fauna. Nevertheless, there are few places on earth where biological wonders can be found in such density. Something that may be judged as an "average achievement" in the mild climate of the plains is a brilliant feat of development and adaption in the rough environment of the mountains.

The special enchantment of the Alps lies not in the grandiose flora but in tiny details that make a plant fit to live.

White dryas, survivors of the Ice Age, sometimes live a hundred years or more.

The thick pink cushions of the moss campion cling with their spreading roots to the movable underground of detritus. The alpine pansy pushes its long tap roots as deep as possible into the ground, penetrating the rock. In the summertime, the rhododendron makes the slopes look as if they've been dipped in flaming red. Its wax-covered leaves prevent any excessive vaporization. Cowering in wind and cold, the cinquefoil and the white dryas creep along the ground. The edelweiss has a thick fur to keep it from drying out on the windy slopes.

The delicate auricula and the crocus seem much too frail for the hard life on the storm-lashed mountains, yet such fragile flowers are the ones that live most tenaciously here. Their endurance and frugality are

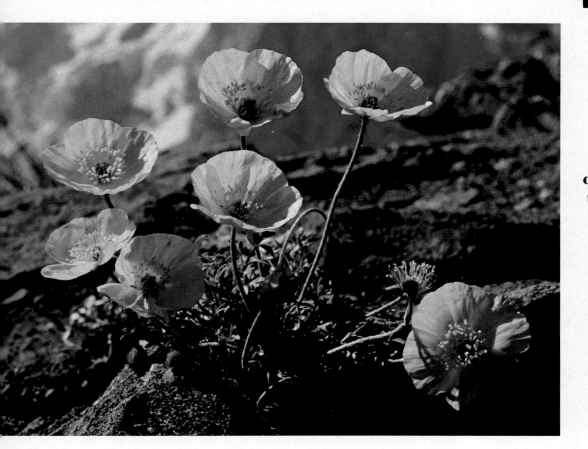

The flowers of the mountains are a strong breed.

Flowers have conquered habitats from the mountain forests to the peaks. The sulphur-yellow anemone (*left*) literally grows out of rock. The hairy primrose (*right*) and the dwarf gentian (*far right*) unfold their delicate blossoms at altitudes above six thousand feet.

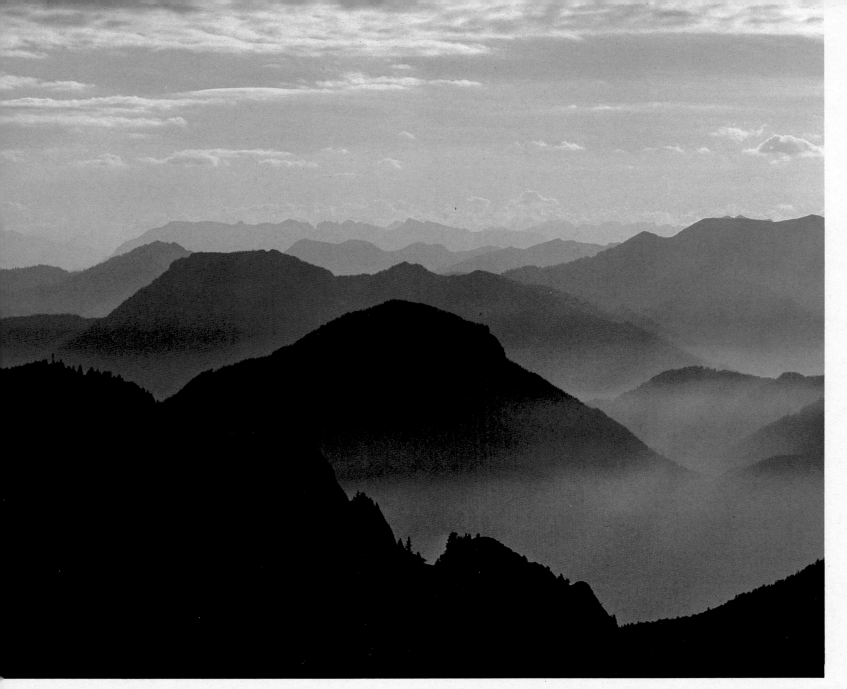

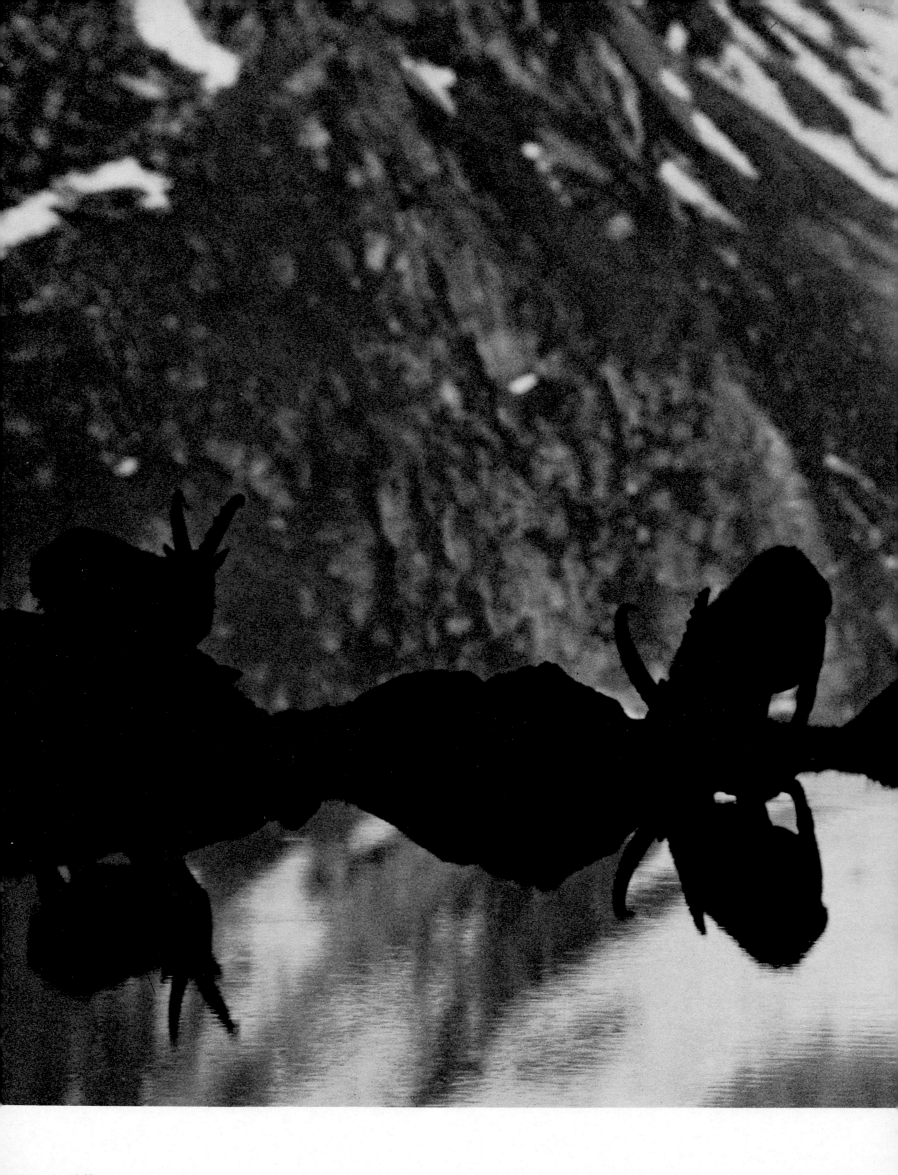

This is no bleak lunar landscape but a world teeming with life.

In no other mountains on earth are the flora and fauna more numerous and the wealth of species richer than in the Alps, and in no other mountain region has nature created more graceful creatures. The heaven flower (*right*) is as blue as a for-get-me-not. As though chained by invisible fetters, it defies raging thunderstorms at altitudes as high as ten thousand feet. In these areas, the flocks of ibexes drink from crystal-clear mountain lakes (*left*).

unsurpassed. They defy the alpine thunderstorms as though chained to the mountain, their fine root webs clutching the naked rock, filtering nutritious salts from the seemingly dead stone. The intense colors of their blossoms cast a spell on this world of gray rock.

The alpine soldanel demonstrates the strength of alpine plants in their winterlong and often summerlong struggle against ice and cold. The extremely delicate violet buds of this flower melt deep funnels into the snow during the spring.

The energy for this floral life comes from the rays of the sun. But even the cold ultraviolet light has a vital impact: it retards the growth of the plants. If the dwarflike flowers of the highlands remain short, they don't run the risk of being broken and uprooted by wind and storm. In

Wind and storms keep the vegetation low on the peaks—a lilliputian world on the Alpine roof of Europe.

an area where the lichen carpets climb all the way up to the edge of the eternal snows, the Lilliputian size is necessary for survival.

On the roof of Europe, it sometimes happens that summer and winter meet—from one moment to the next. Warm foehn rains in December and snow in July are not exceptional. The flora and fauna can endure such extreme reversals of

weather only if they have become inured and resistant through the course of evolution.

Nevertheless, the alpine zone is inhabited by such delicate creatures as the Apollo butterfly, which looks so frail that one would think its filigree wings would be shredded by a light puff of wind.

The wall creeper is probably the most beautiful small bird in the European mountains. Because of the

The golden eagle has become a rarity. When human beings arrive, the king of the air leaves its territory forever.

red dots on its plumage, it is also known as the "flying alpine rose." Its skill in hunting insects has earned it the nickname of "alpine hummingbird."

The dotterel seems more suited to the harsh world of the mountains. From May to September, it settles in the high mountains to raise its young. The dotterel is an expert malingerer. If it feels that its nest or its offspring are threatened by enemies, it pretends to be sick. Reeling around with outspread wings, it looks like easy prey for the attackers, who then focus more on the parent than on the nest.

The golden eagle has found a last refuge in the high mountain region. Because of its majestic appearance, people in many countries have made

Springtime in the mountain forest

Wherever a luxuriant mixed forest pushes into the mountains,
we can be confident that nature is not threatened.

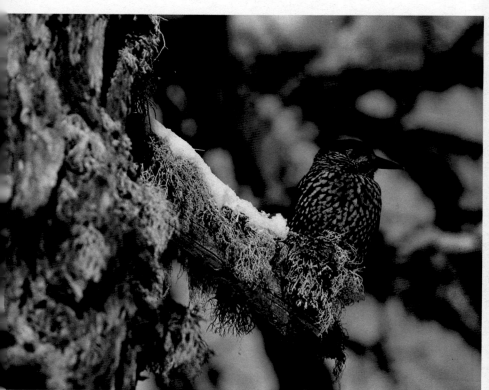

Seemingly intact and fantastically beautiful after the hard winter
When the final snow has melted and the nutcracker (*above*) moves to areas where the trees appear to sport beards, the mountains explode into life.

▶

A balancing act on a peak threatened by an avalanche

▶ ▶

A herd of chamois in a blizzard finds protection from the wind and cold among dwarf pines.

173

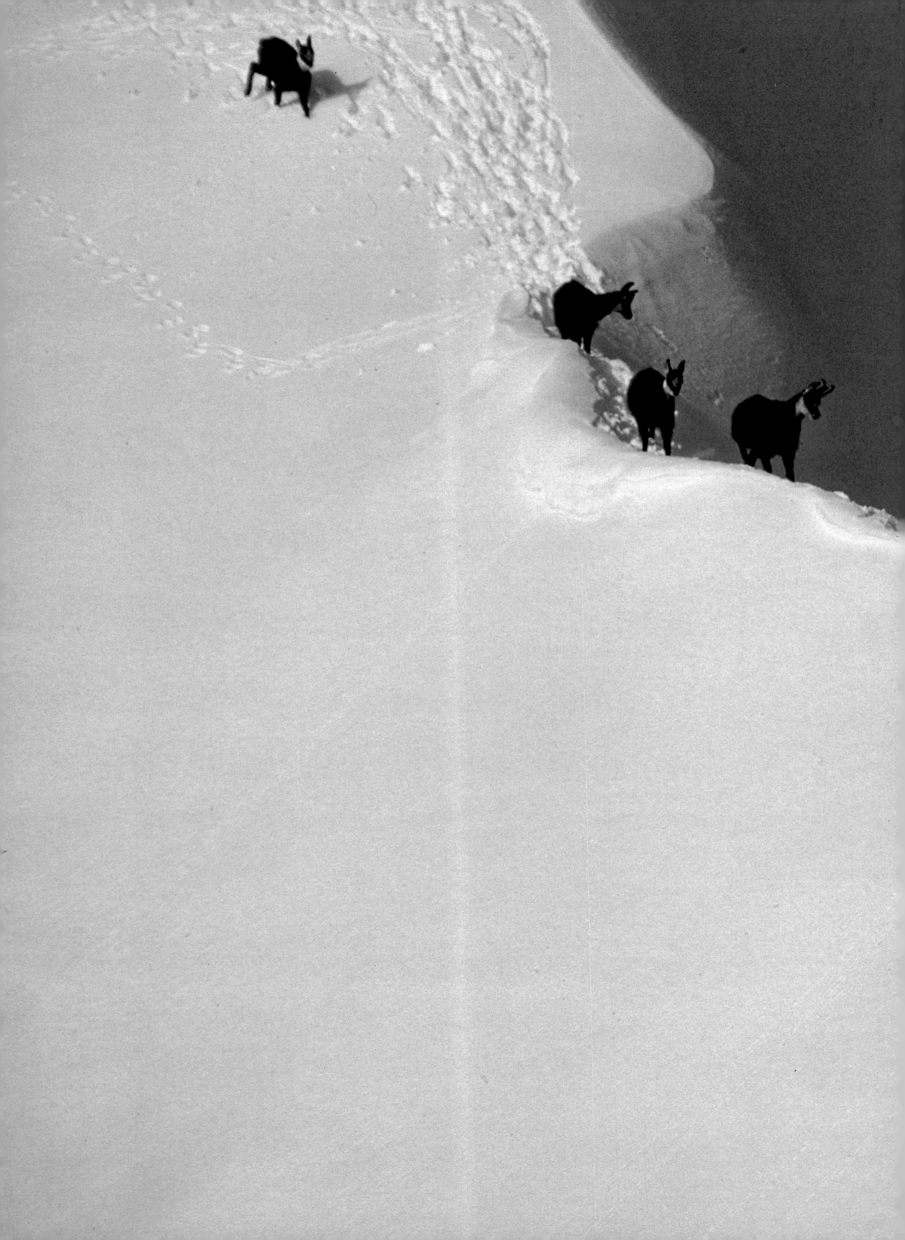

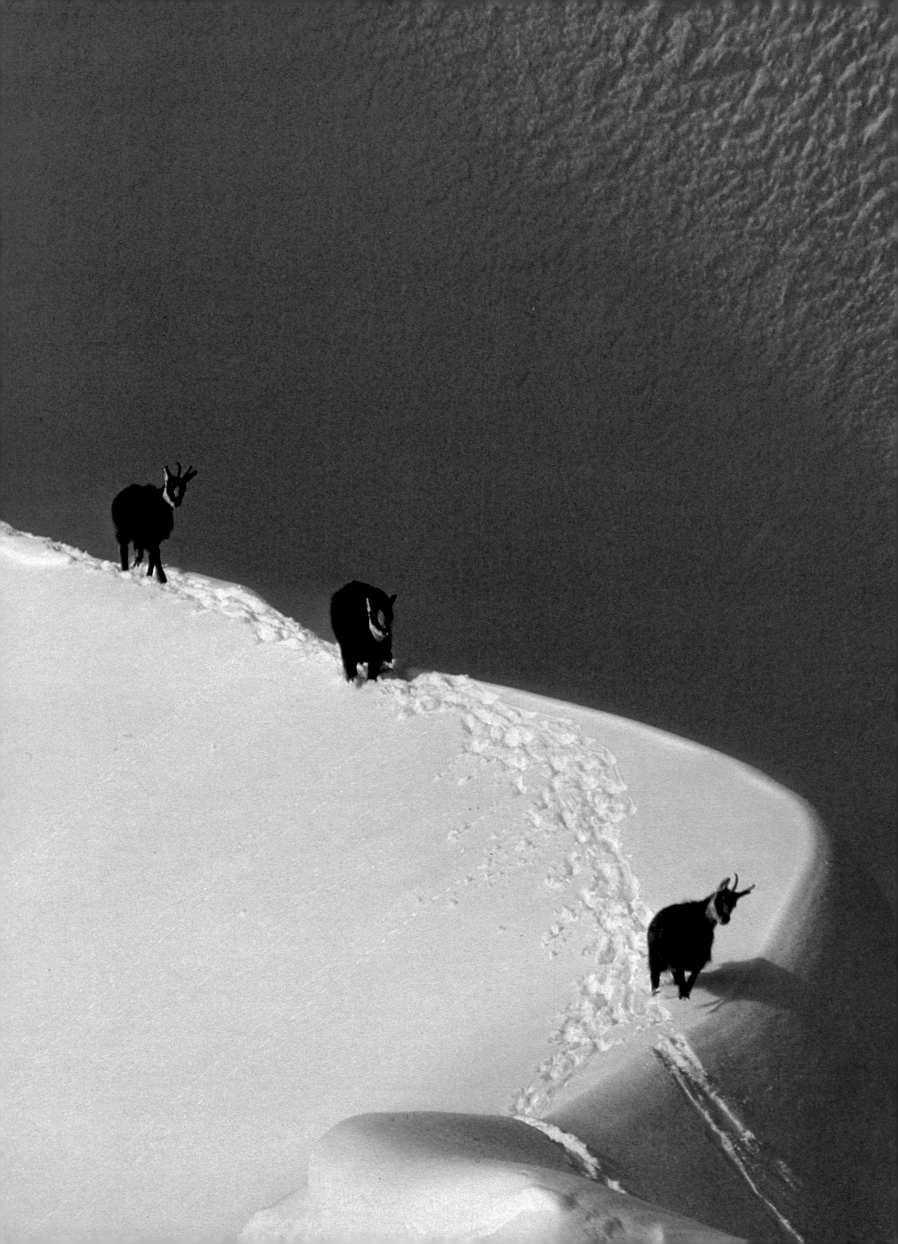

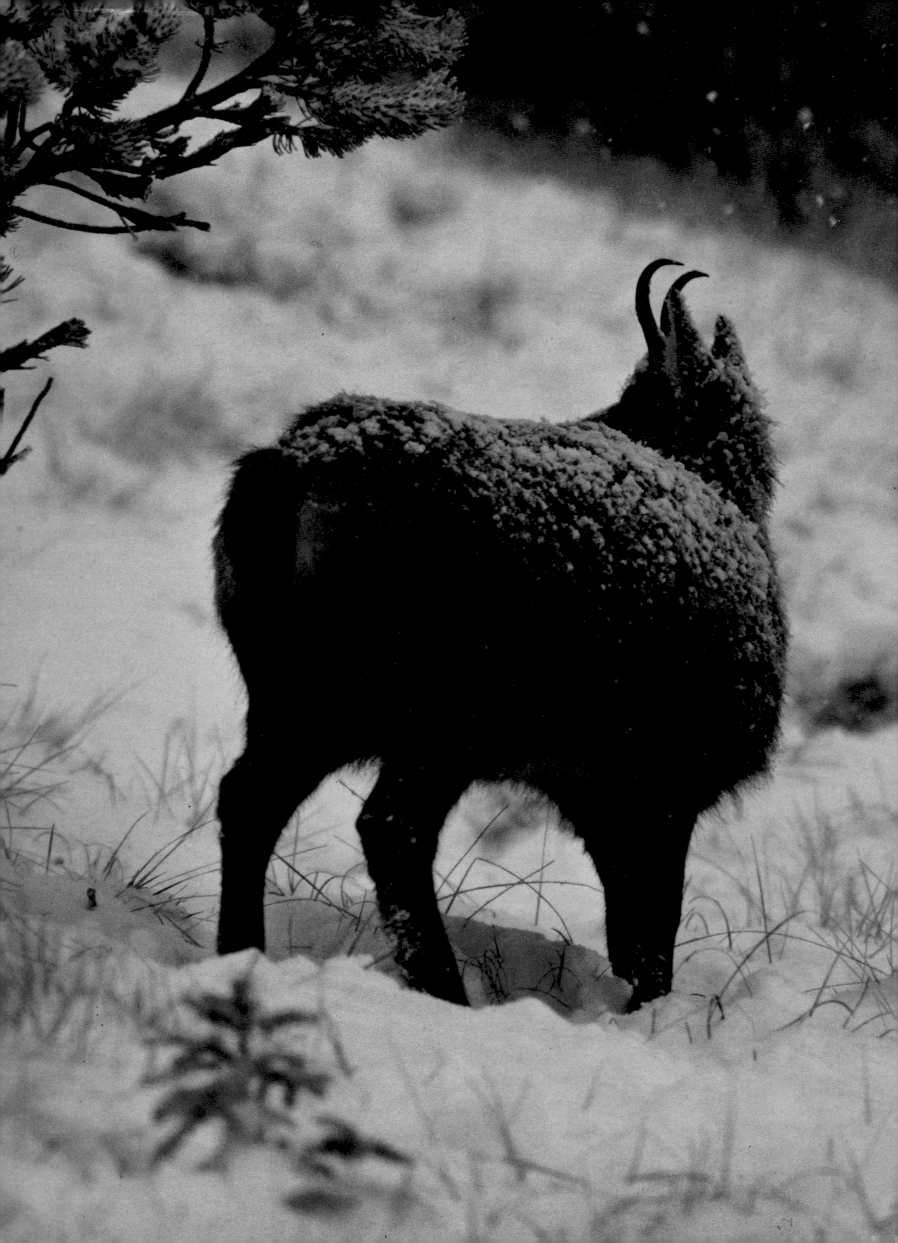

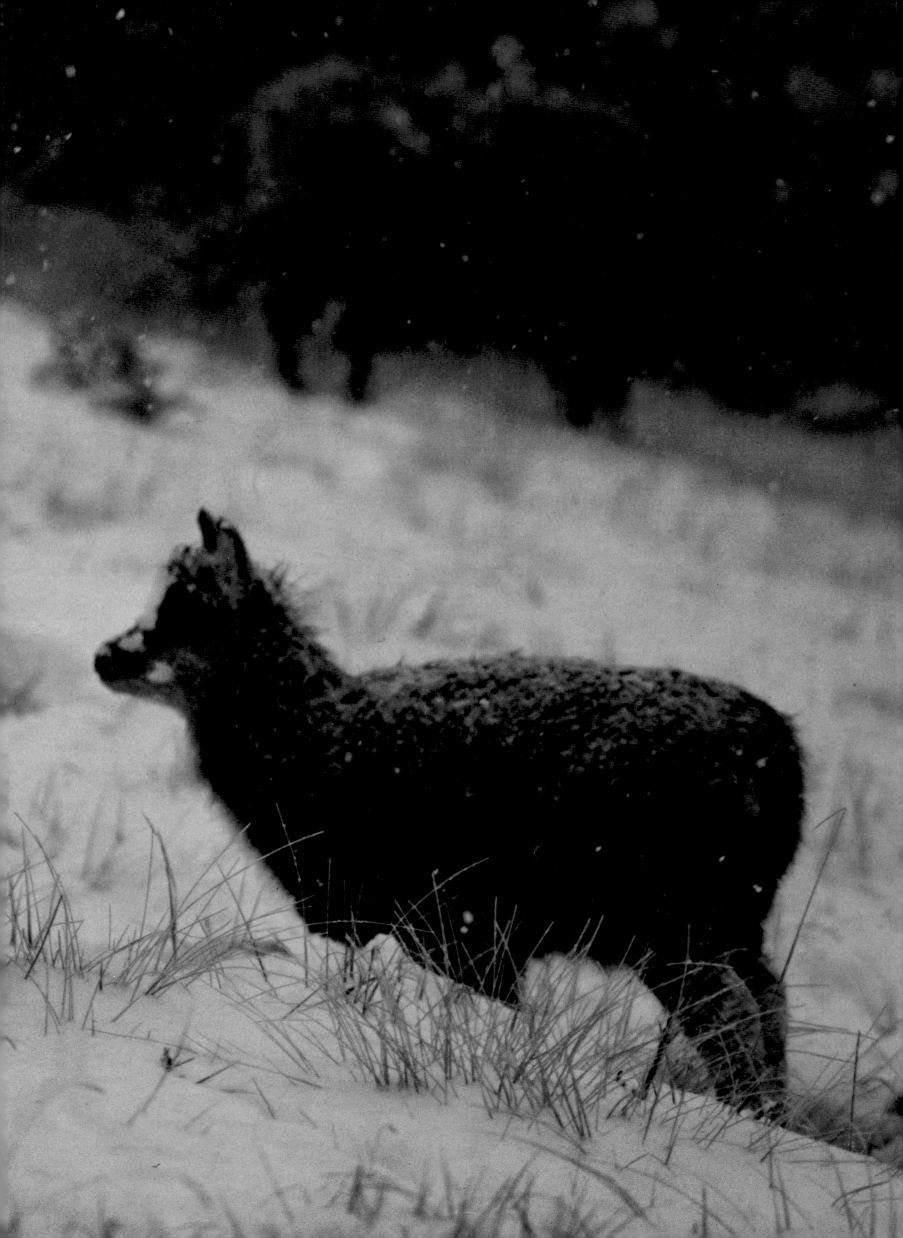

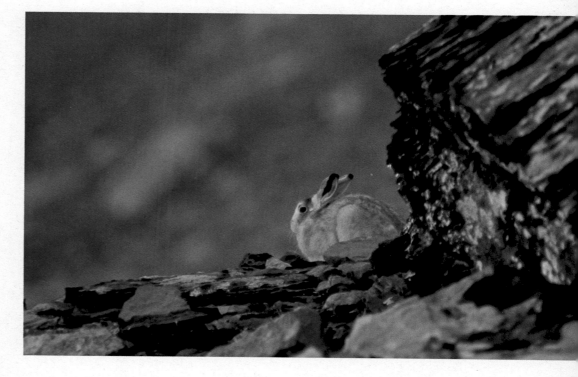

Snowlight—a natural wonder of the high mountains

An extremely rare phenomenon that has hardly ever been photographed, snowlight consists of billions of tiny ice crystals back-lighted by the sun and can be observed only on ice-cold, dreary, foggy winter days. Mountain animals like the white hare (*right*) and the snow grouse in its transitional plumage (*below*) are also astonished by the glistening light.

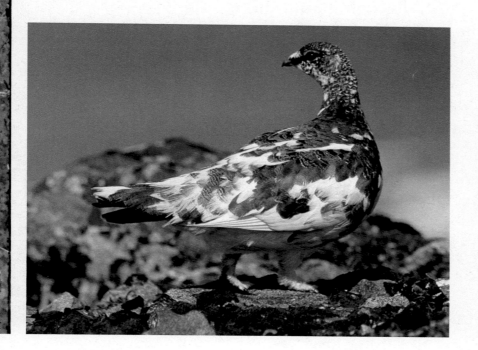

this king of the air their heraldic animal. Nevertheless, it has been ruthlessly hunted for centuries.

Man envied the golden eagle for the prey it caught. He felt he was being robbed of food, and so he showed no mercy to his supposed competitor.

The remaining couples of golden eagles build their nests in inaccessible cliff walls—if, in fact, such places can be found in the Alps. The instant any mountain climber ventures near its clutch of eggs, the eagle flees. It is so frightened of human beings that it deserts the eggs or even the hatched offspring, which then die.

The consequences are disastrous not only for the preservation of this species. Together with vultures, the eagle has always acted as a kind of health police in the Alps, preying on sick or injured animals. Thus, within the individual animal species, only the strong and the sound could increase. Today, eagles are very rare, so human beings have to take over the strenuous job of animal control. However, hunters and gamekeepers are not as successful in carrying out the eagle's natural task, so it comes as no surprise that serious attempts are being made to restore a habitat for the golden eagle.

Of all the creatures in the moun-

The ibex and the chamois frolic over the ridges like daredevils. Their special hooves provide safe footholds.

tains, the ibex and the chamois are the most skillful in negotiating the rocky areas. They are the most mobile and surefooted inhabitants of the Alps, strolling like daredevils along ledges that seem too narrow to be passable. Both species have developed flexible hooves with the cloven toes and unusually soft, vaulted soles which allow them to race over shingle and detritus and balance along steep ridges without losing hold.

In the summertime, the ibex and chamois devour the sparse vegetation in the peak region of the Alps.

During the harsh winters, they move down the mountainside and normally spend the snowy season beneath the tree line in protective forests. Here, they can find enough food; if not, they move to meadows from which the wind has blown away the snow.

In winter, the chamois' short, yellowish summer skin changes into a black winter blanket up to five inches thick which shields them against the cold. The extremely long hair on their backs protrudes from this winter garb, making the chamois a popular catch for hunters, who want the so-called shaving-brush, the hat adornment in a Bavarian alpine costume.

The ibex, the most impressive game in the high Alps, has a similarly dense winter fur that also protects it against cold weather. This powerful climber was found throughout the Alps until the fourteenth century, at which point its population declined rapidly. The culprit was central to a medieval superstition. People regarded the ibex as a "walking apothecary." Its flesh, its innards, its eyes—fresh, dried, or ground into a fine powder—were said to have a curative and/or magical function for all kinds of complaints. Its hair, horns, and hooves became amulets against the magical powers of evil spirits. Even its dung was supposed to have a healing effect on consumption and gout.

A small group of ibexes managed to survive in the Gran Paradiso massif of the Graian Alps (between Italy and France). By selecting goats from this stock, ecologists have renaturalized the ibex in other areas of

Invisible in the snow and camouflaged in rocks and detritus, the snow grouse changes its plumage with the seasons.

its original habitat. Today, the stock, numbering some eight thousand, is considered safe.

Throughout most of the year, chamois and ibexes share the lonesome peaks with a few insects and spiders and several "weatherproof" birds that manage to venture up to these heights.

One such bird is the ptarmigan; its extremely dense plumage shields even its feet and nostrils. The ptarmigan also exploits the insulating effect of the snow, digging a sort of sleeping cave in the snow.

The simplest and most comfort-

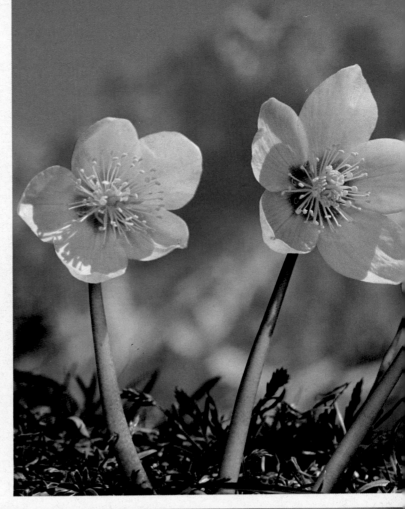

The coming of spring

The Christmas rose (*right*) announces the imminent mountain spring. The wild animals move from the shielded valleys into the higher regions. In the last remaining snow, the black cock (*below* and *far right*) begins its fiery courtship.

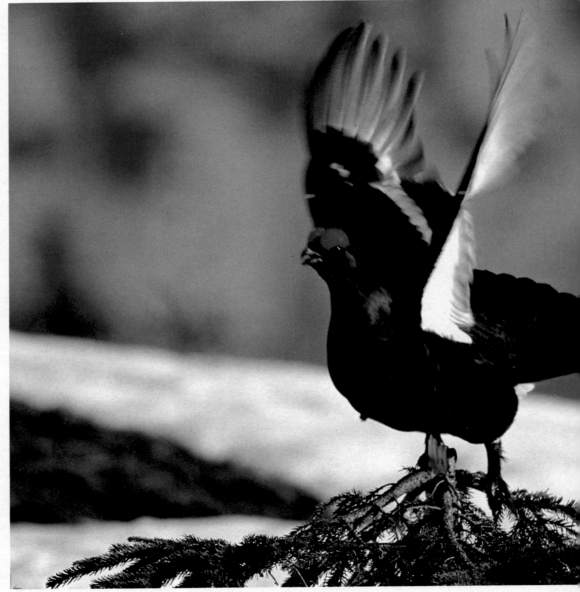

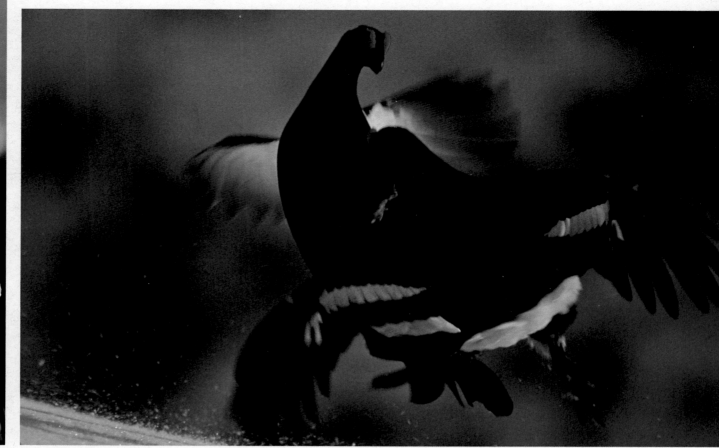

able way of surviving the winter has been developed by the marmot. This creature, the size of a hare, begins hibernating by October at the latest and sleeps for six to eight months. Long before the start of the cold season, however, marmots, who often live in colonies, gather grass and herbs. They transport their collections in large bundles held in their teeth and use this material to "upholster" their winter homes. When its job is done, the marmot

Marmots are guests in the never-never land of the mountains for six months. Then they go to sleep—all winter long.

stuffs up the entrance to its lodging with hay, soil, and stones. The place is now insulated against the cold, and the entire clan drops off into a deathlike rigidity, their body temperatures sinking to as low as forty-one to forty-three degrees Fahrenheit. Every few weeks, the hibernators awake briefly to urinate. At such times, their metabolism is reanimated, warming them temporarily.

In contrast to their slumber, the vitality of these troll-like rodents ex-

plodes in the springtime. Playful free-for-alls make up the daily schedule of this frolicsome time, and the marmot could be said to live the life of Riley in the lush alpine meadows. By autumn, when they prepare to hibernate again, they have stored up more than enough fat for six months.

However, the habitat of these specialized mountain dwellers has been reduced to a terrifying degree. Human beings celebrate the freedom of the mountains, but they interpret it frivolously and thought-

▶

A chamois buck in a snow-covered pasture (*left*) and a white hare (*right*)

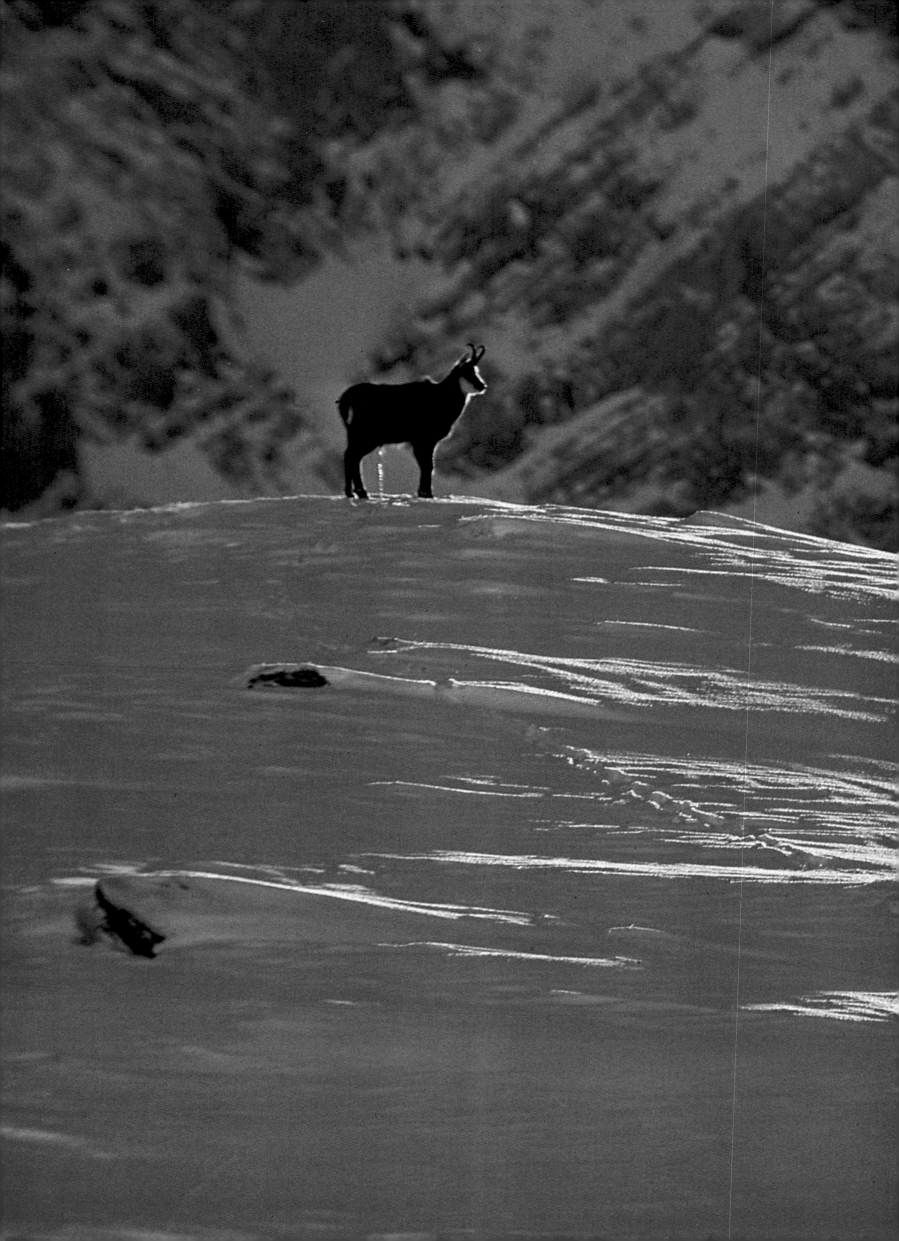

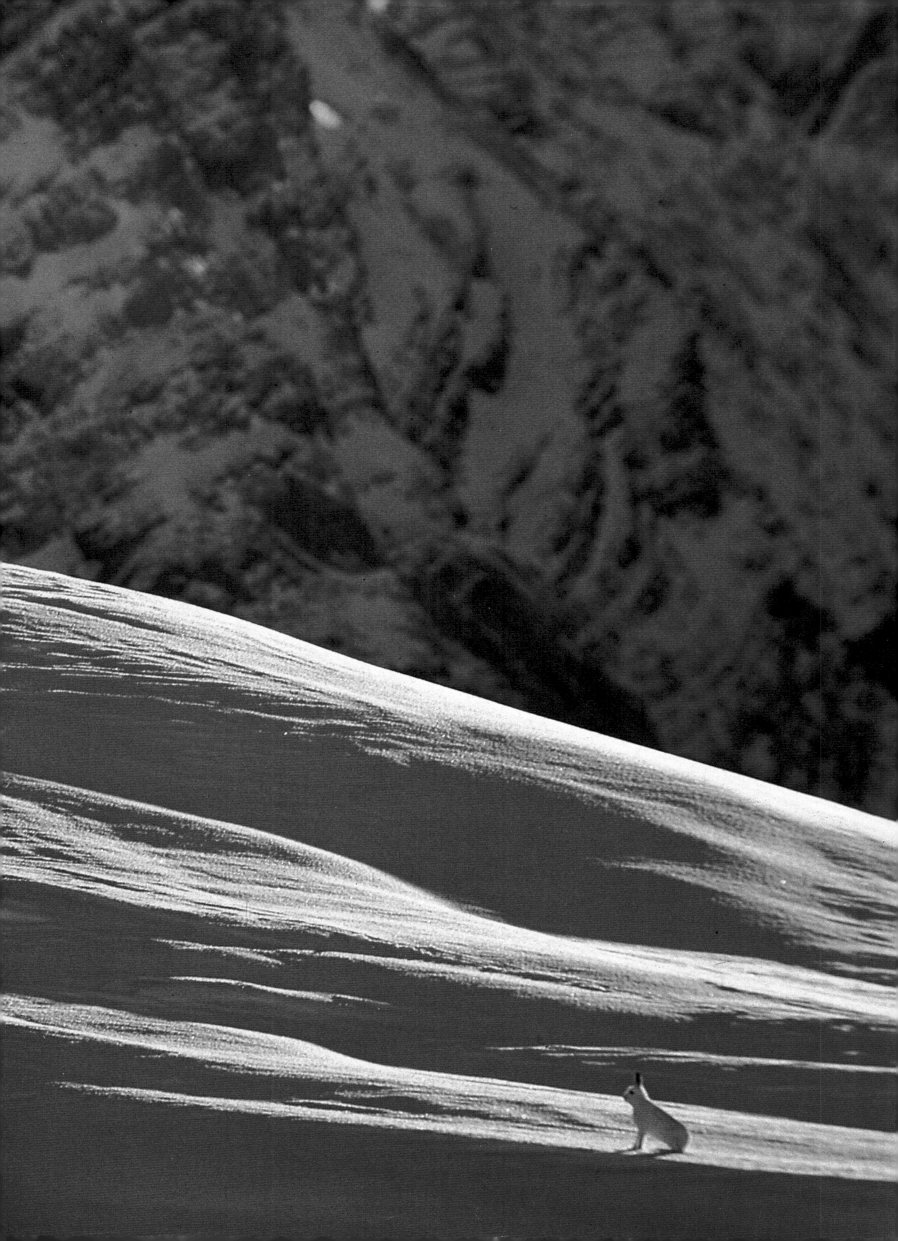

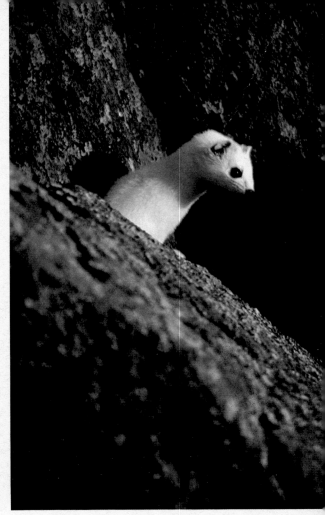

There are many things to admire in the mountains.

The chamois thunders impetuously down the mountain (*right*). A royal ibex (*below*) peers from a dizzying rock ledge. Marmots (*left*) stop and test the wind, and a snow-white ermine (*right*) ogles from its hiding place.

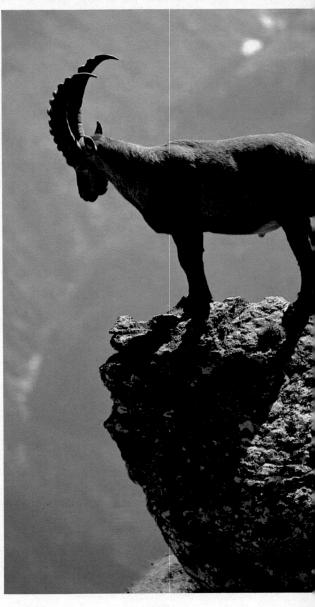

lessly as an opportunity for self-development; unfortunately, the plants and animals suffer in the process.

The Alps are no longer reserved for a few hikers and climbers; during the past twenty years, mass tourism has been destructively exploiting the habitats of the mountains. Paved roads can now be found in any alpine region. Chair lifts and cable cars have already made countless peaks the goals of Sunday outings. All year long, human beings swarm over the heights. The protected rhododendron, gentian, and edelweiss are torn out of the ground with their

Garbage piles—unmistakable signs of hiking and mountaineering trails—rob the mountains of their primeval atmosphere.

roots despite the threat of penalties. Not only are they considered souvenirs, but the illegality of the act provides an additional thrill.

In winter, avalanches of skiers roll over the slopes. Deforested and beaten bare, these slopes are abandoned to a lifeless existence, even when the snow has melted and the winter athletes are gone. The towers of the ski lifts provide no shelter for mating black cocks and mountain cocks. The ring ouzel can no longer build its nest in the branches of dwarf pines. Collapse is imminent for entire habitats that only recently were primeval, undisturbed, and unpolluted.

A few animals have come to terms with their altered environment. Common ravens and alpine choughs profit from the refuse heaps that are thoughtlessly left behind, marking the hiking trails and climbing routes. Even the once timid marmot is venturing closer and closer to civilization—begging for food, to the amusement of countless visitors.

The alpine region cannot and should not be off limits to human beings. On the other hand, people should not continue, much less intensify the present assault on the virgin landscape. In a time when mountain peasants are leaving their farms and the uncultivated meadows are economically valuable only for ski lifts and cable cars, a dangerous shift of the alpine balance of nature is imminent.

The only solution is a stronger and more deliberate protection of nature. Ecologists must act quickly if they are to save and preserve these habitats and their inhabitants—and for our sake as well.

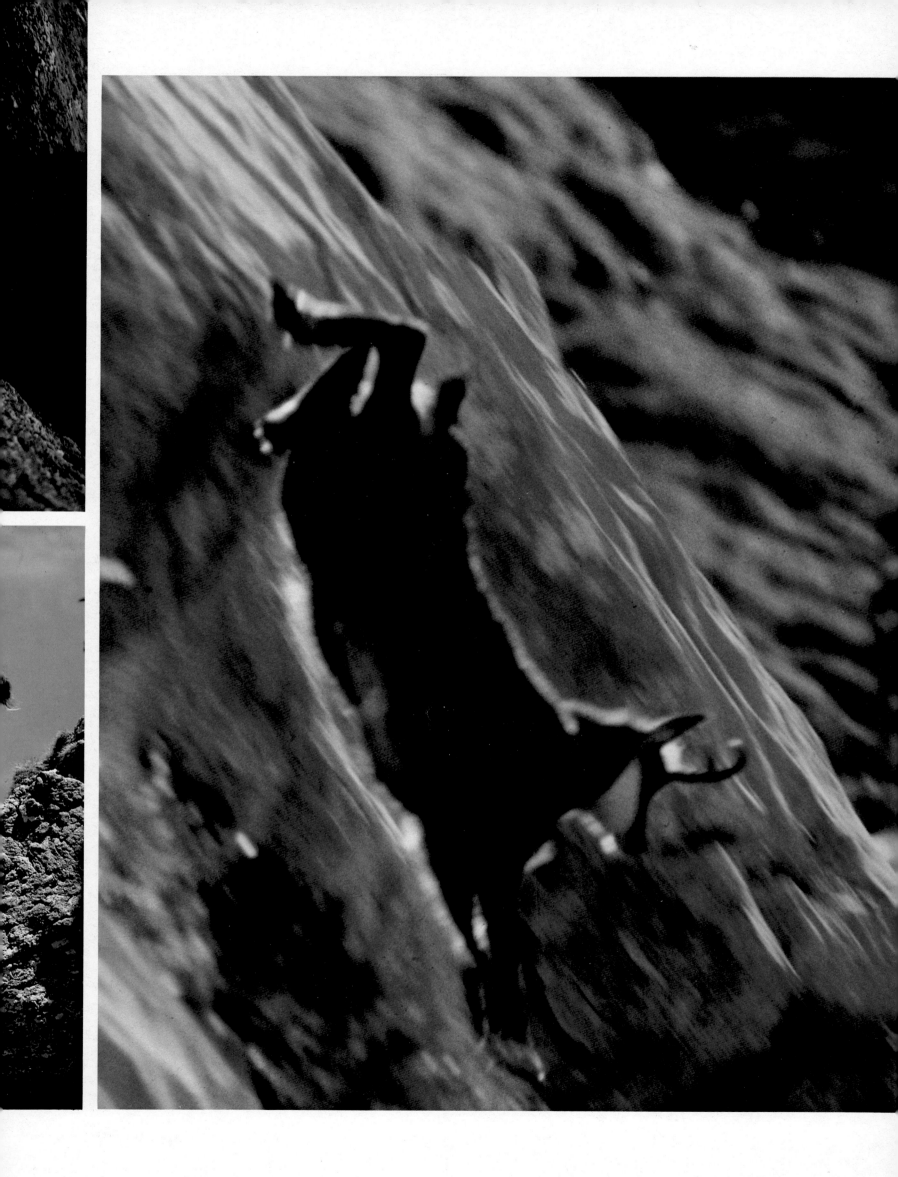

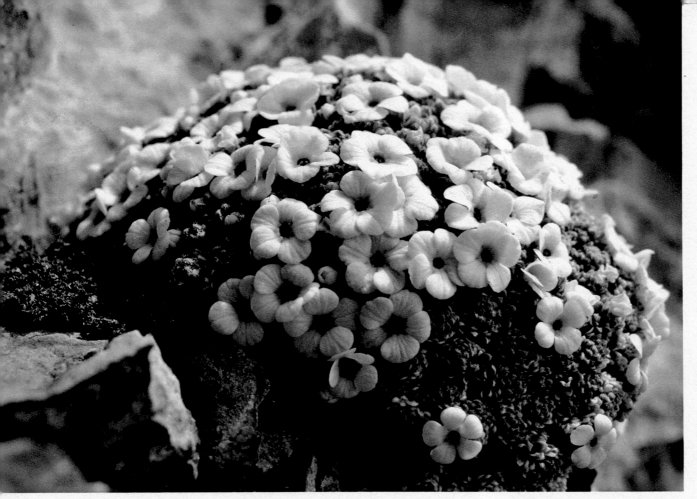

Life that flowers secretly

The wall creeper (*right* and *below*) is one of the rarest bird species in Europe. With its sickle bill, it pokes around for tiny insects in rock clefts. This so-called humming bird of the mountains dwells in a realm of magnificent flowers: the androsace helvetica (*left*), Mont Cenis bellflower (*below*), and mountain pink (*below right*).

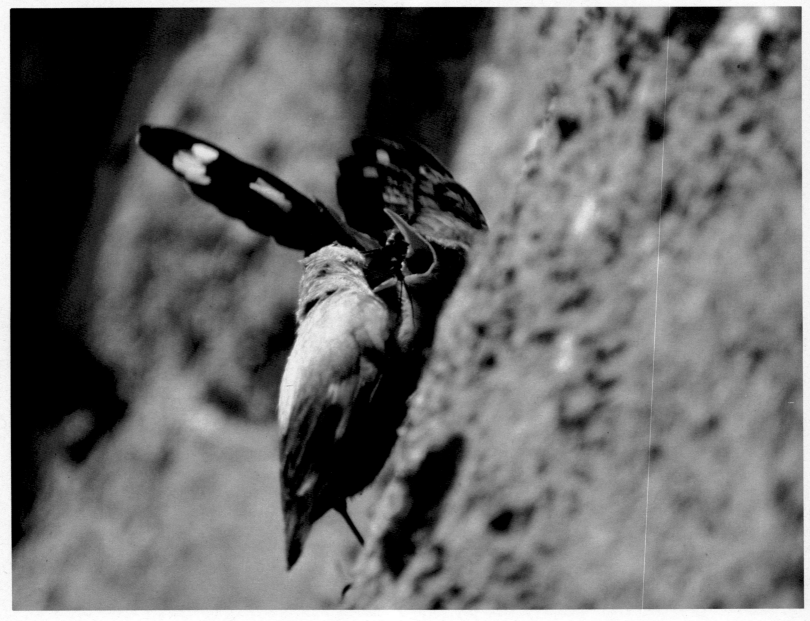

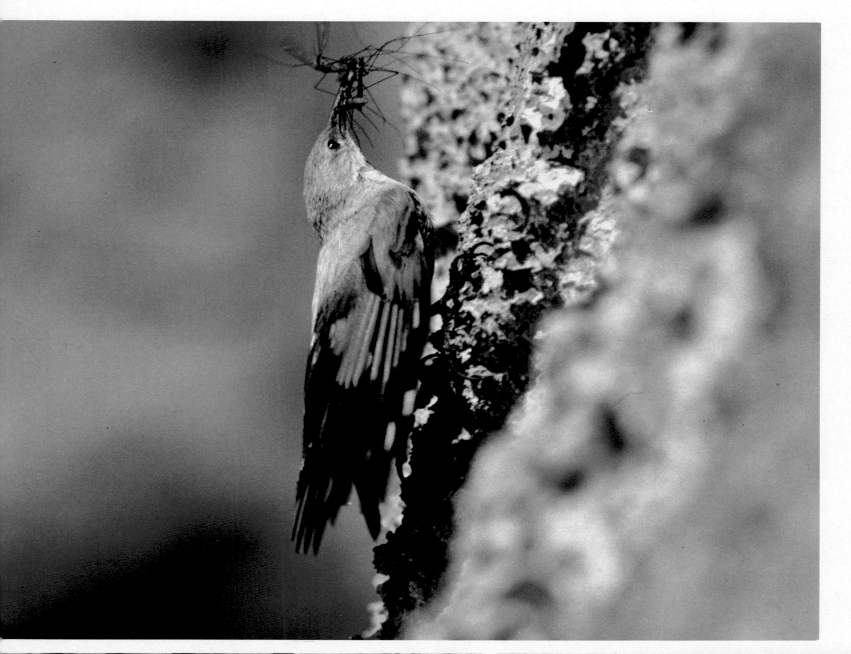

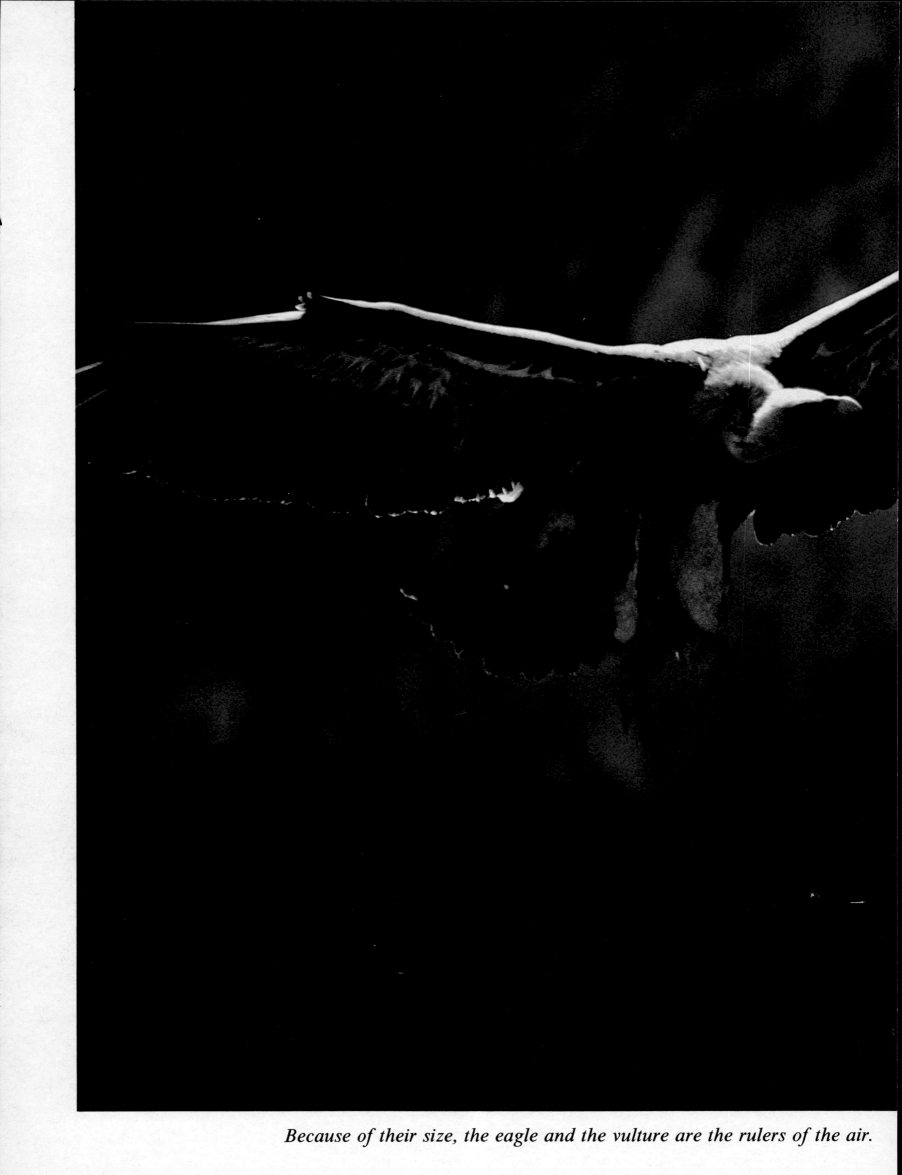

Because of their size, the eagle and the vulture are the rulers of the air.

A griffon vulture, carried by an updraft,
glides through its mountainous territory.

In the southern tip of Spain lies
one of the most important nature preserves in Europe:
the Coto de Doñana.

Adventures

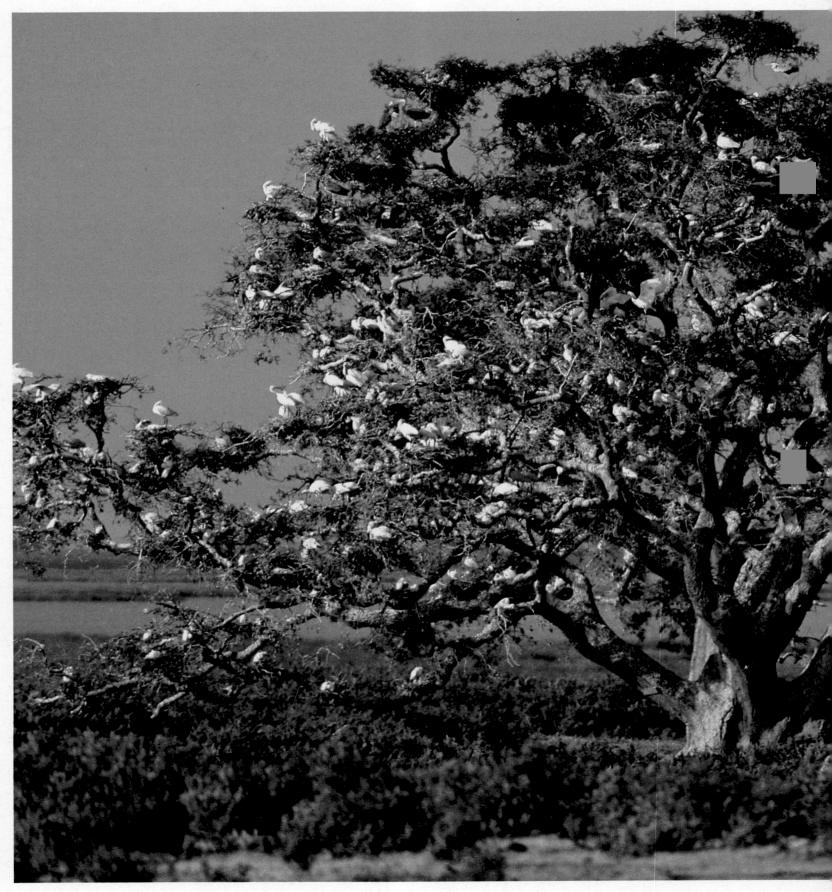

190

Wild Spain: on the Guadalquivir

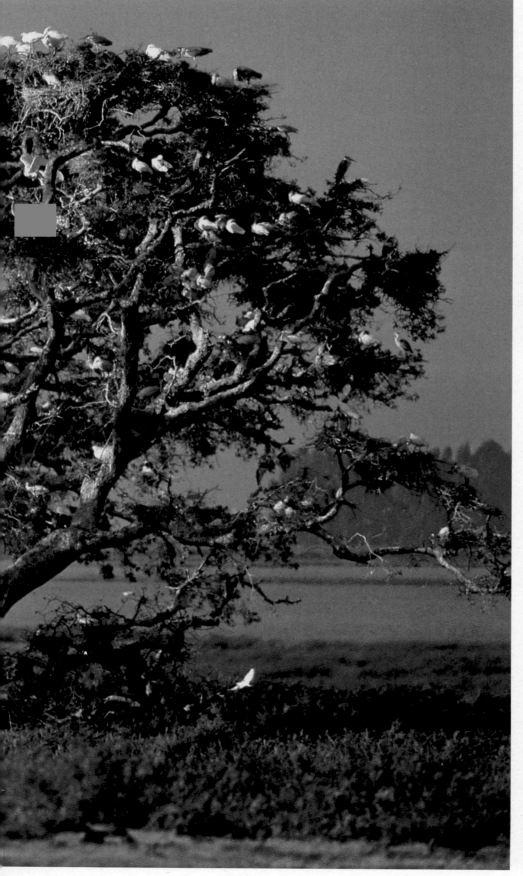

If there is a kingdom of birds, it is surely in the swamps of Andalusia.

Spoonbills, night herons, and cattle heron nest in a cork oak in the Coto de Doñana. The huge birds adorn the ancient tree like huge blossoms. The cattle heron, whose home is chiefly Africa, indicates by its presence just how close the Coto is to the Dark Continent. For migratory birds, the food-filled swamps are an important resting place en route to the warm south.

Spain is a bastion of tourism. Yet beyond the torrent of sun worshipers on the Costa Brava and the Costa del Sol, there lies an untouched natural paradise: the Coto de Doñana.

The life artery of this primeval landscape is the Guadalquivir River, which originates in the Sierra Nevada. Once, this waterway emptied into a delta in the Gulf of Cádiz. Since the Middle Ages, the highest sand dunes in Europe have been pushing the estuary branches of the Guadalquivir into a single bed at its mouth. From the air, the Andalusian river looks like a sparkling water artery amid the green oasis of the stony wastelands of Spain. But, as seductively as the green may beckon, it is deadly for human beings.

Six hundred square miles of land here remain underwater part or all of the time. The Spaniards call this area *Las Marismas,* or the swamps. Venomous snakes, leeches, myriads of mosquitoes, a muggy climate, and, in early days, malaria have caused people to avoid this landscape for thousands of years. This is why Coto Doñana and Las Marismas have been spared the destructive impact of human encroachment. And this is why the gigantic swamps have remained a nature sanctuary—unique in Europe.

Today, large portions of the Coto and Las Marismas are protected by law—as a national park. Visitors can enter the delta only with a special permit. For, at some point during the year, half of all species of European birds make themselves at home here, whether resting or looking for food on the long route to the south or brooding or hibernating or estivating.

Impenetrable wilderness, swamps, and savannah: the perfect preserve for wild animals

Rare predators like the leopard lynx, the wildcat, the European genet, and the mongoose have found a haven in this inaccessible wilderness. Here, the large and often rare diurnal birds of prey are safe and welcome: for instance, the moor buzzard, the Bonelli's eagle, the serpent eagle, the peregrine falcon, the windhover. Once, long ago, the unprotected parts of the Marismas in the north were also an impenetrable wilderness. There were no roads or paths, not even trails. Anyone who

Salt water and fresh water blend in the Guadalquivir.

It is a gigantic food reservoir for waterfowl. One constant guest is the collared pratincole (*right*), which hunts insects in the dusk. Spoonbills (*far right*) lovingly feed their young. With the flattened ends of their beaks, they sieve tiny creatures out of the delta and take them to their nests. Spoonbills live in large colonies, sometimes consisting of more than 450 birds. Braking gently, a spoonbill lands in the branches (*below*).

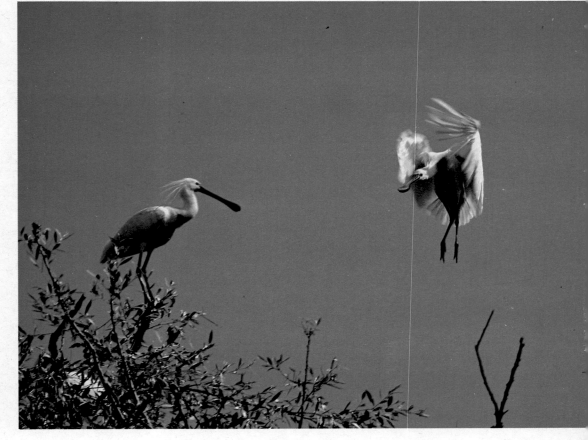

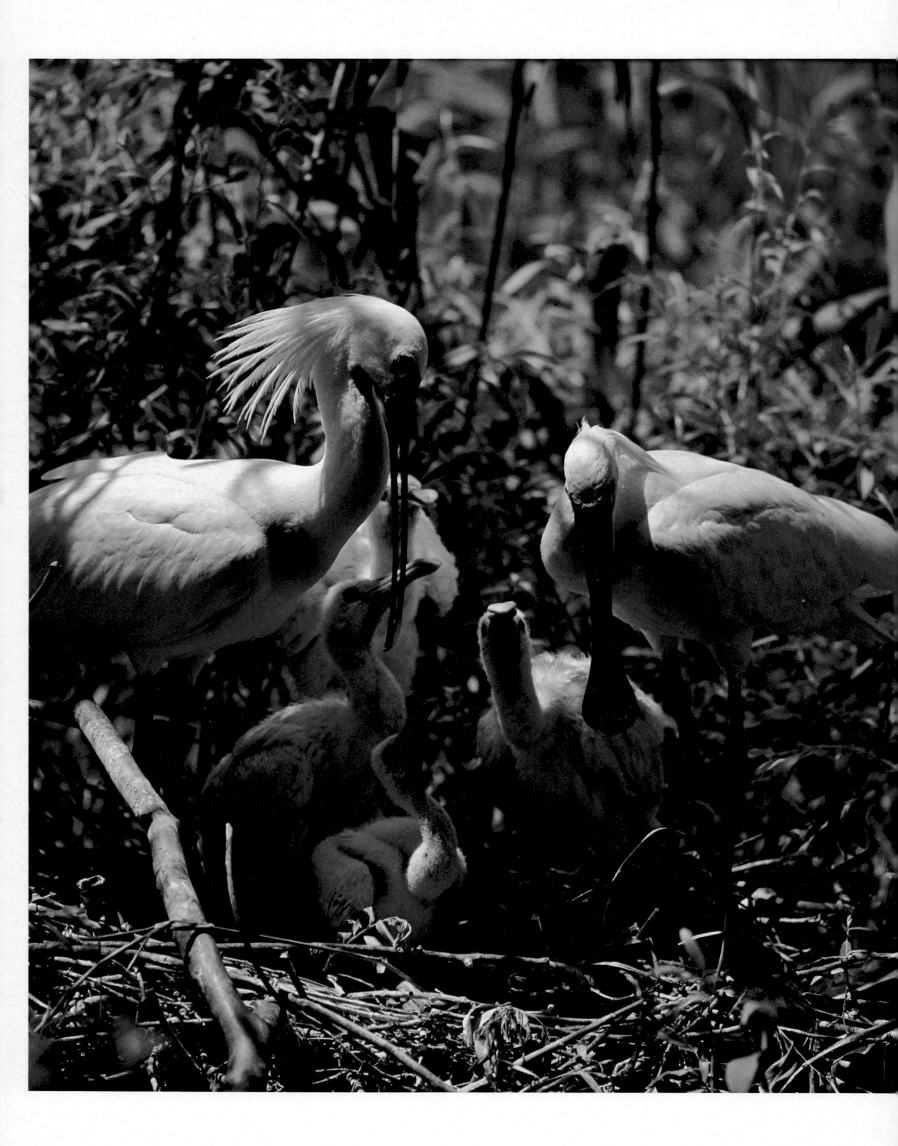

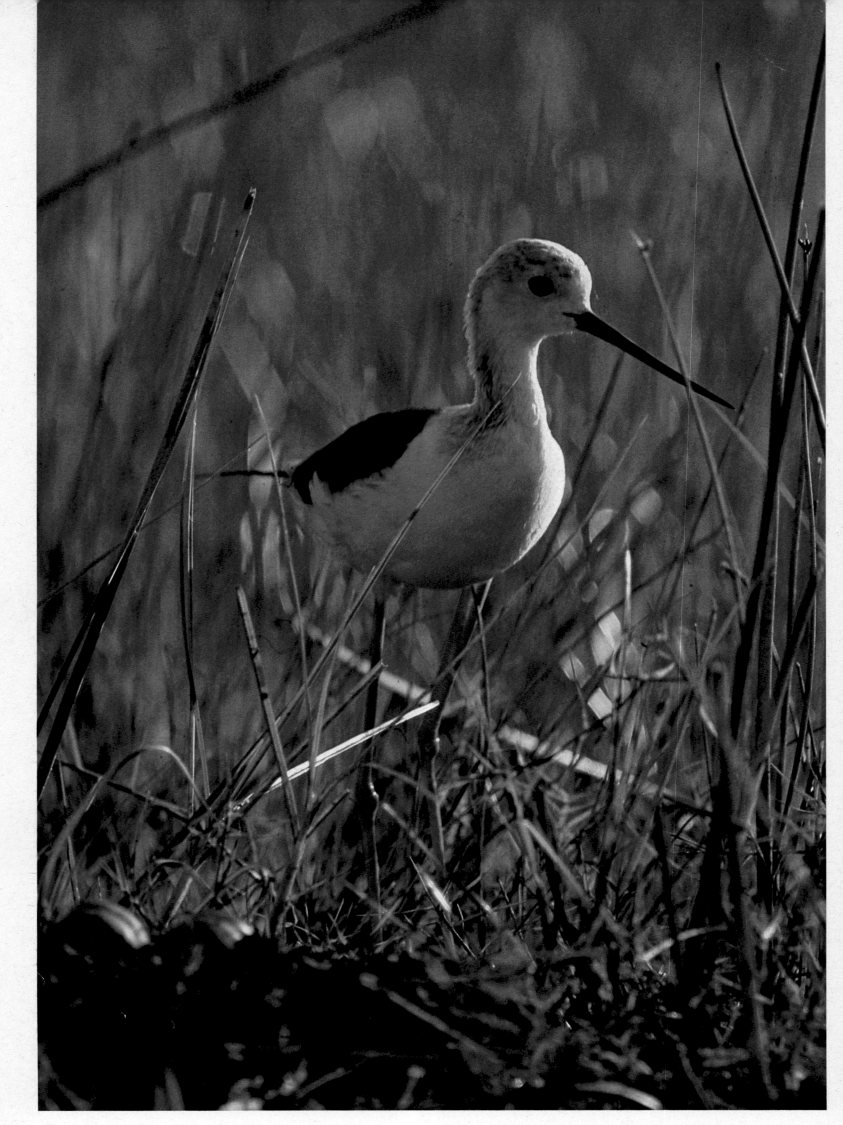

A bird paradise in the jungle of reeds

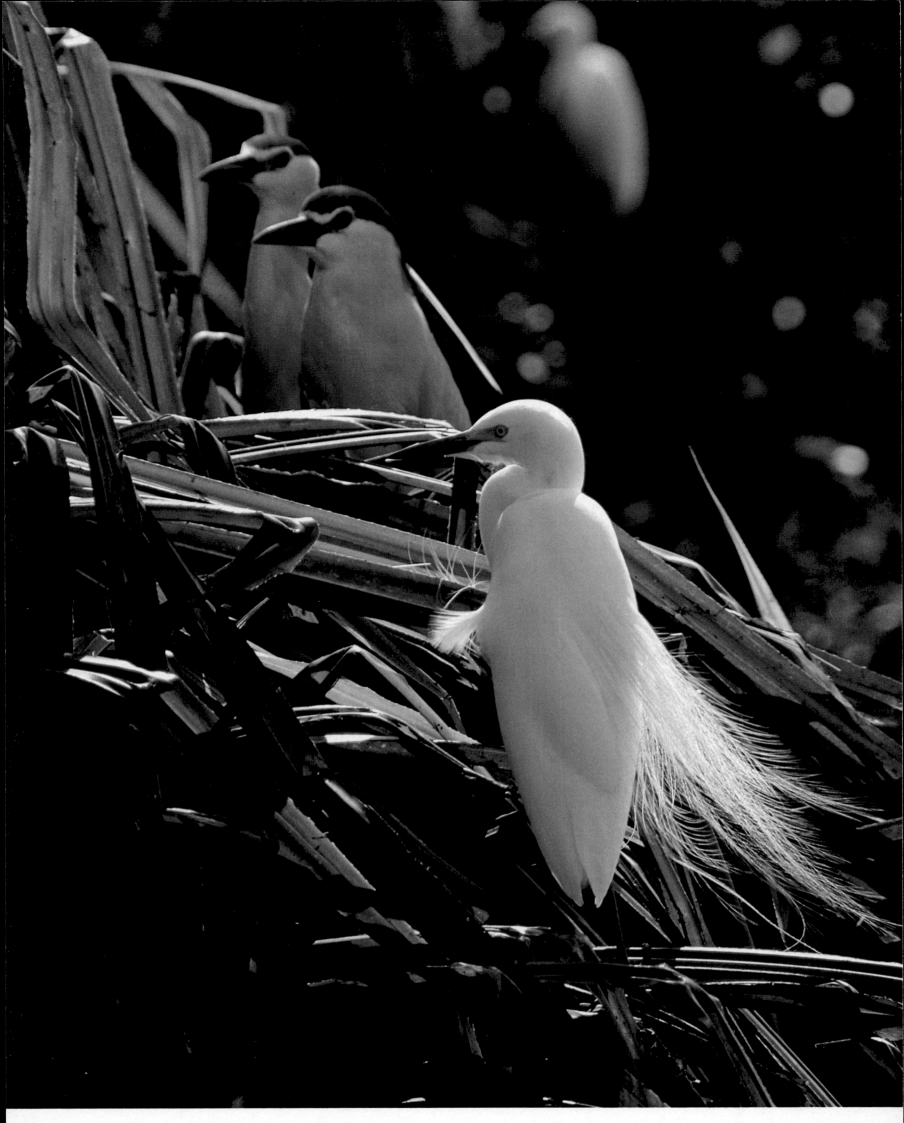

The black-winged stilt with its red legs (*left*)
is as much at home here as the night herons (*above*)
and the little egret (*below*).

195

A brackish swamp and a dry heath: the two are adjacent to one another in the Coto.

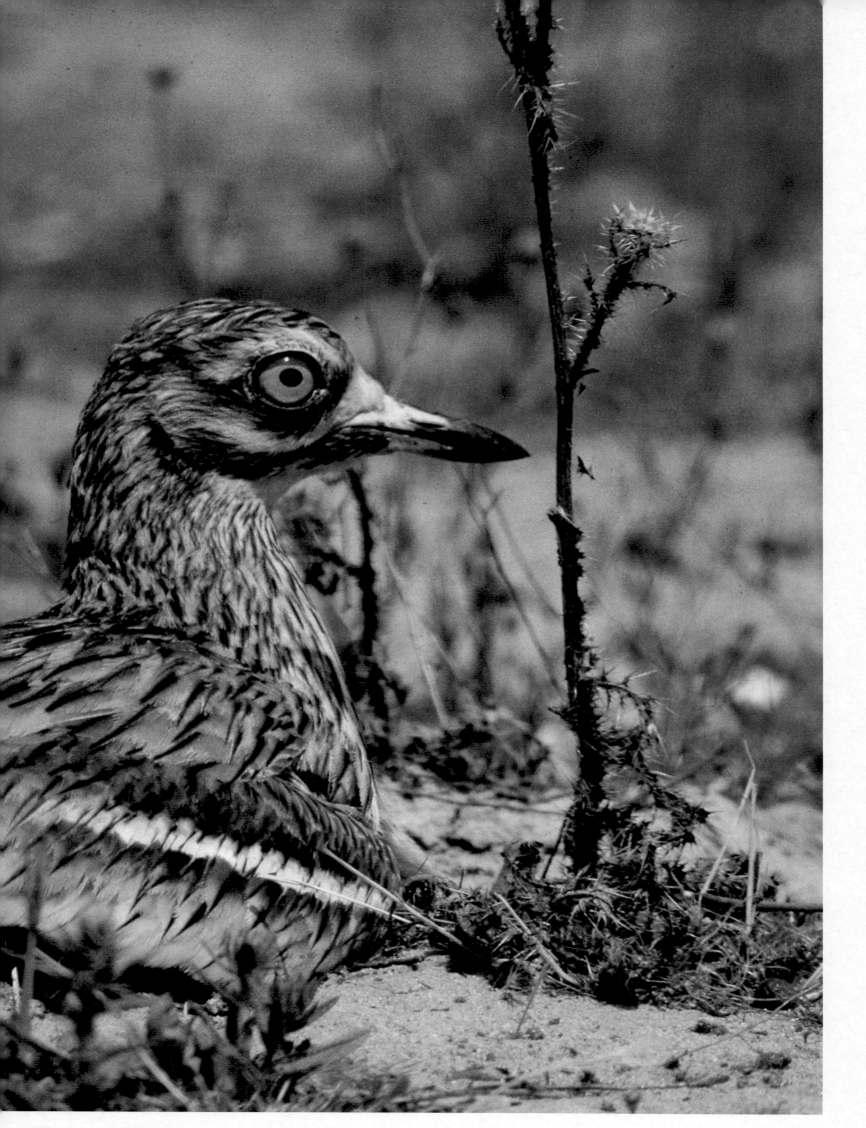

The eye of the stone curlew is like sparkling amber.
This night bird loves the open countryside of the Guadalquivir.

wanted to survey this territory needed a horse and a guide.

During the past few years, however, the threat of urbanization has hovered over Las Marismas. The fruitful swamps were turned into Spain's hothouse because spring comes twice to the Guadalquivir—at the vernal equinox and again at the autumnal equinox. Thus, gigantic rice paddies, olive groves, and cotton fields sprang up among the countless ditches and high dikes. The original landscape of flora and fauna was rigorously pushed southward. Any plant or animal that remained was fought and destroyed by chemicals and violence.

Salvation, at least for the rest of the delta, came from the World Wildlife Fund. This international organization bought two thirds of the swamp, which then became the basis for the Coto de Doñana National Park.

In the dry tree savannah, there is evidence of fallow deer, red stags, wild boar, foxes, and badgers. With a bit of luck, one can also find the footprints of the lynx. The park administration knows of only one hundred fifty to two hundred of these animals. Once, these cats, with their wonderfully patterned fur, were found throughout the Mediterranean area; their skins, however, proved too much of a lure for hunters, and many of the cats were killed off.

The tremendous crowns of the pines house colonies of common ravens and azure-winged magpies. The ravens often fly for miles to get fresh water for their broods, transporting it in their beaks. The azure-winged magpies, which live exclusively in the Pyrenean Peninsula and in the Balkans, pop up with surprising frequency in the pine forests.

A bird colony of 1,300 spoonbills adorns an old tree like gigantic blossoms.

Thousands of spoonbills and herons nest in the cork oaks, which are centuries old. From far away, these birds look like gigantic blossoms. When the young have hatched, ornithologists often count up to thirteen hundred birds on a single tree. (Incidentally, the only other places in Europe where one can find spoonbill colonies are the Dutch island of Texel, Lake Balaton in Hungary, and Neusiedler Lake on the Austrian-Hungarian border.) The spectacle of these birds is so stunning that the visitor may over-

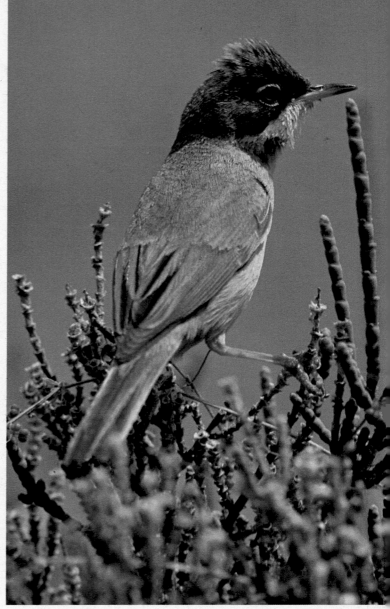

Here the birds feel at home.

The landscape teems with countless species of birds: the spectacled warbler, which loves to sing (*right*); the artistic penduline tit (*far right*), and the azure-winged magpie, which loves to sound warnings (*below*).

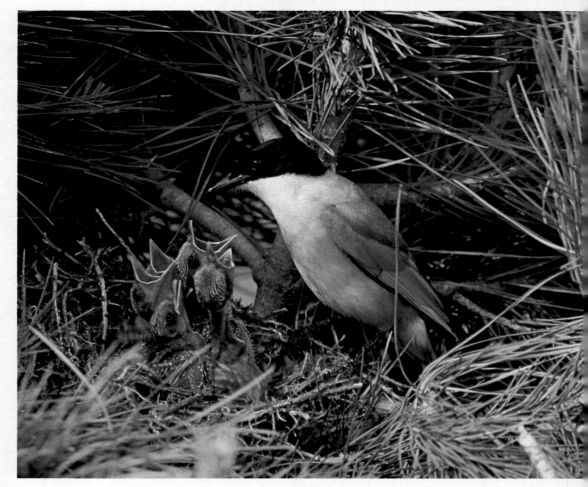

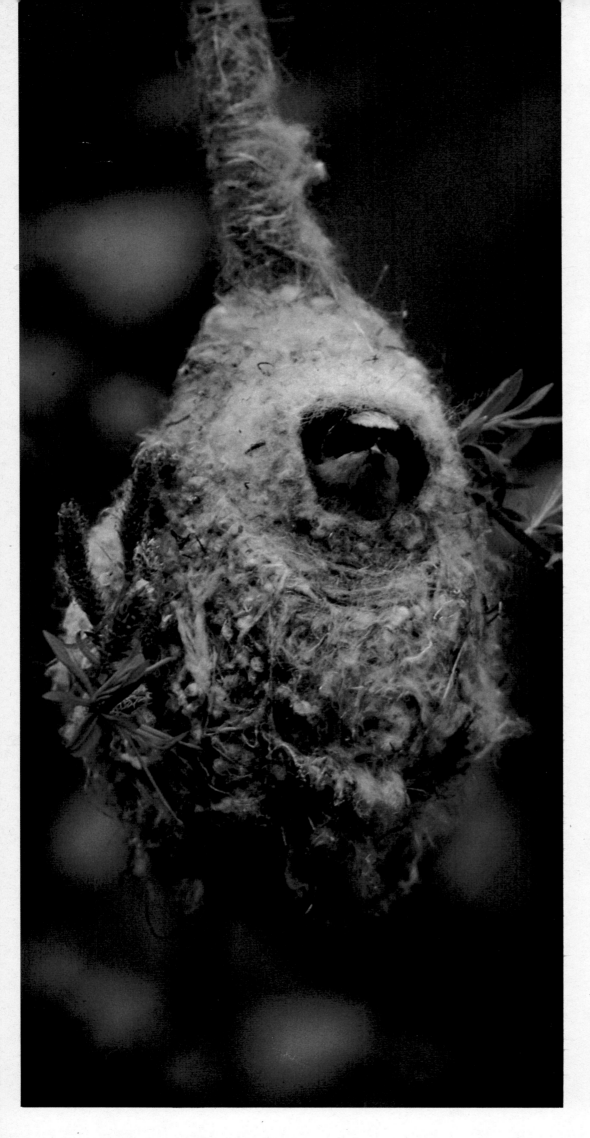

look the tremendous number of smaller birds.

All around their nesting site, the great gray shrikes and the woodchat shrikes have skewered lizards, mice, and insects on the thorns of acacias and the prickly maquis bushes. In the old, dead parts of the trees, there are bats; large-eyed bats, broad-winged bats, bulldog bats, long-winged bats and pipistrelles. These fluttering creatures go on nocturnal outings far into the swamps, where they hunt for rich insect prey by means of ultrasonic waves. In the spring, the female bat bears her

The Coto is the most important stopover for migratory birds. When they arrive, the din is ear-splitting.

young in painful labor. The newborn is then put in a pouch that the mother forms from the tail's patagium. The suckling baby creeps into the mother's breast fur; in this position, she takes it along on her nightly hunting expeditions.

One can frequently spot the golden oriole, the loriot, and the jay cuckoo, which seeks out only magpie nests for its offspring. An unusual spectacle is presented by the gigantic nests of the white stork, which are perfectly circular structures built of branches. During the migration of the birds, the Coto Doñana is the most important stopover on the western flight route of storks from northern Europe. At such times, the huge number of species of songbirds is simply indescribable. For them too, the pine crowns and the heath serve as a resting place. The area is then filled with a deafening hubbub of twittering voices and whirring wings.

Between the tree savannah and the heathland there are freshwater lagoons, the remnants of a delta branch of Madre de las Marismas,

It is a water wasteland swarming with life for five months. Then the plants take over the fresh and salty mud.

which was filled in by the dunes. The lagoons are framed by acid meadows and a wide belt of reeds. Amid sedge, reeds, bulrushes, and cattails, thousands of birds brood here in the spring. Others merely spend the winter. Here too, the

Nature flaunts her intense colors.

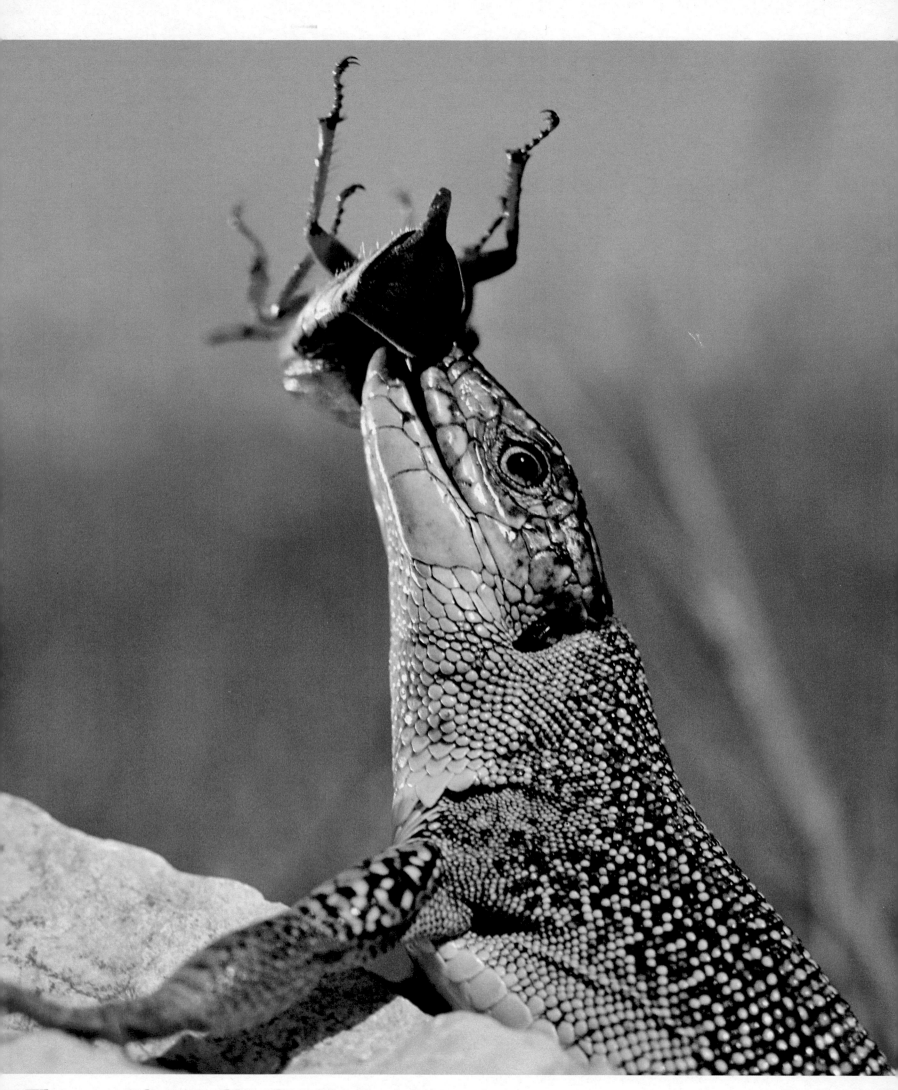

Wherever pink marigolds enliven dry sand dunes,
the iridescent green lizard goes hunting.

wealth of species is fascinating. The biggest lagoon, Santa Olalla, is a playground for the rarest water fowl in Europe: purple herons, white-headed ducks, red-crested pochards, and marbled ducks.

And the waders rest here too: sandpipers, plovers, and terns. A wealth of food is offered by the meadows, reeds, and water. The lagoons also contain Europe's largest salamander, the gallipato or Spanish newt, which can grow to a length of one foot. Rows of gigantic laughing frogs line the shores of the lagoon.

In autumn, the Atlantic rains transform the Coto Doñana and Las Marismas into a lake having a surface area of almost six hundred square miles. Within three months, two feet of rain turn Las Marismas into a water wasteland brimming with life. A gigantic and continuous layer of clay prevents the water masses from oozing off. From November to March, vast portions of the tree heath are under water. The growth of plankton and algae create a population explosion of small animals of many species. More than any other birds, the ducks, herons, and spoonbills are dependent on this paradisal reception after their long journey. The mild Atlantic climate seduces a million ducks and forty-five thousand wild geese into hibernating here and it lures 80 percent of all European graylag geese. When

they set out on the return trip to their homeland, the water is already retreating, and the free surfaces of the swamp are covered by a huge, rank carpet of bushlike glasswort and duckweed. Both plants can not only endure the high salt content of the water for a long time, they actually need the salt. The flowing buttercup stretches its white blossom stars across the watery surface.

Now come the migrant birds from Africa: grebes, terns, seagulls, little egrets, avocets, collared pratincoles, snowy plovers, redshanks, and black-winged stilts.

By the time the ducks and coots hatch their young, the colorful bee eaters arrive. Since there are neither banks nor rises, the bee eaters dig

When the swamps dry out, the fish and frogs die, hence, a banquet for vultures and rats.

their brooding trough in the ground of the "vaetas," the islandlike elevations in the swamp area. The June and July heat dries out the mud areas. Now, the spade-foot, one of the pelobatidae, hides in the cracks of the rifted mire.

Frogs and fish in the many pools and puddles are a welcome meal for birds and snakes. The stags also

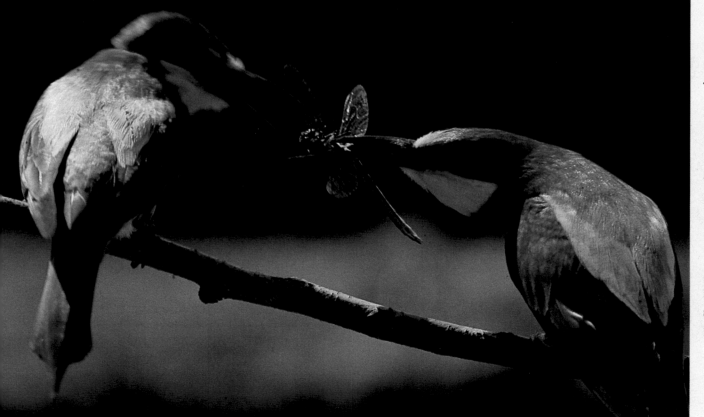

Europe's most colorful birds live here.

The common roller (*right* and *far right*) is the size of a jackdaw. It builds its nest in hollow trees. Like the bee-eater (*left* and *above*) which nests in ground troughs, the roller eats mainly insects, and sometimes frogs and lizards.

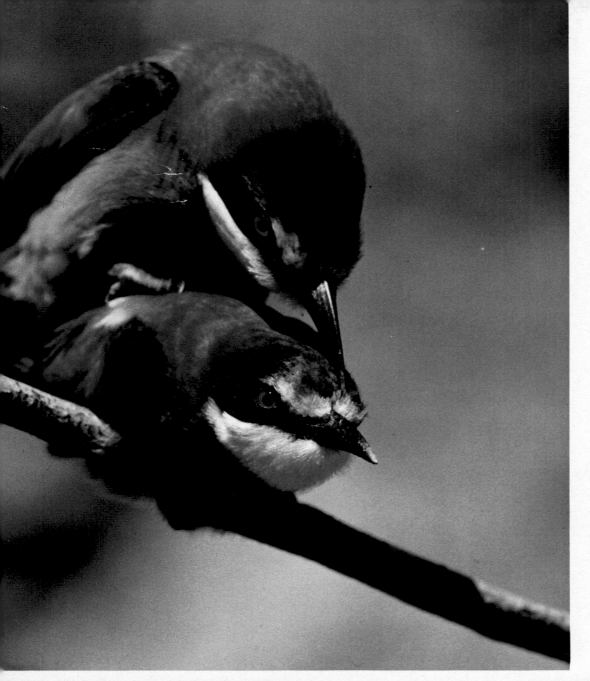

venture out of the pine and cork-oak forests, and one gets to see more wild boar, foxes, hares, rabbits, rats, and mice.

When the mammals follow the water, the vultures fly in wide circles in the sky, for the heat brings certain death to many fish.

In Las Nuevas, the inner part of Las Marismas, water can be found all year long only in a few pools and delta branches. This is where purple herons nest, along with duck colonies and whiskered terns. The purple heron uses a polished hunting technique. It strides silently through the water, standing rigid for minutes at a time until it finally harpoons a

The wild boars, which have no enemies here, devour the few eggs of the flamingoes.

fish with a sure swoop of its bill. By shaking violently, it knocks off the prey and swallows the "flying fish" head first. Along these brackish waters, European flamingoes nest; over six thousand of them live on the Guadalquivir. The only other place in Europe where they can still be found is Camargue in southern France. They have even given a name to one lake in Las Marismas: Lucio de Mari-Lopez or Lake Fla-

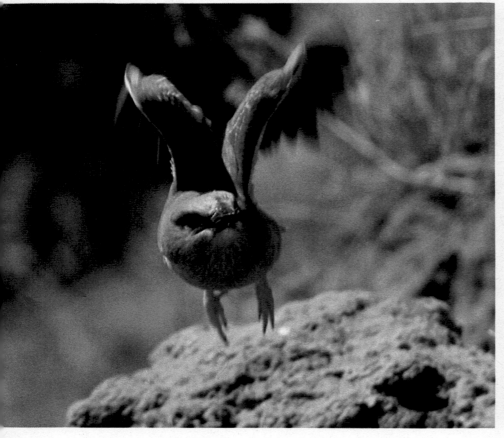

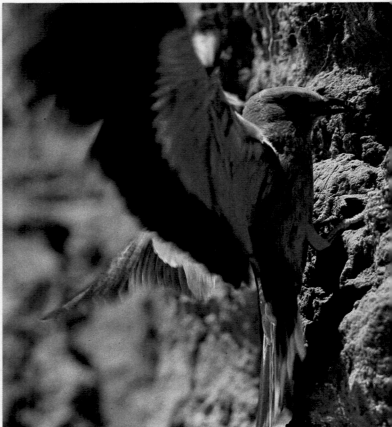

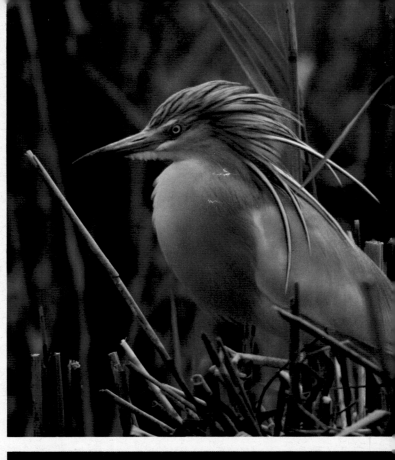

mingo, which lies between Guadiamar and Travieso. Flamingoes are not always to be found in Las Marismas, however. Scientists at the Reserva Biologica de Doñana have discovered why the flamingoes, which have been brooding here for four years, sometimes hatch no young. It seems that herds of wild boar plunder their nests. The wild boar of the Coto have no enemies. In earlier times, wolves and human beings helped keep them at bay, but hunting is officially prohibited in Las Marismas (which does *not* mean that there is no poaching). The last six wolves live in a preserve—the flip side of the ecological balance of "a protected landscape."

Using their crook beaks, flamingoes sieve tiny creatures out of the water: brine shrimps, algae, protists, and floating organic matter. Every day, thirty gallons of water run through a flamingo's bill—until approximately one hundred twenty thousand of the tiny shrimps fill its belly. The European flamingo prefers brackish and salty waters for nesting and for seeking food. Flamingoes nearly always live in large colonies; on Lake Flamingo, the colony numbers up to two thousand. When the majestic birds stride through the water, their plumage seems white touched with a breath of pink. But if the colony is stirred and the flocks are preparing for takeoff, then the white turns into a soft, then strong rosy color. These color changes are caused by the scarlet elytrons (or wing covers) when the wings are spread for flying. Viewed from afar, the swarm looks as if it were changing its hue.

One of the most interesting animals in the Coto and Las Marismas is the mongoose, the European mungo, which bears witness to the

The imperial eagle is the largest bird of prey in the Coto de Doñana.

prehistoric link between Africa and Europe. Separated from its forebears and relatives in North Africa by the Strait of Gibraltar, it developed into a distinct subspecies. The mongoose is known as a sneak thief. During the day, it likes to plunder bird nests, though it lives chiefly on small mammals and reptiles. But the most famous prey of this courageous creature is the snake. The mongoose does not have to fear the snake's poison; it bristles its fur, puffing itself up to twice its normal size, so the

A paradise for herons

The delta of the Quadalquivir offers an almost inexhaustible assortment of food for squacco herons (right), common herons (below), and shimmering little egrets (far right). Where river and ocean water mix, algae and many plankton species live year round, providing a lure for fish.

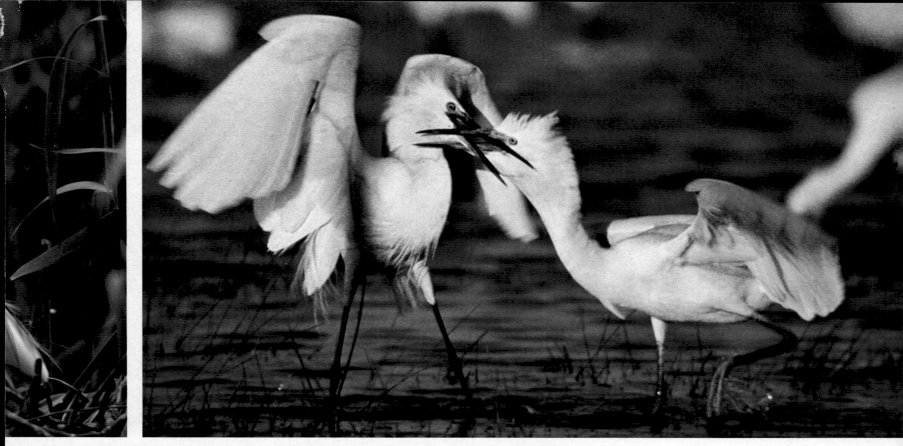

snake bites only the mongoose's fur. These animals can also endure a whopping portion of snake venom.

The mighty imperial eagle makes an unforgettable impression. This beautiful bird of prey, with a wingspan of over six feet, is the Iberian representative of this majestic species. Akin to the golden eagle, it has the latter's form, but also a distinguishing mark: the white pattern of its shoulder feathers. The imperial eagle is—along with the three vultures: the cinerous vulture, the Egyptian vulture (or Pharaoh's chicken), and the griffon vulture— the largest bird living in the Coto. In fact, the huge number of falconiformes here is amazing. Of the thirty-eight European species, twenty-seven nest in the Doñana pines and the watchtowers on the beach.

There is hope that the Coto Doñana and Las Marismas will survive. Once before, some three thousand years ago, the Guadalquivir supposedly prevented human beings from settling there. In 500 B.C., according to legend, the ruins of the city of Tartessus sank on a sand island off the delta—without a trace.

▶

No effort is too great for the little egret when it comes to maintaining spotless white feathers. The long plumes grow only at the breeding season.

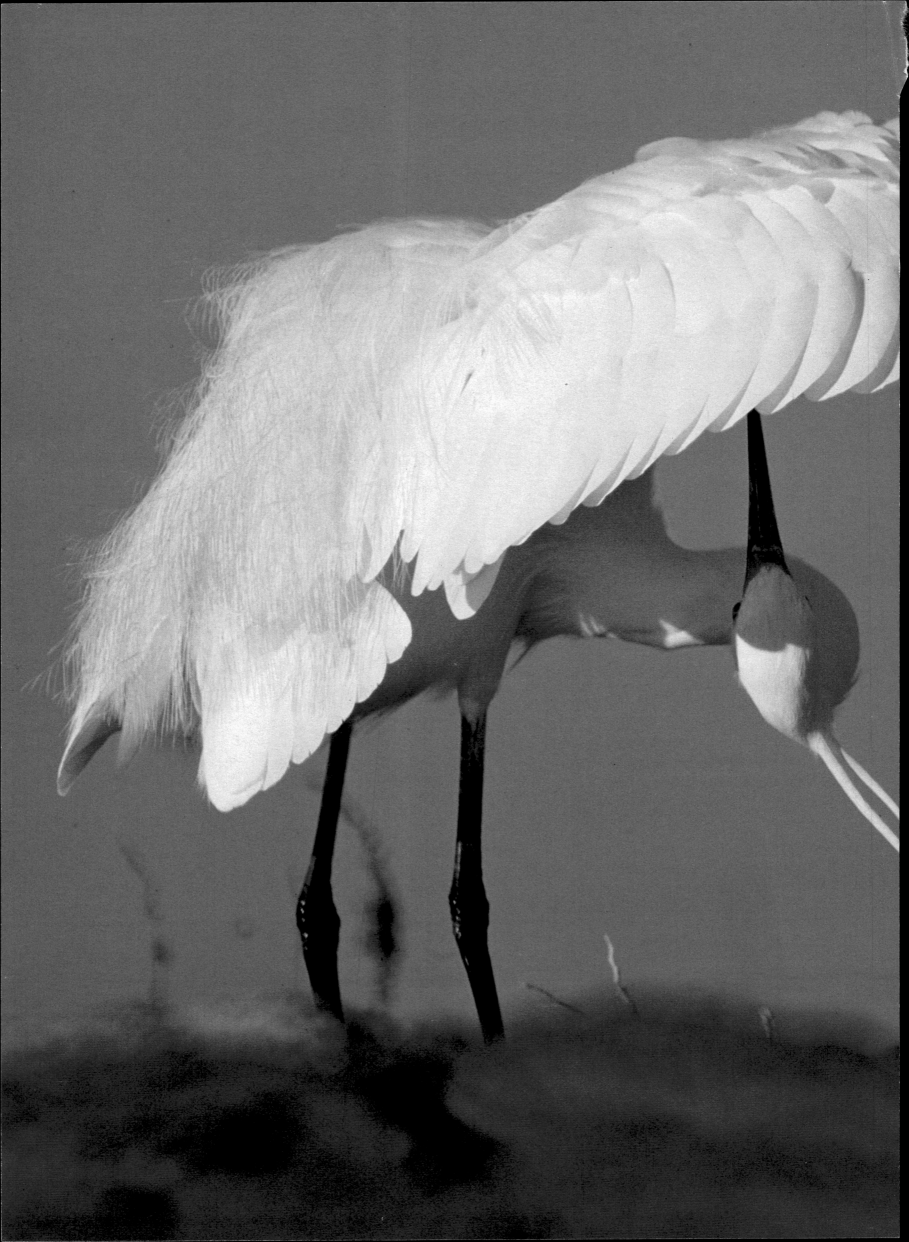

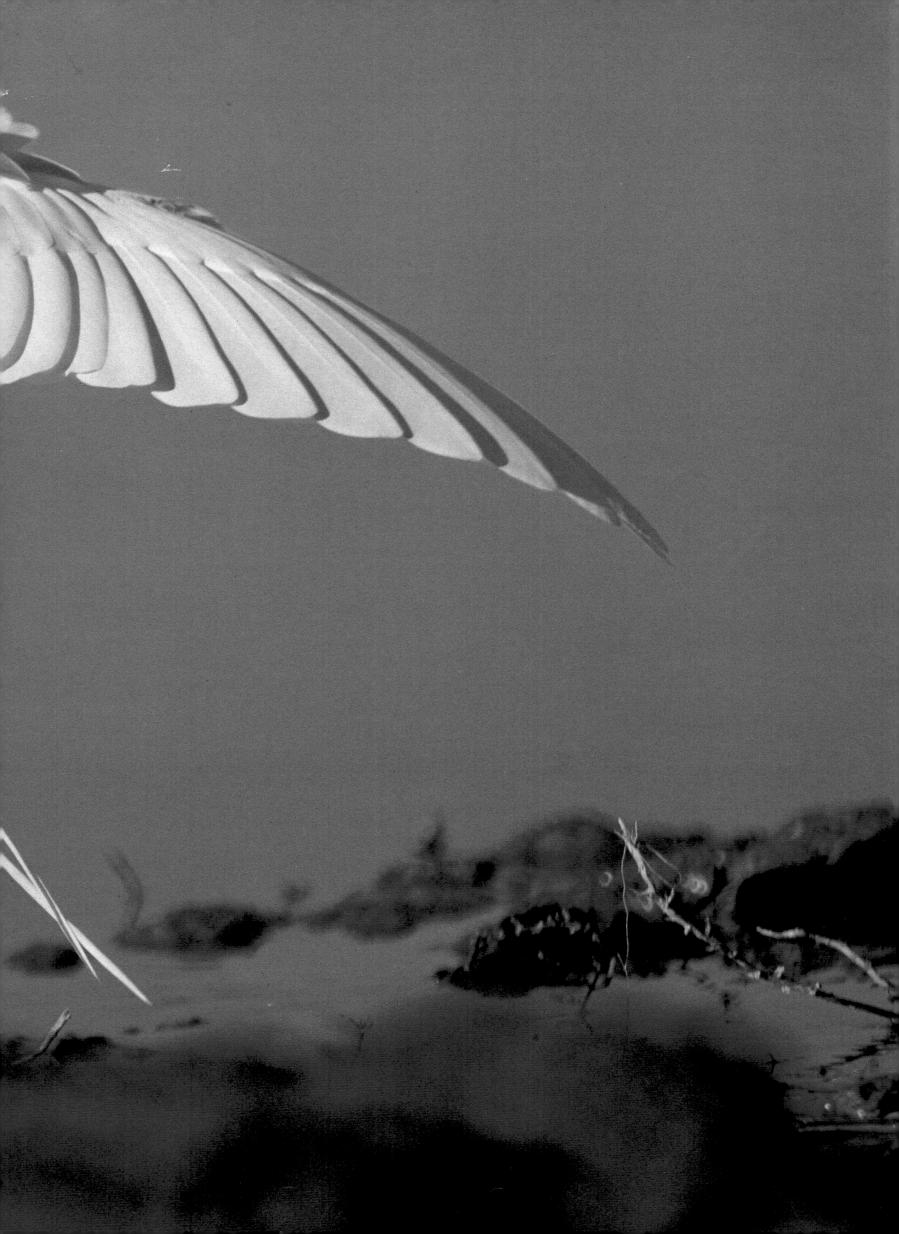

AFR

ICA

No other part of the earth—aside from the polar regions—is more hostile to life than the hot plains of the Sahara.

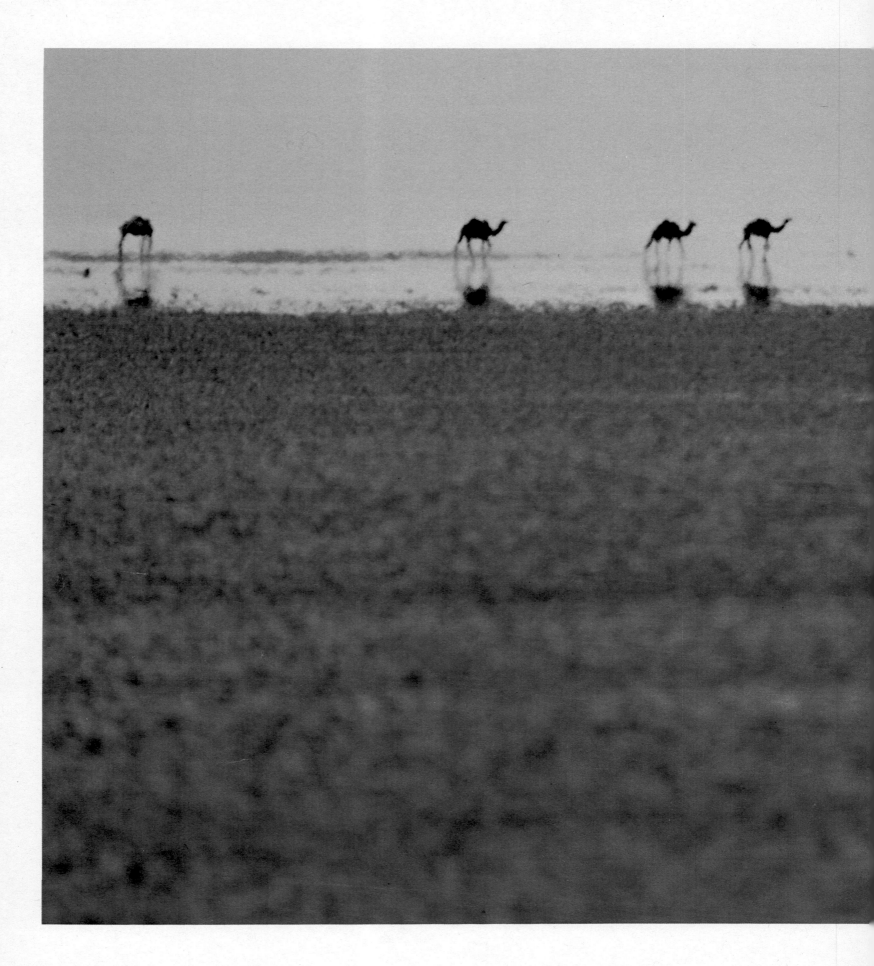

The Sahara Oven: Surviving in Hell

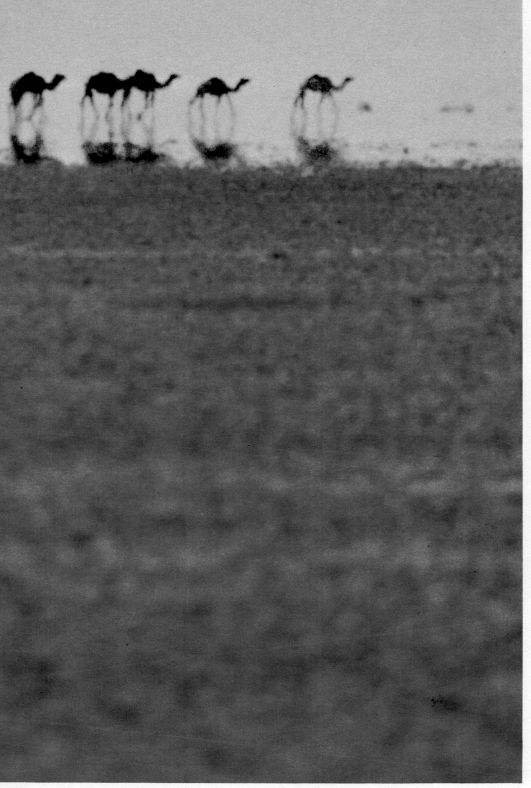

Reflections enliven a mirage.

The camels seem to hover like ghosts over the stony plain. In the red light of the desert sun, refractions create the vision of a body of water, a mirage that has spelled doom for many desert travelers.

Twenty-five hundred air miles from Europe, in the continent of Africa, lies the biggest desert in•the world, the Sahara. Comprising an area as large as that of the continental United States—over three thousand miles long and almost twelve hundred miles wide—the Sahara stretches like a gigantic wound from the Atlantic Ocean to the Red Sea.

Since protective vegetation or life-giving topsoil are absent, we are able to observe the record—and fruits—of millions of years of geological history. The Sahara also demonstrates with almost ghostly clarity what our planet could look like some day. A ruthless annihilatory move by industry and agriculture has been misleadingly termed "cultivation"; under this banner the trail has been blazed for the certain death of areas that once had a rich, abundant plant life. Long ago, the endless sand seas, gravel fields, rocky wastes, and mountain deserts of the Sahara were green and fertile land. It was not so long ago, however, that the North African forests flourished. Many fantastically beautiful cave paintings, about seven thousand years old, depict these bygone riches of the North African landscape. The prehistoric artists were hunters who lived in a true never-never land teeming with elephants, giraffes, leopards, and all sorts of wild animals from the forests and savannahs.

When the Ice Age ended in Europe, the climate changed in North Africa. It became hotter, and the heavy rainfall more infrequent. The hunters were succeeded by cattle raisers who were the first to "cultivate" the land. Giant herds grazed in the wide valleys and, later, on the mountain slopes as well. The forest at the northern edge of the present-day Sahara fell victim to the Carthaginians, who needed wood for their ships.

When the wind blows away the fertile soil, the desert comes—unstoppable and forever.

Around 1000 B.C., horses appeared and the cattle herds followed the wild animals toward the south. Before long, the horses could not find enough to eat either; they were replaced by camels. And the cattle breeders were replaced by nomads in the dry landscape, which grew hotter and hotter. From the begin-

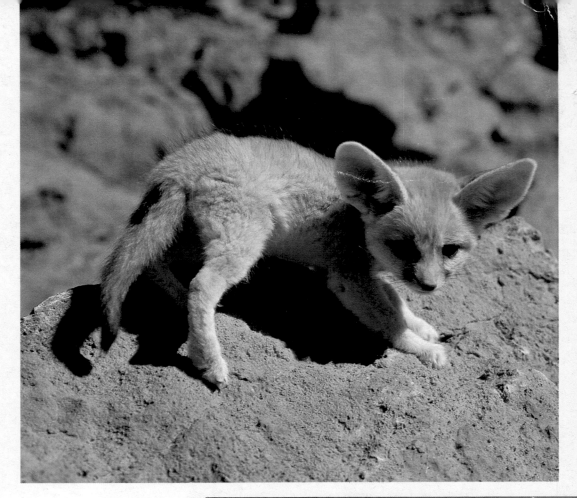

The desert is alive— despite deadly heat.

The fennec or desert fox (*above*) usually emerges from his underground lair only at night. Locusts (*center*) and the sand grouse (*far right*) are true masters of survival in this environment, where grass grows even in sand that is ninety degrees Centigrade.

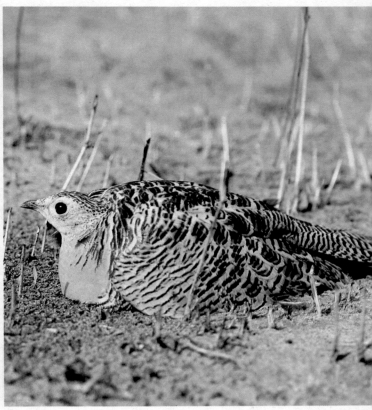

ning of Christianity, the Sahara has been spreading north and south at a startling clip. The evaporation of water has had disastrous consequences—especially in the Sahel zone, the parched borderland between the desert and the savannah. Here, enormous herds of sheep, goats, and cattle, plagued by hunger and thirst, are devouring the grass and bushes down to the roots, continuing the disastrous chain reaction that turned the Sahara into a desert. When the plants die out, the loose topsoil becomes flotsam in the wind.

Any creature that wants to survive here must be able to endure the

Any plant or animal that wants to live must endure the lethal impact of the sun—or hide.

stranglehold of the sun. During the day, sand, gravel, rock, and detritus can get as hot as one hundred eighty and sometimes even two hundred degrees Fahrenheit. But at night, the temperatures sometimes plummet to below freezing. The mountains of the Central Sahara are ten thousand feet high and even higher, and the nocturnal frost wreaks terrible havoc; entire massifs burst and mountains split.

The past few millions of years

213

have seen volcanic eruptions, which also helped to form the Sahara. The lava that flowed into the valleys still lies there, hundreds of yards thick. In contrast, the craters, aggraded by loose masses and often reaching heights of ten thousand feet or more, were eroded by wind and water. The basalt domes have remained unmistakable memorials to past eras, like the towers of giant spectral cities. The rivers deposited tremendous masses of debris in the plains. Here, the wind separated the lightweight sand from the gravel, piling it up into oceans of drifting dunes. These "mountains" can be over a thousand feet high, and the chains of dunes frequently reach a length of sixty miles or more.

The sandy landscapes of the Sahara occupy but one third of the entire area. So consistently beautiful are they that one tends to overlook the deadly effect their movement has on the desert. Yard by yard, they are choking the only remaining green areas in the desert—the oases.

It may sound grotesque, but there is a fish that actually swims in the Sahara sand: the sand skink or *poisson de sable*. Although it belongs to the smooth saurians (lizard family), the skink actually looks more like a fish than a reptile. It requires loose sand in order to "swim." Shielded against the sunlight, the sand skink can dive for insect larvae and other small animals as well as swim away from its pursuers.

In the vicinity of the oases, the pursuers are many. Hyenas and

Estivation is the perfect survival tactic. A desert snail can wake up years later.

jackals are the largest, followed by the fennec, the falcon, the horned viper, the raven, and the great gray shrike—all of which are just as deadly for the skink. Eating, fighting for water, protecting oneself against the sun are challenges that have led to the strangest characteristics and patterns of behavior in the desert. Eating, hunting, and breeding take place when there is little sun: at dusk and at night. Once the force of the sun vanishes, there is a stirring in the sand, on the rocks, and in the gravel of the shingle plains. Then, the head of the horned viper zooms out of its sandy hiding place as it tries to catch a jerboa that's whisking past. The extra long venomous fangs of this most dangerous of all North African desert snakes need only touch the

The fight must go on despite the heat.

During the mating season, thorny-tailed iguanas must fight violently for their territory. However, no fight ever ends in blood. As a rule, the most decisive test of strength is when one of the "fighting cocks" manages to toss the other over his shoulder.

body of the little jerboa to make it die.

A desert animal makes no excess movement, for motion saps energy and, above all, precious water. There is only one animal that can survive for years without water: the desert snail. Once, in a London museum, such a creature slept for four years, until it was placed in water, which brought it to life. Scientists call this phenomenal sleeping process aestivation.

The gerbil, which also lives in the sandy wastes without drinking, takes vital water from its food. The gerbil is preyed upon by scorpions and wind scorpions. These arthopods, often six inches long, have discovered a strange method of saving water. When mating, the male scorpion presses a sperm capsule into the female's back, so that the fluid necessary to preserve the species will not evaporate too quickly. As for vital moisture, the scorpion sucks it out of its prey.

The Mangan grasshopper is a true quick-change artist. The heat causes the rock rubble in the Sahara to form a coat of metallic secretions from inside the stone. Brown debris turns black. The Mangan grasshopper adapts, looking deceptively similar. Naturalists still do not know how it survives on the hot rocks or what it eats.

On the other hand, its distant relative, the desert locust, has been observed by human beings for thousands of years. Swarms of desert locusts have regularly brought famine to human civilization. Scientists have generally researched the phenomenon of the locusts, which was interpreted as fate or providence centuries ago (and even today by the Arabs). The gigantic swarms of huge, iridescent, omnivorous insects are generated by favorable condi-

Locusts eat anything they get their feelers on: plants, animals, even wood and paper.

tions in the breeding areas. Rainy winters offer a paradisal life for the harmless-looking little grasshoppers in the wadis south of the Ahaggar Mountains. However, the greater the number of locusts in one place, the more likely that the next brood will be a swarm. Then, as though at a secret command, millions of fattened locusts rise into the air. The ever-present tradewinds carry them to places thousands of miles away;

215

Agamas feel comfortable only at high temperatures.

These minidragons lie in ambush waiting for food
even in the infernal heat of the desert sun.

wherever they stop to rest, they rain down like artillery fire, devouring everything. They do not even distinguish between bushes, trees, or clothes lines. The Arabs aptly call them the "teeth of the wind."

The loveliest animal in the desert is probably the fennec. With its oversized ears and cute little face, it looks very much like a cat. The mammoth ears of this nocturnal animal are crucial; the fennec can hear every sound, no matter how slight, made by a bug or a mouse. During the day, the ears, which are well-supplied with blood, help keep the animal cool.

The fennec, too, is not directly dependent on water, though its larger relative, the desert fox, needs to drink, just like the jackal and the hyena. Thus, the track of the fennec is anything but a sign of a nearby well or gelta (a spring pond between mountain rocks). In the Ahaggar Mountains, the geltas are the centers of plant and animal life.

One of the experts at mastering the desert climate is the mastigure. This saurian, which can grow as long as two feet, normally feeds on plants. Like any other lizard, it is unable to produce body heat. For this reason, it requires a thorough sunbath every morning in order to come "alive." If the temperature reaches over one hundred degrees Fahrenheit, the mastigure's color rapidly changes from dark to light. In this way, it can do a better job of reflecting the sun's rays. At night, when the cold immobilizes its body, the mastigure creeps into a rocky

niche or under a stone, blocking the entrance with its spiny tail.

The sand agama or toad lizard sinks into sand in the oddest way. Its body vibrates and shakes itself down into the cooler strata. Here, the animal is safe from drying out. Lizard armor has two virtues for saving water: During the early morning hours, dew gathers under the scales, and these scutes seal the body hermetically. Moisture can leave the body only through apertures. If the animal gets too warm, it simply opens its mouth.

The dromedaries are said to have phenomenal characteristics for survival. These mammals, huge by desert standards, have bodies that are geared to withstand the heat from head to toe. Without water, how-

Only the addax truly lives without water. Scrub grass sates its hunger and quenches its thirst.

ever, they cannot live for more than a few days. Dromedaries are descendants of the wild two-humped camels, which can be found now only in the Himalayas. For almost six thousand years, dromedaries have been the domestic animals of nomadic tribes in North Africa and Arabia; no other creature has helped as much as they to make the desert inhabitable for man.

In the Ahaggar and Tassili mountains, there are a few examples left of another survival artist, the addax.

Adapting to the environment is half the battle.

With serpentine movements, a desert viper burrows into the hot sand (*top left* and *center*). A horned viper (*far right*) has already taken the plunge. It now lies in ambush waiting for mice, lizards, and birds. Ephemeral art works of the wind: drifting dunes (*right*) on their restless march through the Sahara.

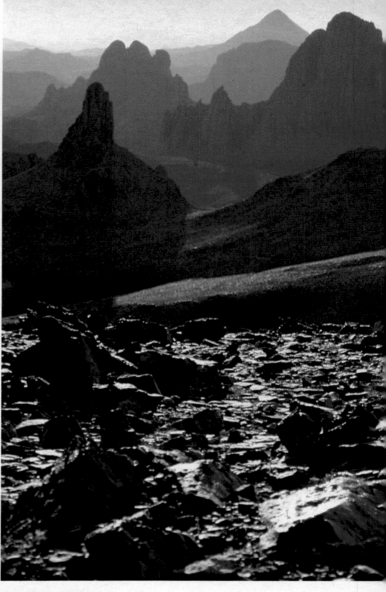

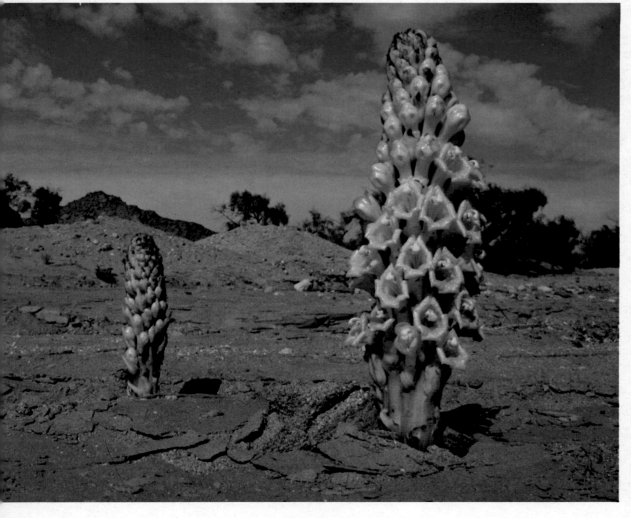

This antelope gets sufficient water for many months from the scrubby vegetation it eats. In dry years, it does without water entirely. In order to find enough food, it goes on long journeys to the south, far into the sandy wastes of Tanezrouft and Ténéré. Ruthless hunting has reduced to a minimum the once tremendous stock of these animals as well as the rock-dwelling aoudads or maned sheep.

An effective means of desert survival has been developed by the pterocle or sand grouse, whose clutches can be found far from the watering holes and oases. The further away they lay their eggs, the fewer predators there are. They raise their offspring three and more miles from the nearest watering place. Without water? The mystery has finally been solved. The father transforms his breast plumage into a water tank. He dips his chest into the water, spreads the deck feathers, and lets the matted fluff soak up fluid like a sponge. The deck feathers then protect his "cargo" from evaporating as he soars home. The chicks drink the thirst-slaking liquid like mammals. Nature ad absurdum!

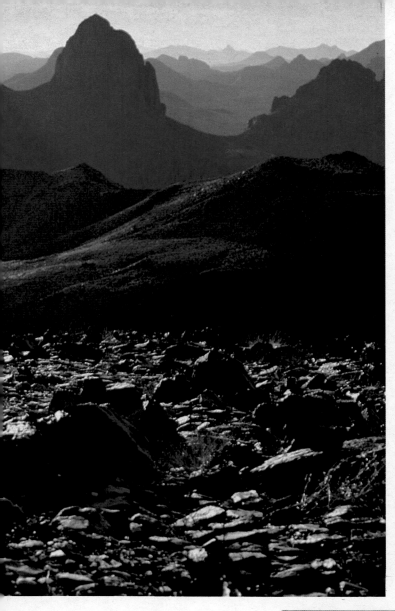

There is life even in the stone deserts.

Only a scant third of the Sahara is covered with sand dunes; the rest of this largest of all deserts is bleak mountain wilderness (*left*). The hermit ibis (*far left*), the elephant shrew (*bottom right*), and toothwort species with yellow blossoms (*bottom left*) show that this lunar landscape is not completely lifeless.

are a remnant of the Mediterranean past. Another technique for survival has been developed by the "wandering tree." No bigger than a bush, it follows the drifting dunes and even changes directions with them. Scientists have not quite figured out this enigma, but it has something to do with the roots, which spread out with the sand and the wind.

The oases look like green splotches in the dismal yellowish brown and black landscape. Date palms and other cultivated plants line these islands of moisture in the desert "sea."

The oases are usually supplied with water by subterranean rock strata. Deep under the earth, as petroleum drillings have revealed, lies an aquiferous or water-bearing stratum. The French hydrologist Sovornin has discovered a tremendous underground sea three times the size of West Germany. Here lie billions of gallons of unused water. Now that the oil supply is limited, desert-dwellers are beginning to bore down to this gigantic store of water, and enormous modern oases, similar to plantations, are coming into existence. However, for every new oasis, a natural watering place in the desert must die, for even the subterranean water supply is limited.

A father—and a bird at that—nursing his young!

All animal life concentrates on those desert areas that contain vegetation. After the winter rainfall,

The desert can turn green and flourish for a few days. Then life vanishes, often for years.

large portions of the otherwise bleak wasteland turn into a short-lived sea of blossoms. Practically over night, heat-resistant seeds burst into desert flowers. The landscape then seems enchanted. The Arabs use the word *akheb* to describe the green and gaily colored mantle of the wadis and slopes. But just two weeks later, the floral magic is gone. The seeds are scattered and capsuled for another year's wait until the next rain.

A reminiscence of the water-rich eras of the Sahara, olive trees have survived for three thousand years in the Air Mountains south of Ahaggar. Likewise, the seventy Duprez cypresses in the Tassili Mountains

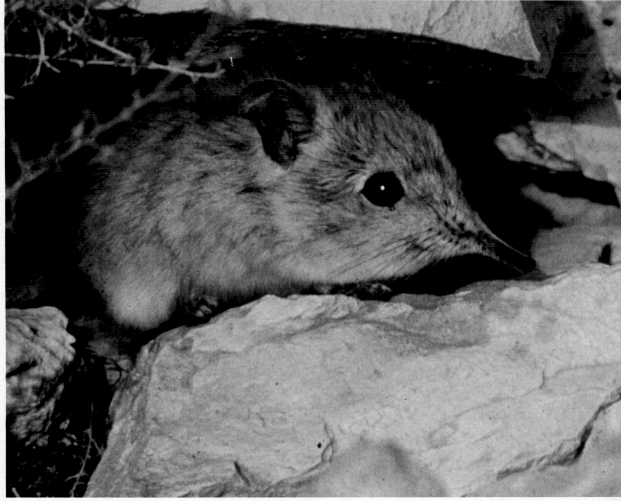

The areas with the most animals are not the tropical rain forests along the equator but the vast grassy plains and savannahs.

Hunters
The Savannah

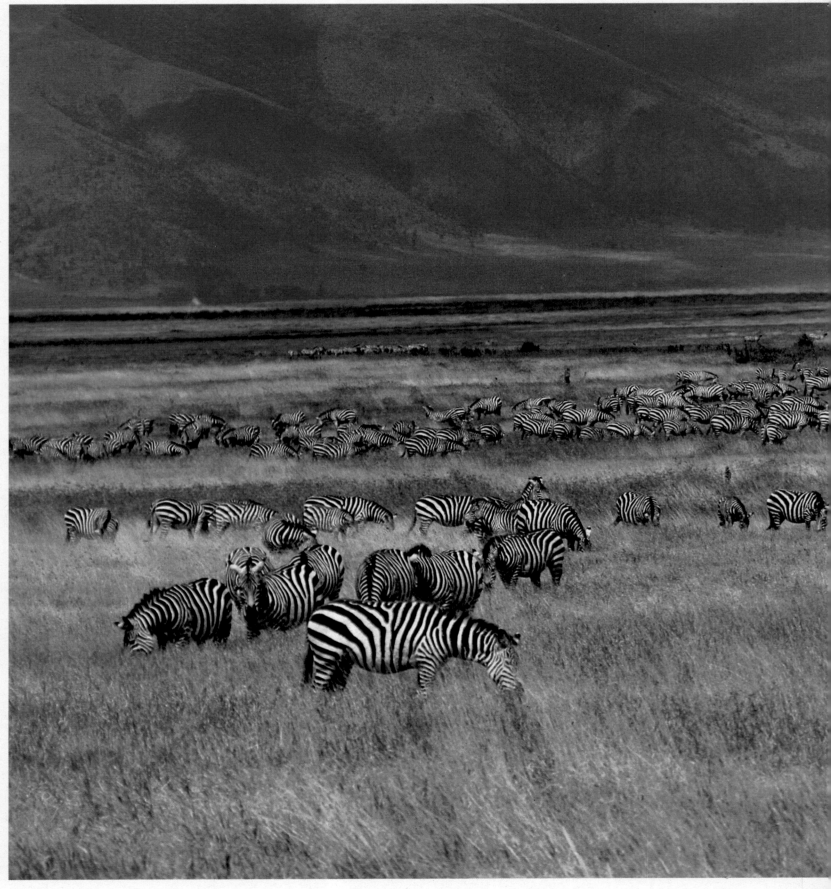

222

and the Hunted: and its Wealth of Game

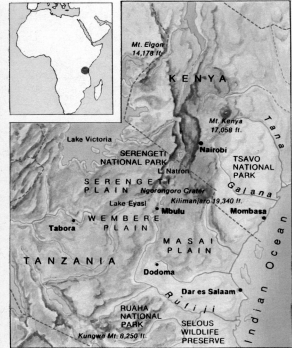

The large herds of plant-eaters are among the hunted.

In the spring, the Serengeti, a sea of grass, harbors more than a million hoofed animals. Giant herds of gnus, zebras, and gazelles then populate the high plateau of northern Tanzania with its rich supply of food.

To many people, Africa means the savannahs, those giant tropical plains of the dark continent. Africa's savannahs stretch from the Cape of Good Hope in the south to the Red Sea in the north and run parallel to the equator. Unlike the jungle and the desert, the savannahs are visibly full of large animals; they are home to the elephant and the lion, the giraffe and the leopard, the ostrich and the hyena, the hippopotamus and the crocodile.

Because of climatic differences, the African savannahs are subdivided into three vegetation zones. The moist savannahs offer a year-round home to gigantic animal communities; but the dry savannahs and the thorn savannahs, with their six to eight months of dry season, force the great herds of gnus, zebras, giraffes, antelopes, gazelles, rhinoceroses and elephants to wander into new grazing areas.

The savannah belt between the Sahel zone in the north and the Kalahari Desert in the south contains most of the national parks, protective zones, and sanctuaries for African wildlife. My expeditions into the animal kingdom have led me to nearly all the savannahs in Africa, and I consider the most fascinating to be the ones east of Lake Victoria, between Ngorongoro, Mount Kilimanjaro, and Mount Kenya. Here we find the Great Rift Valley, a geologically interesting ditch formation—the result of tremendous continental shifts of the earth's crust. Twenty or thirty million years from now, a new ocean will exist here. Its birth has already begun; the chain of lakes in the rift is filled with corrosive brine from inside the earth.

The king of beasts is not all that courageous. Often it lets the hyena hunt for it!

The southernmost point of this continental drift is the Ngorongoro Crater, not far from the famous Olduvai Gorge, where the prehistory and early history of mankind have been excavated. Its twelve-mile diameter makes the Ngorongoro the largest extant crater in the world. Geologists actually designate it as a caldera surrounded by a highland of giant craters. In the middle of the crater there is a soda lake. Despite its tremendous altitude—six thousand five hundred feet above sea

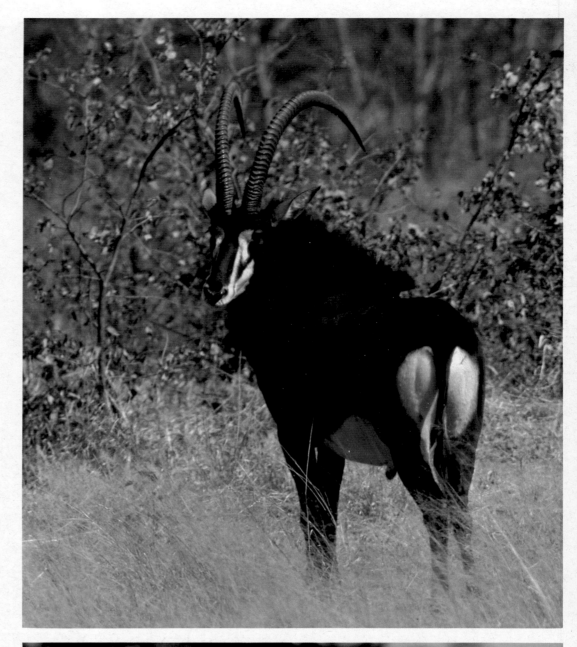

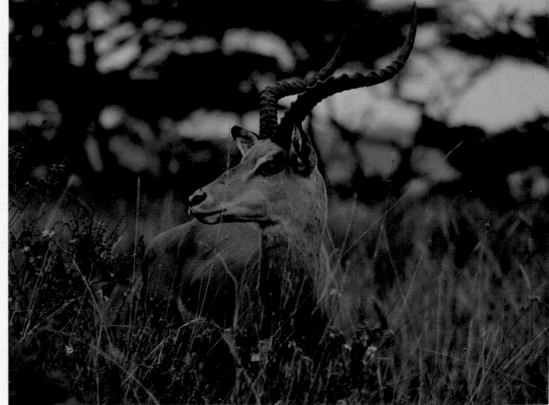

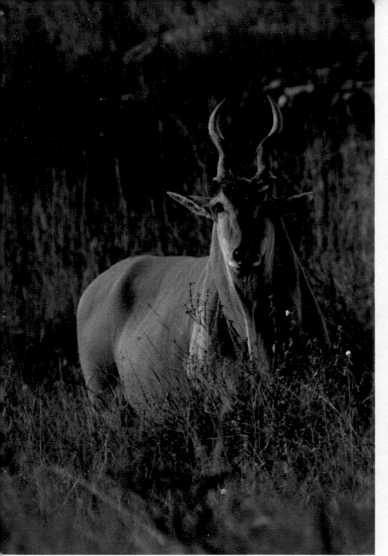

There are loners even among herd animals.

In the wilds of the savannah, every animal species has its secretive individuals. Sable antelopes (*far left*), impalas (*bottom left*), elands (*left*), and waterbucks (*below*) are typical inhabitants of this wilderness of grass and shrubbery.

level—the Ngorongoro is a preserve of lush savannah vegetation with a unique diversity of animals.

One of the things that have made this preserve so famous was the sensational scientific discovery that the lion, an animal renowned for its courage, was in fact rather cowardly! The Dutch zoologist Hans Kruuk and the American primatologist Jane Goodall observed hyena clans in the Ngorongoro Crater. They saw that the hyenas, belying their reputation as carrion eaters, were quite reckless in hunting down their prey. The lions, in contrast, avoided any risks. Another primatologist, George B. Schaller, observed the king of beasts surrounded by its quiet, sleeping mate and cubs and noticed that they went hunting only when their stomachs growled. In the Ngorongoro Crater, the lions feed on their own kills only one third of the time. In most cases, they rob hyenas of *their* prey—which have already been killed.

When lions hunt, however, the spectacle is riveting. Without the male leader of the pride, lionesses

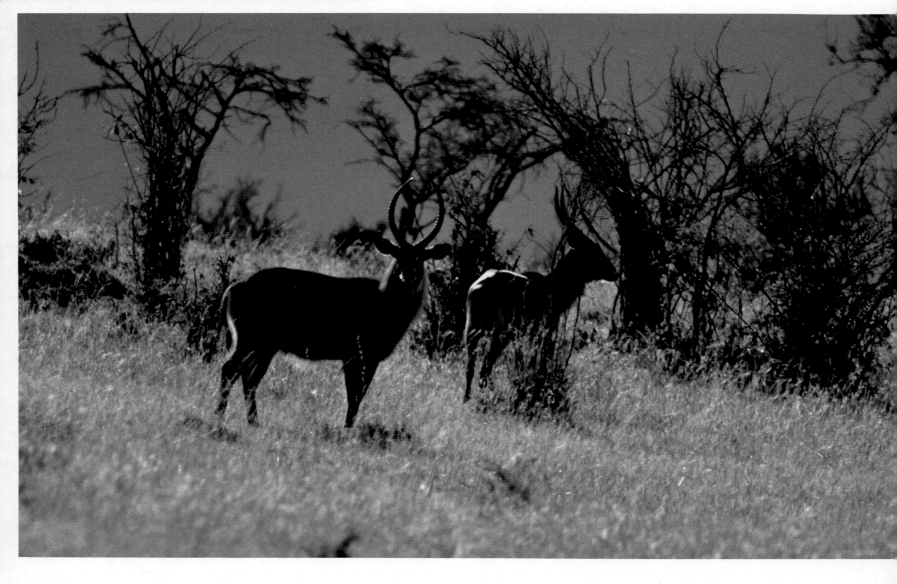

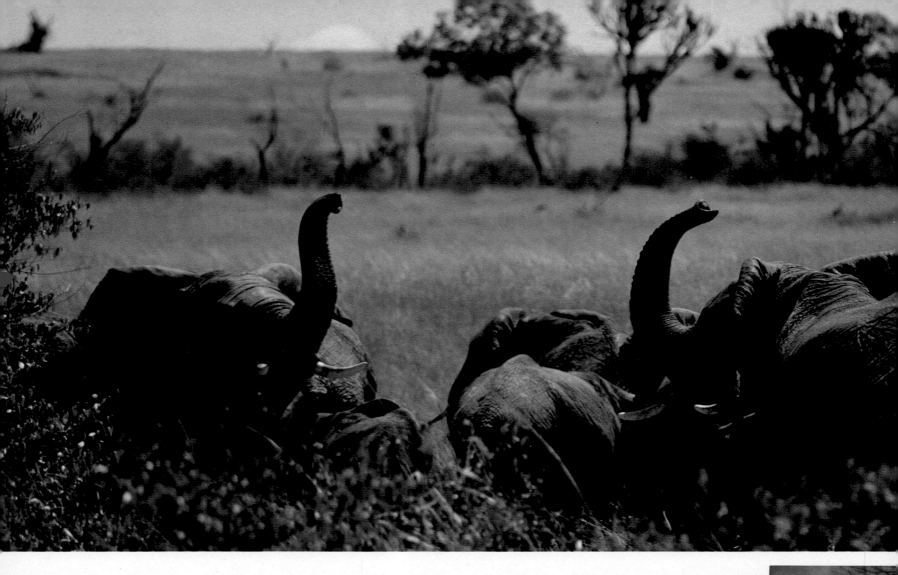

often hunt in a group. They use this tactic in the grassland, which is exposed and provides little cover. A lioness crouches in the grass, while her colleagues circle a herd of gnus, making no effort to remain undiscovered. On the contrary, if the herd does not react to them, they sometimes launch a pseudoattack. The gnus are manipulated into fleeing toward the lurking lioness. As soon as the gnus are close enough, she springs from her hiding place, taking gigantic leaps. The surprised gnu's struggle can last as long as ten minutes, with the lioness clamping her

The entire lion herd devours the prey: first the males, then the females; the cubs get the leftovers.

teeth into the gnu's throat or mouth until the gnu chokes.

When the lioness hunts alone, she uses the very same method; her deadly bite is simply the easiest maneuver. First, the lioness has to pick an animal in the herd. To do so, she steals up very close to the herd. If the terrain is broken or the vegeta-

tion high, she can usually manage to do this undetected. If the prey notices the lioness because of a bird cry or happens to sniff her scent, the cat has no choice but to join the herd in its panicky flight. In so doing, she tries to isolate one animal from the rest. Employing her body's full strength for this task, she sprints along at speeds of up to fifty miles an hour. However, she cannot maintain this speed for long, so young or ill animals often become her victims.

The entire pride of lions feeds on the prey according to a strict pecking order. First, the males devour the best parts, then the females get their chance, and finally, if any meat is left, the offspring have their turn. Fifty percent of these young starve to death in the savannah—a simple method of population control, perhaps, but necessary to keep the large predators from depriving themselves of food.

Lions are among the health police of the savannah. Even if they do not normally chase giraffe herds, they sometimes bag sick or weak animals. Usually, however, the gentle giants either send the lions packing with violent kicks—or vehemently gallop away.

Some eleven thousand giraffes

Savannah animals that we all know

Their respectable size makes elephants (*above*) the true rulers of the savannah. Zebras (*right*), along with gnus, are the most important food source for lions. Hyenas and vultures (*top right*) are usually satisfied with the leftovers.

live in the adjacent territory of Serengeti. These majestic creatures have existed for twenty-five million years, developing out of small hooved animals no larger than deer. Now, they grow as tall as twenty feet. Their great height is absolutely vital if they are to reach the leaves on the branches of the large acacias, but it does have its disadvantages: when drinking, the giraffe has to spread its long front legs very wide apart, making it an easy target for lions, leopards, and hyenas.

The structure of the giraffe herd is unique. It is not led by a head bull but consists only of females and offspring. The males that can mate live

▶

Adult giraffe bulls can grow nearly twenty feet tall and can defoliate trees that are too high even for elephants' trunks.

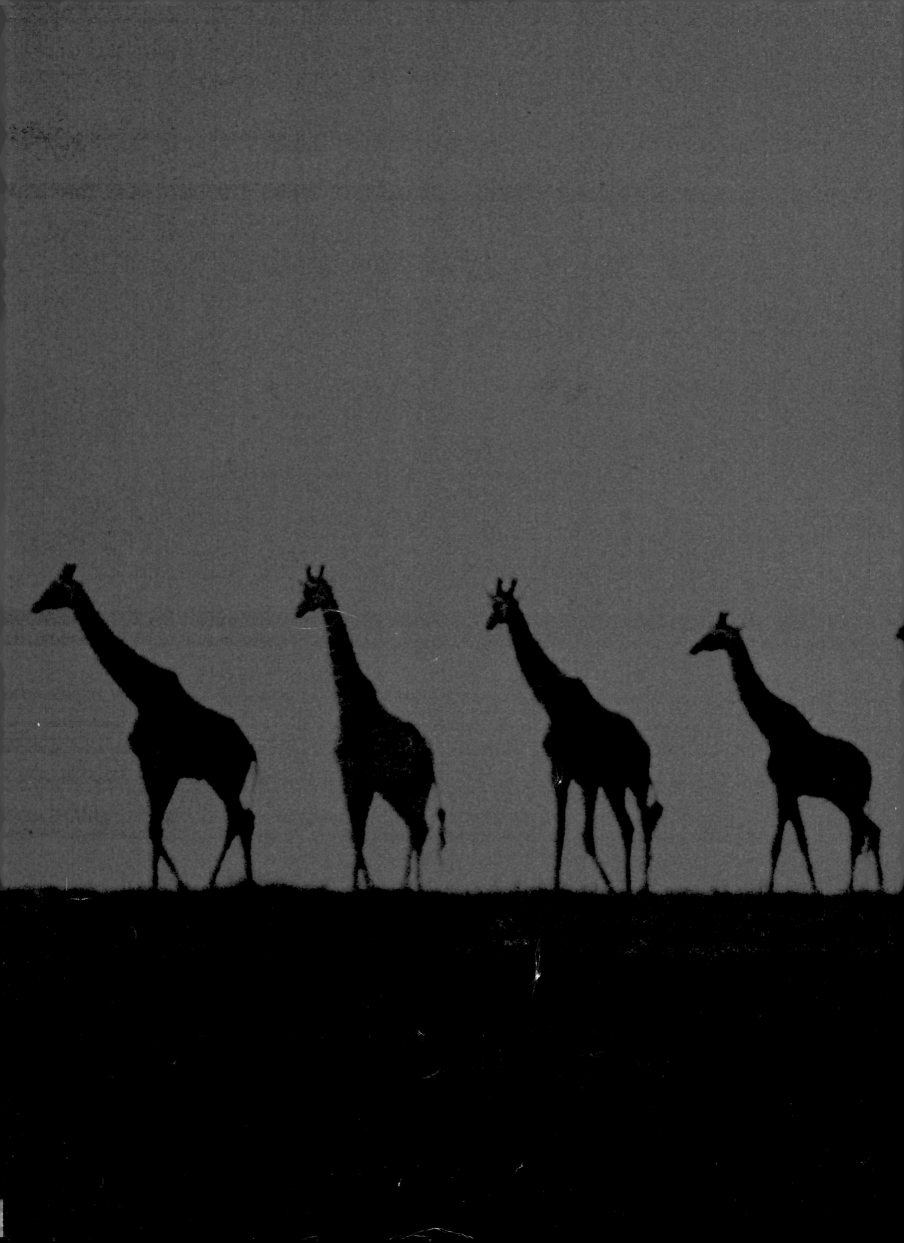

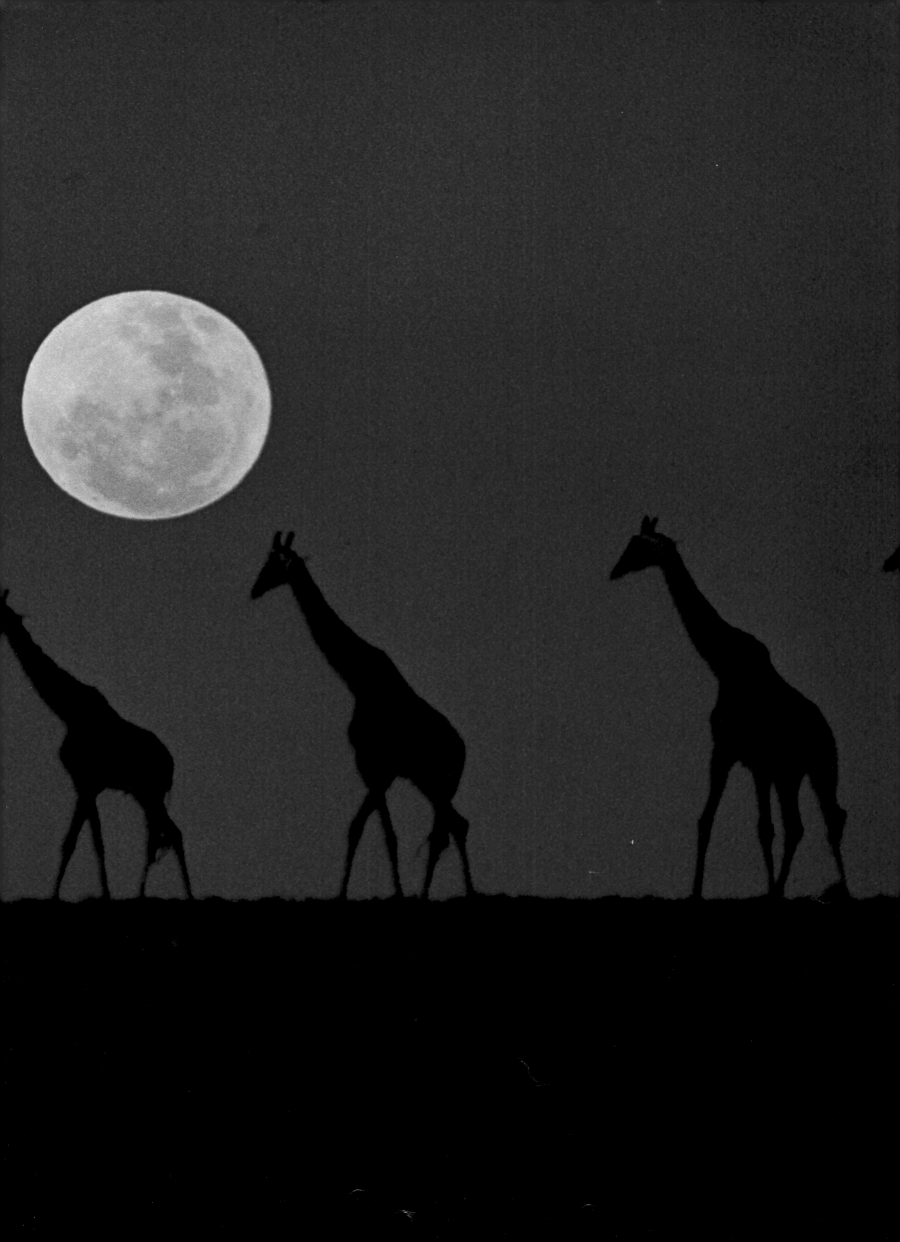

in specific areas, and the herds of females and calves move back and forth among them. This is nature's way of seeing to it that not all children have the same father!

Only one out of three giraffe calves survives the first twelve months. Even if the mother defends her children resolutely and courageously against a pack of lions or cheetahs, the calves have little chance of survival. As is frequent with herd animals, giraffes establish so-called kindergartens: The mothers leave the children in the care of

The giraffe's height helps it to get at juicy acacia leaves.

one mother. Such a nursery is a frequent attraction for predators in the tree and bush savannah.

The skin of every giraffe has an individual pattern. Like the patterns of our fingertips, the network of their coloring is always unique.

Despite the high mortality of the calves, the number of giraffes has risen ominously during the past few years. The acacia stock is already in serious danger, especially since young trees are scarcely replacing the old ones. Any that are spared from the bush fires are soon devoured by antelopes and the ever-hungry elephants.

An ecological catastrophe is astir in the Serengeti. Inside Manyarasee Park, in the south of the Ngorongoro Preserve, huge herds of elephants have already devoured bushes, trees, and grassy areas. Not only is the vegetation dying off, it has no chance whatsoever to grow anew. A tremendous erosion has begun on the slopes. The elephant herds are gradually wandering away. The first have already arrived in the Serengeti, even though this is no land for elephants.

No solution is as yet in sight. Should the intruders be shot, or should nature be given free rein? While the park managers and ecologists are puzzling out the better solution, the elephants are left alone. Elephants are ill prepared for the heat of the savannahs; they prefer cooler surroundings. Hence, it comes as no surprise that the huge animals suddenly pop up on Mount Kenya at an altitude of thirteen thousand feet—in the realm of the perennial snow! Scientists have come up with an explanation for the sensitivity to heat shown by earth's

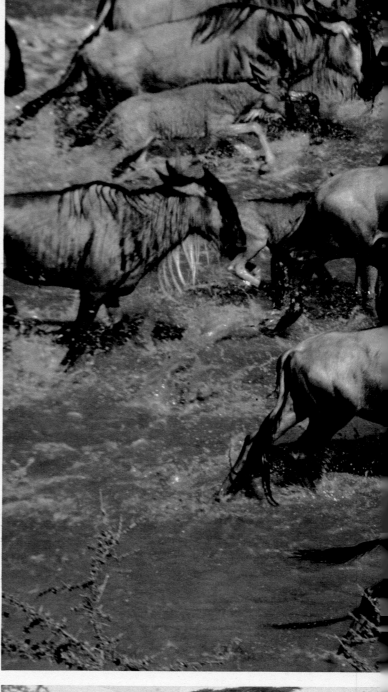

No other ungulate is as much a herd animal as the gnu.

The seasonal wanderings of gnu herds are some of the most unusual spectacles on earth. Weak and old gnus as well as straggling calves are the preferred victims of predatory cats (*below right: cheetah overpowering a gnu*).

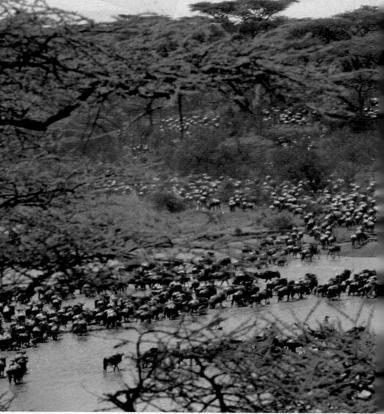

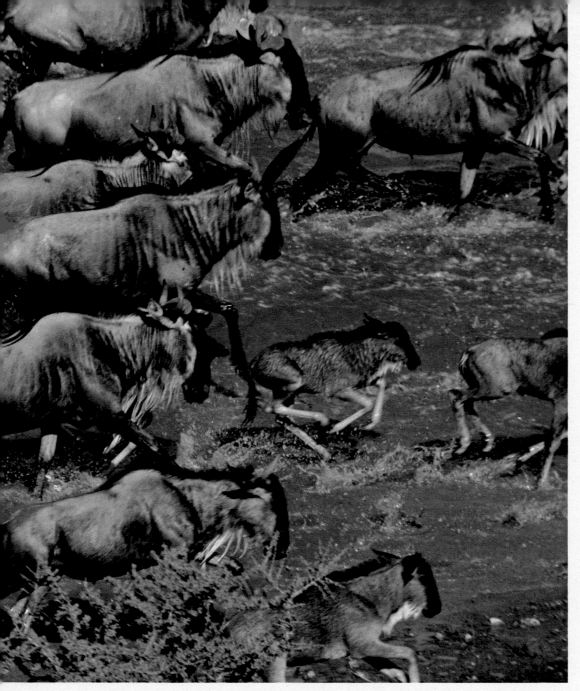

largest land mammal. The tremendous masses of flesh on the elephant's body must be cooled regularly. A Serengeti sunbath without water would therefore spell doom. Unlike the mammals of the savannah, the elephant has almost no sweat glands. It can fan a bit of fresh air with its ears, which are over two square yards in size, but this suc-

The elephant cannot live without water. It requires a daily bath to cool its massive body.

ceeds only in the evening or in the shade of high trees. During the day, the elephant places its ears, which have excellent circulation, close to its body in order to keep them out of the heat as much as possible. However, what really helps the elephant survive in this hostile world is its intelligence, letting it endure the tropics with no cooling system of its own. To protect its body against heatstroke, the elephant uses cool water; with the aid of its trunk, it takes at least one shower a day. If a large water hole or even a nearby lake or river is available, the bath turns into a water battle, in which the entire herd splashes around like exuberant children. Elephant herds will roam as far as fifty miles in one

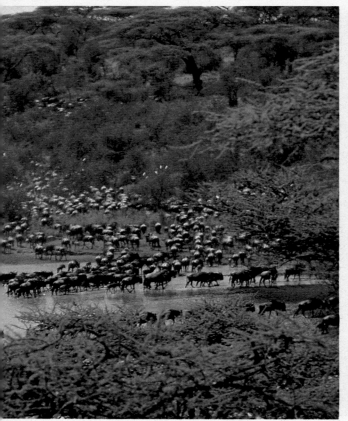

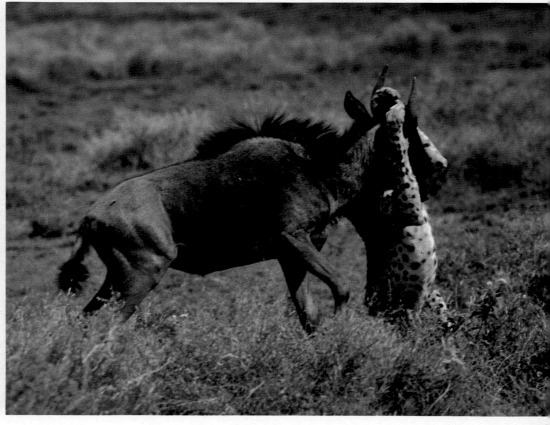

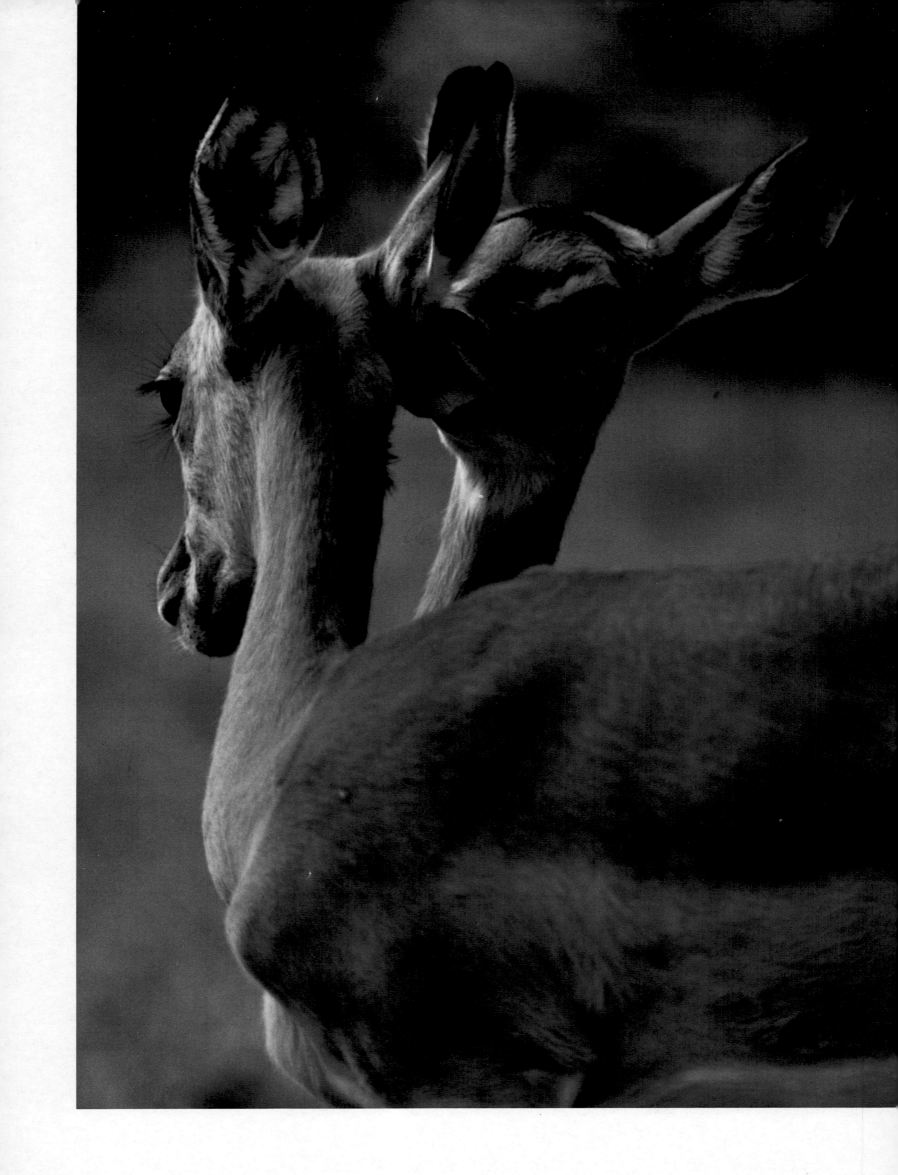

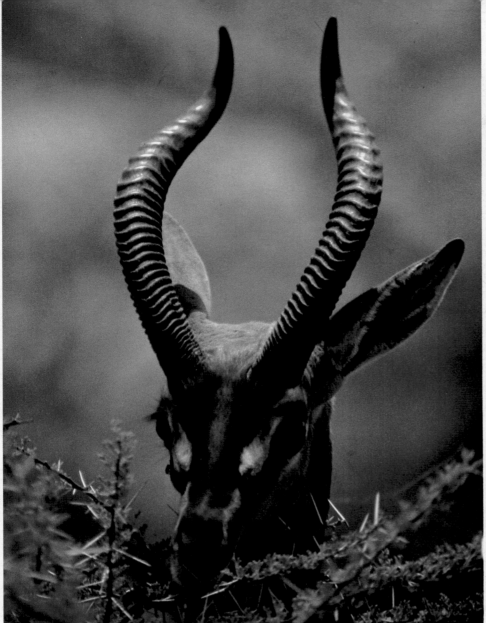

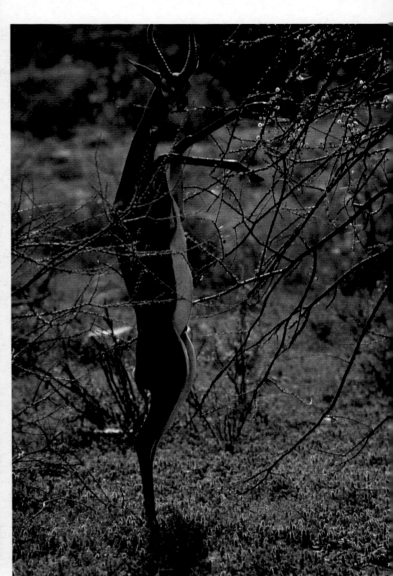

Nimble elegance

Impalas (*far left*) and gerenuks (*above* and *left*) are the most graceful creatures in the savannah. They flee from their enemies as though shot from a bow, leaping over obstacles as broad as thirty feet and as high as ten feet.

233

Large plant-eaters in the water and on land

**Hippopotamuses find protection from the blazing sun in shallow water (*left*).
A black rhinoceros rests in the savannah grass (*above*).
It gladly puts up with the cattle heron.**

Thanks to their gigantic size, they have no natural enemies.

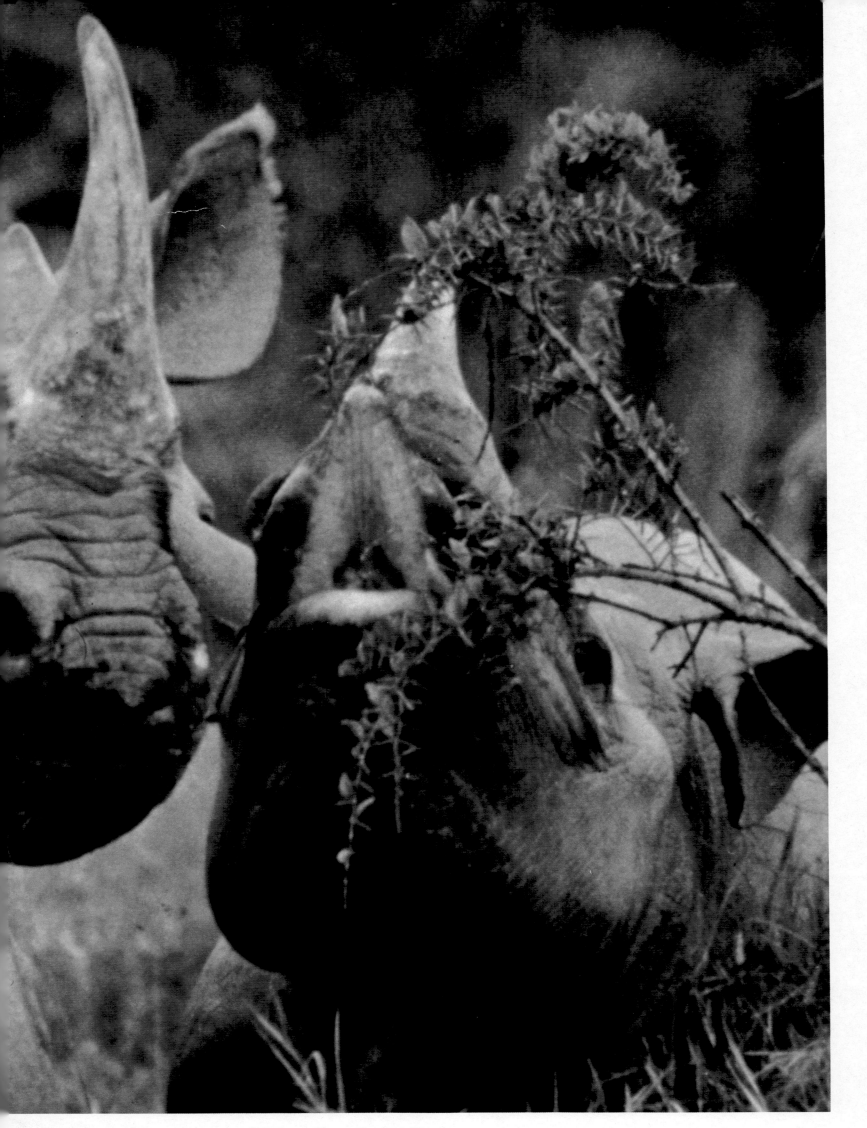

**The rhinoceros is a peaceful savannah dweller.
Its horn has a magic attraction for poachers
for it is said to have magical properties.**

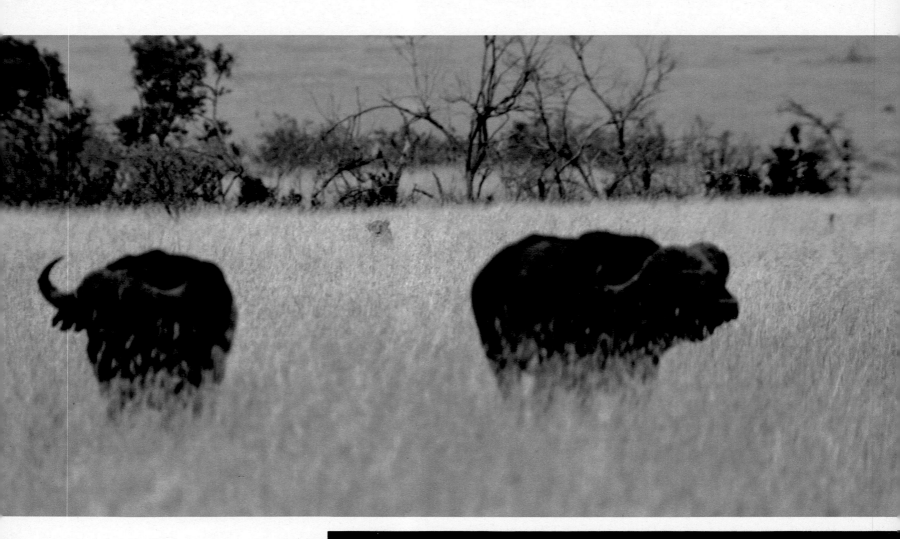

night to find water. But even then, the water hole is not theirs alone. They warn off lions by shrill trumpeting. Although adult elephants do not have to fear lions or leopards, they are still frightened by the nearness of the cats. In contrast, these tremendous creatures feel vastly superior to one inhabitant of the water hole: the crocodile. It is said that an elephant whose trunk was seized by

Crocodiles bite only when hungry—but they bite very hard.

a crocodile pulled out the attacker, hurled it against a tree, and finally slung it over the fork of the tree.

In the savannah, crocodiles can—or rather once could—be found wherever there is water, particularly on the Nile and along its source rivers. Patiently, they wait for prey, either in the reedy banks or underwater, with only their eyes peering above the surface. When the thirsty savannah animals hurry up in herds, the crocodile is assured of rich prey. For, despite its clumsy appearance, it is a skillfull hunter. Suddenly

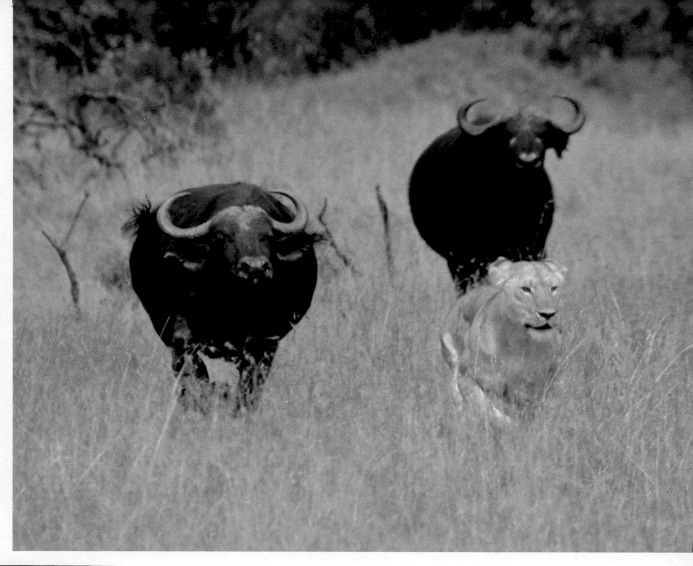

Another side of the savannah: hunters become the hunted.

Grazing Cape buffaloes are attacked by a lioness (*left*), but they resist. The Cape buffaloes drive the attacker away and send her packing (*right*). Cape buffaloes are extremely good fighters; their sharp horns and sharp hooves are effective weapons. The powerful skull of the bulls (*below*) also serves in a fight against rivals.

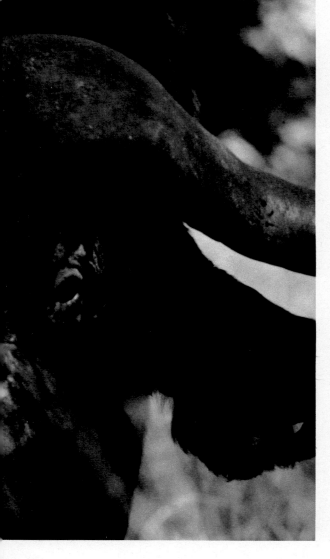

zooming out of the water, it pulls its victim to the ground with a violent bite. Then the struggle begins. Locked in the crocodile's powerful jaws, which can exert a good thirteen tons of pressure, the animal is dragged underwater by a ton of live weight and drowns. Not infrequently, this huge saurian manages to overpower even the strong Cape buffalo. However, the buffalo's death does not end the struggle. The thick body must be torn into pieces small enough for the crocodile's mouth, so the crocodile whips the dead animal around until a piece rips off. Provided with the nourishing "ballast," the crocodile submerges; it has enough to digest for at least a week.

The crocodile's brooding is especially remarkable. After laying some fifty to one hundred eggs and burying them in sand, the female keeps watch near the clutch. She stays there for about three months, almost going without food. If she left her eggs unguarded, they would be easy game for baboons, varans, and mongooses. The crocodile offspring announce their hatching time with loud quacks. The mother then shovels out the clutch, which lies many feet underground. She helps the

young out of the skin of the egg, taking them into her sharp teeth—but so delicately that the babies emerge unscathed. Crocodiles can mate only upon reaching the age of ten. If they manage to survive human hunters, they can live over fifty years.

Crocodiles' skin makes them popular. For a long time, they were fair game for the handbag industry.

One prey of the crocodile is a water-dwelling mammal—the hippopotamus, particularly when young. Hippopotamuses are vegetarians. Together with the other savannah animals they graze on the grassy plain—but only at night. These gigantic colossi of flesh spend the hot daylight hours dozing in a muddy pool or in a cool lake or pond.

An equally massive creature, although purely a land-dweller, is the rhinoceros. Because of its tremendous weight and strength, this harmless plant-eater is avoided by

predators—unless it has an infant only a few days old. The newborn offspring can easily fall victim to lions or tigers. In an attack, the mother rhinoceros is capable of dramatic defense reactions. When she gallops toward the attackers, the earth quakes. To save her child, she employs the full impact of her body, more to drive the pursuers away

Despite its weight and its horn, the rhinoceros mother is powerless against several lions.

than to kill them. But if her horns strike a hunter, it is doomed.

The swiftest hunters in the savannah are cheetahs. Their menu contains mostly smaller animals, like hares or gazelles, and they shoot after prey at high speeds—over eighty miles per hour. The cheetah is the only cat that is unable to retract its claws; like dogs, they race across the ground with their claws extended. These long-legged animals have thus lost the ability to climb trees. Cheetahs are loners, seldom venturing out in family groups to hunt gazelles or gnus. Not infrequently, the attacking cheetah meets its doom under the horns or hoofs of wild cattle. But the cheetah is also attacked by its distant relatives, the lion and the leopard. Seventy percent of young cheetahs die before reaching the third month of their lives. The defenseless offspring fall prey to hyenas in particular. Likewise, drastic changes in weather, e.g., cold winds, can decimate their population.

The cheetah is one of the most endangered species in the African sa-

The cheetah needs a gigantic hunting area. As soon as a human being appears, the cheetah flees, never to return.

vannah. The Serengeti has at least three thousand hyenas, two thousand lions, and one thousand leopards, as opposed to two hundred fifty cheetahs. But there is a further reason why the stock of this wonderfully spotted predatory feline remains small. Cheetahs need an enormous hunting territory. Unlike a lion or leopard, the cheetah responds to human beings by leaving the area. And finally, this rare big

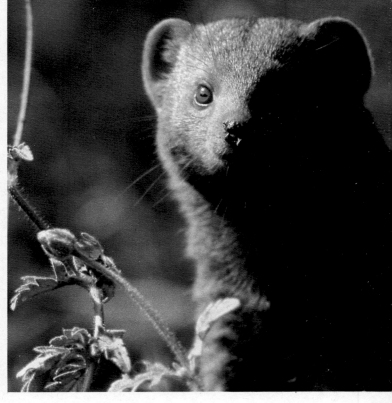

Not only large animals live in the savannah.

Dwarf mongooses frolic around a termite hill (*above*). The group later seeks protection from the noon sun in the cool interior. Watchmen (*above right*) warn against enemies. Mongooses have wonderfully developed senses. In the morning, they like to take a sunbath (*below right*).

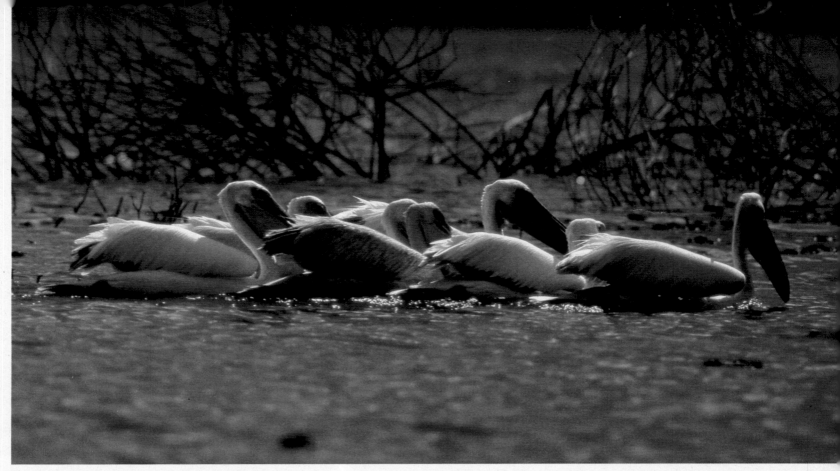

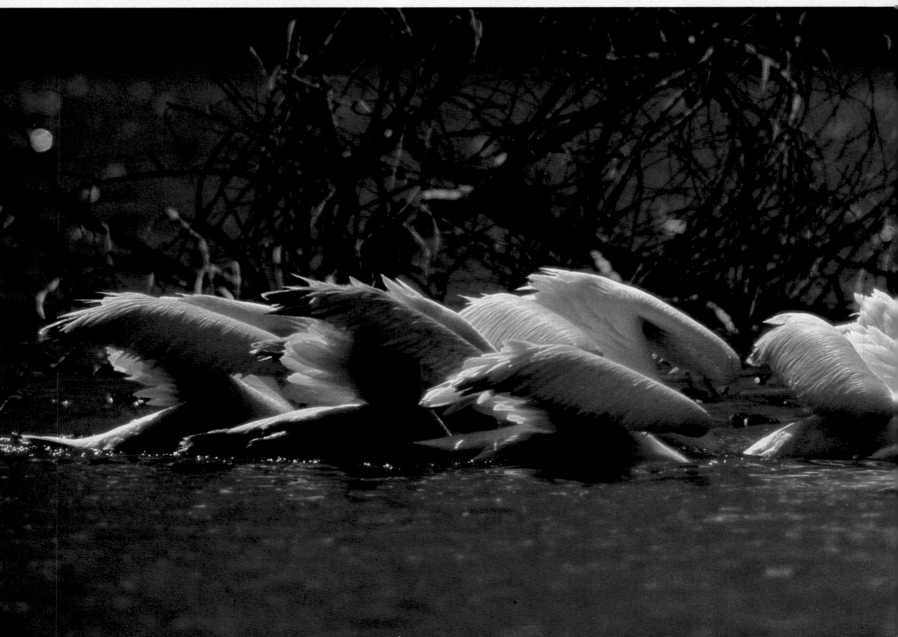

Pelicans live in large groups along the lakes.

Fishing requires teamwork. Pelicans are fine swimmers; in shallow water, they drive the fish together (*above*) and catch them by diving with their gigantic beaks (*below*).

cat is doomed by something else: Its spotted skin has always been a sign of courage and strength for the natives. However, Masai hunters are not the only ones who covet this precious fur—although the women who want to wear it would not likely get within one hundred yards of this creature.

An unusual skin pattern has also made another animal well known: the zebra. However, its stripes are not what attract zoologists. They are far more interested in the zebra's remarkable social behavior within the family group. Unlike any other animal in the savannah, zebras do not desert their weak and young. In fact, the latter have first choice when it comes to water. On long marches, they take breaks specifically for them. If one of the herd goes astray, the leader of the plains zebras does not rest until the lost member is found. The leader is also famed for his sacrificial courage. If one of the mares or colts is carried off by a lion, the stallion risks his life to chase away the hunter. This behavior is unique among the zebras of the plains. When one research group in the Ngorongoro Crater, using a stunning rifle in order to knock out zebras and mark them, shot a mare, the stallion grabbed her neck in his teeth, trying to keep her up. The

Previously undiscovered social behavior: zebras let the sick and the feeble have the first turn at the waterhole.

"greeting" among zebras is according to strict protocol: Mares are greeted by the stallion and the colts, while the stallion is surrounded by the entire clan.

Social contact among plains zebras go beyond the family. When various families graze near one another, the stallions often leave the mares and colts to pay a friendly visit to a stallion in the neighboring group. By contrast, the stallions of Grévy's zebras never approach each other amiably. However, the plains zebras sniff each other at length and without drawing back their ears. In

When antelopes, gnus, and zebras die, the jackals come. They leave the bones for the vultures.

the Serengeti, giant herds of plains zebras wander across the grassy landscape, but they do not exhibit the sensitive social behavior of the small family groups.

No other animal in the savannah has as high a mortality rate as the zebra. Illness, predators, and accidents fell one hundred thousand zebras annually in the Serengeti alone. Many of these are killed by hyenas, lions, or leopards, and the gruesome remains are a banquet for jackals, followed by vultures—a species which never seems to die. Never has a zoologist come upon vulture bones, much less seen one of the birds perish.

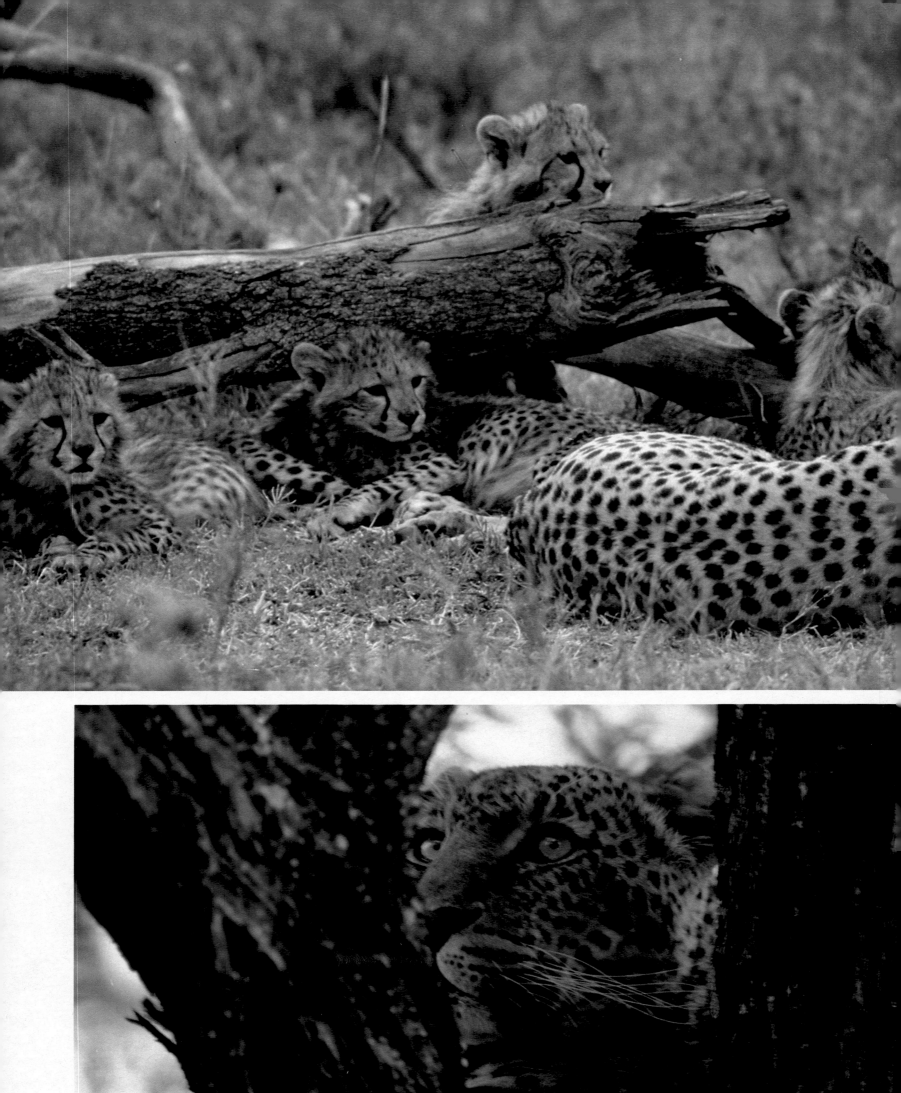

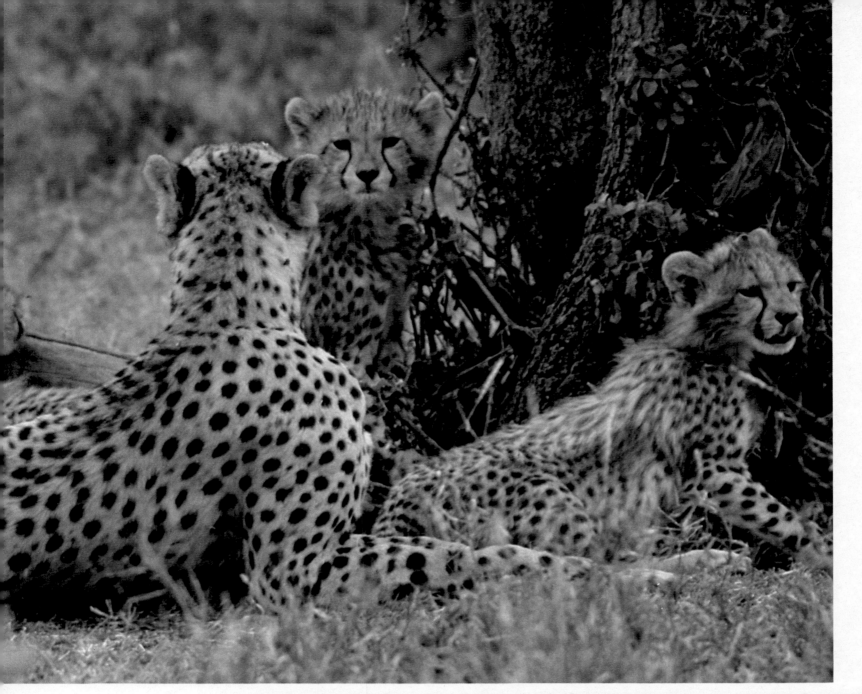

Not even the hunters are safe from enemies.

A cheetah family is a rare sight in the Serengeti (*above*). The clumsy cubs must learn how to hunt swiftly from the very first day of their lives. Not infrequently, they themselves become the prey of the stronger leopard (*left*).

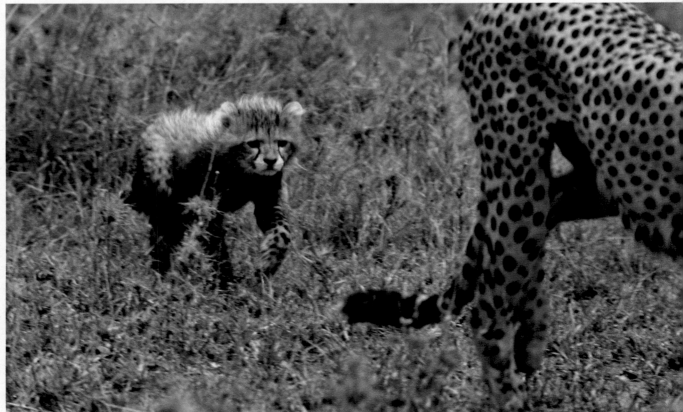

The rainbow over the savannah is deceptive. Soon, the great herds will flee from the threatening storm.

Alert klipspringers, intent on camouflage, remain behind (*left*). So do suricates (*below left*), which flee into their ramified caverns at the first flashes of lightning. Baboons, which are excellent fighters, retreat into the trees in large hordes. Baboons are herbivores, but they will not turn down a meat snack.

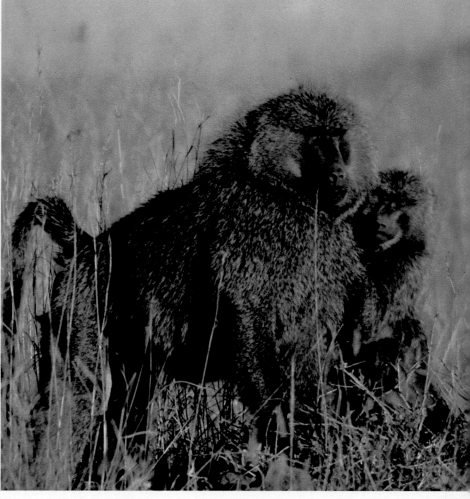

The Congo's tropical rain forest is a green hell for some; for others, a final bastion of the Dark Continent.

The Timid

Anthropoids: Nomads of the Jungle

The impenetrable thicket of the African jungle is full of mysteries.

The second largest jungle territory on earth is still intact, though already threatened. The tropical rain forests in the Congo are the last haven for many animals—a sort of natural museum for eras long past. And scientists still have many questions regarding the flora and fauna here.

Tropical rain forests are among the most impressive jungles on earth. Every day, storms lash the giant trees, some of which, when struck by lightning, snap like matchsticks. The great rivers swell unpredictably and overflow their banks. During the rainy season, the jungle of the Congo Basin is particularly hostile to human beings. And the term "hothouse climate" is really a mild description of the sweltering heat and unusually high humidity.

The Great Congo Forest is the second largest jungle area in the world, stretching from Africa's Atlantic coast to the slopes of the Mitumba Mountains far in the east. Compared with the densely settled coastal region, there are few roads leading into the jungle.

The most conspicuous feature of the tropical rain forest is its vertical structure. The vegetation levels pile up like the floors of a house, reaching a height of two hundred feet. Each of these strata is a world of its own. Animals and plants on any of the various floors are very different from those on the other floors. Light and climate are the decisive factors. The visitor has the impression that few animals live in this endless sea of vegetation, an impression due primarily to the difficulties of observation. In the darkness of the jungle, relatively few small jungle animals can be seen.

Aside from the invertebrate ground animals, most of the jungle creatures live at a height of thirty to eighty feet. Thus, mangabeys, rhesus monkeys, and many reptiles are tree-dwellers. In fact, the Great

In the impenetrable tangle of plants, it is almost impossible to tell which plant embraces what—or which strangles which.

Congo Forest even has an ungulate that lives in trees—the tree hyrax, a live fossil that can be considered the forebear of the elephant and the rhinoceros. Some hundred different species of trees crowd together on any one square mile of the Congo Jungle. Wherever the jungle giants allow a bit of light to filter through, one can find a breathtakingly luxuriant—albeit ghostly—flora. The ground is covered with gigantic ferns. Young trees and bushes rise overhead, enveloped by countless creepers that look like so many

enormous snakes. Wherever these creepers reach the branches of trees, there is a labyrinth of arm-thick lianas, which either embrace the tremendous trunks or hang down like living curtains. Parasitical plants tenant both the vines and the trees, and it is impossible to tell which is clutching which, which lives off which, or which is hugging which to death.

The African rain forest is a preserve of primeval life. Animal species of bygone eras, especially mammals, have withdrawn to safety here. In the course of millennia, their relatives in other areas developed into different creatures. Dwarf musk deer and water chevrotains are among these primitive mammals. With their large upper tusks and their underdeveloped legs, they predate deer and cattle!

Animals whose territory is the deep thicket of the Congo jungle

The greenish gray rhesus monkeys (*right*) are master gymnasts. Their tails function as a fifth hand. The green adders (*far right*) are not lying in ambush for prey but are preparing to mate. The gorilla (*below*) has no enemies, thanks to its strength and intelligence.

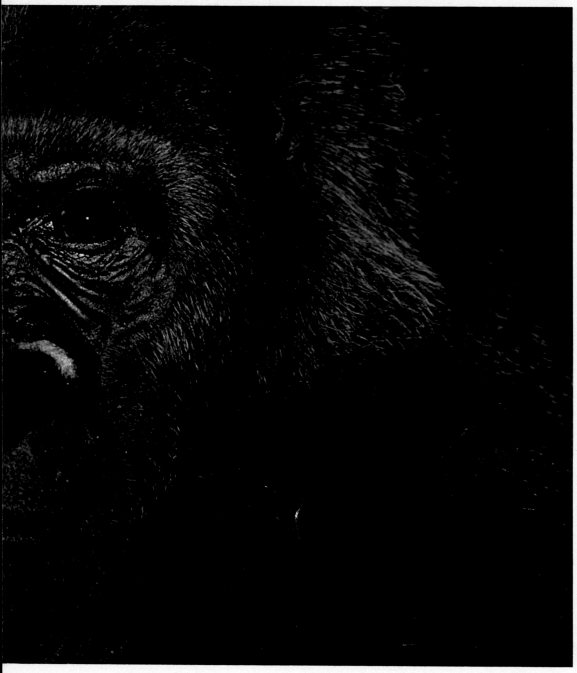

The okapi is especially averse to light. This deer-sized forest giraffe, discovered only a few short decades ago, was a sensation of the African jungle. It is amazingly similar to primeval giraffes of the middle Tertiary. The okapi has preserved his appearance for thirty million years: part zebra (rear), part giraffe (front), and part donkey (center)—as though nature could not make up its mind.

The overwhelming vegetation has allowed two types of mammals to develop: "slippers" and "breakers." The delicate bushbuck, barely the size of a hare, is part of the shy group that slips through the tiniest gaps in trees. On the other hand, the pygmy hippopotamus and several species of pig belong to the "breakers," who push their way through

Gorillas are superior to all other animals.

the underbrush with the aid of their body weight, which rests on short, massive legs. The existence of the most humanlike of all apes, gorillas and chimpanzees, is similarly attributed by scientists to the protective function of the dense jungle.

My first visit to the African jungle was to see the gorillas. They are among the largest jungle animals without enemies (aside from man). Several zoologists have since managed to observe gorillas closely. Bernhard Grzimek, a gorilla expert, has been attacked only once—by

251

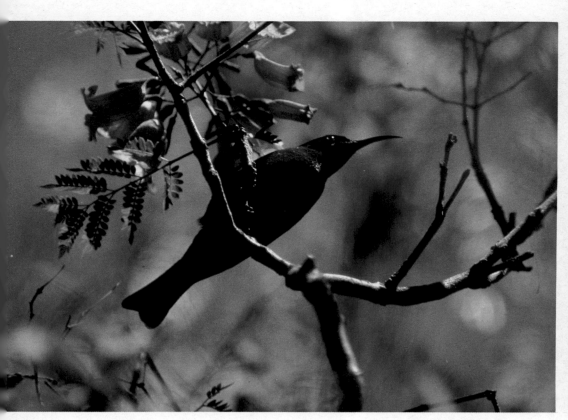

Kasimir, the head of a family of eighteen. Despite twenty years of working with gorillas, Grzimek made a mistake. He kept his movie camera focused for too long a time on the large primate. The otherwise peaceful gorilla felt threatened by the camera's huge "eye" and raced toward Grzimek, screaming, then veered aside only five feet in front of him. Rigid with fear, Bernhard Grzimek managed to survive this

The black anthropoid is peaceful. It eats no meat, just fruit, bark, and shoots.

assault. Had the scientist tried to flee, the animal would surely have bitten him. Grzimek's refusal to budge was in keeping with the social mores of gorillas, among whom it is the inferior that runs away.

Gorillas are nomads. They move through the jungle, wandering from one feeding site to another. As pure vegetarians, they eat mainly leaves, shoots, buds, pulp, and bark. On the other hand, they won't eat sweet fruit—probably because they are too heavy to climb trees for it. They eat fish only in captivity.

Once, in the mountain woods, I encountered gorillas quite by accident. My film team found gorilla spoor in an overgrown banana planting. When the cameraman

sliced off a leaf with a machete, his action was spotted by a male gorilla hidden nearby. His hair-raising bellow and drumming shattered the stillness, and we all froze for a split second in utter fear. Black and brown colossi smashed through the underbrush on all sides. Terrified by their superior strength, we dashed away. Although the entire herd had concealed itself among the shrubs and in the elephant grass, we got away unscathed. The leader of the herd had simply perched on his hind legs, drummed his hands on his chest, and screamed, ominously revealing his gaping maw and sharp teeth. He hoped to drive us away with these psychological weapons. As in most such cases, this was a bogus attack.

Never has any gorilla—à la King Kong—challenged a human being to a show of strength or tried to kidnap a man or a woman. The plot of *King Kong* is pure fantasy!

Two researchers have made a great personal commitment in studying the life of the gorilla: Dian Fossey and George B. Schaller. Schaller describes the large anthropoid as a peaceful and relaxed animal, completely satisfied with itself and its environment—so long as it is left in peace. Dian Fossey, who has spent some two thousand hours in a gorilla family, has established that the individual behavior of gorillas is somewhat universal but not always exactly the same. Every gorilla

Birds that look like iridescent jewels soar through the blossoming lianas.

Gaily colored splotches: the red-breasted sunbird (*left* and *center*), the black-headed oriole feeding its young (*top right*), and the yellow-bellied sunbird (*right*).

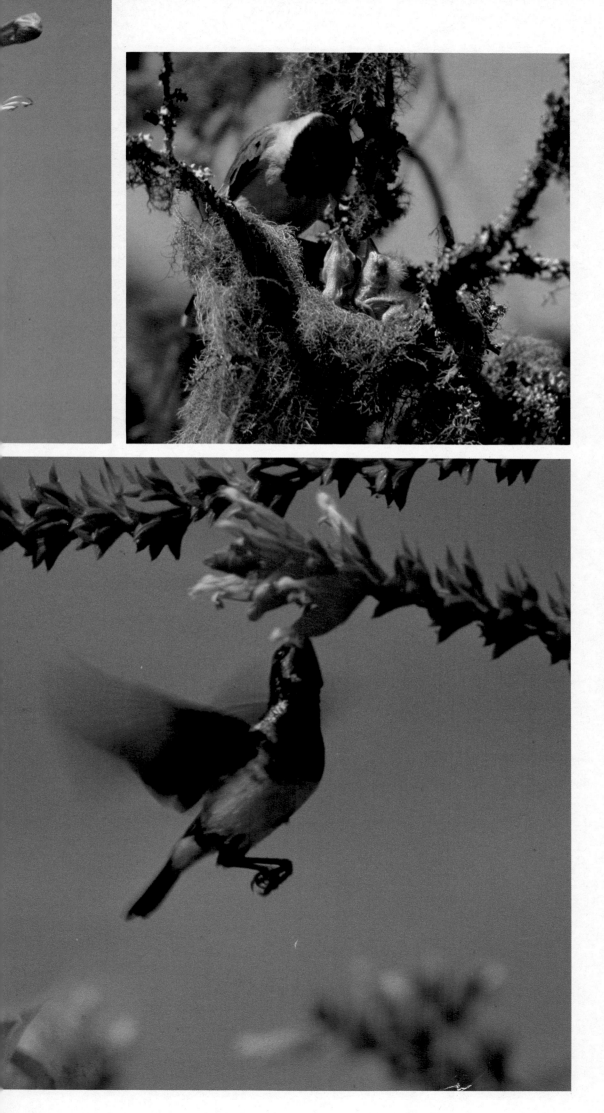

mother raises her offspring differently. One family likes to eat plants that are scorned by another family. It is the model and the influence of the older animals which determine certain behavior for the young. Teaching is more important than inheritance.

Chimpanzees live in the same geographic area. They are smaller than gorillas and enjoy climbing

If their young are threatened, chimpanzees attack leopards and even beat them with clubs.

more. They too are anthropoids but differ from their larger relatives in many respects. Like gorillas, they are usually herbivores, but they also like insects and, in some areas, even the flesh of mammals. When catching insects, they use sticks as tools—an indication of their high intelligence. They poke the sticks around in termite constructions or beehives. If the twig breaks, or leaves get in the way, the chimpanzee gets another.

The chimpanzee's behavior toward enemies is unlike any other jungle animal's. One of the chimp's worst enemies is the leopard. Recovering from their initial fright at the appearance of this big hunter, the entire flock of chimpanzees prepares to attack. This attack is extremely fierce if the leopard is chasing or has actually grabbed a chimpanzee child. Not infrequently, in fact, these anthropoids grab clubs and start

►

Though the verdure of this untouched landscape teems with life, it is hostile to man. But nature also fights against itself: lianas strangle the jungle's giant trees. When the trunks rot and disintegrate in the morass, the lianas die too.

253

Inhabitants of the swampy shore

Looking for food, the hornbill struts through the shallow water (*above*). The emerald gallinule displays the full splendor of its metallically shimmering plumage (*left*). The crowned crane thrones majestically on its nest (*right*). When rising from its hatching work, it strides about with dignity—as though having to represent a lofty style of life.

beating the predatory cat. They wield their clubs at a speed of fifty miles an hour! Such behavior, in fact, has been observed in savannah chimpanzees by researchers, whereas the jungle animals never went beyond an ominous flaunting.

During my travels through the African jungle, I had the chance to observe animals everywhere. Thus, we discovered brooding rhinoceros hornbills, whose hatching behavior is unique. While roosting on her eggs, the female is immured in a cave. The male feeds her and later the young through a narrow crack. So long as the young is unfledged, mother and child remain in the voluntary prison. During the hatching period, the female loses her quill feathers and so cannot fly. There are forty-five species of rhinoceros hornbills, and their bodies grow as long as five feet. They get their name from the hornlike attachment on their bill.

While filming the feeding on a nearby date tree, I got to know another strange bird of the tropics: a

The tropical rain forest still holds many secrets—for example, the palm eagle and the Congo peacock.

palm eagle, which visited our tree to munch on the sweet fruit. This large bird belongs to the falconiformes but lives exclusively on vegetation.

In the Ituri Forest, I managed to spot three specimens of the legendary Congo peacock. Comical as it may sound, this bird was discovered by a researcher in the attic of the Belgian Colonial Museum in Brussels; the stuffed animal had been stored there because no one knew what country it came from. The Congo peacock is certainly not the last discovery of naturalists in the Great Congo Forest. The zoological and botanical map still has many white spots, especially in the tropics. We can be sure that many other sensational discoveries and observations will follow—assuming that the tropical rain forest is preserved in its present size. But that may be a dream. Even now, giant bulldozers and power shovels, under the motto of "infrastructural measures," are stamping their ugly seal on the primordial landscape. Unfortunately, the wounds of civilization never heal.

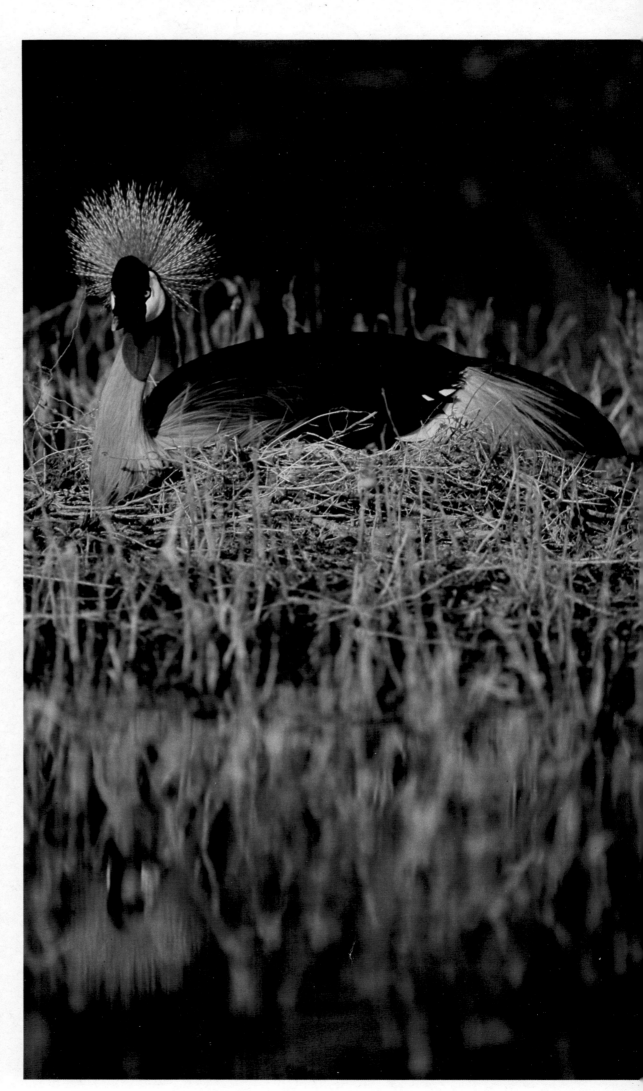

THE AME

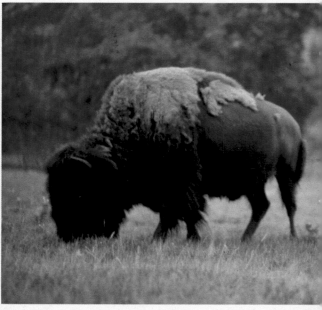

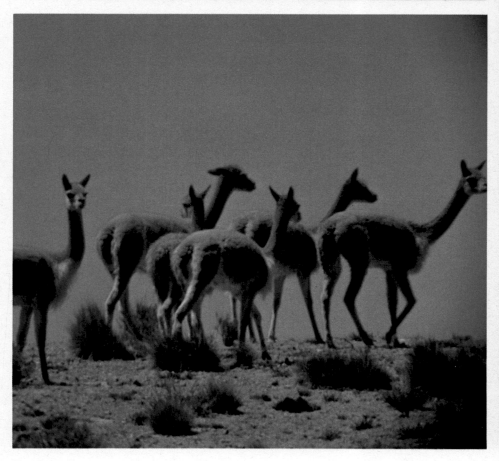

RICAS

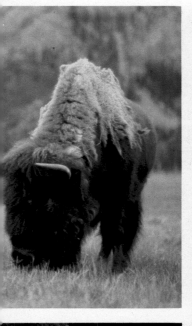

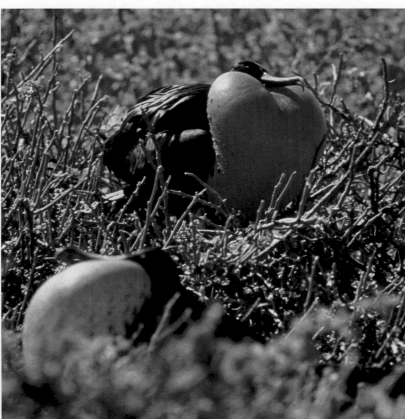

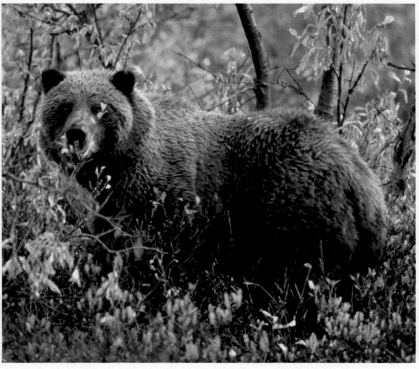

A land virtually created for wild animals. A land where the water is crystal clear. A land that still has wilderness and vast reaches. A land for bears and lynxes, wolves and caribous. Alaska.

Alaska: In the Shadow of Mt. McKinley

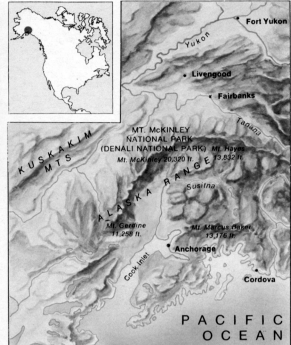

The northern tip of America is still largely untouched by civilization.

Wherever man is able to limit the encroachment of civilization upon the wilderness, nature is able to maintain its balance. The bear can catch its fill of salmon. The wolf can hunt as many caribous as it desires. The forest still belongs to the lynx, and the river still belongs to the otter and the beaver. This world is not without its problems—but it is still beautiful.

Alaska, the forty-ninth state, is also the largest. Formerly a gold-rush paradise, it is synonymous with Eskimos, oil, ice, and snow, but Alaska is, above all, a gigantic wonder of nature: volcanoes, polar sea, mountains twenty thousand feet high, raging torrents, gargantuan glaciers, and an equally impressive flora and fauna. The North Pole is not too far away, but the Pacific, crisscrossed by warm streams, fights the Arctic cold—at least in summer, when Alaska has the same climate as Scandinavia. In the vicinity of the Yukon, the largest river in the Arctic Circle area, the mercury can hit 105 degrees Fahrenheit in July. The winter, however, is bitter cold, the temperatures dropping to way below zero. The frost rules the countryside for nine months and sometimes even longer, but what there is of summer is warm enough to allow the forests to reconquer areas sacrificed to glaciers during the Ice Age.

In southern Alaska, where rain-soaked conifer forests extend all the way to the Pacific, Sitka pines and hemlock firs dominate the scenery. Further north, all the way to the Yukon, the forest is also one of firs and pines.

Crowberries and blueberries grow on the ground, and bluebells and yellow violets blossom along the brooks.

The highest mountains in the south are the Alaska chain, which stretches for six hundred miles

A defiant bastion in the emerald water: the beaver dam

straight across the state. This gigantic range of steep granite pyramids is covered with numerous glaciers and cut by sharp valleys.

Mount McKinley, at 20,320 feet high the tallest peak in North America, has given its name to what is probably the most important and beautiful national park on this continent. Sky-high mountains surround it, dark forests cover the valleys, and roaring cascades plunge over steep walls. Glittering glaciers, emerald lakes, foaming wild creeks, and fantastic rock formations are the backdrops of a wild romantic theater of nature. The animal life has not changed since the days when the first white men arrived. Moose, wapitis, brown bears and black bears wander through the lonesome woods and beavers and otters enliven the crystal-clear lakes.

White Dall Sheep and Rocky Mountain goats, related to the European chamois, graze on the mountain slopes. The small hare and the long-haired marmot are the watchmen in this bleak mountain scenery, sounding the alarm whenever a wolf or glutton approaches.

Almost no animal in the North American wilderness fascinates me as much as the beaver, one of the most astonishing creatures on earth. It digs canals, builds dams, and is a tireless woodchopper; its activities change the face of the entire landscape, though the beaver performs them for its own safety and for the protection of its posterity. A good swimmer, the beaver is quite helpless on land and can easily fall prey to enemies; hence, it usually constructs its home in water, building a hemispherical fortress of branches, twigs, reeds, and mud. The stately edifice is anywhere from six to thirteen feet high and wide. Its entrance lies underwater, but a pipe leads into the residential rooms above the surface. Because high water might flood these "rooms" and a drop in the

Salmon time is bear time—once a year.

The salmon (*above*) arrive punctually every spring. No waterfall is too high for them, no current too strong; these fish nimbly spring up the rivers, individually, in groups, sometimes in an endless train. They are a banquet for the bears, who skillfully fish for the long-desired delicacies, trying to catch them with their front paws (*right*). Sometimes, whole families of bears go fishing (*below*).

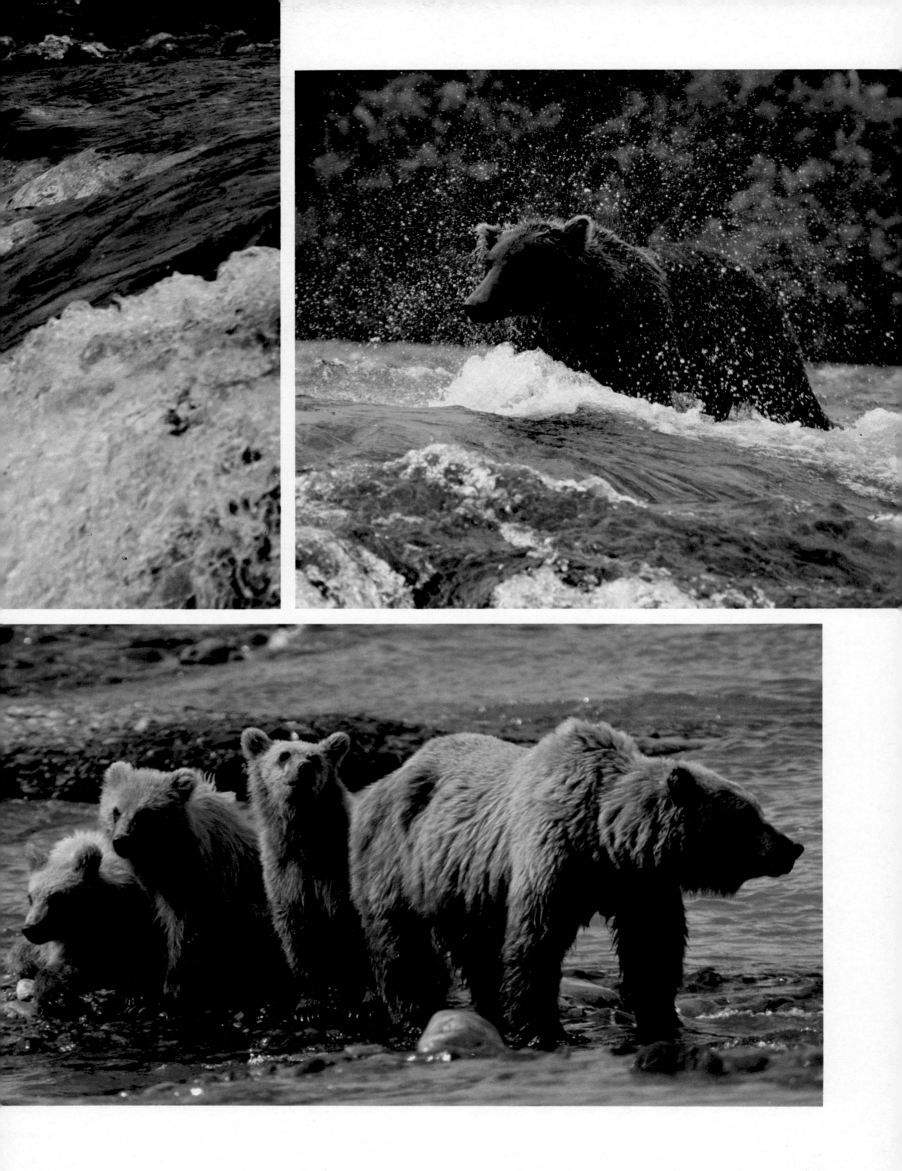

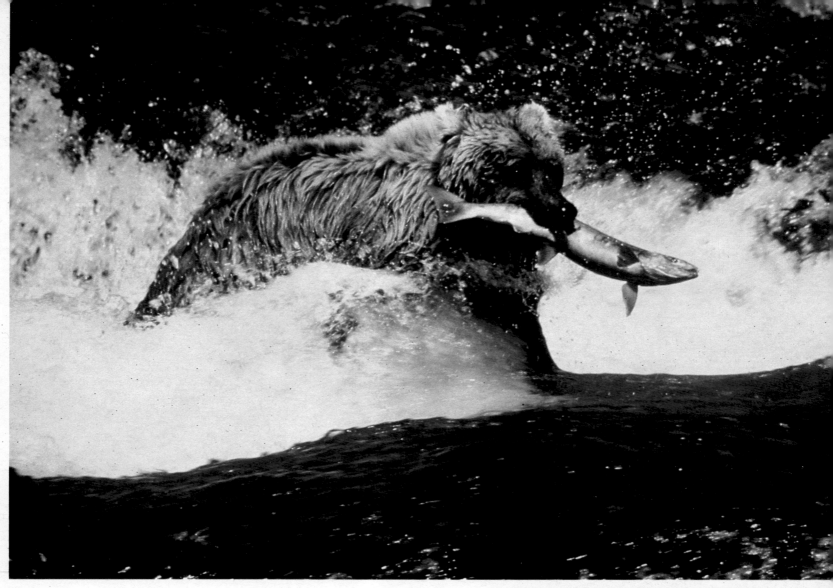

water level might mean that a lynx or glutton could get through the entranceway, the beaver makes sure the water always remains at the same level. If a lake has an outlet, the beaver will build a wooden dam there. If the water level rises after heavy precipitation, a "sluice" is opened to restore the desired level. The same results are gained by these perfect "hydraulic engineers" when they block the outlet if the water level falls during a long drought.

Before the white man penetrated the North American wilderness, an estimated hundred million beavers lived there. Predators, especially bears, coyotes, lynxes, gluttons, and eagles, could not reduce the beaver stock. Indian huntsmen caught only what they themselves needed. But for the white trappers and fur-traders, beaver hunting soon became a highly profitable business, and vast portions of North America were opened up in the search for beaver skins. It was only at the beginning of this century that Canada and the United States issued strict laws to protect the beaver.

Today, throughout the North American wilderness, countless bears still roam freely in the solitude of these deserted areas. The color of their fur ranges from deepest black to the yellowish white of polar bears. For this reason, bears used to be categorized into many species and subspecies, but scientists have now realized that despite conspicuous differences, there are only three species: black bears, brown bears, and polar bears. However, the names *black bear* and *brown bear* give no

When the salmon swims upstream, the bears follow. They nimbly fish for the fat prey.

indication about their true coloring; there are black bears with blond, cinnamon, and dark brown fur.

The glacier bears are a strange breed. In sunlight, their fur color looks aquamarine. So far, they have been sighted only near the Yakutat Bay in Alaska. Brown bears have similar variations. The grizzly, the most frequently sighted bear in the Mount McKinley region, is a brown

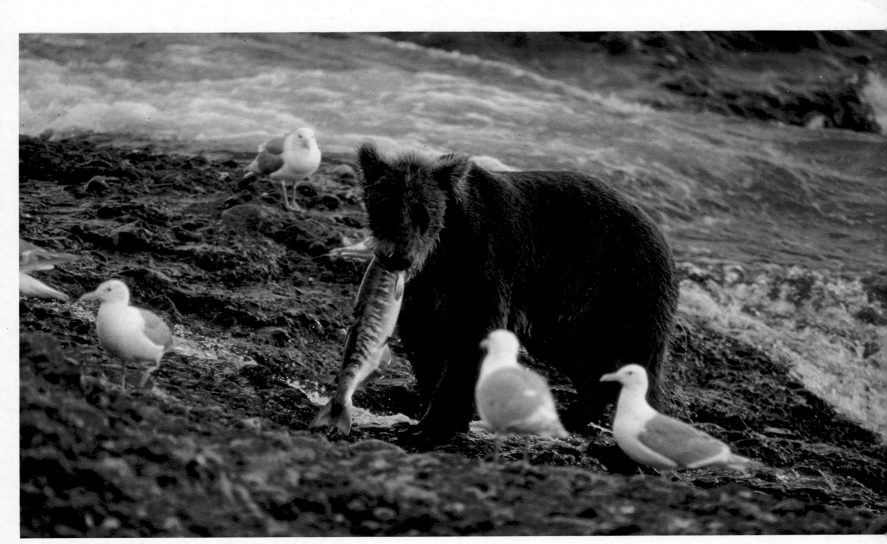

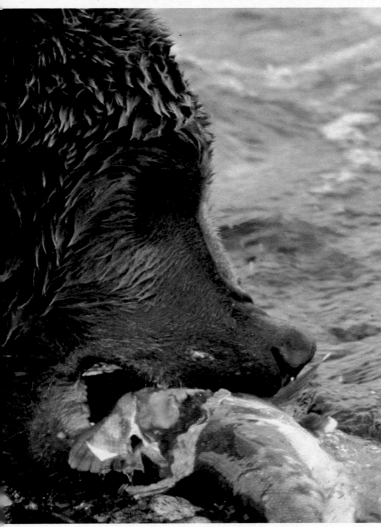

The water hunt is strenuous, and the slippery fish are quick.

When it comes to salmon, bears are not water-shy. For five pounds of fish in a catch, it pays to get one's fur wet (*top left*)! The gulls wait for the leftovers (*above*). A bear eats about eight salmon (*left*) before it feels satiated enough to retreat into its digestive sleep.

bear, as is the Kodiak, which, with a weight of up to two thousand pounds and a length of eleven feet, achieves the massive appearance of the extinct cave bear. I know of no better place in Alaska where one can observe brown bears in the wilderness than along the McNeil River on the Alaskan Peninsula. When the salmon begin swimming upstream in July, the bears come to fish in the river, preferring the shallow areas close to the estuary.

We flew a chartered seaplane from Anchorage to the McNeil. Accompanied by two bear researchers,

▶

When two bears fight, the others profit. The two young bears have come to blows over a fat fish——to the great pleasure of the gulls, which now eat their fill.

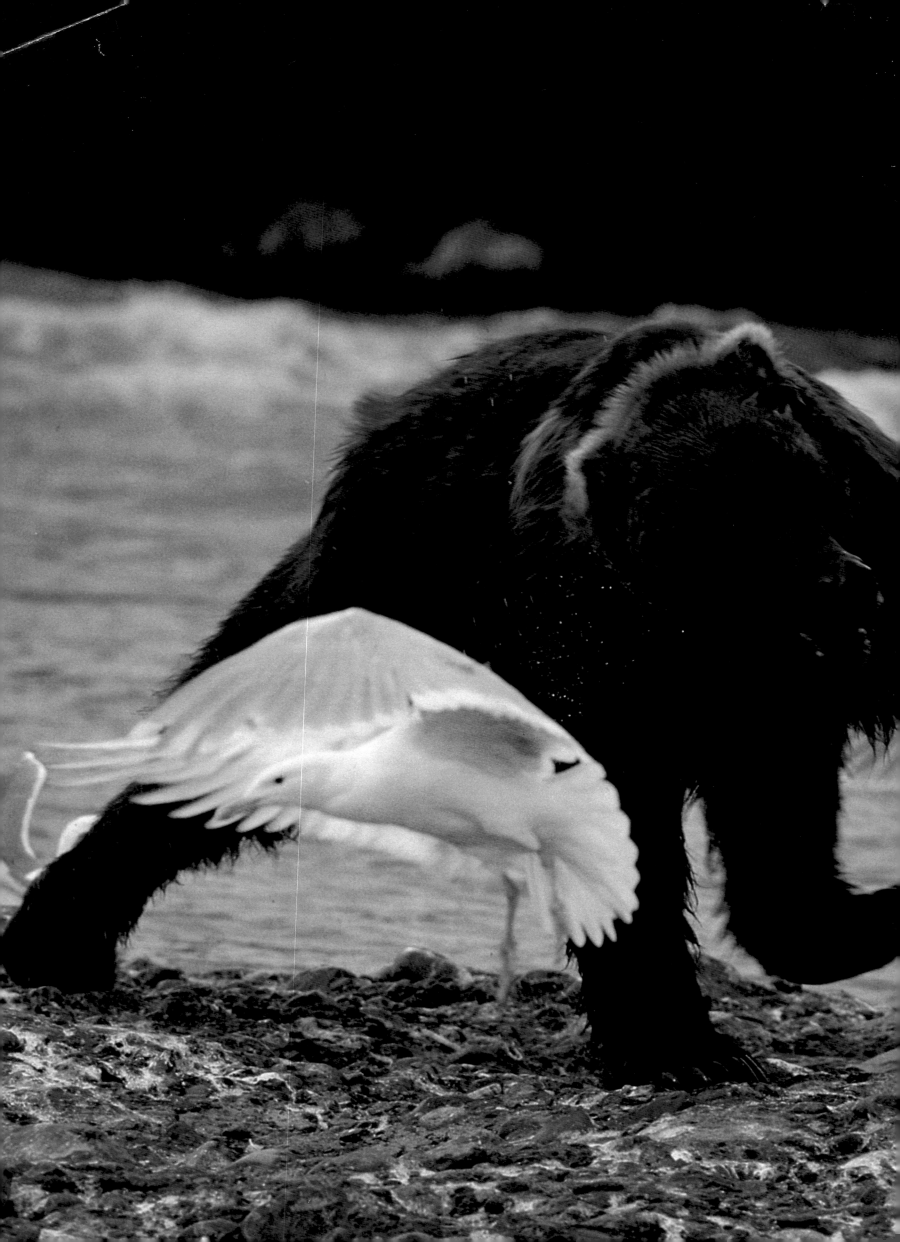

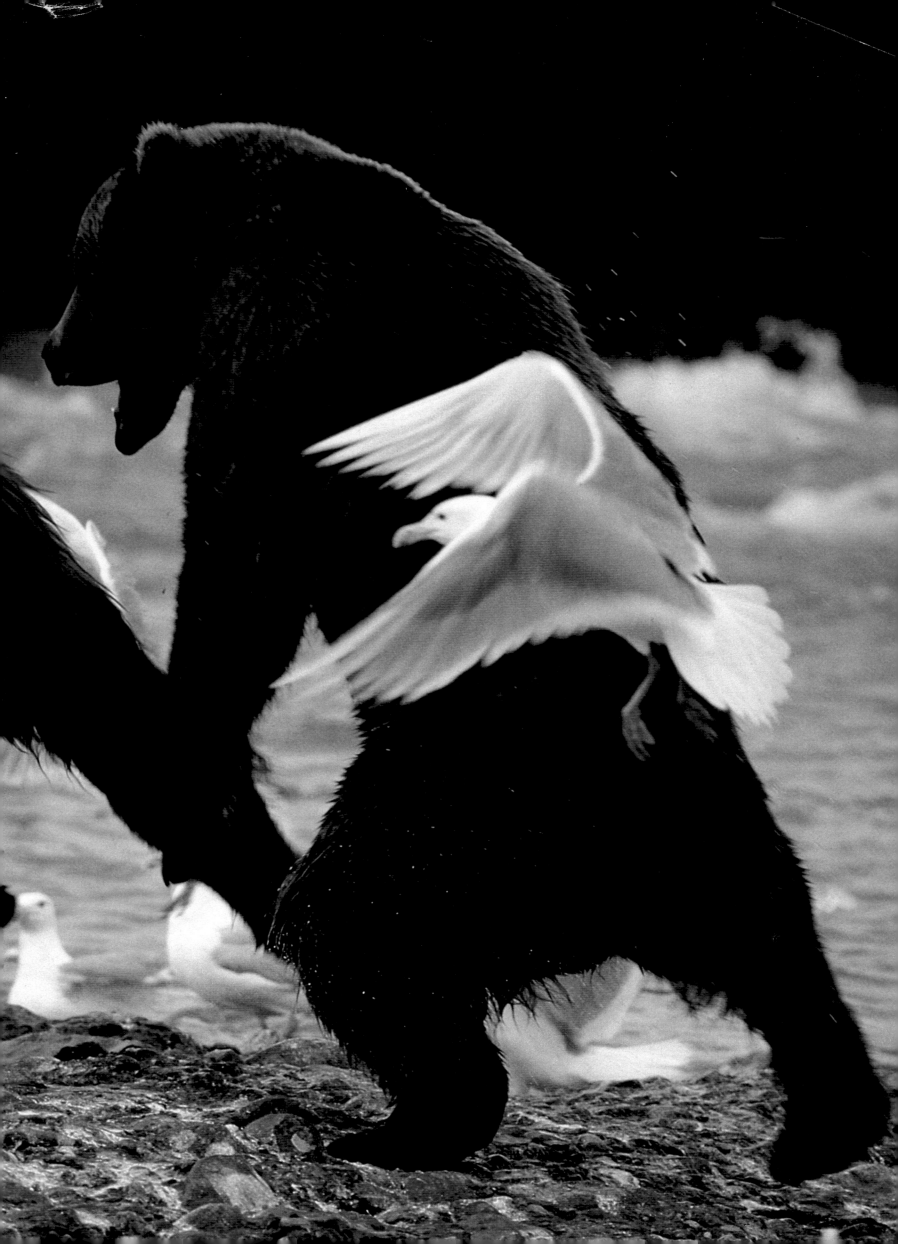

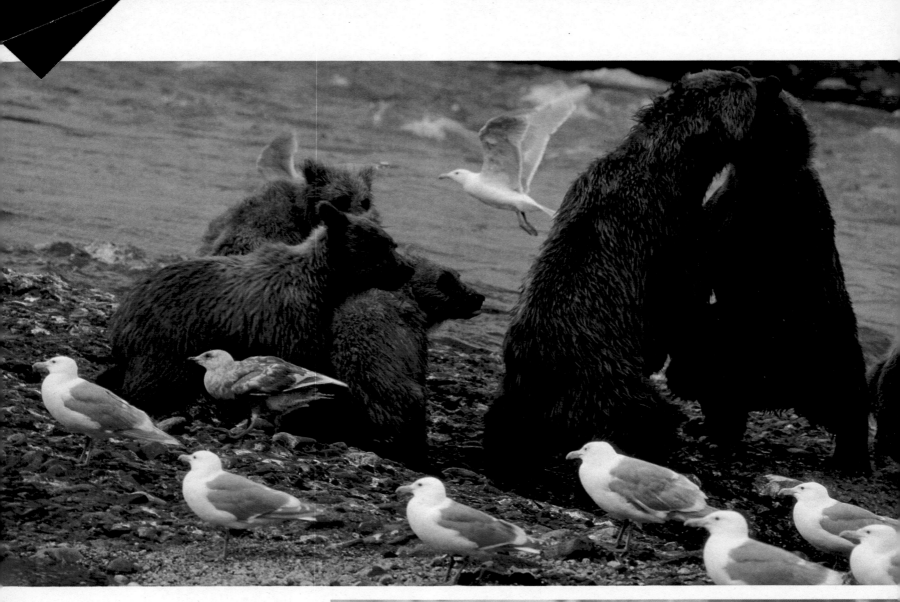

I crossed the river at low water to reach a particularly good observation site on the opposite bank. Despite the shallow water, which only came up to our knees, the current was very powerful. With our packs on our backs, we waded across arm in arm, four strong, to keep our balance in the raging river. Dick Zinsman, a nature lover from Anchorage, and as strong as a bear, had

The salmon is born in fresh water and later returns to these rivers to spawn.

become very familiar with the bear territory after several visits. He advised us to sing as loudly as possible—a precaution against disagreeable incidents with bears. Bears often take a nap to digest a rich meal in the bush zone near water. If they are suddenly awoken, they suspect serious danger; mothers that still have their infants with them are particularly apt to react very violently. Normally, bears do not attack human beings unless cornered.

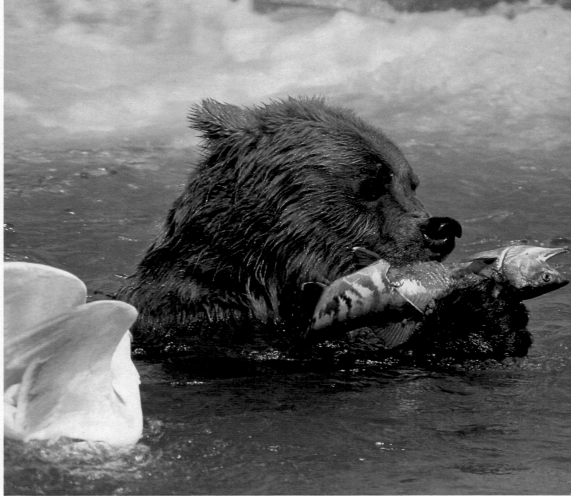

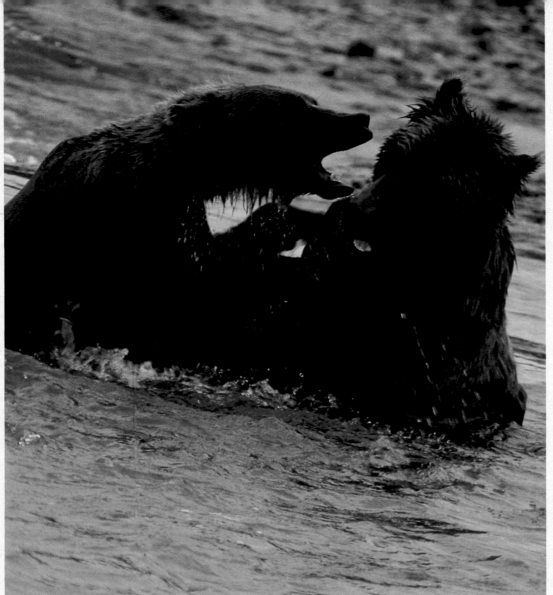

ibly drawn back to produce their own offspring.

They had not swum up this river since their earliest youth but had been living in the salt water of the sea. Nevertheless, they overcome any obstacles en route, employing all their strength to leap over rocky barriers and struggling in dense swarms through the narrow passes. Once they reach their destination, where the females lay their eggs and the males fertilize them, most of these fish die of exhaustion, their life cycle ended.

My greatest expectations were surpassed by far. All at once, we were surrounded by Alaskan brown

Young salmon need cold, clear water. After one to three years, they migrate to the ocean.

bears. A few stood on rocks in the rapids, others in the shallow water near the shore. Even without a telescope, I could make out every detail of their fishing methods. Bears wait, anxiously attentive, until a salmon swims in front of their paws or leaps past their heads to overcome some hindrance. The bear does not use its paws to kill its scaly prey. It seizes the fish in its teeth, bites hard, and only then does it raise both front paws. Otherwise, the still writhing fish might escape. For weeks, the amount of possible booty is inexhaustible. Toward the end of the spawning period, the bear is so fat that it can hibernate effortlessly.

A bear mother with her two playful young came out of the willow undergrowth. Leaving her little ones on shore, the mother leaped into the river with a splash, soon returning with a big salmon, which the two offspring impetuously grabbed. First

When the mother bear believes that her young are in danger, she doesn't just threaten; she strikes.

The mother bear defends her fishing grounds before the eyes of her children. In such a situation, she will fight even with more powerful males (top left). Playfully tussling with her own children, the mother seems as gentle as a lamb (top). A young bear proudly presents his first catch (left).

The countryside generally has a tundra character. Small willows and birches grow only between scattered boulders. We saw deeply trodden bear trails everywhere, but during ninety minutes of hiking, we did not run into a single bear and we reached the rapids without incident. Here we found an ideal observation post. A thirteen-foot-high rocky plate stood on the river bank, and there were stone fragments in five-foot piles upon it. We could set up our cameras and do what we had to without being surprised by bears. From our rock balcony we could view the river for miles in either direction. It was a breathtaking panorama: towering peaks, some of them snow covered, in the background; the forest frontier to the south; the hilly tundra to the north; and in front of us the gurgling, foaming McNeil River with its cliffs, rock terraces, gulches, and roaring cascades. Huge numbers of pink salmon were migrating from the Pacific to their spawning grounds in the upper reaches of the torrent. This was where they themselves had hatched, and now they were irresist-

▶

The Alaskan tundra changes its color when the days grow short. After a few weeks, the storms from the Pacific bring ice-cold rain, a sign that the almost endless winter is not far off.

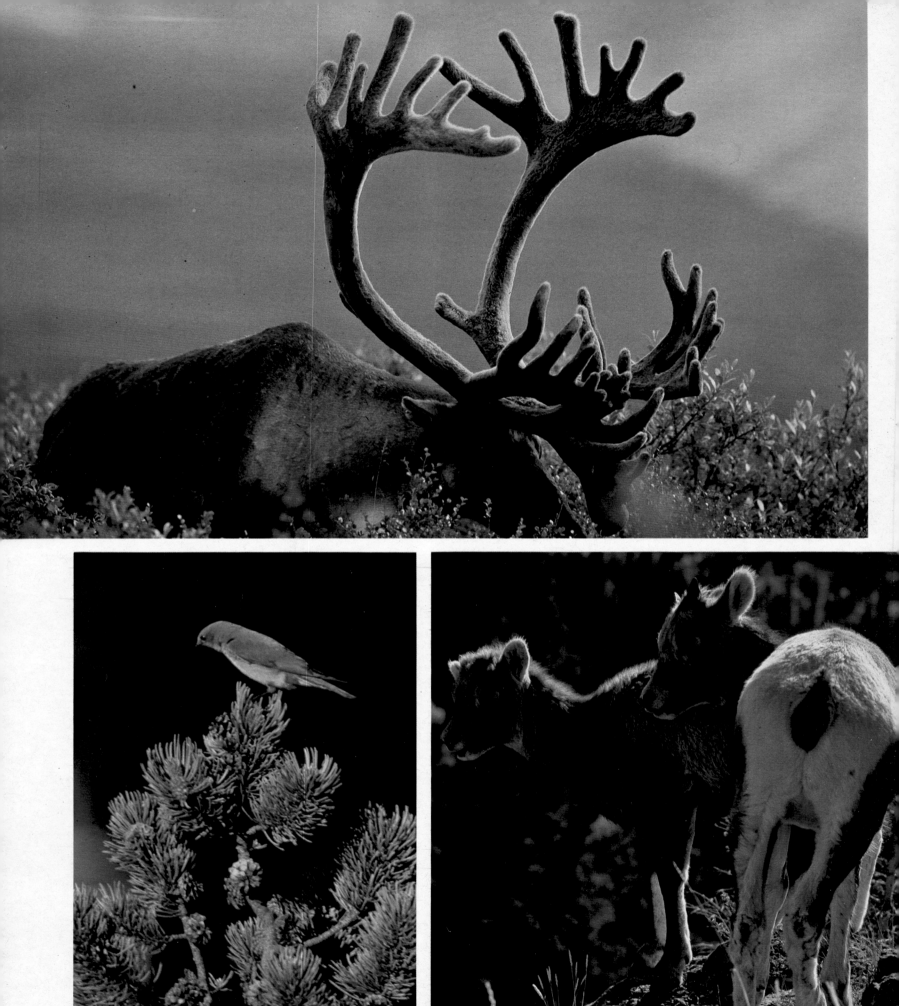

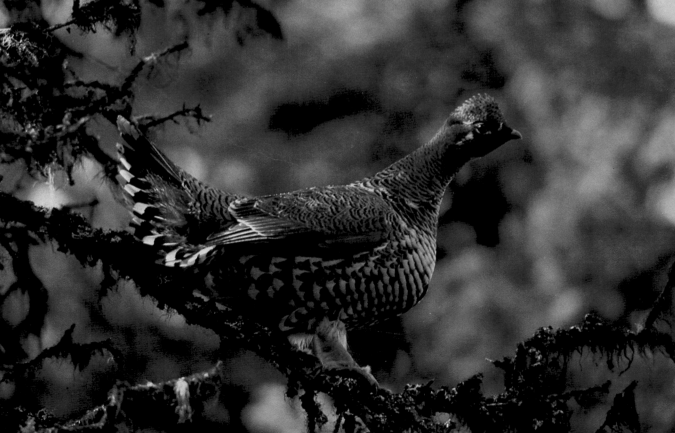

The wonderful fauna of Alaska

The caribou is a wanderer, stopping only to sleep (*top left*). The mountain bluebird shines like a castaway from the tropics (*far left*). The kids of the Rocky Mountain big-horns are skillfull climbers (*left*). For the mountain goat and her kid, no peak is too high (*top*). Hazel grouse also live in this area (*far right*).

they ate the fat fish together, then they began tussling over the best parts. The cubs, spoiling for a fight, perched on their hind legs, slapping each other, and kept this up until the mother appeared with a second salmon, which she dropped between them, thereby restoring peace. Now, each cub had its own prey.

Some bears display a special talent and experience in catching salmon, while others often have quite a struggle until they finally

The bald eagle is the victim of environmental poisons. Alaska is the only place where it lives free of such danger.

clamp a salmon in their teeth. Some bears are so spoiled by the enormously rich supply that they only lick the eggs—the roe—of the heavy female.

Anything left over by the wasteful bears is grabbed by the silvery gull and the bald eagle. Every child in America is familiar with the bald eagle, for it adorns the national emblem of the United States. While

this stately bird of prey does not seem endangered in this primeval wilderness, it appeared to be threatened by extinction in most other parts of its territory. The bald eagle is at the end of a food chain on which the accumulated poisons, herbicides, and pesticides dumped by man in fields and forests are having drastic effects. The bald eagle lives on fish and water fowl, which in turn feed on plankton and other small creatures. Unused poisons gather in them after being carried by strong rainfall from the woods and meadows to the waters. The small creatures are devoured by small fish, which are then devoured by larger fish. Water birds also go fishing, and they then become the prey of bald eagles. A plethora of destructive substances gathers in the bald eagle's body. These toxins can cause thin-shelled eggs, which are squashed during hatching, or embryos too weak to survive.

This turn of events was the alarm signal for many countries to drastically lower the poison content in food and in the environment. Certain poisons, for instance DDT and other chlorinated hydrocarbons, were declared illegal.

The wilderness paradise on the McNeil River brought us a very special surprise. Suddenly, as though chiseled out of stone, a light gray

A world where nature maintains its balance.

A fascinating hunter in the deserted reaches: the wolf (*right*). It hunts and lives in packs. The Rocky Mountain bighorn is one of its victims (*below*). Glacier lilies (*below right*) are among the most beautiful plants in the Rocky Mountains.

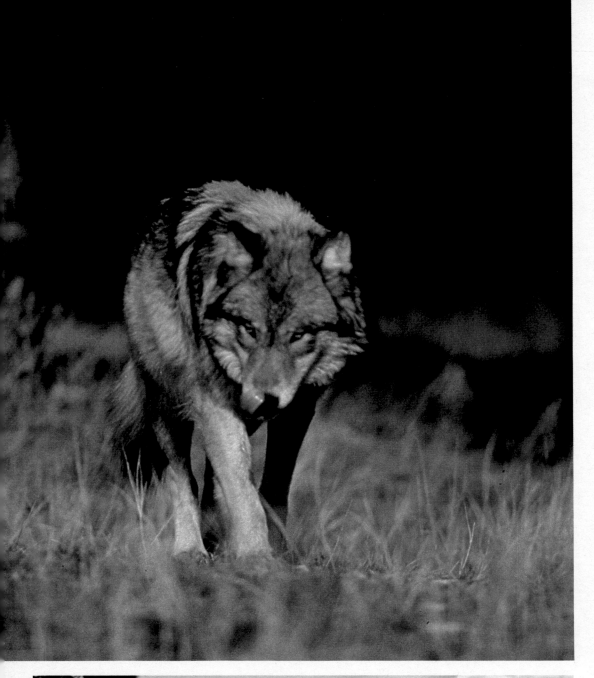

she-wolf stood by the river, gazing eagerly at the migrating salmon. The wolf is one of the most intelligent and also one of the most timid creatures in the wilderness. Its sense of hearing and sense of smell are so finely developed that it is very difficult to observe the wolf hunting in the daylight, much less to capture it on film. Nevertheless, since the wind did not blow across our hiding place, and the whirring of the cameras was swallowed up by the roar of the McNeil, we managed to shoot some film. The she-wolf stepped, first hesitantly, then with a quick resolve, into the whirling water. Three times she snapped in vain at passing salmon. On her fourth try, she succeeded. A three-foot fish was writhing in her teeth as she loped away, presumably to her lair in the tundra, where hungry children were waiting to be fed.

The animal I had most looked forward to meeting was the "king of the arctic wilderness," the polar bear. Nowadays, you have to be very lucky to observe these wonderful creatures in the wild. For too long a time, men have hunted them down, uncontrolled and uninhibitedly. By mid-July the ice had receded far enough, and the Eskimos in a tiny settlement south of Point Barrow were now willing to go out on a first expedition in their seaworthy boat. We were thus led not only to the white bears, but also to other large creatures of the Arctic Ocean and the ice. When, after an hour's ride, Tom, our skipper, pointed ahead

Walruses trumpet across the Arctic Ocean. Their ivory tusks made them a desirable prey.

and shouted: "Beluga!" I looked through my binoculars. Far away, I spotted three ocean mammals that I had never seen before: the white whales of the Arctic. They are not giants among whales, never growing longer than thirteen to sixteen feet. A fog came up and the gray coastline could just barely be made out. Ghostly swarms of auks and guillemots flew by overhead. Then we heard an eerie bellowing, trumpeting, and snoring, which vaguely reminded me of the noises made by elephants and hippopotamuses. It was only when peering through binoculars that I recognized a troupe of some ten walruses swimming past, between the ship and the shore, at

When the winter sun does not rise, the northern lights shine.

The solar wind brings solar particles within the gravitational force of the earth. They begin to shine peculiarly only above the arctic circle.

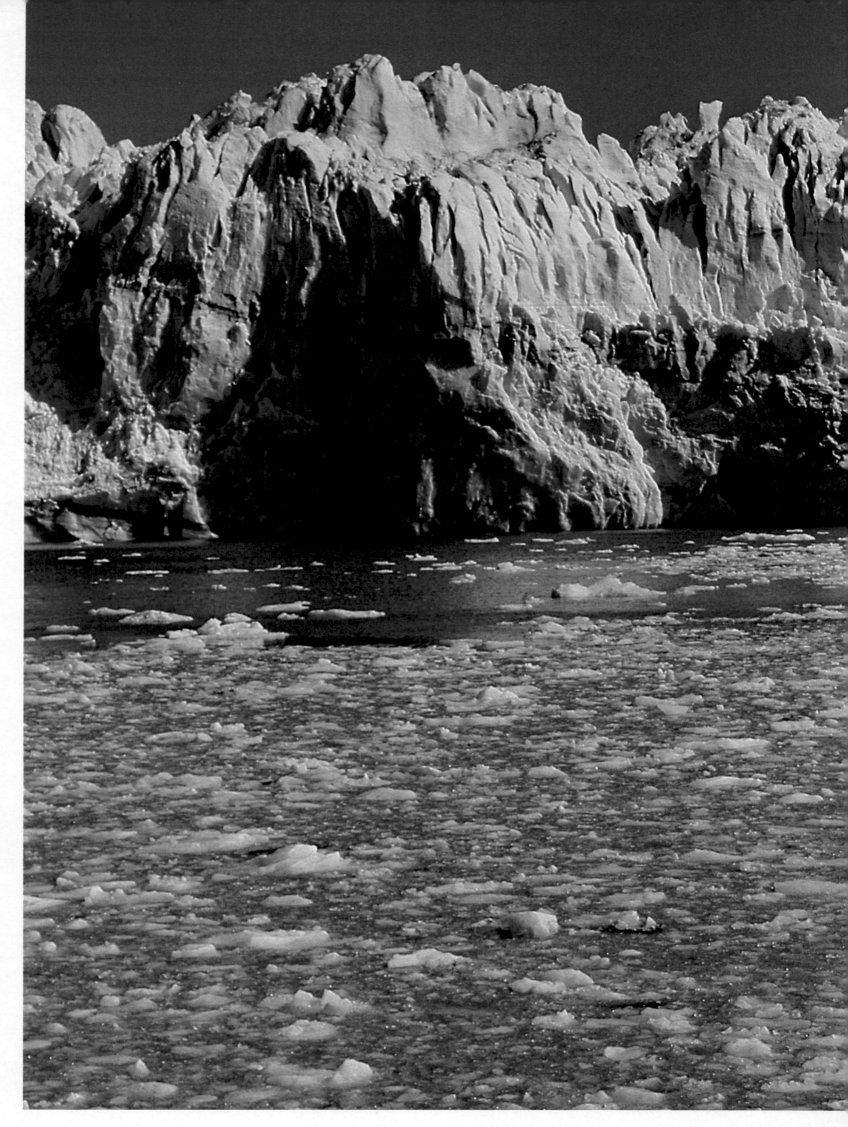

Gigantic ice cascades decorate the Columbia Glacier.

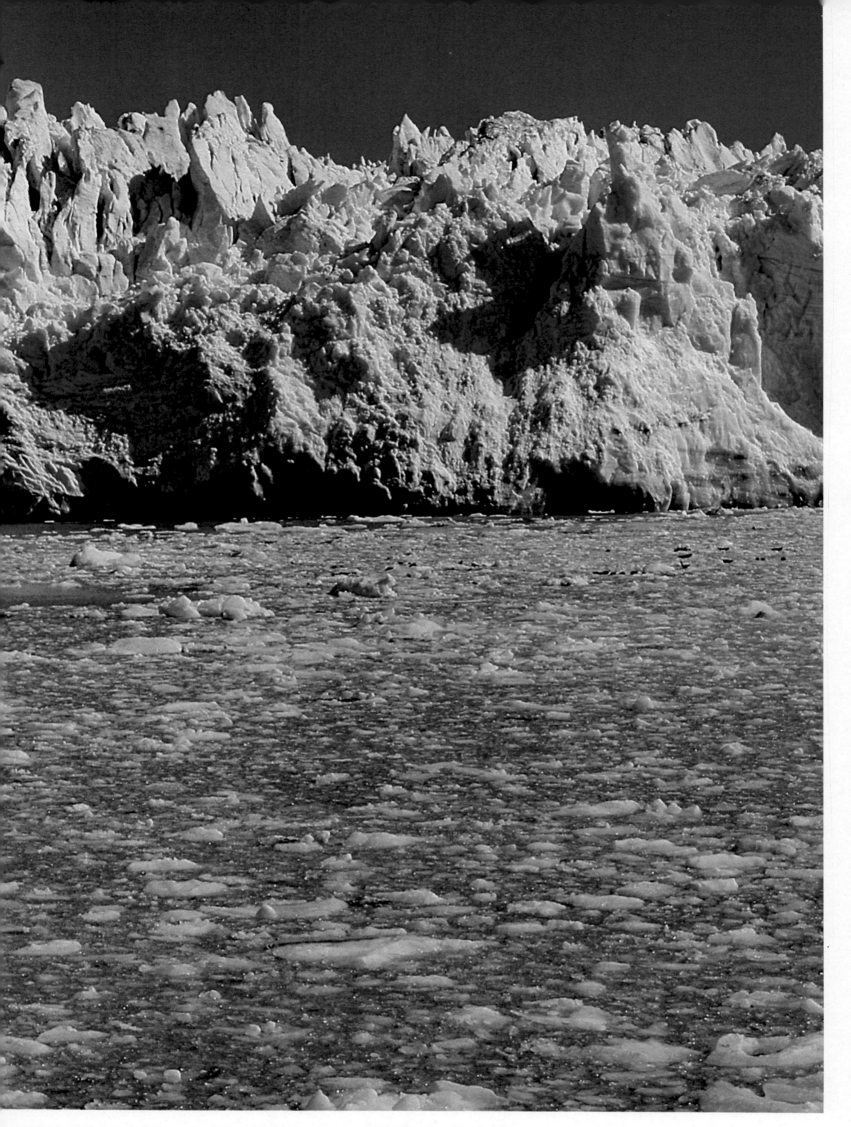

The perennial ice "wanders" forever. When the glacier gives birth,
its "children" drop into the water as icebergs and drift away on the sea.

brief intervals. The movements of these colossi were strikingly balletic in the water, and the powerful bodies appeared almost weightless. Half an hour later, the sunlight had dispelled the final patches of fog, and we followed the walruses, soon discovering their resting grounds. In a fantastic setting, a horseshoe-shaped bay, almost two hundred animals rested. The smooth rock terraces were covered with massive walruses from the inky arctic water all the way to the land. We moved up on them stealthily. The walruses were insensitive to noise, for the bay was filled with their loud trumpeting. A huge bull stood right in front of me, just barely ashore, and I

Walrus bulls are tough fighters. Using their ivory tusks, they break mussels from the rocks.

filmed it up close, as it clumsily plunked its way forward. To move its body—which weighs tons—across the shore rocks, it had to employ its tremendous tusks. Next, a walrus mother with her baby climbed ashore right in front of us. It was touching to watch her push the little one along, tenderly and cautiously, to help it reach dry land. Until the age of two, the young lives mainly from its mother's milk. Then, as a matter of course, it dives down to the mussel banks, which offer the chief nourishment for walruses. They use their ivory tusks to break the mussels from the rocks.

This outing took place during the period of the midnight sun, when twenty-four hours of daylight cause sleeping problems for any stranger. I, at least, am one of those who seldom can fall asleep before 2:00 A.M. Even the Eskimo children rarely go to bed before two or three in the morning. I was fast asleep, having

Polar bears are bigger than other bears—which helps them endure the Arctic cold.

just barely dropped off, when Tom, our skipper, began shaking me, yelling *"nanook."* I learned long ago that this word means "polar bear." A restless wanderer, this bear never lives in a specific place. Meeting one anywhere in the endless area of the Arctic Ocean is a sheer fluke. The

Winter, which lasts eight months, is a harsh time for the animal world.

The moose is a restless wanderer even in the high snow, migrating from one feeding ground to another (*above*). The mountain goat is protected from the grim cold by its thick, shaggy, pure white fur (*far right*). The lynx's prey quickly freezes into a stone-hard supply (*right*).

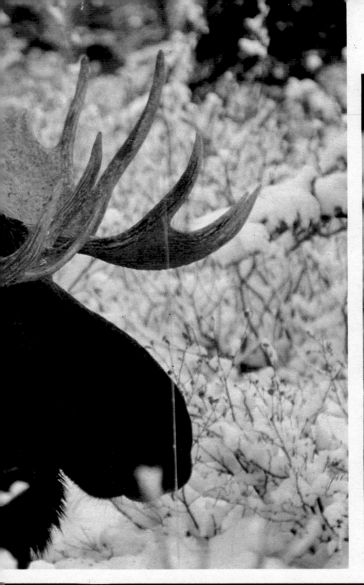

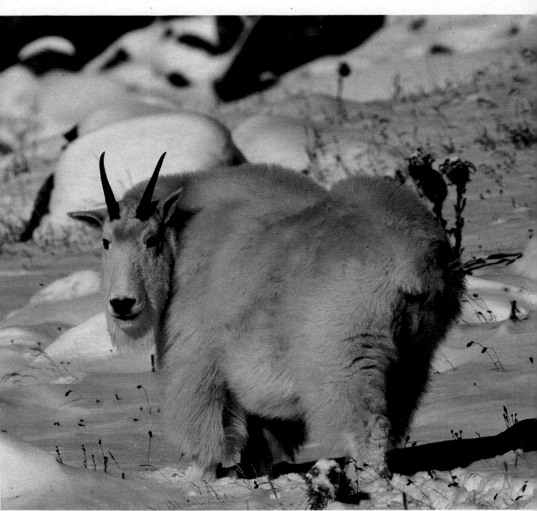

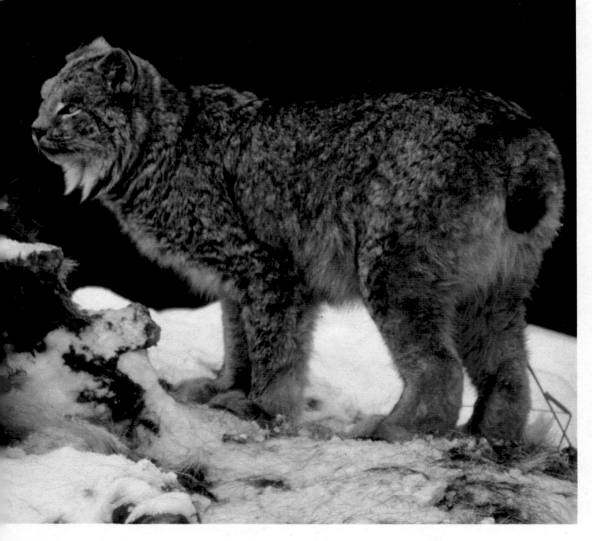

polar bear can grow twelve feet long and almost five feet tall. His only enemies are the Eskimos, who hunt the *nanook* with spears after surrounding him with their dogs. An encounter has always been a dangerous business for man and dog. But a white bearskin commanded high prices, while the meat was, and still is, a delicacy. Recently, however, strict laws have begun to protect the polar bear.

No other sea offers as many surprises as the Bering Sea, between Alaska and Siberia. The combination of the Japan Current, the Pacific Ocean, and the Arctic Ocean makes the Bering Sea one of the foggiest areas on earth and the preferred habitat of animals that sport especially thick and valuable fur—which is why they have been ruthlessly hunted down to the verge of extinction.

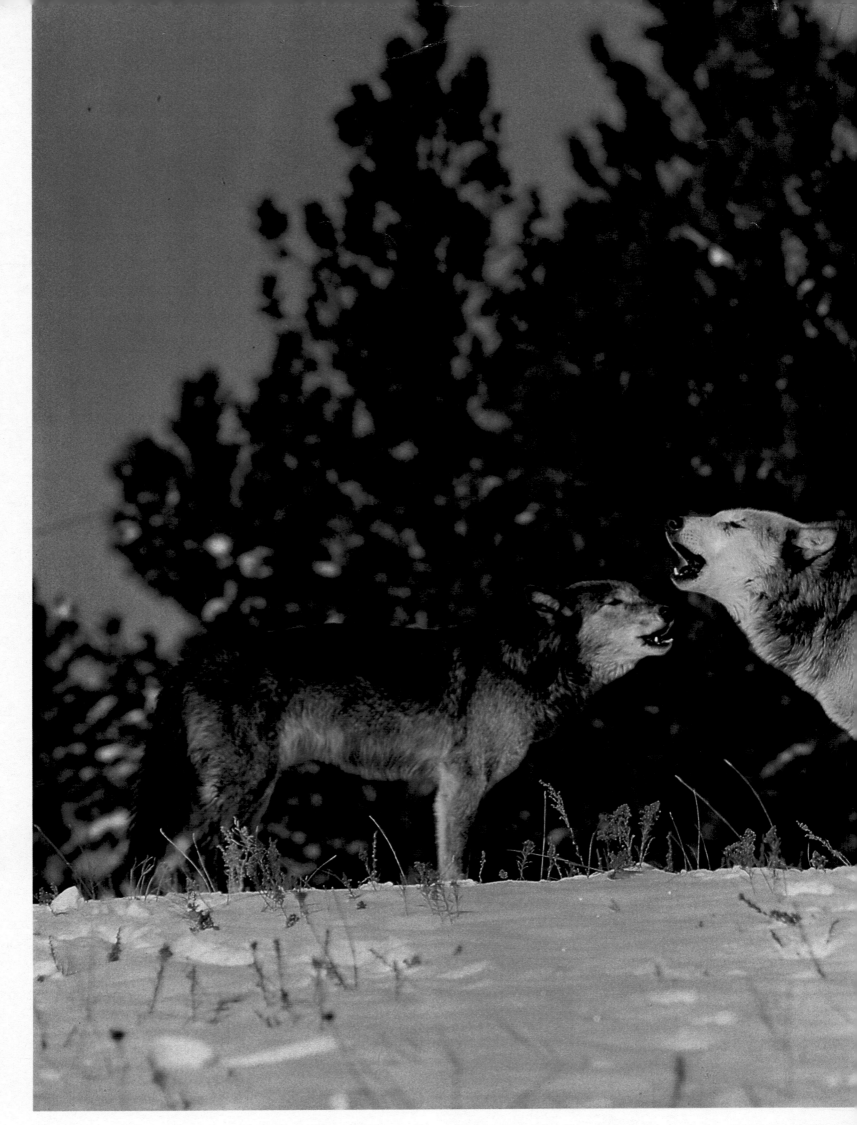

The howl of the wolf resounds throughout the snowy mountain world.

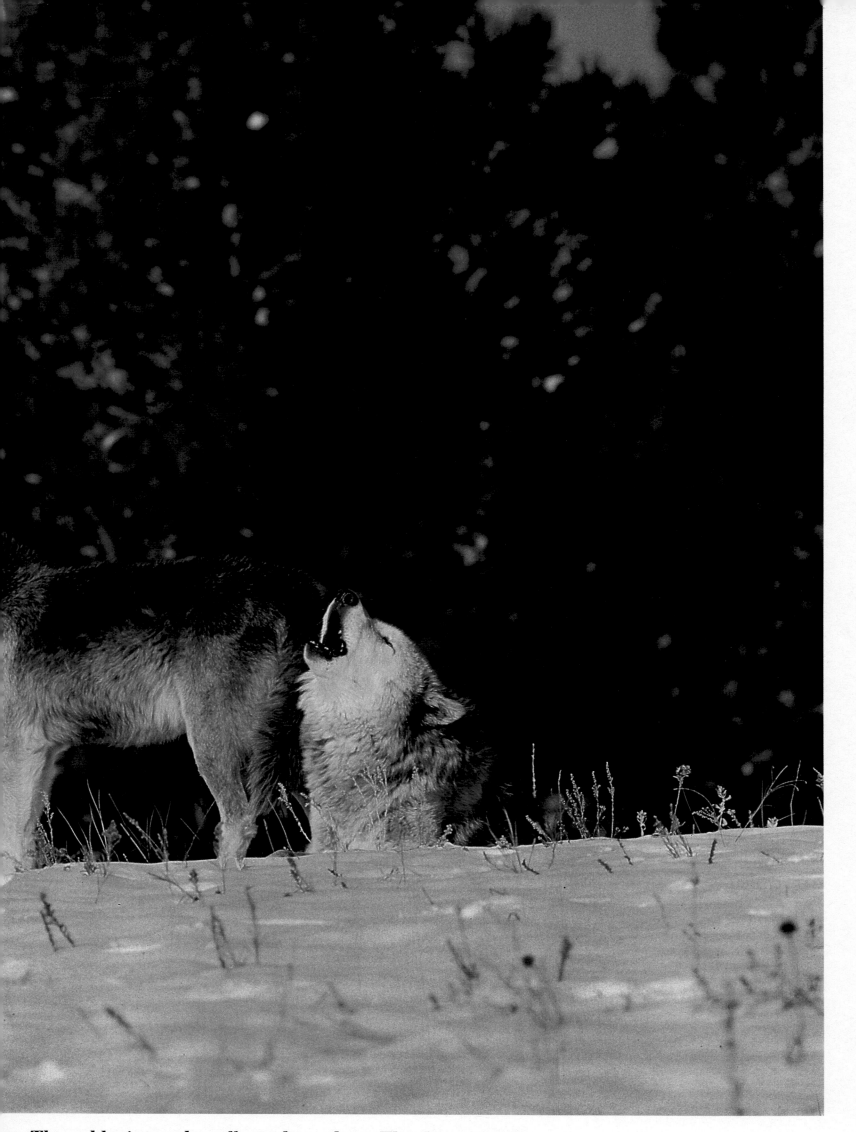

The cold winter also affects the wolves. The deep snow makes it harder to hunt. The pack prepares almost every evening for miles of hunting through the wilderness.

At once fascinating and terrifying, the rugged cliffs of the enormous abyss plunge into endless depths. The Grand Canyon is a unique documentation of primeval forces.

The Grand Canyon: amid the Rocks

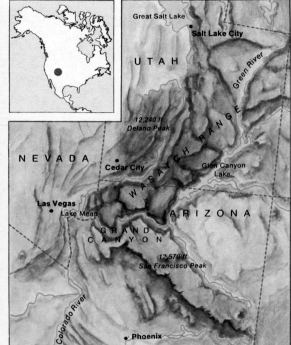

Once upon a time, a river forged a bed for itself.

The Grand Canyon: As wide as twenty miles and as deep as one mile. A mountain range cut into the earth. A moderate mountain climate at the northern end, and desert at the southern end. Deadly heat in its depths. Extreme habitats for flora and fauna, perhaps, but also a refuge for cougars, bobcats, and rattlesnakes.

In 1492 the Spaniards discovered the Americas, a world of wonders which seemed to exist purely to satisfy their insatiable greed for wealth and property. With the dream of gold before their eyes, Spanish soldiers fought their way through the desert of what is now Arizona until suddenly, in a seemingly endless stone plain, a chasm yawned in front of them: the Grand Canyon.

An outing in the Grand Canyon becomes a lesson in geology. Rock walls some 4,000 to 5,000 feet deep line the Colorado River for about 270 miles. The distance between the southern and northern edges varies from three and one half to eighteen miles. The Grand Canyon is like a mountain that digs into the depth of the earth instead of looming into the sky. It turns our picture of the world upside down.

How did this miracle of nature come into being? According to one credible theory, the entire Colorado Plateau, a gigantic plain in the southwestern United States, rose some fifty million years ago. However, the Colorado River began digging its bed into the rocks only some ten million years ago. The force of the water and the detritus carried along were responsible for exposing twelve strata of different rock. Two billion years of geological history are revealed at one glance in the depth of the canyon. If you see the Colorado leisurely rolling along in dry seasons, it seems inconceivable that this river could have dug a can-

The rocks of the Colorado River change color depending on the light—a miracle in stone.

yon one mile deep. However, during high water, a notion of the river's power is revealed; at such times, the water rages through the valley with an unbelievable impact.

The rocks bared by the torrent offer a grandiose play of forms and colors. Cones, columns, and merlons shine gold, orange, red, violet, blue, or green, depending on the light, a sea of colors, changing from minute to minute.

Overwhelmed by this rocky miracle, one might almost overlook the flora and fauna. In fact, the canyon has a far greater variety than one might think possible in this ocean of rock.

There is, however, a sharp difference between the southern and

northern edge of the canyon, which functions like a climatological barrier. If you descend from the northern edge, you feel as if you are traveling from central Canada down to the Mexican coast.

The northern edge, with the Kaibab Plateau behind it, is one thousand feet higher than the southern edge, behind which lies the Coconino Plateau. The former evinces typical mountain vegetation: forests of aspens, Western pines, gold-tooth maples, and Douglas firs with dense underwood. This forest area behind the northern edge of the canyon is populated by small and large animals. The Kaibab squirrel is the only known animal to form a subspecies because of the canyon barrier. It can be found only within a few hundred square miles of the Kaibab Plateau.

During the 1920s, the northern plateau suffered a considerable disturbance in its vegetation. At that time, the canyon predators—pumas, lynxes, coyotes, and foxes—could be hunted freely. As a result, one prey of the puma, the mule (or jumping) deer, increased at a massive rate, causing extensive damage in the forests, which has not been corrected even today. However, gamekeepers

One hundred and fifty years ago, these animals also lived in the prairie.

Fleeing the encroachment of agriculture, the prairie grouse (*right*) and the cougar (*far right*) retreated into the inaccessible canyons. When mating, the Wermuth's grouse (*below* and *below right*) flaunts its puffed-up neck plumage and fan-shaped tail.

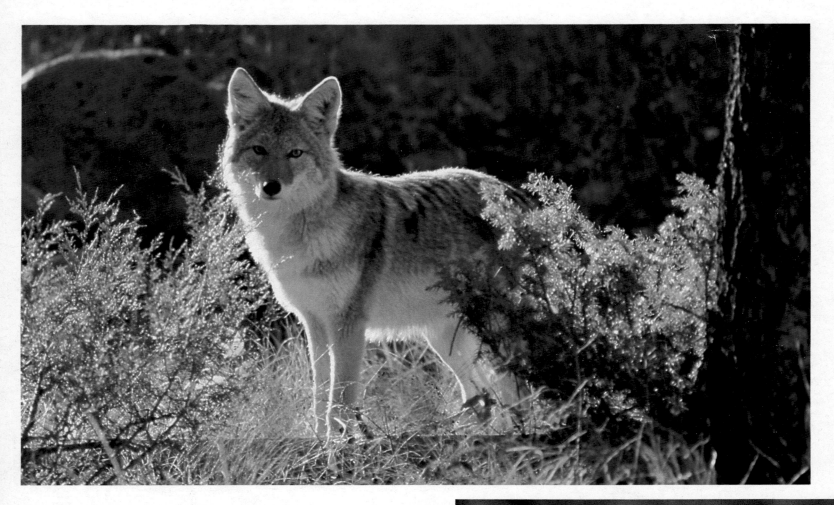

are making sure that the stock of predators remains balanced.

The king of the canyon is the puma or cougar. This purring predatory cat finds rich prey here, but it is no gourmet; if it can't find a stag, hare, skunk, or porcupine, it will make do with rats and mice. Whenever a catch is too big for one meal, the cougar hides the leftovers. Three or four days later—it never hunts more frequently than that—the table is set again. The cougar also seizes grazing cattle. But its alleged liking for human beings is a vicious rumor. The timid cougar withdraws at the least sign of danger and climbs up a tree. It always avoids human beings. The cougar's hide is very popular because of its durability (only the downy skin of young cougars is strewn with black spots), so it must have a safe habitat, which it can only find in the deserted canyon and the sparsely settled environs.

The bobcat is more of a hunting companion for the cougar than a rival. Weighing only one tenth of what a cougar weighs, the bobcat cannot take away the large prey from the larger hunter, so its food consists of squirrels, rats and mice.

The common skunk hunts the same prey as the bobcat. From a distance, this black-and-white mar-

When the Golden West was settled, these were declared outlaws.

Huge herds of bison (*left*) were wiped out; only a tiny number exist today. The prairie dog (*right*), a member of the ground squirrel family, was ruthlessly hunted down because its territory was needed for cattle. Prairie dogs are often the prey of the coyote (*top*). Despite its unpopularity, this "prairie wolf" has managed to survive—perhaps because it is a loner.

ten with its bushy tail is an amusing sight. But if the skunk is in danger, it has a sure weapon. Its anal gland sprays out a perfectly aimed, malodorous secretion. The stench remains with the victim for many weeks.

A typical inhabitant of the northern canyon edge is the tree porcupine. This rodent lives on bark,

The cougar is the king of the canyon. It chases the mule deer, but it also eats rats.

twigs, and young shoots of coniferous trees, in which the skilled climber seeks its food at night. The porcupine is almost more dangerous for attackers than they are for it. In times of peril, it sticks out its thousands of quills, which makes it seem twice its actual size. These quills can cause painful inflammation if they get under the skin.

In the fissures of the canyon slopes, rock roses, and scrub oaks splash the rock with green. Windless heat flickers on the bottom of the canyon. Sometimes the temperature difference between the northern edge and the bottom of the canyon can be as wide as seventy degrees Fahrenheit. Little precipitation occurs. When it snows on the edge of the canyon, not a single flake drifts to the bottom because it melts and evaporates on the way. In this desert climate, there are thorny bushes, pink-blossomed tamarisk shrubs, and living "fossils" like the Arizona walnut and the small-leafed mulberry tree. The candlewood stretches its thin, bizarre twigs into the air, and mallows flower in lavish splendor.

Only one animal really gets along at the bottom of the canyon. Its food demands are meager, and it can live on very little water. This creature is the gila monster. Twenty inches long, it is one of two poisonous lizards to be found in the world. Two fangs are wedged in its lower jaw, but they are not used as a hunting weapon, since the gila monster lives chiefly on birds' eggs. A bite in self-defense becomes necessary at times, and it can have terrible consequences. For large creatures, the bite is not necessarily lethal, but it can cause impairments of locomotion and memory. The black-and-yellow lizard takes care of its water supply with a store of fat in its tail. This deposit is like a camel's hump. During its periodic dry spells the gila monster makes use of this "pantry."

Different worlds in one canyon

Descending from the edge of the Grand Canyon (*far right*) to the Colorado River is like traveling from central Canada to the Mexican coast— a distance of nearly three thousand miles. In the valley, it almost never snows. And when the flowers are already blossoming down by the river, deep winter rules above, along the edges— with snow sometimes twelve feet deep.

The kangaroo rat, one of the animals that the canyon predators track down at night, has a curious appearance. Its tasseled tail is longer than its entire body. It also has powerful hind legs with large paws, and its front paws are stunted. Five inches long, this little mouse is known primarily for its enormous courage when defending itself. If attacked, it performs foolhardy leaps, springing through the air like a dervish.

The climatic difference between the bottom of the canyon and the southern edge is not as great as that

The "barking" mouse performs leaps and somersaults, but they usually don't save its brief life.

between the bottom and the northern edge; hence, the borderlines in the population of flora and fauna are vague. A typical plains vegetation grows on the dry, barren ground: pines, juniper, cacti, and evergreen shrubs, all of them filling the air with fine scents. The yellow pine emits an intense fragrance of vanilla. Characteristic plants of the Arizona desert grow along the edge of the canyon: cactus, agave, and yucca. Agaves cling to the steep slopes

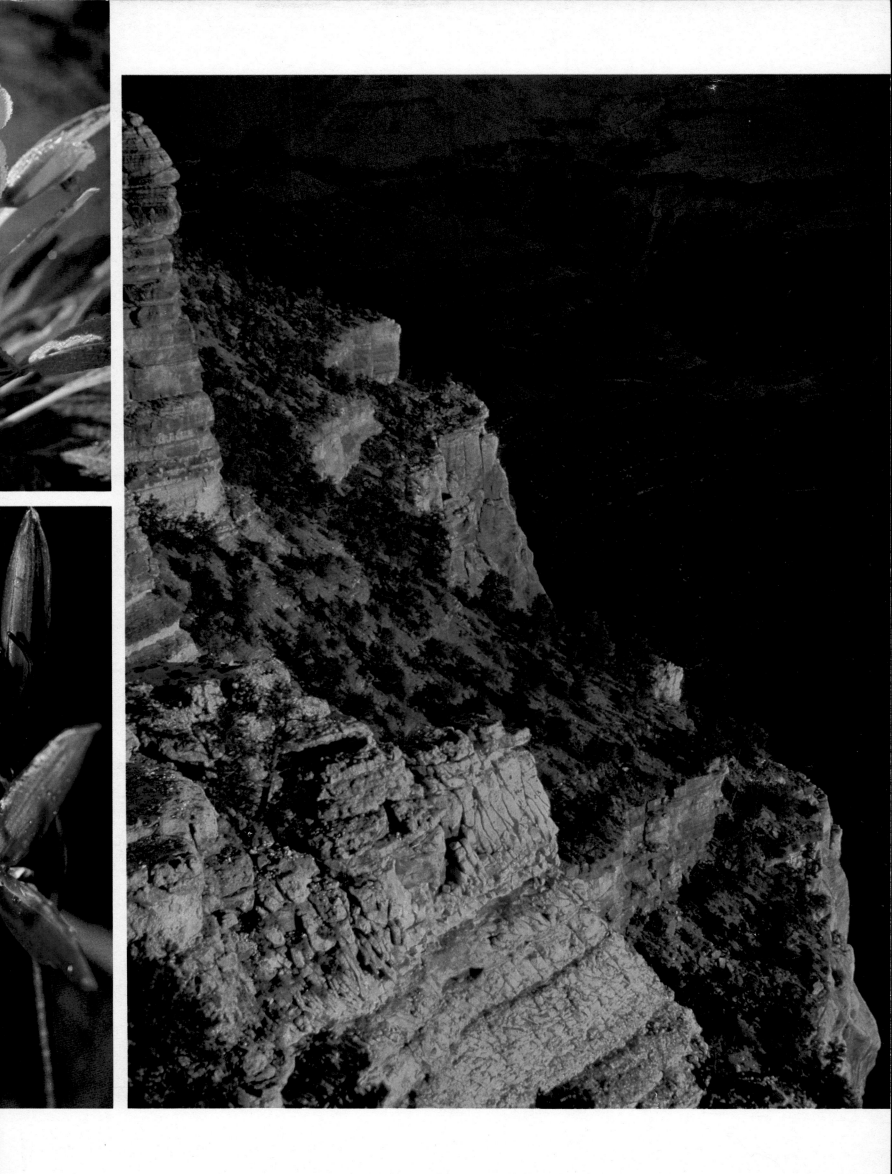

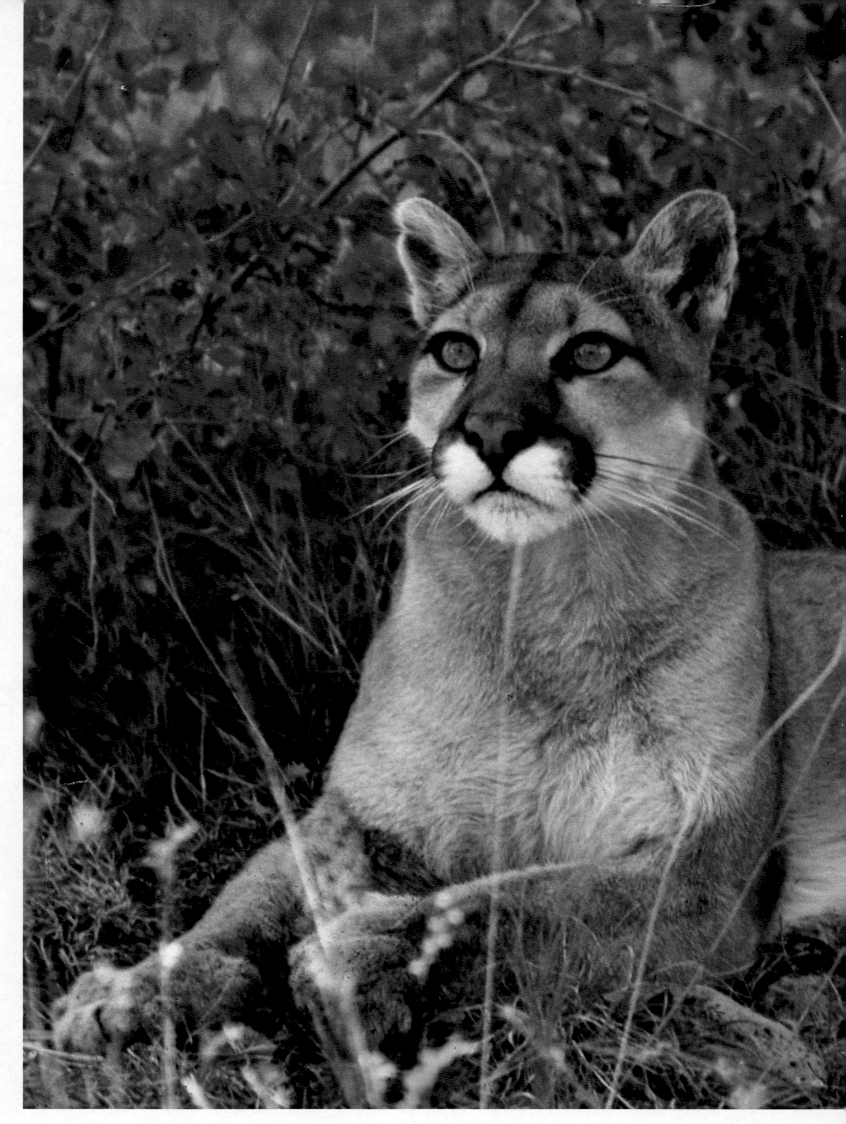

One finds this creature's spoor all over the Grand Canyon.

The puma or cougar is as big as a leopard. It hunts
deer and other herbivores.

directly underneath the edge. Their yellow blossom candelabra stretch many feet into the air, robbing the plant of all its strength. Shortly after flowering, it dies. The yucca—the most beautiful representative is the Yucca baccata—brings forth beautiful white blossoms among its thick swordlike leaves.

The roadrunner eats rattlesnakes. The rattling prey often hangs out of its throat.

In the Coconino Plateau, the most popular bird in America, the roadrunner, finds enough space for its outings. With its long legs, scrubby feathers, and crooked beak, this crow-sized bird is no great beauty. It is called "roadrunner" because it runs along the ground at a great clip. It can fly, but not very well; generally, it prefers the ground. Its popularity is due to both its unique ap-

pearance and its unusual courage. It fearlessly ventures up close to the biggest snakes, pecks them to death lightning fast, and devours them. But there is one problem: the snakes are often too long for the roadrunner; sometimes half a snake dangles out of its bill like an enormous tongue.

One victim of the roadrunner is the best-known snake in America: the rattlesnake. This poisonous creature announces its presence by a loud rattling produced by horny shells at the end of its tail. The rattles remain when the snake sheds its skin and they anchor loosely in the last shell. Its rattling is neither a come-on for prey nor a mating signal—rattlesnakes are deaf—but a warning. They rattle to protect themselves.

The rattlesnake reacts to minimal changes in temperature. With two pitlike depressions between eye and nostril, the rattlesnake tracks down warm-blooded creatures. Its perfect infrared tracing system can distin-

Wherever water is scarce, plants develop a special protection.

In many low-precipitation plateaus and deep valley gulches, the cactus has a sensible mechanism for conserving water even in times of utmost drought. Note, for instance, the hedgehog cactus (*right*). Rainy regions are inhabited by the funny-looking prairie dog (*below right*).

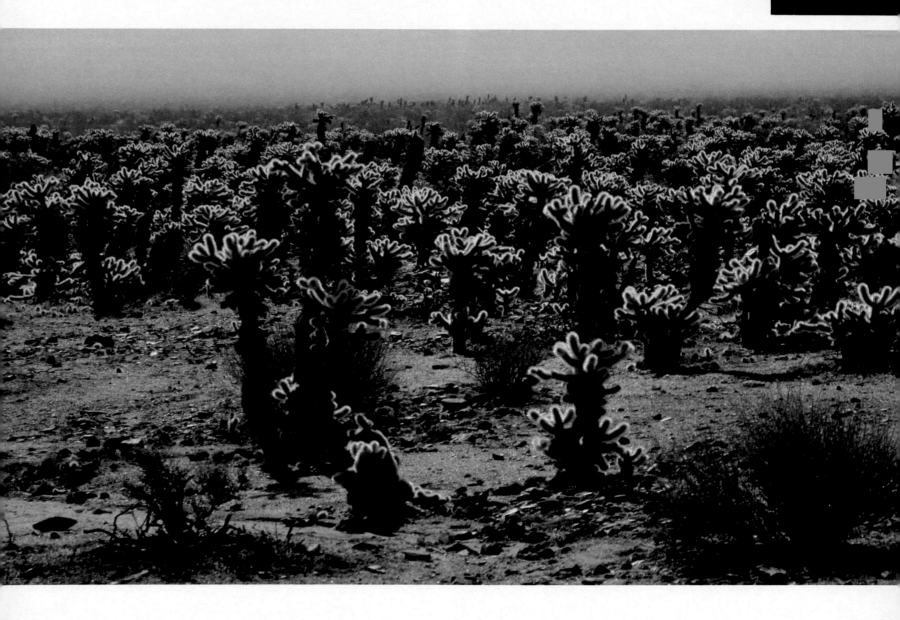

guish even between the colder and warmer parts of the victim. Such talents allow the snake to find prey at night without any problems. The rattlesnake plays an important role in the mythology of the canyon Indians. In their rain ritual, the Hopi Indians perform an impressive snake dance based on a legend from the Grand Canyon. An Indian was once looking for the river's end. He met a snake girl, married her, and brought her back to his village. The inhabitants were afraid, and they drove out the snake woman and her snake children. To punish the offenders, the gods sent a great drought, which ended only when the snakes were brought back to the village.

This unique group of islands in the Pacific Ocean has played a significant part in the development of the theory of evolution.

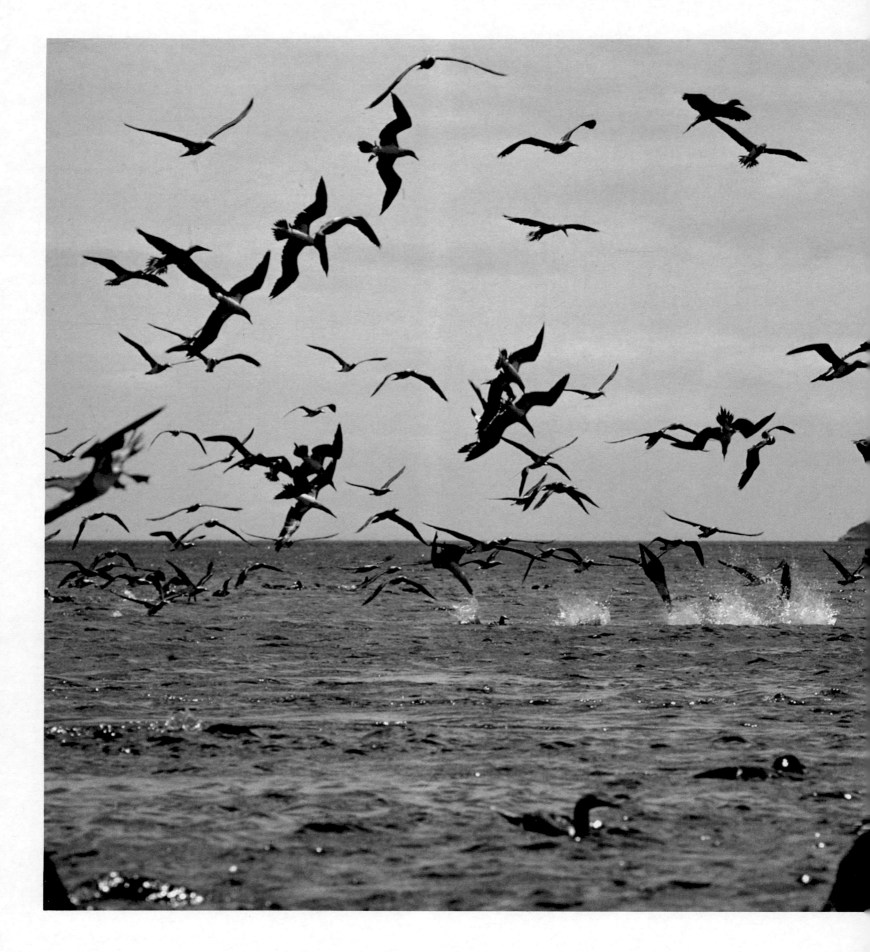

Galapagos: Noah's Ark in the Pacific Ocean

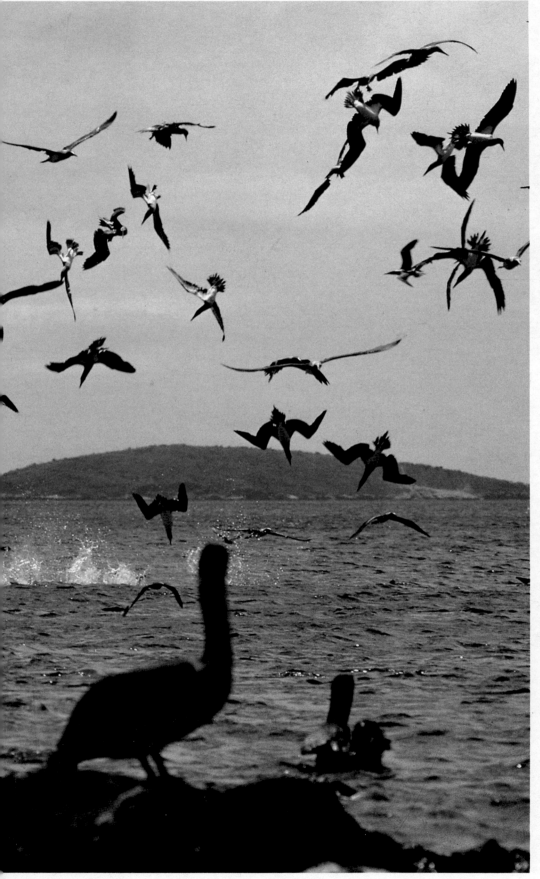

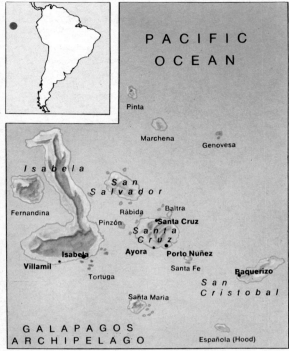

Tricky diving maneuvers of blue-footed boobies

In the coastal areas of the islands, one can observe whole flocks of blue-footed boobies performing their nosedives. This bird does not attack fish when plunging into the water but pushes past the fish, and then grabs it as it surges toward the surface.

Hardly another area has so deeply influenced the question about the origin and development of life as the thirty-two islands in the Pacific Ocean called the Galapagos (Spanish for "tortoise"). Six hundred miles from the Pacific coast of South America, this archipelago was ignored by mankind for centuries. Even its chance discovery by a sailing ship merely elicited astonishment at the population of lizards, tortoises, and birds.

In the nineteenth century, young Charles Darwin circumnavigated the world in the *Beagle*. When he arrived in the Galapagos, he made the crucial discovery that ultimately led to his theory of evolution. Until then, people believed that everything had been created in a single day, that no creature had ever changed—except that a few animal species had died out.

What so fascinated Darwin in these islands was the Galapagos giant tortoise. The tortoise looked slightly different on each island. Darwin discovered tortoise shells that were bent up in front, others that were round, still others with a flat bulge. The variety did not strike the naturalist as random. After all, he concluded, the tortoises living on islands with tree and bush plants had a long neck and a bulging shell in order to stretch their heads as far as posible. On the other hand, the islands with herbage were inhabited by tortoises with short necks and clumsy shells. And yet they all be-

The wonder world of the Galapagos: Marine iguanas, which eat algae, dive into the surf like mini-dragons.

longed to the same species. Darwin correctly presumed that environmental influences had caused the animals to develop into subspecies.

The Galapagos Islands were never joined to the South American continent. They came into being millions of years ago because of suboceanic volcanic eruptions. Most of the creatures living on these volcanic islands arrived millions of years ago on plant reeds or tree trunks from the South American mainland. The Humboldt Current brought them to the remote archipelago, where they had to adapt to completely different conditions in order to survive.

These islands offer zoologists a unique opportunity to study the influence of the environment on the

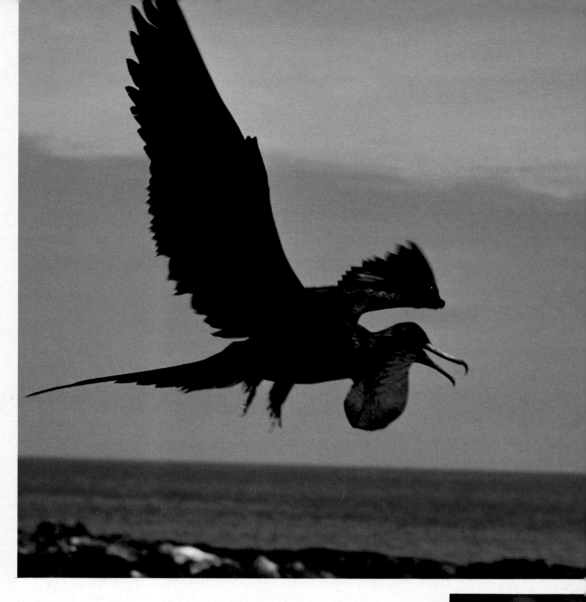

formation of the species. Of particular fascination is the development of the iguanas, which drifted to the volcanic islands hundreds of thousands of years ago from Ecuador's coastal jungle, which is rich in food. Accustomed to the profuse vegetation of the tropical rain forest, the lizards found little to eat on the volcanic islands, aside from salty ocean plants. Human beings die if they drink only seawater, but in the course of time, the iguanas stranded on the Galapagos developed salt glands, and they now excrete concentrated salt solutions from their nostrils. Once they got used to their new food, these lizards multipled so quickly that the algae left by the ebbing tide no longer sufficed for their diet. A further fascinating adjustment took place. Step by step, the iguanas ventured into the water, until they ultimately evolved into marine iguanas, the only saurians that dive to the ocean bottom in order to graze there.

I first encountered these mini-dragons on Narborough, a huge volcanic cone rising barren and aloof from the greenish blue ocean. Since the island has no drinking water, it is

The imagination of creation is bound-less.

The red-billed tropic bird (*right*) is easily recognized by its flowing tail feathers. Two male frigate birds confront one another while mating (*above center*). Note their puffed-up craws. The unshapely crop interferes with the otherwise perfect flying skill of this best of all upwind sailors (*top left*). Red-footed boobies (*far right*) performing their mating ceremony.

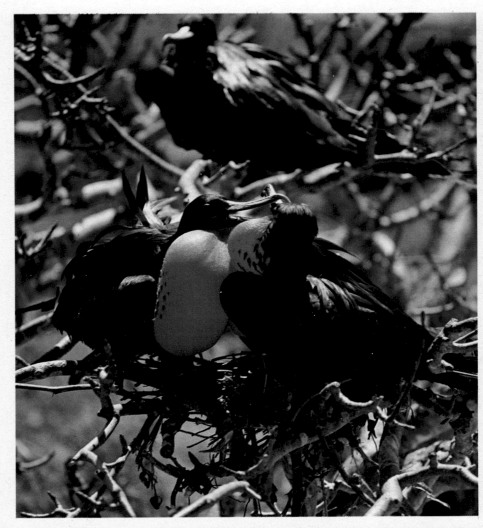

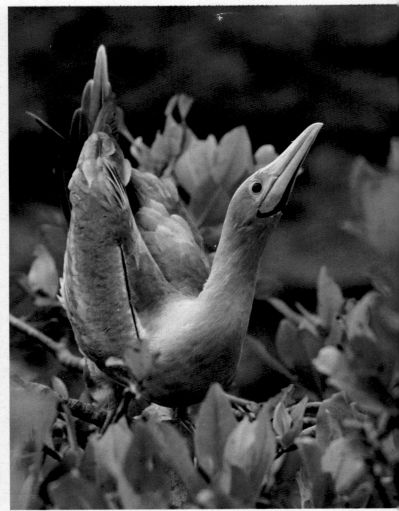

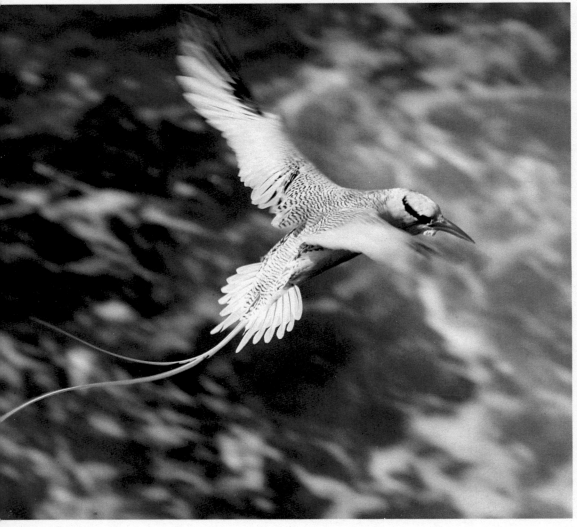

uninhabited. No sooner had we landed in the bay of Punta Espinosa than we were stared at by hundreds of marine iguanas—a fantastic, almost eerie sight. We felt as though we had been brought back to the age of the dinosaurs. All the iguanas lay immobile on the hot lava rock. When the tide recedes, however, the reptile tribe begins to move. The iguanas get up and climb over the lava rocks to the wet reefs that emerge from the surf. As they march to the sea, these mini-dragons keep

The iguanas fear sharks, which lie in ambush outside the bay waiting for stray dragons.

touching the ground with their wide tongues, an action that serves to orient them. The shoreline rocks are richly covered with seaweed, algae, and other ocean vegetation.

We plunged to the bottom of the sea with the iguanas. There, they anchored their long claws into the porous lava stone and, using their

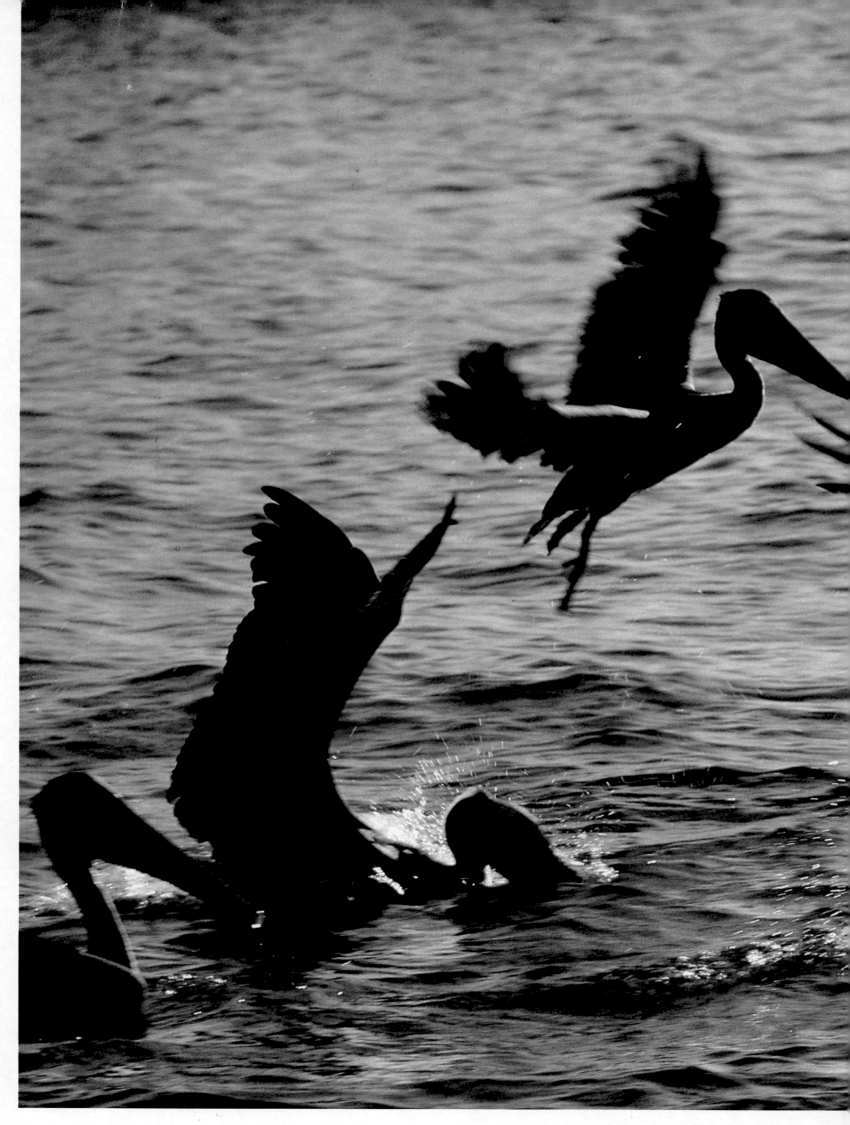

Brown pelicans in Espumilla Bay

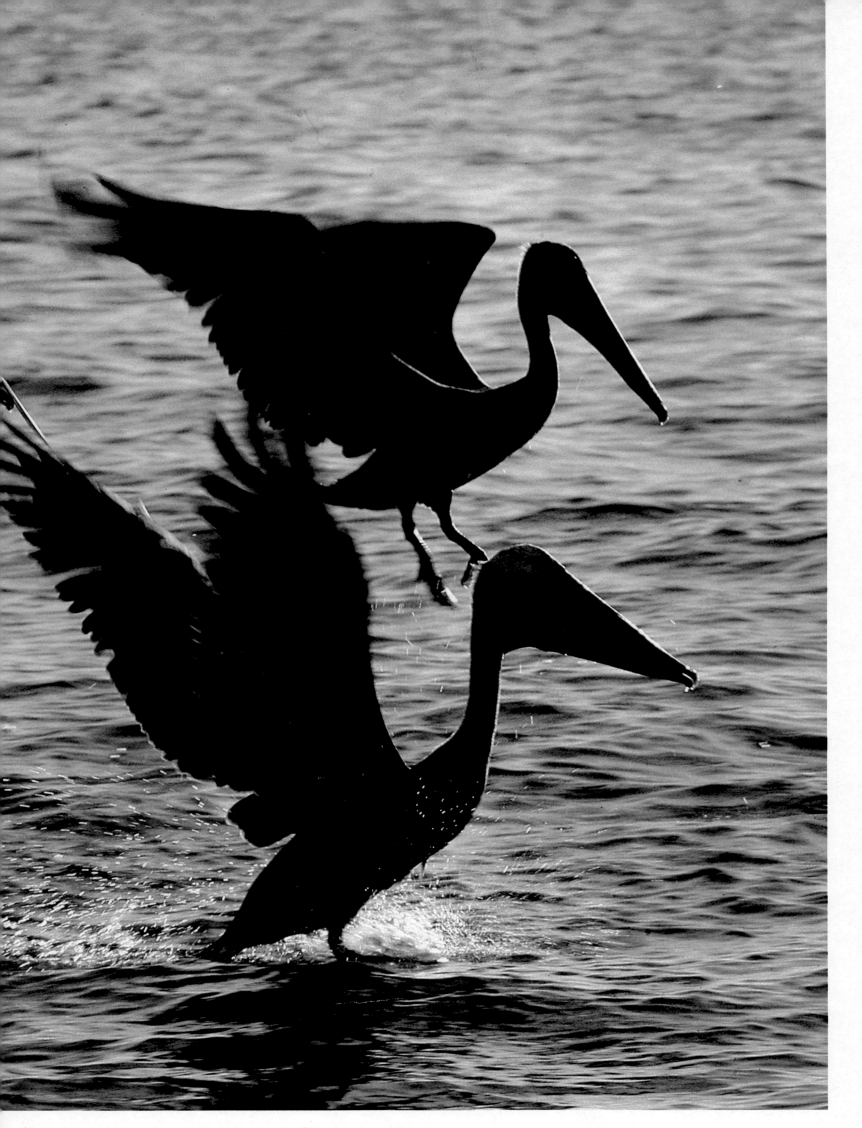

Despite its awkward shape, the brown pelican is a skillful nosediver, which always hunts in flocks.

The "laboratory of nature" works with admirable success.

Fifteen species of finches have developed from a single species. Among them, the "woodpecker" finch stands out. With the help of a sharp cactus spine or a small stick, it pokes purposefully in the porous wood of decayed trees, excavating fat insect larvae.

powerful jaws, they tore algae from the rocks, uninfluenced by the swell. The iguanas can stay underwater as long as fifteen minutes, after which they must resurface in order to breathe. Their food search is perilous. Many sharks lie in ambush, snapping up every iguana they can reach. In the immediate vicinity frolic the only enemies of the adult iguana: blue sharks, white sharks, and hammerheads. These sharks are a natural check for the iguanas; fearing the predatory fish, the marine iguanas remain among themselves on each island.

The road back to the rocky strand, like the road down to the feeding sites, is always a daring venture for the iguanas. The first time I saw the thundering surf and experienced how difficult it was for us to dive into the water through the foaming breakers along the rocky coasts, I assumed that many marine iguanas would be hurt trying to land. So I was astonished to see how skillfully the amphibian reptiles used the breaking waves, which carried them up to the reefs. With undulating bodies and powerful tail strokes, stretching their legs and claws motionlessly under their bodies, they "surfed" back. Their swimming method is fascinating and beautiful.

I also had a chance to watch the mating of the marine iguanas. Each male leader, twenty to fifty inches long (depending on the subspecies), can be recognized by its high dragon's comb. It also has a harem of several females and a sharply staked-out territory. As soon as a young dragon attempts to approach the "ladies of the harem," it is shown its place by the "ruling" male. The harem boss does this with energetic motions of its head and a mouth opened ominously. If this terrifying conduct does not suffice, a fight begins. The two rivals run toward each other at full tilt. One as-

When male iguanas fight over a harem, they hit hard, but blood never flows.

sault follows another, hit after hit, until one of the opponents gives up. Lowering its head as a gesture of humility, it leaves the jousting ground. No iguana was ever hurt, since the powerful jaws are not used, nor did I ever see the stronger animal pursue the weaker one. After all, nature only wants the stronger one to be fruitful and multiply.

A further interesting change in behavior and physical structure is shown by the Galapagos cormorant. In all other areas where it lives, the

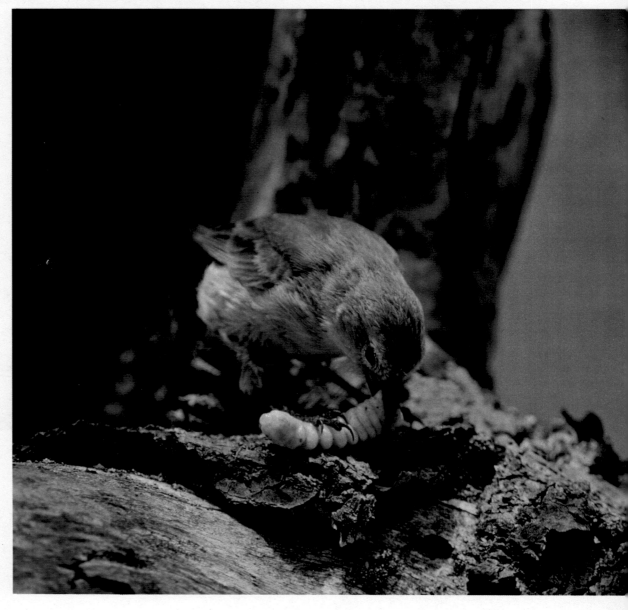

cormorant can fly; in the Galapagos islands, it has lost this ability. Its primaries have atrophied because it has no enemies to fly away from. Furthermore, its food swims right past its bill, as it were, so that it doesn't have to go on long outings.

While the giant tortoises may have made Darwin realize how the various breeds developed, it was a group of tiny birds, the so-called Darwin's finch, that made the British naturalist hit upon something else. He saw that new species can evolve because of altered environmental influences. A long, long time ago, he assumed, a couple of finches had wandered to the remote archi-

Hunger forced the finches to eat different food. The "woodpecker finch" even uses tools.

pelago. Either a storm had driven them far across the ocean, or else the little birds had been stranded here with some flotsam. At first, they did not suffer; indeed, they were better off than most of the other animal species that voyaged from the South American mainland to the Pacific archipelago. Then the finches multiplied, and since no skillful predator

went after them, their descendants spread throughout the group of islands. But as the tribe of finches got larger and larger, their customary food no longer sufficed. Ultimately, hunger forced them to adapt to other food sources. In accordance with the selective system of Darwin, fourteen different species of finch evolved in the isolation of the archipelago. They are distinguished by the shape of their beaks, which allows them to utilize the food available in their habitats: flycatchers and "kernel-biters" (hawfinches), insect-eaters, seed-pickers, and larvae-hunters.

The "woodpecker" finch is absolutely unique. Only the Galapagos have favored the development of this bird, which hunts for food with the help of tools. In so doing, it employs various tricks. This finch specializes in pulling insects and their larvae from borings and bark cracks in branches and trunks. Like the woodpecker, whose position these finches have adopted in the archipelago, it pecks its beak on cracks and barks in order to startle the insects. Sometimes, it places one ear against the wood to listen if some prey is stirring. If the bird has discovered a larva or bug, it pecks a tiny twig off the tree, small enough to use as a crowbar. The lever effect of the tool helps the bird break off the decaying bark—or else it keeps poking around until the insect leaves its hiding place.

In the southeastern part of Hood, the lively world of birds is richly represented. On the flat coastal strip of Punta Cevallos, xemas and blue-footed boobies, tropic birds and albatrosses nest so close together that we had to watch every step we took to avoid harming any of the

These exotic creatures made the Galapagos islands world-famous.

When Charles Darwin discovered the Galapagos islands, he found a specific species of tortoise on each island; each differed in the shape of its shell. The top photo shows a Hood tortoise hatching. An example of peaceful coexistence: a lava iguana on the primeval skull of a marine iguana (*right*).

Albatrosses are outstanding sailors. Before their weddings, they dance with their mate-to-be, sharpening their bills.

clutches. Most of the birds remained on their nests, occasionally tweaking our legs. The Galapagos (or waved) albatross, the only one of thirteen species to live on the equator, nests only on the small island of Hood. With a wingspan of eight feet, it is one of the smaller species. The gigantic wandering albatross has a wingspan of twelve feet.

When mating, the tropical albatrosses perform bizarre dances and

greet one another in a ceremonial fashion. The ritual begins with each bird taking rolling steps and leaning its head on its left or right shoulder. These movements look grotesque because this excellent glider with its giant webs is awkward on its feet. After a few dance steps, the partners halt and perform a strange sharpening of their bills. Craning their necks horizontally, they hastily rub beaks, then thrust up their heads and threaten each other with wide-open beaks. Next come a few more dance steps, then the rhythmic beak-rubbing. But suddenly, one of the birds sticks its beak weapon straight up and emits a long howl of triumph. Finally, the two birds bow to each other several times. The beaks point down invitingly. Both animals settle on the established brooding site and tenderly stroke each other's neck plumage.

The entire Galapagos archipelago, which belongs to Ecuador, has been declared a national park. The "wild" animals are strictly protected. Human beings may enter the islands only as visitors. However, the evidence of bygone pirates and whalers is clearly visible. Wild pigs, once introduced as "provisions," are

Domestic animals, now running wild, threaten the natural balance of the islands. Gamekeepers have to protect these islands as a document of evolution.

ubiquitous. These imported enemies destroy the eggs and tiny young of birds, tortoises, and iguanas. There are also runaway goats, which eat the food of tortoises and other Galapagos animals, and there are rats, dogs, and cats, which plunder the clutches of both tortoises and birds.

On the island of Santa Cruz, in the center of the Archipelago, the Darwin Foundation has been established. This research station is supported by huge contributions—from as far away as the Zoological Society of Frankfurt. It offers scientists the possibility of carrying out investigations in a unique outdoor laboratory. Needless to say, the park administrators make every effort to maintain the natural balance of the archipelago by keeping any animals introduced by man to an endurable minimum.

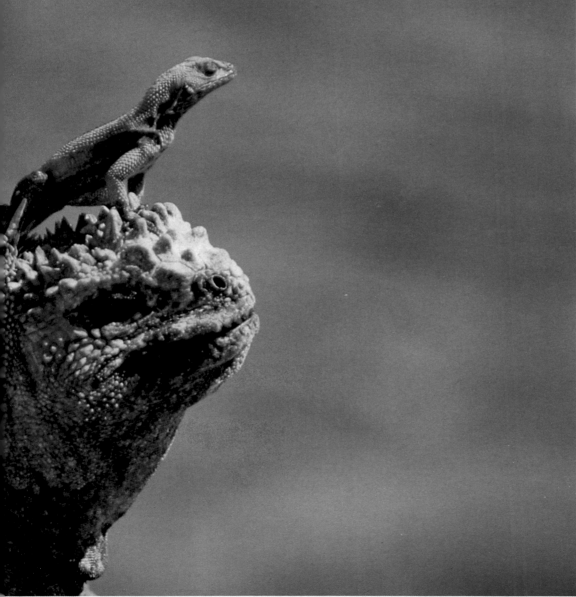

► **Looking like dinosaurs hewn in stone, the world's only marine iguana is a harmless herbivore.**

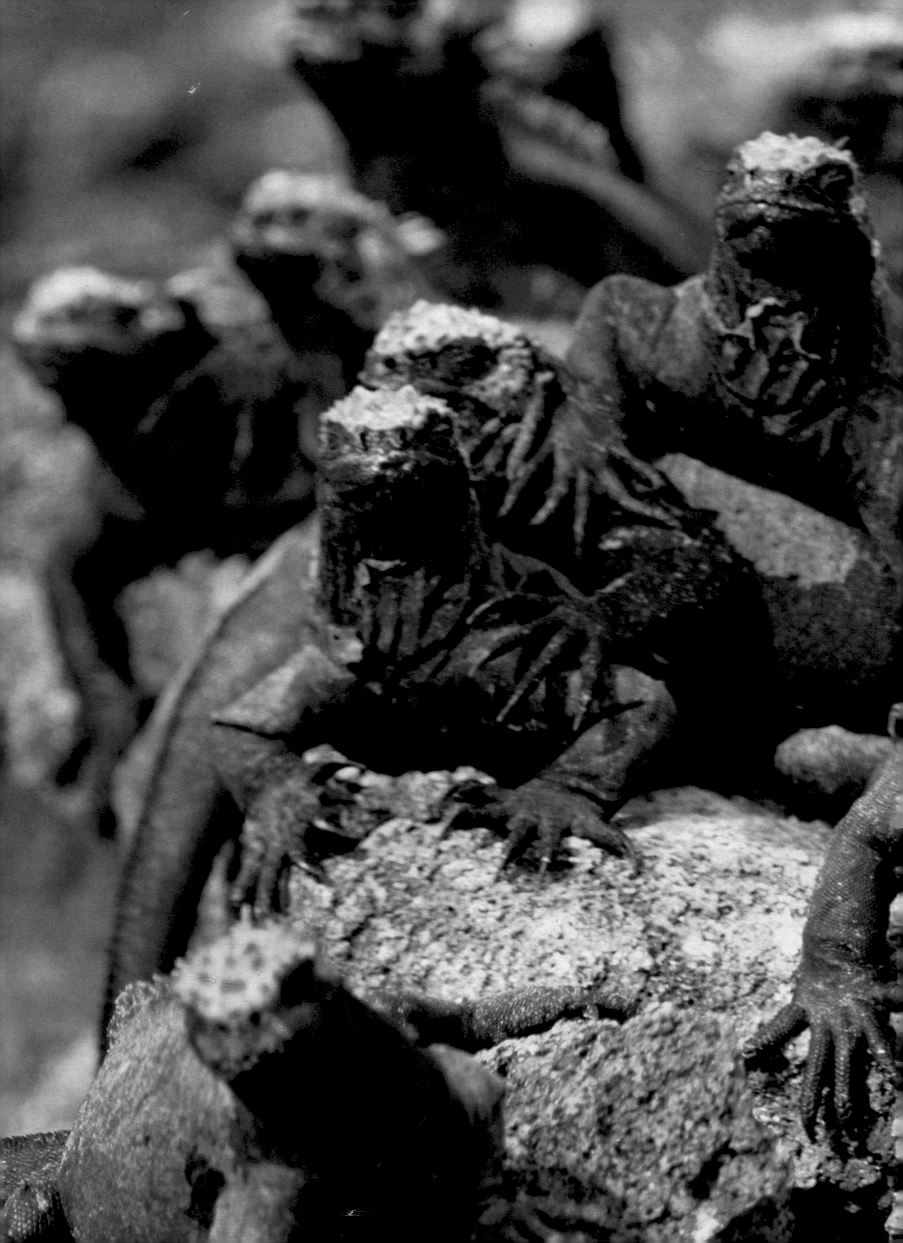

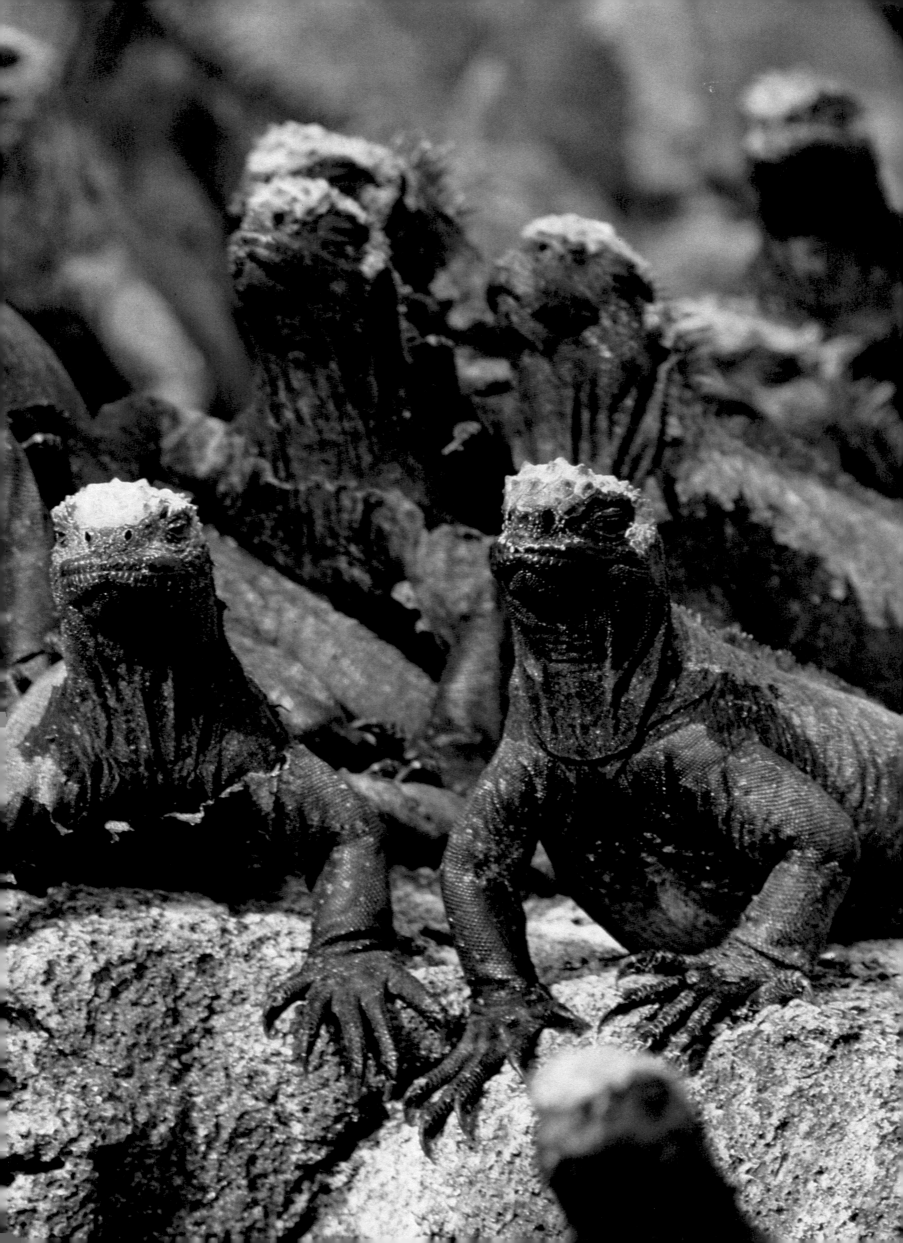

The Andes is the longest mountain range on earth. The vicuña—a timid, graceful animal the size of a colt—grazes on the bleak plateaus.

The Gold

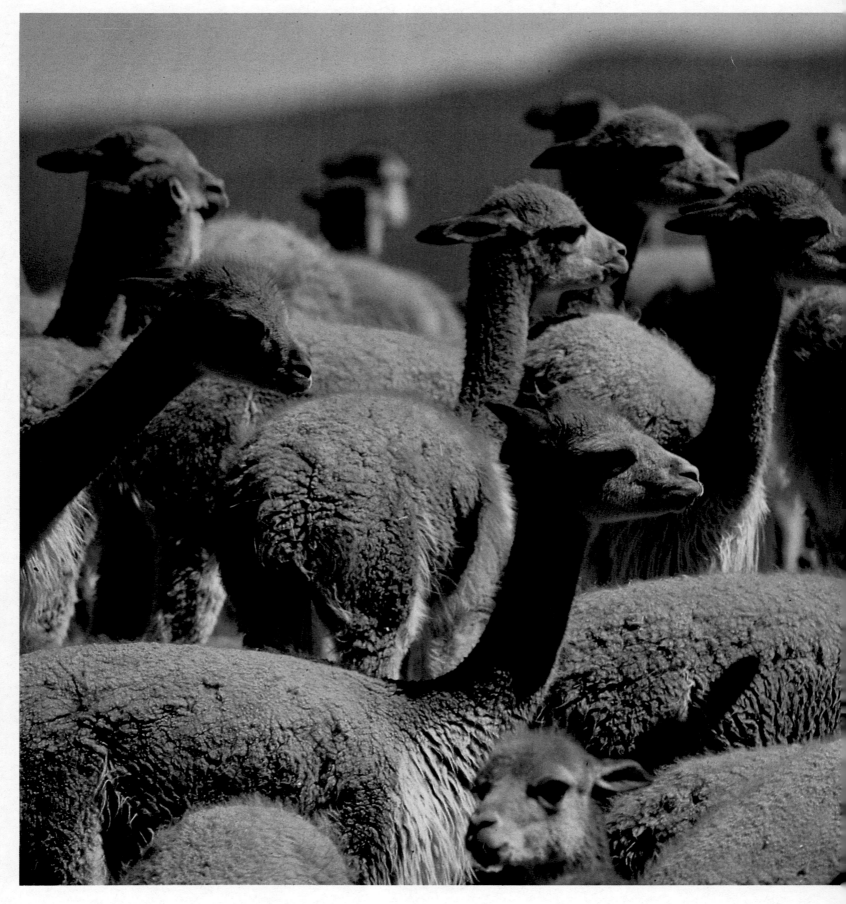

Wild Vicuña: en Fleece of the Andes

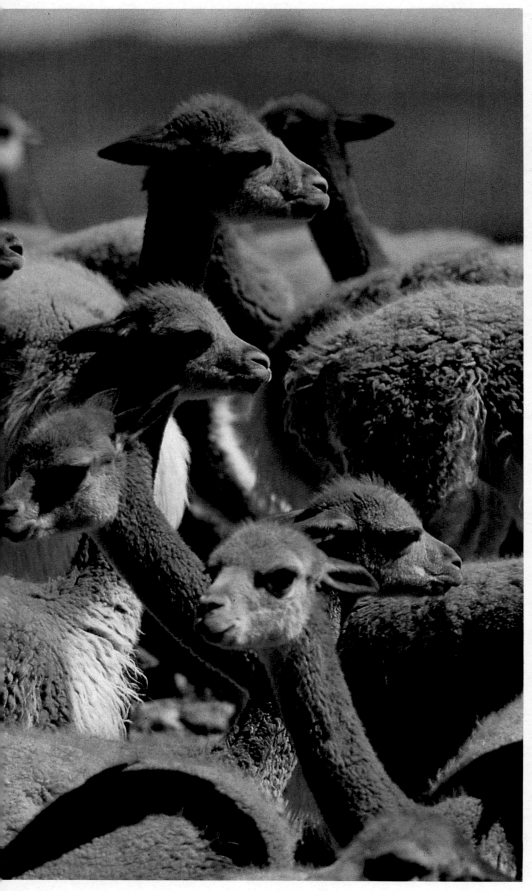

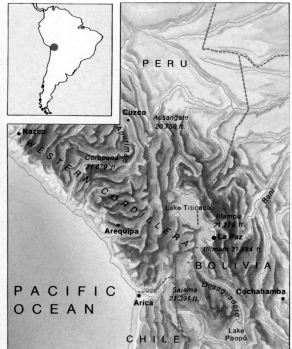

The wild relatives of the tame desert camels

The silky soft wool of the vicuñas is more than three times as fine as merino wool. The Inca kings rigorously restricted the hunting of these precious creatures of the Andes. A brisk trade in vicuña skins led to the near extinction of these animals in our century. Intensive protective measures are now helping to increase the stock.

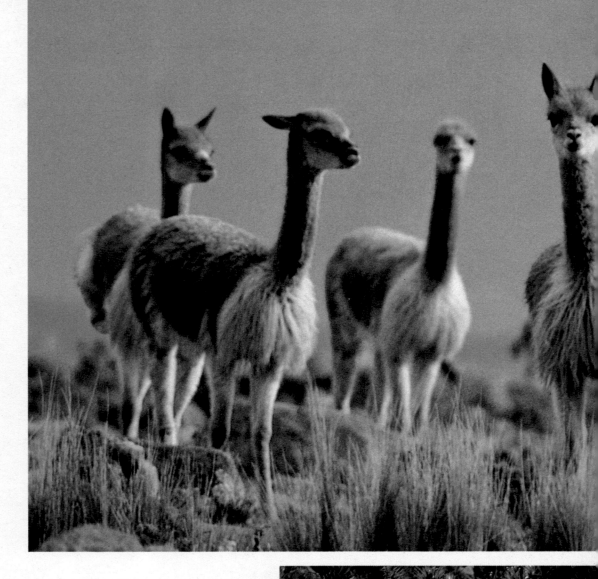

South America does not just consist only of jungle. The fascination of this continent lies in the contrasts between the three climatic zones of the coast, the Andes, and the Amazon. Nature goes to extremes here. Peru, Bolivia, and Chile, viewed as a geographic unit, offer landscapes as well as flora and fauna that are uniquely varied and astonishingly rich. At the point where the Humboldt Current forges coldly against the coast, the number of species of ocean fauna leaves one speechless. The wildly proliferating Amazon jungle, with several thousand miles of trackless tropical rain forest, holds undiscovered secrets. Only the Andes, almost five thousand miles of far-flung mountain ranges and plateaus, are deadly in their peak regions. In the puna, the high temperature differences between day and night can reach one hundred twenty degrees Fahrenheit—depending on the altitude. In the regions above thirteen thousand feet, frost occurs almost every night.

The puna plateau lies between the Cordilleras. It is ruled by sun, wind, and frost.

The lack of frost-free zones, the low precipitation (in some years there is no rainfall at all), the sometimes extraordinary wind conditions, and the intense sunshine all require a high measure of adaptation from the living creatures in the puna. Vast, endless plains are covered with ichu grass and tola heath. Only rarely is the monotony of this plant society interrupted by the green of the bofedale (high moors): oases fed by wellsprings in the midst of the barren waste. Clumps of bulrushes dot the scenery. But they suddenly halt on a hill range, where they are replaced by tola plants and cushions of richly resinous llareta plants. This wind-shielded borderland offers protection to many small animals. The accumulations of rock and detritus store up heat during the day. At night, they cool off very slowly. These microclimate zones allow many insects to survive. They, in turn, are the food basis for birds, amphibians, and reptiles.

At the first rays of the sun, the sun worshipers of the puna start their day. The sand lizards, still rigid from the nightly cold, press flat to the earth and the rocks, spreading out their body surface. In this way, they can store up as much heat as possible to fuel their activities. At just a few degrees of warmth, they can go hunting and remain active when other reptiles have already become numb with cold. Sand lizards are viviparous, that is, they do not lay eggs like their relatives in regions with more favorable climates. Instead, their offspring mature in the

Vicuñas survive because their blood corpuscles are oval and are able to pass through the finest capillaries.

mother's body until they are fully capable of living on their own.

Soon after the sand lizards, the mountain viscachas appear in the entrances of their caverns and bask in the warming sun. Kin to the chinchilla and the size of a rabbit, the viscacha has rabbit ears and a bushy, curly tail, which is rolled out to serve as a probe and an additional steering instrument. Miniature versions of the viscachas live in the immediate vicinity: the Phyllotis mice.

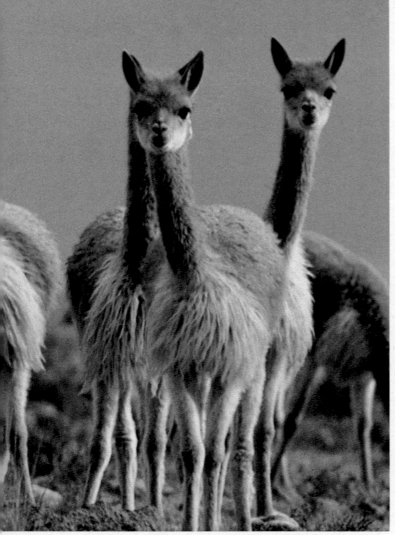

Bleak life in the puna

In the rough, grassy prairie, where little rain falls, the nights are bitter cold, even in summer. A bit of hard grass and some bromelia plants thrive (*below*). The vicuña, whose heart and lungs have adapted to the thin mountain air, has to make do with the sparse vegetation.

These gnomes, always hectically active, are usually on guard against their enemies, the falconiformes. To find food, they move only a few yards from their lairs to the open surfaces of the bofedale. At the least sign of danger, they whisk back to their protective homes of detritus.

The small inhabitants of the puna can balance the extreme weather conditions by residing in microclimate zones. The larger animals have to develop special forms of adaption guaranteeing their survival. For example, the gracile vicuña is shielded by its extremely thick and fine coat of hair. Other cameline animals have round blood corpuscles, but the vicuña's are oval, so that they can pass through the finest capillaries. The special form of this oxygen carrier allows an efficiency that is vital for this animal. Geared to passive defense, it has to be able to escape easily in a thin atmosphere poor in oxygen, seventeen thousand feet above sea level.

Vicuñas live in family groups of up to fifteen. The safety and supervision of the herd is the job of the

Vicuñas have the finest wool. Once, it was reserved solely for the Inca kings.

male leader, which has to defend the territory against intruders and which must fight smaller predators and wild dogs. When a male reaches the age of six months, it is expelled from its family. With no established territory of their own, up to two hundred of them join together into bachelor associations that restlessly roam about among the firmly delineated territories of the family groups. Since no bachelor has a leadership position, these "associations" are extremely vulnerable to danger. Poachers with long-range firearms have an easy time of it. If a stallion is killed, the others do not flee. They remain where they are, thronging together fearfully and thus offering an excellent target: they can be slaughtered one after the other.

Among the Incas, products of vicuña wool were the exclusive

▶

A fleeing flock of vicuñas. Despite the thin air, they can reach speeds of thirty miles an hour.

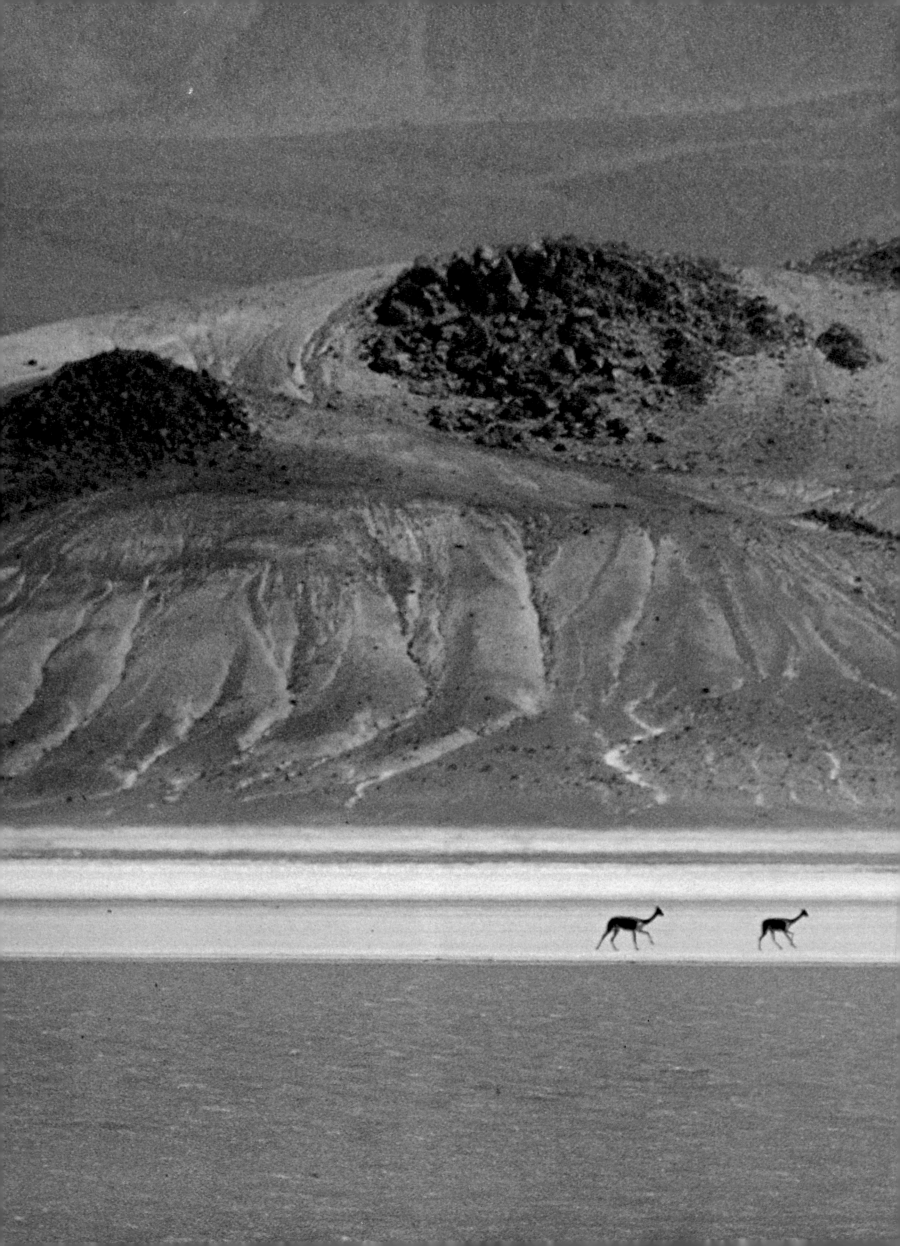

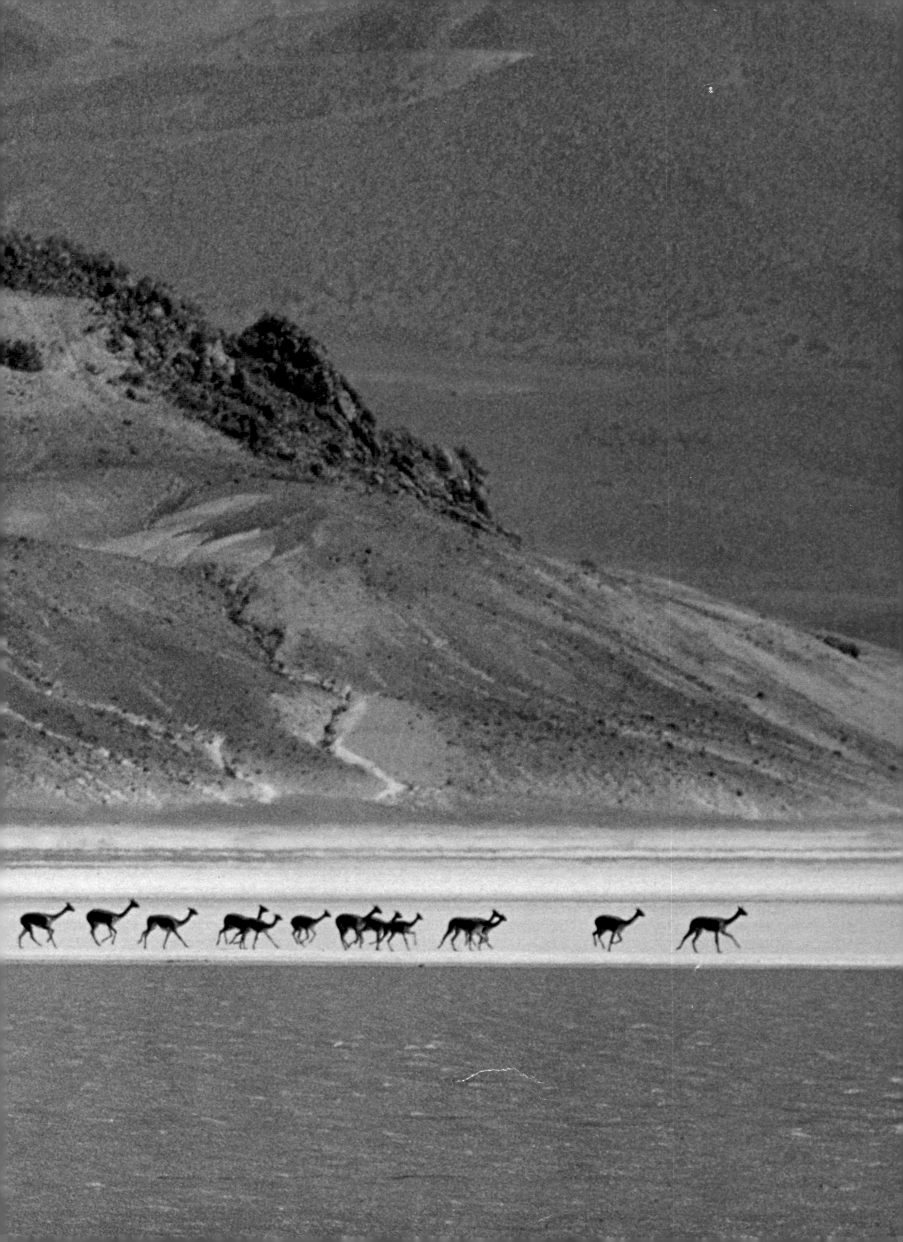

property of the ruling class. Inca rulers had clothing of the finest vicuña wool, which they wore once and then sacrificed to the sun. However, the Incas were not heedless in using the great reservoir of the vicuña stocks. Their animal husbandry and management could be regarded as exemplary for our time. The animals were hunted only every three years. Several thousand Indians would form a chain of drivers, herding the animals into prepared corrals where they were carefully shorn and then set free again. Some of them, mostly young studs, were killed, and their meat was made available to the inhabitants of the hunting area.

In the seventeenth century, when the Spanish conquistadors came to

Once hunted and killed for their wool, vicuñas are now protected legally.

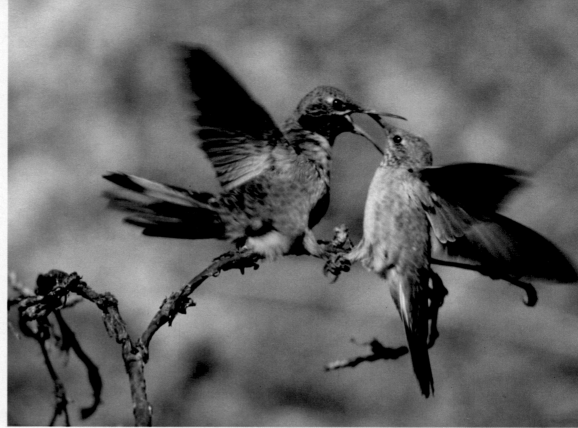

the New World looking for gold, they also discovered the "golden fleece of the Andes." Vicuña wool is the finest in the world. The Spaniards began an uncontrolled hunt, which has continued to the present. Despite productive laws passed by Peru in 1825 and 1920, the wool and hides of fifty thousand vicuñas were exported between 1902 and 1907. This destructive exploitation went on uncontrolled until 1969, when ecology experts finally got together. They not only settled on rigorous protective measures, but they also established preserves to be run by specialists in Bolivia, Chile, Peru and Argentina. In the preserves of Peru's Pampas Galeras, and Chile's National Park, the vicuña stocks are no longer endangered. One can see how much sense it makes to manage the wildlife in a territory when one compares the areas in the Andes, where only domestic animals graze,

Domestic animals crush the sparse mountain vegetation underfoot, but vicuña hooves do not harm the plants.

with those areas used exclusively by vicuñas. Domestic animals, that is, sheep, horses, and cattle, tear up the parched earth with their hard-edged hooves, destroying the sparse sod, and thus promoting erosion in large areas. In contrast, the vicuña's clo-

A dwarf with a high-speed lifestyle

In the Andes, hummingbirds can be found at all altitudes—from the tropical rain forest to the snow line in the mountains. The main foods of these tiny birds are blossom secretions and small insects. With whirring wings, they "stand" in front of nectareous cactus blossoms (*right*), feeding one another during the mating season (*above*). In the highlands of the Peruvian Andes, the giant hummingbird nests in the outstretched branches of a cactus tree (*far right*).

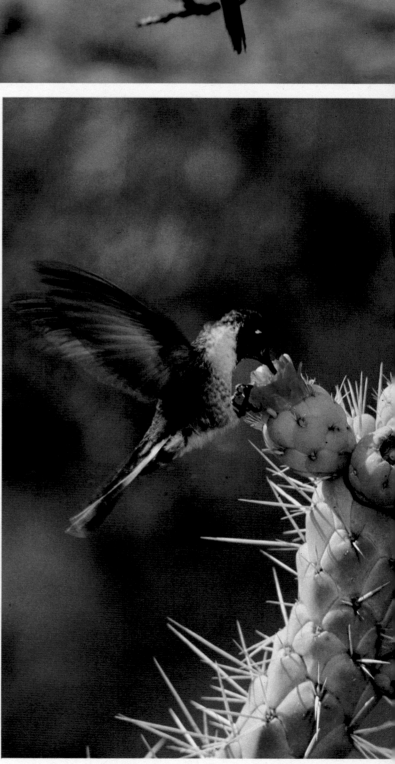

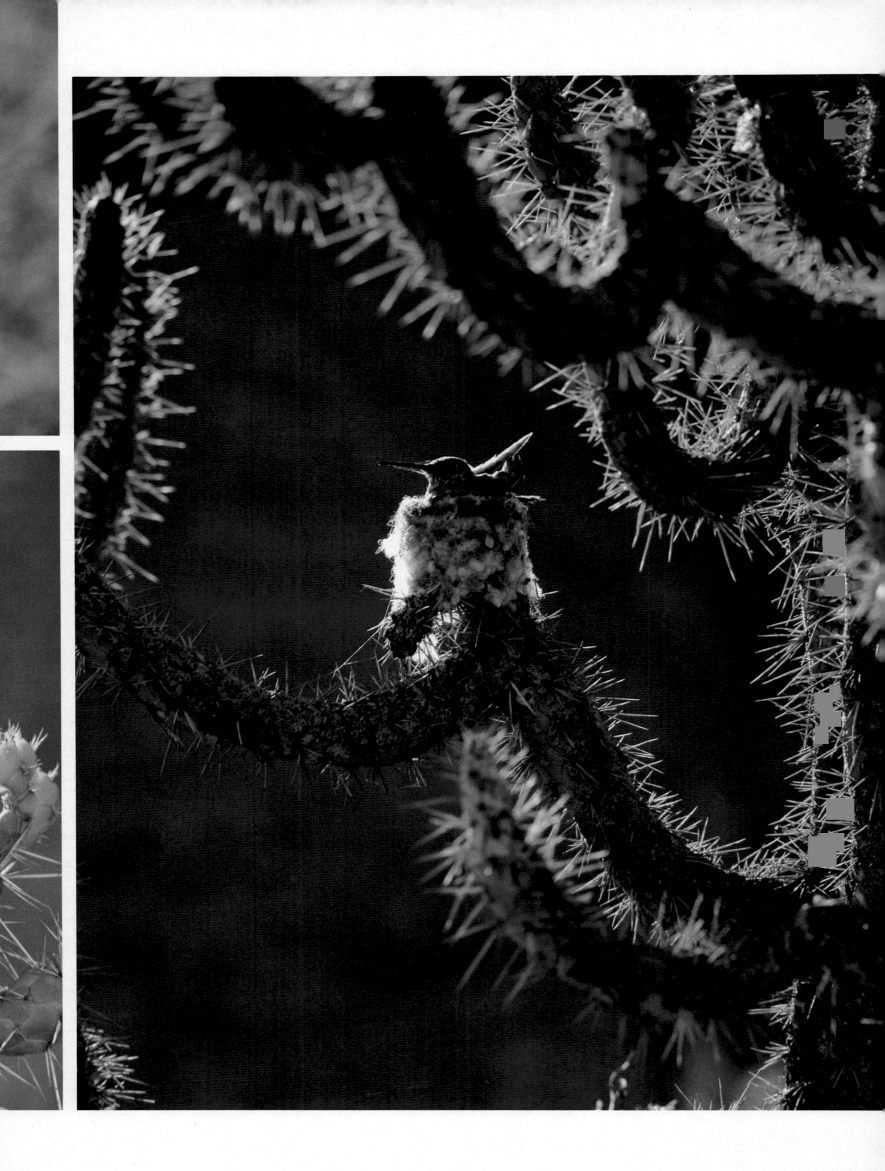

ven hooves are underlaid with elastic cushions. These bolsters allow the graceful amblers to gain a sure foothold in impassable terrain without destroying the sparse cover of vegetation. The sharp nippers, which never stop growing, allow the vicuña to munch on hard, low-growing, siliceous forage plants without tearing them out or even loosening them.

The size of the family territory is based on the amount of available

Bachelors must fight the old leaders if they are to become leaders of vicuña families.

fodder; it can encompass anywhere from eight to eighty acres. During the period when the bachelor associations disband and the three-year-old studs try to conquer their own territories and families, the old leaders are under constant stress. If a young stallion crosses the territorial border, the leader first attempts to command respect by rearing on its hind legs. Finally, it threatens its opponent broadside. If the intruder is not impressed, an energetic attack is unavoidable. Stretching its neck and head way out front like an aggressive farm goose, the territorial boss zooms straight ahead, its willingness to fight supported by a shrill neighing, something like that of a pony. Such an attack is usually sufficient to drive away the would-be encroacher. Seldom does a real fight begin—and only when the mating season has reached its highpoint, and the stronger bachelors intrude more and more pushily into the family territories. Wild tussles result, with violent biting, wrestling, neighing, bellowing, grunting, and whistling. The foals are born between January and May after eleven months' gestation. Compared with

A short time after they are born, vicuña babies can run and climb like their mothers.

other animals, their birth weight is high: twenty-four pounds. Two days before giving birth, the mother becomes restless and slowly separates from the rest of the family. The actual process of birth lasts only ten or fifteen minutes. A short while after birth, the colt can follow its mother and is taken into the family group.

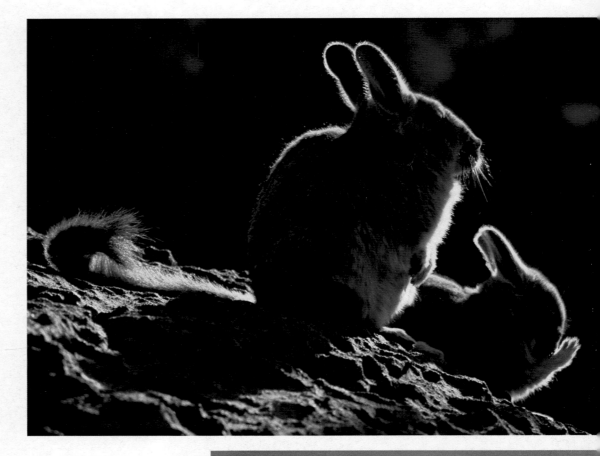

The kingdom of the condors is the Andes.

With a ten-foot wing-span, the condor (*far right* and *below*) is the largest car-rion-eating bird on earth. It has naked wattles, plus turkey-like skin creases around its eyes. The "king of the Andes" can survive at altitudes of sixteen to twenty thousand feet. Another of the few creatures that can survive in these regions is the three-pound viscacha, a relative of the rare chinchilla.

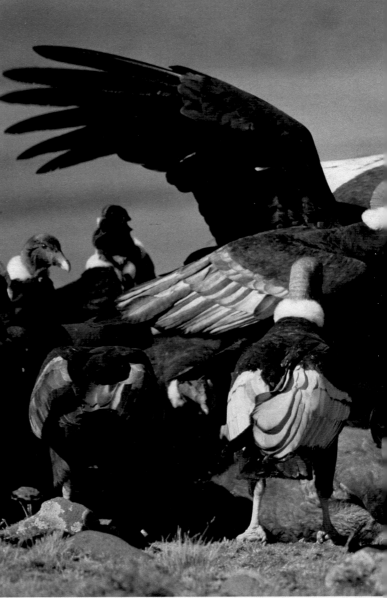

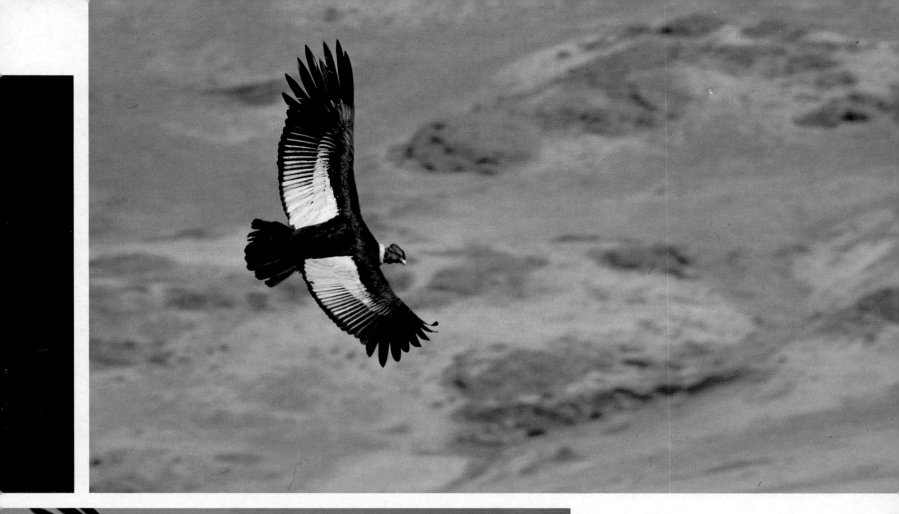

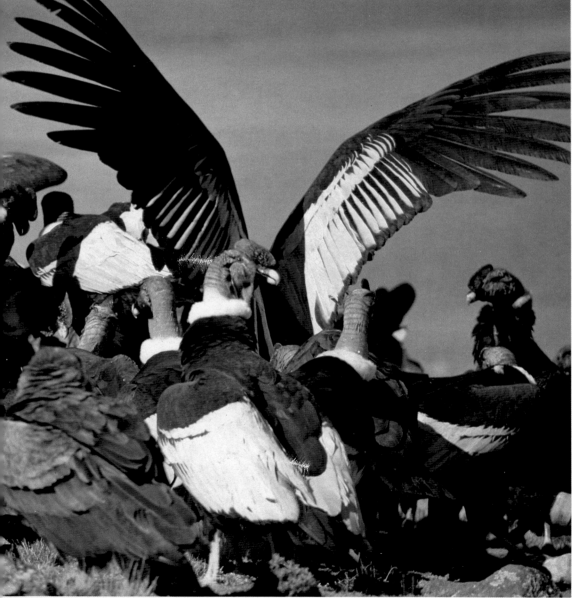

On the flat plateau of the puna, nearly all the plants grow close to the ground to avoid the wind. Not even the hardened species of cacti grow tall, but thrive in flat bolsters, pushing out their blossoms only a few inches into the prickly defense ring of their thorns. However, in the protected level of the valleys, between the volcanoes, tall plants have a chance to survive. The most unusual is puya raimondi, which can grow to a height of thirty feet. This plant is a relic from the period when the Andes were still a flat, swampy territory. Puya raimondi has managed to adjust to the constant growth of the Andes, and now it bucks the harshest climatic conditions. It is surrounded by a tuft of sharp, prickly leaves, which, like a defensive ring, prevent herbivores from getting at its main stem. Only once in its period of growth, after approximately one hundred years, does it form a candlelike inflorescence which looms out of its center and bears several hundred blossoms with millions of seeds for the continued survival of the species. The inaccessible rosette tuft is not only a protected place and nesting site for several species of small birds, it can also be a lethal trap for them in a rash escape from falcons. The fleeing bird seeks refuge in this razor-sharp tangle and is ultimately skewered.

Rainbow-colored birds, spiders the size of plates, voracious piranhas: paradisal beauty juxtaposed with wild cruelty. The Amazon jungle has all this and more.

Humm
Mysteries

ingbirds and Jaguars: cf the Amazon Jungle

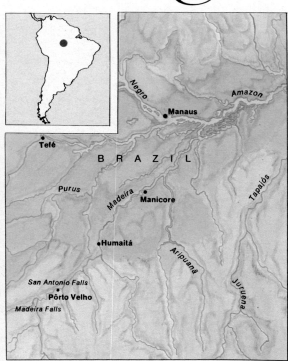

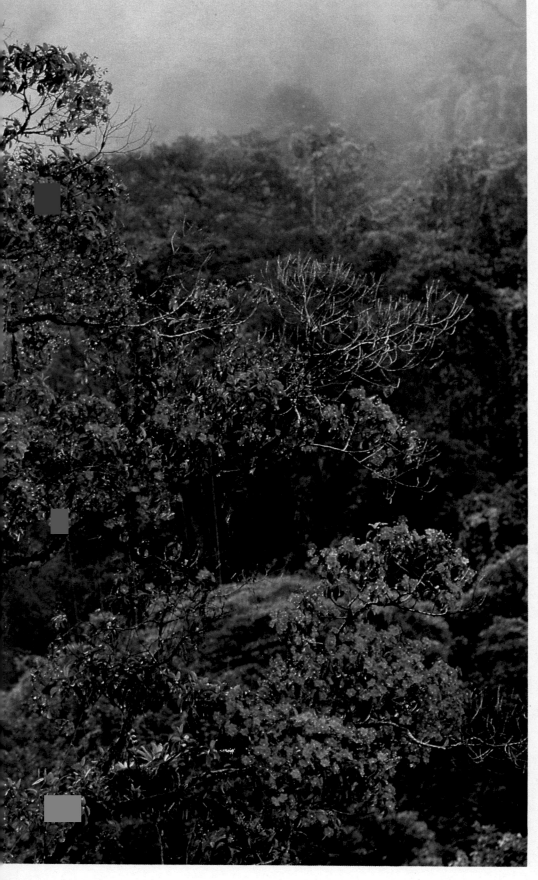

The secret blossoming miracles of the rain forest

In the murky darkness of the Amazon jungle, there are few flowers, and most of them are small and wan. The miraculous blossoms in splendid colors proliferate high up in the tops of trees. The loveliest flower of all, a gaily colored, iridescent orchid that shines like a small flag in the green hell, is called "daughter of the air" by the natives.

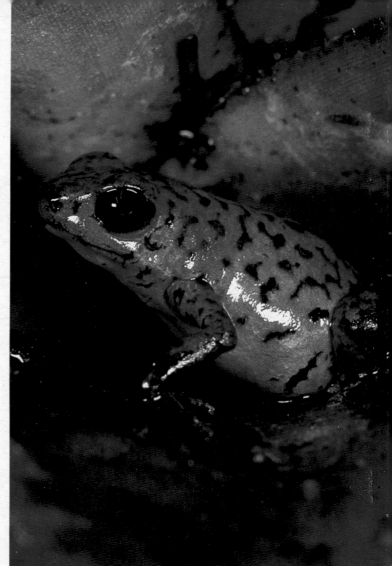

The overall area of the Amazon River system is extraordinarily large. The river basin comprises 2.8 million square miles, an area twenty-eight times the size of West Germany. In such a gigantic territory, the rainy seasons occur at different times in different parts as a balance measure.

In the region of the Rio Negro, a tributary of the Amazon, and around the Xingu, flowing from the south through Mato Grosso, the Amazon jungle is a true paradise. It has an unbelievable variety of flora and fauna.

A creature that has adjusted quite astonishingly to treetop life is the frog, which requires water for laying its eggs. Its young likewise need water to develop. There are frog species that carry their eggs or tadpoles piggyback to water accumulated in tree hollows or on bromelia shrubs. Such places offer the best conditions for the development of frog offspring. These "tree-climbing frogs" are particularly shielded against natural enemies. Their skin has poison glands, which are feared by all animals. Even snakes, who feed largely on frogs, will attack the venomous frogs only once in a lifetime. In earlier days, Indians used the skin secretions of these dendrobates to produce venoms for their arrows.

Countless mammals live all the way into the "roof" zone of the jungle: coatis, opossums, honey bears, ocelots, tree porcupines, and sloths. Along with armadillos and ant bears, sloths are mammal specialties endemic to South America, which was separated from North America during the Tertiary. Sloths live in

For sloths, the world is upside down. Special muscles permit this odd posture.

two genera with seven species from Central America all the way up to northern Argentina. These bizarre animals, for whom the world is always upside down, are especially adapted to tree life. The reversal of their hair growth provides them with a "part" on their bellies. In their extreme adjustment to leaf food, they have neither foreteeth nor canine teeth. Because they hang, only the flexor muscles are necessary for locomotion; the extensor muscles (which, for instance, man needs to prevent his legs from collapsing

Aquatic life in the Amazon basin

Countless animal species inhabit the seething water wilderness: the peaceful water hog (below), the largest rodent on earth today; the poisonous strawberry frog (right) whose skin secretion was used by the Indians for their arrow tips; and the predatory piranha (far right), one of the most feared hunters in the world.

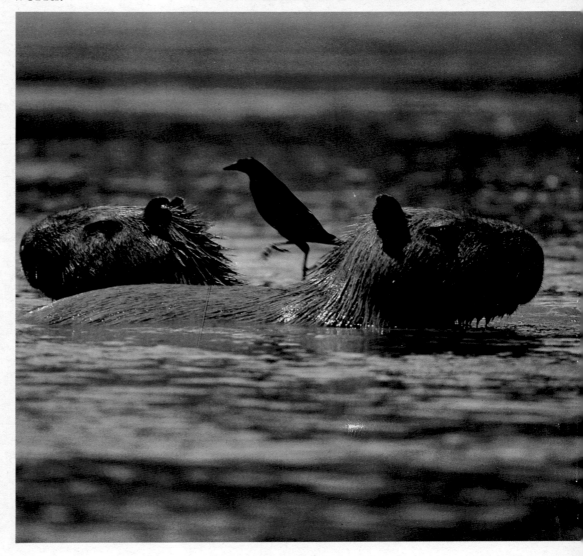

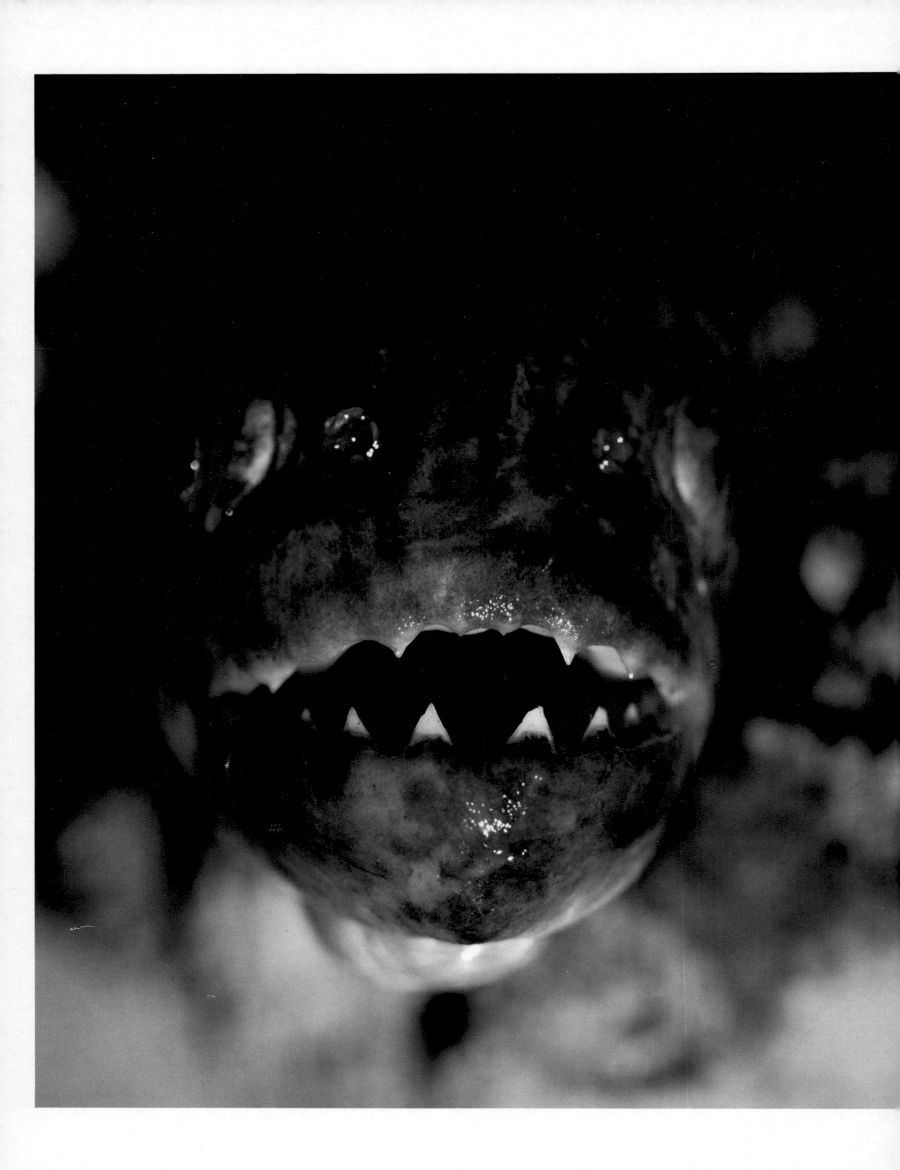

when he stands) are too weak to carry them.

Even greater than the variety of mammal species is the wealth of freshwater fish in South America. The number of species is estimated at twenty-four hundred to twenty-seven hundred! More than half live in the catchment basin of the Amazon. A comparable variety cannot be found in any other river area on earth. The huge mass of species and individuals belongs to the suborder of the characidae, of which over a thousand species occur in South America. These include the piranha,

Piranhas—which eat only in schools, never alone—have sharp teeth. All that remain of their victims are the bones.

a freshwater predator living in schools. The second most frequent group is that of the Siluriformes. The family of the cichlidae, represented by a good hundred species, acquired fame because so many of them are interesting decorative fish appropriate for aquariums.

The rivers of the Amazon Basin also have such unique species as the freshwater ray, the lungfish, the arapaima (which grows up to ten feet), the electric eel, and countless viviparous fish.

The bird world of the Amazon is stunningly beautiful. One of the most exciting species is the large macaw with its conspicuous croak and magnificently colored plumage. The most splendid representative of the fifteen gaily colored macaw species is the red ara, whose tail is over twenty-five inches long. It is an unforgettable experience to see this bird in the harsh light of the sun, flying over a river or a forest clearing.

Birds as tiny as bees, hummingbirds are brilliant fliers. They hover like dragonflies.

"The most valuable gift that the Western Hemisphere has contributed to the bird world is the fantastically beautiful family of the hummingbirds, 319 flying jewels of indescribably spendid colors and very tiny size." This observation by an enthusiastic student will be shared by anyone lucky enough to see these legendary flying artists on the Amazon. Because of its tiny size

and its outstanding flying talent, the hummingbird has assumed a lifestyle very similar to that of insects. Hummingbirds draw their unusually large energy requirement from the sugar of blossoms and get their necessary protein from the small insects they find here. Blossoms beckon from the floor of the forest to the crowns of the gigantic trees. These various habitats have forced the most diverse adjustments of hummingbirds in regard to shape and coloration. The fairy (or Princess Helen's) hummingbird is just over two inches long from the point of its bill to the tip of its tail, no longer than a bumblebee and weighing at most two grams. A further peculiarity of hummingbirds is the way they fly—like insects. Many insects move their wings like a flag-waver describing a figure eight with his flag. That's exactly what hummingbirds do with their wings. The labor of a hummingbird can readily be compared to that of a propeller, but while the propeller keeps whirling in one direction, the hummingbird moves its wings back and forth. Since its wings curve upward pas-

Mysterious fauna in the largest rain forest on earth.

The enormous wealth of species in the Amazon rain forest contrasts sharply with the number of individual representatives of any single species. Because of the almost impenetrable density of the vegetation, the animals are hard to spot—and even harder to photograph. Nevertheless, here are a sloth (*far right*), a marsh deer (*below*), and an ocelot (*right*).

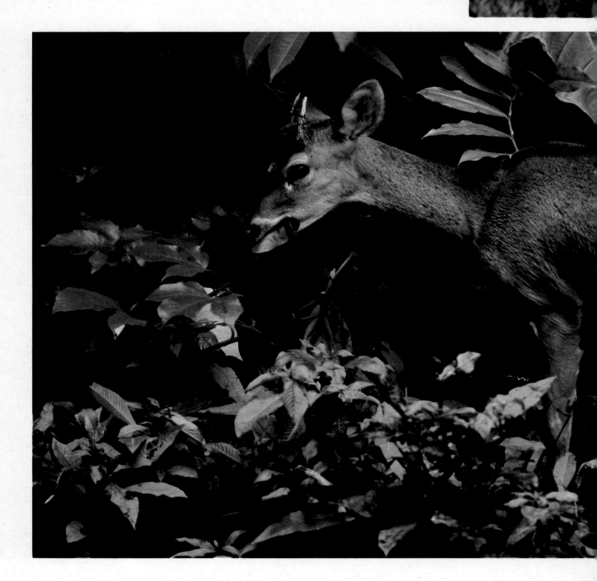

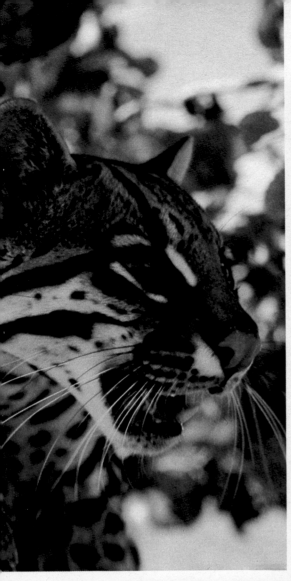

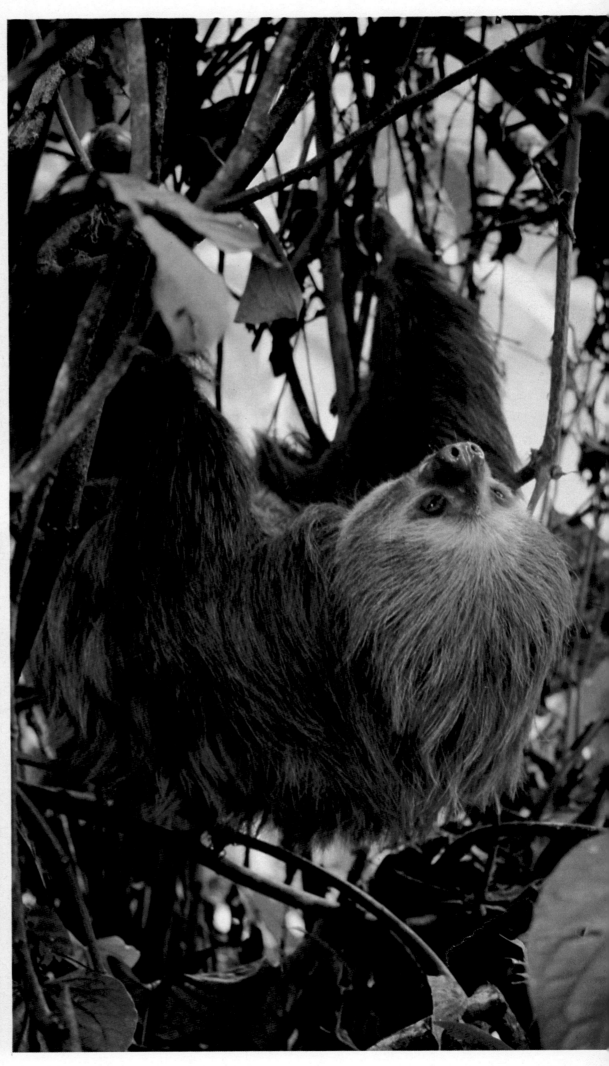

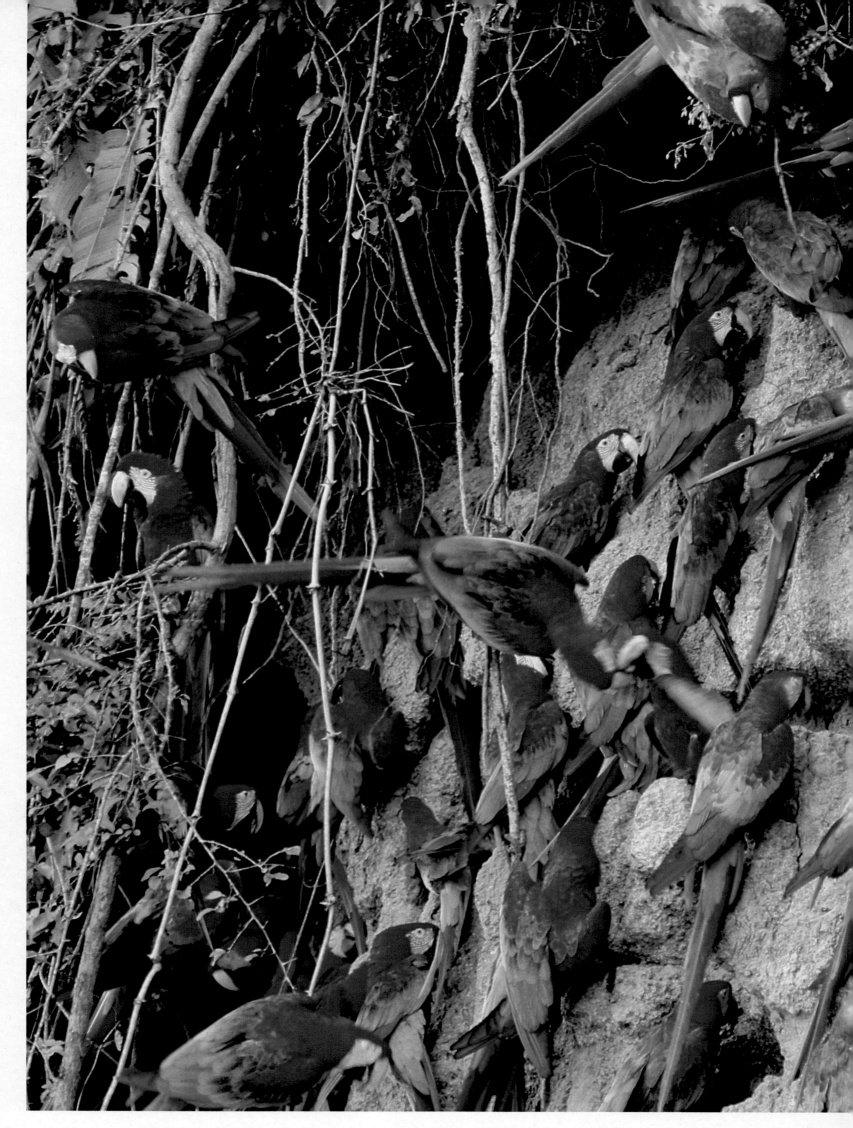

The magnificence of South American birds is unparalleled anywhere else on earth.

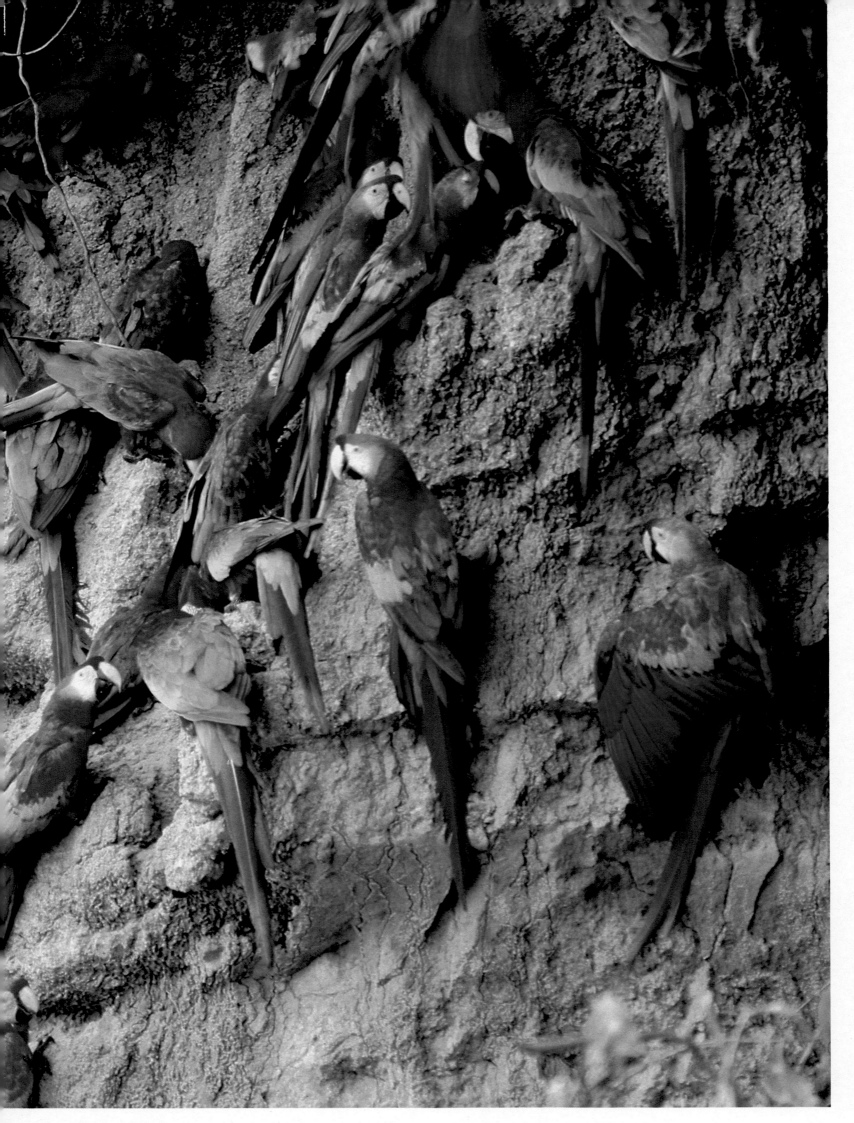

The brightly colored macaws are a beautiful sight in the Amazon rain forest.

sively, an aerial force lifts the bird whether its wings beat forward or backward. The propulsive thrust that a propeller creates, pulling an aircraft forward, is aimed upward in the hummingbird as in a helicopter. Anyone observing hummingbirds up close will easily perceive that they dash about from blossom to blossom, like syrphids. The tinier the species of hummingbird, the speedier its movements. A hummingbird can suddenly halt in mid-flight, hover, and then strike off in any other direction. For a long time, even zoologists were mystified by the hummingbird's style of flying: the zooming toward a blossom, the lingering while hovering and sucking nectar, the wild retreat and dash toward another blossom, and especially the backward flight. The hummingbird's wings move seventy-five

No other bird can fly backward. Modern cinema technology unmasked this secret of the hummingbird.

times per second; hence, the described actions could not be followed with normal eyes. Modern film equipment, capturing the whirring flight of these birds at three thousand images per second, enabled scientists to undertake a precise analysis of the miracle of the hummingbird's flight. To perform these high aerial achievements, its wings are endowed with unusually developed flying muscles, which make up no less than 25 to 30 percent of the entire body weight.

The Amazon territory is the dreamland of all butterfly collectors. However, many of the most magnificent butterflies inhabit the lofty roof of the forest and are therefore difficult to admire up close. The wealth of butterflies in South America is confirmed by an English explorer, Henry Walter Bates: "One can gain some notion of the variety of the butterflies living here when I mention that during an hour's outing one can count no less than seven hundred species."

There is no animal that can get people in the Amazon territory more excited than the jaguar. *El tigre,* as it is usually called here, is still viewed as the incarnation of the devil, interfering with progress and therefore to be fought by any means.

In proportion to its size, the jaguar is the most powerful of all the big cats. Having migrated from the north down to South America dur-

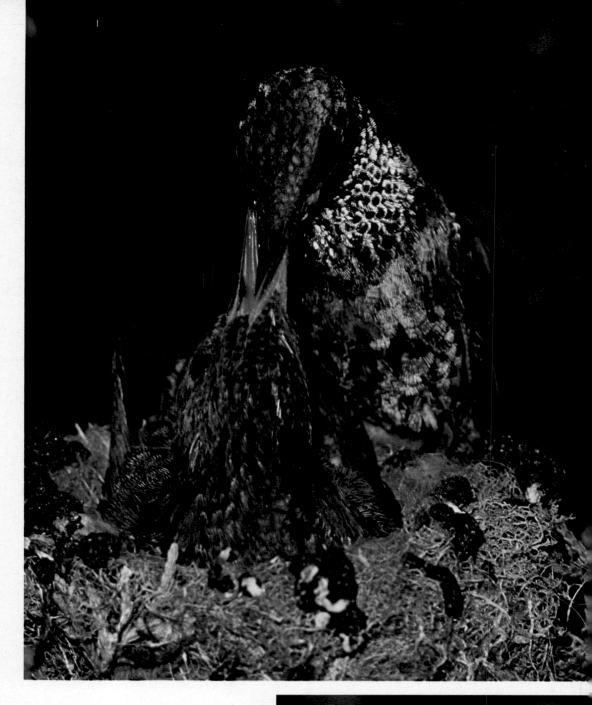

ing the Ice Age, it adapted wonderfully to the ancient animal world of the large island continent. The preferred quarry of the jaguar is either the relatively slow water hog, the peccary, or even fish, tortoises, snakes and caymans, for *El tigre* has neither the speed of the Indian tiger

The jaguar's strategy and strength have made it infamous. "El Tigre" hunts fish, caymans, and hogs.

nor the elegance and mobility of the panther. It is deliberate in its movements and inventive in its attack strategies, and its superiority lies more in its strength than in its nimbleness or leaping ability. The jaguar's favorite habitat is the tropical river forest by lonesome waters;

Birds that fly like dragonflies

Like dragonflies or syrphids, the hummingbird, the smallest and the most colorful bird in the world, can virtually "stand" in the air while sucking nectar from a blossom (*right*). In its whirring flight, its wings move back and forth fifty to eighty times a second. The hummingbird's clutch is so tiny that two or three eggs can fit inside a wedding ring (*bottom left*).

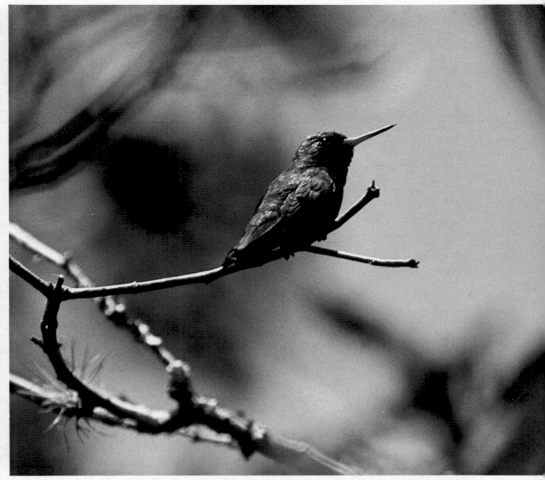

*Their plumage spar-
kles in the sun like
precious gems.*

The tiniest hum-
mingbirds grow
scarcely larger than
a bumblebee. The
hermit weighs all of
two grams. Every
species of humming-
bird looks for spe-
cific blossoms that
are also fertilized by
these birds. The
hummingbird's
tongue serves as a
sucker to gather nec-
tar for the hungry
brood.

Acrobats at dizzying heights

A tiny monkey, the funny barrigudo (or woolly monkey) (*above*) lives high in the treetops where a large portion of jungle life takes place. Like the squirrel monkey (*left*) and the spider monkey (*far left*), the woolly monkey has a prehensile tail, which functions as a fifth limb.

such areas are rich in wild animals and far away from human beings. Often, the jaguar remains in its territory for many years. During the day, it pushes into the shoreside thicket to doze away the hot daylight hours. Like the leopard in the African savannah, jaguars like to climb trees, where they find shade and coolness.

The secrets of the Amazon are far from being solved. The river and the region are simply too overwhelming.

One of the strangest large mammals of the Amazon is the tapir. Although related to the rhinoceros and the horse, it represents an older stage of evolution. The tapir especially likes to stay near water, leaping into it in case of danger. An outstanding swimmer, it enjoys grazing on swamp and water plants but also feeds on the leaves and twigs of low trees. As a forest animal living in dense vegetation, the tapir smells and hears especially well, though its eyesight is not as highly developed. These primeval proboscideans have a successful history behind them: They have survived on this planet for some fifty million years.

The Amazon is a symbol not only of a fascinating animal world but also of adventure, rubber, gold, and diamonds. The Amazon means thrills and excitement: curare, anacondas, and headhunters. The romance of adventure lurks side by side with terror—because no explorer has as yet truly conquered the mysterious river. Anyone who has survived its tribulations will say that any description, any picture, is merely part of a gigantic puzzle—a puzzle that will not be completed in this century.

▶

Very few birds seek their food along the shores of the rivers. Those that do include the heron and the fiery red ibis, which hunt fish with their long bills.

331

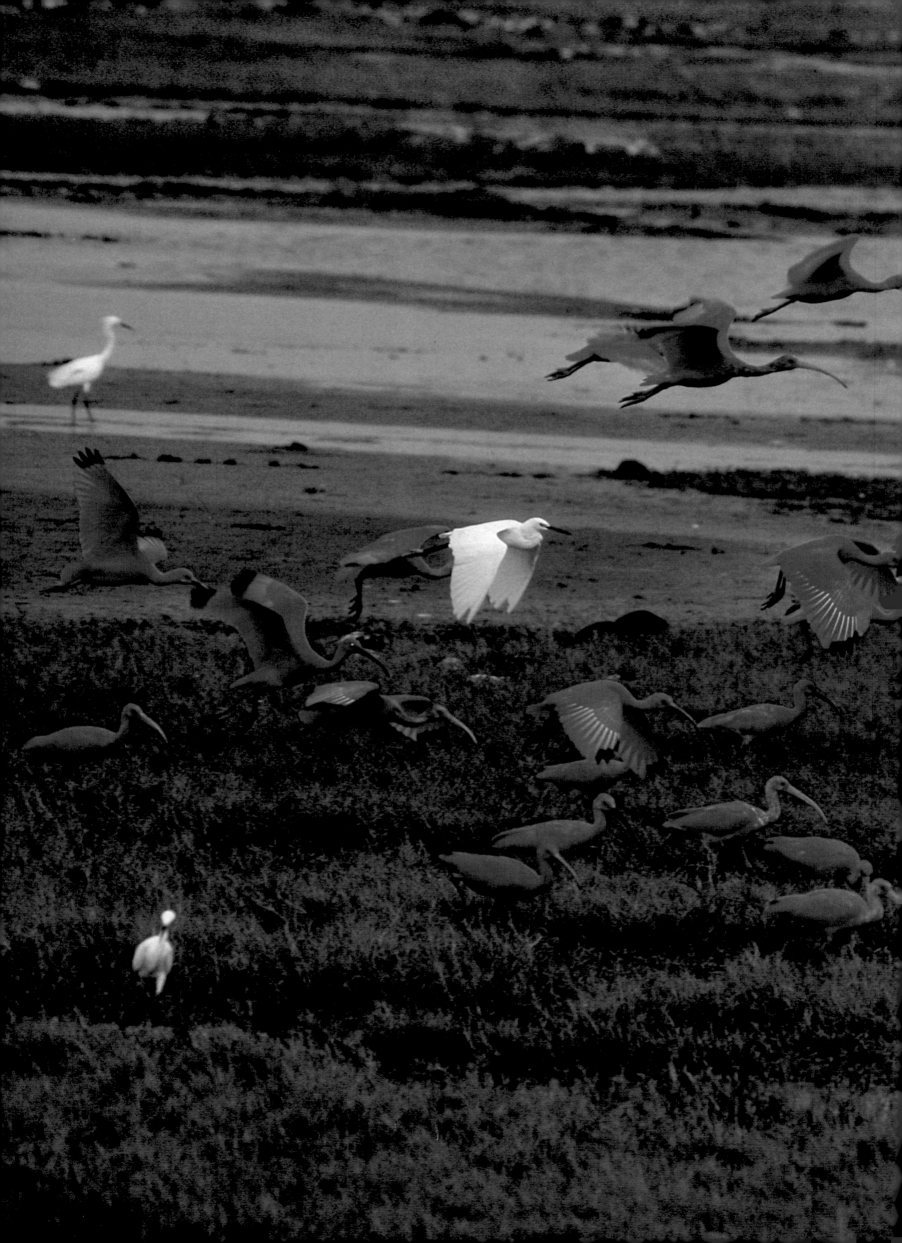

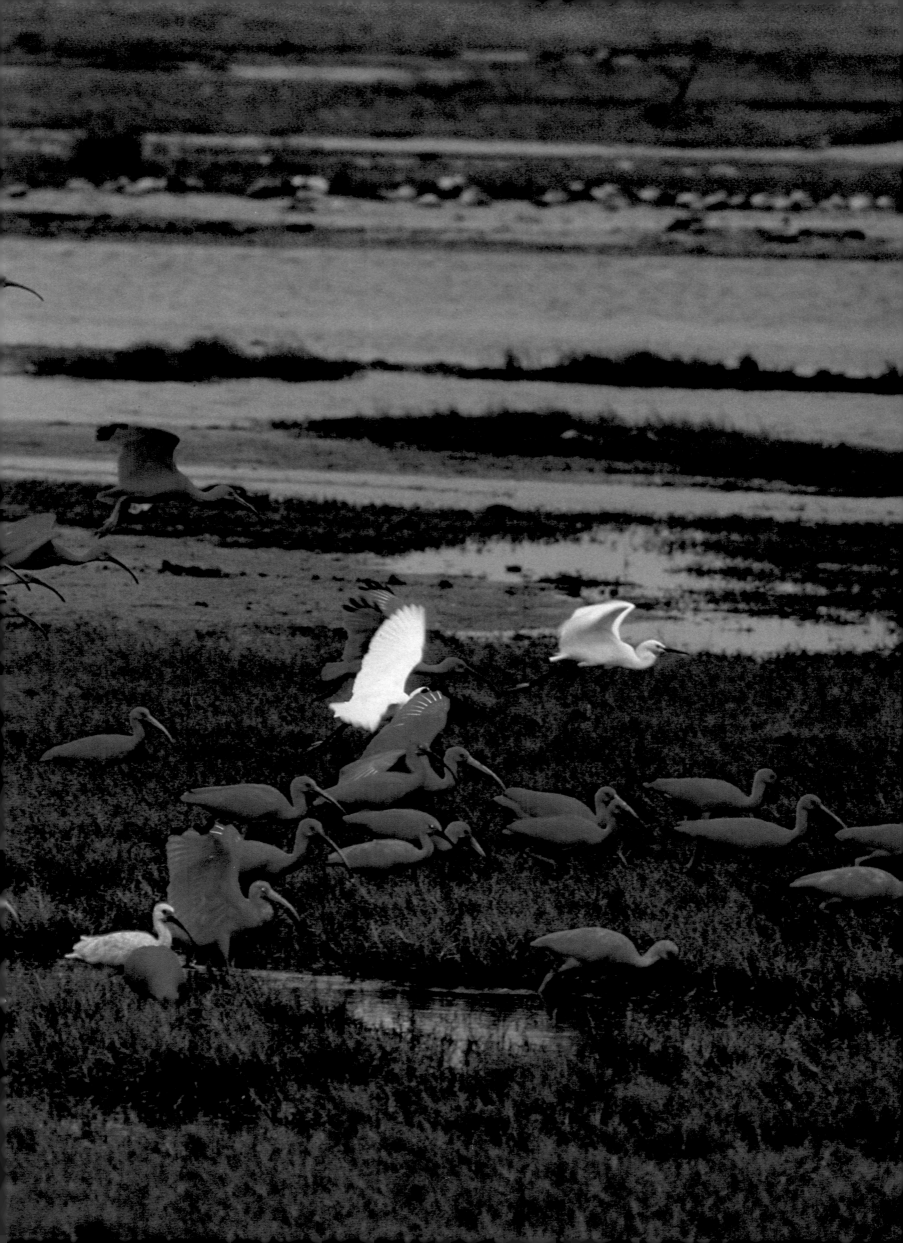

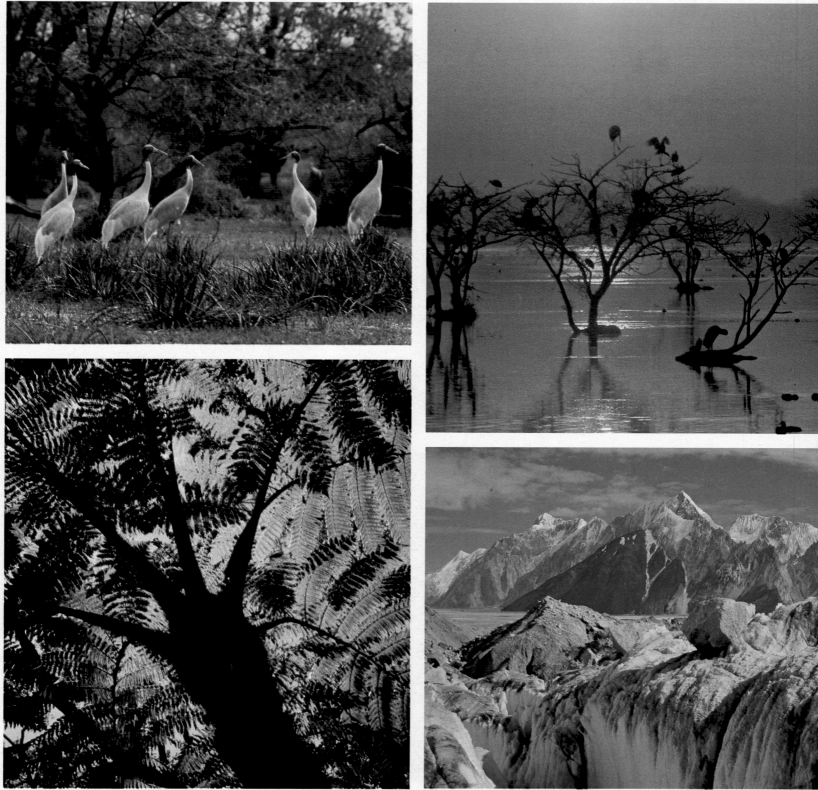

IA

The second largest island on earth is a wild, unexplored land. Legend has it that the colorful birds of its forests sleep on rainbows.

New Guinea's

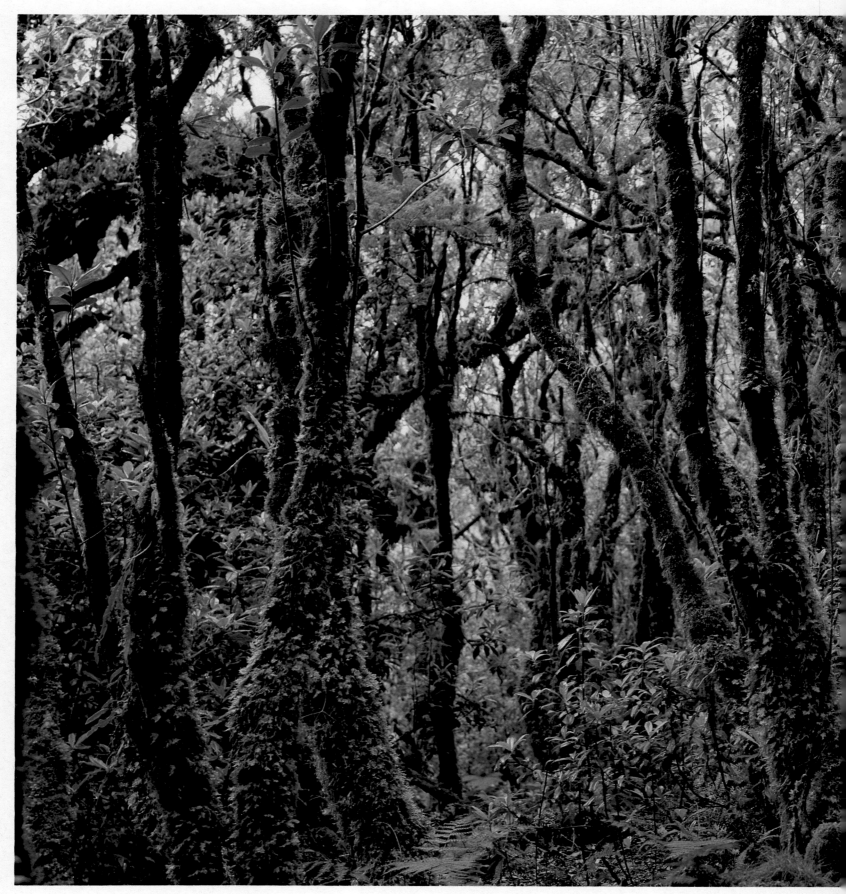

The Crows Of Heaven: Birds of Paradise

Whites have been settling this jungle island for less than a century.

Green, dark jungle as far as the eye can see—New Guinea seems to consist only of green. The tropical rain forest proliferates to heights of twelve thousand feet and ends along the coast and on the naked rocky peaks of the volcanoes.

North of Australia lies the second largest island on earth: New Guinea, a barely explored landmass encompassing over three hundred thousand square miles. Tropical vegetation—an almost impenetrable jungle and a densely entangled thicket in fogbound mountain forests—covers most of this giant island. New Guinea has an unusual, even fantastic fauna. It is home to the Victoria pigeon, which is as big as a goose, and to the smallest parrots, the longest lizards, and the man-sized cassowary, as well as thirty-eight of the forty-three known species of birds of paradise. The latter are so named not because they are considered beautiful but because for a long time it was believed that they "never touched the earth or any earthly thing." The most fantastic stories were told about the life-style of these birds, which supposedly fed on raindrops and slept on rainbows. New Guinea was virtually unknown in Europe when princes and rich collectors began lavishing huge sums on the shimmering skins of these birds.

Finally, the naturalist Carolus Clusius managed at least to establish more or less where these birds lived, namely, the Papua Islands. By 1774, twelve different species of this bird had been identified, and naturalists were certain that they came from New Guinea. But it was another fifty years before the first naturalist saw the homeland of the bird of paradise with his own eyes. He was the Frenchman René Lesson.

Birds of paradise were an enigma for a long time. It was thought that they could not possibly come from the earth.

A generation later, explorers began their voyages to discover new species of the bird of paradise. The search for these sparkling jewels of the jungle became a passion for many.

The "romantic era of discoveries" is still not over. A more precise study of the way these birds live remains to be done, and I made up my mind to contribute what I could.

At the International Ornithologists' Congress at Cornell University in Ithaca, New York, I received valuable information for my fascinating but immensely different project. I learned that the red Marquis Raggi's birds of paradise, whose so-

cial mating ritual is considered something of a phenomenon, have become very rare in the vicinity of native settlements. In order to find them today, one must hike through a vast, arduous untracked wilderness, where the native guides and bearers are not always reliable. Furthermore, the birds "dance" in the tops of jungle trees some seventy to one hundred feet high. It is therefore necessary to do extensive construction work, building high platforms and ladders.

Dancing birds in the tops of the green jungle giants: a wild mating in an intoxication of colors.

We found the first mating sites on the jungle slopes of the Kub Mountains. Three days later, our native helpers had put up a solid observation post on a tree one hundred feet high. Construction work was possible only during the hot noon hours, when no bird of paradise happened to be nearby. The slightest disturbance during its mating would have driven it away for a long time.

It was still darkest night when we all met in front of the observation post after a half-hour hike through dripping bushes and grass. When

Concealed in the rain forest where no humans come

Blue-necked birds of paradise copulating (*right*). These less colorful birds of paradise perform a poignant dance when mating. Marquis Raggi's bird of paradise (*below*) and the blue bird of paradise (*below right*). Head over heels, it unfolds its plumage.

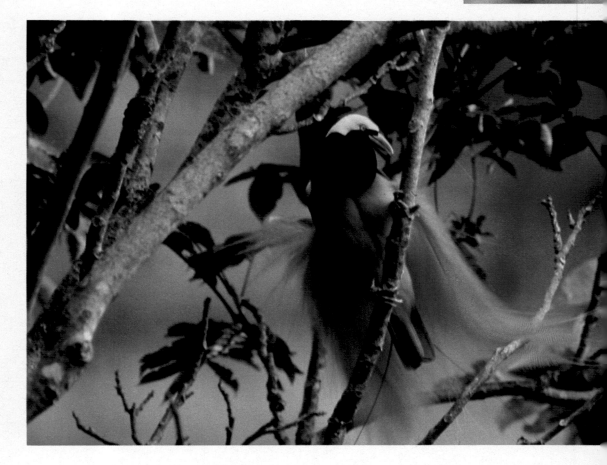

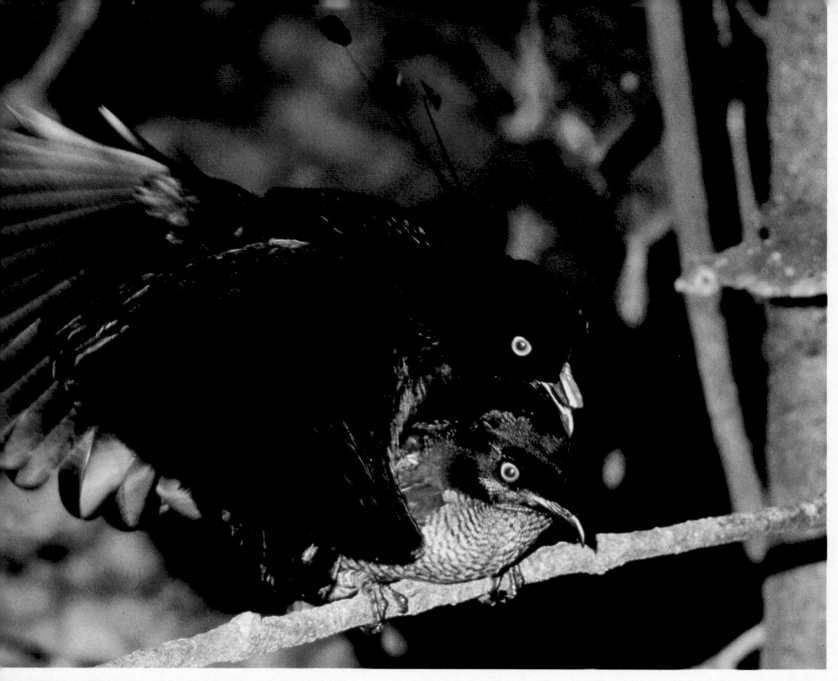

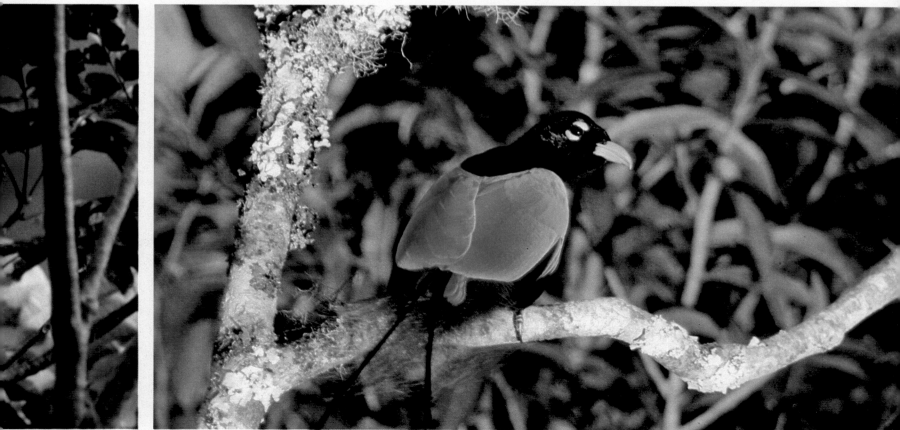

The beauty contest takes place at dawn.

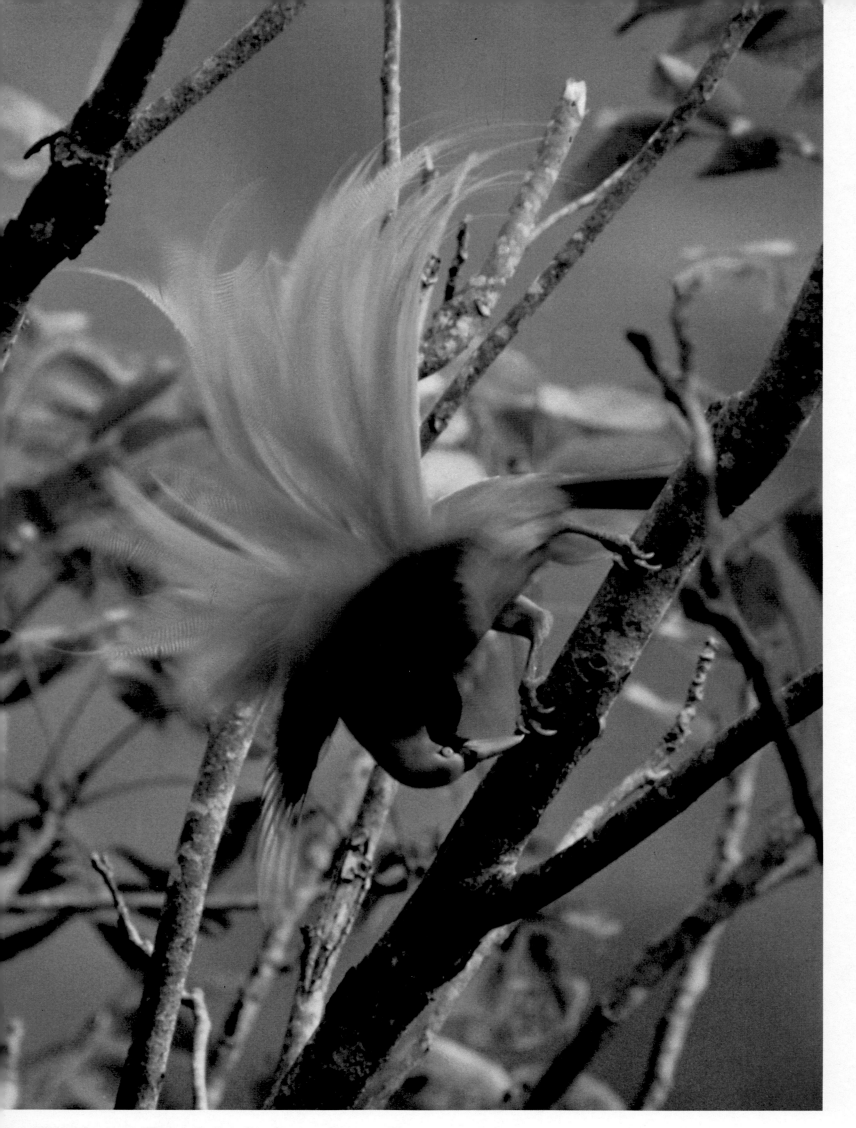

The Marquis Raggi's bird of paradise puffs up its plumes
into a magnificent "blossom" when mating.

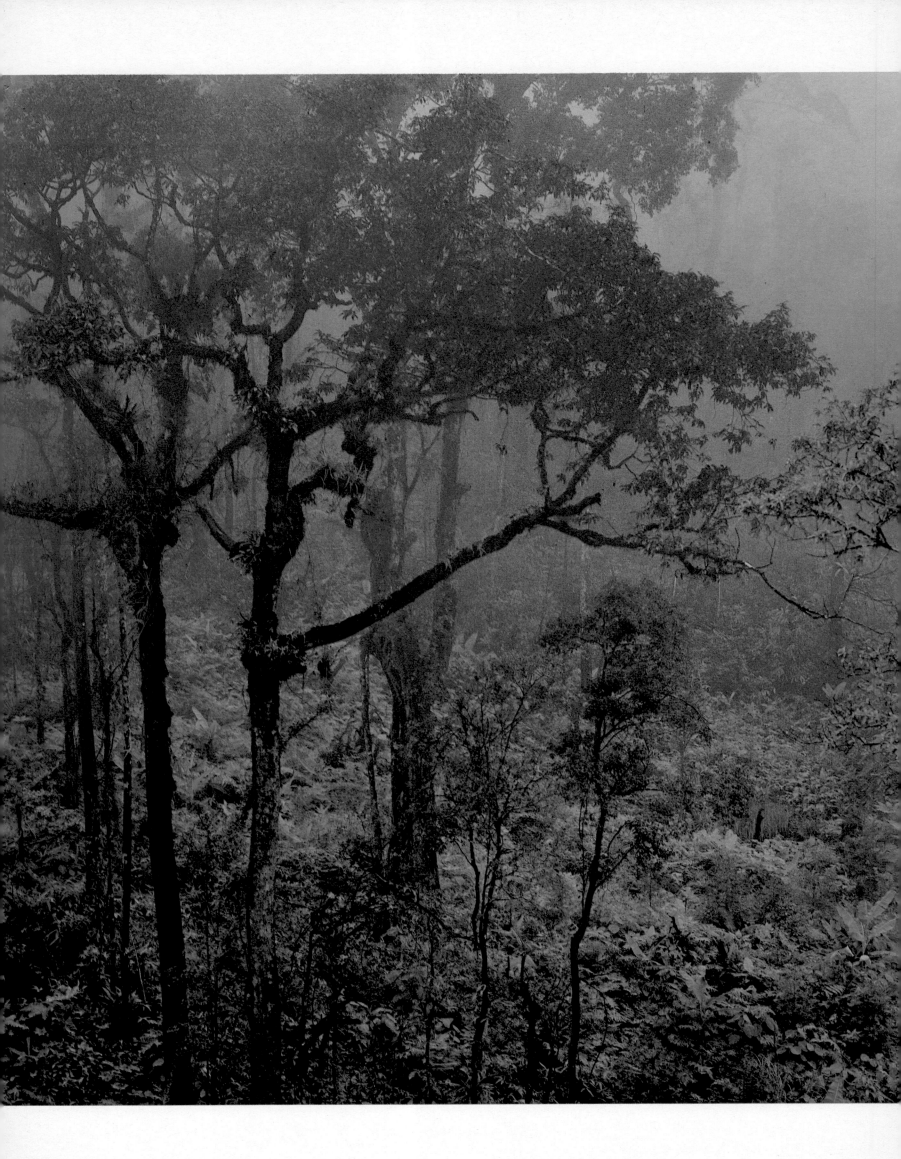

our native helpers left us, the first light of dawn began to shimmer through the leaves of the treetops, and we heard the first "barking" of the birds of paradise. They were still in the trees in which they sleep, a few hundred yards away. Ten minutes later, when we heard the first heavy beating of wings, we inched our heads forward to peer through the tiny peepholes and spy the first bird. Three or four more arrived at the crown of the tree at short intervals.

Each male occupied a slanting (usually) branch within the treetop in order to pursue his courtship from it. The aim is to make a conspicuous bid for attention; hence the barking cries and the beating of wings. In between, the birds nibbled at the few remaining leaves on the "mating" branch so that the birds would not be covered by them or hindered in their dancing. All at once, the barking changed into an excited singing.

Only the most beautiful male can bewitch the female. Then comes the wedding—and a red feathered veil.

Quickly, the birds hurried up and down their branches, unfolding their red plumage, which now looked like blazing flames. The reason for the commotion was a female, with plain brown plumage, which had flown to the tip of the tree and was sizing up the excited suitors.

The choice of a mate is the exclusive prerogative of the female, who always selects the strongest and most splendid male. Her choice asserts his supreme position in the hierarchy of this mating community by occupying the highest place in the treetop. Only when his position is challenged by a younger male will the female "ask" the latter to marry her.

Although four other males wooed the female, she was fascinated by the one at the top of the tree. Another female arrived and tried to drive away her rival, but failed. The cock utterly ignored the second female. For two or three minutes, he continued dancing before his *adorata,* after which they celebrated their "wedding" on the mating branch. The male draped the female in his shimmering red veil of feathers—a discreet baldachin.

I also had several chances to witness the unusual mating rituals of other species of the bird of paradise. The blue bird of paradise hangs head down from a branch, spreading

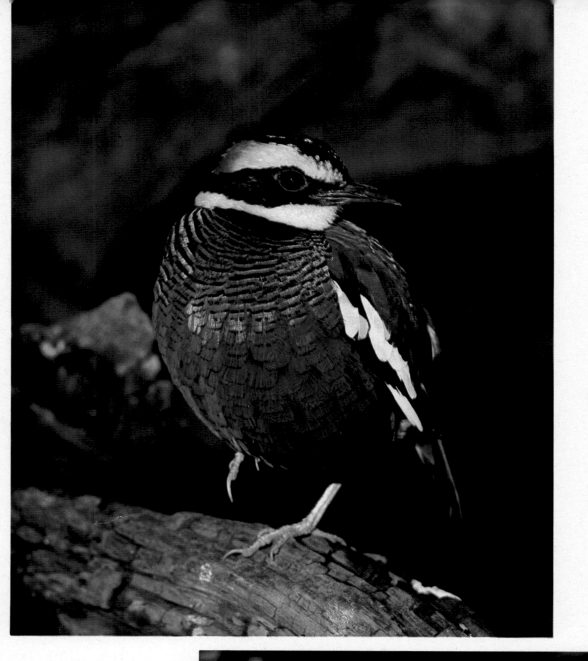

Where the forest becomes inaccessible, the bird of paradise has its territory.

The blue-tailed pitta (*above*) and the Victoria pigeon (*right*) shimmer like jewels in the darkness of the forest. The magnificent plumage of the birds is not just an adornment. It also functions as camouflage in the riot of blossoms in the trees.

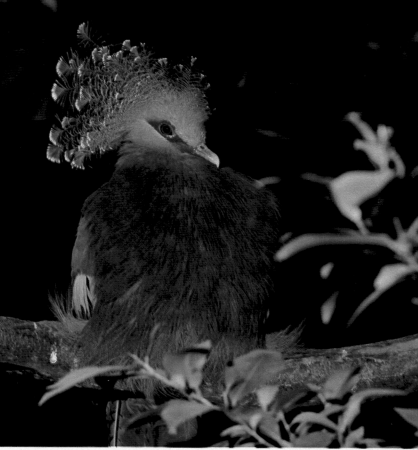

343

out its radiant dark blue plumage into a half-moon shaped veil with a velvety black oval field in the middle. In twitching movements, this bird transforms its unfolded plumage into an almost unreal play of colors. The King of Saxony's bird of paradise is one of the smallest. This dwarf usually lives in the tops of jungle trees, and never indulges in a conspicuous social mating ritual like the Marquis Raggi's bird of paradise. The unique feature of the King of Saxony's bird of paradise is the plume on either side of its head. It is about twice the length of its body

Lacking any decorative plumes, the Omann's bower bird adorns itself with red berries, creating an illusion for the female.

and looks as if it were composed of many small matte enamel plates.

The largest bird of paradise is the great bird of paradise, which I observed in the higher mountain forests of New Guinea. This velvety black bird, with its two radiant white, almost forty-inch tail feathers is a splendid vision as it glides from slope to slope over the deep green valleys.

The result of these unusual mating rituals is noteworthy: Since the females choose only the most conspicuous and extraordinary males, such characteristics are self-perpetuating.

The Lauterbach's bower bird which is found in the highlands of New Guinea, offers a fascinating study—and one that contrasts vividly with those described above. The size of a thrush, this bird has a plain brownish gray coloring. In order to attract a female, he gathers as many as three thousand small sticks to erect a "love bower" that serves as a cloister. The sticks are bound together so tightly that the large construction can be carried off in one piece. At the center of the cloister lie fruits and small stones, as many as a thousand, and a few red berries. If a female comes to visit, the male picks up a red fruit in his beak and presents it as a betrothal gift. While doing so, he performs a little dance and revolves his head. This bird has lost his red tuft in the course of evolution; he now utilizes the red berry as a surrogate.

The most astonishing skills I observed were those of the short-crested bower bird. His love bower

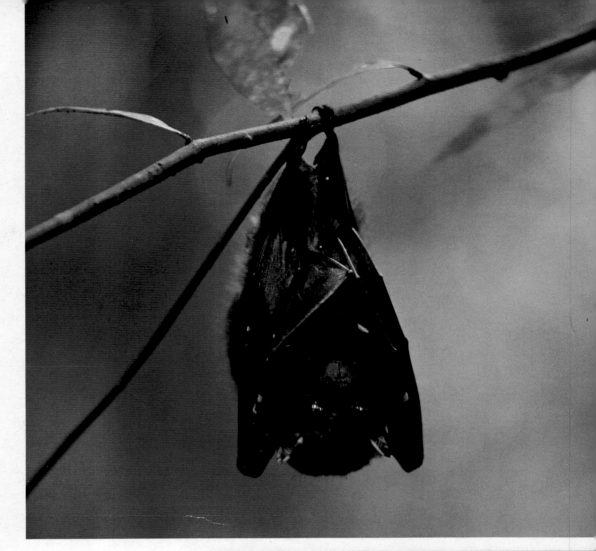

Precious gems in the tropical rain forest

Hanging head-down from a branch, the tube-nosed fruit bat (*above*) is fast asleep. Its membranous flight apparatus protects and camouflages the bat. The color of the weevil (*top right*) serves to frighten away enemies. It lives on the sap of plants. The tree frog (*right*) can seize hold of even the smooth parts of plants with its broad toes. There, it lies in wait for insects, which it catches with its long tongue.

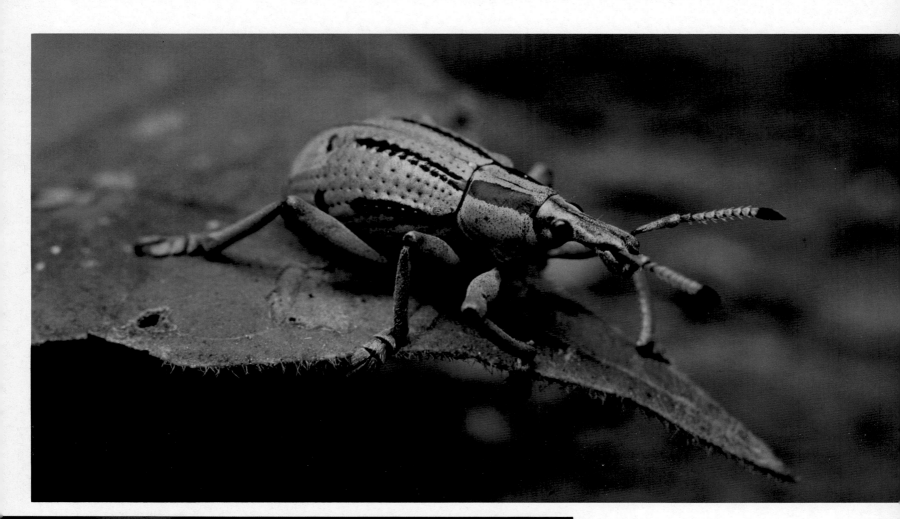

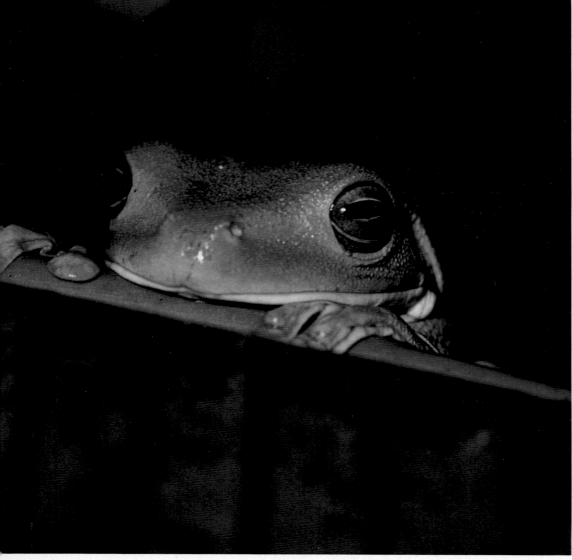

had a rainproof, cathedral-shaped top and two front entrances. The wall between these entrances was covered with black green moss and designed like a mosaic; on the left side lay shiny blue beetles; on the right side, fragments of snail shells. These were displayed as in a shop window, and yellow blossoms separated the two. Everything was carefully and accurately placed into the moss. In front of the "hut," a "garden" spread out, scattered with "flowers" and surrounded by a semi-circular "fence" richly adorned with red and yellow fruit.

Birds of paradise are indeed more fascinating than I had ever suspected.

▶

A creature living in the forest does not necessarily have to be a good climber. The tree kangaroo climbs to the high branches only to eat. It prefers hopping about on the ground.

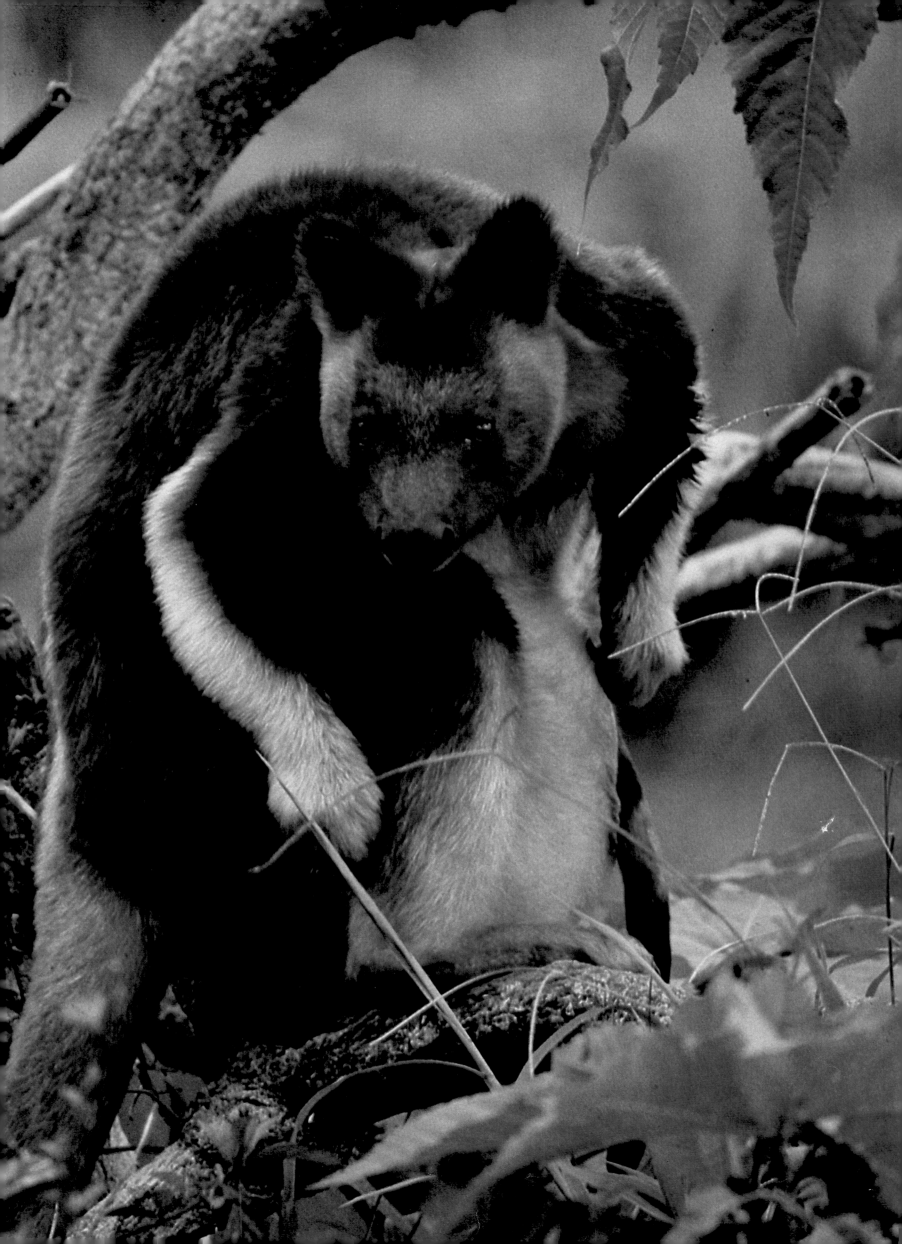

The Himalayas—where the earth stretches up to heavenly heights, and solitude surrounds the mountain peaks. Undisturbed quiet encircles plants and animals, whose refuge is the roof of the world.

The Home

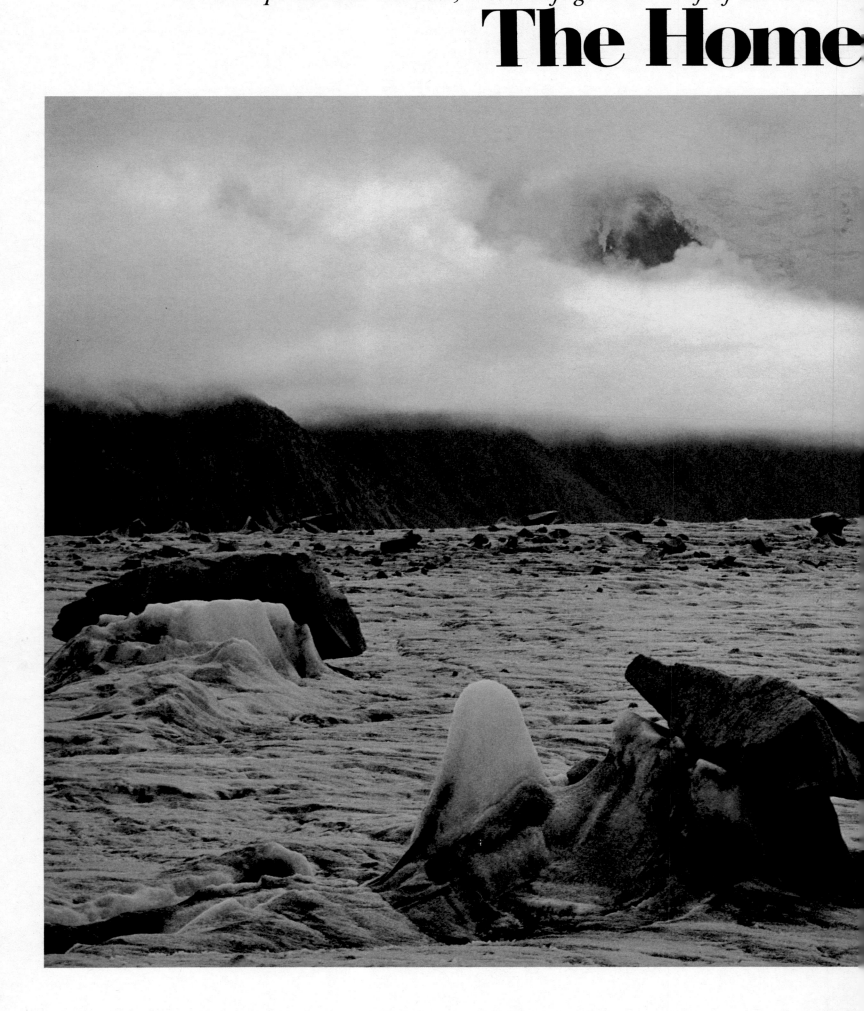

A World in the Clouds: of the Snow Leopard

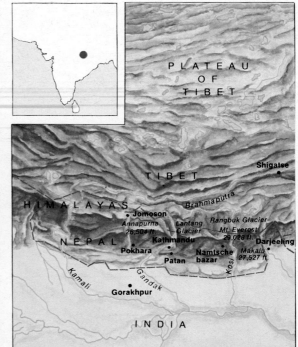

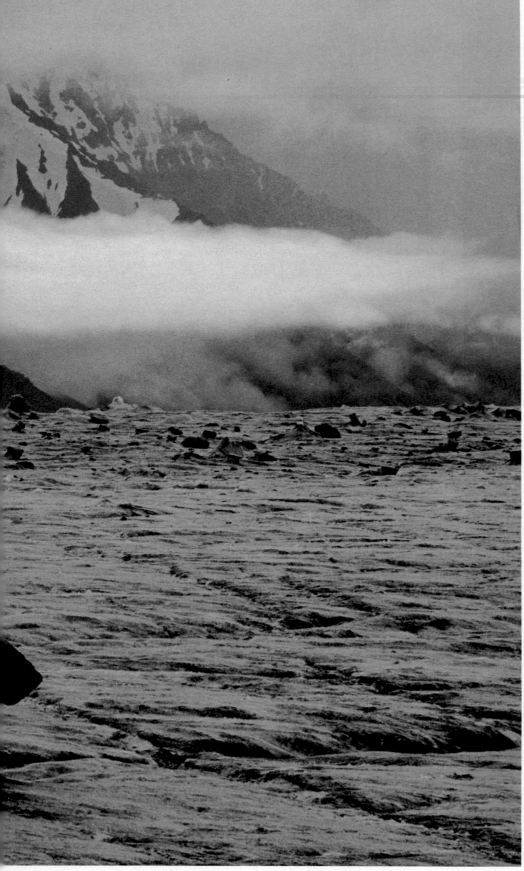

The highest mountain on earth is the "peak of the sky." We call it Mount Everest.

Mist, a breathlike veil, plays about the peaks. Fog creeps cunningly between the rocks, swallowing the sun. Ominously dark clouds tower above the white cottony variety and cast off their cargo in raging blizzards.

Himalaya means "home of the snow." For people born in the Himalayas, this area is also the home of the gods; and for adventurous mountaineers, the Himalayas are the home of world records.

On the highest snow fields on earth, for instance on Mount Everest, Annapurna, or the K 2 peaks, there are neither plants nor animals. In order to see the wildlife of the Himalayas, the observer must descend to more modest heights—down to the snow line, at an altitude of fifteen thousand to twenty thousand feet. If we look down from this altitude, we see spread before us an incredible range of flora and fauna. So full of extremes is this world that it looks like a fairy tale to the outsider. The chain of the Annapurna peaks climbs to twenty-five thousand feet from the Pokhara Valley, which is twenty-four hundred feet high. A tropical downpour can strike a jungle at the foot of the Himalayas at one hundred degrees Fahrenheit, while above, in the regions of eternal snow, the mercury can plunge to minus seventy degrees Fahrenheit.

After the great monsoon rains, the freshly washed world of the Himalayas glows. Summer temperatures prevail at an altitude of thirteen thousand feet, enabling a wealth of flowers to explode into bloom. The edelweiss forms bright felt carpets. Poinsettias unfold their blossoms like red parasols—which sometimes have a diameter of twenty inches. The rhododendron, which is the national flower of Nepal, grows at all altitudes up to the snow line and

Snow leopards are lonesome hunters. They avoid human beings—protecting themselves and their beautiful skins.

ranges from a dwarf shrub to a tree one hundred feet tall. And then there is another flower—the flower of yearning, of romance: the blue poppy. In the Bhyundar Valley, among fog-enshrouded rocks, one feels as if one is entering another world. Here the rare blue poppy forms a blue ocean thirteen thousand feet above sea level.

A few species of mammals have retreated into the high rocky areas, where they endure the severe climate because they need the solitude provided by this region. This is the home of what is probably the most beautiful predatory feline: the snow

leopard. This mountain panther, with its thick, beautiful whitish gray fur spotted with black, seldom comes down to the tree line. Only hunger and poor hunting in the higher zones drive the lonesome hunter into the valleys. Normally, the snow leopard finds its food at dizzying heights. Its favorite prey, the Siberian steinbok, also inhabits the region between trees and snow. The snow leopard, so retiring a creature that even inhabitants of the Himalayas seldom catch sight of it, feeds on musk deer as well. This stag without antlers has long, saber-shaped tusks, which it desperately uses as weapons in a fight. However, the musk deer's "vampire" bite is virtually useless against men armed with rifles, who want the musk gland for the manufacture of valuable perfumes.

Many loners of the animal world dwell in the solitude of the Himalayas—the yaks, for instance. The largest living species of wild cattle, they tramp about in the sixteen-thousand-foot-high region, seeking

The most beautiful hunter in the Himalayas

The snow leopard (*below*) steals all the way down to the bleak high valleys. His thick, magnificently spotted skin is both camouflage and protection; the snow leopard is almost invisible in the snowfields of the high mountains.

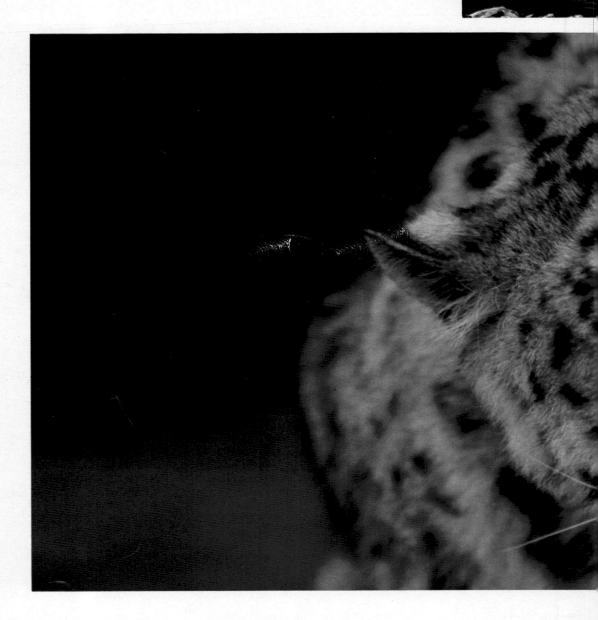

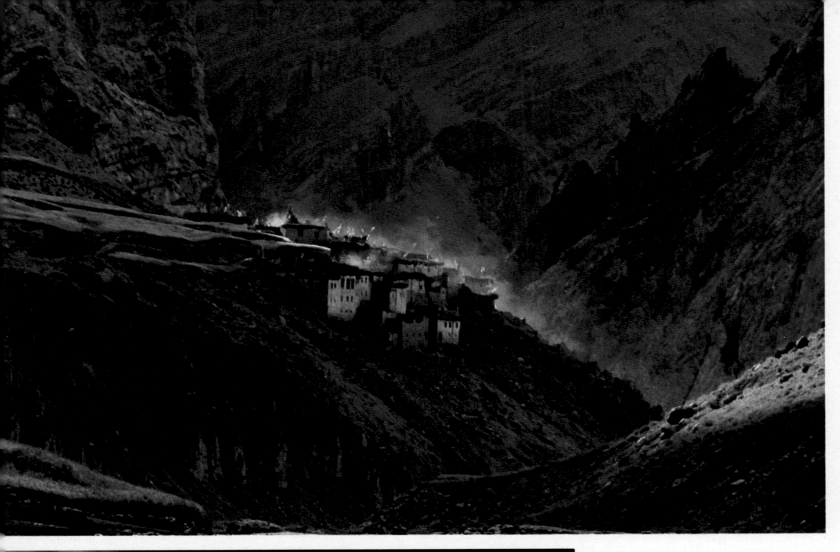

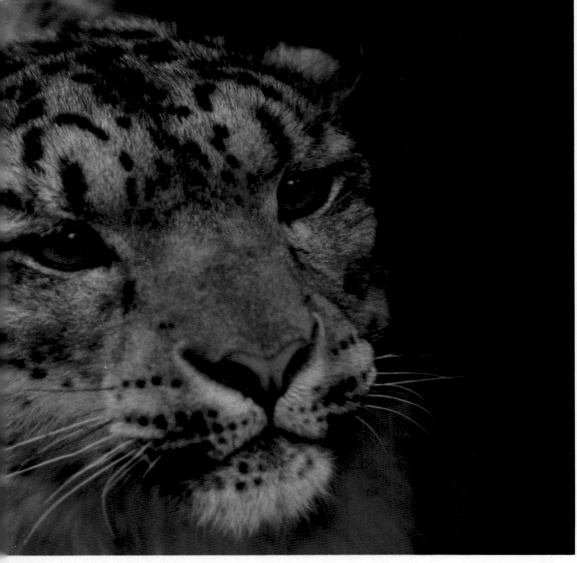

food for their massive bodies. Thick, long, shaggy fur shields the yaks against the impact of winter temperatures (often minus seventy degrees Fahrenheit). Their short legs, small ears and eyes, and narrow nostrils also contribute to their ability to dam up heat.

The tahr and the markhor, the wild mountain goats of the Himalayas, are excellent climbers, although the tahr supposedly used to

The roof of the world looms out of the jungle: a borderland for plants and animals.

be an animal of the plains. The markhor buck has an impressive appearance. Instead of the typical goat beard, it has a long-fringed mane covering its entire throat, and its long horns perch on its head like two huge corkscrews.

Falconiformes rule the air above the Himalayan peaks. Buzzards, falcons, and eagles circle in the sky, looking for prey that makes its home in the rocky region: for instance, the Mongolian mountain mouse and the long-eared pika. With its tiny paws, muzzle, and tail, the pika looks like

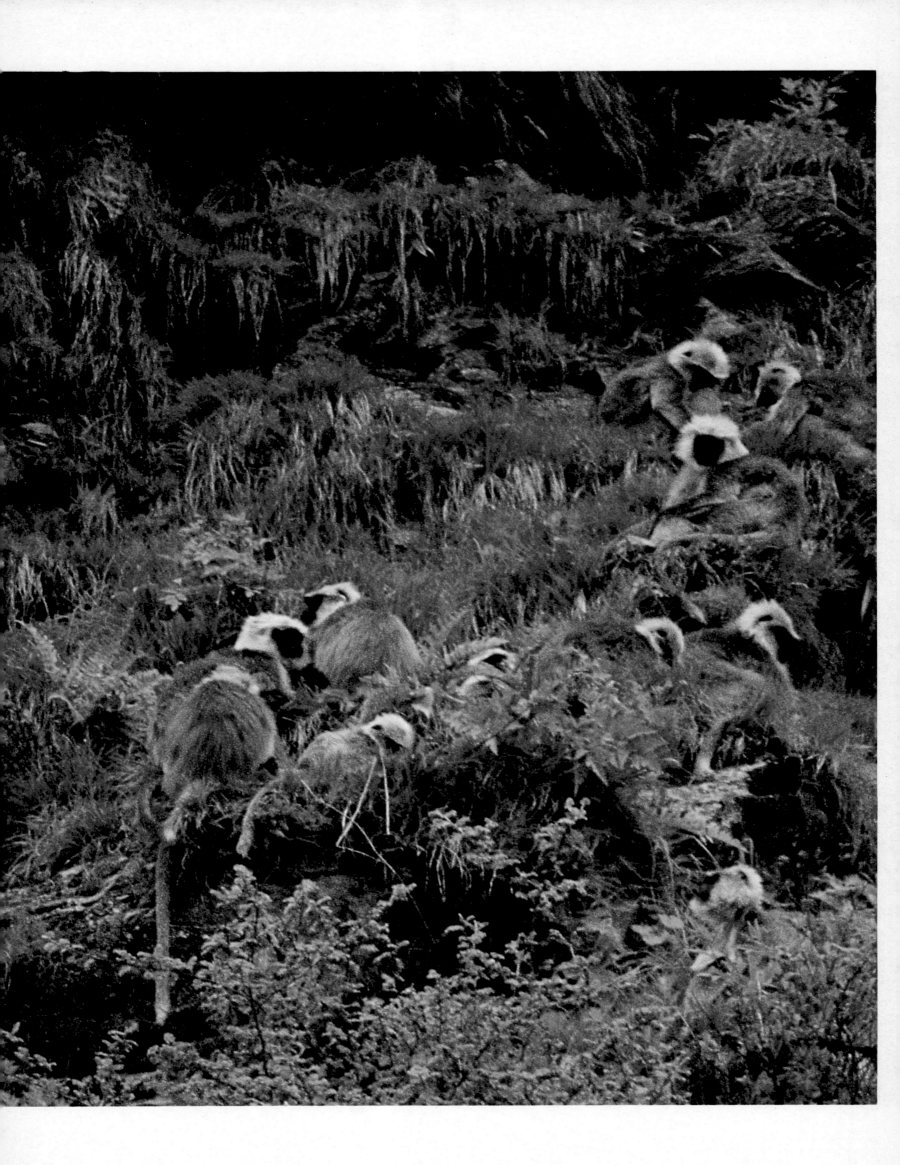

a woolly egg. It lives in underground colonies, leaving thousands of mounds like molehills on the thin layer of soil. Vultures, the carrion-eaters among the birds, are extremely numerous. Black (or ash-colored) vultures, Himalayan vultures, griffon vultures, and bearded lammergeiers soar silently through the air, borne by the thermal currents and driven by the search for prey.

An entirely different world opens up on the southern side of the Himalayas. At the foot of the sea of rock lies the moist land, the terai—a jungle. Until the 1950s, this portion of Nepal was a paradise for the Indian rhinoceros, the Bengal tiger, the gavial, the gaur (wild ox), and many other special representatives of the animal kingdom.

For human beings, the swampland of the terai used to be uninhabitable; only a small malaria-resistant tribe lived between Rapti and Reu in the Chitawan Valley. But once malaria was wiped out, the countryside was inundated not only by monsoon rains but also by people seeking land. They made the soil arable and cultivated it. Rice paddies emerged where untouched jungle

The tropical rain forest thrives in the broad valleys of the large rivers.

Langurs, seeking edible fruit, wander through the forests which are damp from the monsoon. White hair and a white beard frame the black face of these monkeys (*right*). The panda, a relatively rare species, is, like the black-and-white giant panda, a tenant of the bamboo jungle (*below*).

had once proliferated. Settlement also brought poachers. The horn of the Indian rhinoceros, the crocodile skin of the gavial, and the hide of the Bengal tiger promised quick wealth for little effort. The wildlife populations shrank drastically, and the end of these species appeared imminent. In 1962, the territory south of the Rapti River was declared a rhinoceros sanctuary, and ten years later, Royal Chitawan National Park was established here. In its 220 square miles, naturalists are trying to safeguard and maintain this habitat of endangered species. Salvation came at the last minute for the Indian rhinoceros, the second-largest land-dwelling mammal,

▶

The snow leopard has a conspicuously small head. Compared to its African relatives, the snow leopard's tail is extremely long.

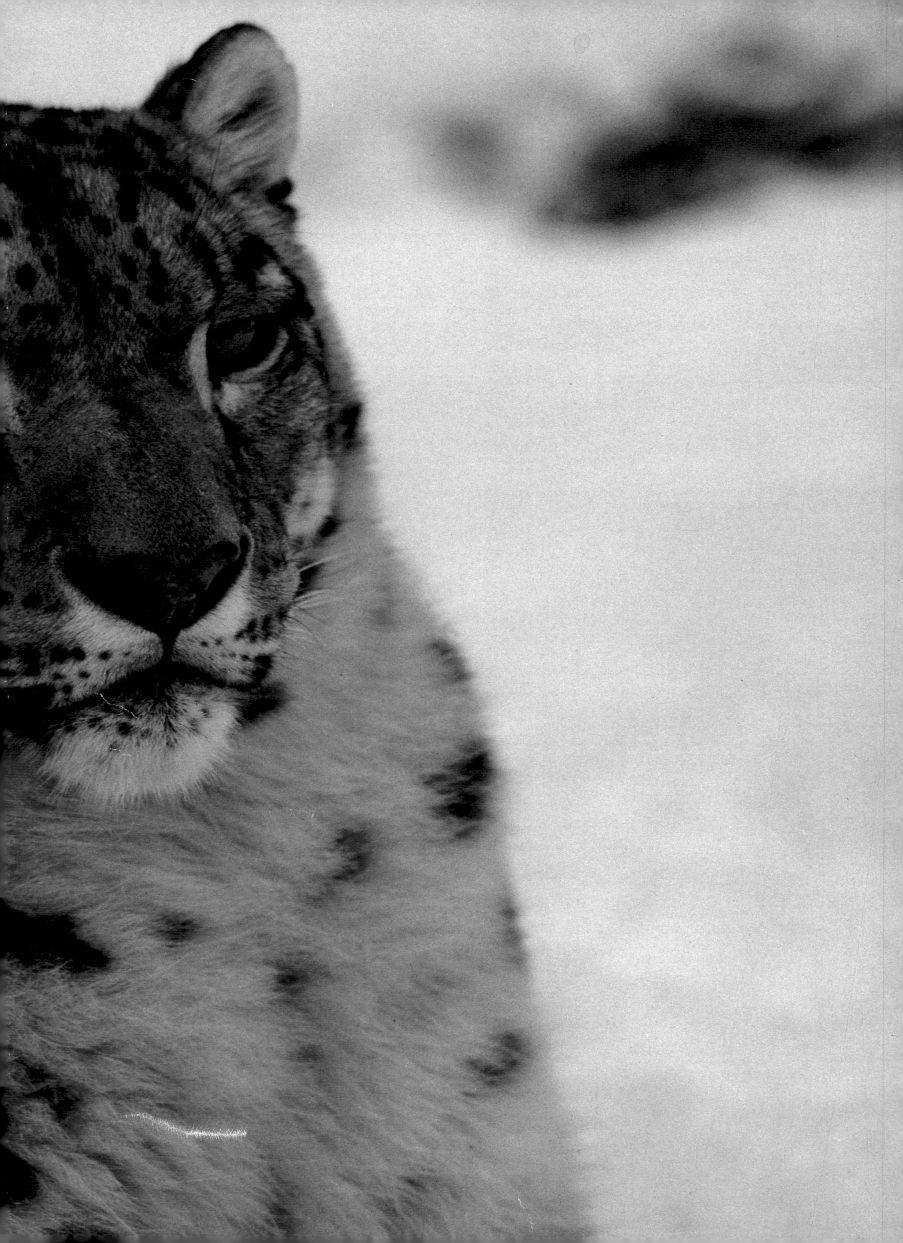

The rhododendron is the national flower of Nepal.

In spring and summer, the shrubs and trees, which grow as high as one hundred feet, create a crimson and purple sea of blossoms on the mountain flanks.

*The flower of yearn-
ing, the blue poppy*

**During the summer,
the Himalayan blue
poppy transforms
the green mountain
meadows into sky-
blue fields. At such
times, the earth and
the heavens seem to
blend. The rock jas-
mine (*left*) stretches
its red blossoms
from thick cushions
into the clear moun-
tain air. In the val-
leys, the yellow
poppy unfolds its
splendid blossoms
(*below*).**

which had been virtually extermi-
nated because its horn, when pul-
verized, supposedly could increase
male potency.

However, these primeval giants
still roam the swamp, accompanied
by a flock of mynahs. The mynah
picks parasites out of the rhinoc-

**A unique occurrence:
Human beings had
to leave a valley
so that the animals
could live in peace.**

eros's hide and feasts on the insects
routed by the huge animal. Danger
seldom threatens the mynahs on a
rhinoceros's back, for no one dares
venture up to a mature rhinoceros,
especially if it is a mother with off-
spring. The maternal rhinoceros at-
tacks anything that seems perilous.

The gavial is a more peaceful
creature. It is the last remaining spe-
cies of its group, a family of crocodi-
lians, and is on the verge of extinc-
tion because its reptile skin is
especially profitable. One can easily
tell the gavial sexes apart. The male
has a potatolike bump on its nose.

The Bengal tiger finds rich prey in
the National Park. Particularly
timid, the tiger is a nocturnal hunter.
During the day, it steals cautiously
through the dense undergrowth of
the jungle. Tigers are certainly not
harmless, and some older cats can
even become man-eaters, especially
if they have been shot and can no
longer hunt. In Chitawan Park,
some thirty adult tigers have enough
space to hunt without getting in each
other's way. Their prey ranges from
the small muntjac, the clumsy hog
deer, and the nicely patterned axis,
to the almost horse-sized sambar.
The Bengal tiger also risks attacking
rhinoceros calves and gaurs.

Rarely do human beings act on
behalf of endangered animals rather
than their own economic profit. The
National Park of Nepal is an excep-
tion, and its establishment is helping
to advance the day when wild ani-
mals will not just live on in pictures
from the past.

▶

**Freedom is not
boundless above the
clouds. There is no
room for great
splendor in the thin
air of the ice region.**

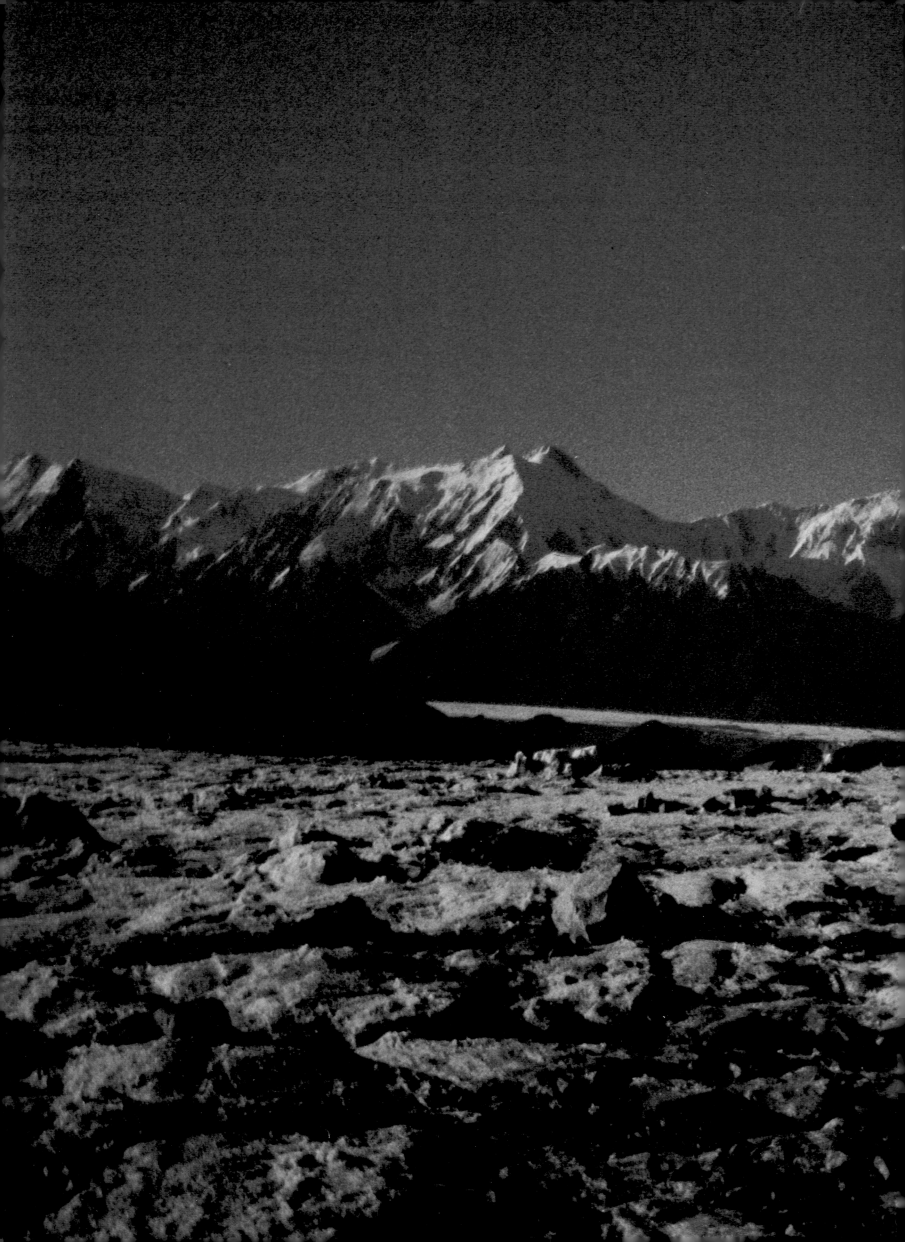

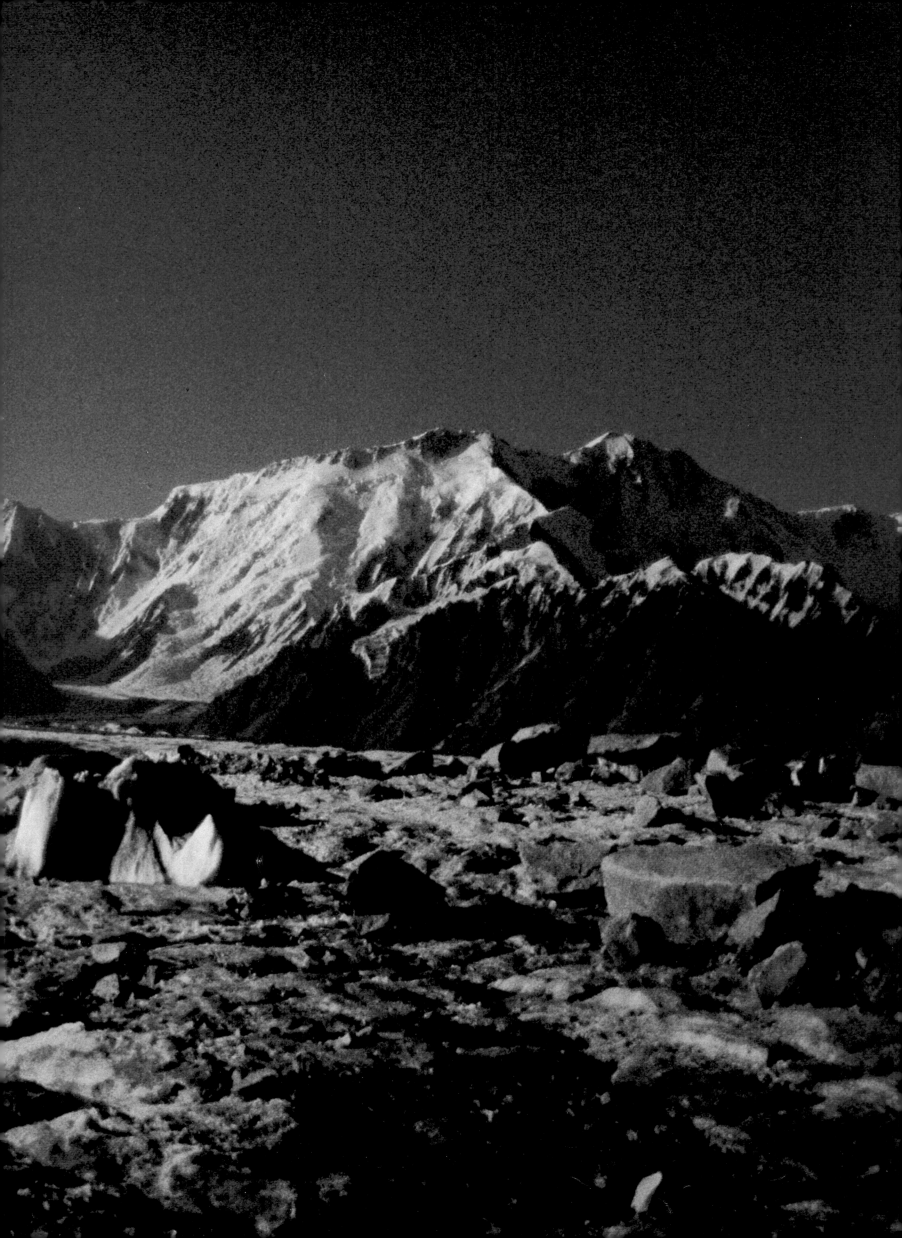

Virginal and green—a gigantic island full of miracles, gaily colored orchids, and timid orangutans

The Foggy Realm

Mysterious Borneo: of the Rain Forest

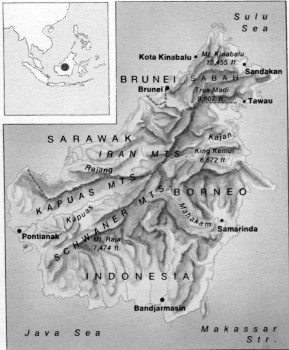

Heat and humidity lure the most marvelously colored flowers.

When the monsoon drops its heavy load of rain over the giant jungle, a fireworks of blossoms explodes. Adorned with small drops of water, they glisten, beckoning insects. This has only one purpose: the plant wants to be fertilized and to form seeds.

The birth of the third largest island on earth took place less than fifteen million years ago. Compared with other islands and continents, it is virginal. If Eden had not been located between the Euphrates and the Tigris, surely the new island of Borneo—the tropical jungle land between Asia and Australia—would have become paradise.

Neither saurians nor other primeval reptiles cavorted in Borneo. Prehistoric life, which occurred everywhere else on the globe, did not visit Borneo. Nevertheless, this green island in the Malay Archipelago teems with life as do few other areas on earth. Next to the Amazon and the Congo, Borneo has the third largest jungle territory in the world; it reaches from the coast up into the mountain landscape. Only Mount Kinabalu, 13,455 feet above sea level, towers as naked rock out of the forest. Nowhere does the tropical rain forest have as many species, nowhere is it as fascinatingly exotic as in Borneo. It is a jungle full of wonders. Under its protection, the largest flower on earth, the rafflesia, unfolds its heavy petals. On the ground, the mushrooms shine wraithlike at night, while above them swarms of luminous beetles send their messages through the darkness. In Borneo, reptiles fly, fish stroll on dry land or even climb trees, plants keep pet ants, and spiders eat mice. However, the rain forest also offers "normal" animals: elephants, leopards, rhinoceroses, anthropoids, beautiful birds, and bizarre marsupials.

There are rain and fog galore in Borneo. The vegetation is rank and lush. It is a green paradise.

The flora and fauna came here long ago from Asia and Australia. During the last great Ice Age, when the surface level of the oceans sank very low, the islands of the Malay and Indian archipelagos were suddenly attached to the continents. The jungle and its creatures went on a march lasting millennia across these landbridges. When the water returned, all islands up to the Philippines were filled with a tremendous amount of vegetation and countless species of animals.

At some point, human beings—Negritos—also came to Borneo and were driven out by other groups—Malayan tribes—who became

The birds are as gaily colored as blossoms or butterflies.

Loud colors are not only conspicuous, they actually camouflage the birds in the radiant play of colors among the blossoms. The bee eater (*right*) easily finds prey among them, and many other birds feel safe from enemies near the flowers.

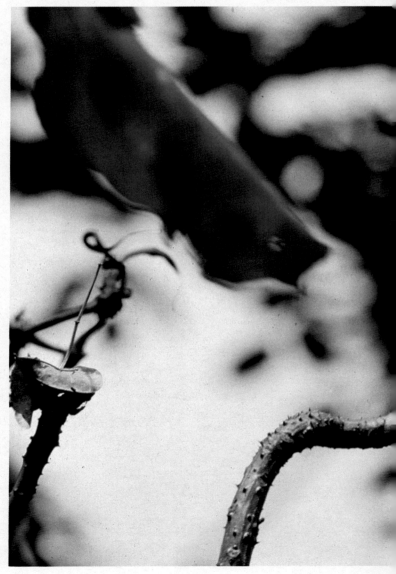

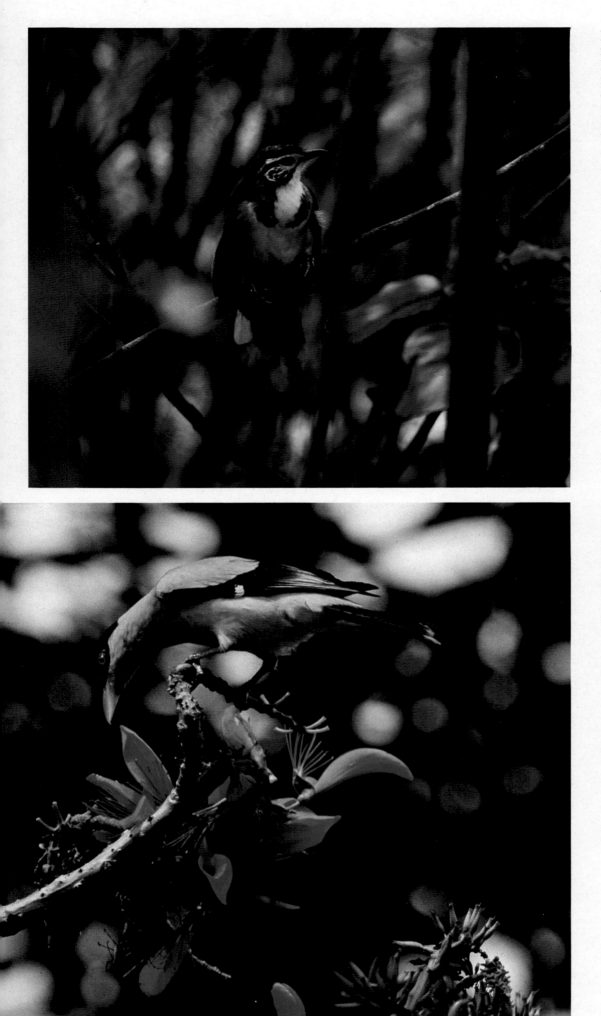

known as headhunters. But this never had any crucial impact on the large island. It was only with the arrival of Europeans that nature receded step by step. Today, gigantic pruning saws are slicing their way into the tropical rain forest, for lumber is the island's most important export item. Borneo is particularly favored because of its closeness to the equator. The monsoon comes twice a year, once from the northwest, a second time from the south.

Borneo's many large rivers empty huge amounts of water into the ocean, but the sky opens its sluices every day. Storms sweep over the jungle in the afternoon. The forests on the mountain flanks vanish in the fog—plunging into the sea of clouds. This gives the entire island a constant hothouse climate.

Like other rain forests, the Bornean jungle is constructed on multi-

Orchids dazzle with the fantastic magic of their blossoms. New species are discovered all the time.

ple levels. Mushrooms, mosses, and ferns thrive at the bottom. The next level is filled with bushes and young trees. At the top are the crowns of jungle trees, one hundred seventy feet high. The tangle of branches is interwoven not only with lianas, but also with epiphytes—communities of ferns and orchids of enchantingly magnificent colors. At heights of fifty feet and more, they live on light and air—and on the fog of the rain forest. So far, naturalists have discovered seventy-two species of orchids, but they surmise that hundreds of unknown species are proliferating here.

Borneo is not just an orchid paradise, it also offers ideal conditions for carnivorous plants. The pitcher plants, of which sixty-seven species have developed in the jungle island, capture their victims in a cunning way. Their pitcherlike or kettlelike

▶

When the plants have usurped a place in the sun, it may take another hundred years for the next tree to reach the light.

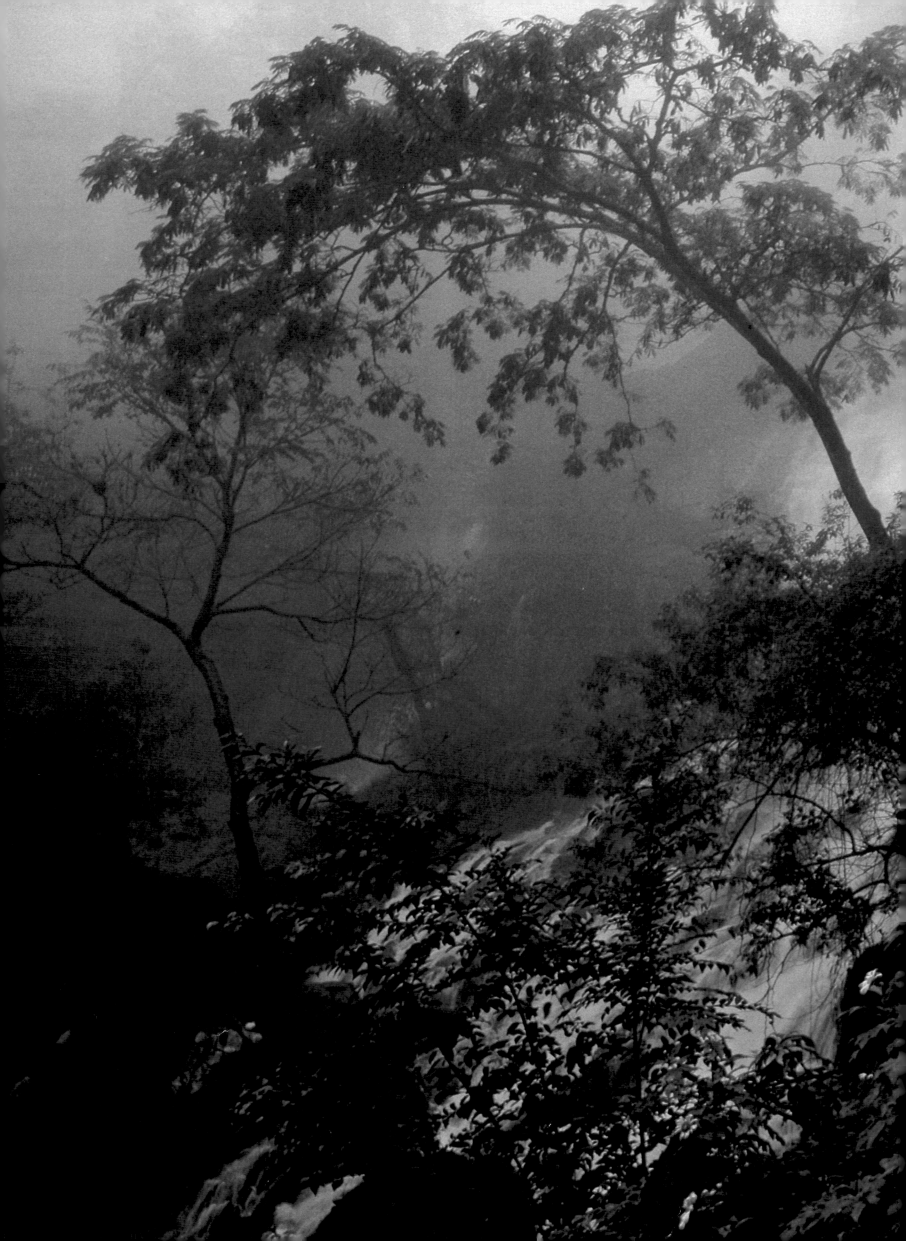

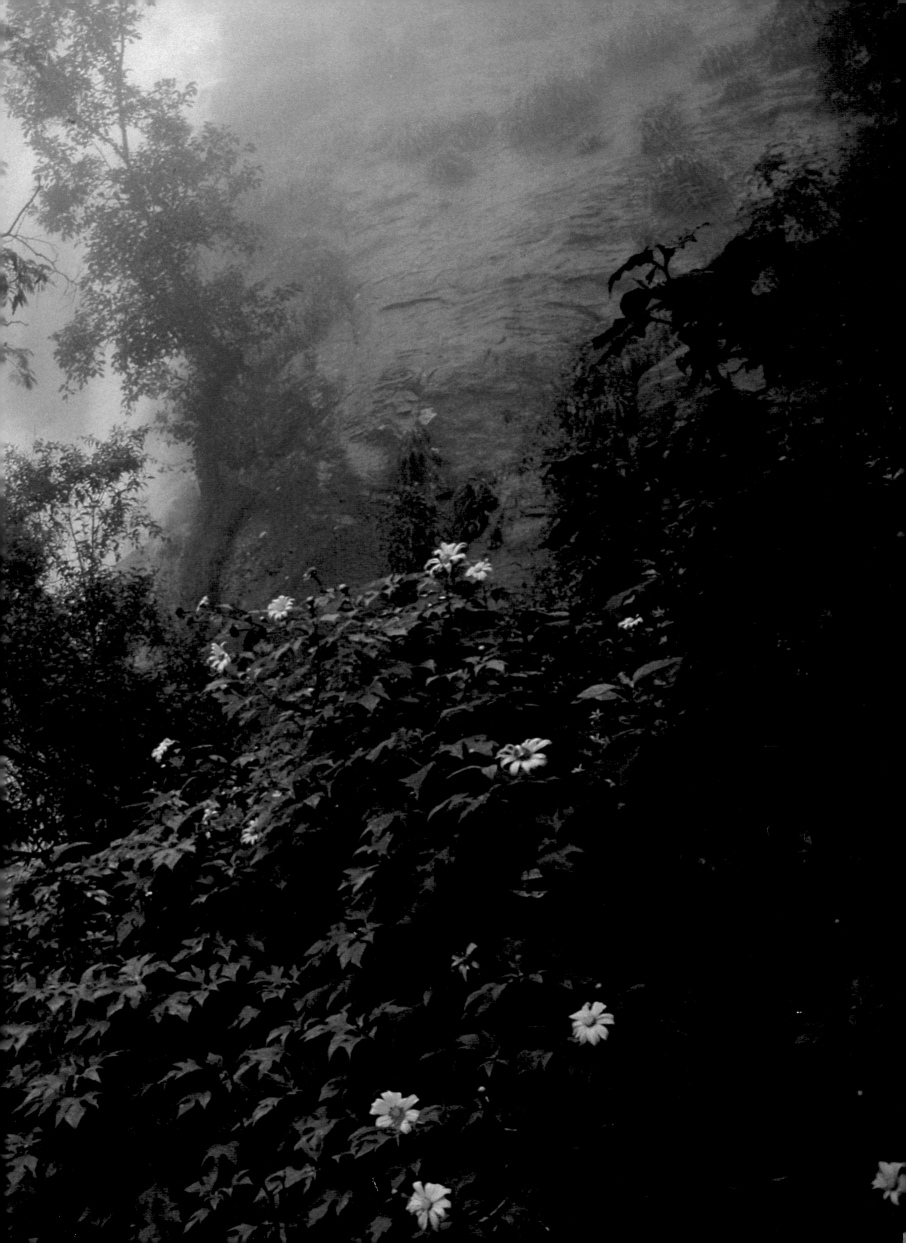

blossoms are filled with a corrosive digestive fluid. Lured by nectar glands on the upper edge, insects climb voluntarily into the blossom, where the smooth edge quickly spells their doom. Unable to hold on, they drop into the fluid. There, the plant "digests" them. The protein of the flies, beetles, butterflies, and bees, which contains minerals and nitrogen, makes up for the plant's lack of contact with the ground. Another epiphyte has a nodule with a labyrinth of corridors, where ants set up housekeeping. Since ants are clean creatures, they send their refuse into special dead ends. The roots of the plant run through these "cloacae" and "garbage dumps." In this way, the plant has access to nitrogen and vital salts, even though it is far from the ground. Indeed, the ants are also useful in destroying caterpillars and other pests and parasites.

Other ants, like the tree ant, build nests in between the leaves by weaving many leaves together. They bridge the gaps by teamwork: A couple of ants form live bridges as they climb over one another and so are able to get to remote leaves for their nests. Finally, they use a trick to join the leaf edges. They employ their silk-spinning larvae as small "weaver shuttles."

Special attractions in the jungle are the flying lizards, flying frogs, and flying snakes, all of which prac-

Bornean flying snakes parachute downward on a cushion of air. Lizards sail from tree to tree.

tice free falls from the heights—something seen nowhere else on the globe. And they do not do this merely to flee. The Bornean flying snake, three feet long, glides from high branches, changing its round body into a flat band. On its underside, it draws in two bulges, in which an air cushion emerges. It can sail

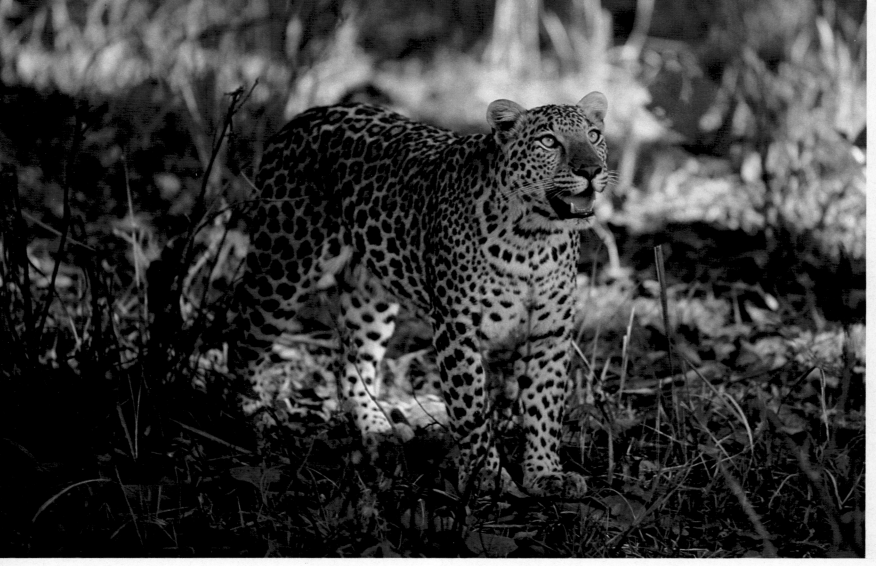

Hunters and the hunted in the jungle

Leopards (*left* and *below left*) are the feared enemies of the gibbon (*below right*). These skillful hunters will climb any tree, and can get all the way to the top. However, the gibbon is a superior gymnast, and is able to use its tail as a fifth hand. Only weak or careless gibbons are caught by the spotted cats.

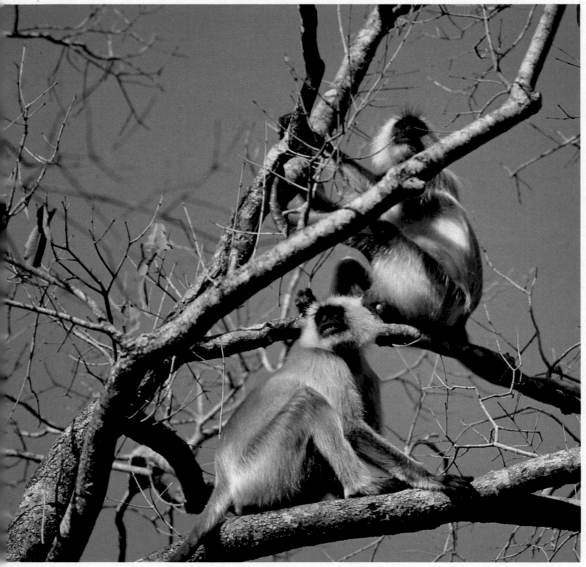

into the underbrush at a rapid clip without injury.

While the snake can fly only short distances, the flying dragon (or flying lizard) soars from tree to tree. An agamid, the flying dragon hangs head down from branches, waiting for ants, its chief food. When these lizards fly, they spread not only a collar but also winglike folds of skin on the sides of their bodies. These "sails" have red, blue, or yellow spots, unlike the camouflage coloring of the agamids. Only the males can fly; the females have to climb down. However, they descend only to lay eggs.

The fringed (or flying) gecko leaps from a tree only if escaping. It has flying membranes between its toes as

A flying frog has membranes instead of webs between its toes. Its eggs stick to leaves.

well as stiff edges to the skin on its head, trunk, and tail. Before it leaps, these edges spread out to provide buoyancy for the falling animal.

The flying frog likewise has membranes instead of webs between its toes. This tree-dweller no longer spawns in water but now lays its eggs high in the branches of the gigantic jungle trees. The female wraps the eggs in a protein mass that she beats into foam with her hind legs. The sticky package is then pasted to leaves.

There is a mammal that has also developed into a perfect flyer: the flying lemur. The size of a cat, this animal has an elastic flying membrane, which extends on both sides from the chin to the tip of the tail. When the lemur leaps, it only has to spread its legs in order to become a triangular "kite," gliding and sailing distances of up to 450 feet. Flying

Primates are the most highly developed mammals. Twenty-one species live in Borneo!

membranes between its toes are of great help. These lemurs also hang upside down from branches. Like bats and marsupials, they build no nests; instead, they carry their children around in their flying membranes.

The flying squirrel is also a skillful glider. Only its legs are equipped with flying membranes, and its tail is used for steering. However, in order

to use this effortless form of locomotion, these animals must first scale a high tree.

Unique in the fauna of Borneo is the number of primate apes that have developed to the point where scientists regard them as the closest relatives of man. The typical features of primates include large brains, forward-pointing eyes, prehensile hands, and flattened fingernails. Twenty-one species of primates live in Borneo, including the tarsier, the loris, the tree shrew (or tupi), the gibbon, ape, macaque, the nose ape (or proboscis monkey) and the orangutan.

This last animal is the Asiatic counterpart of the African anthro-

Orangutans are loners. They look for nutritious fruit in the branches of jungle trees.

poids. Unlike the gorilla or chimpanzee, however, the orangutan lives exclusively in the trees and predominantly alone. Only the females wander through the jungle with one or two children. Orangutans are peaceful herbivores, though this does not prevent them from occasionally robbing a bird's nest, an anthill, or a beehive. Cautiously balancing on the branches, the orangutan moves from tree to tree—always

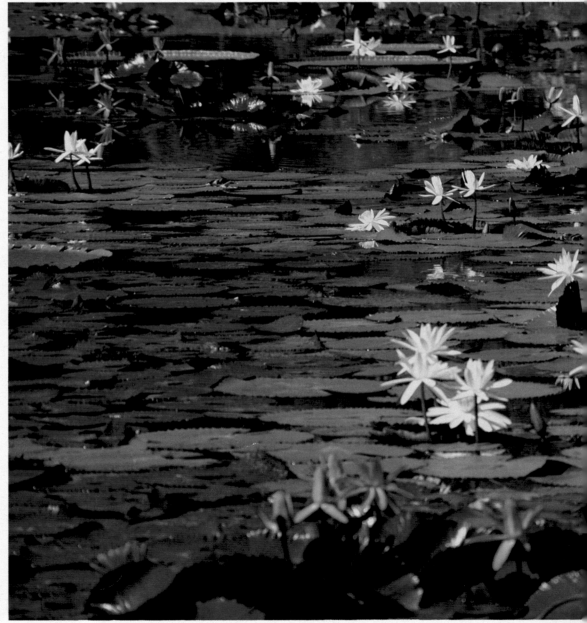

Magnificently hued symbols of life

Buddhists regard the lotus (*top right*) as a radiant example of the beauty of life. In the rivers' branches, which have no currents, and in the lakes, the water lilies extend their blossoms over the water as though at a secret command (*left*).

in quest of wild fruit. Although rich in insects, the jungle is not a copious pantry for fruit gatherers. In Borneo, the trees can bear fruit only in accordance with the monsoon seasons. Hence, the production of blossoms and fruit is not always in a steady sequence, and the apes have to look farther afield.

However, they do not leap from tree to tree but use springy bounces, flexible saplings, or vines to swing from one feeding site to the next. Only the young animals can frolic about in the branches, using both hands and feet. Fully grown orangutans are very powerful. Nevertheless, there are few serious fights

The orangutan is rigorously protected. Nevertheless, many of its babies are kept as pets.

among them, even when it comes to territorial arguments. They prefer avoiding human beings, the sole threat to the orangutan.

A century ago, there were supposedly five hundred thousand orangutans here. Today, at best five thousand to seven thousand of them live in the rain forests of Sumatra and Borneo. Although these close relatives of man are under absolute protection, mothers are still killed when

371

men try to rob them of their trusting young. In Malaysia and Indonesia, the offspring are very popular as pets. The island natives likewise keep orangutans in their huts as live toys for their children. On a jungle island off the coast, Barbara Harrison of the Sarawak Museum in Kuching, established a refuge for such apes that are injured by civilization. These creatures are slowly reaccustomed to their natural surroundings, especially the task of hunting for food.

The gibbon is far more mobile, but smaller and less intelligent. It lives in the same territories as the orangutan and also feeds on fruit. With its extremely long arms, it leaps and pulls itself along the branches hand over hand. The gibbon, too, has no tail, which does not prevent it from crashing through the treetops in truly acrobatic leaps. They roam the woods in families, and their daily group behavior is human in many respects. Not only

do the children fight and scuffle, but so do the parents. A gibbon family has its territory, and this creature has developed a poignant ceremony to protect a territory against jealous

Gibbons start the day by screaming and singing; their concert resounds throughout the jungle.

neighbors or bachelors. The gibbon's day is begun by the male, who emits a whimpering and lamenting howl, sounding almost as if it came from a bird. After the first breakfast, the female joins in with a vengeance, then the young successively take up the noisy staccato. The father and the children allow the female to conclude the song. Longer passages are followed by short cries at a higher and higher pitch, until a concert volume is reached. The refrain

Life under the green, leafy roof can be dangerous.

The green tree snake lies in wait with its head in a defensive position (*above*). The slender loris (*left*) is a skillful hunter. With its parallel eyes and its developed prehensile hands, it is a primate—a relative of man.

is then supported by the rest of the family—as loudly as possibly.

Their mobility makes the gibbons skillful gatherers, for whom the best is just good enough. But their daily schedule is strenuous. In the early afternoon, they withdraw to the tree branches in order to tend to their bodies and rest.

The exact opposite of the lively gibbon is the loris. Belonging to the lemur family, lorises are amusing animals, characterized by their extremely slow and deliberate movements which enable them to surprise insects or birds, which cannot notice the approaching danger. The offspring of this little clown resemble toy animals rather than wild jungle beasts. With their huge frontal eyes, lorises can see like human beings. Their mouths always seem to be grinning. A further trait classifies them as primates: They bear only

▶

Fully grown orangutans have faces framed with bulges of fat. These bulges serve to store food.

If the fish gets fed up with the sea . . .

. . . it goes ashore. Mudskippers even climb trees. Their gill covers can store water.

A contest in forms and colors

High in the trees, the most beautiful flowers on earth— the orchids—open their buds. Vanda coertuea (*far left*) and Dneder super-bum (*left*) are unde-manding plants. To-gether with other epiphytes, they form a virtual forest of blossoms within the jungle (*below*).

one child, which clings to its mother's fur and is carried around.

Man's other relatives in Borneo are not always as lovely as the gib-bon or the loris. The tarsier is down-right ugly. Barely six inches long and equipped with a tufted tail, this primate seems to be all eyes. In pro-portion to the animal's overall size, his eyes are 150 times larger than those of a human being. The extra thin ears are also huge. A creature with such sharp senses catches rich prey among the smallest animals and insects. Its peculiar appearance gave the tarsier a bad reputation among the natives, who considered it bad luck to run into one.

Tarsiers used to range over North America and Europe sixty million years ago. However, the tarsier in Borneo has not changed in the least. Its legs, with which it pushes its way

back from trees, resemble those of its forebears exactly. When it leaps, it makes a 180° turn in order to land on its legs. In this action, the long tail helps the body to balance itself.

Toward the ocean, the jungle changes into an impenetrable man-grove thicket. Lapped at by brackish water at high tide, this labyrinth of roots turns into a true never-never land at low tide. The stiltlike roots of the mangroves function like a sieve

The mudskipper lives both on land and in the water.

in the river and ocean water. At the same time, the root tangle serves as a habitat for a giant army of fiddler crabs. Instead of a pair of nippers, the male crab has only one nipper— on either the right or the left arm. In contrast to the female, the male can thus eat with only one hand, as it were. Otherwise, the enormous or-ange nipper serves to put on a show during the selection of mates: The male waves the nipper around force-fully in front of the female.

The mangrove swamp houses a strange amphibian. It is a fish, yet it is capable of living on land and even climbing trees: the mudskipper. This creature lies in water like a hippo-potamus, with only its eyes peering out. It has the ability to store water in its gills, and this supply enables the mudskipper to seek food ashore for minutes at a time or to climb up a mangrove sprout. At high tide, scores of mudskippers come out of the water and cling to the smooth tree trunks with disk-shaped hold-fasts that have developed from chest fins.

►

Where the rain del-uges the earth every day, the waterfowl live in paradise. The saurus crane does not have to hunt prey for a long time; the reedy shore is teeming with frogs.

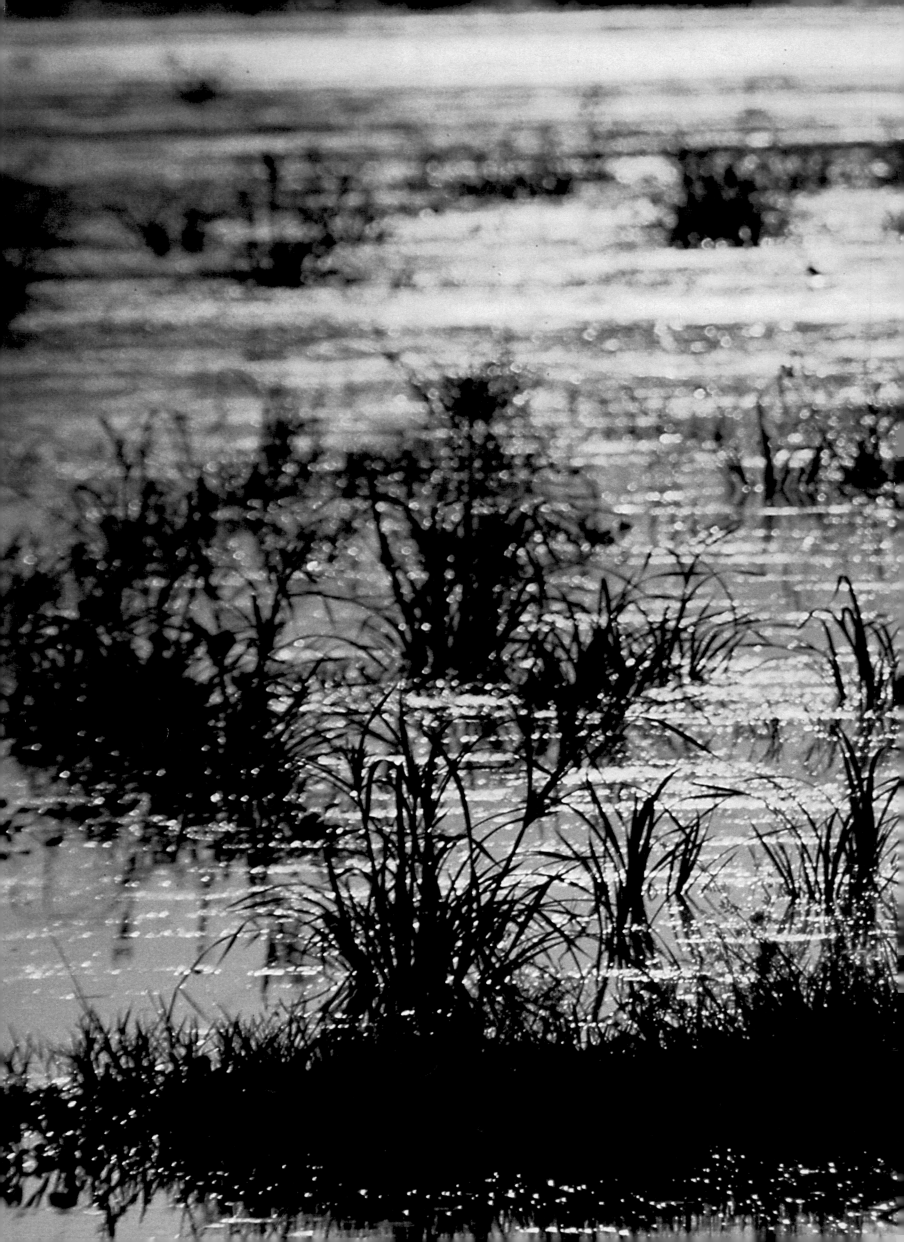

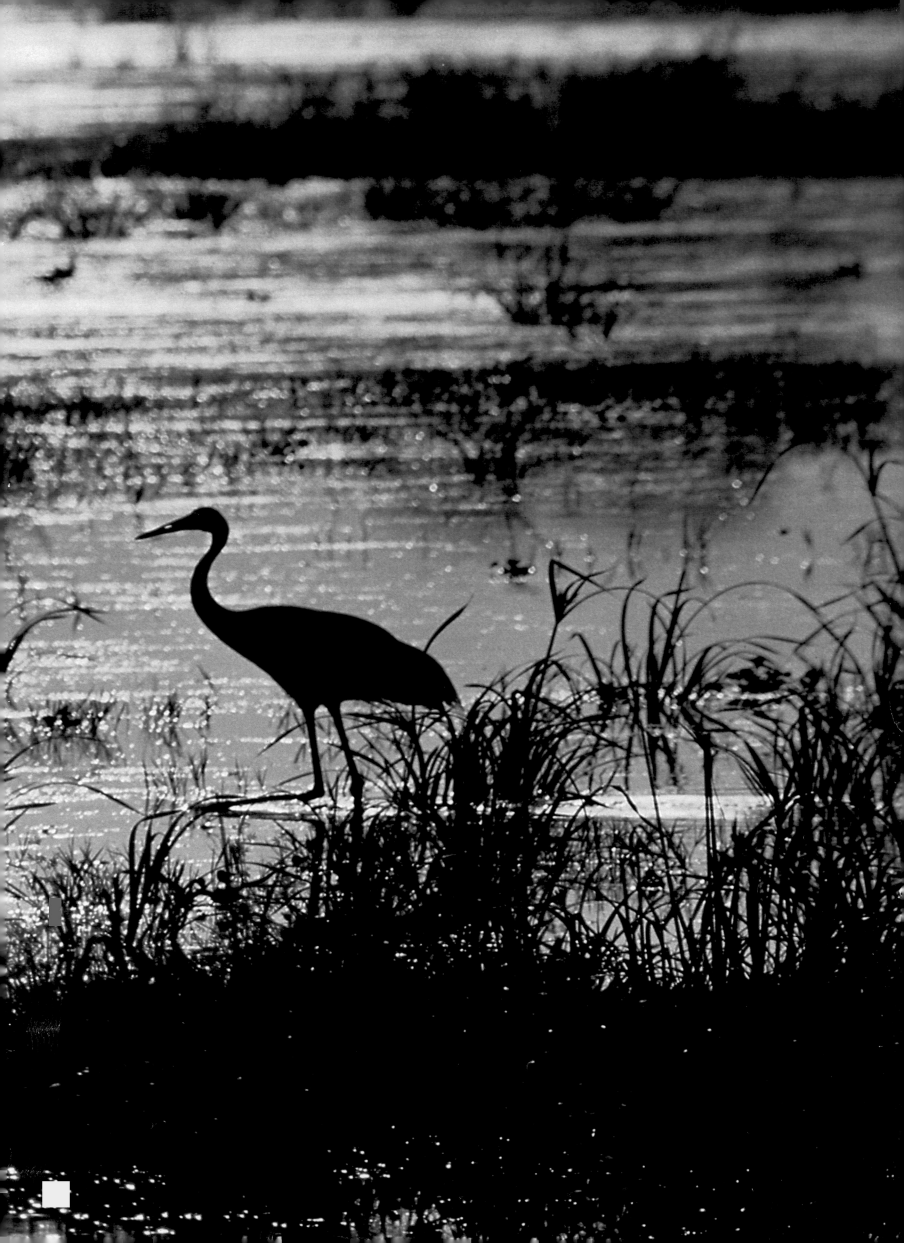

Southeast Asia is the home of the tiger.

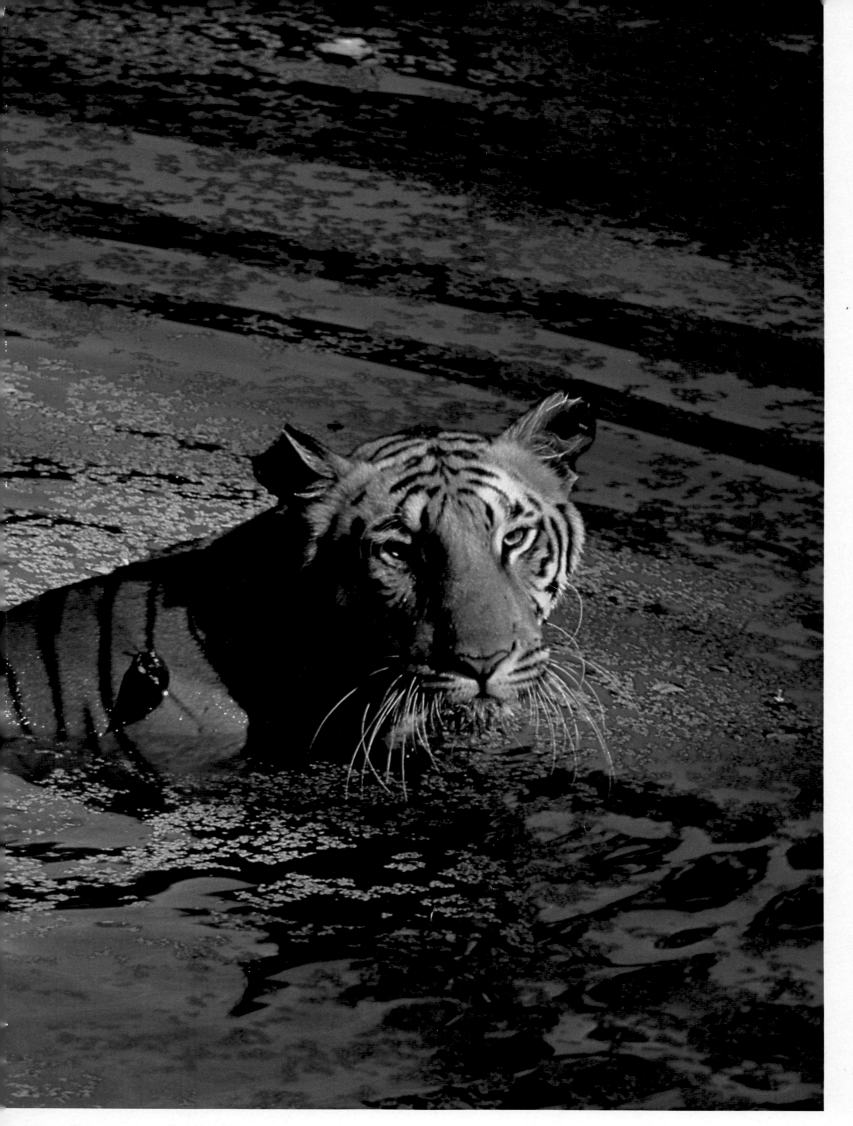

Not all cats are water-shy.
If the tiger is after tasty prey, it will leap into the water.

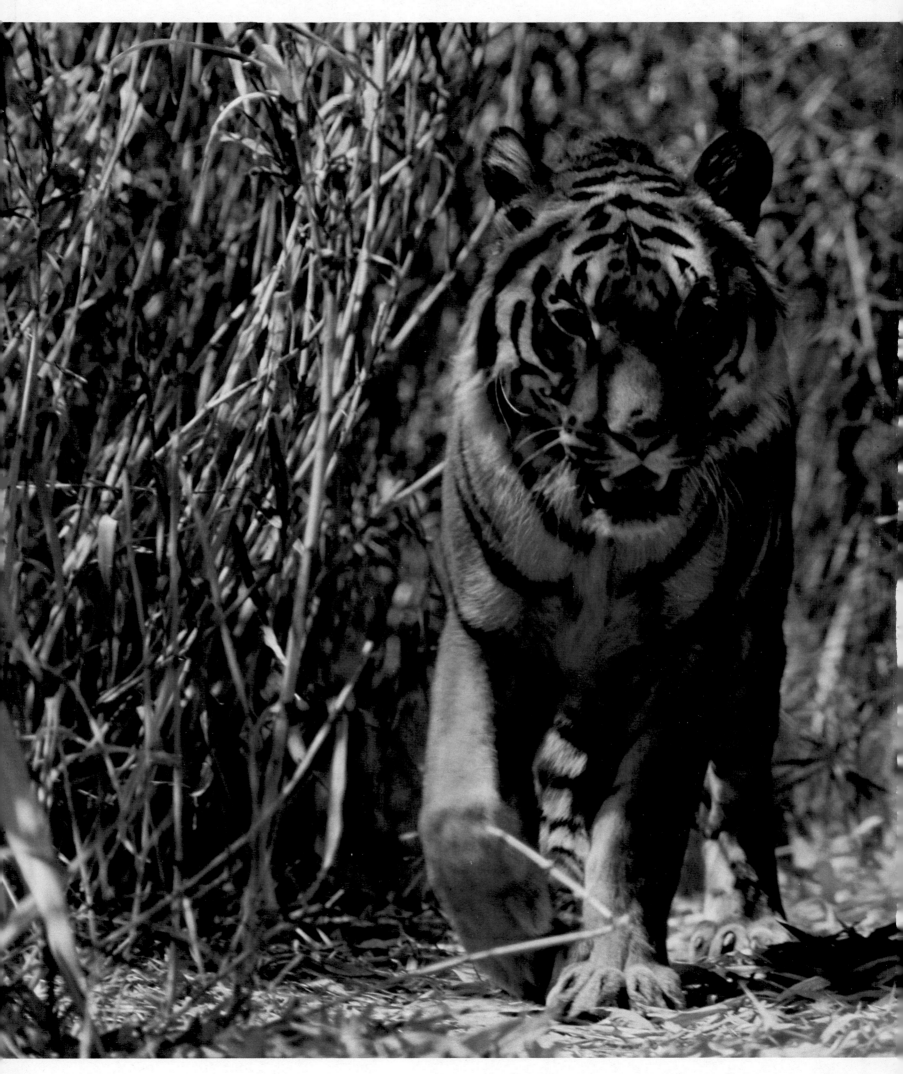

*Evening in the jungle: some animals are sated;
others are driven to hunt by their hunger.*

The tiger prefers to sneak up on its prey from under cover (*left*).
Wood storks stand on the shore of a lake, their craws filled with food.

AUST

RALIA

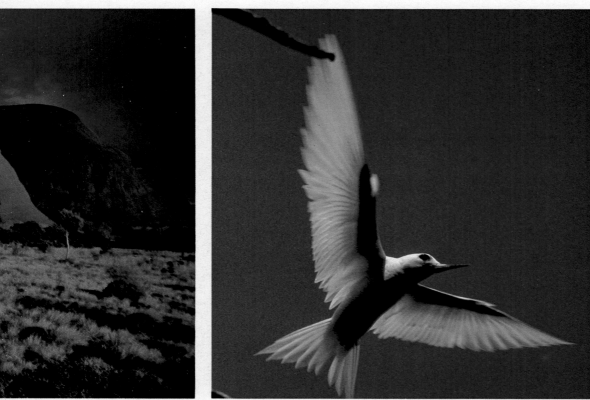

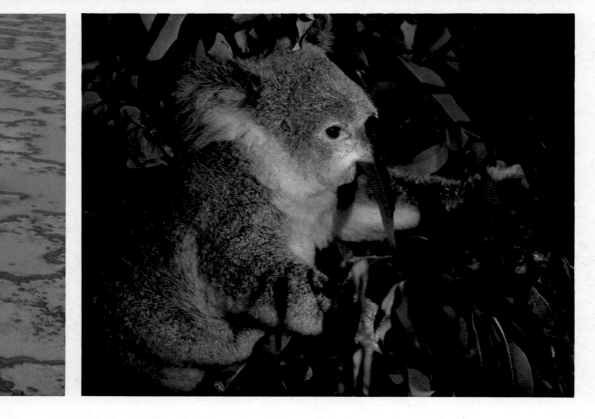

A continent full of curiosities, its fauna dates from the distant biological past of our planet.

The Continent

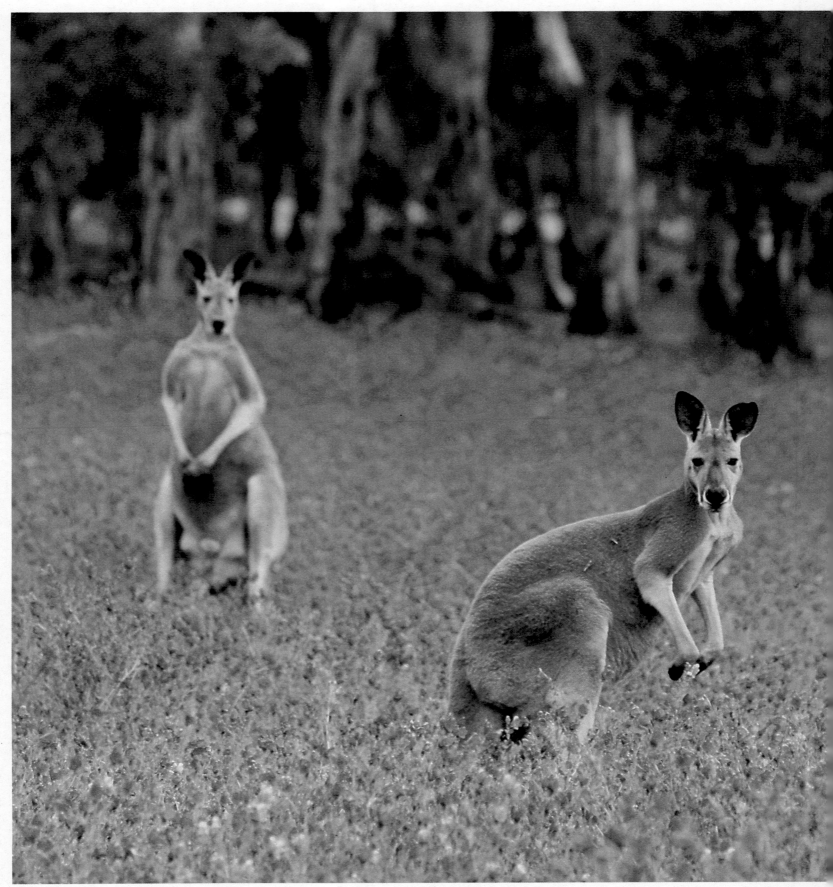

The Australian Bush: of Kangaroos

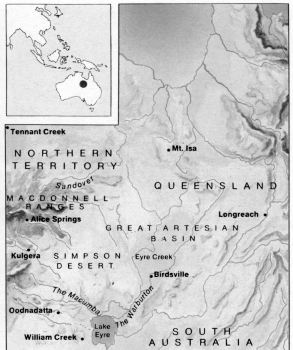

Australia was separated from the rest of the world fifty million years ago.

In Australia, creatures that have no kin on any other continent—aside from minor exceptions in South America—have survived.

Two centuries ago, English settlers reaching Australia were astonished to find the fauna of this island continent completely different from that of their homeland. The emu, a giant bird, could not fly. The swans were black. And nearly all the mammals carried their young in an abdominal pouch. Australia's native mammals are marsupials. They include the red kangaroo, the great gray kangaroo, and the tiny wombat. Millions of years ago, the entire globe was populated with marsupials until, in a later era, the land bridge between Australia and southeast Asia sank into the ocean. While other animals continued their development and adaptation on the other continents, the marsupials became extinct, surviving only in Australia.

Australia is often called the land of living fossils. The fact that an animal such as the marsupial could survive here is most likely due to their peculiar way of procreating. The kangaroo offspring spends only thirty or forty days in the womb, leaving it as an embryo, a naked "worm" less than one inch long. Blind and awkward, it creeps through the mother's peritoneum, landing safely in the pouch. There, it attaches itself to a teat, from which it can be removed only by force.

Protected by the pouch, the embryo develops into a lively youngster called a joey. It remains in the pouch for about six months, during which period it assumes the typical kangaroo shape. By the time it stretches its head out of the pouch for its first look around, it may weigh between four and eight pounds. Henceforth, it lives alternately in and out of the pouch, either nibbling grass on its own or sucking its mother's breast.

When danger threatens, the baby kangaroo simply jumps into its mother's pouch head first.

When confronted by danger, it leaps headlong into the protective pouch, turns around, and lets its legs dangle out. This allows a large joey to hold tight while its mother escapes with powerful leaps.

The great kangaroos can take forty feet leaps and jump ten feet in the air when fleeing. Such tremendous leaps are made possible by their large, powerful hind legs. When the kangaroo moves more slowly, especially when seeking food, it appears to move on three hind legs: The very muscular tail pushes the body forward at every step.

The red kangaroo and the great gray kangaroo tend to live in large herds and love to socialize. During the mating season, the males wage grotesque fights to establish a hierarchy. They hop around with one another, tall and upright, first shadowboxing, then landing a solid punch at the right moment.

One of Australia's most amusing creatures is the koala bear, the model for the teddy bear. Zoologically, this marsupial has nothing to do with the bear family. Koalas are perfectly adapted to life in the trees and they effortlessly scale high trunks and leap from branch to branch, as skillfully as monkeys. Like most marsupials, koalas are nocturnal, often sleeping through the heat of the day in the fork of a branch with their backs against the trunk.

Unlike the kangaroo, the koala young spends only a short period in its mother's pouch, after which the

An undisturbed paradise until 150 years ago

The koala (*below right*) and the countless species of kangaroo—especially the wallaby (*right*)—were severely victimized. This is true in part even today. Only the laughing jackass, a species of kingfisher, has managed to keep up its numbers.

mother carries it on her back or in her arms. During climbing "outings," the young gets to know the best feeding sites. Of the more than four hundred species of eucalyptus, the koalas eat the leaves of only ten. This makes it hard to keep these

Koalas, the amusing inhabitants of the eucalyptus forests, carry their young piggyback.

popular animals in a zoo, for huge amounts of fresh eucalyptus leaves must be brought to them every day.

The thick woolly fur of the koala smells of eucalyptus. No vermin can survive in it. Koalas can do without water, since they get the necessary moisture from their leafy food. In the language of the natives, koala means "I do not drink."

Until forty years ago, the harmless and completely defenseless koalas

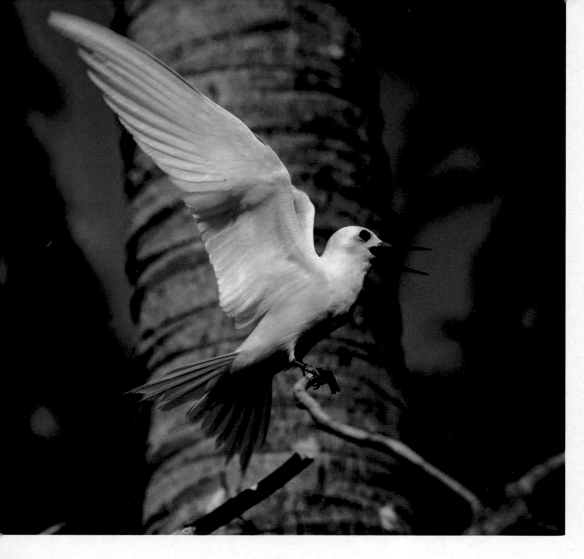

Snow-white and fantastically beautiful

Unlike other terns, the fairy tern simply lays its eggs on the bare forks of branches, never building a solid nest. Sometimes, the nesting site is so small that the bird cannot really perch; it has to brood in a half crouch.

were ruthlessly hunted down for their beautiful fur. During the first quarter of this century, an estimated ten million koalas were killed; many of these ended up in European nurseries as teddy bears. Today, Australian laws guarantee their protection.

Of all the amazing creatures in Australia, none has astonished people more than the platypus. When the first stuffed specimens arrived in Europe, they were regarded as skillful syntheses of different animals. A furry creature with a duck's bill was simply inconceivable. The platypus's tail is like a beaver's, but densely hirsute instead of scaled. Its front feet are similar to those of the Old World otter, but a lot longer and with much longer and wider webs, which are excellent for paddling. The relatively soft bill is more flexible than a duck's; one of its functions is to help the platypus burrow through the muddy bottoms of brooks, rivers, and ponds. Although nimble on land, the platypus goes ashore only to reach different feeding sites.

The platypus lives in the waters of eastern Australia, from subtropical Queensland to the island of Tasmania. It combines the essential features of a bird, a mammal, and a reptile. The female lays eggs, hatches them in a nesting hole, and feeds mother's milk to her young—though not through lactary glands. Instead, the children get the vital milk through her skin. As a further peculiarity, the platypus has the heart of a mammal but the reproductive organs of a reptile. The

A beak like a bird, a heart like a mammal, and reproductive organs like a reptile

urine, the excrement, and the male semen or the female's offspring exit through the same aperture. The platypus is thus one of the most primordial mammals, the so-called monotremes.

The bush zone of Australia is inhabited by bizarre reptiles. For example, many peculiar features are united in the frilled lizard. This dangerous-looking, but quite harmless creature has a gigantic collar. When erect, the collar commands respect and is meant to frighten off enemies and rivals. Territorial fights often take place in the presence of a female. The winner then struts around the female. If she hurries away, the

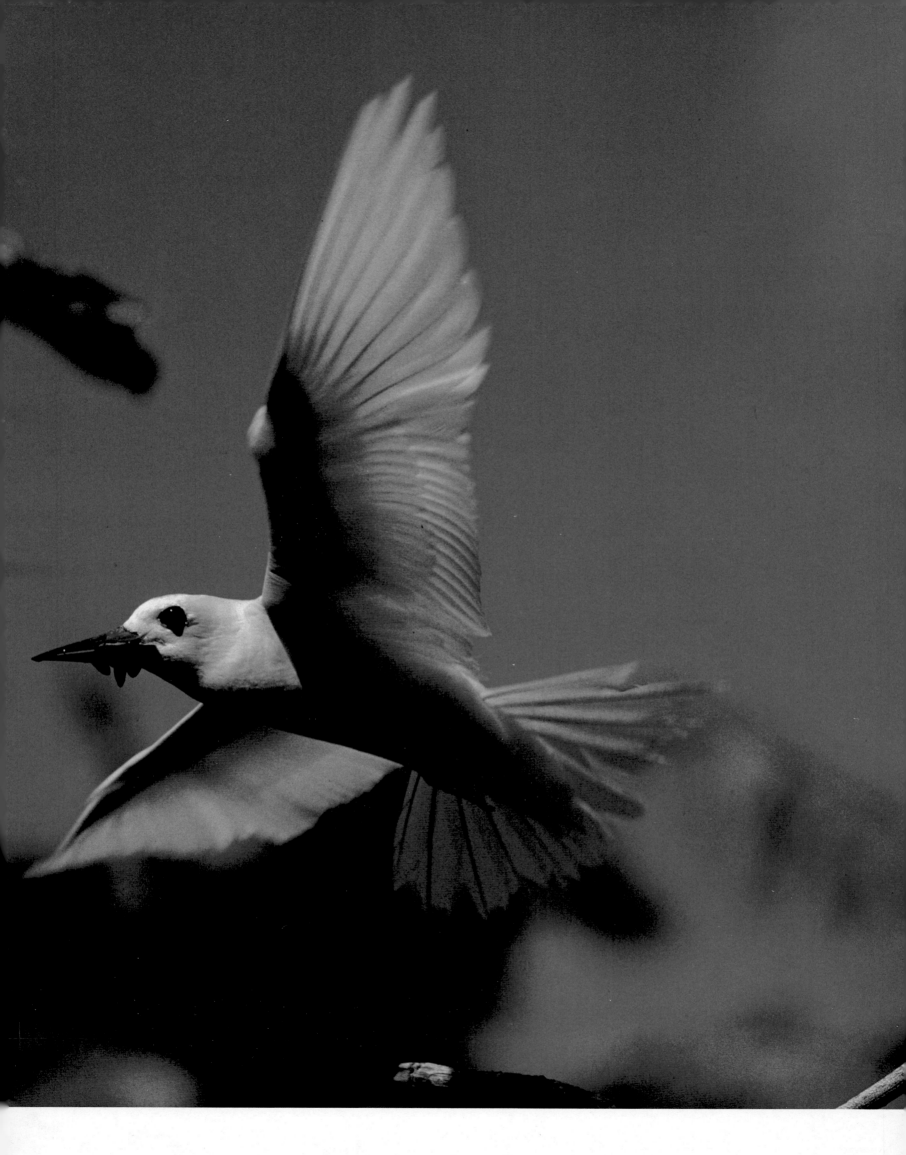

male follows her. The faster he runs, the higher he gets up on his hind legs. Soon the little dragon is hurrying along with its upper body vertical, and with its long tail balancing its weight. Thus, it looks exactly like a miniature of the giant dinosaurs of prehistoric eras.

Equally remarkable is the occurrence of snakes in Australia. There are about 140 species, almost 80 of them more or less venomous. A few are dangerous to man, although fatal cases of snakebite are relatively infrequent. The carpet snake and one species of python are welcome sights near farms, for they wipe out mice, rats, and rabbits.

The scrub fowl heats its nest with eucalyptus leaves. The cock checks the temperature in the incubator.

The birdlife of Australia also is characterized by unusual species. One of the most striking is the emu. After the Masai ostrich, the emu is the second largest bird in the world. The emu, one of the two national animals of Australia (the other is the kangaroo), can reach the stately height of five feet. Courtship among the emus is the female's task. In mating season, the female calls for males and makes the selection from a large number. When the eggs are laid, the female has completed her job for the preservation of the species; the abandoned male has to tend the clutch alone and then take care of the young, which hatch after two months. It does this every bit as well as any bird mother! When danger threatens, the father dashes away in a well-acted flight, while the chicks hide in the grass, where their camouflage makes them virtually invisible to enemy eyes.

The wondrous birds of Australia include three turkeylike species that build vast earth constructions for their eggs. These edifices can be as high as sixteen feet and as wide as fifty. No other bird species goes to such efforts. The scrub fowl is an interesting example in this respect. At the start of the Australian spring (when winter visits the other side of the globe), this bird scrapes eucalyptus twigs and leaves into the hatching pit and then builds a high mound of sand upon it. This makes the inside warm enough for fermentation. The hen then lays an egg roughly every eight to twelve days. These are the only times that the hen

opens the incubator. Having laid her eggs, she runs away. The cock closes the incubator and shifts a mound of sand upon it. Since the heat inside must remain constant, the cock checks the temperature every time the incubator is opened. He evidently does his testing with his tongue.

Anyone having little or no acquaintance with Australia may picture the fifth continent as consisting

A bird that can do remarkable imitations of saws or trains: the lyre bird

mainly of bleak desert, bare mountains, or dry plains—but in fact, hardly a scant one-third of the land corresponds to this notion. The vegetation may be sparse in many places, but the hot outback is no Sahara. In coastal areas, where mountain ranges catch the clouds drifting in from the sea, there are vast, dense, and sometimes almost impenetrable jungles. The jungles of Victoria, near the coast, form fascinating hothouses. Their floor is covered with thick undergrowth, with splendid tree ferns looming overhead, as high as twenty-three feet—all this in the

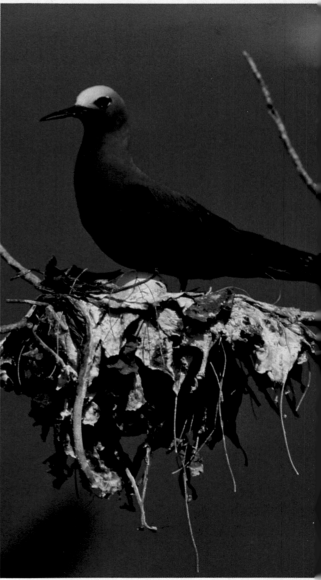

The smallest continent is a paradise for birds.

Along with marsupials, the emu (*left*) is typical of the peculiar fauna in Australia. This bird, which does not fly but runs, is almost as large as an ostrich. Rainbow lorises (*far left*) and the Woddie tern are likewise typical of the rich bird life of the Australian region.

shadow of the *Eucalyptus regnans*, the giant among the numerous eucalyptus species.

This fairy-tale forest is the home of the lyrebird. This attractive bird is the size and shape of a pheasant, but its plumage is far more splendid. The cock not only sings its own enchanting song, it can do remarkable imitations of any songs and sounds that penetrate its jungle territory. There is no bird in its vicinity that it cannot imitate flawlessly, not to mention the buzzing of a power saw, the whistling of a railroad train, or the beeping of a car.

When the first settlers discovered the lyrebird in 1798, they were so excited that they thought it must be a survivor from paradise. The long, unusually beautiful lyre-shaped tail feathers which gave it its name unfortunately turned out to be a best-selling item for hats. As a result, these birds were ruthlessly hunted for decades. For more than thirty years, however, the lyrebird has been rigorously protected throughout Australia. Today, it lives undisturbed—and not just in vast, carefully tended sanctuaries. The lyrebird is the pet bird of the entire nation, and any poacher has to pay a huge fine. This singer with the thousand voices will live on in Australia, just like the kangaroo, the koala, the platypus, and the spiny anteater.

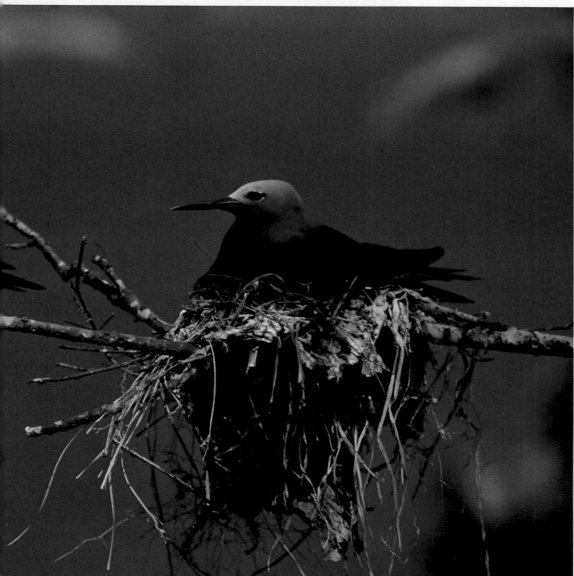

▶

Gigantic flocks of the leadbeater's cockatoo inhabit the Australian bush. If cockatoos cannot nest in trees, they look for abandoned rabbit hutches to do their brooding.

395

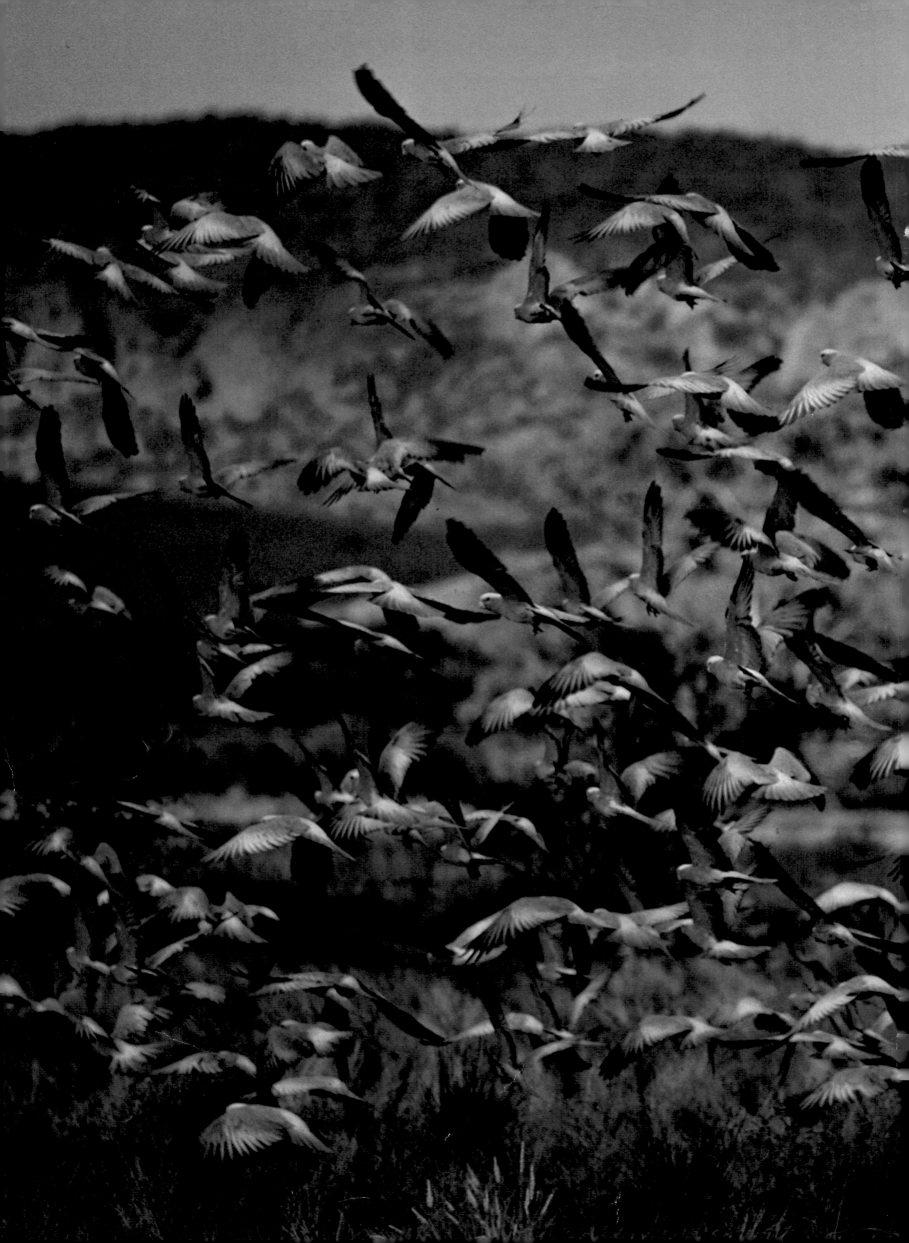

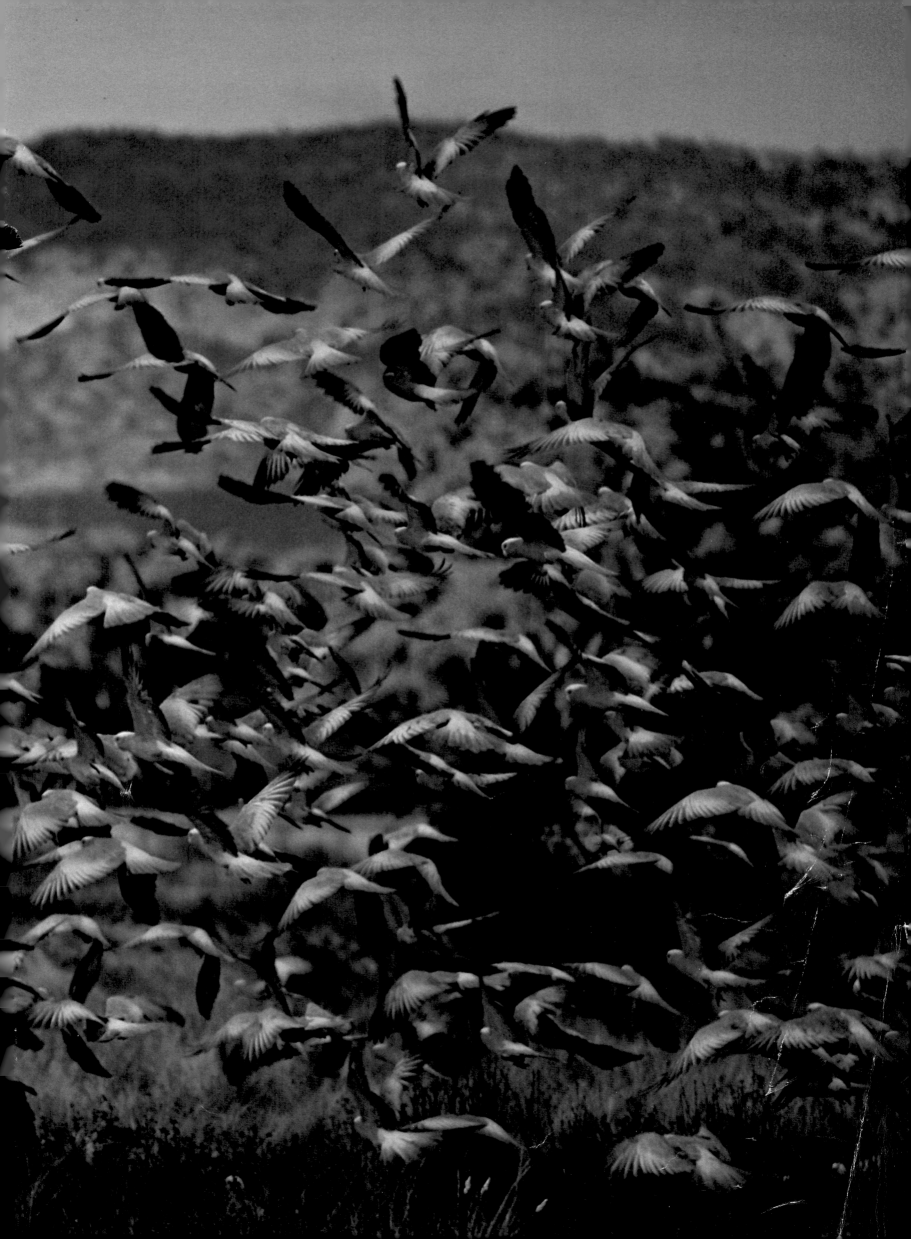

Hidden in the shade of the forest

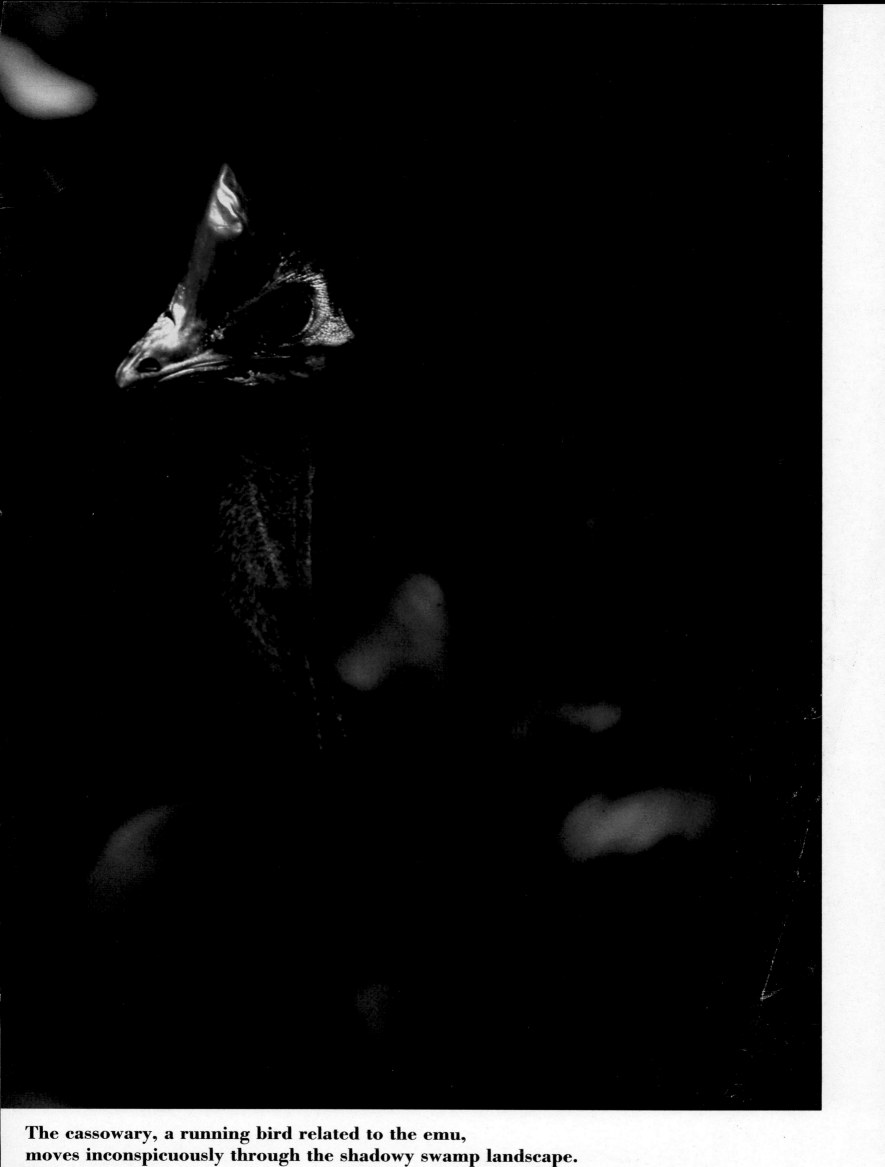

The cassowary, a running bird related to the emu,
moves inconspicuously through the shadowy swamp landscape.
Its bristly plumage shields it against the thorny undergrowth.

The 1,200-mile reef off the northeast coast
of Australia contains enough limestone to build
eight million Egyptian pyramids.

The

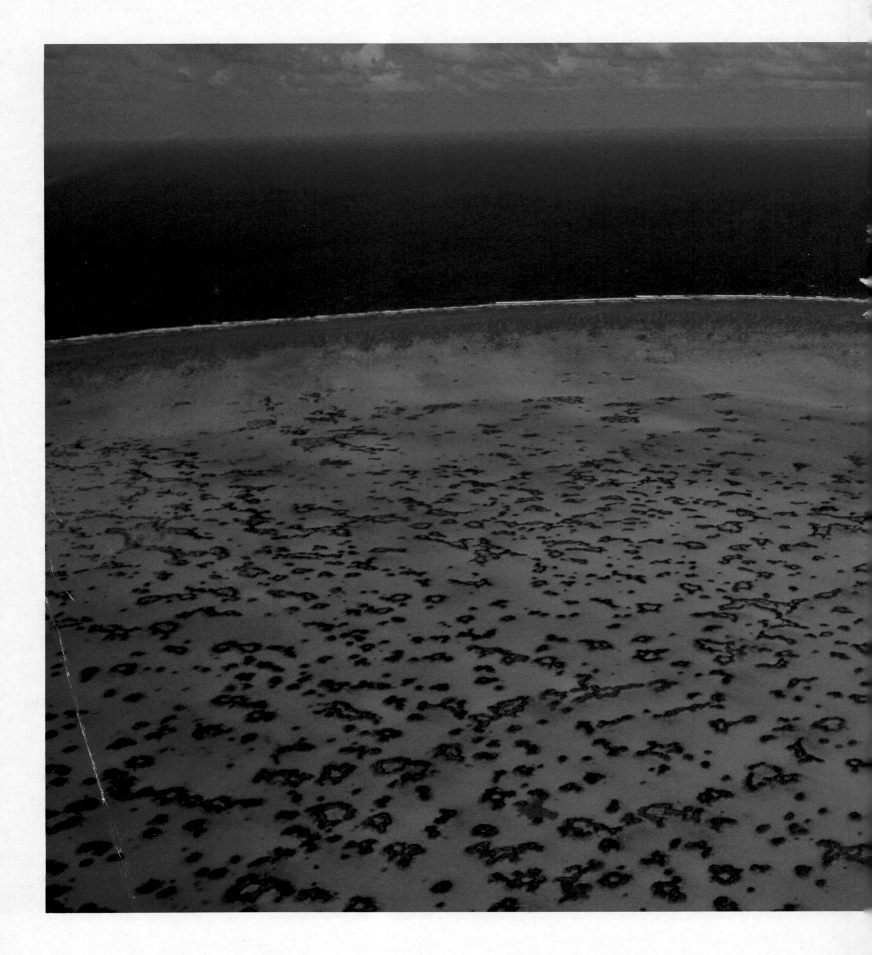

Great Barrier Reef: A Fairy Tale in Coral

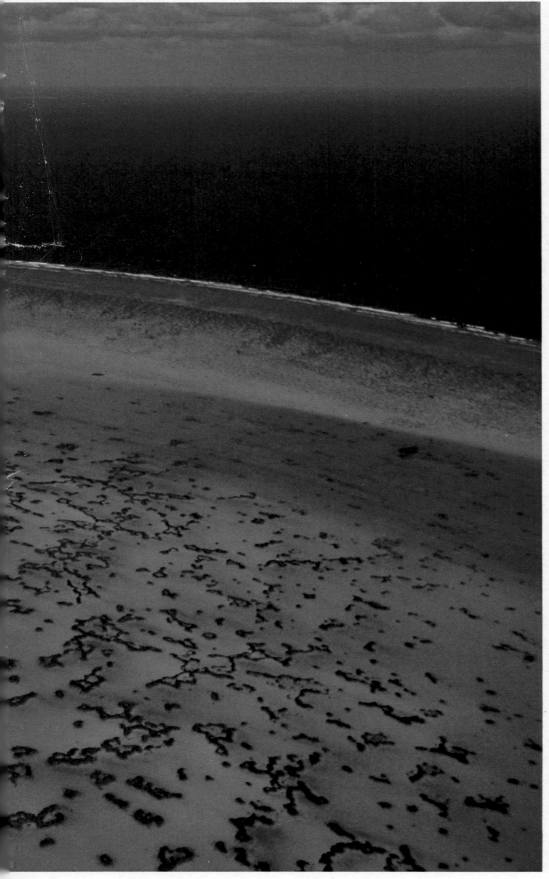

The reef atolls lie in the sea like jewels on bluish-green silk.

A realm of miracles and splendors, the reef is the largest edifice created by living creatures. In its countless grottoes and chasms, its caves and fissures, its ponds and pools, it houses a gigantic variety of familiar and unfamiliar animals: swimming, hovering, creeping, and drilling inhabitants of the ocean.

Over the course of millions of years, the coast of northeastern Australia sank into the Pacific Ocean. During that time, myriads of coral skeletons accumulated into the largest organic edifice on earth—the Great Barrier Reef, a strip 1,200 miles long and only 60 miles wide lying 170 to 560 feet beneath the turquoise waters off the Australian coast.

The architects of this gigantic wall are tiny animals, feather-light coral polyps (anthozoans). A single polyp in its limestone envelope is an extremely minute, barely visible little "stone"; in league with billions of others, however, the corals form magnificent structures similar to the great Oriental and Indian flowered carpets. Indeed, for centuries the corals were regarded as ocean flowers—albeit dangerous ones. Coral reefs were the terror of ships' pilots—and sailors. Countless clippers smashed against them and sank into the deep; even today the wrecks, recalling as they do romantic pirate adventures and the possibility of buried loot, are a powerful lure for divers and thrill-seekers.

The famous naturalist Charles Darwin put an end to the "flower" legend. During his great exploratory voyage in the South Seas, he explained the secret of the coral islands and solved the problem so

On the lime skeletons of their forebears, coral polyps build their tiny houses.

thoroughly that latter day scientists have been able to add little new information.

There are twenty-five hundred species of anthozoans, which are divided into two large groups: reef-building corals (madrepores) and deep sea corals. The coral islands, mountains, and reefs consist of the calcareous skeletons of the tiny polyps. Each animal is fastened permanently in a calcareous cup, comparable to a snail's shell, and lives in large colonies. The tiny carnivores stretch their movable tentacles out for any passing food and then wave animal plankton into their gullets. Each layer of dead corals serves to anchor the next. Thus, the coral structure climbs from stratum to stratum, level to level, slowly reaching the ocean surface. Here, the construction halts, for the polyps die above the water.

Nevertheless, there are coral atolls

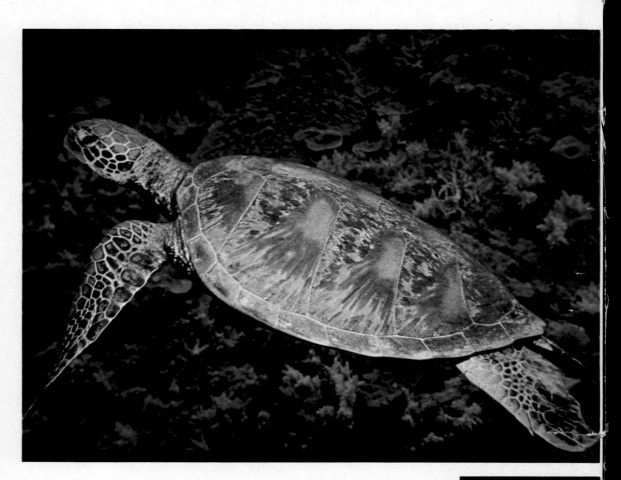

that rise above the water. Darwin managed to explain this phenomenon, too. These coral mountains did not grow beyond the water surface but were catapulted aloft by volcanic eruptions or slowly rose out of the sea because of shifts in the earth. Conversely, volcanic islands often sank, providing the perfect surface for a coral reef; hence, the South Sea atolls. Live corals settled on the steep flanks of these submerged islands, forming reefs along the coast. As the atolls submerged, faster than the corals could build, only the ring of the coral reef remained, enclosing a circular lagoon. The powerful surf smashed holes into the coral circle—

Algae, which provides the food for the polyps, makes the coral shoals grow twice as fast.

and an atoll was born. The petrified coral banks in the South Seas have been measured to depths of five thousand feet.

Darwin did not have microscopes with which to enlarge objects, so he failed to discover something that modern scientists have noted: the symbiosis of coral polyps and zoonxanthellae. The latter are one-

Fantastic colors and eccentric forms

The colorful patterns of the fish are meant to signal other members of the species: Stop! This territory is occupied! Unimpressed by this orgy of colors, an ocean turtle (*above*) rows by, its aged face as expressionless as stone.

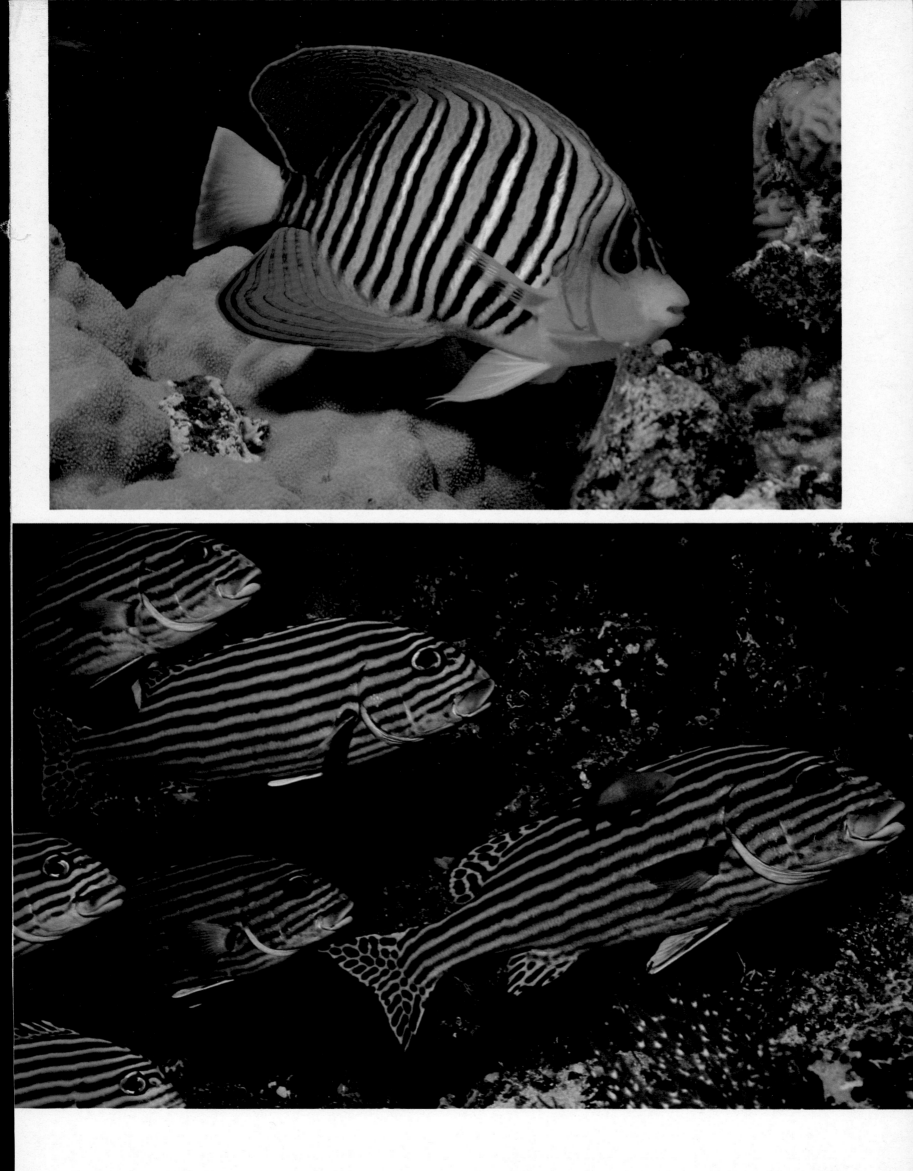

celled, spherical algae that spend their lives within the polyp. The animal cannot live without these algae, and vice versa. The polyp receives oxygen and food from the countless tiny zoonxanthellae; in return, the polyp's waste—carbon dioxide, nitrogen, phosphorus, and trace elements—feeds the algae. Freed of excess baggage, as it were, the polyp devotes all its energy to growing. It forms its skeleton with calcareous excretions of its body, similar to the way the snail forms its house. The corals reproduce asexually, by continuous forking and budding, and sexually, by producing tiny larvae.

Although each polyp is an individual animal, most of the coral species can grow only in close company with millions of other polyps. But the growth of a coral depends not only on the species but on the depth and temperature of the water. The average rate of growth for all species of reef coral is no more than half an inch per year. However, staghorn

corals can grow as much as two and a half inches per year.

There are species of massive corals, like the porites, which grow a lot more slowly. They have very small polyps, more than sixty of which can fit comfortably in one-tenth of a square inch. One hundred million polyps can perch on the surface of a coral boulder sixteen feet high and with a diameter of twenty feet!

Animals that look like flowers, the polyps stretch out their venemous tentacles mostly at night.

It is impossible to describe the variety of coral formations: they take on the shape of trees, bushes, plates, fans, disks, carnations, bird plumes, antlers, and other bizarre formations. They shimmer in every color of the rainbow. However, the splen-

The eighth wonder of the world lies under water.

Living coral colonies shimmer in countless nuances of color. Only dead corals are chalky white. Billions, even trillions of dead skeletons have erected an edifice here. The overall surface area is almost as large as that of West Germany.

didly radiant colors of the reef corals represent living creatures; dead coral colonies are nearly always gray, white, yellowish, or light pink.

The live stratum of a coral shoal is no more than a thin skin on the skeleton of dead animals. Storms break off parts of the coral boulders and roll them to the reef. In the course of time, these dumping grounds crumble into grainy coral sand. Crabs are usually the first inhabitants of the new atoll. Ocean birds settle here, and their droppings diffuse the seeds of a modest vegetation. After a few thousand years, humus soil develops, and bushes, trees, and palms begin growing. When tidal waves and typhoons destroy the flora, this growth must begin anew. The higher the atoll, the less chance of destruction.

A dive into a coral reef is one of the most exciting excursions into the animal kingdom. There is an overwhelming wealth of form and color. Schools of gaily hued fish hunt and are hunted. Sharks zoom by like torpedoes, rays flutter past like magic carpets, and the turtles are as large as kitchen tables! The blues, reds, greens, and yellows of the fish are not whims of nature; the unusual patterns and colors of the coral fish, for example, function as signals. They indicate to the competition which coral areas are already occupied. The spots, stripes, and shadings on the fish's body serve as camouflage, blurring the outlines between the fish and its surroundings.

Underwater hygiene: the cleaner fish, acting as the barracuda's toothbrush, eats parasites and leftovers.

Fish that otherwise confront one another as hunters and prey live in complete harmony here. For instance, normally the small cleaner fish is food for sea bass, barracudas, and other big fish. But here, the cleaner fish is a welcome guest which pulls out parasitic isopods and copepods from the bodies of the predatory giants. The slender cleaner fish swims into their open gills and even their yawning mouths to perform a cleaning ceremony beneficial to both; the predator is freed of parasites, and the little fish finds rich food.

There are several species of predatory fish in the reef that can be dangerous to human beings. Amateur divers, who have greatly decimated

The coral reef—a tremendous biomass of tropical seas

Spheres and stars, fronds and waving hair, honeycombs and cylinders——the wealth of forms is indescribable.

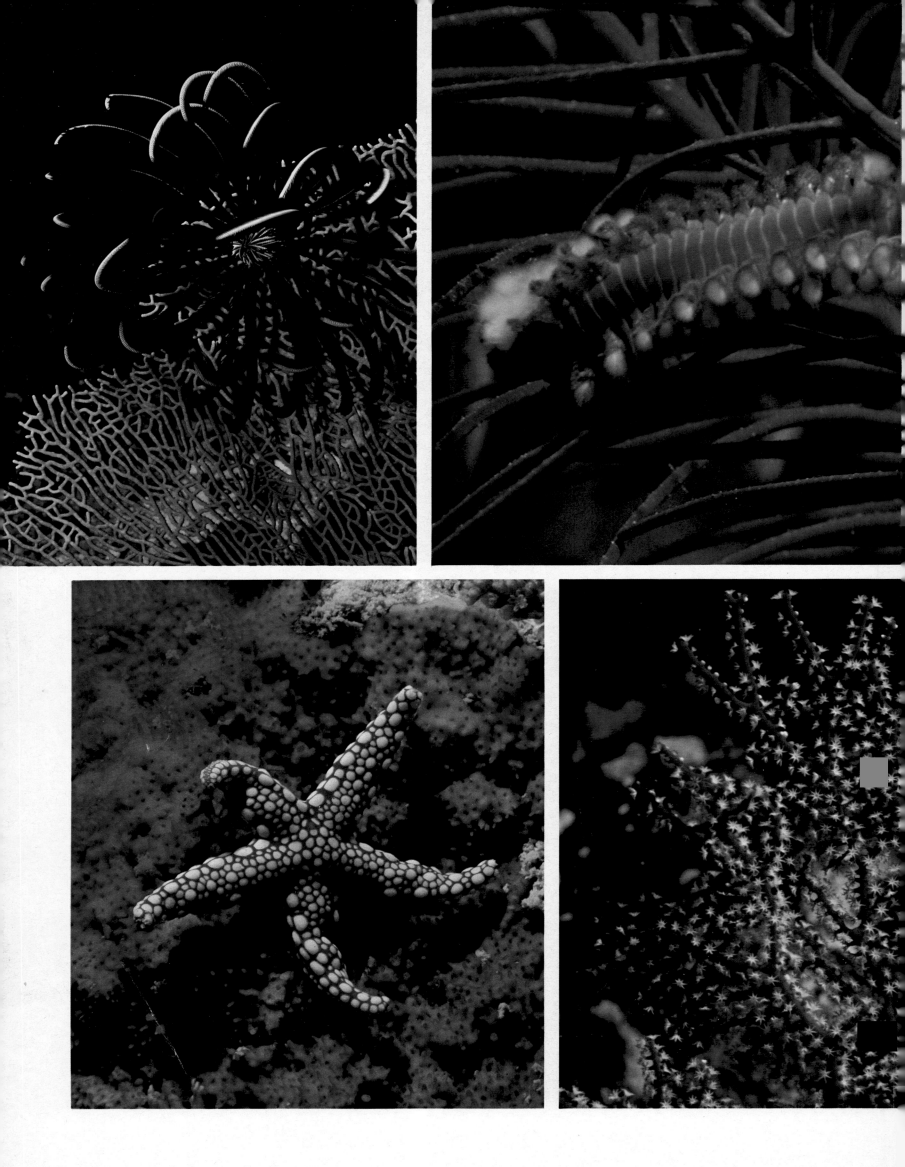

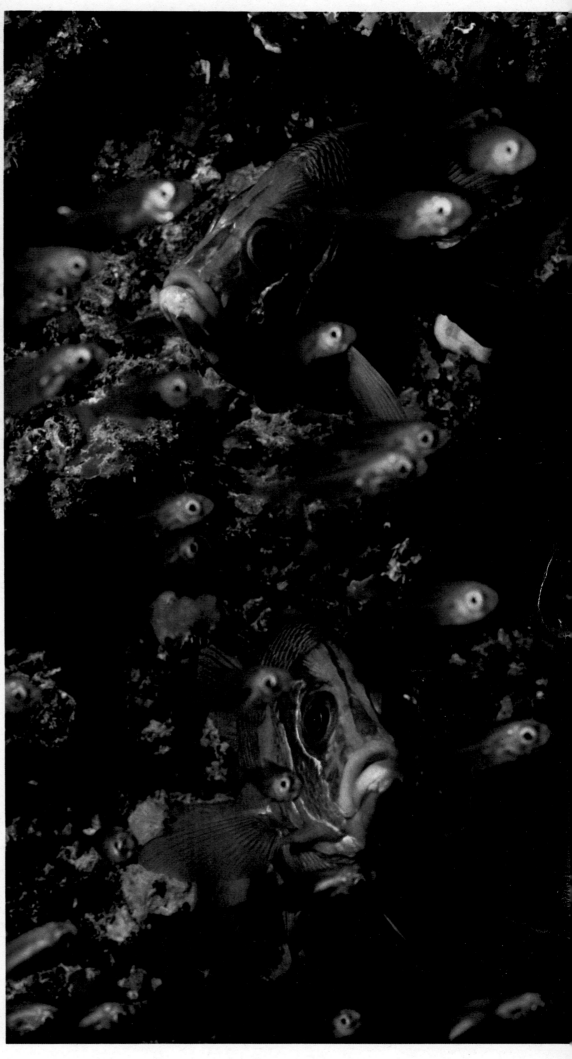

A treasure trove as rich as the Arabian Nights

Divers can experience nothing more beautiful than the silent fairy-tale world of a coral reef. There are animals that eat plankton and look like flowers and hedges of "antlers." Others form "lilac bushes," "organ pipes," and "mushrooms"—a bizarre and exotic wealth of starfish and other fish.

the fish stock of the coral world with their unbridled harpoon hunting, have plenty of stories about the predators. Encounters with sharks are frequent; there are 250 species, from the pygmy shark, barely six inches long, to the giant, sixty-foot-long whale shark. The latter, however, is a harmless plankton eater and is not dangerous. There are some ten species of shark that can be vitally dangerous to human beings. Every year, approximately three hundred people fall victim to shark attacks, but it is sheer nonsense to call these fish bloodthirsty killers.

The great barracuda is known as the pike of the sea because of its appearance and the way it hunts. Barracudas lurk along the edge of the coral reef, waiting for prey. They are almost immobile as they lie in ambush—scarcely discernible by their prey because of their fine camouflage. If a school of anchovies approaches, the barracuda shoots into their midst, snaps up a fish, and devours it on the spot. Then it quietly waits again in its ambush position until a new opportunity comes along.

Peculiar and dangerous inhabitants of the reef

Despite all its beauty and splendor, the reef is not a safe place. Along with tiger sharks and sea serpents, rays and morays, the sensitive edifice of hard animal "envelopes" is inhabited by poisonous jellyfish, snails, and mussels; hence the rule for divers: Do not touch anything!

reef is the manta ray or devilfish, a cartilaginous fish related to the shark. The span of its pectoral fins can reach fifteen to twenty-five feet. Rays, however, only look dangerous; they eat plankton and small fish.

One of the most interesting atoll visitors is the sea turtle, of which there are three species in the reef territory: the green turtle, the hawksbill, and the loggerhead. With its five-hundred-pound body, the green turtle is the largest creature on the

The green ocean turtle weighs five hundred pounds. It is the largest animal in the reef.

barrier reef. Because of its tasty meat, it used to be slaughtered in great numbers. The same fate befell the hawksbill, which was prized for its desirable and highly profitable carapace. Fortunately, Australians realized the danger of extinction; thirty years ago, they placed this animal under rigorous protection.

New research has revealed that the sea turtle lays eggs several times in the course of a laying period, burying fifty to two hundred eggs in the sand of the beach. Turtles do not practice brood care, and their young are extremely anxious to be free of the nest. As soon as their tiny flippers permit it, they kick their way through the sand of the egg pit up to the surface. Their innate sense of direction shows them the shortest path to the ocean. These are moments of utmost danger, for sea fowl and large crabs pounce on the easy prey, wolfing down the soft-shelled baby turtles, which are scarcely longer than a human finger. Only about one tenth of them manage to reach the sea, where countless predators also lie in ambush. It is assumed that only 2 or 3 percent of the young turtles make it to adulthood—and parenthood.

▶

The coral gardens shine with the splendor of an oriental rug, but only the tiny polyps living on the uppermost stratum of the lime mountain are colored.

Rays, anglers, and sea devils rest on the bottom in between the coral shoals, where they surprise small fish and prawns. The angler opens its mouth, luring its prey with a wormlike skin appendage, which waves back and forth like bait.

The moray is one of the most feared predators of the coral reef. It

The gigantic biomass in the reef also lures the tremendous tiger sharks. They are not harmless for divers.

tends to be about five feet long, but lengths of ten feet have been observed.

The sea serpent is a rather frequent denizen of the reef. This reptile, which is perfectly adapted to ocean life, has a nasal aperture on top of its snout, and a tail with flattened sides. From time to time, they have to surface in order to get some air. Sea serpents can grow to a length of six feet or more.

A fearful creature in the barrier

Index

List of Photographers

o — above
u — below

English Translation © 1981 by Franklin Watts, Inc.
All rights reserved.

Photographs © 1980 by Naturalis
All rights reserved.

First published in 1980 by
Naturalis Verlags- und Vertriebsgesellschaft mbH
Munich–Mönchengladbach

Publisher	**Kurt Blüchel**
President	Joachim F. Hamacher
Designer	Claus-J. Grube
English Text Designer	Nancy Kirsh
Picture Editor	Klaus Griehl
Text Editors	Wolfgang Thielke, Petra Apfel
English Text Editor	Elizabeth R. Hock
Maps	Rudolf Renk, Munich
Technical Production	Josef Bütler, Zurich
	American Book–Stratford Press, Inc.
Printer	Ringier & Co., AG, Zofingen
Bindery	Sigloch, Künzelsau

Printed in Switzerland by Ringier & Co., AG

Library of Congress Catalog Card No. 81–51121
ISBN: 0–531–09857–5